CULTURE
&VALUES

To Clark Baxter
Slim customer, cherished friend

CULTURE & VALUES

A SURVEY OF THE HUMANITIES

VOLUME I

NINTH EDITION

LAWRENCE S. CUNNINGHAM

John A. O'Brien Professor of Theology
University of Notre Dame

JOHN J. REICH

Syracuse University
Florence, Italy

LOIS FICHNER-RATHUS

The College of New Jersey

Australia • Brazil • Canada • Mexico • Singapore • United Kingdom • United States

Culture & Values:
A Survey of the Humanities, Volume I,
Ninth Edition
Lawrence S. Cunningham, John J. Reich,
Lois Fichner-Rathus

Product Director: Monica Eckman

Product Manager: Sharon Adams Poore

Content Developer: Rachel Harbour

Product Assistant: Danielle Ewanouski

Senior Marketing Manager: Jillian Borden

Senior Content Project Manager: Lianne Ames

Senior Art Director: Cate Rickard Barr

Manufacturing Planner: Julio Esperas

IP Analyst: Christina Ciaramella

IP Project Manager: Kathryn Kucharek

Production Service: Thistle Hill Publishing Services, LLC

Compositor: Cenveo® Publisher Services

Text and Cover Designer: Chrissy Kurpeski

Cover Image: © imageBROKER/Alamy Stock Photo

For product information and technology assistance, contact us at
Cengage Customer & Sales Support, 1-800-354-9706
or support.cengage.com.

For permission to use material from this text or product, submit all requests online at **www.copyright.com**.

Library of Congress Control Number: 2016945332

Student Edition:
ISBN: 978-1-305-95810-4

Loose-leaf Edition:
ISBN: 978-1-337-11658-9

Cengage
200 Pier 4 Boulevard
Boston, MA 02210
USA

Cengage is a leading provider of customized learning solutions with employees residing in nearly 40 different countries and sales in more than 125 countries around the world. Find your local representative at **www.cengage.com**.

To learn more about Cengage platforms and services, register or access your online learning solution, or purchase materials for your course, visit **www.cengage.com**.

Printed at CLDPC, USA, 08-22

Contents

Rome 123

Early Civilizations of South Asia, China, and Japan 165

The Rise of the Biblical Tradition 203

Early Christianity: Ravenna and Byzantium 229

The Islamic World 253

The Rise of Medieval Culture 279

The High Middle Ages 309

The Fourteenth Century: A Time of Transition 341

The Fifteenth Century 375

The High Renaissance and Mannerism in Italy 415

Reading and Playlist Selections

ⓘ MindTap for *Culture & Values*, Ninth Edition, provides direct links to the unabridged versions of these literary excerpts in the Questia online library.

Preface to the Ninth Edition

The ninth edition of *Culture & Values* continues its mission to inform students of the history of humankind through the lens of the humanities—language and literature, art and architecture, music, philosophy, and religion. Through the study of the humanities, we aim not only to *know* but to *understand*—to consider what humans across time and lands have thought about; and how they have felt or acted; how they have sought to come to terms with their relationship to the known and the unknown; and how culture has influenced them to develop and express their ideas, ideals, and their inner selves. *Culture & Values* encourages students to place their own backgrounds and beliefs in context and to consider how understanding both their own and other heritages contributes to becoming a citizen of the world in the 21st century.

WHAT'S NEW IN THE NINTH EDITION

Professors who have taught with earlier editions of the book will find that the ninth edition is familiar, yet, in many respects, quite new. Readers of the ninth edition will discover a new chapter on the Americas, three new types of features, and new works throughout, including numerous new maps.

New Features

The ninth edition has three new features designed to engage students and to demonstrate the relevance of the humanities to their contemporary world:

THE NEW CULTURE AND SOCIETY FEATURE highlights relationships between cultural and social developments, both ancient and modern. A sampling of topics includes:

- The "Theater of War," a project in which contemporary screen and stage actors participate in readings of ancient Greek tragedies to heighten awareness of posttraumatic stress disorder (PTSD) among veterans of the Iraq and Afghanistan wars.
- "A Technological Revolution: The Export of Humanist Learning," discusses how the invention of moveable type and the innovation of papermaking combined to make possible the widespread dissemination of knowledge in the West.

THE NEW CONNECTIONS FEATURE draws parallels between works of art and literature, relays contemporary responses to ancient events, and offers engaging new perspectives on cultural figures and monuments. Examples include:

- The use of computerized tomography (CT scanning) by Italian archaeologists excavating in Pompeii to better understand the daily lives and habits of the citizens of Pompeii prior to the eruption of Mount Vesuvius in 79 CE.
- The literary musings of 19th-century American writer Washington Irving—renowned for *The Legend of Sleepy Hollow*—that were inspired by his stay in the legendary Moorish palace, the Alhambra, in Granada, Spain.

THE NEW RELIGION FEATURE presents essential aspects and tenets of belief systems past and present, including:

- The Four Noble Truths of Buddhism
- The Five Pillars of Islam

WHAT'S NEW IN THE NINTH EDITION—CHAPTER BY CHAPTER

1 Beginnings

- New illustrations and new works of art, including Neanderthal jewelry dating back 130,000 years and handprint stencils dating from 35,000 BCE from the El Castillo Cave in Spain
- Culture and Society feature: "Mesopotamia: Tycoons of Trade"
- Connections feature: The Rosetta Stone

2 The Rise of Greece

- Excerpts from Robert Fitzgerald's translation of *The Odyssey*
- Connections feature: The Death of Sarpedon in Homer's *The Iliad* and Attic vase painting

3 Classical Greece and the Hellenistic Period

- New illustrations, including dramatic views of the Acropolis in Athens
- Culture and Society feature: "The Women Weavers of Ancient Greece"

- Culture and Society feature: "Theater of War," a program in which contemporary actors, including Jake Gyllenhaal and Paul Giamatti, do readings of the Greek play *Ajax* to help Iraq and Afghanistan veterans cope with PTSD

- Connections feature: The Pergamon Altar through the lens of contemporary German photographer Thomas Struth

4 Rome

- Excerpts from Rolphe Humphries's translation of Virgil's *The Aeneid*

- New illustrations of the Ara Pacis, the Pantheon, the Column of Trajan, and more

- Connections feature: A comparison of Ibsen's *Cataline* and Cicero's speeches against his accused conspirator

- Connections feature: A comparison of the character of Julius Caesar in Shakespeare's tragedy and stoic philosophers in ancient Rome

- Connections feature: Anthropologists' use of CT scanning to investigate the daily lives and habits of Pompeiians prior to the eruption of Mount Vesuvius in 79 CE

- Connections feature: A comparison of Mussolini's "Square Colosseum" and the ancient Roman Colosseum

5 Early Civilizations of South Asia, China, and Japan

- New coverage of Southeast Asia (including Java and Cambodia) and Japan

- New illustrations, including photos, of the citadel of Mohenjo-daro and the Longmen grottoes of Luoyang, China

- Connections feature: The use of holographic projection to "bring back to life" Afghanistan's Bamiyan Buddhas, destroyed by the Taliban in 2001

6 The Rise of the Biblical Tradition

- New illustrations, including images of Syria's Synagogue at Dura-Europos and the Church of the Holy Sepulcher in Jerusalem

- Connections feature: William Blake's watercolor drawings and engraved illustrations for the Book of Job

- Connections feature: The looting of Dura-Europos and the bombing of Palmyra by the Islamic State

7 Early Christianity: Ravenna and Byzantium

- New illustrations

- Discussion of the Blues versus the Greens and the Nika riots in Byzantium

- Connections feature: A comparison between St. Augustine's views as expressed in *The Literal Meaning of Genesis* and the Church's sentencing of Galileo for heresy

- Connections feature: The Sarah Bernhardt/Theodora nexus—the 19th-century actress's identification with the Byzantine empress

8 The Islamic World

- Discussion and illustration of the poetic inscriptions and *miradors* of the Alhambra palace

- Discussion and illustration of the intersection of the Cathedral and the Mosque of Córdoba

- Connections feature: The shrine of John the Baptist in the Umayyad Great Mosque in Damascus

- Connections feature: American writer Washington Irving's *Tales of the Alhambra*

- Connections feature: The Islamic art of tessellation in Seville's Alcázar palace

9 The Rise of Medieval Culture

- Excerpts from Seamus Heaney's translation of *Beowulf*

- New illustrations, including images of Saint Sernin in Toulouse and the Palatine Chapel at Aachen

- Connections feature: The role of Irish monks in preserving the works of antiquity during years of European instability

10 The High Middle Ages

- New illustrations of French cathedral architecture, sculpture, and stained glass

- New chapter preview: The monastery at Skellig Michael, setting for the final scene of *Star Wars: The Force Awakens*

- Connections feature: Abelard and Héloïse, love and death

11 The Fourteenth Century: A Time of Transition

- New discussion and illustration of Gloucester Cathedral

- Connections feature: Judy Chicago celebrates 14th-century feminist Christine de Pizan in *The Dinner Party*

- Connections feature: Critical responses to Brunelleschi's *duomo* for Santa Maria del Fiore (the Cathedral of Florence)

12 The Fifteenth Century

- Culture and Society feature: "A Technological Revolution: The Export of Humanist Learning"

- Connections feature: Cosimo de' Medici and Donatello

- Connections feature: Botticelli's Venus and the Aphrodite of Knidos

13 The High Renaissance and Mannerism in Italy

- New illustrations, including new views of the Sistine Chapel, the Tempietto, and the Villa Rotunda

- Connections feature: Papermaking and Leonardo's experimental sketches and drawings
- Connections feature: The mutilation and restoration of Michelangelo's *Pietà*

Familiar Features in the Ninth Edition

A DYNAMIC, ELEGANT, AND ACCESSIBLE DESIGN that features brilliant, accurate color reproductions of works of art along with large-format reproductions of original pages of literary works. Students will be able to fully appreciate the visual impact of these works and may be inspired to seek out art in museums and to visit historic sites.

CHAPTER PREVIEWS draw students into the material of each chapter by connecting intriguing works of art and other images with the ideas and ideals that permeate the eras under discussion, encouraging students to face each new period with curiosity and anticipation. At the same time, the previews reinforce connections to the knowledge students have accumulated from previous chapters.

COMPARE + CONTRAST features present two or more works of art or literature side by side and encourage students to focus on stylistic, technical, and cultural similarities and differences. The features promote critical thinking by encouraging students to consider the larger context in which works were created, honing their interpretive skills and challenging them to probe for meaning beyond first impressions. Compare + Contrast features parallel the time-honored pedagogy of analyzing works of art, texts, and ideas by describing their similarities and differences.

TIMELINES in each chapter give students a broad framework for the periods under discussion by highlighting seminal dates and events.

END-OF-CHAPTER GLOSSARIES provide students with an efficient way to access and review key terms and their meanings.

THE BIG PICTURE feature at the end of each chapter summarizes the cultural events and achievements that shape the character of each period and place. Organized into categories (Language and Literature; Art, Architecture, and Music; Philosophy and Religion), the Big Picture reinforces for students the simultaneity of developments in history and the humanities.

ACKNOWLEDGMENTS

We first acknowledge the reviewers—our colleagues who, as instructors in the humanities survey, collectively have shaped student encounters with art, music, religion, philosophy, and literature over generations. The extent to which *Culture & Values*, Ninth Edition, meets their pedagogical needs and inspires their students—and yours—is a direct result of their willingness to share—and our commitment to learn from—their expertise and experiences. They have had the enduring patience to read the text meticulously to inform us of any shortcomings, and they have inspired us with their unique pedagogical visions. Sincere gratitude and thanks to the reviewers for the ninth edition: Yubraj Aryal, Purdue University; Terri Birch, Harper College; Steven Cartwright, Western Michigan University; Erin Devin, Northern Virginia Community College; Taurie Gittings, Miami Dade College; Charles Hill, Gadsden State Community College; Sean Hill, Irvine Valley College; Garry Ross, Texas A&M University—Central Texas; Arnold Schmidt, California State University, Stanislaus; Teresa Tande, Lake Region State College; and Scott Temple, Cleveland Community College.

The authors acknowledge that an edition with revisions of this magnitude could not be undertaken, much less accomplished, without the vision, skill, and persistent dedication of the superb team of publishing professionals at Cengage Learning. First and foremost is Sharon Adams Poore, our Product Manager, who, as always, guides a project with steady and collegial hands, seamlessly meshing author and publisher, needs and desires, idea and reality. She is our touchstone, our champion, our trusted friend; Rachel Harbour, our Content Developer, worked intensely day by day, bringing her grasp of cultural matters and her global insights to the evaluation and enhancement of nearly every word and phrase in the manuscript—all for the better; Danielle Ewanouski, Product Assistant; Lianne Ames, our veteran Senior Content Project Manager, the enviable master of all she surveys, who guarantees that all of the pieces fit and that everything keeps moving along consistently and coherently, and who always finds a way to marry pedagogy, aesthetics, and quality of production in spite of crushing deadlines; Cate Barr, our Senior Art Director, whose splendid taste, acumen, and flexibility resulted in the exceptional print or digital text you find before you—without Cate as our design "rudder," we would never bring the ship of our dreams to port; Christina Ciaramella, Intellectual Property Analyst; Kathryn Kucharek, Intellectual Property Project Manager; and, last but not least, Jillian Borden, our Senior Marketing Manager—without Jillian's strategic and boundlessly creative mind, her enthusiasm and energy, and belief in the authors and products in her keeping, our efforts to support the teaching of humanities might never come to fruition.

We can only list the others involved in the production of this edition, although they should know that we are grateful for their part in making *Culture & Values* a book we are proud to present:

Chrissy Kurpeski, interior and cover designer; Angela Urquhart, editorial project manager at Thistle Hill Publishing; and Corey Smith and Kristine Janssens, photo and literary permissions researchers at Lumina Datamatics.

Lois Fichner-Rathus would also like to thank Spencer Rathus, her husband, silent partner, and true-to-life "Renaissance man" for the many roles he played in the concept and execution of this edition.

ABOUT THE AUTHORS

Lawrence Cunningham is the John A. O'Brien Professor of Theology at the University of Notre Dame. He holds degrees in philosophy, theology, literature, and humanities. John Reich, of Syracuse University in Florence, Italy, is a trained classicist, musician, and field archaeologist. Both Cunningham and Reich have lived and lectured for extended periods in Europe.

Lois Fichner-Rathus is Professor of Art and Art History at The College of New Jersey. She holds degrees from the Williams College Graduate Program in the History of Art and in the History, Theory, and Criticism of Art from the Massachusetts Institute of Technology. In addition to being co-author of *Culture & Values*, she is the author of the Cengage Learning textbooks *Understanding Art* and *Foundations of Art and Design*. She teaches study-abroad programs in Paris, Rome, Spain, and Cuba and resides in New York.

RESOURCES

For Faculty

MINDTAP® FOR INSTRUCTORS Leverage the tools in MindTap for *Culture & Values*, Ninth Edition, to enhance and personalize your course. Add your own images, readings, videos, web links, projects, and more to your course Learning Path. Set project due dates, specify whether assignments are for practice or a grade, and control when your students see these activities in their course. MindTap can be purchased as a stand-alone product or bundled with the print text.

Connect with your Learning Consultant for more details via *www.cengage.com/repfinder*.

FULL READINGS IN QUESTIA This edition's MindTap includes free access to Questia, an online research library with tens of thousands of digital books and millions of academic journal articles. Links to the full versions of many of the literary works excerpted in the ninth edition appear within the MindTap version of the text. Look for the Questia icon next to individual readings on pages x–xiii of the print book to see which readings are available and linked within MindTap.

For Students

MINDTAP FOR STUDENTS MindTap for *Culture & Values* helps you engage with your course content and achieve greater comprehension. Highly personalized and fully online, the MindTap learning platform presents authoritative Cengage Learning content, assignments, and services, offering you a tailored presentation of course curriculum created by your instructor.

MindTap guides you through the course curriculum via an innovative Learning Path Navigator where you will complete reading assignments, annotate your readings, complete homework, and engage with quizzes and assignments. This edition's MindTap features a two-pane e-reader, designed to make your online reading experience easier. Images discussed in the text appear in the left pane, while the accompanying discussion scrolls on the right. Highly accessible and interactive, this new e-reader pairs videos, Google Map links, and 360-degree panoramas with the matching figure in the text.

WRITING AND RESEARCH TOOLS IN QUESTIA The MindTap for this edition of the text includes free access to Questia, a digital research library replete with tips and instruction on how to complete research- and writing-based activities for your course. You can view tutorials and read how-to advice on the steps of completing a research paper, ranging from topic selection to research tips, proper citation formats, and advice on how to structure a critical essay. Look for links to many of these resources available through Questia right in the Learning Path of your course.

CULTURE & VALUES

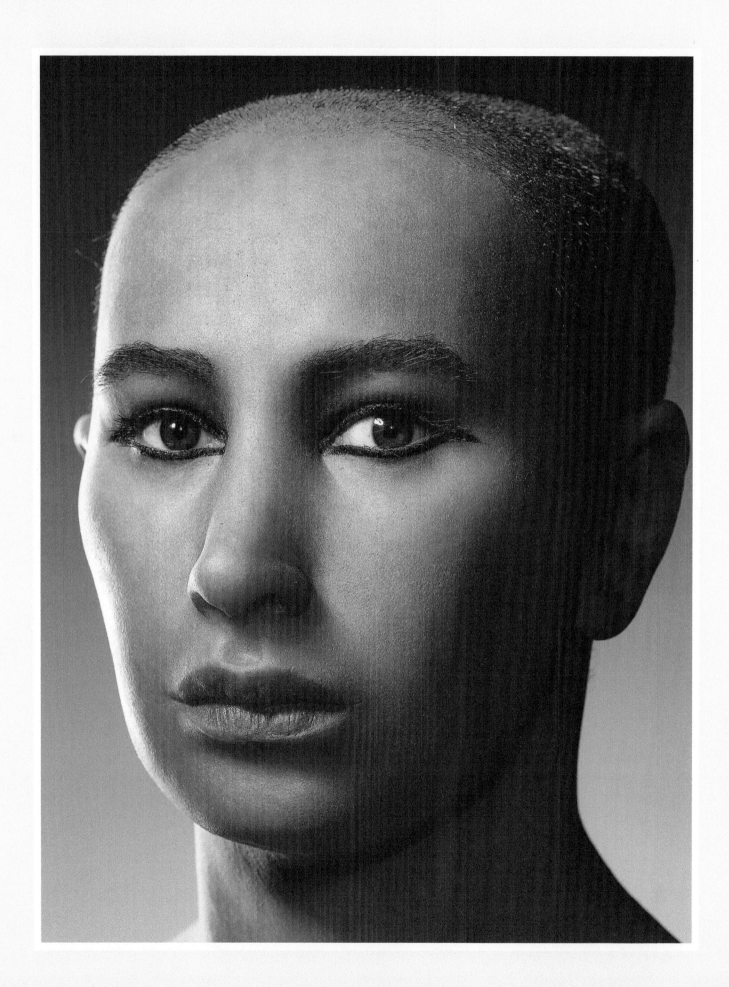

Beginnings

PREVIEW

The Valley of the Kings, Luxor, Egypt; January 5, 2005: Nearly 3300 years after his death, Tutankhamen's leathery mummy was delicately removed from its tomb and guided into a portable CT scanner. It was not the first time—or the last—that modern technology would be tapped to feed the curiosity of scientists, archaeologists, and museum officials about the mysteries surrounding the reign and death of the legendary boy-king Tut who was crowned at the age of eight and died only 10 years later. Earlier X-rays revealed a hole at the base of Tut's cranium, leading to the suspicion that he was murdered. This time around, the focus—and the conclusions—changed. Scientists found a puncture in Tut's skin over a severe break in his left thigh. As it is known that this accident took place just days before his death, some experts on the scanning team conjectured that this break, and the puncture caused by it, may have led to a serious infection and Tut's consequent death. (Otherwise, the young pharaoh was the picture of health—no signs of malnutrition or disease, with strong bones and teeth, and probably five and a half feet tall.)

Scientists, including experts in anatomy, pathology, and radiology, spent two months analyzing more than 1700 high-resolution three-dimensional images taken during the CT scan. Then artists and scholars took a turn. Three independent teams, one each from Egypt, France, and the United States, came up with their own versions of what Tut might have looked like in life: a bit of an elongated skull (normal, they say), full lips, a receding chin, and a pronounced overbite that seems to have run in the family. It was the first time—but certainly not the last—that CT scans would be used to reconstruct the faces of the Egyptian celebrity dead (Fig. 1.1).

We stare at Tut's image, and his gaze transfixes us. We set aside the bubble-bursting fact that it is a computer-generated rendering, not unlike any we might see in video games, and allow ourselves to put a face to the name. The unknown becomes tangible; the myth, a reality. What does this fixation reveal about us, about our needs, about human nature? Perhaps that we have a desire to connect with the *humanness* of our ancestors, to know them as we know anyone else. We study history to discover how events have sculpted the course of human existence and to fill in our chronological blanks. But it is in the study of what people thought about themselves and cared enough about leaving behind—philosophy and religion, literature, the arts and architecture—that we find our connection to humanity.

◀ **1.1 King Tutankhamen's face reconstructed.** This silicone bust is believed to be an accurate forensic reconstruction of the face of the Egyptian pharaoh, also called King Tut, who died some 3300 years ago at the age of about 18 or 19. It is based on CT scans of the mummy.

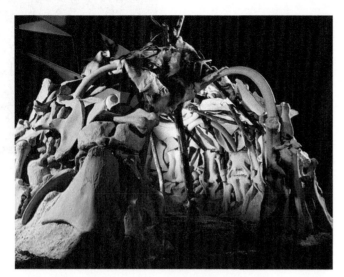

▲ **1.2 Mammoth Bone Hut, Teeth Tusks, and Tar Pits, ca. 15,000 BCE. Exhibit, The Field Museum of Natural History, Chicago, Illinois.** This house was built of hundreds of mammoth bones by hunters on windswept, treeless plains in Ukraine. Working as a team, hut builders needed only a few days to haul together hundreds of massive bones and stack them into a snug abode.

BEFORE HISTORY

Archaeologists have unearthed bits and pieces of culture that predate the age of Tutankhamen by thousands, if not tens of thousands, of years. Scientists have determined that our species—*Homo sapiens*—walked the Earth at least 150 millennia before the famous pharaoh was born. And incredible as it may seem, a thousand centuries before Tut adorned his eyes with black pigment, someone in a prehistoric workshop was mixing paint.

The words *Stone Age* can conjure an image of our human ancestors dressed in skins, huddling before a fire in a cave, while the world around them—the elements and the animals—

threatens their survival. We may not envision them as intelligent and reflective, as having needs beyond food, shelter, and the survival of the species. But they did have beliefs and rituals; they did make art and music. They were self-aware. They wanted to preserve and communicate something of who they were, what they had done, and how they mattered, even if they had, as yet, no ability to write.

What we know about the origins of the human family is constantly changing. As this book was being revised for its ninth edition, for example, researchers announced the discovery of a new hominid species—*Homo naledi*—whose bones were found deep in a South African cave by that name. The discovery seems to suggest that the bodies were purposefully placed in the remote chamber and are an indication of some sort of ritualized burial practice.

Prehistoric art and culture—created before recorded history—are divided into three phases that correspond to the periods of the Stone Age: Paleolithic (ca. 2,500,000–ca. 10,000 BCE; the Old Stone Age), Mesolithic (ca. 10,000–ca. 8000 BCE; the Middle Stone Age), and **Neolithic** (ca. 5500–ca. 2500 BCE; the New Stone Age). Archaeological finds from the Stone Age include cave paintings; relief carvings; figurines of stone, ivory, and bone; jewelry; and musical instruments. The first works of art feature "stenciled handprints," geometric symbols, animals, and abstracted human figures. The earliest humans found shelter in nature's protective cocoons—the mouth of a yawning cave, the underside of a rocky ledge, the dense canopy of a wide-spreading tree. Beyond these ready-made opportunities, they sought ways to create shelter. But before humans devised ways of transporting materials over vast distances, they had to rely on local possibilities. Fifteen thousand years ago, humans dragged the skeletal remains of woolly mammoths to a protective spot and piled them into dome-like structures complete with a grand entrance framed by colossal tusks. The author Howard Bloom quipped, "First came the mammoth, then came architecture" (**Fig. 1.2**). In all, very few Stone Age structures have survived.

Before History

2.5 Million BCE	10,000 BCE 8000 BCE	1600 BCE
PALEOLITHIC PERIOD (OLD STONE AGE)		**NEOLITHIC PERIOD (LATE STONE AGE)**
First ritual burying of the dead		Humans settle communities
Neanderthals make jewelry		Agriculture begins; farmers make and use pottery
Homo sapiens (and perhaps Neanderthals) create paintings on cave walls		Humans create large-scale sculptures and architecture
Humans carve small figurines		Humans continue to carve small figurines
Hunting provides the main food source		Tools and weaponry are made of bronze
Implements and weapons are made of stone		

Paleolithic Developments

Archaeological evidence points to the existence of Neanderthals (our cousins, but not our direct ancestors) going back 300,000 to 500,000 years; paleontologists who discovered the first fossilized remains of the species in Germany's Neanderthal Valley coined the term *Neanderthal*. These "cousins" of ours populated parts of Europe, Asia, and Africa—the continent to which we can trace our own, true genetic ancestry—that of *Homo sapiens*—back about 150,000 years. We, too, spread northward into what is now Europe some 43,000 to 45,000 years ago and coexisted with Neanderthals for, perhaps, 10,000 to 15,000 years. By sometime around 30,000 BCE, however, the Neanderthal species was extinct. How and why this happened is not definitively known, although *Homo sapiens* may have brought it about. That does not mean, however, that Neanderthal DNA ceased to exist; intermingling and interbreeding between Neanderthals and *Homo sapiens* has ensured that a least a bit of their genetic legacy survives in us.

You may have heard the word *Neanderthal* slung as an insult toward someone seen as brutish, uncultured, intellectually

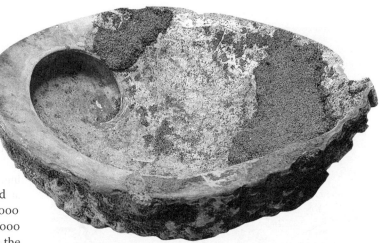

▲ **1.4 Abalone shell, ochre filled, ca. 100,000 BCE, Blombos Cave, Still Bay, South Africa. Residue of liquefied ochre-rich mixture ca. ¼" (5 mm) deep.** It is believed that humans mixed the first known paint in this abalone shell.

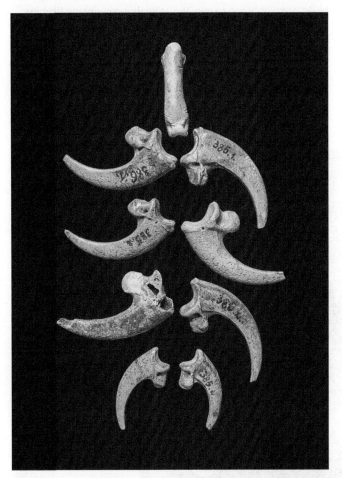

▲ **1.3 A Neanderthal Necklace or Bracelet Made of Eagle Talons, ca. 130,000 BCE.**

backward, or basic-skill-deprived, and the genesis of our claim to superiority certainly has its roots in the perception that Neanderthals were a primitive group superseded by our own, "superior" ancestors. It is a narrow picture at the very least. Recent discoveries of rock art in a Gibraltar cave have contributed to debunking previously held notions that Neanderthals had neither the brainpower nor the technical means for artistic expression. Excavations in what is modern-day Croatia have yielded, among other things, necklaces and bracelets fashioned from eagle talons (**Fig. 1.3**), indicating that Neanderthals were interested in body adornment, whether as objects of ritual or luxury.

First and foremost, though, the **Paleolithic** period is marked by the making of tools. *Homo sapiens* used blades of flint rock to create hammerstones, chisels, axes, and weapons that were useful in cutting and gathering edible plants and also in hunting game. Flint was also the material that led to the real technological and, hence, developmental game changer for Stone Age humans: the discovery of fire. Learning to maintain it and harnessing its potential became the wellspring of material culture.

The importance of such tools—such technology—to human survival is clear. But a discovery in a South African cave has given us insight into Stone Age "chemistry": 100,000 years ago, *Homo sapiens* created paints for their cave murals and, perhaps, body decoration from earth pigments that they pounded and ground and liquefied to a consistency that could be scooped out of a large abalone shell with a spatula made of bone (**Fig. 1.4**).[1]

It is also possible that Neanderthals created some of the earliest cave paintings we find in present-day Spain. The ones in

1. C. S. Henshilwood et al. A 100,000-year-old ochre-processing workshop at Blombos Cave, South Africa. *Science* 334, no. 6053 (2011): 219–222.

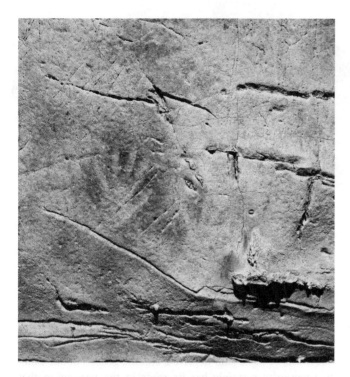

▲ **1.5 Hand Stencils at the El Castillo Cave in Spain, ca. 35,000** BCE. Archaeologists have wondered whether the earliest European cave paintings were made by Neanderthals.

question include handprints, reddish disks, club-like symbols, and other geometric designs (**Fig. 1.5**). Depictions of animals came later and were more likely to have been created by our direct ancestors.

Many of the great cave paintings of the Old Stone Age were discovered by accident in northern Spain and southwestern France. At Lascaux, four teenagers found a hole in the ground and went exploring and discovered vibrant paintings of bison, horses, and cattle that are estimated to be more than 15,000 years old. At first, because of their realism and fresh appearance, the paintings were thought to be forgeries, but geological methods proved their authenticity.

One of the most splendid examples of Old Stone Age painting, the so-called Hall of the Bulls (**Fig. 1.6**), was found in a cave at Lascaux in southern France. Here, lively animals—bulls, reindeer, horses—were drawn on the walls, some superimposed upon one another, stampeding in all directions. The artists captured the simple contours of the beasts with bold, confident black lines and then filled in details with shades of ground ochre and red pigments. A variety of materials and techniques were used to create an element of naturalism. Chunks of raw pigment were dragged along the rocky wall surface, and color was applied with fingers and sticks. Some areas of the murals reveal a "spray-painting" technique in which dried, ground pigments were blown through a hollowed-out bone or reed. Although the tools were simple, the results were sophisticated. **Foreshortening** (a perspective technique) and modeling (using light and gradations of shade to create an illusion of roundness), although rough and basic, are combined to give the animals a convincing likeness.

Why did early humans create these paintings? We cannot know for certain, though it is unlikely that they were merely decorative. The paintings were found in the deepest, almost unreachable, recesses of the caves, far from the areas that were inhabited. New figures were painted over earlier ones with no regard for a unified composition; researchers believe that

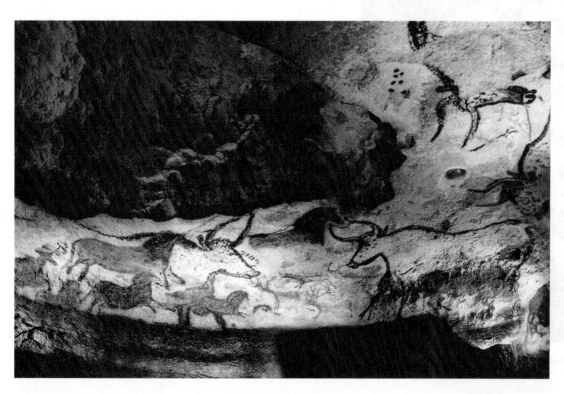

◄ **1.6 Hall of the Bulls, ca. 16,000– 14,000** BCE. Cave paintings like these were probably associated with prehistoric rituals that may have included music. Some researchers believe that the caves may have been chosen for their acoustical properties and that the paintings had some sort of magical significance connected to game hunts during the hunter-gatherer phase of Paleolithic culture.

successive artists added to the drawings, respecting the sacredness of the figures that were already there. Some have conjectured that the paintings covering the walls and ceilings embellished a kind of inner sanctuary where religious rituals concerning the capture of prey were performed. In capturing these animals in art, did Stone Age people believe that they would guarantee success in capturing them in life?

Archaeological evidence also suggests a relationship between music and art in the Paleolithic period. The remains of several ancient flutes with finger holes, carved from bone and ivory at least 35,000 years ago, were found in caves near wall paintings (**Fig. 1.7**).[2] Were these Paleolithic concert halls? Because the art appears in the deeper recesses of the caves, one scientist has conjectured that the spots were chosen for their acoustical resonance and afterward painted with backdrops for ritual ceremonies. The natural acoustics of a carved-out cave would have amplified musical rhythms and voices. We can picture a mysterious-looking interior, illuminated by torches, with early humans singing and dancing before the images and chanting to the music of flutes and drums, the sounds echoing through the spaces.

Prehistoric artists also created small figurines, called Venuses by the first archaeologists who found them. The most famous of these is the so-called *Venus of Willendorf* (**Fig. 1.8**), named after the site in Austria where it was unearthed. The tiny stone sculpture is just over four inches high and bears characteristics similar to those of other female figures that may represent earth mothers or fertility goddesses: the parts of the body associated with fertility and childbirth are exaggerated in relation to the arms, legs, and head. Does this suggest a concern for survival of the species? Or was this figure of a fertile woman created and carried around as a talisman for fertility of the earth itself—abundance in the food supply? In any case, early humans may have created their images, and perhaps their religion, as a way of coping with—and controlling—that which was unknown to them.

Neolithic Developments

During the New Stone Age, life became more stable and predictable. People domesticated plants and animals, and food production took the place of food gathering. Improved farming techniques made it possible for a community to accumulate stores of grain and thereby become less dependent for its survival on a good harvest each year. In some areas, toward the end of the Neolithic period, crops such as maize, squash, and beans were cultivated. Pottery was invented around 5000 BCE, and not long afterward, metal began to replace stone as the principal material for tools and weapons. The first metal used was copper, but it was soon discovered that an alloy of copper and tin would produce a far stronger metal: bronze. The use of bronze became widespread, giving its name to the Bronze Age, which lasted from around 3000 BCE to the introduction of iron around 1000 BCE. In some places, writing appeared. People began to move into towns and cities, and significant architectural monuments were erected.

Jericho was built around an oasis on a plateau in the Jordan Valley of the Middle East. As Jericho prospered, the inhabitants saw the need to protect themselves—and their water—from roaming nomads, so they built the first known stone defenses. The walls surrounding the city were 5 feet thick, and remains have been found of at least one circular tower, 30 feet high and 33 feet in diameter, constructed (without mortar) of precisely laid stones (**Fig. 1.9**). The tower had an interior staircase leading to the top from which guards could have kept watch for invaders and used the high ground to defend against them. Jericho was abandoned ca. 7000 BCE, but another level of excavation revealed that it was occupied by a second wave of settlers.

◀ **1.7 Bone flute**, ca. 35,000 BCE, Isturitz (Pyrénées), France. Vulture wing bone, hollow, 8⅜" (21.2 cm) long. Musée d'Archeologie Nationale, Saint-Germain-en-Laye, France.

▶ **1.8** *Venus of Willendorf*, ca. 28,000–25,000 BCE, Willendorf, Austria. Limestone, 4¼" (10.8 cm) high. Naturhistorisches Museum, Vienna, Austria. This figurine is one of numberless representations of earth-mother goddesses from the Paleolithic period. Parts of the body associated with fertility and childbearing have been emphasized.

2. N. J. Conard, M. M. Malina, & S. C. Münzel. New flutes document the earliest musical tradition in southwestern Germany. *Nature* 460 (2009): 737–740.

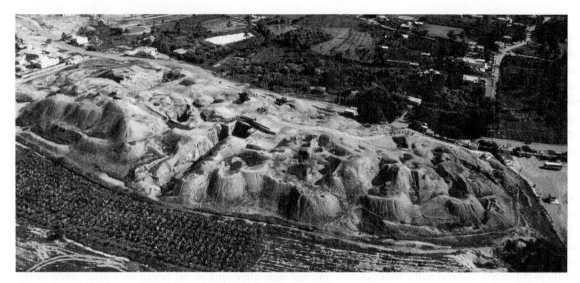

◀ **1.9 Aerial view of Neolithic Jericho, ca. 8000–7000** BCE. The defensive walls of the Neolithic city of Jericho were constructed of stone without mortar.

Human skulls with facial features restored in plaster were found buried beneath the floors of Jericho's houses. Painted details that individualize the skulls suggest that they served as rudimentary portraits, perhaps of ancestors.

Arguably the most famous monument that we know of dating from the Neolithic period is Stonehenge (Fig. 1.10), located on Salisbury Plain in southern England. It consists of two concentric rings of colossal stones surrounding others placed in a U configuration. Some of these *megaliths* (from the Greek, meaning "large stones") weigh several tons and are evidence of Neolithic engineering capabilities. The purpose of Stonehenge remains an ongoing subject of speculation ranging from the outrageous to the plausible. Archaeologists and astronomers posited some time ago that the monument served as a solar calendar and observatory that charted the movements of the sun and moon, as well as eclipses. Theories, for the most part, aim to explain the scale and configuration of the stones from the perspective on the ground. But in the fall of 2015, Julian Spalding—an art critic and former museum director—floated another idea: perhaps what we are looking at now is a foundation of stone "stilts" that supported a massive circular wooden platform for ceremonies and participants. In an interview in the British newspaper, *The Guardian*, Spalding said, "All the interpretations to date could be mistaken. We've been looking at Stonehenge the wrong way: from the earth, which is very much a 20th-century viewpoint. We

▼ **1.10 Stonehenge, ca. 2550–1600** BCE, **Salisbury Plain, Wiltshire, England. Approximately 24' high × 97' across (732 × 2957 cm).** The function of Stonehenge remains a mystery, although it is believed to have been some sort of astronomical observatory and solar calendar.

haven't been thinking about what they were thinking about."[3] Whether his theory stands the test of time is yet to be determined, but Spalding's point regarding the role that our limited worldview plays in stifling new perspectives and inquiry is well taken.

The Neolithic period in Europe overlapped with the beginning of civilization in the Middle East, ca. 5000 BCE. *Civilization* is so broad a term that it is not easy to define simply. Societies that qualify for the label "civilized" generally possess most, if not all, of the following characteristics:

- some form of urban life involving the construction of permanent settlements—cities, in short
- a system of government that regulates political relations
- the development of distinct social classes, distinguished from one another by the two related factors of wealth and occupation
- tools and specialized skills for the production of goods, leading to the rise of manufacturing and trade
- some form of written communication, making it possible to share and preserve information

3. D. Alberge. (2015, March 15). Circular Thinking: Stonehenge's Origin Is Subject of New Theory. *The Guardian.*

- a shared system of religious belief, whose officials or priests often play a significant role in community affairs

Civilization is no guarantee of what most people would consider civilized behavior. As the 20th century demonstrated, some of the most civilized societies in history can be responsible for incalculable human suffering.

The wellsprings of our own civilization reach back to developments in ancient cultures across the globe, including the great river cultures established in the Fertile Crescent of Mesopotamia's Tigris and Euphrates Rivers and along the Fertile Ribbon of the Nile River in Egypt. Water provided sustenance and, as for the ancient cultures of the Aegean, opportunities for trade and interaction with other parts of the known world.

MESOPOTAMIA

Civilization began in what is today the country of Iraq, on land made fertile by the Tigris and Euphrates Rivers that join and empty into the Persian Gulf. Called the Fertile Crescent, that area of land is essentially flat and, thus, ultimately indefensible. The story of ancient civilization in this region—Mesopotamia— is the story of a succession of ruling peoples, each with their own language, religion, customs, and art.

Mesopotamia

3500 BCE	2332 BCE	2150 BCE	1600 BCE	612 BCE	559 BCE	330 BCE	636 CE
SUMERIAN	AKKADIAN	NEO-SUMERIAN AND BABYLONIAN	HITTITE AND ASSYRIAN	NEO-BABYLONIAN	ACHAEMENIAN	GRAECO ROMAN AND SASSANIAN	
First cities emerge, the largest at Uruk Cuneiform writing is developed First ziggurats and shrines are constructed First palaces indicate royal authority Reign of Gilgamesh	Sargon unifies Mesopotamia Akkadian is spoken throughout the region Earliest preserved hollow-cast bronze statues	Akkadian empire collapses Mesopotamia is reunited by the kings of Ur Sumerian becomes the chief language Ziggurat at Ur is built Hammurabi gathers 282 laws into a judicial code	Hittites sack Babylon but then leave Mesopotamia Assyrians control major trade routes Ruthless kings build fortified and lavishly decorated palaces Assyrian Empire falls	Neo-Babylonian kings control the former Assyrian Empire Nebuchadnezzar II rebuilds Babylon Hanging Gardens become one of the Seven Wonders of the Ancient World Cyrus of Persia captures Babylon and founds Achaemenian dynasty	Reign of Cyrus the Great and expansion of Persian Empire Egypt falls to Achaemenians Darius I and Xerxes build vast palace complex at Persepolis Achaemenian line ends with defeat by Alexander the Great	Alexander integrates Mesopotamia and Persia into the Graeco-Roman Empire Sassanians challenge Roman rule in Asia New Persian Empire is established Sassanians are driven out of Mesopotamia by Arabs after 400 years	

COMPARE + CONTRAST

Mystery Ladies of the Ancient World

Austria, Bulgaria, Syria, Egypt, Ecuador, India, China, Siberia, Sudan—what do these places have in common? Their prehistoric sites have all yielded versions of what seem to be earth mothers or fertility goddesses, suggesting that in very early cultures, a feminine deity may have occupied the top spot in the pantheon of gods.

As much ties them together as distinguishes them. Their heads and faces are relatively small and far less detailed than other parts of the body, and in almost every example, the limbs

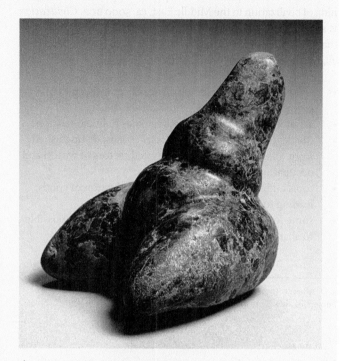

▲ **1.12 Female figurine, 7000–6000 BCE, Syria. Hardstone, 2 ½" (6.4 cm) high. Private collection.**

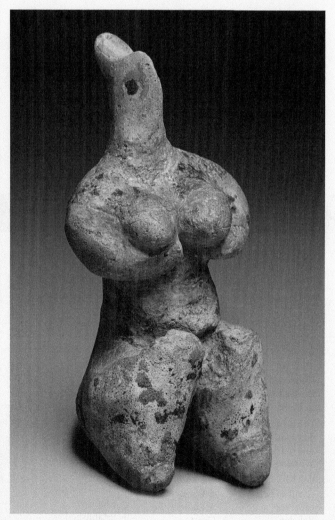

▲ **1.11 Female figurine, 4300–4000 BCE, Turkey. Clay and pigment, 4 ⅛" high × 1 ⅞" wide × 1 ⅝" deep (10.4 × 4.7 × 4.2 cm). Brooklyn Museum, New York.**

are either shortened and stumpy, spindly, or wholly absent (Fig. 1.11). The conclusion that these figurines may be associated with fertility—or, if not, that they most certainly indicate a fascination with the life-giving mysteries of the female body—is drawn from the fact that attributes of the female body associated with fertility and childbearing are emphasized or exaggerated

Beyond their basic similarities, the statuettes differ significantly from one another in terms of style and also, perhaps, function. Most of them are tiny, suggesting that they may have been portable talismans. Some, like the Cycladic idols (see Fig. 1.42), the ancient Nubian figure from present-day Sudan (Fig. 1.12), and the so-called *Bird Lady* from predynastic Egypt (Fig. 1.13) are highly simplified or abstract and have a certain appeal to the modern eye. Others, like the *Lady of Pazardzik* from Bulgaria, exhibit fine attention to decorative detail (Fig. 1.14).

Archaeologists and art historians have debated the meaning of the figures, but no real clue to whom or what they represent has survived. Perhaps they served some

ritual purpose or perhaps they were simply dolls. But since they outnumber the men significantly (there are many more sculptures of female figures than male figures in prehistoric art), one thing is clear: the female body represented power.

▲ **1.14 Lady of Pazardzik, ca. 4500 BCE, Bulgaria. Ceramic (burnt clay), 7 ½" (19 cm) high. Naturhistorisches Museum, Wien, Austria.** This enthroned goddess figure is embellished with incised lines in the pattern of a double spiral, an ancient symbol of regeneration.

▲ **1.13 Female figure, ca. 3500–3400 BCE, Egypt. Painted terra-cotta, 11 ½" high × 5 ½" wide × 2 ¼" deep (29.2 × 14 × 5.7 cm). Brooklyn Museum, New York.**

RELIGION

The Gods and Goddesses of Mesopotamia

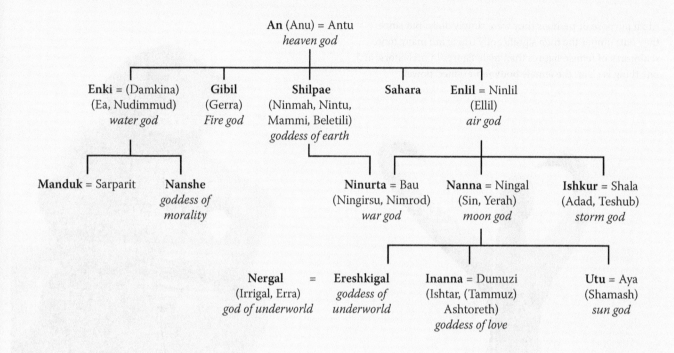

An (Anu) = Antu
heaven god

Enki = (Damkina)
(Ea, Nudimmud)
water god

Gibil
(Gerra)
Fire god

Shilpae
(Ninmah, Nintu,
Mammi, Beletili)
goddess of earth

Sahara

Enlil = Ninlil
(Ellil)
air god

Manduk = Sarparit

Nanshe
*goddess of
morality*

Ninurta = Bau
(Ningirsu, Nimrod)
war god

Nanna = Ningal
(Sin, Yerah)
moon god

Ishkur = Shala
(Adad, Teshub)
storm god

Nergal =
(Irrigal, Erra)
god of underworld

Ereshkigal
*goddess of
underworld*

Inanna = Dumuzi
(Ishtar, (Tammuz)
Ashtoreth)
goddess of love

Utu = Aya
(Shamash)
sun god

The history of Mesopotamia can be divided into two major periods: the Sumerian (ca. 3500–2350 BCE) and the Semitic (ca. 2350–612 BCE, when Nineveh fell). The Sumerian and Semitic peoples differed in their racial origins and languages; the term **Semitic** is derived from the name of Shem, one of the sons of Noah, and as a name for a group of people, it is generally used to refer to those speaking a Semitic language. In the ancient world, these included the Akkadians, Babylonians, Assyrians, and Phoenicians. The most commonly identified Semitic group is the Jewish people, whose traditional language, Hebrew, falls into the same group; they also originated in Mesopotamia (for a discussion of the early history of the Jews, see Chapter 6). Arabic and some other Mediterranean languages—including Maltese—are also Semitic.

Sumer

The earliest Sumerian communities were agricultural settlements on the land between the Tigris and Euphrates Rivers (see Map 1.1). Because the land here is flat, dikes and canals

▲ MAP 1.1 **Ancient Mesopotamia and Persia.**

were needed to irrigate farmland, to control flooding during the rainy season, and to provide water predictably during the rest of the year. Since such large-scale construction projects required a great deal of manpower, small villages often consolidated into towns.

The focus of life in a Sumerian town was the temple, sacred to the particular god who watched over it. The Sumerian gods were primarily deifications of nature: sky and earth, sun and moon, lightning and storms. Anu was the god of the sky, Nanna the god of the moon, and Abu the god of vegetation. The chief religious holidays were linked to the seasons and revolved around rites intended to ensure bountiful crops. The most celebrated was the New Year festival, held in recognition of the pivotal moment when the cold and barren winter (connected to the death of the fertility god Tammuz at the end of his yearly life cycle) made way for a fertile spring (made possible by his resurrection and sacred marriage to the goddess Inanna).

Governing in cities like Uruk was primarily in the hands of the priests, who controlled and administered economic as well as religious affairs. The king served as the representative on earth of the god of the city but, unlike the Egyptian pharaoh, was never thought of as divine nor became the center of a cult. His focus was guarding the spiritual and physical well-being of his people—building grander temples to the gods they relied on or providing for more sophisticated irrigation systems to ensure sustenance. The acquisition of personal wealth, enduring fame, or deified status was not a goal, yet the kings had great power.

The White Temple at Uruk (**Fig. 1.15A** and **Fig. 1.15B**), so called because of its whitewashed walls, is among the

▲ **1.15A Reconstruction of the White Temple and ziggurat.** The White Temple and ziggurat is so called because of its whitewashed walls.

earliest and best-preserved shrines in the region. It stands on a **ziggurat**, a platform some 40 feet high whose corners are oriented toward the compass points. As grand as it is, the White Temple pales in comparison to the scale of later ziggurats (the ziggurat known to the Hebrews as the Tower of Babel, a symbol of mortal pride, was some 270 feet high). Sumerians believed that their gods resided above them and that they would descend to meet their priests in the temples built high above the ground. They called these shrines waiting rooms for the gods.

Votive sculptures found beneath the floor of a temple to Abu in Tell Asmar (**Fig. 1.16**) reinforce the essential role of religion in Sumerian society. These works functioned as stand-ins, as it were, for donor worshippers who, in their absence, wished to continue to offer prayers to a specific deity. They range in height from less than 12 to more than 30 and are carved from gypsum (a soft mineral found in rock) with alert inlaid

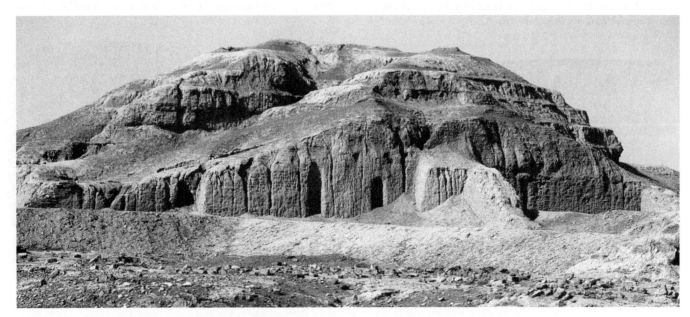

▲ **1.15B The White Temple and ziggurat, ca. 3200–3000 BCE, Uruk (modern Warka), Iraq.** *Ziggurat* means "pinnacle" or "mountaintop" and is the name of the elevated platform on which a temple sits. Mesopotamians thought their gods would come down from the heavens and reveal themselves there.

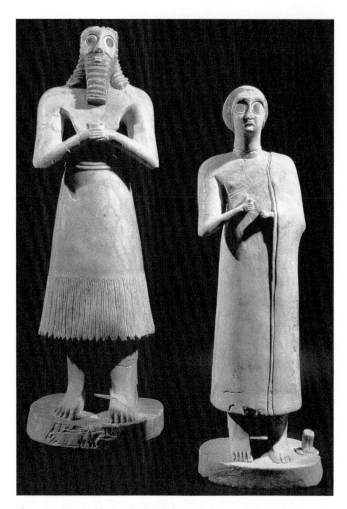

▲ **1.16 Statues from Abu Temple, ca. 2700 BCE (Sumerian, Early Dynasty period), Tel Asmar. Gypsum with shell and black limestone inlay, male figure, 28¼" (72 cm) high, female figure, 23" (59 cm) high. National Museum, Baghdad, Iraq.** Votive figures were placed in temples as stand-ins for absent worshippers.

eyes of shell and black limestone. The figures are cylindrical, and all stand erect with hands clasped at their chests around now-missing flasks. Distinctions are made between males and females: The men have long, stylized beards and hair and wear knee-length skirts decorated with incised lines describing fringe at the hem. The women wear dresses with one shoulder bared and the other draped with a shawl. Although these sculptures are gypsum, the Sumerians worked primarily in clay because of its abundance. They were expert ceramists and, as we have seen, were capable of building monumental structures with brick while their Egyptian contemporaries were using stone. It is believed that the Sumerians traded crops for metal, wood, and stone and used these materials to enlarge their repertory of art objects.

The Sumerian repertory of subjects included fantastic creatures such as music-making animals, bearded bulls, and composite man-beasts with bull heads or scorpion bodies. These were depicted in lavishly decorated objects of hammered gold inlaid with **lapis lazuli**. Found among the remains of Sumerian royal tombs, they are believed by some scholars to have been linked to funerary rituals.

For a long time, the Sumerians were the principal force in Mesopotamia, but they were not alone. Semitic peoples to the north became increasingly strong, and eventually they established an empire that ruled all of Mesopotamia and assimilated the Sumerian culture.

By far the most important event of this stage in the development of Sumerian culture was the invention of the first system of writing, known as **cuneiform** (**Fig. 1.17**). The earliest form of writing was developed at Uruk (now Warka, in southern Iraq), one of the first Mesopotamian settlements, around the middle of the fourth millennium BCE. It consisted of a series of simplified picture signs (pictographs) that represented the objects

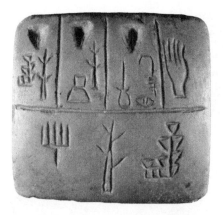
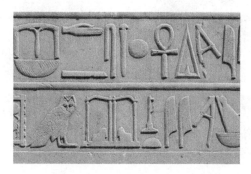
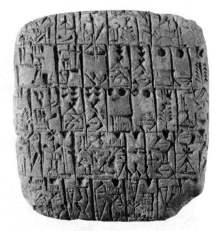

▲ **1.17 Forms of early writing.** Left: Tablet, ca. 3200 BCE, Kish, Iraq. Limestone, 1¾" (4.5 cm) long × 1¾" (4.3 cm) wide × ⅞" (2.4 cm) deep. Musée du Louvre, Paris, France. Among the earliest examples of writing, the pictographs on this tablet show a list of slaves' names with a hand on the upper right representing their owner. Center: Detail of a limestone bas-relief, ca. 2065–1785 BCE (Middle Kingdom) near the White Chapel of Karnak, Thebes, Egypt. This hieroglyphic inscription is dedicated to Amon-Min in his role as god of fertility. Note the "life" sign—the "ankh" —the fourth sign from the right on the top line. Right: Terra-cotta tablet, ca. 2550 BCE, Sumer. Musée du Louvre, Paris, France. The cuneiform writing in this inscription records a bill of sale for a house and field paid for in silver. Note that the cuneiform signs have lost their resemblance to picture writing.

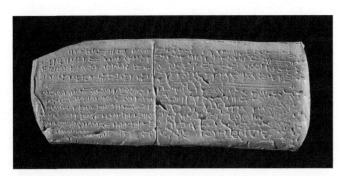

▲ **1.18 The Ugarit Tablet, c. 1400** BCE. **Clay. National Museum of Damascus, Syria.** The oldest known piece of musical notation to date, Ugarit Tablet H6 also contains instructions for the singer and harpist as well as tips on how to tune the harp.

they described and, in addition, related ideas. Thus, a leg could mean either a leg itself or the concept of walking. The signs were drawn on soft clay tablets, which were then baked hard. These pictorial signs evolved into a series of wedge-shaped marks that were pressed in clay with a split reed. The cuneiform system (*cuneus* is the Latin word for "wedge") had the advantages of being quick and economical, and inscribed clay tablets were easy to store. The ability to write made it possible to trade and to keep detailed records, and with the increasing economic strength this more highly organized society brought, several powerful cities began to develop.

Musical texts in cuneiform writing have been found, suggesting that the Mesopotamians had a rich tradition of music theory and practice. There is credible evidence that they had a system of interrelated heptatonic scales—scales with seven pitches per octave (**Fig. 1.18**).

THE ***EPIC OF GILGAMESH*** The most famous of Sumerian kings, Gilgamesh, ruled the city of Uruk sometime between ca. 2700 and 2500 BCE. Under his reign, the massive city walls around Uruk were constructed, but his name is more famously associated with the mythic tales that evolved into the first great masterpiece of poetic expression—the *Epic of Gilgamesh*. It has come down to us on 12 clay tablets dating to about 2000 BCE—including Tablet XI, the so-called flood tablet (**Fig. 1.19**)—found

▶ **1.19 Tablet XI (the Flood Tablet) of the** *Epic of Gilgamesh*, **700–600** BCE, **Nineveh (Kuyunjik), Iraq. Clay tablet fragment, 6" long × 5 ¼" wide × 1 ¼" deep (15.24 × 13.33 × 3.17 cm). The British Museum, London, United Kingdom.** The stone fragment identified as Tablet XI was one of 12 found in the library of King Ashurbanipal in Nineveh, Assyria.

in the library of the Assyrian king Ashurbanipal in the city of Nineveh. Believed to have been written originally by Sumerians in cuneiform, it later was reworked by Akkadians, Babylonians, and Assyrians. Although the origins of the epic date back several millennia, our access only dates back to the decipherment of cuneiform writing in the mid-19th century.

There is no doubt that Gilgamesh is an actual historical figure, although the superhuman adventures that form the basis of the epic might lead us to think otherwise. The epic begins, in Tablet I, with his glorious ancestry—he is one-third human and two-thirds divine—followed by the consequences of his sometimes inglorious deeds:

READING 1.1 THE *EPIC OF GILGAMESH*

Gilgamesh

Supreme over other kings, lordly in appearance,
He is the hero, born of Uruk, the goring wild bull.
He walks out in front, the leader,
And walks at the rear, trusted by his companions.
Mighty net, protector of his people,
Raging flood-wave who destroys even walls of stone!
Offspring of Lugalbanda,[4] Gilgamesh is strong to perfection,
Son of the august cow, Rimat-Ninsun, … Gilgamesh is awesome to perfection.

Our impression of Gilgamesh is soon tempered, however, by our awareness that in spite of his wisdom, might, and heroics (or, perhaps because of them), his people find him arrogant and oppressive. One voice tells us that Gilgamesh "struts his power over the people like a wild bull." The principal deity of Uruk, Anu, becomes aware of the discontent of the people and calls upon the mother goddess, Aruru, to create a worthy adversary for Gilgamesh—Enkidu. Unlike Gilgamesh, Enkidu is kind and—living in a forest at one with nature and its creatures—untainted by the damaging consequences of civilization. Their encounter represents the opposition of the ideals of nature and culture that is a familiar theme in the humanities.

Gilgamesh becomes aware of the gods' object lesson and uses a trapper disgruntled by Enkidu's protection of the animals as a pawn to strip him of the power he holds in his natural realm. The idea is to introduce

4. A king of Uruk.

CULTURE AND SOCIETY

Mesopotamia: Tycoons of Trade

The stone tablets that bear *The Epic of Gilgamesh*, regarded widely as the first great work of literature, possess an almost reverential status. The famed Rosetta Stone, a granite-like slab recording decrees carved in three different scripts, did nothing less than solve the puzzle of Egyptian hieroglyphics. Clay tablets discovered on the island of Crete and the Greek mainland, inscribed in so-called Linear B, led to the realization that this previously indecipherable text was actually written in a form of early Greek.

These three examples of inscribed tablets are archaeological showstoppers to be sure. But they are only a minuscule part of the writing and quite ordinary recordkeeping that were a part of daily life in the early river civilizations of Mesopotamia and Egypt.

Business majors: this one's for you!

A trove of clay tablets unearthed by archaeologists in the ancient city of Kanesh record 30 consecutive years of the economic life of a city that *New York Times* contributing editor, Adam Davidson, called the "hub of a massive global trading system that stretched from Central Asia to Europe."* In his August 2015 column, "On Money," Davidson examines the trading practices of this 4000-year-old community and ponders the lessons that they offer for addressing the impact of global trade in our own time.

Between 1890 and 1860 BCE, Davidson writes, " . . . a few hundred traders . . . left their hometown Assur, in what is now Iraq, to set up importing businesses [600 miles away]. Kanesh's traders sent letters back and forth with their business partners, carefully written on clay tablets and stored at home in special vaults. Tens of thousands of these records remain."

"The picture that emerged of economic life," Davidson continues, "is staggeringly advanced. The traders of Kanesh used financial tools that were remarkably similar to checks, bonds and joint-stock companies. They had something like venture-capital firms that created diversified portfolios of risky trades. And they even had structured financial products: People would buy outstanding debt, sell it to others, and use it as collateral to finance new businesses." And, as in contemporary business, they had lawsuits (Fig. 1-20).

But in an ancient example of the roller-coaster ride that is the economic marketplace, fortunes in Kanesh collapsed. "Over the 30 years covered by the archive," Davidson notes, "we see an economy built on trade in actual goods—silver, tin, textiles [what we call commodities]—transform into an economy built on financial speculation, fueling a bubble that then pops." What followed was a deep recession and eventual recovery brought about by the imposition of simpler and tougher trade regulations. The Kanesh case study strikes a familiar chord in our own financial world.

The discovery of the tablets and their contents illustrates, perhaps surprisingly, that wealth was not only in the hands of the ruling and priestly classes but that it was actually possible as a business entrepreneur to amass significant amounts of money if he was skilled and clever enough. Nonetheless, Davidson tells us, "Trade brought enormous wealth [only] to a dozen or so families." Income inequality was a problem back then, just as many acknowledge it is today. However, the author also points to ways in which these ancient businessmen addressed that problem, suggesting that history might offer some solutions: " . . . rather than hold all of it for themselves, the wealthy were made to redistribute a high percentage of their earnings through taxes and religious foundations that used the money for the public good. This way, the wealth created by trading with Kanesh made nearly everybody—at least every free citizen—better off."

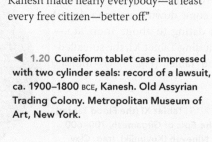

◀ 1.20 **Cuneiform tablet case impressed with two cylinder seals: record of a lawsuit, ca. 1900–1800 BCE, Kanesh. Old Assyrian Trading Colony. Metropolitan Museum of Art, New York.**

* Davidson, Adam, "On Money," *New York Times Magazine*, August 30, 2015, pp. 22–26.

a prostitute. Enkidu will engage in sexual intercourse with the woman and, as a consequence, be rejected by the animals. In other words, his brush with the debauchery of civilization will tear him from the bosom of nature. All goes according to plan. Shamhat, a harlot from the temple at Uruk, "civilizes" Enkidu in the forest and exhausts his energy. It is a tale that resonates with the biblical story of Adam and Eve and their banishment from the Garden of Paradise after giving in to Satan's temptation:

READING 1.2 THE *EPIC OF GILGAMESH*

The Harlot

The animals arrived and drank at the watering hole,
The wild beasts arrived and slaked their thirst with water.
Then he, Enkidu, offspring of the mountains,
Who eats grasses with the gazelles,
Came to drink at the watering hole with the animals,
with the wild beasts he slaked his thirst with water.
Then Shamhat saw him—a primitive,
A savage fellow from the depths of the wilderness!
. . . .
Shamhat unclutched her bosom, exposed her sex, and he took in her voluptuousness.
She was not restrained, but took his energy.
She spread out her robe and he lay upon her,
She performed the primitive task of womankind.
His lust groaned over her;
For six days and seven nights Enkidu stayed aroused,
And had intercourse with the harlot
Until he was sated with her charms.
But when he turned his attention to his animals,
The gazelles saw Enkidu and darted off,
The wild animals distanced themselves from his body.
Enkidu . . . his utterly depleted body,
His knees that wanted to go off with his animals went rigid;
Enkidu was diminished, his running was not as before.
But then he drew himself up, for his understanding had
 broadened.

After the encounter, Enkidu allows Shamhat to lead him to Uruk, where it is his intention to challenge Gilgamesh, overtake him with his might, and bring his oppressive tactics to an end. It is Gilgamesh who prevails in their contest, however. Still, Gilgamesh is impressed by Enkidu's strength and force of character, and the two become cherished and loyal friends. Enkidu's kindness and generosity inspire Gilgamesh—who had been the embodiment of arrogance and tyranny—to become a better person and a more amiable and caring ruler. But, as humans often are in epic narratives, Gilgamesh is not content to leave this life without an enduring legacy.

In Tablet II, Enkidu informs Gilgamesh of the lure of the Cedar Forest and of Humbaba, a demon charged by the chief Sumerian god, Enlil, with protecting it. Humbaba's "mouth is

fire," Gilgamesh is told, but this does not deter him from the decision to go with Enkidu to the forest. "Human beings' … days are numbered," Gilgamesh says, "and whatever they keep trying to achieve is but wind." Thus, Gilgamesh, recognizing that fame is fleeting and unsatisfied with his own achievements to date, declares that he will use this adventure to "establish fame for eternity!" and "make [himself] more mighty." Armed with specially forged weapons—an axe, hatchet, swords, and armor—he will lead on, pressing against the danger, and Endiku can follow. In Tablet III, the elders of Uruk and Gilgamesh's mother enjoin Enkidu to watch over Gilgamesh.

In Tablet V, the two kill Humbaba, despite Humbaba's pleas for mercy and his expressed willingness to become Gilgamesh's servant. They also cut down the tallest cedar in the forest from which they fashion a raft, and sail down the Euphrates River, displaying the severed head of their demon adversary as an open challenge to the gods to retaliate. Of course, this display of foolish pride will come back to haunt Gilgamesh, just as it does in other epics.

Tablet VI finds the goddess Inanna (later known as Ishtar) smitten with Gilgamesh, who spurns her advances. She tries to get even by asking her father, Anu, to send the Bull of Heaven to attack Gilgamesh, but the brave king dispatches the beast with skill and courage.

In Tablet VII, Enkidu shares with Gilgamesh his ominous dreams following the slaying of the sacred bull: The gods have decided that he, Enkidu, should die as retribution for the slaying and as a way to punish Gilgamesh's arrogance and pride. The gods will take from Gilgamesh that which is most precious to him. Enkidu becomes gravely ill and dreams about the terrors of the underworld he will encounter after death:

READING 1.3 THE *EPIC OF GILGAMESH*

A Dream of the Dead

Enkidu's innards were churning,
Lying there so alone.
He spoke of everything he felt, saying to his friend:
"Listen, my friend, to the dream that I had last night.
The heavens cried out and the earth replied,
And I was standing between them.
There appeared a man of dark visage—
his face resembled the Anzu,[5]
his hands were the paws of a lion,
his nails the talons of an eagle!—
he seized me by my hair and overpowered me.
[Then he] turned me into a dove,
so that my arms were feathered like a bird.
Seizing me, he led me down to the House of Darkness, the
dwelling of Irkalla,[6]

5. The lion-headed eagle of mythology.
6. Another name for the netherworld.

to the House where those who enter do not come out,
along the road of no return,
to the House where those who dwell do without light,
where dirt is their drink, their food is of clay,
where, like a bird, they wear garments of feathers,
and light cannot be seen, they dwell in the dark,
and upon the door and bolt lies dust.
On entering the House of Dust,
everywhere I looked there were royal crowns gathered in heaps,
everywhere I listened, it was the bearers of crowns who
in the past had ruled the land."

The heartbreaking loss of Enkidu brings home to Gilgamesh the reality and the nearness of death. In Tablet X, he comes upon a tavern keeper, Siduri, who notices that the king's cheeks are emaciated, his expression desolate, his features haggard. Gilgamesh's loss of his friend and of any illusion of escaping death under normal circumstances frames a quest for immortality. He embarks on an arduous journey, along which he encounters many who urge him—to no avail—to surrender his pursuit and, instead, to live the life that the gods have granted him to the fullest:

READING 1.4 THE *EPIC OF GILGAMESH*

The Tavern-Keeper by the Sea

"Gilgamesh, where are you wandering?
The life that you are seeking all around you will not find.
When the gods created mankind
they fixed Death for mankind,
and held back Life in their own hands.
Now you, Gilgamesh, let your belly be full!
Be happy day and night,
of each day make a party,
dance in circles day and night!
Let your clothes be sparkling clean,
let your head be clean, wash yourself with water!
Attend to the little one who holds onto your hand,
let a wife delight in your embrace.
This is the true task of *mankind*."

Eventually, Gilgamesh reaches the home of Utnapishtim, a righteous man who was granted immortality by the gods after following their commands to build an ark to save his relatives, craftsmen, and all the beasts of the field from a great flood that lasted seven nights and six days. The story of the flood is recounted in Tablet XI, the so-called "Flood Tablet." As readers, we cannot help but notice the parallels between the flood in the *Epic of Gilgamesh* and the flood in the Hebrew Bible's Book of Genesis. In addition to the gripping details of the cataclysmic event—torrential rains, the postflood landing of the ark on a

mountaintop, and the release of birds from the ark to retrieve evidence that the waters were receding—the tablet contains, as does the story of Noah, specifics on the ark's construction. The sides of Utnapishtim's ark were 120 cubits long (one cubit measuring approximately the length of one's forearm between the middle fingertip and elbow), the floorplan had many compartments, and the entry door could be sealed when the boat was launched.

The flood memorialized in the *Epic of Gilgamesh* likely refers to an historic event in which seawater from the Mediterranean flooded lands in ancient Mesopotamia; it may have been a source for the story in the Hebrew Bible:

READING 1.5 THE *EPIC OF GILGAMESH*

The Story of the Flood

"Just as dawn began to glow
there arose from the horizon a black cloud.
Adad[7] rumbled inside of it,
before him went Shullat and Hanish[8],
heralds going over mountain and land.
Erragal[9] pulled out the mooring poles,
forth went Ninurta[10] and made the dikes overflow.
The Anunnaki[11] lifted up the torches,
setting the land ablaze with their flare.
Stunned shock over Adad's deeds overtook the heavens,
and turned to blackness all that had been light.
The ... land shattered like a ... pot.
All day long the South Wind blew ... ,
blowing fast, submerging the mountain in water,
overwhelming the people like an attack.
No one could see his fellow,
they could not recognize each other in the torrent.
The gods were frightened by the Flood,
and retreated, ascending to the heaven of Anu.[12]
The gods were cowering like dogs, crouching by the outer wall.
. . . .
Six days and seven nights
came the wind and flood, the storm flattening the land.
When the seventh day arrived, the storm was pounding,
the flood was a war—struggling with itself like a woman
 writhing (in labor).
The sea calmed, fell still, the whirlwind (and) flood stopped up.
. . . .
I looked around for coastlines in the expanse of the sea,
and at twelve leagues there emerged a region (of land).
On Mt. Nimush the boat lodged firm,
Mt. Nimush held the boat, allowing no sway."

7. The chief storm god.
8. Heralds of the storm god, Adad.
9. Joint ruler of the netherworld.
10. The god of war.
11. A group of 50 minor gods.
12. The sky god.

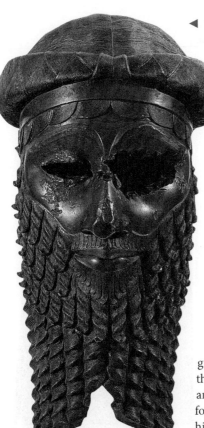

The earliest surviving example of a hollow-cast sculpture, this bronze head may have been part of a full-length portrait of King Sargon. The eyes were mutilated but were originally inlaid with gems or other semiprecious materials.

Utnapishtim, who was granted everlasting life by the gods for his heroism and piety, sets a challenge for Gilgamesh to prove his worthiness of the same reward, that is, to stay awake for seven nights and six days. Gilgamesh falls asleep almost immediately and is about to leave the company of Utnapishtim empty-handed, when he is given a parting gift: instructions for where to find an underwater plant that will render him young once more. Gilgamesh ties stones to his feet, walks along the ocean floor, and recovers the thorny plant, only to have it stolen by a serpent.

Gilgamesh returns to Uruk to await death, exhausted, resigned, but wiser. Enlil, the father of the gods, tries to console him in spite of the fact that he killed Humbaba in the Cedar Forest. Gilgamesh, after all, does possess certain gifts: wisdom, courage, the skills to be victorious in battle, and the ability to govern with greatness. Together, these would stand as a monument to his memory, unsurpassed for generations.

Unlike the ancient Egyptians, the Mesopotamians saw life as a continual struggle whose only alternative, death, was bleak. Egyptians, if they were righteous, could expect a contented existence in the life after death, but for the Mesopotamians, the prospects were less hopeful. Although ancient Mesopotamian views on the afterlife and netherworld changed over time, it seems that the best a dying person could hope for was a not-so-great version of life on earth.

The *Epic of Gilgamesh* touches on universal themes about human nature—the elevation of some human beings over others; the perils of disregard for nature and the natural order of things; the virtues and rewards of the simple life and the pleasures of love, companionship, food, and drink; the fear of death; and the desire for fame and glory that will be some equivalent

to the immortality that is beyond human reach. Gilgamesh is encouraged to live to the fullest the life he was given—to seize the day (*carpe diem*, as the Romans would later say)—and not to be distracted by that which is unattainable.

Akkadian and Babylonian Culture

The *Epic of Gilgamesh* blends elements of history and mythology to tell the story of a Sumerian king in a powerful Mesopotamian city ca. 2700–2500 BCE. Shortly after his time, between 2350 and 2150 BCE, the whole of Mesopotamia fell under the control of the Semitic king Sargon and his descendants. The art of this Akkadian period (named for Sargon's capital city, Akkad) continued the trends of the Sumerian age, although total submission to the gods was tempered by the acknowledgment of human achievement. A copper head from Nineveh (**Fig. 1.21**), perhaps a portrait of Sargon, is the first known life-size **hollow-cast** sculpture in the history of art. It was once part of a complete figure that was later destroyed; the deep gouging of the eye sockets suggests mutilation associated with acts of conquest. Even so, the head exudes the king's power, authority, and superiority. Of the relatively few Akkadian works that survive, the Victory **Stele** of Naram-Sin (**Fig. 1.22**) shines as one of the most significant. The relief sculpture commemorates the military exploits of Sargon's grandson and successor, Naram-Sin. The king, represented somewhat larger in scale than the other figures, ascends a mountain, trampling his enemies underfoot. He is accompanied by a

▶ **1.22 Victory Stele of Naram-Sin, ca. 2300–2200 BCE (Akkadian), Susa, Iran. Rose limestone, 79" × 41" (200.7 × 104.1 cm). Musée du Louvre, Paris, France.** King Naram-Sin marches victoriously up a mountain under symbols of protective gods, crushing his enemy as he goes. Conceptual representation is used in describing the figures.

group of marching soldiers with spears erect, whose positions contrast strongly with those of the fallen enemy. One of the conquered wrestles to pull a spear out of his neck, another pleads for mercy, and another falls headfirst off the mountain. The chaos on the right side of the composition is opposed by the rigid advancing on the left. All takes place under the watchful celestial bodies of Ishtar and Shamash, the goddess of fertility and god of justice.

The artist used **conceptual representation** in the figures of the king and his men. That is, all of the parts of the body are there and they have identifying characteristics, but the body is not as it would appear to the eye at a single moment in time. Conceptual representation mixes and matches optimal frontal and profile views: one can see legs in profile, the triangular shape of a frontal view of the torso, and a profile head with a frontal eye. If there is any naturalism, it was reserved for the enemy, whose soldiers fall to their deaths in a variety of contorted positions. It may be that the convention of conceptual representation was used as a sign of respect.

Akkadian rule was brought to an abrupt and violent end with the invasion of the Gutians from Iran. The Sumerian cities rallied in retaliation, however, and the region again came under their control. The Neo-Sumerian state was then established but, characteristically, was short-lived.

THE LAW CODE OF HAMMURABI By around 1800 BCE, independent city-states once again took shape in Mesopotamia; one of them was Babylon. Its most famous and powerful king, Hammurabi, united the region under the name Babylonia, created a centralized government, and gathered the laws of the various local states into a unified code that stands as one of the earliest attempts to achieve social justice by legislation. It was a major development in the growth of civilization. The Stele of Hammurabi (**Fig. 1.23**) is the physical embodiment of the law—the Hammurabic Code. The lower three-quarters of the basalt stele bear the inscription and the upper part depicts Hammurabi, in profile, in the presence of the seated god Shamash. Just as in the Victory Stele of Naram-Sin, that presence is intended to make the point that the gods sanction this human behavior. What impresses us is the nitty-gritty of the code's legal provisions, ranging from those that pertain to family court and medical malpractice to very specific punishments to be meted out for criminal offenses (see Reading 1.6).

The Assyrians

By 1550 BCE, Babylonia had been taken over and occupied by the Kassites, a formerly nomadic people. In turn, they fell to the Assyrians—fierce warriors whose conquests in the region evolved into a vast empire. The peak of Assyrian power in Mesopotamia was between 1000 and 612 BCE; at that same historical moment, Greek civilization had begun on a much

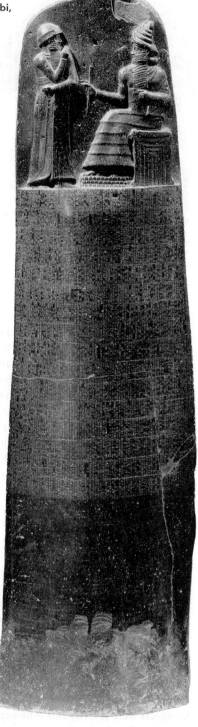

▶ **1.23 Stele inscribed with the Law Code of Hammurabi,** ca. 1760 BCE, Susa, Iran. Basalt, 88" high (223.52 cm) (entire stele). Musée du Louvre, Paris, France. Hammurabi, the legendary lawgiver of Babylon, stands before the throne of the god Shamash, who sanctions his authority. On the stele beneath the relief sculpture, the Hammurabic Code is incised in cuneiform.

smaller area of land across the Aegean Sea.

A magnificent fortified palace complex was constructed during the reign of Ashurnasirpal II (883–859 BCE) in the Assyrian capital of Nimrud on the Tigris River. The alabaster walls of the palace interiors were decorated lavishly with carved reliefs that featured assorted scenes of violence— battles, hunts, dying soldiers, and suffering animals. The reliefs expand upon the stylistic vocabulary of earlier Mesopotamian art. In a fragment depicting the king Ashurnasirpal II hunting lions (**Fig. 1.24**), the figures have vigor and move freely, their actions very convincingly portrayed. The artist attempts to illustrate depth within the very shallow space by placing one figure in front of another, as in the soldiers with shields on the left and the horses rearing in unison on the right. Unlike the figures in the Victory Stele of Naram-Sin, which were rendered using conceptual representation, these soldiers appear more the way the eye would actually see them—pretty much in full profile. This is called

READING 1.6 THE LAW CODE OF HAMMURABI

Selected provisions, including "an eye for an eye and a tooth for a tooth"

131. If a man accuses his wife and she has not been taken in lying with another man, she shall take an oath in the name of god and she shall return to her house.
142. If a woman hates her husband and says, "Thou shalt not have me," her past shall be inquired into for any deficiency of hers; and if she has been careful and be without past sin and her husband has been going out and greatly belittling her, that woman has no blame. She shall take her dowry and go to her father's house.
145. If a man takes a wife and she does not present him with children, and he sets his face to take a concubine, that man may take a concubine and bring her into his house. That concubine shall not take precedence over his wife.

162. If a man takes a wife and she bears him children and that woman dies, her father may not lay claim to her dowry. Her dowry belongs to her children.
191. If a man destroy the eye of another man, they shall destroy his eye.
200. If a man knock out a tooth of a man of his own rank, they shall knock out his tooth.
206. If a man strike another man in a quarrel and wound him, he shall swear: "I struck him without intent," and he shall be responsible for the physician.
219. If a physician operate on a slave of a freeman for a severe wound with a bronze lancet and cause his death, he shall restore a slave of equal value.
220. If he open an abscess (in his eye) with a bronze lancet, and destroy his eye, he shall pay silver to the extent of one-half of his price.

optical representation. Worth noting also is the repetition of imagery that tells two parts of the story simultaneously. We see the king in the center, facing backward on his chariot, shooting a lion with his bow and arrow. To the right of the relief, we see that same lion dead and trampled under the horses' hooves.

Within a few years of the fall of the city of Nineveh in 612 BCE to the Babylonians—who had previously been under Assyrian domination intermittently—the Assyrian Empire fell. The Babylonian kings established their city of Babylon (**Fig. 1.25**) as the center of Mesopotamia, where they stayed in power for just over 100 years until the Persians conquered

them in 520 BCE. Neo-Babylonia is the name given to this period, which has two contrasting claims to fame: the 50-year-long captivity of the Hebrews and King Nebuchadnezzar's building of the Hanging Gardens of Babylon, one of the Seven Wonders of the Ancient World.

Persia

As Persia, led by Cyrus the Great (c. 590–529 BCE), marched toward empire, Babylonia was but one of a growing list of casualties. By the sixth century BCE, the Persians had already

▼ **1.24 Ashurnasirpal II hunting lions, 883–859 BCE, Palace of Ashurnasirpal II, Nimrud, Iraq. Panel 19, alabaster relief, 88" × 35" (223.5 × 88.9 cm). The British Museum, London, United Kingdom.** Themes of violence against humans and animals characterize Assyrian reliefs.

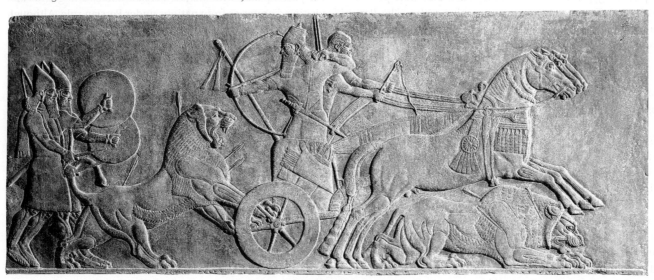

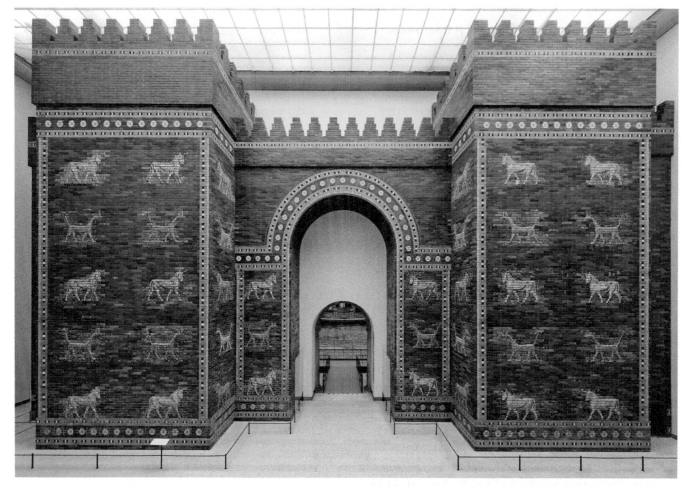

▲ **1.25 Ishtar Gate (reconstruction of outer gate), sixth century BCE, Vorderasiatisches Museum, Staatliche Museen zu Berlin, Germany.** Covered with glittering blue glazed bricks and stylized figures of dragons, bulls, and the goddess, Ishtar's sacred lion, the gate—one of a pair—marked the northern entrance to Nebuchadnezzar's Babylon.

conquered Egypt; less than a century later, they were poised to subsume Greece into their far-reaching realm. The Persian Empire stretched from southern Asia to northeastern Europe and would have included southeastern Europe had the Greeks not been victorious over the Persians in a decisive battle at Salamis in 480 BCE. Cyrus's successors grew the empire until the defeat of Darius II by Alexander the Great in 330 BCE.

The citadel at Persepolis, the capital of the ancient Persian Empire, was a sprawling complex of palatial dwellings, government buildings, grand stairways, and columned halls whose architectural surfaces were richly adorned with relief sculpture. A processional frieze from the royal audience hall (**Fig. 1.26**) illustrates a technique that is notably different from Assyrian imagery. The Persian relief is more deeply carved; that is, the figures stand out more against the background. They are fleshier, more well-rounded. The artist has paid particular attention to detail, distinguishing the costumes of

the participants, who include Persian nobles and guards and visiting dignitaries from nations under Persian rule. Although the procession is regimented, some figures twist and turn in space, alleviating the visual monotony. Persian art is also characterized by fanciful animal forms and stylized floral decoration.

In 525 BCE, Persia conquered the kingdom of Egypt, where civilization had begun some 3000 years earlier.

ANCIENT EGYPT

Geography was a major determinant in the development of civilization in Egypt, just as it was in Mesopotamia (see **Map 1.2**). Because rainfall was sparse along the Nile River, agriculture was dependent on the yearly flooding of the river and the ability to control it. At the delta of the Nile was Lower

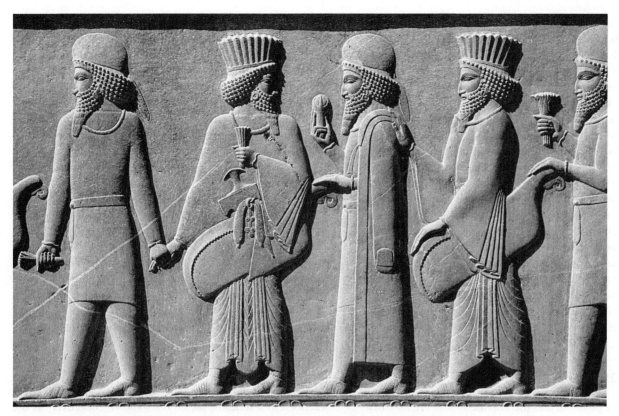

▲ **1.26 Processional frieze (detail) from the royal audience hall, ca. 521–465 BCE, Persepolis, Iran. Limestone, 100" (254 cm) high.** The figures of visiting dignitaries to the court at Persepolis are rendered using both optical and conceptual representation.

Egypt, broad and flat, within easy reach of neighboring parts of the Mediterranean. Upper Egypt, more isolated from foreign contacts, consisted of a long, narrow strip of fertile soil, hemmed in by high cliffs and desert, running on either side of the Nile for most of its 1250 miles (2000 kilometers). In total area, ancient Egypt was only a little larger than the state of Maryland.

The extraordinarily long span of Egyptian history was divided into 31 dynasties by an Egyptian priest, Manetho, who wrote a *History of Egypt* in Greek around 280 BCE. Modern scholars still follow his system, putting the dynasties into four groups and calling the period that preceded them predynastic. The four main divisions, with their approximate dates, are the *Old Kingdom*, beginning ca. 2575 BCE; the *Middle Kingdom*, starting ca. 2040 BCE; the *New Kingdom*, from ca. 1550 BCE; and the *Late Period*, from ca. 1185 BCE until Egypt was absorbed into the Persian Empire around 500 BCE. The periods were separated from one another by intervening times of disturbances and confusion.

During the final centuries of the Late Period, Egypt was invaded by the Nubians of the upper Nile, a black people whom the Egyptians called Cushites. Overrunning first Upper Egypt in 750 BCE and then Lower Egypt around 720 BCE, they and their successors, the Nobatae, helped preserve Egyptian culture through the periods of foreign rule.

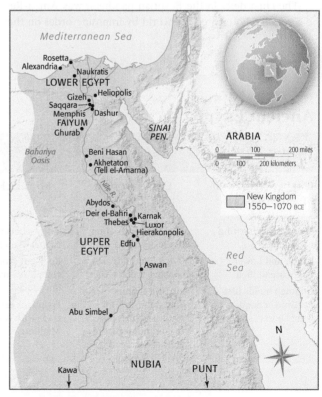

▲ **MAP 1.2 Ancient Egypt.**

Despite its long history, the most striking feature of Egyptian culture is its unity and consistency. Nothing contrasts more strongly with the process of dynamic change initiated by the Greeks—and still characteristic of our culture today—than the relative absence of change in Egyptian art, religion, language, and political structure over thousands of years. Naturally, even the Egyptians were subject to outside influences, and events at home and abroad affected their worldview. It is possible to trace a mood of increasing pessimism from the vital, life-affirming spirit of the Old Kingdom to the New Kingdom's vision of death as an escape from the grim realities of life. Nevertheless, the Egyptians maintained a strong resistance to change. Their art, in particular, remained conservative and rooted in the past.

In a land where regional independence already existed in the natural separation of Upper from Lower Egypt, national unity was maintained by a strong central government firmly controlled by a single ruler, the **pharaoh**. The pharaoh had absolute power over all matters temporal and spiritual, although the preservation of belief and ritual fell to an official bureaucracy of priests whose influence increased over time.

Egyptian Religion

The gods, the pharaoh, and the afterlife—these are inextricably intertwined in Egyptian religion. Like the Mesopotamians, Egyptians worshipped many deities, but unlike the kings of Mesopotamia, the pharaoh stood among them as a living god and their near equal.

The chief deity in the Egyptian pantheon was Amen-Re, the sun god who created the world by imposing order on the primeval chaos of the universe. He then created the first among many gods, whose generations of immortal progeny included Osiris (the god of order who was responsible for civilization), Seth (the god of chaos who killed his brother Osiris and cut him into pieces), Isis (the goddess of mourning and sister of Osiris, who gathered the pieces of her brother, brought him back to life, and then mated with him), and Horus (the sky god and offspring of Osiris and Isis). The pharaohs were believed to be the children of the goddess Hathor, herself a daughter of Re. They were identified with the sky god Horus during life and with Osiris, ruler of the underworld, after death; in Egyptian art, the pharaoh often wears the signature bowling-pin-shaped crown of Osiris, which was similar to the crown of Upper Egypt (as seen in Fig. 1.27).

The most striking aspect of Egyptian religion is belief in an afterlife. Notions about the possibility that mortals could continue having experiences that resembled those of their present lives after passage into an underworld motivated righteous behavior—and the construction of lavish and well-equipped tombs that would anticipate whatever needs were to come. Not all Egyptians had grand tombs, but all had the hope of continuing to *be* after death. Elaborate funeral rituals prepared the deceased for judgment.

The funeral rites, together with their meaning, were described in a series of sacred texts known collectively as the *Book of the Dead*. The god who presided over these ceremonies was Osiris. Osiris owed his own resurrection to the intervention of Isis, protector of the living and the dead, and his rebirth was a divine parallel to the annual flooding of the Nile, which was essential to agriculture. Worship of Isis became an important and enduring Egyptian cult; a temple to her was even

Ancient Egypt

3500 BCE	2575 BCE	2040 BCE	1550 BCE	1070 BCE	30 CE
PREDYNASTIC AND EARLY DYNASTIC	OLD KINGDOM	MIDDLE KINGDOM	NEW KINGDOM	FIRST MILLENIUM	

Hieroglyphic writing is invented	First mummification of the deceased	Thebes becomes the capital of unified Egypt	Wealth leads to the flowering of art and architecture	Egypt comes under Persian rule in 343 BCE
Upper and Lower Egypt are unified	Great Pyramids are constructed at Gizeh	Rock-cut mortuary complexes are introduced	Hatshepsut reigns as pharaoh for two decades, the first female monarch recorded in history	Alexander the Great conquers Egypt in 332 BCE
Imhotep builds first pyramid at Saqqâra for King Djoser	Artistic canons are established for statues of pharaohs to communicate the eternal nature of their divine kingship	Egyptians establish trade with eastern Mediterranean cultures	Akhenaton establishes monotheism	Alexandria, the new waterfront capital, faces the Mediterranean and the Hellenistic world
			Return to polytheism with the reign of Tutankhamen	Egypt becomes a province of the Roman Empire in 30 BCE

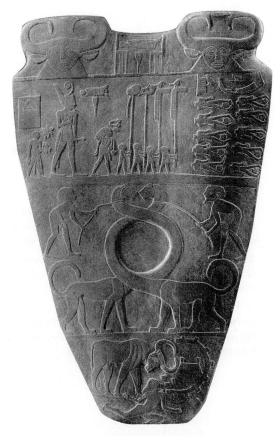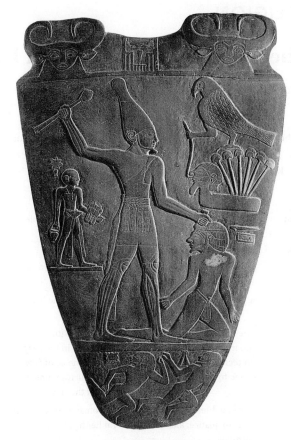

▲ **1.27 Narmer palette, ca. 3200 BCE. Front (left) and back (right) views. Slate, 25" high × 16½" (63.5 × 42 cm) wide. Egyptian Museum, Cairo, Egypt.** The shallow reliefs on both sides of a cosmetic palette, likely used for ceremonial purposes, commemorates the unification of Lower and Upper Egypt under a single ruler, King Narmer.

found among the ruins of the ancient Roman city of Pompeii. Our knowledge of the meaning of these and other texts was made possible by unlocking the key to their writing system of **hieroglyphics**.

The Romans had a significant history with Egypt; after it collapsed, they subsumed it as a province of their empire and even built temples there. But Egypt was largely ignored thereafter until the late 18th century, when Europeans began to take a strong interest in the exotic culture after an expedition to the country led by French emperor Napoléon Bonaparte in 1799. It was then that the **Rosetta Stone** was discovered, a large stone fragment inscribed with text in three languages: ancient hieroglyphics, demotic (a late Egyptian language), and Greek. Jean-François Champollion (1790–1832) deciphered the hieroglyphics by comparing them to the more familiar Greek.

Old Kingdom

The first golden age of Egyptian civilization arrived with the **Old Kingdom**, but Egypt's history along the Nile goes back

farther. The land had been divided into two kingdoms: Upper and Lower Egypt. Unification of the two kingdoms occurred over a few centuries, but it is commemorated as a specific, single event in the palette of King Narmer (**Fig. 1.27**).

The slate object resembles Egyptian cosmetic palettes that had shallow wells in which to mix paint—applied around the eyes, as our athletes do today, to reduce the glare of the sun. The size of the Narmer palette and the event represented on it suggest that it had a ceremonial rather than utilitarian purpose. Imagery is carved in shallow relief on both sides of the palette, and Narmer is depicted on both. On the back he is shown wearing the crown of Upper Egypt (a bowling-pin shape), ready to strike a captive whom he has grabbed by the hair. To the right, a falcon—the god Horus—is perched on a cluster of papyrus stalks that sprout from an object that includes a man's head. The papyrus is a symbol for Lower Egypt, and Horus holds a rope tied around the man's neck; he is, perhaps, the ruler of Lower Egypt who has been vanquished by Narmer. On the other side of the palette, the imagery is carved in three separate **registers**, or horizontal bands, of different widths. In the center register, the palette's hollowed-out

RELIGION

The Gods and Goddesses of Egypt

Amun	King of the Gods	A man with a ram head or wearing an ostrich-plumed hat	**Osiris**	God of the dead; ruler of the underworld	A mummifed man wearing a cone-shaped headdress with feathers
Anubis	God of embalming and the dead	A man with the head of a jackal	**Ptah**	God of crafts; according to one creation myth, a creator who spoke the words that brought the world into being	A man carrying a staff, dressed in a white cloak
Aten-Ra	A form of the sun god Ra, made the one god during the reign of Akhenaton	A sun disk with rays that end in hands			
Atum	A creator god	A man with a double crown	**Ra**	Sun god; the most important god of the ancient Egyptians	A man with the head of a hawk and a headdress with a disk of the sun
Hathor	The wife of Horus; a protective goddess; also the goddess of love and joy	A woman with a headdress of horns and a sun disk	**Seth**	Brother of Osiris; god of chaos and evil who threatened harmony in Egypt	A man with the head of an unidentified animal
Horus	A god of the sky	A man with the head of a hawk			
Isis	The sister and wife of Osiris and mother of Horus; a protective goddess who used magic to help the needy	A woman with a headdress in the shape of a throne or of cow horns surrounding a disk of the sun	**Thoth**	Scribe of the gods; gave Egyptians the gift of hieroglyphics	A man with the head of an ibis, holding a palette for writing
Ma'at	The daughter of Ra; goddess of truth, justice, and harmony	A woman with a feather on her head			

well is framed by the elongated, intertwined necks of animals tamed by two men with leashes. Narmer appears in the top register, looking over the pile of enemy dead whose heads have been cut off and neatly tucked between their legs. This is not the first time that we have seen such a monument to a royal conquest, complete with gory details; we saw a similar version in the Akkadian Victory Stele of Naram-Sin (see Fig. 1.22). In both works, the kings are shown in commanding positions, larger than the surrounding figures, but in the Narmer palette, the king is also depicted as a god. The top of the palette, on both sides, features the goddess Hathor, distinguishable by her feminine face and horns.

Narmer is shown larger than the people surrounding him to indicate his status as a divine ruler. The artist has used conceptual representation: his head, hips, and legs are carved in low relief and in profile, and his eye and upper torso are shown as from a full frontal view. Narmer's musculature is defined with incised lines that appear more as stylized patterns than as realistic details. The artist worked within strict artistic conventions that would last some 3000 years. Art historian Erwin Panofsky observed that these strict conventions reflected Egyptian belief and their attitude toward life, "directed not toward the variable, but toward the constant, not toward the

symbolization of the vital present, but toward the realization of a timeless eternity."[13]

ARCHITECTURE The Narmer palette was found in a temple, and the imagery carved in relief on both sides is intended either to record a momentous historical event or to carefully construct an image of the king as an absolute ruler whose dominion is god-given. In either case, unlike a great deal of Egyptian sculpture, it has nothing to do with the funerary rituals that support the Egyptian obsession with an afterlife.

Colossal tombs are the most spectacular monuments to Egyptian beliefs and the glory of its pharaohs. One of the earliest is the stepped pyramid of King Djoser (**Fig. 1.29**), designed by Imhotep, a royal architect whose name is the first artist's to be recorded in history. Like so many hotshot architects to the present day, Imhotep's talent reached mythic proportions. He was even deified after his death. At first glance, the pyramid may seem to resemble a ziggurat with its wedding-cake stacking of sloping rectangles that diminish in size from bottom to top. But this is the important distinction: the ziggurat is a temple and

13. E. Panofsky. Uber das Verhaltnis der Kunstgeschichte zur Kunsttheorie, *Zeitschrift für Ästhetik und allgemeine Kunstwissenschaft 18* (1925): 129–161.

CULTURE AND SOCIETY

Righteousness as the Path to Rebirth

Early Egyptian belief held that only the pharaoh could be reborn, upon death, and continue into an afterlife. As the centuries passed, the pharaoh's unique prerogative was extended to priests, the pharaoh's court, and their families. The *Book of the Dead*—also known as the *Book of Emerging Forth into the Light*—was intended as a sort of manual of spells, incantations, and declarations that would facilitate passage through the underworld and into the afterlife. The most important part of this journey was the judgment of the deceased before Osiris, god of the underworld. In one passage, an Egyptian official named is brought to judgment by the jackal-headed god Anubis (**Fig. 1.28**). Hunefer must declare that he has not committed any one of 42 sins (some of which are listed here); his declaration of innocence is verified as his heart is weighed on a scale against the Feather of Truth. If the heart is lighter, proof of righteousness will be revealed. But if the heart is heavy—the origin of the expression "having a heavy heart"—his soul will be lost forever.

I have not done crimes against people,
I have not mistreated cattle,
I have not sinned in the Place of Truth.
I have not known what should not be known,

I have not done any harm.
I did not begin a day by exacting more than my due,
My name did not reach the bark of the mighty ruler,
I have not blasphemed a god,
I have not robbed the poor.
I have not done what the god abhors,
I have not maligned a servant to his master.
I have not caused pain,
I have not caused tears.
I have not killed,
I have not ordered to kill,
I have not made anyone suffer.
I have not damaged the offerings in the temples,
I have not depleted the loaves of the gods,
I have not stolen the cakes of the dead.
I have not copulated nor defiled myself.
I have not increased nor reduced the measure,
*I have not diminished the arura**
I have not cheated in the fields.
I have not added to the weight of the balance,
I have not falsified the plummet of the scales.
I have not taken milk from the mouth of children.

* Acreage.

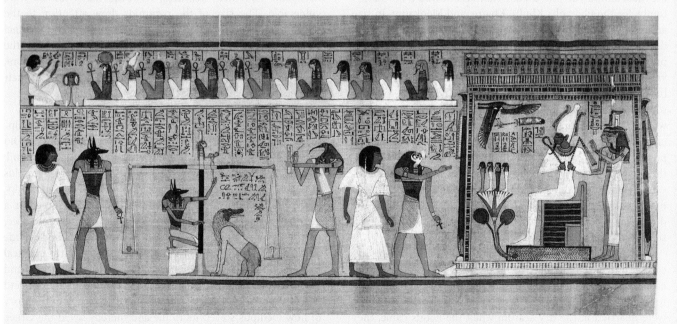

▲ **1.28** Last judgment of Hunefer, from his tomb at Thebes (modern-day Luxor), Egypt, ca. 1300–1290 BCE (Nineteenth Dynasty). Painted papyrus scroll, 13 ½" (34.3 cm) high. British Museum, London, United Kingdom.

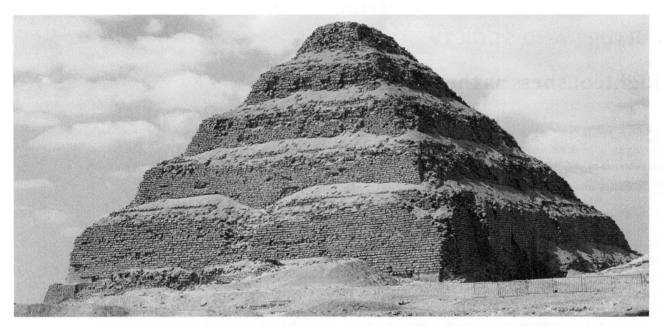

▲ **1.29 Imhotep, stepped pyramid of Djoser, ca. 2630–2611 BCE (Third Dynasty). Saqqâra, Egypt.** The architect, Imhotep, is the first artist whose name is recorded.

the pyramid is a tomb. Djoser's pyramid was the centerpiece of a mortuary complex that included a funerary temple and other structures arranged around a large court. Beneath the temple was a vast underground network of rooms, designed, presumably, to serve as Djoser's palace in the afterlife.

The most recognizable remains of Old Kingdom Egypt, and the most famous, are the Great Pyramids at Gizeh (**Fig. 1.30**)—tombs for the pharaohs Khufu, Khafre, and Menkaure. In size and abstract simplicity, these structures show Egyptian skill in design and engineering on a massive scale—an achievement probably made possible by slave labor, although recent excavations suggest that the building of the great monuments may have been essentially the work of farmers during the off-season. In any case, the pyramids and almost all other Egyptian works of art perpetuate the memories of members of the upper classes and bear witness to a lifestyle that would not have been possible without slaves. We still know little about the slaves or the poor Egyptians who were farm laborers. Many of the slaves were captured prisoners who were forced to labor in government quarries and on the estates of the temples. Over time, the descendants of slaves could enlist in the army; as professional soldiers they could take their place in Egyptian society.

The construction of the pyramids was an elaborate and complex affair. Stone quarried on the spot formed the core of each structure, but the fine limestone blocks originally used for facing, now eroded away, came from across the Nile. These were quarried in the dry season; when the floods came, they were ferried across the river, cut into shape, and dragged into place. The interiors of the pyramids contained a network of galleries, air shafts, and chambers, one of which held the mummified body of the pharaoh surrounded by the treasures that were

to follow him into the next life. The pharaohs planned these massive constructions as their resting places for eternity and as monuments that would perpetuate their names. Their success was partial: 4500 years later, their names are remembered—their pyramids, still dominating the flat landscape, symbolize the enduring character of ancient Egypt. As shelters for the occupants and their treasures, however, the pyramids were vulnerable. The size of the pyramids drew attention to the riches hidden within them, and robbers were quick to tunnel through and plunder them, sometimes only shortly after the burial chamber had been sealed. During the Middle Kingdom, Egyptians would design less vulnerable dwelling places for their spirits.

SCULPTURE The earliest examples of Egyptian sculpture are small—figurines, ivory carvings, ceramics. The Old Kingdom brought with it life-size sculpture in the round. Khafre, who commissioned the second of the three pyramids at Gizeh, is connected to the most famous of Egyptian sculptures, the colossal Great **Sphinx** (**Fig. 1.31**) that served as a guardian for his tomb. The aloof tranquility of the human face, perhaps a portrait of the pharaoh, set on a lion's body made an especially strong impression 1500 years later on the classical Greeks, who saw it as a divine symbol of the mysterious and enigmatic. Greek art frequently uses the sphinx as a motif, and it also appears in Greek mythology, most typically in the story of how Oedipus solved its riddle and thereby saved the Greek city of Thebes from disaster.

Khafre's appearance is preserved for us in several statues, such as the one carved in diorite (a gray-green stone) in which he is seated on a throne ornamented with the lotus blossoms

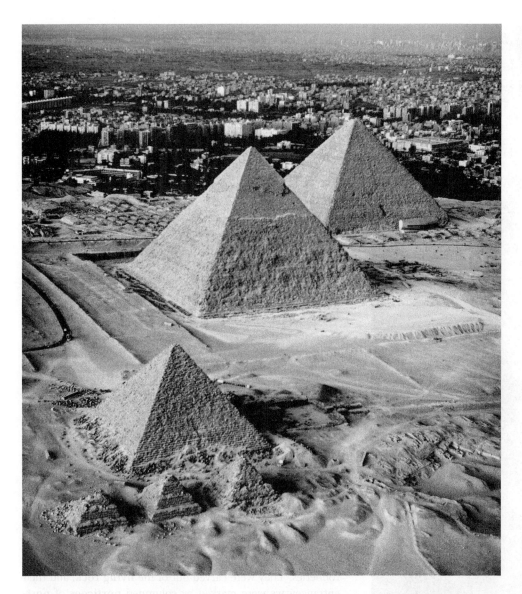

◄ **1.30** The Great Pyramids at Gizeh, Egypt. From bottom: pyramids of Menkaure, ca. 2490–2472 BCE; Khafre, ca. 2520–2494 BCE; and Khufu, ca. 2551–2528 BCE. The pyramid tombs were only one part of a vast funerary complex that included temples and ceremonial causeways.

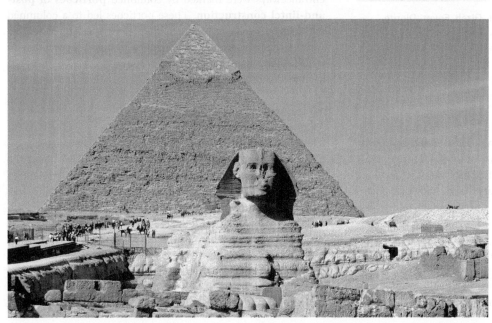

◄ **1.31** The Great Sphinx, ca. 2520–2494 BCE (Fourth Dynasty), Gizeh, Egypt. Sandstone, 65' high × 240' long (19.8 × 73.2 m). Part of the funerary complex of Khafre, the colossal sculpture has the body of a lion and the head of a man; it may be a stylized portrait of the pharaoh.

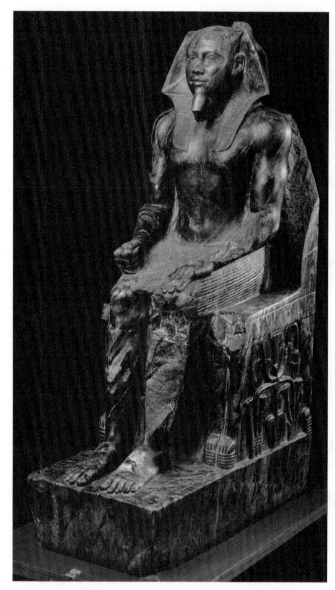

▲ **1.32 Statue of Khafre, ca. 2500 BCE, Gizeh, Egypt. Diorite, 66" high (167.6 cm). Egyptian Museum, Cairo, Egypt.** The pharaoh's divine power is represented by Horus, the falcon god of the morning sun, perched behind his head.

and papyrus that symbolize Upper and Lower Egypt (Fig. 1.32). The artist contained the figure within the overall shape of the stone block from which it was carved. The legs and torso appear molded to the throne, and the arms and fists are attached to the body. A sense of solidity is maintained and, with that, a certain confidence that the sculpture would remain intact. Few pieces, if any, were likely to break off. Permanence was essential, as sculptures like these were created as alternate dwelling places for the *ka*, or soul, should the mummified remains of the deceased disintegrate.

Khafre was rendered according to a specific **canon of proportions** relating anatomical parts to one another that relied on predetermined rules, not on optical fact. (Naturalism was intermittent in Egyptian art, and more evident in the Middle Kingdom and the Amarna period.) He sits rigidly; his frontal gaze reminiscent of the staring eyes of the Mesopotamian votive figures. Khafre is shown with the conventional attributes of the pharaoh: a finely pleated kilt; a linen headdress gracing the shoulders; and a long, thin beard (present on the carved faces of both male and female pharaohs), part of which has broken off. The sculptor's approach to anatomy and drapery is realistic, and details are shown with great precision, but the features of the pharaoh are idealized; it is a portrait not of an individual but of the concept of divine power, power symbolized by the falcon god Horus perched behind the pharaoh's head. The calmness, even indifference, of the expression is particularly striking.

Middle Kingdom

The art of the Old Kingdom reflects a mood of confidence and certainty that ended abruptly around 2200 BCE with a period of violent disturbance. Divisions between the regions began to strengthen the power of landowning local governors. By the time of the **Middle Kingdom**, it was no longer possible for pharaoh, priests, or nobles to face the future with complete trust in divine providence. Middle Kingdom art reflects this new uncertainty in two ways: As the Old Kingdom came to represent a kind of golden age, artists tried to recapture its lofty serenity in their own works, interspersed with some experimentation outside the mainstream of strict conventionalism. At the same time, somber expressions and more sensitively rendered royal portraits reveal the more troubled spirit of the age. The occupation of a Middle Kingdom pharaoh was hardly relaxing.

A striking aspect of Middle Kingdom architecture was the **rock-cut tombs**, which may have been designed to prevent robberies. They were carved out of the **living rock**, and their entranceways were marked by columned **porticoes** of **post-and-lintel construction**. These porticoes led to a columned entrance hall, followed by a chamber along the same axis. The walls of the hall and tomb chamber were richly decorated with relief sculpture and painting, much of which has a liveliness not seen in Old Kingdom art.

New Kingdom

The Middle Kingdom also collapsed, and Egypt fell under the rule of the Hyksos, foreigners with Syrian and Mesopotamian roots. They introduced Bronze Age weapons to Egypt, as well as the horse and the horse-drawn chariot. Eventually the Egyptians overthrew them, and the **New Kingdom** was launched. It proved to be one of the most vital periods in Egyptian history, marked by expansionism, increased wealth, and economic and political stability.

The art of the New Kingdom combined characteristics of the Old and Middle Kingdom periods. The monumental

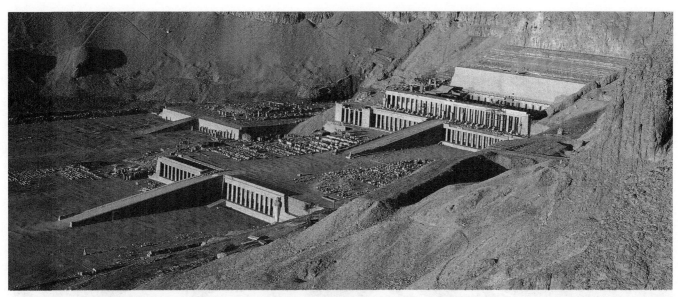

▲ 1.33 **Mortuary temple of Queen Hatshepsut, ca. 1480 BCE, Thebes, Egypt.** Some statues of Queen Hatshepsut show her with the same ceremonial false beard seen in sculptures of male pharaohs.

forms of the earliest centuries were coupled with the freedom of expression of the Middle Kingdom years. A certain vitality appeared in painting and relief sculpture, although sculpture in the round retained its solidity and sense of permanence, with few stylistic changes.

Egypt's most significant monuments continued to be linked to death or worship of the dead. During the New Kingdom, a new architectural design emerged—the **mortuary temple**. Mortuary temples were carved out of the living rock, as were the rock-cut tombs of the Middle Kingdom, but their function was quite different: they served as a place for worshipping the gods, pharaohs, and their queens during the pharaoh's life, and a place where the pharaoh would be memorialized and worshipped after death.

One of the most impressive mortuary temples of the New Kingdom is that of the female pharaoh Hatshepsut (**Fig. 1.33**). The temple backs into imposing cliffs and is divided into three terraces, which are approached by long ramps that rise from the floor of the valley to the top of pillared **colonnades**. Although the terraces are now as barren as their surroundings, during Hatshepsut's time they were covered with exotic plants. The uppermost level features numerous large sculptures of Hatshepsut standing or seated, all in a rigid frontal pose. The interior of the temple was just as lavishly decorated, with some 200 large sculptures as well as painted relief carvings. Sculptures of Hatshepsut are to some extent stylized according to typical conventions, although her face is recognizable from one work to another. In many portraits, her body is masculinized. She wears the same pleated kilt, royal headdress, and false beard that the male pharaohs do. In others, she is represented as a woman with slender proportions, breasts, and a delicate, distinctive angular face. After the death of her husband,

Hatshepsut ascended to the throne of Egypt as the regent for her son, who was still too young to succeed his father. However, in time she seized the title of pharaoh for herself, ruling Egypt for two decades. Reliefs in her mortuary temple intended to justify her actions show her father, Thutmose I, crowning her as king as the gods look on. We have seen other examples of rulers who presented their achievements as sanctioned by deities, such as Naram-Sin (see Fig. 1.22) and Hammurabi (see Fig. 1.23). Hatshepsut was succeeded by her son, Thutmose III, who had her portraits destroyed.

Ramses II, who reigned over the Egyptian Empire from 1279 to 1213 BCE, ordered the construction of the New Kingdom's most spectacular temple complexes and monumental statuary—bigger was better. Like Hatshepsut's rock-cut mortuary temple, the temple at Abu Simbel (**Fig. 1.34**) was cut into the area's natural rock cliffs. The entrance is flanked by colossal sculptures of Ramses that are 65 feet high—sitting down. Picture the pharaoh rising from his throne; it is truly awe-inspiring. Inside, along the walls of the first room, colossal sculptures representing Ramses as the god Osiris stand across from one another as silent and powerful sentinels. Inner chambers placed along a single axis press some 200 feet deeper into the rock and are covered with painted wall reliefs that depict the conquests of Ramses and his interaction with the gods. Looking at the scale of Abu Simbel embedded in rock, the notion of moving it would seem outrageous and incredible. But it was moved. In the 1960s, Egypt's Aswan High Dam project was undertaken, creating a reservoir that would have put this and other monuments under water. Abu Simbel was moved 700 feet; the relatively miniscule Temple of Dendur—given to the United States by Egypt in 1965 and now in the collection of New York's Metropolitan Museum of Art—was also rescued.

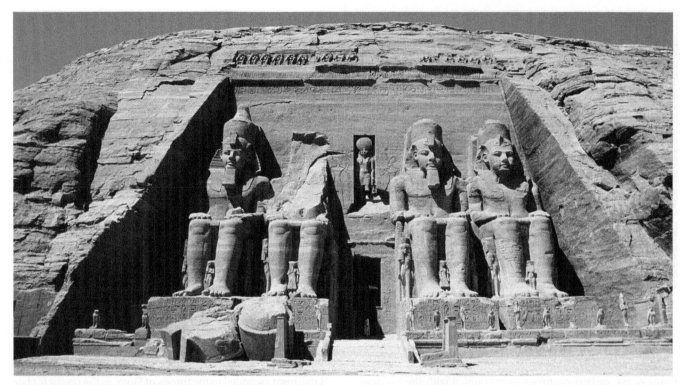

▲ **1.34 Temple of Ramses II, ca. 1290–1224** BCE. **Originally at Abu Simbel, Egypt; now relocated because of the creation of Lake Nasser. Approximately 65' high (colossi) (19.8 m).** Ramses II glorified his accomplishments as ruler of the Egyptian Empire in his rock-cut temple at Abu Simbel in Nubia. The four seated monumental figures at the entrance are images of the pharaoh. The temple was literally moved with the building of the Aswan High Dam to save it from complete submersion in the dam's reservoir.

▶ **1.35 The hypostyle hall of the temple of Amen-Re, ca. 1290–1224** BCE **(Nineteenth Dynasty). Karnak, Thebes, Egypt.** The monumental columns of the hypostyle audience hall of the temple at Karnak are carved with sunken reliefs that maintain the overall smooth profile of the column shaft. Two styles of columns are used, one in the shape of an open flower (or bell) and the other in the shape of a closed bud.

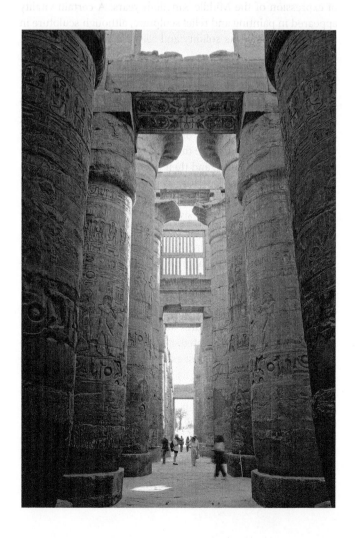

The temple of Amen-Re at Karnak (**Fig. 1.35**) represents another type of complex. Unlike the temples of Queen Hatshepsut and Ramses II, the temple of Amen-Re was built to honor several gods and was expanded by successive pharaohs, including Ramses. The site is vast—almost 250 acres—and was surrounded by a 26-foot-high wall. Like all complexes of this design, entry was through an enormous stone gateway called a pylon that led first to an open courtyard and then into a *hypostyle* hall—an audience hall that was reserved only for the pharaoh and priests. Beyond the hall was a dimly lit ritual chamber—the sanctuary. The hypostyle hall of the Karnak complex even today is a remarkable site. The columns number 134 in all, and some of them reach a height of 75 feet; they supported substantial **lintels** that, in turn, supported the roof. Between the vertical shaft of the **column** and the lintel is a **capital** in the shape of either

a closed bud or an open flower. The shafts of the columns are covered with **sunken reliefs** with figures, hieroglyphics, cartouches, and decorative motifs.

THE AMARNA REVOLUTION: THE REIGN OF AKHENATON AND NEFERTITI During the mid-14th century BCE, the pharaoh Amenhotep IV (r. 1379–1362 BCE) instituted radical changes in religion and politics. Egyptian gods were many, but Amenhotep IV abandoned almost all of them. He pronounced Aton the one and only true god and worshipped that deity—symbolized by a sun disk—exclusively. It did not stop there; he changed his name to Akhenaton and declared himself the son and only legitimate prophet of Aton. He moved the capital of Egypt from Thebes—where it had been since the beginning of the New Kingdom—north to Tel el Amarna. The period of Akhenaton's reign is called the Amarna Revolution.

The most sincere and moving expression of Akhenaton's devotion to Aton survives in the form of a hymn to the god:

READING 1.7 AKHENATON

From "Hymn to the Sun"

When in splendor you first took your throne
 high in the precinct of heaven,
 O living God,
 life truly began!
Now from eastern horizon risen and streaming,
 you have flooded the world with your beauty.
You are majestic, awesome, bedazzling, exalted,
 overlord over all earth,
 yet your rays, they touch lightly, compass the lands
 to the limits of all your creation.
There in the Sun. you reach to the farthest of those
 you would gather in for your Son,[14]
 whom you love;
Though you are far, your light is wide upon earth;
 and you shine in the faces of all
 who turn to follow your journeying.

In his monotheistic zeal, Akhenaton emptied temples dedicated to deities other than Aton and ordered the name of Amen-Re, the former chief god, scratched out wherever it appeared.

In addition to instigating upheavals in religion, Akhenaton cast aside time-honored artistic conventions and initiated a radically new, though short-lived, style. Curving lines and soft, feminized forms flouted the rigidity of Old and Middle Kingdom conventions. One of the most striking works of the Amarna period is the bust of Akhenaton's wife, Queen Nefertiti (**Fig. 1.36**). In profile, the arc formed by her heavy crown,

14. The pharaoh Akhenaton is referring to himself.

▲ **1.36** Bust of Queen Nefertiti, ca. 1344 BCE. Painted limestone, 19 ¾" (50 cm) high. Ägyptisches Museum, Berlin, Germany. *Nefertiti* means "the beautiful one has come."

sinuous neck, and delicate upper back is, simply, elegant. Nefertiti's refined features, enhanced by vividly painted details, give us some idea of what must have been an arresting beauty (her name means "the beautiful one has come").

The portraits of these royals take an endearing turn in a small sunken relief of Akhenaton, Nefertiti, and their three daughters (**Fig. 1.37**). Such intimacy had never before been seen in images of the pharaoh. Despite the looming presence of the sun disk Aton, whose rays shine on the couple and their family and sanctify the scene, Akhenaton more than anything else comes across as a dad. He holds one of his daughters gently in his arms and kisses her. Nefertiti has one of the children

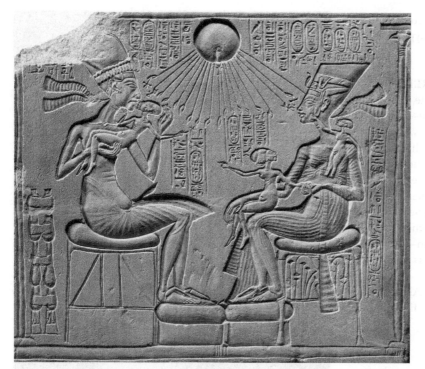

◀ **1.37 Akhenaton, Nefertiti, and three of their children, 1353–1335** BCE**, Amarna, Egypt. Limestone relief, 13" × 15¼" (32.5 × 39 cm) high. Ägyptisches Museum, Berlin, Germany.** The royal family sits beneath the rays of the sun disk Aton, whose cult was at the center of Akhenaton's reforms. The extreme ease and naturalism of the style is typical of the Amarna period.

regimented artistic styles of the earlier dynasties. With Akhenaton's death came the death of monotheism in Egypt. His belief in a single god who ruled the universe was threatening to the priests, who had a vested interest in preserving the old polytheistic traditions. Not surprisingly, Akhenaton's successors branded him a heretic and fanatic and cut out his name from all of the monuments that survived him.

TUTANKHAMEN AND THE POST-AMARNA PERIOD The reaction against Akhenaton's religious policy and the Amarna style was almost immediate. Akhenaton's direct successor Tutankhamen, however, is not remembered for leading the opposition—or for any event in his short life. He owes his fame to the treasures found intact in his undisturbed tomb on February 17, 1922. These sumptuous gold objects still show something of the liveliness of Amarna art, but a return to conservatism was beginning.

on her lap and another perched on her shoulder. The latter is clearly the youngest and is playing with an object dangling from her mother's crown, as any child would.

Akhenaton's revolutionary reforms were short-lived. After his death, they were repealed; it was as if the clock were turned back. His successors reestablished the capital in Thebes, restored the temples to Amen-Re, and returned to the more

It is not so much for what they reveal about trends in art that the treasures of Tutankhamen are significant. The discovery of the tomb is important for a different reason. Our knowledge of the cultures of the ancient world is constantly being revised by the work of archaeologists; many of their finds are minor, but some are major and spectacular. In the case of excavations such as the tomb of Tutankhamen, the process of uncovering the past sometimes becomes as exciting and significant as what is discovered.

Tutankhamen—the famed boy-king Tut—died at about age 18. His tomb was not discovered until 1922, when a British archaeological team led by Howard Carter unearthed a trove of gold objects, many inlaid with semiprecious stones. By far the most spectacular find was three gold coffins nested one inside the other, the last of which held the young pharaoh's mummified body; the

CONNECTIONS The discovery of King Tut's tomb in 1922 was one of the most sensational feats in archaeological history. But it was the rediscovery of the Rosetta Stone, which had been unearthed and used in building a medieval Ottoman fort, in 1799 by a soldier in Napoleon's French army that unlocked the secret of decoding hieroglyphic text and made it possible for scholars to translate the previously untranslatable Ancient Egyptian language. The text on the stone is a decree issued by King Ptolemy in 196 BCE that is inscribed in three scripts: Ancient Egyptian, Demotic (a script developed in Lower Egypt and typically used for documents), and Ancient Greek (a readable language that was the starting point for deciphering the Egyptian hieroglyphics).

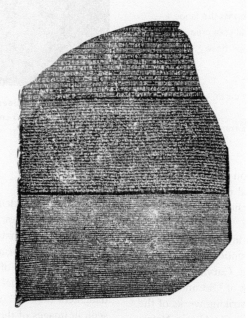

▲ **Rosetta Stone, discovered in Egypt, 1799. The British Museum.**

three together weighed almost 250 pounds (the weight of a black bear). The innermost coffin (Fig. 1.38) is magnificent in detail: Tut's effigy is fashioned of hammered gold inlaid with turquoise, lapis lazuli, and carnelian (a brownish-red semi-precious gem), and his eyes are of **aragonite** (a mineral) and **obsidian** (black volcanic glass). He clutches the royal attributes of the crook and the flail. Tut's body was found inside this coffin, wrapped in fine linen with a solid-gold mask, also with inlaid stone, placed over his head and shoulders. Carter described his awe at the discovery: "And as the last was removed a gasp of wonderment escaped our lips, so gorgeous was the sight that met our eye: a golden effigy of the young boy king, of most magnificent workmanship, filled the whole of the interior of the sarcophagus."[15]

After Tutankhamen, the conventions of the earlier periods of Egyptian art—along with their characteristic rigidity—reappeared. The aura of permanence that was so valued endured for another 1000 years virtually unchanged, despite the empire's gradual decline.

LITERATURE Much art and architecture from ancient Egypt has survived, but all that remains of literature is some scattered fragments. From the Old Kingdom, only religious texts such as the *Book of the Dead*, and others intended to ease the soul's passage to the afterlife, have come down to us. Lyric poetry and narratives of the New Kingdom, however, paint a picture of a much richer and more diverse literary tradition.

The Leiden Hymns were written on a papyrus that dates to the rule of Ramses II, ca. 1238 BCE. In one, the author describes the self-creation of Aton, the sun god and chief deity who was "skilled in the intricate ways of the craftsman." The first lines of the hymn acknowledge that the form of the god is ultimately unknowable and unfathomable.

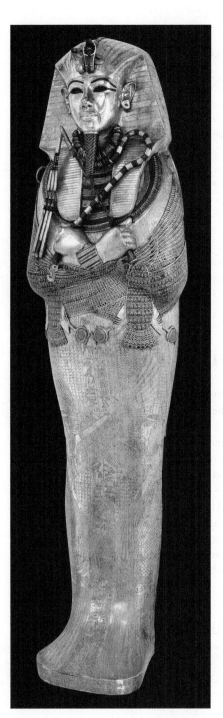

▲ **1.38 The innermost coffin of King Tutankhamen, ca. 1323 BCE. Tomb of Tutankhamen, Thebes, Egypt. Gold inlaid with semiprecious stones, 73¾" (187.3 cm) high. Egyptian Museum, Cairo, Egypt.** Three nesting gold coffins, the smallest of which held Tut's mummified body, weighed as much as an average-size black bear.

READING 1.8 THE LEIDEN HYMNS

From "God is a master craftsman"

God is a master craftsman;
 yet none can draw the lines of his Person.
Fair features first came into being
 in the hushed dark where he mused alone;
He forged his own figure there,
 hammered his likeness out of himself–
All powerful one (yet kindly,
 whose heart would lie open to men).

Love songs are among the most engaging and accessible literary works of the period, honest in their reflections on the joys and torments of the heart in the game called love. They range in sentiment from romantic and coquettish to seductive and frankly erotic.

READING 1.9 LOVE SONG

"Love, how I'd love to slip down to the pond"

Love, how I'd love to slip down to the pond,
 bathe with you close by on the bank.
Just for you I'd wear my new Memphis swimsuit,
 made of sheer linen, fit for a queen—
Come see how it looks in the water!

15. A. C. Mace. (1923). Work at the Tomb of Tutankhamun. *The Metropolitan Museum of Art Bulletin.*

READING 1.10 LOVE SONG

From "My love is one and only, without peer"

So there she stands, epitome
 of shining, shedding light,
Her eyebrows, gleaming darkly, marking
 eyes which dance and wander.
Sweet are those lips, which chatter
 (but never a word too much),
And the line of the long neck lovely, dropping
 (since song's notes slide that way)
To young breasts firm in the bouncing light
 which shimmers that blue-shadowed sidefall of hair. . . .
(He who could hold that body tight
 would know at last
 perfection of delight)

READING 1.11 LOVE SONG

"I think I'll go home and lie very still"

I think I'll go home and lie very still,
 feigning terminal illness.
Then the neighbors will all troop over to stare,
 my love, perhaps, among them.
How she'll smile while the specialists
 snarl in their teeth! —
 she perfectly well knows what ails me.

THE PREHISTORIC AEGEAN

Three civilizations developed during the Bronze Age in the area of the Aegean Sea: the Cycladic, Minoan, and Mycenaean civilizations (see **Map 1.3** on page 38). Cycladic culture sprang up during the Bronze Age on an archipelago (a cluster of islands) in the Aegean between the coasts of mainland Greece and Asia Minor. On the island of Crete in the southern Aegean, the Minoan civilization—the first great one in Europe—thrived until it was destroyed by natural catastrophe. And on mainland Greece, the Mycenaeans—forerunners of the ancient Greeks—built great citadels and lavished their tombs with gold. Centuries after their demise, the Greek poet Homer immortalized these Mycenaeans in his *Iliad*, an epic tale of the war between the Greeks and the Trojans. His epithet "Mycenae, rich in gold" was one of the inspirations for archaeological adventures that yielded the remains of a glorious civilization.

The Cycladics

Little is known about Cycladic culture. As with all prehistoric cultures, there are no written records. The people of the Cyclades islands used bronze tools and produced imaginative painted pottery. The most famous and idiosyncratic works, however, are the abstract marble figurines (**Fig. 1.39**) found in great quantities, in many cases buried with the dead. The statues range in height from a few inches to almost life-size; the average is about a foot high. Most of the figures are female

The Prehistoric Aegean

3000 BCE	2000 BCE	1600 BCE	1400 BCE	1200 BCE
Settlements and burial sites on Cyclades and Crete indicate thriving cultures and economies	Minoans construct palace complexes on Crete that are destroyed by fire ca. 1600 BCE	Mycenaean civilization flourishes on mainland Greece	Mycenaeans construct great fortified palace citadels and beehive-shaped tombs	
Cyclades are the center of the marble industry in the Aegean	Volcano destroys the island of Thera ca. 1600 BCE	Gold masks and other objects are placed in shaft graves of powerful elite	Mycenaean war against Troy ca. 1250 BCE	
Cycladic sculptors carve figurines for graves to accompany the deceased into the afterlife	Palace at Knossos on Crete is rebuilt; vast, rambling design is legendary home of King Minos and the Minotaur's labyrinth	Mycenaeans occupy Crete	Destruction of Mycenaean palaces ca. 1200 BCE	
	Development of writing using a linear script	Center of Aegean culture shifts from Crete to the mainland	Greek-speaking Dorians establish themselves on the mainland	

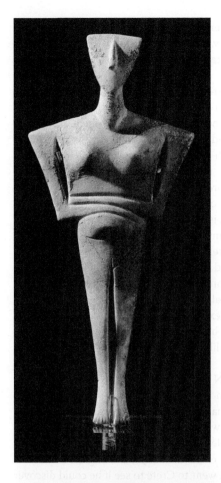

◀ **1.39 Figurine of a woman, ca. 2600–2300 BCE, Chalandriani, Syros, Greece. Marble, 18" (45.7 cm) high. National Archaeological Museum, Athens, Greece.** This statuette was found at a grave. It is unclear whether it represents the deceased or a goddess. The artist composed her body schematically from triangular shapes.

and typically nude, portrayed in highly simplified terms—a few geometric shapes with incised details used sparingly. The minimalist quality of the slender bodies—thin arms and legs, smallish head, protruding breasts, and triangle defining the pubic area—would suggest a connection to the earth-goddess or fertility figures we have already seen (see Figs. 1.11 to 1.14). The truth is, we have no idea whether they represent goddesses, or why they were carved, or what purposes they served. Figures of men playing musical instruments were also found in graves, suggesting that music was a part of funerary rituals or perhaps entertainment in the afterlife. They, too, are carved in simple, abstract shapes.

Excavations at Akrotíri on the southernmost Cycladic island of Thera have revealed extraordinary frescoes that were preserved in volcanic debris following an eruption ca. 1638 BCE. The *Spring Fresco* (**Fig. 1.40**) may be art history's first example of pure landscape painting created solely for the purpose of interior decoration. The artist made no attempt to describe accurately the hilly landscape dotted with leafy plants and sprigs of flowers. Instead, we see an eye for color and patterns, for undulating shapes and rhythmic lines that have a mood-elevating effect. The birds that fly and glide and, in one place, nearly kiss complete the carefree ambience.

Politically speaking, when the Theran eruption occurred, the island was most likely a satellite of the Minoans on Crete. The *Spring Fresco* has its artistic counterpart in the palace decorations at Knossos on the northern coast of Crete.

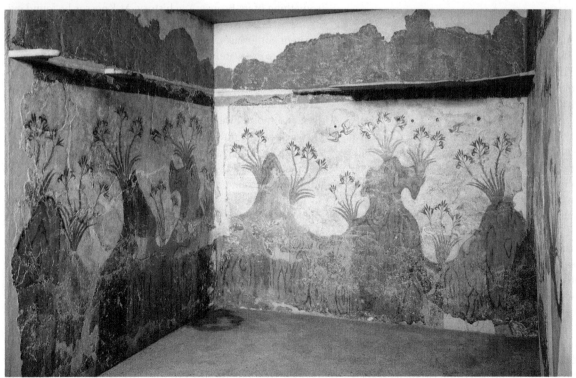

▲ **1.40 Landscape with swallows (*Spring Fresco*), ca. 1650–1625 BCE, Room Delta 2, Akrotíri, Thera, Greece. Fresco, 98" (250 cm) high, central wall, 102 ¼" (260 cm) long, side walls, 87 ¼" (222 cm) long and 74" (188 cm) long. National Archaeological Museum, Athens, Greece.** The fresco found on the Cycladic island of Thera may be the earliest known example of landscape as a purely decorative device.

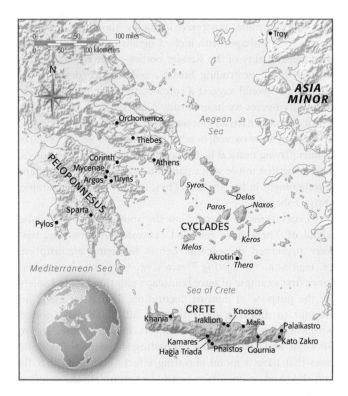

▲ MAP 1.3 **The prehistoric Aegean.**

The Minoans

Cycladic civilization developed in small settlements on the smallest islands of the Aegean. On Crete, however, there were palaces, and among them a famed one at that. The palace of the legendary King Minos at Knossos was constructed during the prime of Cretan civilization, rebuilt on the ruins of an earlier one that had been destroyed.

In Greek mythology, Minos was the offspring of Europa and Zeus, who abducted Europa in the guise of a white bull. As the king of Crete, Minos constructed a glorious palace with a labyrinth (a maze designed by his architect Daedalus). Inside the labyrinth roamed the Minotaur—a monstrous creature that was half man, half bull (*taurus* means bull), the product of the union of Minos's wife Pasiphae with a bull. Every year, according to the myth, King Aegeus of Athens presented seven boys and seven girls to Minos as tribute, whereupon they were sent into the maze to be devoured by the Minotaur. This gory sacrificial custom continued until Theseus, cofathered by Aegeus and the god Poseidon, volunteered to take on the beast. He went to Knossos with the new group of intended victims and, with the help of the king's daughter Ariadne (who had fallen in love with him), killed the Minotaur in its lair in the middle of the labyrinth. He then escaped with Ariadne and the Athenian boys and girls. Theseus later abandoned Ariadne on the Cycladic island of Náxos, but the god Dionysus discovered her there and comforted her. (In the early 20th century, the composer Richard Strauss would write a comedic opera called *Ariadne auf Naxos*—"Ariadne on Náxos.")

What does the Greek myth of Minos, the Minotaur, and the labyrinth tell us? That the Greeks had a picture of Knossos as a prosperous and thriving city from which a powerful and ruthless king ruled Crete. By the time Athens reached its golden age in the fifth century BCE, what remained of Knossos—or what Homer refers to as "Crete of a hundred cities"—was nothing more than legend. The Greeks never went in search of the roots of the legend, but this is not surprising. Archaeology, after all, is a relatively modern pursuit, and there is little indication of any serious enthusiasm in classical antiquity for the material remains of the past. For many centuries, the story of Minos and the labyrinth was thought to be a good tale with no foundation in fact. When we look at the restored view and plan of the palace at Knossos (**Figs. 1.41** and **1.42**), we see a sprawling complex with a central court for processions or games surrounded by buildings whose configurations can only be described as maze-like.

THE EXCAVATION OF KNOSSOS In the 1870s, the German businessman and amateur archaeologist Heinrich Schliemann proved that the stories of the war against Troy—and the Mycenaeans who had waged it—were far from mere legends. Was it possible that the mythical palace of King Minos at Knossos also really existed? In 1894, the English archaeologist Arthur Evans first went to Crete to see if he could discover something of its Bronze Age history. At Knossos he found evidence of ancient remains, some of them already uncovered by amateur enthusiasts. He returned in 1899 and again in 1900 with a permit to excavate. On March 23, 1900, serious work began at Knossos, and within days it became apparent that the finds represented a civilization even older than that of the Mycenaeans. The quantity was staggering: pottery, frescoes, inscribed tablets, and more. Evans's discoveries at Knossos (and finds later made elsewhere on Crete by other archaeologists) did much to confirm legendary accounts of Cretan prosperity and power. Yet these discoveries did far more than merely give a true historical background to the myth of the Minotaur. Evans had in fact found an entire civilization, which he called Minoan after the legendary king. Evans is said to have once remarked modestly, "Any success as an archaeologist I owe to two things: very short sight, so I look at everything closely, and being slow on the uptake, so I never leap to conclusions."

Actually, the magnitude of his achievement can scarcely be exaggerated. All study of the Minoans has been strongly influenced by his initial classification of the finds, especially the pottery. Evans divided the history of the Bronze Age in Crete into three main periods—Early Minoan, Middle Minoan, and Late Minoan—and further subdivided each of these into three periods. The precise dates of each can be disputed, but all of the excavations of the years following Evans have confirmed his reconstruction of the main sequence of events.

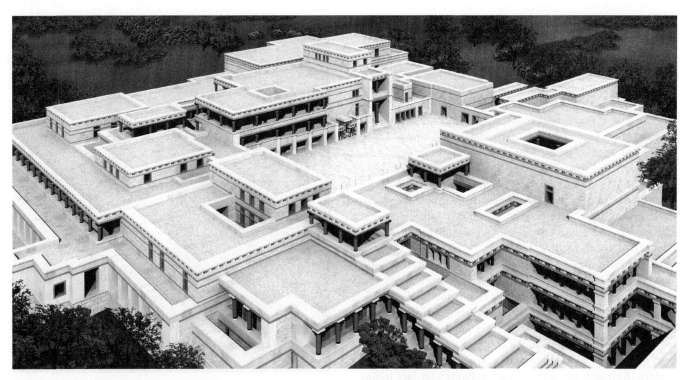

▲ **1.41 Restored view of the palace (looking northwest), Knossos (Crete), Greece, ca. 1700–1370** BCE
(John Burge). Each Cretan palace had a central court with a north–south orientation, state apartments to the west, and royal living quarters to the east.

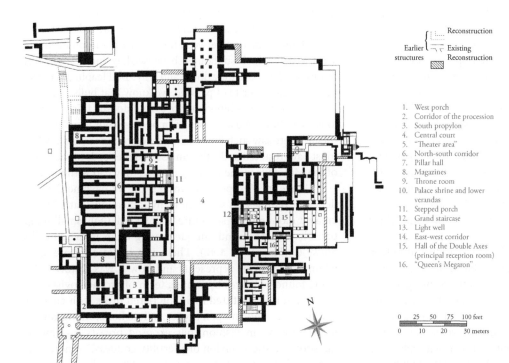

Reconstruction

Earlier structures — Existing Reconstruction

1. West porch
2. Corridor of the procession
3. South propylon
4. Central court
5. "Theater area"
6. North–south corridor
7. Pillar hall
8. Magazines
9. Throne room
10. Palace shrine and lower verandas
11. Stepped porch
12. Grand staircase
13. Light well
14. East–west corridor
15. Hall of the Double Axes (principal reception room)
16. "Queen's Megaron"

0 25 50 75 100 feet
0 10 20 30 meters

◄ **1.42 Plan of the palace at Knossos (Crete), Greece, ca. 1700–1370** BCE. The maze-like plan may have given birth to the myth of the Minotaur, half man and half bull, which roamed the labyrinth of the palace of King Minos and devoured Greek youths.

LIFE AND ART IN THE MINOAN PALACES During the Early Minoan period, small settlements began to appear in the south and east of Crete, and the first contacts were established with Egypt and Mesopotamia. Around 2000 BCE, these scattered towns were abandoned and large urban centers evolved, marking the beginning of the Middle Minoan period and the first major development in Minoan civilization—the palaces. More than elaborate homes for ruling families, they functioned as small cities. Sometime around 1600 BCE, these structures from what is called the Old Palace period were destroyed by a fire that may have followed an earthquake and were then rebuilt on an even grander scale. These palaces of the Late Minoan period represent the zenith of Minoan culture. The best-known is the one at Knossos; others were found at Phaistos, Malia, and Kato Zakros.

The main palace buildings were constructed around an open rectangular courtyard and included the king's and queen's bedrooms, a throne room, rooms for public receptions and banquets, a shrine, spaces for religious ceremonies, administrative offices, and work areas for slaves and craftsmen. The complex also included residences ranging from servant quarters to private houses for aristocrats and religious leaders. Although the plan seems haphazard, in fact it was not: rooms with similar or related functions were clustered together. Rows upon rows of magazines (storage areas) were stocked with large vessels of grain and wine, embedded in the earth for safekeeping and natural refrigeration. Beneath the palace were the makings of an impressive water-supply system of terra-cotta pipes that would have provided running water. The palace was designed to remain cool in summer and be heated easily in winter.

Aside from amenities that suggest a high standard of living, the scale and complexity of the palace architecture befit an impressive maritime power. The architects expanded outward from the central court and also built upward. Some parts of the palace are three stories high and accessed by gradually ascending staircases with light wells—vertical shafts running down through the building that bring light to the lower stories (Fig. 1.43). Characteristic Minoan columns can be seen in the stairwells and throughout the palace. Minoan columns were carved of wood and thus have not survived. We do know that they tapered downward and were narrowest at the base. This proportion is the reverse of standard columns found in Mesopotamia, Egypt, and, later, Greece. Cushion-shaped capitals loom large over the curious stem of the column shaft, which was painted bright red or blue.

The rough stonework of the thick palace walls was hidden behind plaster painted with vibrant, colorful landscapes like the *Spring Fresco* found on Thera. Many of the paintings depict subjects that reflect the palace's island setting—fish, sea mammals, coastal plants—but others, like the bull-leaping fresco (Fig. 1.44), clearly illustrate some sort of ceremony or ritual. As a bull leaps through space, front and hind legs splayed, a trio of youths performs daring feats. One takes the bull by the horns, a second vaults over its back, and a third lands safely with the flourish of a gymnast scoring a perfect ten. Although

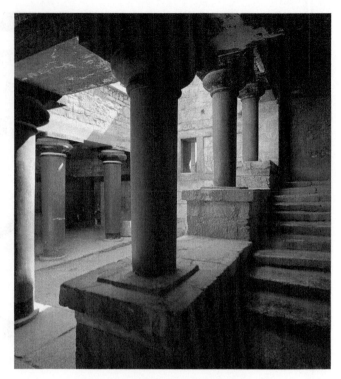

▲ **1.43 Stairwell to the residential quarter of the palace, Knossos (Crete), Greece, ca. 1700–1370 BCE.** The different levels of some buildings were accessed by staircases that were illuminated by light wells. Unlike Egyptian (and later Greek) columns, Minoan columns tapered toward the base. The columns shown here are reconstructions.

the body types and flowing black locks all look the same, the light-skinned youths are female and the one with dark skin is a male. This distinction between the sexes is common in ancient art: the males look suntanned because they spend more time outdoors. What are they doing and why? Bull leaping may have been a ritual or a rite of passage; we know that bulls were slain by the Minoans as a blood sacrifice. And doesn't this maneuver look exceptionally dangerous? Can one help but wonder if visitors to Crete saw such bull-leaping ceremonies—some of which must have resulted in death—and sowed the seeds of the legend of the Minotaur in the retelling of what they had witnessed?

Unlike in Mesopotamia and Egypt, we have neither evidence of temples on Crete nor any indication that Minoans created monumental sculpture of any kind. Only small sculptures have been found; unique among them is the so-called *Snake Goddess* (Fig. 1.45). There is a bit of a debate about whom this figurine represents and how it was restored after being found in pieces by Evans's team of archaeologists. The female figure is outfitted in a long tiered dress with an apron over her hips and an open bodice. While her clothing appears to be Minoan in fashion, her exposed breasts prompt the question, "Is she a version of a fertility goddess?" If not, is she another deity or perhaps a priestess? Although the rulers of the palaces seem to have been male, research suggests that Minoans worshipped female deities associated with fertility

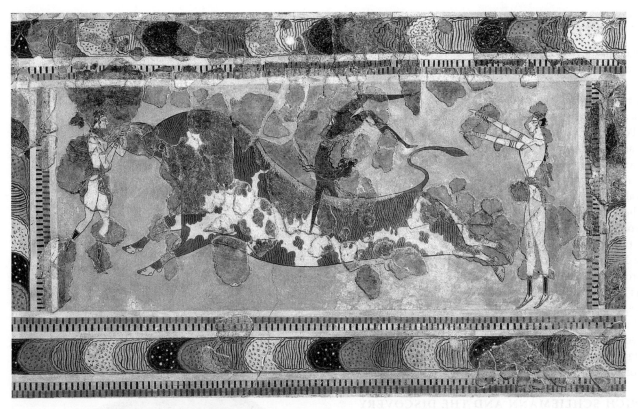

▲ **1.44 Bull-leaping fresco, ca. 1500 BCE, Palace, Knossos (Crete), Greece. Fresco, 32" (81.3 cm) high, including border. Archaeological Museum, Herakleion, Greece.** Bull leaping may have been a rite of passage or part of a blood-sacrifice ritual. The young women's skin is light and the young man's is suntanned, a common convention for distinguishing gender.

and that their palaces were sited in relation to the topography of the island, which resembles the shape of the female body. Absent decipherable texts, there is little that we know for certain about Minoan religion.

LINEAR A AND LINEAR B Throughout the Late Minoan period, there is evidence of cultural exchange—including artistic styles—between Crete and Mycenae on mainland Greece. During the second millennium BCE, two Minoan writing systems were devised and used in the palace for administrative and religious purposes. Linear A remains undeciphered; but in 1952, Michael Ventris discovered that Linear B—a written syllabic language—spread from Crete to Mycenae on the mainland and is in fact an early form of Greek.

THE DECLINE OF CRETE Minoan political and military power in the region declined, and there is credible evidence that the Mycenaeans occupied Crete and the palace at Knossos by 1450 BCE. Centuries earlier, at the same time that the new palaces were being constructed on Crete, the Mycenaeans were coming into their own. By 1500 BCE, a Mycenaean culture—distinct from the Minoans—was flourishing on the mainland. By the time that Knossos was utterly and finally destroyed—ca. 1200 BCE—the Mycenaeans had already erected their great, fortified citadels on the mainland.

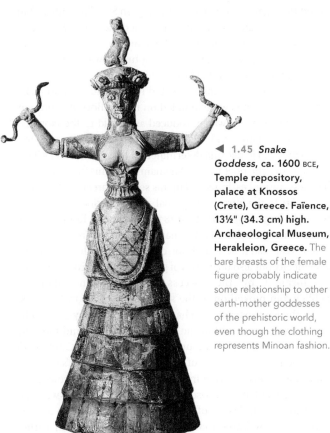

◄ **1.45** *Snake Goddess*, **ca. 1600 BCE, Temple repository, palace at Knossos (Crete), Greece. Faïence, 13½" (34.3 cm) high. Archaeological Museum, Herakleion, Greece.** The bare breasts of the female figure probably indicate some relationship to other earth-mother goddesses of the prehistoric world, even though the clothing represents Minoan fashion.

The Mycenaeans

The origins of the Mycenaean people are uncertain, but we do know that they came to the Greek mainland as early as 2000 BCE and spoke Greek. They are named after the largest of their settlements, at the city of Mycenae. Most of the centers of Mycenaean culture were in the southern part of Greece known as the Peloponnesus, although there were also some settlements farther north, the two most important of which were Athens and Thebes. The Mycenaeans were sophisticated in the forging of bronze weaponry and versatile in the arts of ceramics, metalworking, and architecture. The Minoans clearly influenced their art and culture, but by about 1400 BCE, Mycenae had become the natural leader in the Aegean area. Mycenaean traders traveled throughout the Mediterranean, from Egypt and the Near East as far west as Italy; their empire became more prosperous and more powerful. One successful expedition was launched against Troy on the coast of Asia Minor ca. 1250 BCE, perhaps because of a trade rivalry. A short time later (around 1200 BCE) the Mycenaean empire fell, its major centers destroyed and most of them abandoned. Invasion by enemies, internal strife, and natural causes have all been suggested, but the fall of the Mycenaeans remains mysterious.

HEINRICH SCHLIEMANN AND THE DISCOVERY OF MYCENAE Like the Minoans, the Mycenaeans were familiar from Greek myths long before their material remains were excavated; they were famous in legend for launching an expedition against Troy, across the Aegean Sea. The Trojan War (ca. 1250 BCE) and its aftermath provided the material for later Greek works—most notably the *Iliad* and the *Odyssey*, Homer's two great epic poems—but for a long time it was believed that the war and even Troy itself were only myths.

Heinrich Schliemann dedicated his life and work to proving that the legends were founded on reality. Born in Germany in 1822, Schliemann was introduced as a child to the Homeric poems by his father and was overwhelmed by their incomparable vividness. He became determined to discover Homer's Troy and to prove the poet true. Schliemann made his first fortune in business, retired early, picked up his second career, and devoted his profits to the pursuit of his goal. After a period of study and travel, he began excavations in 1870 beneath the Roman city of Ilium, where he believed the remains of Homer's Troy lay buried. Three years later, he found not only walls and the gate of the ancient city but also quantities of gold, silver, and bronze objects.

Inspired by the success of his Trojan campaign, Schliemann moved on to the second part of his task: to discover the Mycenaeans who had made war on Troy. In 1876 he began to excavate within the walls of Mycenae, and there he almost immediately came upon the Royal Grave Circle with its stupendous quantities of gold treasures. Homer's description of Mycenae as "rich in gold" had Schliemann convinced that the royal family whose graves he had unearthed was that of Agamemnon, leader of the Mycenaean expedition against Troy. We now know that the finds date to an even earlier

period, and later excavations both at Mycenae and at other mainland sites have provided a much more exact picture of Mycenaean history. This does not diminish Schliemann's achievement; however unscientific his methods, he had proved the existence of a civilization in Bronze Age Greece that surpassed in splendor even the legends. He had opened a new era in the study of the past.

MYCENAEAN ART AND ARCHITECTURE Like the Minoans, the Mycenaeans constructed great palace complexes, but unlike Cretan palaces, theirs were fortified. Lacking the natural defense of a surrounding sea that was to Crete's advantage, the Mycenaeans faced constant threats from land invaders. They met them with massive fortifications, such as those found in the citadels at Tiryns (Homer referred to it as "Tiryns of the great walls") and Mycenae (**Fig. 1.46**). At 20 feet in thickness,

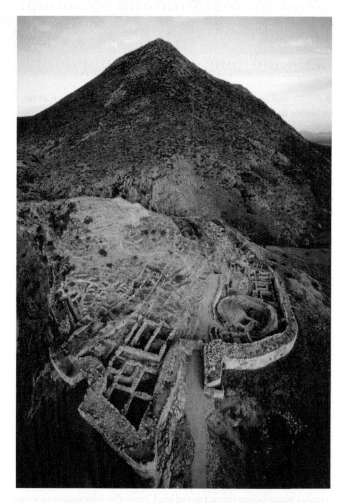

▲ **1.46 Aerial view of the citadel of Mycenae, ca. 1600–1200** BCE, **Mycenae, Greece.** Mycenaeans lived in vast palace complexes surrounded by massive fortification walls. Schliemann's Grave Circle A can be seen to the right in this photograph of the citadel at Mycenae, just inside the Lion Gate at the end of the path in the foreground.

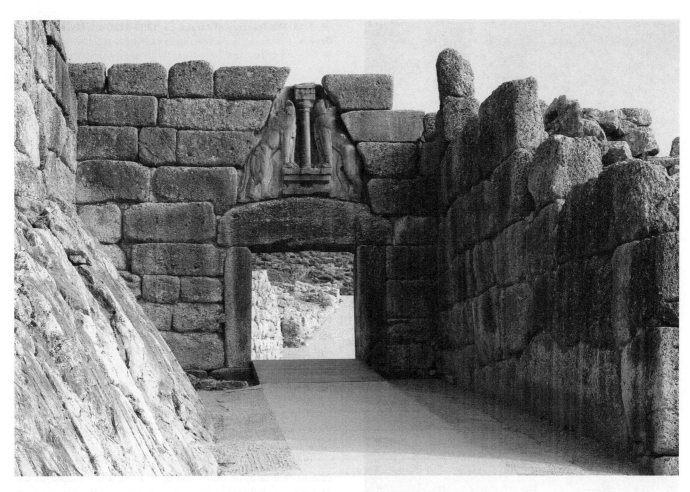

▲ **1.47 Lion Gate, ca. 1300–1250 BCE, Mycenae, Greece. Sculpture above lintel: 114½" (290 cm) high.** A relief sculpture of facing lions, with monumental heads carved in the round and attached to the relief, sat in the relieving triangle above a post-and-lintel gateway.

the sheer scale of the defensive walls makes the collapse of Mycenae incomprehensible. The stones laid were so enormous that Greeks later attributed the erection of the walls to a race of giants—the **Cyclopes**. Art historians still refer to the materials and construction techniques used in the citadels as **cyclopean masonry**.

The need for impenetrable fortification did not, however, preclude aesthetic solutions to architectural challenges. Although little painting survives, we know that some interiors were embellished with frescoes. Most of the sculpture unearthed is small in scale, but an example of monumental sculpture can be seen at one of the entryways to the citadel of the city of Mycenae—the so-called Lion Gate (**Fig. 1.47**).

The actual gateway is an example of post-and-lintel construction: a heavy stone lintel rests on two massive weight-bearing pillars. Around the gateway, stones are piled high

in **courses** (rows) and **beveled** (cut at an angle) to form a **corbeled arch** that frames an open **relieving triangle** (so called because the design relieves the weight that is typically born by the lintel in post-and-lintel construction). The relieving triangle, in this instance, was filled with a triangular slab of stone carved in relief. Two facing lions rest their front paws on the base of a Minoan-style column, the slant of their bodies corresponding to the diagonal lines of the triangle. Their heads, now gone, were carved in the round from separate pieces of stone and fitted into place. Although these guardian figures are not intact, their size and realistic musculature, carved in high relief, comprise an awesome sight—one that signified to intruders the strength of the army within the walls.

The corbeling technique was used to great effect in the construction of domed spaces in **tholos** tombs—beehive-shaped burial chambers entirely covered with earth so that they

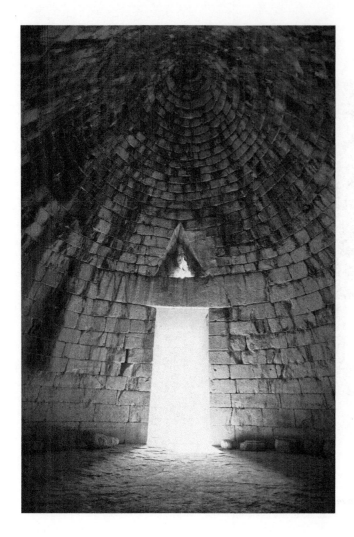

◀ **1.48 The Treasury of Atreus, ca. 1300–1250** BCE**, Mycenae, Greece.** This tholos, or beehive, tomb so impressed Schliemann that he believed it had to be the tomb of the legendary King Atreus—but it is not.

Homer's epithet for Mycenae was upheld with Schliemann's discovery of extraordinary quantities of finely wrought gold objects in simpler, more inconspicuous graves in a mound just inside the Lion Gate; the tholos tombs, like the pyramids before them in Egypt, were plundered well before the modern excavations. Archaeologists refer to this burial mound as Grave Circle A. The most impressive finds were gold funerary masks, one of which Schliemann believed was that of Agamemnon himself (**Fig. 1.49**).

Masks such as these were created from gold hammered into thin sheets and then given shape by pressing parts of the sheet from the underside to create raised surfaces. The masks were found over the faces of the deceased, and there was clearly some attempt to distinguish one person from another. Some aspects of the masks were stylized, such as the ears, eyebrows, and coffee-bean-shaped eyes, but the artists did endeavor to recreate specific portrait features. Schliemann found many other luxurious objects, including gold cups, bronze vessels, and daggers inlaid with silver and gold. As with other ancient burial practices, we conclude that the Mycenaeans stocked their tombs with precious objects they believed would have some purpose in the afterlife.

Something—the onslaught of better-equipped enemies, internal warfare, or both—brought about the collapse of the Mycenaean civilization ca. 1200 BCE. A few of the palaces were inhabited again, and some Mycenaeans fled eastward, where they settled on the islands of Rhodes and Cyprus off the southern coast of Asia Minor. By 1100 BCE, renewed violence extinguished the last traces of Bronze Age culture in Greece, and a period followed about which we know almost nothing. The people who emerged from this Dark Age would sow the seeds of the West's most influential civilization and enduring artistic legacy—that of ancient Greece.

look, from the outside, like simple mounds. The Treasury of Atreus (**Fig. 1.48**), so named by Schliemann because he believed it to be the tomb of the mythological Greek king Atreus, is typical of such constructions. The tomb consists of two parts: the **dromos**, or narrow passageway leading to the tomb proper; and the tholos, or tomb chamber. The dome is constructed of hundreds of stones that were laid on top of one another in concentric rings of diminishing size and precisely shaped by stoneworkers. The Treasury rose to a height of 43 feet and enclosed a vast amount of space, an architectural feat not to be duplicated until the Romans constructed the dome of the Pantheon using concrete.

◀ **1.49 Funerary mask, ca. 1600–1500** BCE**, Grave Circle A, Mycenae, Greece.** Beaten gold, 10 ¼" (26 cm) high. National Archaeological Museum, Athens, Greece. Shaft graves for members of the royal family in Grave Circle A yielded a cache of splendid gold objects, giving credence to the poet Homer's description of the city as "Mycenae, rich in gold."

GLOSSARY

Aragonite (p. 35) The primary mineral in mother-of-pearl, the iridescent inner layer of a mollusk shell.

Beveled (p. 43) Cut to create a slanted edge.

Canon of proportions (p. 30) A set of rules (or formula) governing what are considered to be the perfect proportions of the human body or correct proportions in architecture.

Capital (p. 32) In architecture, the uppermost part of a column on which rests the horizontal lintel.

Colonnade (p. 31) A series of columns, usually capped by a lintel, that can support a roof.

Column (p. 32) A vertical weight-bearing architectural member.

Conceptual representation (p. 19) The portrayal of a person or object as it is known or thought (conceptualized) to be rather than copied from nature at any given moment. Conceptual figures tend to be stylized rather than realistic.

Corbeled arch (p. 43) An arch in which each successive layer of stone projects slightly beyond the course below.

Course (p. 43) A horizontal row of stone or brick.

Cuneiform (p. 14) A system of writing featuring wedge-shaped characters; used in ancient Akkadian, Assyrian, Babylonian, and Persian writing.

Cyclopean masonry (p. 43) Walls constructed of extremely large and heavy stones.

Cyclopes (p. 42) A mythical race of one-eyed giants known for their inhuman strength.

Dromos (p. 44) A narrow passageway leading to a tomb.

Foreshortening (p. 6) A perspective technique used to convey the appearance of contraction of a figure or object as it recedes into space.

Hieroglyphics (p. 25) An ancient Egyptian system of writing that used pictures or symbols.

Hollow-casting (p. 19) A sculpture technique using molds that are lined with molten material—such as copper or bronze—rather than filled with the material (which would yield a solid rather than a hollow form).

Lapis lazuli (p. 14) An opaque blue, semiprecious stone.

Lintel (p. 32) In architecture, a horizontal member supported by posts or columns, used to span an opening.

Living rock (p. 30) Natural rock formations, as on a mountainside.

Middle Kingdom (p. 30) The period in ancient Egyptian history ca. 2040–1640 BCE.

Mortuary temple (p. 31) An Egyptian temple in which pharaohs worshipped during their lifetimes and were worshipped after death.

Neolithic (p. 4) The New Stone Age.

New Kingdom (p. 30) The period in ancient Egyptian history ca. 1550–1070 BCE, marked by the height of Egyptian power and prosperity; also referred to as the Egyptian Empire.

Obsidian (p. 35) A black, semiprecious, glass-like substance formed naturally by the rapid cooling of lava.

Old Kingdom (p. 25) The period in ancient Egyptian history ca. 2575–2040 BCE, during which the civilization achieved its first golden age.

Optical representation (p. 21) The portrayal of a person or object as it is seen at any given moment from any given vantage point.

Paleolithic (p. 4) The Old Stone Age, during which the first sculptures and paintings were created.

Pharaoh (p. 24) An ancient Egyptian king believed to be divine.

Portico (p. 30) A roofed entryway, like a front porch, with columns or a colonnade.

Post-and-lintel construction (p. 30) Construction in which vertical elements (posts) are used to support horizontal crosspieces (lintels).

Prehistoric (p. 4) Prior to record keeping or the written recording of events.

Register (p. 25) A horizontal band that contains imagery; registers are usually placed one on top of another to provide continuous space for the depiction of a narrative (like a comic strip).

Relieving triangle (p. 43) An open triangular space above a lintel, framed by the beveled contours of stones, that relieves the weight carried by the lintel; seen, for example, in the Lion Gate at Mycenae.

Rock-cut tomb (p. 30) A burial chamber cut into a natural rock formation (living rock), usually on a hillside.

Rosetta Stone (p. 25) An ancient Egyptian stele dating to 196 BCE with text inscribed in three languages: hieroglyphics, demotic Egyptian, and Greek. Discovery of the stone enabled Europeans to decipher the meaning of hieroglyphics.

Semitic (p. 12) A family of languages of Middle Eastern origin, including Akkadian, Arabic, Aramaic, Hebrew, Maltese, and others.

Sphinx (p. 28) A mythical creature with the body of a lion and the head of a human, ram, or cat. In ancient Egypt, sphinxes were seen as benevolent, and statues of sphinxes were used to guard the entrances to temples.

Stele (p. 19) An upright slab or pillar made of stone with inscribed text or relief sculpture, or both. Stelae (pl.) served as grave markers or commemorative monuments.

Sunken relief (p. 32) In sculpture, the removal of material from a surface so that the figures appear to be cut out or recessed.

Tholos (p. 44) A tomb chamber in the shape of a beehive.

Votive (p. 13) In a sacred space like a temple, a voluntary offering to a god put in place as a petition or to show gratitude; as in votive candle.

Ziggurat (p. 13) In ancient Mesopotamia, a monumental platform on top of which a temple was erected. The height of the ziggurat was intended to bring worshippers closer to the gods.

THE BIG PICTURE BEGINNINGS

BEFORE HISTORY

Language and Literature

- Stone Age cultures, for the most part, had no written language, but symbols seem to have been used to record events or transmit beliefs.

Art, Architecture, and Music

- Paintings and relief sculptures on cave walls and small, portable figurines indicate the ability and desire of early humans to represent the world around them.
- Flutes with finger holes, carved of bone and ivory, suggest that music was played, perhaps for rituals in acoustically resonant spaces that also featured art.
- Houses were built of mammoth bones, including arched doorways framed by enormous tusks.
- In the settlement of Jericho in the Middle East, ca. 7500 BCE, a fortification wall and 30-foot-high tower was constructed in cut stone without mortar. In the same place, human skulls with features reconstructed in plaster were placed beneath the floors of houses.
- Pottery appeared in quantity, revealing technical skill in painting and firing.
- During the late Neolithic period, monumental stone architecture appeared, including Stonehenge, whose elaborate design may have functioned as a solar calendar.
- In the Aegean, carved idols representing the female figure were buried with the dead in simple graves.

Philosophy and Religion

- Paleolithic art and the evidence of musical traditions support the existence of rituals. It remains unclear, however, what these rituals may have been and what role the art played in them.
- Objects and embellishments were buried with the dead, suggesting a belief in an afterlife.
- Jericho's plastered skulls may have been linked to a belief that ancestors were mediators between the human world and the unknown world of the afterlife.
- Large numbers of nude female figurines were carved, suggesting worship of a mother goddess that may have been associated with fertility rituals.

MESOPOTAMIA

Language and Literature

- In Sumer, pictographs were used in early documents referring to business and administrative transactions. By ca. 3000 BCE, these signs were simplified into wedge-shaped characters in a form of writing called cuneiform.
- The life of the Sumerian king and hero Gilgamesh was glorified in an epic poem, the first work of literature in ancient history.

Art, Architecture, and Music

- Ziggurats with temples were constructed by the Sumerians.
- Small statuary was placed in temples; luxury items of gold and finely crafted objects made of wood and inlaid with lapis lazuli, shell, and other semiprecious materials were placed in tombs of the wealthy.
- Life-size, hollow-cast bronze sculptures illustrated sophisticated metalworking techniques.
- The Assyrian kings built sprawling and lavishly decorated palaces in citadels with defensive walls.
- Relief sculpture exalted the power of kings, invested by the gods, in images of victorious military campaigns.
- King Nebuchadnezzar of Babylon created the Hanging Gardens, one of the Seven Wonders of the Ancient World and perhaps the earliest example of landscape architecture.
- The Persians built a citadel at Persepolis, a vast complex of administrative buildings, religious structures, and ceremonial spaces adorned with reliefs and architectural sculpture.
- Musical instruments were placed in royal burial sites, and musicians were depicted in art. Musical texts inscribed on tablets in cuneiform writing suggest a rich and highly developed theory and practice.

Philosophy and Religion

- Mesopotamian civilizations were polytheistic, and most deities were connected to nature.
- Mesopotamians believed that their gods resided above them and would descend to meet their priests in the temples built high upon the platforms of ziggurats. Sumerians called these shrines waiting rooms.

ANCIENT EGYPT

Language and Literature

- Egyptian language appeared in written form ca. 3400 BCE in hieroglyphics, a complex writing system that consists of stylized pictographs. It was deciphered after the discovery of the Rosetta Stone.
- The earliest Egyptian texts had a sacred purpose, but in the Middle Kingdom, literature expanded to narratives, poetry, love songs, history, biography, scientific texts, and instructive literature.
- The *Book of Emerging Forth into the Light* (also known as the *Book of the Dead*)—placed in burial chambers—is an illuminated papyrus scroll bearing spells and incantations that were deemed necessary to ease the passage of the deceased through the underworld.

Art, Architecture, and Music

- Egyptians created narrative paintings and reliefs, statuary, and colossal sculptures. For most of their history, the human figure was rendered according to strict pictorial codes.
- The first record of an artist's name—Imhotep—dates to Old Kingdom Egypt. He was the famed architect of the stepped pyramid of King Djoser.
- The three Great Pyramids at Gizeh, splendid pharaonic tombs, were constructed within the short span of 75 years.
- In the Middle and New Kingdoms, pyramidal tombs were replaced with tombs and mortuary temples carved into Egypt's imposing rocky cliffs.
- Amenhotep IV (Akhenaton) cast aside time-honored artistic conventions and initiated a radically new, but short-lived, style. Curving lines and soft, organic shapes flouted the traditional canon of geometric forms.
- Musical instruments including lyres, pipes, and flutes were found in burial chambers, which, along with fresco paintings of musicians, indicates that music was vitally connected to Egyptian life and ritual.

Philosophy and Religion

- Throughout almost its entire history, Egypt was polytheistic.
- Deities, subdeities, and nature spirits were worshipped; they were responsible for all aspects of existence and inspired mythology and ritual that affected the daily lives of all Egyptians.
- Egyptians were obsessed with immortality and the possibilities of life after death. Bodies were preserved through mummification, and burial rituals sought to provide the deceased with the means to continue a life similar to that of this world.

THE PREHISTORIC AEGEAN

Language and Literature

- Linear A is a hieroglyphic script used mainly on seals in ancient Crete; Linear B, an early form of Greek, began on Crete and spread to Mycenae. Only Linear B has been deciphered.

Art, Architecture, and Music

- The Cycladic culture produced imaginative pottery and large numbers of nude female figurines carved in a simplified, abstract style.
- Small Cycladic sculptures of musicians playing a harp and double flute were found in a grave, suggesting that music was a part of funerary rituals.
- In the second millennium BCE, sprawling maze-like palaces were constructed at Knossos on the island of Crete and decorated with wall frescoes illustrating bull-leaping rituals, goddesses, and lively scenes from nature.
- Funerary masks and assorted objects of gold were fashioned by the Mycenaeans and placed, with their dead, in shaft graves; the Mycenaeans also built large beehive-shaped tombs with corbeled, domed ceilings.
- Citadels with massive fortification walls were constructed in Mycenae and Tiryns.

Philosophy and Religion

- In the absence of deciphered texts, Minoan religion remains a mystery. As in other prehistoric cultures, however, female figurines may have been connected to worship of an earth mother or fertility goddess.
- A bull-leaping ritual in a Minoan fresco may portray a fertility or initiation rite or ritual blood sacrifice.
- Luxurious and finely crafted objects of silver and gold found at Mycenaean burial sites suggest some belief in an afterlife.

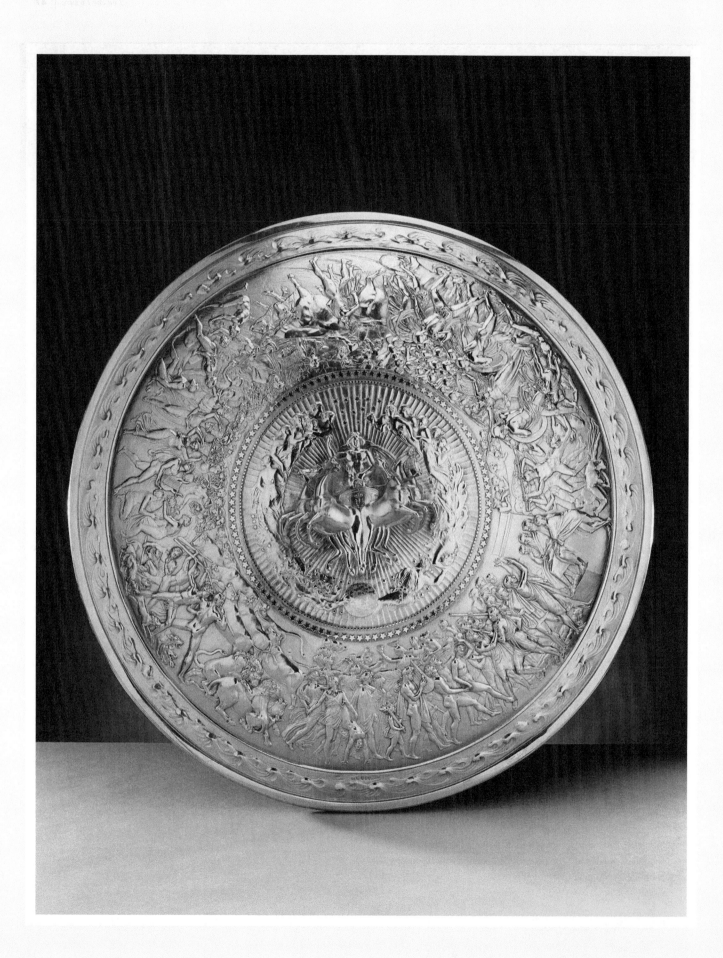

The Rise of Greece

2

PREVIEW

We know nothing of Homer except for his name. We have no idea what he looked like. We do not know for certain where he was born. We have no definitive proof that *The Iliad* and *The Odyssey*—as we read them today—were the work of his hand. But someone, some single voice, wove the stories of generations of bards, who sang of a long-past heroic age as far back as the eighth century BCE, into an epic narrative that would be written down, canonized, and commemorated. By law, the 15,693 lines of *The Iliad* would be recited in Athens every four years. And Homer, the "immortal poet," would be known as its author.

Homer's epics underscore the importance of the Mycenaean legacy to the Greeks, the shaping of their identity, and their emerging sense of self. The poems speak to us of the relationship between humans and their gods and the delicate interplay of fate—ordained by the divine, and destiny—shaped by the actions of an individual with free will. Enmeshed in the heroic figures of *The Iliad* and *The Odyssey* are Homer's reflections on the human condition as it is affected by the destruction of war and the security of peace. These become vivid in his description of the great shield of Achilles, forged by the god Hephaestus himself, in the 18th book of *The Iliad*. The shield's imagery is a microcosm of Greek culture and values, set in the contexts of the world and human life. In our mind's eye, we see the earth, sky, and the sea; the sun, moon, and stars; and "two noble cities filled with mortal men." One is besieged, its inhabitants locked in battle with an enemy army, death all around. Life goes on in the other, unburdened by conflict: a wedding takes place, a law case is brought to court for justice, fields are plowed, harvests are reaped, and grapes are picked for the making of wine. The two scenarios are juxtaposed, as if to suggest that these two, discrete aspects of humanity will endure, irreconcilable.

Homer's descriptive powers have yielded various physical manifestations of the shield's narrative, including one by John Flaxman (Fig. 2.1), completed in 1817 on commission for Rundells, a British jewelry firm. Achilles's "indestructible shield" was prominently displayed at the 1821 coronation banquet of the United Kingdom's King George IV, the son and successor of George III, "the king who lost America" to the Colonists a few decades earlier.

◀ **2.1** John Flaxman, *The Shield of Achilles*, 1821. Silver-gilt 35 ¾" (90.7 cm) diameter. The Royal Collection, London, United Kingdom.

EARLY GREECE

Western culture's debt to the ancient Greeks lies principally in the achievements of their city life: art, politics, philosophy, history, and all the other factors described in this and the following chapter. Greece itself, however, was basically an agricultural society, and as Homer implies in the description of Achilles's shield, most cities viewed farming and its products as of the highest importance to the community. Athenian young men, at the age of 18, swore an oath to protect their city's grain, vines, figs, and olives, as well as to obey its laws (**Fig. 2.2**).

Survival depended on healthy eating. On the whole, the average Greek's diet was simple, based chiefly on cereals. Bread was unleavened and often had various herbs and flavorings—thyme, rosemary, olives—mixed in the dough. Sweet loaves contained raisins and dried figs. According to one ancient gourmet, citizens of Athens could choose from 72 varieties of bread.

With starch as the basic filler, the Greeks added a wide variety of accompaniments: beans and lentils, olives, onions, and cheese, generally using goat milk for the latter. Poorer Greeks probably lived mainly on this simple diet, along with anchovies and sardines, washing it all down with water ("the best drink of all," says the poet Pindar).

Prosperous diners could flavor their food with fine olive oil, for which Athens was famous throughout the Mediterranean,

◀ **2.2 Antimenes (attr.), Men Harvesting Olives, 520 BCE. Black-figure amphora, 16" (40.64 cm) high. British Museum, United Kingdom.** Imagery on Greek vases ranges from mythological and historical subjects to vignettes of everyday life. Much of what we know about the look of battle armor, musical instruments, farming practices, and textile looms—to name a few things—comes from their representations on painted pottery.

and eat excellent fruit, also an Athenian specialty. Game such as hare and pheasant was popular, but on the whole, meat remained a rarity, even for the wealthy. Homer's heroic banquets, at which warriors slaughtered whole oxen and roasted them over coals, represented only a dream for most of his audience. Fish was more common. Both fresh Mediterranean tuna and dried tuna imported from the Black Sea were popular, as were squid and shrimp.

The Greeks drank their wine diluted with water and often added honey and spices. They exported it in jars made waterproof by an inner layer of pine resin—the origin of the retsina (resinated wine) still drunk in Greece today.

The Early History of Greece

One of the major turning points of history, ca. 1000 BCE, was the advent of the Iron Age in the Mediterranean region. Athens

The Rise of Greece

1100 BCE	1000 BCE	750 BCE	600 BCE	480 BCE
DARK AGE	THE HEROIC AGE	THE AGE OF COLONIZATION	THE ARCHAIC PERIOD	
Collapse of Mycenaean Empire; Greece split into city-state including Athens, Thebes, and Sparta	Development of Iron Age culture at Athens	Greeks expand trade network and found colonies throughout Mediterranean from Egypt to the Black Sea	Solon reforms Athenian constitution in 594 BCE	
Greece loses contact with the outside world	Life of Homer	Greeks adopt Phoenician alphabet	Growth of Athenian power and expansion of Persian Empire	
Widespread poverty	Greeks begin colonizing in East and in Italy	Evolution of large free-standing sculpture	Greek cities in Asia Minor rebel against Persian rule	
	Olympic games founded 776 BCE	Development of aulos (flute) and cithara (stringed instrument)	Persian Wars begin; forces of Darius I defeated at Marathon 480 BCE	
			Forces of Xerxes win battle of Thermopylae and sack Athens but Greeks defeat Persians in navel battle at Salamis	

had been a Mycenaean city long before the Iron Age began; but by the fifth century BCE, it would become the intellectual and cultural center of Greece, which would form the foundation of Western civilization.

The Mycenaeans had writing, they were accomplished builders, and they were skilled metalworkers, but this legacy was lost when their civilization came to an abrupt and violent end ca. 1100 BCE. What followed was a century of disturbance and confusion—what has been called the Dark Age of ancient Greece. The people of the Iron Age had to discover for themselves, and develop from scratch, almost all of the aspects of civilization—organized government and society, writing and literature, religion and philosophy, art and architecture. To follow their first attempts is to witness the birth of Western civilization.

The history of early Greece falls naturally into three periods, each marked by its own distinctive artistic achievement. During the first 300 years or so of the Iron Age, culture developed at a slow pace. The Greeks had only limited contact with other Mediterranean peoples, living in relative isolation. Yet it is during this period that *The Iliad* and *The Odyssey*, two epic poems considered to be the first great works of Western literature, found their origins in stories that were sung by bards throughout Greece. Because the themes of these poems are heroic, the early Iron Age in Greece is also known as the *Heroic Age*. The artistic style of this period is called *Geometric* because of the prevalence of abstract motifs in vase painting, but it is important to note that at the same time that the heroic epic narratives were being composed, the Greeks returned to the representation of the human figure in their art.

By the beginning of the eighth century BCE, Greek travelers and merchants had already begun to explore the lands to their east and west. They sailed from the mainland and established colonies throughout the Mediterranean from Egypt to the Black Sea. Over the next 150 years (ca. 750–600 BCE), called the *Age of Colonization*, the Greeks were exposed to new and different ideas; they adopted the Phoenician alphabet, and in art they borrowed motifs and styles from Mesopotamia and Egypt that can be seen in the *Orientalizing* period. These foreign influences were assimilated in the *Archaic* period (ca. 600–480 BCE), when life-size statues appeared and the first large temples were constructed. The Archaic period was a culmination of the first 500 years of Greek culture, but it was also the period during which a series of wars with Persia shook Greece to the core. With the Greeks' ultimate victory over the Persians, their relationship to the world took a decisive turn, paving the way for the *Classical* period (discussed in Chapter 3).

The Heroic Age (ca. 1000 BCE–750 BCE)

During the period of Mycenaean supremacy, most of Greece was united under a single authority. With the fall of Mycenae, the social order of the Bronze Age collapsed. Greece was split into independent regions whose borders were determined by topography—mountain ranges and high hills that crisscross the rugged terrain. Each of these geographically discrete areas developed an urban center that controlled the surrounding countryside. Thus Athens became the dominant force in the geographical region known as Attica; Thebes oversaw the territory of Boeotia; Sparta controlled Laconia; and so on (see **Map 2.1**, "The Greek World"). These independent,

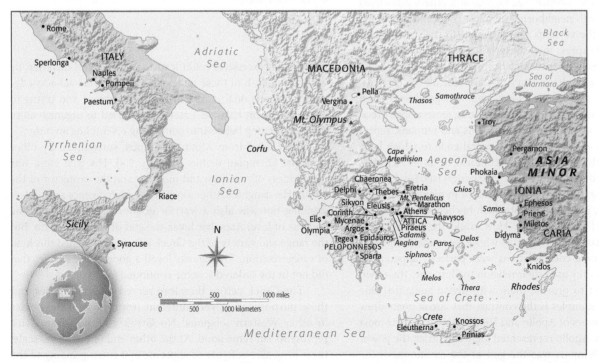

◄ MAP 2.1 **The Greek World.**

self-governing cities were called *city-states*, or **poleis** (singular *polis*). They served as the focal point for all political, religious, social, and artistic activities within their regions. Citizens felt a loyalty toward their own city-state that was far stronger than any sense of community they may have had with fellow Greeks over the mountains. Fierce competition among city-states led to bitter and destructive rivalries. The city-state structure of government in Greece had its pros and cons: on the one hand, it created an unequaled concentration of intellectual and cultural developments; on the other, it fostered a tendency toward internal squabbling at the least provocation.

Even though city-states were in frequent conflict with one another, the citizens all called themselves *Hellenes* (the people of Hellas, the ancient name for Greece), and they all spoke Greek—the common language that separated them from the outsiders. They shared sanctuaries, such as the one at Delphi, and came together for the Panhellenic (all-Greek) games; the first ancient Olympic Games were held in 776 BCE (Fig. 2.3). And in times when the future of Greece was at risk of coming under the thumb of non-Greek-speaking nations—*barbarians*, to the Greeks—the city-states rallied.

Religion

The fragmentation of social and cultural life in the early years of Greece's history had a marked effect on the nature of Greek religion and mythology. A mass of folktales, primitive customs, and traditional rituals sprang up during the Heroic Age but were never combined into a single unified belief system. Individual cities had their own mythological traditions, some of them going back to Bronze Age Greece and others influenced by encounters with neighboring peoples. Poets and artists felt free to choose the versions that appealed to their own tastes or helped them express their ideas. What was consistent about Greek religion was its inconsistency: Often there are varying versions of the same basic story that are difficult to reconcile. The very characters of the Greek gods and goddesses often seem confused and self-contradictory. Zeus, for example, president of the immortals and father of gods and humans, represented the concept of an objective moral code to which both gods and mortals were expected to conform; he imposed justice and supervised the punishment of wrongdoers (see Fig. 2.4). Yet this same majestic ruler was also involved in many love affairs and seductions, in the course of which his behavior was often undignified and even comical. How could the Greeks have believed in a champion of morality whose own moral standards were so lax? These contradictions were perfectly apparent to the Greeks, but they used their religion to illuminate their own lives rather than to provide them with divine guidance. One of the clearest examples is the contrast that Greek poets drew between the powers of Apollo and Dionysus, two of their most important gods. Apollo represented logic and order, the power of the mind; Dionysus was the god of the emotions, whose

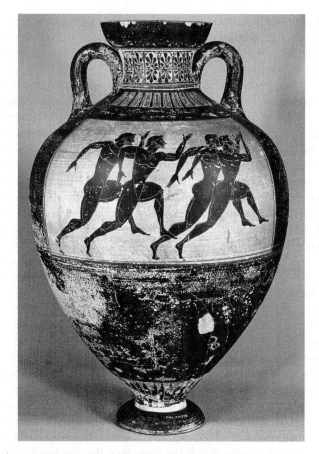

▲ **2.3** Panathenaic amphora with footrace, sixth century BCE, 24 ¼" (61.8 cm) high, 16 ⅛" (41 cm) diameter. National Museum of Denmark, Copenhagen, Denmark. Competitive games in many Greek cities drew participants from all of the city-states. Events included athletic competitions—what we today associate with the Olympics—but the earliest games showcased poetry and music contests. The award for the victorious was typically a Panathenaic amphora—a two-handled vase filled with precious oil.

influence, if excessive, could lead to violence and disorder. By worshiping both of these forces, the Greeks were acknowledging an obvious dual nature in human existence and trying to strike a prudent balance. Later Greeks tried to organize all of these conflicting beliefs into something resembling an order.

Zeus ruled from Mount Olympus, surrounded by other principal Olympian deities (see Fig. 2.4). His wife Hera was the goddess of marriage and morality and the protector of the family. His daughter Athena symbolized intelligence and understanding but was also a warrior goddess. Aphrodite was the goddess of love; Ares, her lover, the god of war; and so on. But the range and variety of the Greek imagination defied this kind of categorization. The Greeks loved a good story, so tales that did not fit the ordered scheme continued to circulate.

The Greek deities therefore served many purposes, but these purposes were very different from those of the deities in other Western religions. No Greek god, not even Zeus, represents supreme good. At the other end of the moral scale, there is no Greek figure of supreme evil corresponding to the

RELIGION

The Principal Deities of Ancient Greece

Zeus	King of the gods; brother of Poseidon and Hades; god of the sky
Hera	Sister and wife of Zeus; goddess of marriage
Poseidon	Brother of Zeus and Hades; god of the sea
Hephaestus	Son of Zeus and Hera, and husband of Aphrodite; god of fire and metalworking
Ares	Son of Zeus and Hera, and lover of Aphrodite; god of war
Apollo	Son of Zeus and Leda, daughter of a Titan; twin brother of Artemis; god of prophecy, light, and music; associated with the sun
Artemis	Twin sister of Apollo; goddess of wild animals and the hunt; associated with the moon
Demeter	Sister of Zeus; goddess of agriculture and fertility
Aphrodite	Daughter of Zeus and the nymph Dione; wife of Hephaestus; mother of Eros by her lover Ares and of the Trojan hero Aeneas by the mortal Anchises; goddess of love and beauty
Athena	Daughter of Zeus, born full-grown from his head; goddess of wisdom and warfare; protector of Athens
Hermes	Son of Zeus and the nymph Maia; messenger of the gods and guide to travelers
Dionysus	Non-Olympian; son of Zeus and the mortal Semele; god of wine
Hades	Non-Olympian; brother of Zeus and Poseidon; god of the dead and king of the underworld

Judeo-Christian concept of Satan. The Greeks turned to their deities for explanations of natural phenomena and the psychological characteristics they recognized in themselves. At the same time, they used their gods and goddesses as another way of enhancing the glory of their individual city-states, as in the case of the cult of Athena at Athens. Problems of human morality required human, rather than divine, solutions. The Greeks turned to art and literature, rather than prayer, to seek solutions.

The Homeric Epics

At the beginning of Greek history stand two epic poems that even the quarrelsome Greeks saw as national—indeed, universal—in significance. *The Iliad* and *The Odyssey* have, from that early time, been held in the highest esteem.

The ancient Greeks were not sure who had composed *The Iliad* and *The Odyssey*, when and where the author had lived, or even whether one person was responsible for both of them. Tradition ascribed the epics to a blind poet called Homer; almost every city worthy of the name claimed to be his birthplace. Theories about when he had lived ranged from the time of the Trojan War, around 1250 BCE, to 500 years afterward.

The problem of Homer's identity, and whether he existed at all, continues to vex scholars to this day. In any case, most experts would probably now agree that the creation of *The Iliad* and *The Odyssey* was highly complex. Each of the epics consists basically of several shorter folktales that were combined, gradually evolving over a century or more into the works as we now know them.

The first crystallization of these popular stories had probably occurred by around 800 BCE, but the poems would still not appear in their final form for more than a century. The first written official version of each epic was probably not made before the late sixth century BCE. A scribe working at Alexandria in the second century BCE made the edition of the poems used by modern scholars.

Where, then, in this long development must we place Homer? He may have been the man who first began to combine the separate tales into a single whole; or perhaps he was the man who, sometime after 800 BCE, imposed an artistic unity on the mass of folk stories he had inherited. The differences between *The Iliad* and *The Odyssey* have suggested to several commentators that a "different Homer" may have been responsible for the creation or development of each work, but here we enter the realm of speculation. Perhaps it would be best to follow the ancient Greeks, contenting ourselves with the belief that at some stage in the evolution of the poems they were filtered through the imagination of the first great author of the Western literary tradition, without being too specific about precisely which stage it was.

Both epic narratives, then, evolved from oral tradition and reflect that fact. There are occasional minor inconsistencies in plot. Phrases, lines, and entire sections are often repeated—a strategy for memorization. All of the chief characters are given standardized descriptive adjectives—**epithets**—that accompany their names whenever they appear: Achilles is "swift-footed" and Odysseus is "cunning."

The heroic world of warfare is made more accessible to the poem's audience through the use of elaborate similes that compare the story's events to familiar vignettes of everyday

COMPARE + CONTRAST

Gods into Men, Men into Gods

Early in the 19th century, one of France's most influential painters borrowed something from Homer. It was only a brief episode, but it inspired an imposing canvas that gave a face to a famous name: Zeus.

> She sank to the ground beside him, put her left arm round his knees, raised her right hand to touch his chin, and so made her petition to the Royal Son of Cronos. (*The Iliad*, book 1)

Jean-Auguste-Dominique Ingres depicted the fearsome king of the gods and ruler of the sky on his imperial throne—one arm raised and wrapped around his royal scepter and the other casually resting on a cumulus cloud. His stare is intense, and his physique is powerful. He is mighty in strength and, from the looks of it, unshakable in will. Or is he? The body of a beautiful woman curls serpentinely around his knee. She lays one arm across his lap and stretches the other upward to touch his beard. She is Achilles's mother, Thetis, and she is worried about her son, who is out fighting bloody battles against the Trojans. What she wants from Zeus is some sort of intervention; she cannot leave Achilles's life to fate. Thetis entreats Zeus, grabbing delicately at his beard. It is a gesture he cannot resist.

▲ **2.5 Jean-Auguste-Dominique Ingres, Jupiter and Thetis, 1811.** Oil on canvas, 128¾" × 102⅜" (327 × 260 cm). Musée Granet, Aix-en-provence, France.

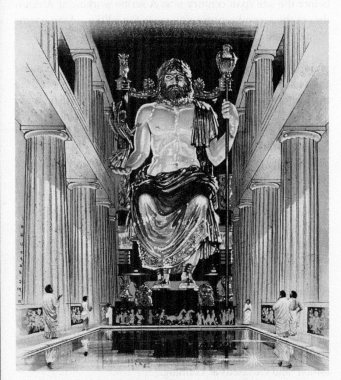

▲ **2.4 Phidias, statue of Zeus in the Temple of Zeus at Olympia, Greece, ca 435 BCE.** (Imaginary reconstruction, gouache, © Sian Frances).

The cult statue that resided in the Temple of Zeus at Olympia (**Fig. 2.4**) was the inspiration for Ingres's image of Zeus (whose Roman name is Jupiter) in his *Jupiter and Thetis* (**Fig. 2.5**). The original, definitive representation has not survived except in small replicas. Composed of ivory and gold and 43 feet high, it was one of the Seven Wonders of the Ancient World in ancient times. Ingres painted his canvas in 1811, but at the time it was not well received. It languished in his studio for almost a quarter century until the French government purchased the work.

On the other side of the Atlantic Ocean, only a dozen years after Ingres's composition was painted, the United States Congress commissioned a statue of George Washington for the Rotunda of the Capitol building in Washington, DC. Chosen for the project was Horatio Greenough, an American sculptor who had studied in Rome and whose works were inspired by classical ideals. When he delivered his monumental portrait of the Father of the Country in 1840, Greenough could never have imagined that

▲ **2.6** Horatio Greenough, *George Washington*, 1840. Smithsonian American Art Museum. Marble, 136" × 102" × 82½" (345.4 × 259 × 209.6 cm). The National Museum of American History, Washington, DC.

Washington **(Fig. 2.7)**, an ambitious ceiling fresco in the Rotunda dome. The painter, Constantino Brumidi, kept Washington's clothing on but nonetheless depicted him as a god—or at least glorified him as an ideal. Washington holds court on a ring of clouds that gives way to a golden, celestial light. The president is flanked by personifications of Liberty and Victory/Fame, a godlike man in a circle of 13 beautiful maidens—symbols of the 13 founding states. As a counterpart to Zeus, Washington is in fitting company: around the base of the dome, six groups of figures represent subjects including war, science, commerce, and agriculture. Visitors from the Greek and Roman pantheons accompany their personifications and representatives: Minerva (the Greek Athena, goddess of wisdom) imparts knowledge to Benjamin Franklin, Robert Fulton, and Samuel F. B. Morse; Ceres (the Greek Demeter, the goddess of agriculture) sits on a McCormick reaper. Elsewhere, Venus (the Greek Aphrodite) holds the transatlantic cable under Neptune's (Poseidon's) supervision, and Vulcan (the Greek Hephaestus), at his anvil, forges a cannon and a steam engine.

The U.S. forefathers established a democracy based on the guiding principle of shared governance that had its origin in ancient Greece. But symbols were as important as actions: it is no coincidence that the buildings of the U.S. capital—Washington, DC—bear an obvious resemblance to classical temple architecture, and no surprise that George Washington—as close to a god in stature as one could get—might be portrayed as Zeus's beneficent doppelganger.

the reception of his masterpiece would be so chilly—literally. George Washington, naked from the waist up and masquerading as Zeus **(Fig. 2.6)**, drew sharp criticism and biting sarcasm. It was laughable to some and, to many, outrageously offensive. When the sculpture was taken from its intended prominent display in the Capitol Rotunda to a spot outside on the lawn, the sarcasm continued; one of the common jokes had George Washington reaching for his clothes, which were on display in a nearby building. Congress was clearly concerned about the first president's image, literally and figuratively. It was brought in from the cold and first displayed in the Smithsonian Castle; in 1964, the 11-foot-high-monument was moved to what is now the National Museum of American History. Greenough's representation of George Washington prompts the question, 'What might the first president have thought of this portrayal, this deified status?' If Washington himself would have rejected this notion soundly, others did not. The deification of the first president is indeed the subject of *The Apotheosis of*

▲ **2.7** Constantino Brumidi, *The Apotheosis of Washington* (detail), 1865. Ceiling fresco, Capitol, Washington, DC.

life in the early Iron Age; the massing of the Greek forces, for example, is likened to a swarm of flies buzzing around pails of milk.

Although the two poems are of a single tradition, they differ in spirit. *The Iliad* is somber, taut, direct. The theme is concentrated, and the plot is easier to understand—and certainly easier to explain—than that of *The Odyssey*, which is more digressive and lighthearted. But *The Odyssey* is not a lesser work; if anything, its range and breadth of humanity are even greater, and its design is more elaborate.

THE METER OF *THE ILIAD* AND *THE ODYSSEY*

The Iliad and *The Odyssey* are written in **heroic verse**, which is generally associated with the meter, or rhythm, of epic poetry in Greek and Latin. The form is **dactylic hexameter**. A *dactyl* is a unit or foot of poetry containing three syllables—a long syllable followed by two short syllables; *hexa-* means "six" and derives from the same root as the six-sided geometric figure we call a hexagon. Thus a line of dactylic hexameter consists of six dactyls.

So how do you read a poem in dactylic hexameter? By stressing syllables according to the long and short rule. Think of basic musical notation. A dactyl is read like a quarter note followed by two eighth notes in terms of emphasis and rhythm:

Just as there are equivalents in musical notation, so are there in dactylic hexameter. A **spondee** is a unit that can take the place of a dactyl in the same way that a quarter note can take the place of two eighth notes.

Just as replacing eighth notes with quarter notes in music will slow the rhythm, so do spondees slow the pacing of the narration in poetry.

Dactylic hexameter does not fit the English language very well, so we find few examples in English poetry. An exception that comes close is Henry Wadsworth Longfellow's poem "Evangeline," first published in 1847. Here are the first two lines; read them aloud and try to key into the rhythm:

> This is the forest primeval. The murmuring pines and the hemlocks
> Bearded with moss, and in garments green, indistinct in the twilight,...

Now take a look at the first two lines of the verse with the stresses in boldface type, and pace your reading so that you emphasize those stressed words:

> **This** is the / **for**est prim- / **ev**al. The / **mur**muring / **pines** and the / **hem locks**,
> **Beard**ed with / **moss**, and in / **gar**ments / **green**, indis- / **tinct** in the / **twi light**,...

You will notice that the structure of each line is not perfect dactylic hexameter. (Neither was the meter perfectly consistent in *The Iliad* and *The Odyssey*.) The first line has five dactyls and then a final foot with two accented syllables—a spondee. The second line ends in a spondee as well. But notice the third foot in the second line, *garments*; it consists of a stressed or accented syllable followed by only *one* unaccented syllable (as opposed to the two in a dactyl). This foot is called a **trochee**. Homer did the same thing—mixed dactyls with spondees and trochees. The variation stimulates interest and allows for emphasis, even as the overall structure remains quite formal.

The extracts from Homer's epics do not appear here as translated in dactylic hexameter, but here is what the first few lines of *The Iliad* look like:

Thinking of reading *The Iliad* and *The Odyssey* in musical terms brings us closer to the reality of how these epic narratives were orally formed and kept alive, before the invention of writing would preserve them "in print." The first lines of both poems, in fact, contain the word *sing*, and, depending on the translation, *sing* may be the first word. The consensus among scholars seems to be that what we call Homer's poems are an amalgam of contributions to the basic stories by generations of singer-performers. In Book 8 of *The Odyssey*, we meet one such performer and recognize the esteem in which such singer-performers are held and their value in transmitting memory:

READING 2.1 HOMER

The Odyssey, Book 8, lines 47–49, 78–84, and 90–98

"Call in our minstrel,
Demódokos, whom God made lord of song,
heart-easing, sing upon what theme he will."...
In time, when hunger and thirst were turned away,
the Muse brought to the minstrel's mind a song
of heroes whose great fame rang under heaven:
the clash between Odysseus and Achilleus[1],
how one time they contended at the godfeast
raging, and the marshal, Agamemnon,
felt inward joy over his captains' quarrel;...
So ran the tale the minstrel sang. Odysseus
With massive hand drew his rich mantle down
over his brow, cloaking his face with it,
to make the Phaiákians miss the secret tears
that started to his eyes. How skillfully
he dried them when the song came to a pause!
threw back his mantle, spilt his gout of wine!
But soon the minstrel plucked his note once more
to please the Phaiákian lords, who loved the song;...

THE ILIAD The action of *The Iliad* takes place during the final year of the Greeks' siege of Ilium, or Troy. The audience enters the story in the middle of things—**in medias res**. In due course, the reason for the siege will be illuminated: While on a diplomatic mission to Sparta, Paris, a prince of Troy, ran off with Helen, the wife of King Menelaus. (Menelaus's father was Atreus and his brother was Agamemnon—names associated with the tombs and treasures we saw from Mycenae in Chapter 1.) The Trojan War commences when the brothers, along with a thousand ships, set sail for Troy to reclaim Helen. Even though the events of the war permeate the text of the poem, they are secondary to the principal theme of *The Iliad*, stated in the opening lines of Book 1. The poet begins by invoking the goddess who provides his inspiration; his words establish the tragic mood of the story to follow:

READING 2.2 HOMER

The Iliad, Book 1, lines 1–7

Sing, goddess, the anger of Peleus' son Achilleus
and its devastation, which put pains thousandfold upon the
 Achaeans,
hurled in their multitudes to the house of Hades, strong souls
of heroes, but gave their bodies to be the delicate feasting
of dogs, of all birds, and the will of Zeus was accomplished
since that time when first there stood in division of conflict
Atreus' son the lord of men and brilliant Achilleus.

1. Achilles.

Sing is not the only important word in the opening lines of *The Iliad*; another is *anger*. The context for the poem may be the Trojan War, but the subject of the poem is Achilles's anger and its consequences. Its message is a direct one: we must be prepared to answer for the results of our own actions and realize that when we act wrongly, we will cause suffering both for ourselves and, perhaps more important, for those we love.

"What god drove them to fight with such fury?" begins the second verse, and therein we come to learn the backstory for Achilles's rage. Agamemnon took his lover from him, a captive named Briseis, who was part of Achilles's share of the spoils of another battle. But there is much more to this story. Agamemnon himself has a captive who shares his bed—a young woman named Chryseis whose father, Chryses, we are told, is a priest of Apollo. When Agamemnon rejects the pleas of Chryses to set his daughter free, the old man prays to the god to visit destruction on Agamemnon's army of Achaeans. A plague ensues and ravages the Achaeans until Agamemnon agrees to surrender Chryseis. But the king wants something in return for his sacrifice. Achilles suggests that Agamemnon wait for compensation until more booty arrives, but with a clear assertion of authority, Agamemnon takes Briseis from Achilles. Achilles's response is to remove himself from the fighting. His absence wreaks havoc on the Achaeans, and this is what the opening verse of *The Iliad* alludes to; Achilles's rage "...put pains thousandfold upon the Achaeans, / hurled in their multitudes to the house of Hades,..."

Agamemnon eventually (Book 9) admits that he behaved too high-handedly (although he makes no formal apology) and, through intermediaries, he offers Achilles generous gifts to return to the fighting and save the Greek cause. Achilles rejects the king's effort to make amends and stubbornly nurses his anger as the fighting resumes and Greek casualties mount. While Achilles continues to sulk, his dearest friend, Patroclus, suits up in Achilles's armor and, thus disguised, leads the Achaeans into battle. Patroclus slays Trojan warriors one after the other, accounting for some of the most graphic, unromanticized depictions of war in the poem:

READING 2.3 HOMER

The Iliad, Book 16, lines 462–466 and 477–491

Now as these two advancing had come close to each other
there Patroclus threw first at glorious Thrasmylos
who was the strong henchman of lord Sarpedon, and
 struck him
in the depth of the lower belly, and unstrung his limbs'
 strength.
Sarpedon with the second throw then missed...
 Once again Sarpedon threw wide with a cast of his shining
spear, so that the pointed head overshot the left shoulder
of Patroclus; and now Patroclus made the second cast with the
brazen

spear, and the shaft escaping his hand was not thrown vainly
but struck where the beating heart is closed in the arch of the
 muscles.
He fell, as when an oak goes down or a white poplar,
or like a towering pine tree which in the mountains the
 carpenters
have hewn down with their whetted axes to make a ship-timber
So he lay there felled in front of his horses and chariots
roaring, and clawed with his hands at the bloody dust; or as
a blazing and haughty bull in a huddle of shambling cattle
when a lion has come among the herd and destroys him
dies bellowing under the hooked claws of the lion, so now
before Patroclus the lord of the shield-armored Lykians
 died raging,...

CONNECTIONS

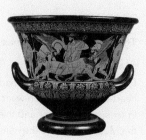

▲ Euphronios and Euxitheos' *Death of Sarpedon* (see Fig. 2.19)

Homer's image of a mighty Sarpedon falling on the battlefield "as when an oak goes down or a white poplar, / or like a towering pine tree…" is evoked in Euphronios's representation of the dead warrior being carried off to the Underworld. The scale and insistent horizontality of Sarpedon's body seems to reference Homer's simile in Book 16 of *The Iliad*—certainly a work with which the painter would have been familiar.

When Patroclus is killed by the Trojan leader, Hector—who mistakenly believes that he has slain the Achaeans' greatest warrior—Achilles enters the fight with a vengeance. But not before the god Hephaestus forges for him a new suit of armor—("fine armor for him, such as another / man out of many men shall wonder at, when he looks on it.") and a magnificent shield (a visual translation of which is the opening image in this chapter). Achilles's anger toward Agamemnon is now turned on the Trojans, and on Hector in particular.

It is in Book 22 that Hector meets his death at the hands of Achilles. Their final, decisive encounter begins with a request on the part of Hector:

READING 2.4 HOMER

The Iliad, Book 22, lines 250–259

"Son of Peleus, I will no longer run from you, as before this
I fled three times around the great city of Priam, and dared not
stand to your onfall. But now my spirit in turn has driven me
to stand and face you. I must take you now, or I must be taken.
Come then, shall we swear before the gods? For these are the
 highest
who shall be witnesses and watch over our agreements.
Brutal as you are I will not defile you if Zeus grants
to me that I can wear you out, and take the life from you.
But after I have stripped your glorious armor, Achilleus,
I will give your corpse back to the Achaeans. Do you do
 likewise?"

Achilles coldly refuses, saying to Hector "Argue me no agreements. I cannot forgive you. / As there are no trustworthy oaths between men and lions, / nor wolves and lambs have spirit that can be brought to agreement / but forever these hold feelings of hate for each other…" Hector hurls his spear at Achilles, but it glances off his shield. And so it followed in this one-on-one fight to the death that Achilles killed Hector with his own spear and then "shamed noble Hector" by dragging his body

behind his chariot outside the walls of Troy (**Fig. 2.8**). Even as Achilles lights Patroclus's funeral pyre to usher his friend to the underworld, he vows once more to feed Hector's body not to the "hungry flames" but to the wild dogs.

As we move to the final book of *The Iliad*, it is interesting to reflect on the parallelism of the opening and closing of the epic narrative. Recall Agamemnon's rejection of the priest, Chryses's pleas for the return of his daughter, Chryseis, in exchange for a large ransom. Agamemnon's arrogance and cold-heartedness is met with disastrous consequences for his soldiers, forcing him to relent. In the last book (Book 24), King Priam goes to Achilles, beseeching him to return the body of his son, Hector, so that he may accord him a proper burial. In spite of his vow to the contrary, Achilles, touched by the heartbroken man's pleas, not only returns Hector's body to his father, but he orders that the body be washed, properly anointed, and regally dressed before it is brought back to Troy. As Hector's body lies in state awaiting departure, Achilles extends worthy hospitality to his royal guest, offering him food and drink and a safe place to rest. Achilles's sympathetic response underscores his heroism and sets him apart from the prideful Agamemnon:

READING 2.5 HOMER

The Iliad, Book 24, lines 517–526

 "Ah, unlucky,
surely you have had much evil to endure in your spirit.
How could you dare to come alone to the ships of the Achaeans
and before my eyes, when I am one who have killed in such
 numbers
such brave sons of yours? The heart in you is iron. Come, then,
and sit down upon this chair, and you and I will even let
our sorrows lie still in the heart for all our grieving. There is not
any advantage to be won from grim lamentation.
Such is the way the gods spun life for unfortunate mortals,
that we live in unhappiness, but the gods themselves have no
 sorrows."

◀ **2.8 The Diosphos painter, lekythos with Achilles dragging the body of Hector, ca. 500 BCE. Black-figure painting, 8¼" (21 cm) high. Musée du Louvre, Paris, France.** Achilles drags Hector's body after killing him, thus avenging the death of Patroclus. The winged goddess Iris petitions for the return of Hector's body to Hector's parents.

The Iliad ends with the funeral rites and burial, in Troy, of Hector, "breaker of horses."

As is clear even from this brief summary, there is a direct relationship between human actions and their consequences. The gods appear in *The Iliad* and frequently play a part in the action, but at no time can divine intervention save Achilles from paying the price for his unreasonable anger. Furthermore, Achilles's crime is committed not against a divine code of ethics but against human standards of behavior. All of his companions, including Patroclus, realize that he is behaving unreasonably. Although the setting of *The Iliad* is heroic, even mythic, the theme of human responsibility is relatable—universal.

From its earliest beginnings, therefore, the Greek view of morality is in strong contrast to the Judeo-Christian tradition. The gods are not at the center of the Homeric universe; rather, it is human beings who are at least partly in control of their own destiny. If they cannot choose the time when they die, they can at least choose how they live. The standards by which human life will be judged are those established by one's fellow humans. In *The Iliad*, the gods serve as divine umpires: they watch the action and comment on it, and at times enforce the rules, but they do not affect the course of history. Humans do not always, however, fully realize the consequences of their behavior. In fact, they often prefer to believe that things happen "according to the will of the gods" rather than because of their own actions. Yet the gods claim no such power. In a remarkable passage at the beginning of Book I of *The Odyssey*, we see the world for a moment through the eyes of Zeus as he sits at dinner on Mount Olympus: "How foolish men are! How unjustly they blame the gods! It is their lot to suffer, but because of their own folly they bring upon themselves sufferings over and above what is fated for them. And then they blame the gods."[2]

THE ODYSSEY The principal theme of *The Odyssey* is the hero Odysseus's return to his kingdom of Ithaca after the Trojan War—his homecoming, or **nostos**, as the Greeks called it. His journey takes 10 years—the same length as the war itself—and is fraught with perilous adventures with the likes of one-eyed giants and an array of monsters, a seductive enchantress and romantic young girl, a floating island and a visit to the underworld. We do not meet Odysseus in person, however, until the fifth book of the poem. The first four tell the story of his son's attempts to find out more about the father he has never seen. Telemachus was born on the very day that Odysseus was called to fight in the Trojan War, and he is now 20 years old. These four chapters, known as the Telemachy, describe Telemachus's visits to other Greek leaders who have returned safely from Troy, including Menelaus and Helen. They tell Telemachus of his father's bravery and also that he has been seen alive. If the subject of *The Iliad* is Achilles's anger and its consequences, the subject of the Telemachy is Odysseus's absence and its consequences. It is in these four books that we come to learn about what transpires in the palace: Odysseus's wife, Penelope, is plagued by suitors who are eating them out of house and home—and worse, they want Penelope to declare Odysseus dead and remarry. The prize is the throne of the kingdom of Ithaca. Telemachus tries to evict them:

READING 2.6 HOMER

The Odyssey, Book I, lines 417–430

"You suitors of my mother! Insolent men,
now we have dined, let us have entertainment
and no more shouting. There can be no pleasure
so fair as giving heed to a great minstrel
like ours, whose voice itself is pure delight.
At daybreak we shall sit down in assembly
and I shall tell you—take it as you will—
you are to leave this hall. Go feasting elsewhere,
consume your own stores. Turn and turn about,
use one another's houses. If you choose
to slaughter one man's livestock and pay nothing,
this is rapine; and by the eternal gods
I beg Zeus you shall get what you deserve:
a slaughter here, and nothing paid for it!"

2. H. D. F. Kitto, *The Greeks*. Piscataway, NJ: Transaction Publishers, Rutgers–The State University of New Jersey, 1951, 1964, p. 54.

CULTURE AND SOCIETY

Fate, Chance, and Luck

The Greeks had conflicting ideas on just how much human lives were preordained by a force in the universe that they called *fate*. Homer speaks of three Moirai, goddesses who dispensed to every person their ultimate fate: Klotho spun the thread of life, Lachesis measured its length, and Atropos cut the thread at the moment of death (**Fig. 2.9**).

Neither Homer nor the later Greeks seems clear on how the Moirai related to the other gods. One author, Hesiod, describes them as the daughters of Zeus and Themis (Righteousness), whereas Plato calls them the daughters of Ananke (Necessity). Sometimes fate is a force with unlimited power, feared by humans and deities alike—including the almighty Zeus. On other occasions, Zeus may intervene with fate on behalf of an individual; even humans sometimes succeed in reversing their fate.

The Greeks also acknowledged another powerful force in the universe—that of pure chance. The goddess of chance, Tyche (or Fortune), may bestow lavish benefits on individuals, but she does so at random. Her symbols—wings, a wheel, and a revolving ball—convey her variability. With the general decline of traditional religious beliefs in later Greek history, Tyche was revered for her potency.

The Romans adopted the Greek Moirai (in the form of the Parcae), but they paid far more attention to *luck*, worshipped as the goddess Fortuna. She appeared in numerous aspects pertinent to human situations in need of a little good fortune, although she could bring bad luck as well. To name but a few, Fortuna Victrix brought victory in war, Fortuna Annonaria brought abundant harvests, and Fortuna Redux assured safe return from a journey.

▲ **2.9 Atropos cutting the thread of life. Bas-relief.** Photo by Tom Oates.

The suitors, however, are not the least bit intimidated by Telemachus. At the beginning of Book 2, one of them—Antinoös—rips into Telemachus and his mother Penelope. He rants and blames Penelope for their languishing at the palace; she has hatched a plan to keep the suitors at bay, and they are on to her treachery:

READING 2.7 HOMER

The Odyssey, Book 2, lines 91–114

 "What high and mighty
talk, Telémakhos! No holding you!
You want to shame us, and humiliate us,
but you should know the suitors are not to blame—

it is your own dear, incomparably cunning mother.
For three years now—and it will soon be four—
she has been breaking the hearts of the Akhaians,
holding out hope to all, and sending promises
to each man privately—but thinking otherwise.
"Here is an instance of her trickery:
she had her great loom standing in the hall
and the fine warp of some vast fabric on it;
we were attending her, and she said to us:
'Young men, my suitors, now my lord is dead,
let me finish my weaving before I marry,
or else my thread will have been spun in vain.
It is a shroud I weave for Lord Laërtês,
when cold death comes to lay him on his bier.

> The country wives would hold me in dishonor
> if he, with all his fortune, lay unshrouded.'
> We have men's hearts; she touched them; we agreed.
> So every day she wove on the great loom—
> but every night by torchlight she unwove it;..."

The suitors, contemplating Telemachus's rage, come to believe that he will murder them; they will have to kill the boy first. Telemachus walks down to the sea and prays for the gods to be near him as he travels the sea for news of his father. Athena hears him and speaks to him in the guise of Mentor (we get the meaning of the word *mentor* from this passage). She tells him that he has his "father's spirit" and that she will sail beside him as she did with his father "in the old days":

READING 2.8 HOMER

The Odyssey, Book 2, lines 292–300

"The son is rare who measures with his father,
and one in a thousand is a better man,
but you will have the sap and wit
and prudence—for you get that from Odysseus—
to give you a fair chance of winning through.
So never mind the suitors and their ways,
there is no judgment in them, neither do they
know anything of death and the black terror
close upon them—doom's day on them all."

Telemachus sails off, but his journey is more than information gathering; it is also his journey to manhood. He will return to Ithaca and the suitors stronger and angrier. He just needs help. And he will get it once he finds his father.

In the meantime, Odysseus has spent seven years with the nymph Calypso. Even though they have slept together and he reassures her that she is more beautiful than his wife, Odysseus wants to be back home. The only problem is that he is captive: he has no crew and no vessel. Athena petitions Zeus to intervene and take him from Calypso's grasp; Zeus complies and sends the messenger god Hermes to see to it. Zeus's words to Hermes frame what will be Odysseus's harrowing experiences as he wanders the unknown seas on his way back to Ithaca:

READING 2.9 HOMER

The Odyssey, Book 5, lines 32–47

"Hermês, you have much practice on our missions,
go make it known to the softly-braided nymph
that we, whose will is not subject to error,

order Odysseus home; let him depart.
But let him have no company, gods or men,
only a raft that he must lash together,
and after twenty days, worn out at sea,
he shall make land upon the garden isle,
Skhería, of our kinsmen, the Phaiákians.
Let these men take him to their hearts in honor
and berth him in a ship, and send him home,
with gifts of garments, gold, and bronze—
so much he had not counted on from Troy
could he have carried home his share of plunder.
His destiny is to see his friends again
under his own roof, in his father's country."

At the beginning of Book 9, Odysseus arrives at the Phaeacians and recounts to King Alcinous the details of what he encountered—and endured—along the way. The reader is presented with an edited version of Odysseus's trials in his own words. The symbolism of some of his adventures is interesting. The Lotus-Eaters offer his sailors a plant (perhaps cannabis) that will make them forget their homeland. Odysseus calls to them, "All hands aboard / come, clear the beach and no one taste / the Lotus, or you lose your hope of home." The hero becomes single-minded in his efforts to resume his life and restore order in his kingdom.

Odysseus finally returns home in the last half of the poem, but he does so in disguise. Without revealing his identity to his ever-faithful wife Penelope, he kills all of the suitors in a bloodbath with Telemachus at his side. Homer keeps us waiting for the love scene—the moment of recognition—until almost the last lines of the poem. All ends as it should: Odysseus, his father Laertes, and his wife Penelope are reunited. War is replaced with peace, discord with harmony, disorder with hierarchical structure, and destruction with the potential for creativity. The gods assert and insinuate themselves, but humans make decisions about the lives they want to lead. *The Odyssey* closes with these lines, spoken by Athena (in disguise):

READING 2.10 HOMER

The Odyssey, Book 24, lines 603–614

Athena
cast a grey glance at her friend and said:

"Son of Laërtês and the gods of old,
Odysseus, master of land ways and sea ways,
command yourself. Call off this battle now,
or Zeus who views the wide world may be angry."

He yielded to her, and his heart was glad.
Both parties later swore to terms of peace
set by their arbiter, Athena, daughter

COMPARE + CONTRAST

Unraveling Penelope

Epithets in Homer's *The Iliad* and *The Odyssey* are legendary. Achilles is "swift-footed," Athena is "bright-eyed," and the sea is "wine-dark." Homer describes Odysseus as a man of action and Penelope, his wife and queen, as cautious. Odysseus is hotheaded, whereas Penelope is circumspect and discreet. Of all of the characters in the Homeric epics, Odysseus holds the record for epithets; to name a few, he is a man of twists and turns, much enduring, wise, greathearted, cunning, and the great teller of tales.

By most traditional accounts, Penelope is long-suffering; her husband is gone for 20 years—10 in the Trojan War and 10 more trying (or so he would say) to get home—while she minds the kingdom and fends off the suitors who would replace Odysseus as ruler of Ithaca. While she waits for her husband, not knowing if he will ever return, she devises a clever way to stall what appears to be the inevitable (marrying one of the ungracious suitors who have been cluttering the palace). She tells the suitors that she will choose among them only after she finishes the funeral shroud that she is weaving for her father-in-law. Unbeknownst to them, Penelope works on the shroud by day and then unravels the threads at night. We are hard-pressed, in Homer, to find any passages in which Penelope is anything less than steadfast and loyal. In *The Odyssey*, the triumphant values of marriage and family—the patriarchal order—overshadow Penelope's emotional profile. Even when the two are reunited, Penelope does not reproach Odysseus for his lengthy absence. As soon as she understands that the man before her is Odysseus, her heart melts, and she even apologizes for not recognizing him immediately:

> *her knees*
> *grew tremulous and weak, her heart failed her.*
> *With eyes brimming tears she ran to him,*
> *throwing her arms around his neck, and kissed him,*
> *murmuring:*

> *"Do not rage at me, Odysseus!*
> *No one ever matched your caution! Think*
> *what difficulty the gods gave: they denied us*
> *life together in our prime and flowering years,*
> *kept us from crossing into age together...."*

> *Now from his breast into his eyes the ache*
> *of longing mounted, and he wept at last,*
> *his dear wife, clear and faithful, in his arms,*
> *longed for*
> * as the sunwarmed earth is longed for by a swimmer*
> *spent in rough water where his ship went down*
> *under Poseidon's blows, gale winds and tons of sea.*
> *Few men can keep alive through a big surf*
> *to crawl, clotted with brine, on kindly beaches*
> *in joy, in joy, knowing the abyss behind:*

of Zeus who bears the stormcloud as a shield—
though still she kept the form and voice of Mentor.

Homer's epics were the backbone of history as the early Greeks taught it, and a steady reminder of the culture's values. They were recited every four years in Athens, and school children knew the lines of *The Iliad* and *The Odyssey* by heart. They reinforced an unshakable Greek identity, rooted in the common ancestry of heroes.

Geometric Art

Two important things characterize Greek art during Homer's time: the return of the human figure and the adaptation of motifs and styles from Eastern cultures as the Greeks came to explore and trade with more of the world around them. The first efforts toward regenerating the visual arts and architecture were tentative; after all, knowledge of how to paint or sculpt or engineer buildings was completely lost in the Dark Age.

A large vase used as a grave marker in the Dipylon cemetery in Athens is one of the earliest works of Greek art to feature the human figure and is an example of the Geometric style (**Fig. 2.10**). It is over three and one-half feet tall and by shape is a **krater**. Except for the large areas of black on the foot (pedestal) of the vase, the surface is decorated with geometric motifs, some of which may have been inspired by the patterns of woven baskets—zigzags, triangles, diamonds, and, at the very top, a **meander** (a maze-like design). Two thick bands encircle the widest part of the vase and feature numerous abstract figures. The imagery is connected to the purpose of the vase; this one and others like it had holes in their bases so that offerings poured into

and so she too rejoiced, her gaze upon her husband,
her white arms round him pressed as though forever.
 The Odyssey, Book 23, lines 231–240 and 259–270

It was left to other poets and writers to construct a fuller picture of who Penelope might have been and how she really felt about her husband, his tales, and his immortalization. In his *Heroides,* the Roman poet Ovid penned a letter from Penelope to Odysseus in which she informs him of the badgering suitors who, she says, are "playing the part as king" and squandering his wealth. Penelope tells him that she will always be his, but she also lets him know that he is "rashly absent" and even hints that he may not be so different from these suitors:

Why should I relate to you Pisandrus and Polybus and the
dreadful Medon, and the greedy hands of Eurymachus and
Antinous, and others, all of whom you, rashly absent, are feeding
on things gained by your blood.

Anne Killigrew, a 17th-century English poet, also drafted a letter to Odysseus from Penelope. In the first lines, Penelope beseeches her "dearest Lord" to return so that she can cease to mourn his absence. But in the second stanza, she shares something that is haunting her:

Sometimes I think, (but O most Cruel Thought,)
That, for thy Absence, th'art thy self in fault:

That thou art captiv'd by some captive Dame,
Who, when thou fired'st Troy, did thee inflame
And now with her thou lead'st thy am'rous Life,
Forgetful, and despising of thy Wife.

In the 20th century, Dorothy Parker's poem "Penelope" imagined how Penelope may have bided her time waiting for Odysseus and what thoughts and emotions she may have concealed:

In the pathway of the sun,
In the footsteps of the breeze,
Where the world and sky are one,
He shall ride the silver seas,
He shall cut the glittering wave,
I shall sit at home, and rock;
Rise, to heed a neighbor's knock;
Brew my tea, and snip my thread;
Bleach the linen for my bed.
They will call him brave.

What are your thoughts on Penelope's magnetism as a poetic subject? What do these gendered representations suggest about the prevailing gender ideologies when the poets were writing? Do they reflect contemporary views or aim to upend them?

them could seep down to the dead below. In the upper band, a man lies on a funeral bier flanked by women who mourn his passing. The thick, squat U shape that floats above him, painted in a checked pattern, represents a shroud that has been lifted to reveal his corpse. In the band below, a funeral procession is depicted, complete with horse-drawn chariots and men carrying apple-core shields from behind which protrude their heads and legs. Distinctions are made between the males and females (the deceased has a penis sticking out of his thigh and the women have breasts in their armpits), but overall they march along with the same rigidity of geometric patterns. The figures are a familiar combination of frontal, wedge-shaped torsos; profile legs and arms; and profile heads with frontal eyes: conceptual representation.

Vase painting was the dominant genre in Geometric art, although the human figure—which made its reappearance during the eighth century BCE—was also portrayed in small bronze sculptures and ivory statuettes.

The Age of Colonization (ca. 750 BCE–600 BCE)

During Homer's era and the Geometric period of Greek art, individual city-states were ruled by small groups of aristocrats who concentrated wealth and power in their own hands. As centuries of peace led to further prosperity, ruling classes became increasingly concerned with the image of their individual city-states. They functioned as military leaders but also became patrons of the arts. The success of the city-state created fierce pride and competition. In the eighth century BCE, festivals began at Olympia, Delphi, and other sacred sites, at which athletes and poets—representing their city-states—would compete for recognition and the title of best.

As trade with fellow Greeks and with Near Eastern peoples increased, economic success became a crucial factor in

the growth of a polis; shortly before 600 BCE, individual poleis began to mint their own coins. Yet political power remained in the hands of a small hereditary aristocracy, leading to frustration among a rapidly growing urban population. Both the accumulation of wealth and the problem of overpopulation led to a logical solution: colonization.

Throughout the eighth and seventh centuries BCE, enterprising Greeks went abroad either to seek their fortunes or to bolster them. To the south and east of Greece, colonies were established in Egypt and on the Black Sea, and to the west, in Italy and Sicily. Some of these, like Syracuse on Sicily or Sybaris in southern Italy, became even richer and more powerful than the mother cities from which the colonizers had come. Inevitably, the settlers took with them not only the culture of their polis but also their intercity rivalries, often with disastrous results.

▲ 2.11 Corinthian black-figure amphora with animal friezes from Rhodes, Greece, ca. 625–600 BCE. 1' 2" high. British Museum, London. The black-figure technique and the bands with animals and floral designs are characteristic of the Orientalizing style of Greek pottery. Finer details were incised into the black glaze.

▲ 2.10 Geometric krater from Dipylon cemetery, Athens, Greece, ca. 740 BCE. Terra-cotta, 42⅝" (108.3 cm) high, 28½" (72.4 cm) diameter. Metropolitan Museum of Art, New York, New York. This depiction of a funeral and the cemetery location on this immense vase suggest that it was originally a grave marker. The bottom is open, perhaps to allow for visitors' libations to seep into the ground beneath. The Geometric period of Greek art takes its name from the geometric patterns on vases from this era.

The most significant wave of colonization was that which moved eastward to the coast of Asia Minor. From there, colonizers established trade contacts with Near Eastern peoples, including the Phoenicians and the Persians. Within Greece, this expansion to the east had a significant effect on life and art. After almost 300 years of cultural isolation, in a land cut off from its neighbors by mountains and sea, the Greeks were brought face-to-face with the immensely rich and sophisticated cultures of the ancient Near East. New and different ideas and artistic styles were seen by the colonizers and carried back to Greece by traders. Growing quantities of Eastern artifacts—ivories, jewelry, metalwork, and more—were sent back to the Greek city-states as well as to colonies in Italy. So great was the impact of the interchange with cultures such as Mesopotamia and Egypt that the seventh century BCE is called the **Orientalizing period** (*orient* means "east").

CULTURE AND SOCIETY
..

Life and Death in the World of Homer

Homer's passage in *The Iliad* on Achilles's shield is an example of **ekphrasis**, a literary device in which a work of art is described in such detail that a clear visual picture emerges. He shares with us two cities—and two sides of the coin of human experience: the destructive realities of war and the potential for creativity and productivity in times of peace. Their blending in a unified realm on the shield that the god Hephaestus forged for Achilles suggests that the two are distinct, but related, imperatives: war, which for all of its devastation provides the opportunity for heroism and for *arete* (reaching the highest human potential); and peace, which provides the opportunity for orderly existence, culture, and the pursuit of societal ideals. As such, the shield not only serves as a microcosm of the world but also captures the contrasting themes of *The Iliad* and *The Odyssey*.

In one city, weddings and wedding feasts go on while a claim between two parties over compensation for the murder of a relative is settled by a group of elders; the justice system works. But in another city, inhabitants are besieged by enemy troops:

…the city's people were not giving way, and armed for an ambush. Their beloved wives and their little children stood on the rampart to hold it, and with them the men with age upon them, but meanwhile the others went out [to battle].

…and Hate was there with Confusion among them, and Death the destructive;
she was holding a live man with a new wound, and another one unhurt, and dragged a dead many by the feet through the carnage.*

The clothing upon her shoulders showed strong red with the men's blood.
All closed together like living men and fought with each other and dragged away from each other the corpses of those who had fallen.
 [*The Iliad*, Book 18, lines 513–516 and 535–540]

As gruesome as this event is, most of the remaining lines of the passage illustrate the consequences of *uneventful* times—orderly, bountiful, and joyous life made possible by peace:

*He** made on it a great vineyard heavy with clusters, lovely and in gold, but the grapes upon it were darkened and the vines themselves stood out through poles of silver. About them*
he made a field-ditch of dark metal, and drove all around this a fence of tin; and there was only one path to the vineyard, and along it ran the grape bearers for the vineyard's stripping. Young girls and young men, in all their light-hearted innocence, carried the kind, sweet fruit away in their woven baskets, and in their midst a youth with a singing lyre played charmingly upon it for them, and sang the beautiful song for Linos in a light voice, and they followed him, and with singing and whistling
and light dance-steps of their feet kept time to the music.
 [*The Iliad*, Book 18, lines 561–572]

* Death.
** Hyphaestus.

Orientalizing Art

The influence of Eastern cultures on Greek art can be seen in the lively depictions of animals and fantastic beasts on pottery, which call to mind the human–animal blends of Mesopotamia and Egypt. Corinth, in particular, dominated the export business in painted ceramics early on. The city-state grew very wealthy because of its strategic location on an isthmus that connects the Peloponnesus to the Greek mainland—an excellent geographic position for trade. Corinthian artists developed a vibrant version of black-figure vase painting that featured Eastern motifs—sphinxes, winged humans, composite beasts, and floral patterns—arranged in bands to cover almost the entire surface of the vessel. White, yellow, and purple paint were often used to highlight details, producing a bold and striking effect (**Fig. 2.11**). Pottery workshops were busy meeting the market

demands in Corinth, as they were in Athens. During the Archaic period, Athenian potters and painters would be the dominant players in this craft.

Corinthian vases have been found throughout Greece, and also as far away as Italy, Egypt, and sites in the Near East—even Russia. Who would not have wanted to own an elegant little flask for perfume, oil, or makeup that would be recognized instantly as Corinthian? Corinth's political influence and economic strength throughout the seventh and early sixth centuries BCE was attributable in part to the commercial success of these little pots and their contents.

The Athenians brought two interesting things to the art form that pushed beyond the decorative aesthetic of the Corinthians: the focus on the human figure and the telling of stories. As the Athenians began to take over an increasing share of the market for painted vases and their contents, Corinth's position declined

and a trade rivalry developed between the two city-states, which would lead to devastating conflict during the Peloponnesian War.

The Archaic Period (ca. 600 BCE–480 BCE)

In the early seventh century BCE, hereditary aristocrats began to lose their commanding status. In Athens, the legislator and poet Solon (ca. 639–559 BCE) reformed the legal system in 594 BCE and divided the citizens into four classes; members of all four could take part in the debates of the assembly and sit in the law courts. A new class of rich merchant traders, who had made their fortunes in the economic expansion, gained power by capitalizing on the discontent of the oppressed lower classes. These new rulers were called *tyrants*, although the word had none of the unfavorable implications it now has. The most famous of them was Pisistratus, who ruled Athens from 546 BCE until 528 BCE. Many tyrants were patrons of the arts who oversaw revolutionary changes in the arts.

Archaic Art

The influence of Eastern cultures, particularly Egypt, defined Greece's early attempts at life-size statuary. The first Greek settlers in Egypt were given land around the mid-seventh century BCE by the Egyptian pharaoh Psammetichos I, and it is surely no coincidence that the earliest Greek stone sculptures, which date from roughly the same time period, markedly resemble Egyptian cult statues. By 600 BCE, though—the beginning of the Archaic period—the entire character of Greek painting and sculpture had changed. Greek artists abandoned abstract designs and rigid Egyptian conventions and began to focus on **naturalism**. Early representations of the human figure modeled in bronze, carved in stone, or painted in silhouettes on vases were schematic, stylized. During the Archaic period, artists asked such questions as, What do human beings really look like? How do perspective and foreshortening work? What in fact is the true nature of appearance? For the first time in history, artists began to reproduce the human figure in a way that was true to nature rather than merely echoing the standard formats of their predecessors.

It is tempting to view Archaic works of art as steps along the road to perfection in the Classical era, or Golden Age, of the fifth and fourth centuries BCE, rather than to appreciate them for their own groundbreaking qualities. But doing so seriously underestimates the vitality of one of the most creative periods in the development of Greek culture. In some ways, in fact, the spirit of adventure, of striving toward new forms and new ideas, makes achievement during the Archaic period more exciting; perhaps the poet Robert Louis Stevenson was on to something when he said that it is better to travel hopefully than to arrive.

STATUARY The first life-size marble sculptures from the Archaic period feature two characteristics that depart from the traditional Egyptian format: the male body was depicted fully in

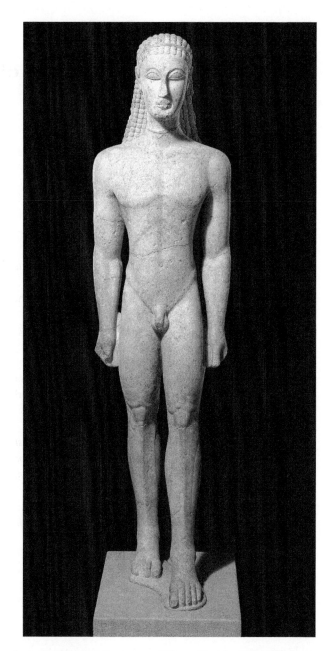

▲ **2.12 New York Kouros, ca. 600 BCE. Marble, 76⅝" (194.6 cm) Metropolitan Museum of Art, New York, New York.** Early Greek artists working with life-size figurative sculpture adopted the poses of their Egyptian prototypes, albeit with significant exceptions: they freed the figure from the block of stone and depicted the body in the nude.

the nude, and it did not conform to the overall shape of the block of stone from which it was carved, as it did, for example, in the figure of King Khafre (see Fig. 1.32). Yet the New York Kouros[3] (**Fig. 2.12**) still reflects the Egyptian influence: one foot striding forward, fists clenched and attached to the sides, stylized muscular detail, and flat planes in the face. **Kouroi** (singular *kouros*) were carved as votive figures for temples or grave markers.

3. So-called because the kouros resides at New York's Metropolitan Museum of Art.

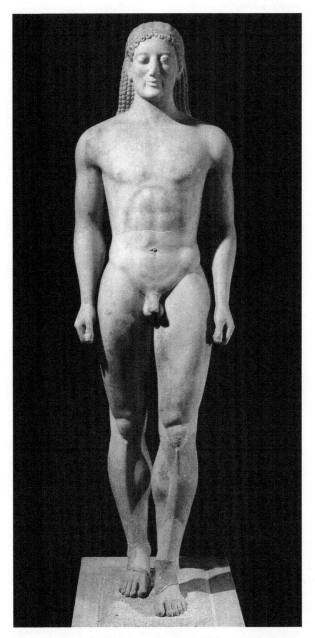

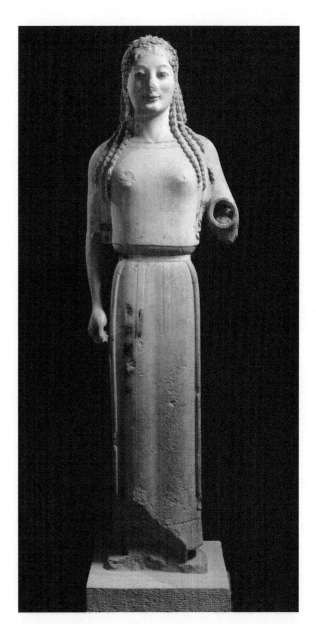

▲ **2.13 Kroisos, ca. 530 BCE. Marble, 76" (193 cm). National Archaeological Museum, Athens, Greece.** An inscription on the base of the funerary sculpture informs us that it was erected in honor of a warrior who died heroically in battle. Although the stance remains rigid, the figure is overall more naturalistically rendered.

▲ **2.14 Peplos Kore, ca. 530 BCE. Marble, 48" (122 cm). Acropolis Museum, Athens, Greece.** The statue is named after the woolen dress, or peplos, one of four garments on the goddess figure. Her missing arm was extended and probably held an attribute associated with her. Traces of paint lend a lifelike appearance and tell us that the Greeks painted their stone sculpture.

Kroisos (**Fig. 2.13**), a kouros figure that served as a marker on the grave of a fallen soldier by that name in Anavyssos, Greece, is later than the New York Kouros by about 70 years, and it shows significant progress toward naturalism over that period of time. The shape and proportions of the body are more realistic, as are the flesh of the face and the flow of the hair down the back. The patterned lines describing muscle groups in the New York Kouros give way to a much more accurate portrayal of the chest, groin, kneecaps, and ankles. Some of the conventions remain the same, but the statue has a sense of vigor. Kroisos's lips are curled into what looks like a smile, although it is not a smile at all as we

would define it. Scholars believe that this so-called archaic smile signified that the person depicted in stone was alive.

Archaic statues of the female figure were also found on the Acropolis. The feminine **korai** (singular *kore*) were also created as votive statues, although unlike the kouroi, they were clothed. When the Persians sacked Athens in 480 BCE, they destroyed temples and smashed large quantities of sculpture. When the Athenians returned to their city after defeating the Persians, they reverently buried the pieces. This is why traces of paint have remained on many works, including the so-called Peplos Kore (**Fig. 2.14**). Archaeologists assigned her this title because of her long, woolen

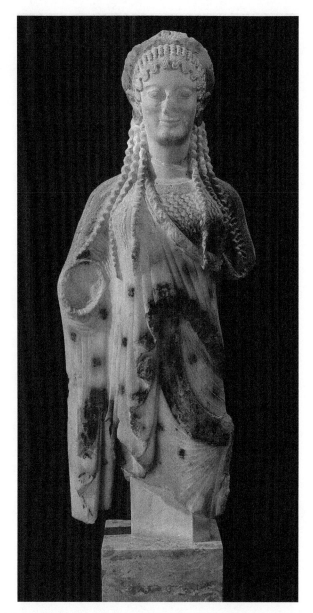

▲ **2.15 Kore in Ionian dress, from the Acropolis, Athens, Greece, ca. 520–510 BCE. Marble 1'9" high. Acropolis Museum, Athens.** The more lifelike quality of this smiling kore is attributable to the myriad folds and flowing lines and curves that dominate the surface.

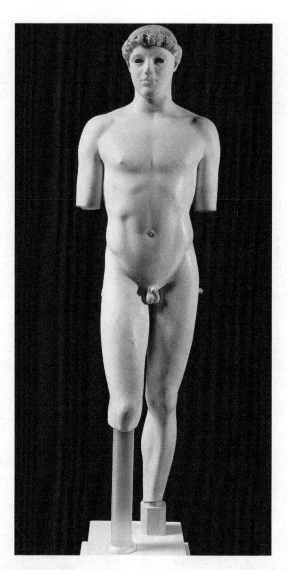

▲ **2.16 Kritios Boy, ca. 490 BCE. From the Acropolis, Athens. Marble, 46" (116.8 cm). Acropolis Museum, Athens, Greece.** The archaic smile has been superseded by a more natural expression, as the turn of the body is shown realistically in the movement of the hips and stomach muscles. Note the extraordinarily fine surface of the stone, which distinguishes between skin, muscle, and bone.

belted garment, although scholars have now determined that she is actually wearing several garments, one of which is seen only in representations of goddesses. Thus, the Peplos Kore, once thought to represent a votive offering, is likely an image of a goddess whose attribute (held in her left hand) is missing. In spite of her columnar shape and fixed gaze, the surviving touches of pigment add to a subtle, more lifelike appearance than we find in the (male) kouroi.

Only 10 to 20 years after the Peplos Kore was carved, *korai* would feature several more stylistic characteristics that improved this lifelike aspect. The rigidity of the drapery in the Peplos Kore, for example, is replaced with myriad folds and sweeping curves in a smiling kore in Ionian dress (**Fig. 2.15**). Her face is serene and her posture is erect, but everything

else "moves"—the thin, delicate lines of her light, linen chiton (dress) as well as the thicker folds of the more substantial fabric of the mantle that drapes over her shoulders and cascades over the chiton. Even her long, curly locks fall in a more naturalistic way than in the Peplos Kore. The paint that remains on the kore in Ionian dress gives us a clear impression of the intricate patterns that would have graced these fashionable garments.

Freestanding statuary such as we have been discussing is only one type of sculpture that we find in Greece. **Relief sculpture**—delicate carving on stone or marble slabs—was widely used for decorating grave stele (gravestones) and embellishing temple architecture.

TOWARD THE CLASSICAL ERA Kritios Boy (**Fig. 2.16**) marks a literal turning point between the late Archaic and early

▶ 2.17 Ergotimos and Kleitias, François Vase, 570-560 BCE. Black-figure ceramic, 26" (66 cm) high, 22⅜" (57 cm) diameter. Museo Archeologico Nazionale, Florence, Italy. This black-figure krater, intended for mixing wine with water, may have been commissioned for a wedding, because one of the painted bands depicts the marriage of Peleus (a mortal) to Thetis (Achilles's mother and a goddess)—the only "mixed marriage" recorded in Greek mythology. Other bands show heroic episodes—including the hunt for the Calydonian boar and a chariot race at the funeral games for Patroclus.

Classical styles: for the first time in ancient art, the figure is neither looking nor walking straight ahead. The head and the upper part of the body turn slightly; as they do so, the weight shifts from one leg to the other and the hips position themselves accordingly. Having solved the problem of how to realistically represent a standing figure, the sculptor has tackled a new and even more complex one—depicting a figure in motion. The consequences of this breakthrough would lead to the perfection of the heroic nude in the Classical period.

The range of Archaic sculptures is great, and the best pieces communicate the excitement of their makers in solving new artistic challenges.

VASE PAINTING By the mid-sixth century BCE, there were also significant innovations in vase painting. Exekias perfected the **black-figure technique**, in which black figures were set against a reddish background and enhanced with details that were incised, or cut, into the surface with a sharp instrument. The combination of black figures and red ground was achieved through three separate and specifically controlled kiln firings, in which oxygen was either introduced to or withheld from the kiln. The vase itself was created from relatively coarse clay, and the figures were painted on the surface with a brush using a mixture of finer clay and water (called a **slip**). Through the successive firing phases, the composition of the clay pot and the painted figures reacted differently: the pot remained the reddish clay color, and the figures turned black. After all of this was said and done, the very fine details were added.

The versatility of the black-figure technique is seen in the François Vase (**Fig. 2.17**), an early example that was signed by both the potter (Ergotimos, the artist who created the vessel using a potter's wheel) and the painter (Kleitias). The imagery of the very large krater, which was found in an Etruscan cemetery in Italy, was divided into bands, or registers—as on the Corinthian vase in Figure 2.13—but, rather than patterned decoration, the François Vase features an action-packed narrative

with mythological figures and battles, including one with the hero Achilles. Only the lowest register of the vase bows to the Orientalizing style, with its fantastic beasts.

The genuine breakthrough in black-figure painting came with Exekias, whose command of the art form was unparalleled in his day. His draftsmanship and power of expression can be seen in yet another vase painting whose subject comes from *The Iliad*—Ajax the Greater playing a game of dice with his cousin Achilles (**Fig. 2.18**). Unlike the figures in the François Vase, which still reflect old conventions in their conceptual representation, Exekias's protagonists are rendered in almost-full profile. The almond-shaped eyes, drawn in profile, are the only feature out of

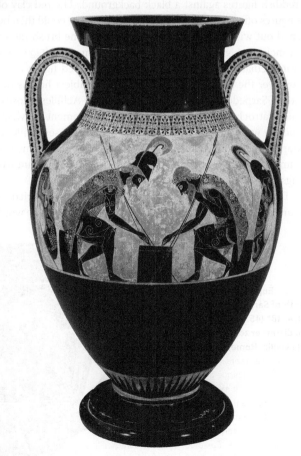

▲ 2.18 Exekias, Achilles and Ajax Playing Dice, ca. 540–530 BCE. Amphora, 24" (61 cm). Museo Gregoriano Etrusco, Vatican City State, Italy. As both potter and painter, Exekias complemented the shape of the vessel with his figural compositions, creating a unified work. He was unparalleled in the black-figure technique.

sync in an otherwise optical approach. Both men hunch over a small table, their spears resting on their shoulders. Achilles is on the left, helmet on; their shields are resting behind them as if propped against a wall. It is a moment of calm between the cousins, and yet the game of chance that they play is prophetic: Ajax will carry Achilles's dead body off the battlefield.

Exekias was both the potter and the painter of this work, and the fluid relationship between the shape of the vessel and the scene reveal that fact. The imagery is placed on the broadest part of the vase, and the curving lines of the men's backs are echoed in the soft tapering of the vase toward the handles and neck. Similarly, the V shape created by the intersecting spears corresponds to the taper of the vase toward its base.

However accomplished Exekias was in rendering figures, their blackness ultimately thwarted their potential for naturalism. But around 530 BCE, the **red-figure technique** was developed, and vase painting reached its apogee. The same firing process was used, but instead of painting the figures on the pot with the slip (which, remember, created black figures against the reddish background), the artist outlined the contours of the figures and then painted everything *but* the figures (the entire background, that is) with the slip. This reversal resulted in reddish figures against a black background. The red clay of the figures offered a neutral-colored expanse that could then be fleshed out with much detail, applied with a fine brush rather than incised. A glimpse at the work of Euphronios (**Fig. 2.19**) will immediately show the advantages of the red-figure technique over the black-figure technique. The subject here is the death of Sarpedon, a Trojan warrior killed by Achilles's closest friend, Patroclus. In the description of the moment in which Sarpedon was felled by Patroclus's hand, Homer uses simile to juxtapose the graphic violence of the world of war with a mental picture of nature and ordinary life—the normalcy of familiar things longed for and taken for granted.

Euphronios depicts Sarpedon, now dead, being carried to the underworld by two winged figures, Hypnos (Sleep; the word

hypnotic is related) and Thanatos (Death). Hermes, the messenger god, watches over the group; in his hand is the attribute that helps us to identify him—a magical rod called a *caduceus*. The characters are rendered in naturalistic poses: the winged helpers are shown in profile, and Sarpedon is depicted in a mostly frontal view (although his legs and arms twist realistically). The artist has described the musculature, the wings, the armor, and the clothing in great detail—all in delicate, linear brushwork. Colorful painted accents are used on Sarpedon's flowing hair and the blood that is streaming from several wounds. The static quality that pervades Exekias's vase has disappeared. The relationship of the scene to the shape of the pot is again noteworthy—as is the symmetrical composition.

Although some artists continued to produce black-figure works (there are even a few painted in black-figure on one side and red-figure on the other), by the end of the Archaic period, almost all had turned to the new style. The last Archaic vase painters were among the greatest red-figure artists. Works such as the Euphronios Vase have a solidity and monumentality that altogether transcend the usual limitations of the medium.

Temple Architecture

Some aspects of Egyptian architecture influenced Greek architects, although by the Archaic period, the basic design of Greek temples was established, and it differed significantly from any prototypes the Greeks may have seen in their travels throughout the Mediterranean and Near East. The earliest Greek temples were made of wood and, like the Sumerian temples, mudbrick; none of these survives. By the seventh century BCE, more permanent materials were used, such as limestone and marble quarried at sites on the Aegean Islands (Náxos and Páros) and the mainland.

The model for Greek temple architecture that emerged in the Archaic period was based on the Mycenaean *megaron*, a rectangular reception hall that had a portico with two columns. That basic shape appears at the center of the floor plan of a typical Greek temple (**Fig. 2.20**) and consists of a *pronaos* (portico); a **cella**, or *naos* (a large room that held the cult statue of the god or goddess to whom the temple was dedicated); and an *opisthodomos* (a rear-facing portico). When columns surround this central grouping of rooms, it is called *peristyle*; **peripteral** temples had a single row of columns around the cella and porticos, whereas dipteral temples had a double row. The length of a typical temple was roughly twice the width (although earlier temples were longer and narrower); the number of columns on the long side of the temple is twice that on the short end. This compulsive ordering of parts to the whole

▶ **2.19 Euphronios and Euxitheos, Death of Sarpedon, ca. 515 BCE. Terracotta, 18" (45.7 cm) high, 21 ¾" (55.1 cm) diameter top. Museo Nazionale di Villa Giulia, Rome, Italy.** Red-figure technique was more versatile than black-figure technique and allowed for more naturalism. It offered a neutral-colored expanse that could then be fleshed out with much detail, applied with a fine brush. This calyx krater, created and signed by the potter Euxitheos and the painter Euphronios, was, for a long time, in the collection of the Metropolitan Museum of Art in New York. Following a high-profile controversy over the acquisition of the work for the museum's collection, it was returned to Italy, where it was found. It is now exhibited at the Museo Nazionale di Villa Giulia in Rome.

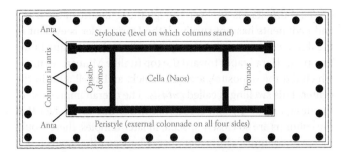

▲ 2.20 Plan of a typical Greek peripteral temple. The typical plan of a Greek temple is rectangular, with an inner sanctuary (cella) surrounded by columns. The cella held a cult statue of the deity to whom the temple was sacred.

reflected the Greeks' emerging sense of the perfect, or ideal. It characterized architectural design as well as proportions in sculpture.

The systems used for determining proportions, as well as specific design detail, are known as Greek architectural **orders**. The two most commonly featured are the *Doric* and *Ionic* orders (Fig. 2.21); the Doric is associated with mainland Greece and the Ionic with Asia Minor (Ionia) and the Aegean Islands. The two orders were not exclusive to the regions in which they developed and were sometimes mixed.

DORIC AND IONIC ORDERS: A COMPARISON The Doric and Ionic orders share certain characteristics. Both are examples of post-and-lintel construction in which the posts are columns and the lintels consist of two parts—the *architrave* and the *frieze*. These two horizontal elements, along with the cornice (the lower edge of the triangular frame of the short ends of the gable roof), comprise the *entablature*. The sloping sides of this triangular frame are called the *raking cornice*; within the wide triangle—the *pediment*—both orders featured sculpture carved in relief. In both orders, the columns sit on the top step of a platform—the *stylobate*. The *column shafts*, which typically consisted of smaller drum-shaped cylindrical sections stacked one on top of the other, were carved top to bottom with vertical striations called *fluting* (20 flutes that meet at right angles in the Doric order, 24 in the Ionic order, all separated by narrow vertical bands). Both orders also feature *capitals* at the top of the column shaft, on which rest the lintels. From there, however, the styles differ. Let us take a look from the bottom up.

The column in the Doric order rests directly on the stylobate; in the Ionic, the column shaft has an intricately carved base. The Doric capital is like a flattened cushion or spreading convex disc; the Ionic capital consists of a distinctive scroll, or *volute*. The architrave in the Doric order is a flat-surfaced slab; in the Ionic order, this element is divided into three thinner,

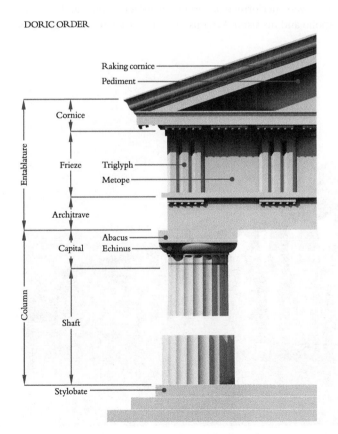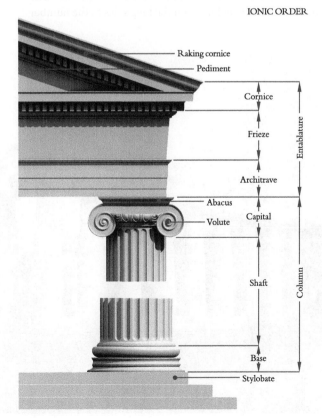

▲ 2.21 Elevations of Doric and Ionic orders. The Doric and Ionic orders are two of the three styles associated with Greek architecture. (The third, the Corinthian order, was infrequently used, although it became a favorite among Roman architects.) Distinction among the orders is mainly to be found in the capitals and the frieze. Artwork by John Burge.

projecting horizontal bands. Perhaps the most distinguishing feature of the orders, aside from the capitals, is the frieze. In the Doric order, the frieze is carved with an alternating pattern of *triglyphs* and *metopes* around the entire outer perimeter of the temple; the triglyphs are divided by grooves into three vertical bands, and the metopes, which appear blank in our figure, are often carved with sculptural decoration. In the Ionic order, this frieze (which also appears blank) was a continuous (rather than partitioned) space that provided an uninterrupted space for relief carving.

The two orders produced different effects. The Doric order suggested simple dignity; the absence of decorative detail drew attention to the weight and massiveness of the Doric temple. Ionic temples, on the other hand, conveyed a sense of lightness and delicacy by means of ornate decorations and fanciful carving. The surface of an Ionic temple is as important as its structural design.

An early example of the Doric order is found in the Temple of Hera I—also known as the Basilica at Paestum in Italy (Fig. 2.22). All that remains of the enormous rectangular structure is its peripteral colonnade (its single row of columns that stood around the cella) and parts of the entablature that sat on top of it. The floor plan reveals a variation on the design of a typical temple's central rooms: the Temple of Hera I has a pronaos with three (rather than two) columns, a cella divided into two zones by a row of seven columns, and no rear portico. The ratio of the number of columns on the long sides to the number on the short sides is 2:1. Even though the sculpture of the frieze and pediments has not survived, the Doric order is evident in the fluted columns and their capitals. The column shafts in the Temple of Hera I taper toward the top (unlike Minoan columns, which did the opposite), are quite thick, and swell a bit in the center. This swelling is called *entasis*. The overall impression of the design is stocky and somewhat heavy due to the fact that the columns are so closely spaced; in later temples, there would be fewer columns with wider spaces between them, yielding a more graceful result.

MUSIC AND DANCE

The history of Greek music is much more difficult to reconstruct than that of the visual arts and architecture. Although frequent references to performance make it clear that music played a vital role in all aspects of Greek life, less than a dozen fragments of Greek music have survived, and the system of notation makes authentic performance of these fragments impossible.

To the Greeks, music was associated with the divine. Athena created the flute, and Hermes, a tortoise-shell lyre; Amphion was taught to play the lyre by Hermes and used it to cajole stones into the foundation of the city of Thebes; the songs of Orpheus moved trees and tamed wild beasts. Choral odes were performed in honor of various gods: gratitude to Apollo and his sister Artemis for delivery from misfortune was

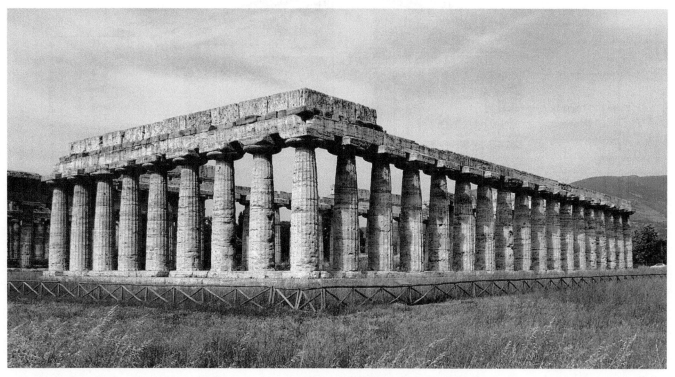

▲ **2.22 Temple of Hera I (Basilica), ca. 540–530 BCE (looking northeast). Paestum, Italy.** This temple to Hera is one of the earliest surviving Greek temples. The bulging columns and spreading capitals are typical of Doric architecture of the Archaic period. The temple probably featured a Doric frieze of triglyphs and metopes, but none of this embellishment has survived.

▲ **2.23 Amphora, ca. 490 BCE. Red-figure vase attributed to the Berlin painter. Terra-cotta, 16 5/16" (41.50 cm) high. Metropolitan Museum of Art, New York, New York.** A musician accompanies himself on the kithara, an instrument with seven strings.

expressed by the singing of a paean, or solemn invocation to the gods; the **dithyramb**, or choral hymn to Dionysus, was sung in his honor at public ceremonies. Music was also a feature at the Pythian and Olympic Games.

In Book 9 of *The Iliad*, when Agamemnon's ambassadors arrive at the tent of the "divine Achilles," they find the great hero singing "of men's fame," accompanying himself on a "clear-sounding, splendid and carefully wrought" lyre. In fact, evidence suggests that early Greek music was primarily vocal and that musical instruments (**Fig. 2.23**) were used mainly to accompany the singers. The first composer whose existence we can be relatively certain of was Terpander, who came from the Aegean island of Lésbos and lived during the first half of the seventh century BCE. He developed a seven-note scale for the **kithara**, an elaborate seven-string lyre, with which he accompanied vocal music. The simple lyre (following Hermes's invention) was relatively small and easy to hold, and had a sound box made of a whole tortoise shell and sides formed of goat horns or curved pieces of wood. The kithara, by contrast, had a much larger sound box made of wood, metal, or even ivory, and broad, hollow sides, to give greater resonance to the sound. The musician had to stand while playing; the instrument had straps to support it, leaving the player's hands free. Another

musical instrument developed at about this time was the **aulos**, a double-reed instrument similar to the modern oboe. Like the kithara and lyre, the aulos was generally used by singers to accompany themselves; some song lyrics have survived.

Purely instrumental music seems to have been introduced at the beginning of the Archaic period. We know that in 586 BCE, Sakadas of Argos composed a work to be played on the aulos for the Pythian Games at Delphi—a well-known piece that remained popular for centuries. The first piece of program music in history, it revolves around the myth of the god Apollo's defeat of Python, the dragon-serpent guard of the oracle at Delphi. In addition to athletic contests, which would come later, the Pythian Games featured competitions in poetry and music. Sakadas was the first to win and took the prize a total of three times.

MUSIC THEORY Early Greek music, as far as we can tell, was **monophonic**, that is, made of single melodies based on notes—placed in intervals—that comprise a system of scales. Music composition featured a series of distinct scale types, or modes, each of which had its own name and character (see Chapter 3). According to the doctrine of **ethos** (summarized by the philosophers Plato and Aristotle in the fourth century BCE), the unique sound of each mode reflected the characteristics and temperament of the tribe for which the mode was named (for example, Dorian after the Dorians on the Peloponnesus, Phrygian and Lydian after groups in Asia Minor). Music written in a specific mode was so powerful that it could affect human behavior in a specific way. Thus, the Dorian mode incited firm, powerful, even warlike feelings, whereas the Phrygian mode produced passionate, sensual emotions.

An understanding of doctrines of musical theory was considered fundamental to a good general education. A vast literature on music theory developed, with philosophical implications that became explicit in the writings of Plato and Aristotle; through this literature, some information on early music has been preserved. Dance, however, was described more rarely in writing—although Homer's description of Achilles's shield in Book 18 of *The Iliad* details an elaborate scene:

READING 2.11 HOMER

The Iliad, Book 18, lines 590–605

And the renowned smith[4] of the strong arms made elaborate
 on it
a dancing floor, like that which once in the wide spaces of
 Knosos
Daidalos built for Ariadne of the lovely tresses.
And there were young men on it and young girls, sought for
 their beauty
with gifts of oxen, dancing, and holding hands at the wrist.
 These

4. Hyphaestus.

wore, the maidens long light robes, but the men wore tunics
of finespun work and shining softly, touched with olive oil.
And the girls wore fair garlands on their heads, while the young
 men
carried golden knives that hung from sword-belts of silver.
At whiles on their understanding feet they would run very
 lightly,
as when a potter crouching makes trial of his wheel, holding
it close in his hands, to see if it will run smooth. At another
times they would form rows, and run, rows crossing each other.
And around the lovely chorus of dancers stood a great multitude
Happily watching, while among the dancers two acrobats
led the measures of song and dance revolving among them.

LITERATURE

Our knowledge of literary developments between the time of Homer and the Archaic period is limited. An exception is Hesiod, who probably lived during the late eighth century BCE. He is the author of a poetic account of the origins of the world called the *Theogony* and a rather more down-to-earth long poem, the *Works and Days*, which mainly concerns the disadvantages in being a poor, oppressed (and depressed) farmer in Boeotia, where the climate is "severe in winter, stuffy in summer, good at no time of year."

A link between Hesiod's two major works is to be found in an opening passage of the *Theogony* in which the Muses appear to the poet as he is tending sheep and set him on the path to his new career:

READING 2.12 HESIOD

Theogony, lines 25-42

The Muses once taught Hesiod to sing
Sweet songs, while he was shepherding his lambs
On holy Helicon; the goddesses
Olympian, daughters of Zeus who holds
The aegis, first addressed these words to me:
"You rustic shepherds, shame: bellies you are,
Not men! We know enough to make up lies
Which are convincing, but we also have
The skill, when we've a mind, to speak the truth."
So spoke the fresh-voiced daughters of great Zeus
And plucked and gave a staff to me, a shoot
Of blooming laurel, wonderful to see,
And breathed a sacred voice into my mouth
With which to celebrate the things to come
And things which were before. They ordered me
To sing the race of blessed ones who live
Forever, and to hymn the Muses first
And at the end. No more delays: begin.

Following is Hesiod's description of the origins of the universe and the genealogy of the gods—constructed from episodes ranging from the tender to the terrible. Consider the following lines from a section of the poem that describes the battle for supremacy between the Titans and the Olympian gods led by Zeus:

READING 2.13 HESIOD

Theogony, lines 690–697 and 705–717

Zeus no longer checked his rage, for now
His heart was filled with fury, and he showed
The full range of his strength. He came from heaven
And from Olympus, lightening as he came,
Continuously; from his mighty hand
The bolts kept flying, bringing thunder-claps
And lighting-flashes, while the holy flame
Rolled thickly all around....

 To the ear
It sounded, to the eye it looked as though
Broad Heaven were coming down upon the Earth:
For such a noise of crashing might arise
If she were falling, hurled down by his fall.
Just such a mighty crash rose from the gods
Meeting in strife. The howling winds brought on
Duststorm and earthquake, and the shafts of Zeus,
Lighting and thunder and the blazing bolt,
And carried shouting and the battle-cry
Into the armies, and a dreadful noise
Of hideous battle sounded, and their deeds
Were mighty, but the tide of the war was turned.

The result of the bitter struggle is the creation of the human societal order under which the Greeks lived. Along the way, Hesiod weaves an elaborate ancestral tapestry of generations of rivalries and alliances, including some threads of typical and not-so-typical family squabbling.

As the Greeks expanded their trade with eastern and western countries during the eighth century BCE, they were influenced by many cultural traditions. Although in many ways Hesiod's *Theogony* is idiosyncratically Greek, it does owe something to Near Eastern creation epics—particularly those of Egypt and Babylonia.

As the Archaic period approached, a burst of energy that had also revolutionized the visual arts produced a new wave of poets. The medium they chose was lyric verse.

Lyric Poetry

The emergence of lyric poetry was, like developments in the other arts, a sign of the times. The heroic verse of Homer was

intended for the ruling class of an aristocratic society that was interested in the problems of mighty leaders like Agamemnon and Achilles and had the leisure and the inclination to hear of their great and not-so-great deeds. Lyric verse—intended to be accompanied by a lyre—is concerned above all else with the poet's own feelings, emotions, and opinions rather than the glories of battle and adventures of heroes. The writers of the sixth century BCE did not hesitate to tell us how they felt about life, death, love, drinking too much wine, or anything else that crossed their minds.

More than any other Greek lyric poet, Sappho has captured hearts and minds throughout the ages. She is the first woman to leave a literary record that reflects her own personal experiences. Her poems have survived only in fragmentary form, and the details of her life remain unclear and much disputed.

Sappho was born ca. 630 BCE on Lésbos and spent most of her life on the island. She seems to have combined the roles of wife and mother (she mentions a daughter in her work) with those of poet and teacher; within her own lifetime, she was widely respected and was surrounded by a group of younger women who may have come to Lésbos to finish their education, in much the same way that American writers used to go to Paris. They probably stayed until it was time for marriage; some of Sappho's poems reflect on the bittersweet parting of women from each other's company as they prepare to assume their lives as married women.

The affection between Sappho and her circle of pupils was deep and sincere and is reflected in her poems. The nature of this affection has been debated: Was there a homoerotic relationship between her and the young women she mentored? Such relationships—between older and younger men—were not unusual or unacceptable. They, too, lasted until men went off to marry and have their own families.

Sappho's poems do mention men, but often only as a point of departure for her passionate emotional responses to women. She probes the depths of her own passions and, by describing them, reveals dimensions of female sensuality—and her own:

READING 2.14 SAPPHO

"Like the very gods in my sight is he"

Like the very gods in my sight is he who
sits where he can look in your eyes, who listens
close to you, to hear the soft voice, its sweetness
 murmur in love and
laughter, all for him. But it breaks my spirit;
underneath my breast all the heart is shaken.
Let me only glance where you are, the voice dies,
 I can say nothing,
but my lips are stricken to silence, under-
neath my skin the tenuous flame suffuses;
nothing shows in front of my eyes, my ears are
 muted in thunder.

And the sweat breaks running upon me, fever
shakes my body, paler I turn than grass is;
I can feel that I have been changed, I feel that
 death has come near me.

The chief subject of Sappho's poetry is love, but her work also gives voice to the contrasting and equally painful agonies of loneliness and passionate commitment. Poems such as these reveal a reluctant resignation that comes only from profound understanding:

READING 2.15 SAPPHO

"Age and Light"

Here are fine gifts, children,
O friend, singer on the clear tortoise lyre,
all my flesh is wrinkled with age,
my black hair has faded to white,
my legs can no longer carry me,
once nimble as a fawn's,
but what can I do?
It cannot be undone,
No more than can pink-armed Dawn
not end in darkness on earth,
or keep her love for Tithonos,
who must waste away;
yet I love refinement, and beauty and light
are for me the same as desire for the sun.

Just as contemporary sculptors and painters sought to understand their physical bodies by analyzing them, so Sappho revealed, both to herself and to us, the complex inner world of human emotion.

PHILOSOPHY

The century that saw the expression of the intimate self-revelations in lyric poetry was also marked by the development of rational philosophy, which challenged the religious beliefs and traditions of Homer and Hesiod and scoffed at the notion that gods took human form. A philosopher-poet (and religious critic) named Xenophanes of Colophon (ca. 560–478 BCE) quipped that if horses and cows had hands and could draw, they would draw gods that looked like horses and cows.

The word *philosophy* literally means "love of wisdom," but in the Western tradition it usually refers to inquiries into the nature and ultimate significance of the human experience. Some of its branches are logic (the study of the structure of valid arguments), metaphysics (investigation into the nature of ultimate reality), epistemology (the theory of knowledge), ethics (moral

philosophy), aesthetics (the philosophy of the arts and, more generally, taste), and political philosophy.

Philosophers of the Archaic period turned away from religious teachings for the first time in history. Instead, they used the power of human reason to investigate how the world came into being and how it works, and to understand the place of humans in it.

PRESOCRATICS During the sixth century BCE, a wide variety of schools of philosophical thought developed, collectively described by the catchall label Presocratic. All of these early philosophers lived and died before the time of Socrates (469–399 BCE) and his pupil Plato (ca. 427–347 BCE), two of the greatest names in Greek philosophy. However, these sixth-century philosophers had little in common with one another except the time in which they lived. Thus it is important to remember that the term *Presocratic* does not describe any single philosophical system. Many of the so-called Presocratic philosophers, with their investigations into the origins of the world and the workings of nature, were examining questions that we would consider scientific rather than philosophical. The various schools were united principally by their use of logic and theoretical reasoning to solve practical questions about the world and human existence. Unlike subsequent philosophers, the Presocratics had no predecessors on whom to base their ideas or methods. They created the discipline as they went along.

The earliest school of philosophy developed with the *Materialists*, who sought to explain all natural phenomena in terms of one or more of the earth's elements. Thales of Miletus (ca. 624–546 BCE), who is usually accorded the title of "first Western philosopher," posited that water alone underlay the changing world of nature. Even though limited and ultimately faulty, his notion that the world had evolved naturally, rather than as a result of divine creation, was revolutionary and marked a fundamental break from the Homeric view of the world. Thales countered the widespread Greek belief that natural forces were the handiwork of the gods. He argued, instead, that natural and human-driven events had concrete, scientific explanations: Occurrences in nature, rather than the whims of Zeus, accounted for unpredictable weather; the traits of human beings, rather than disputes among the gods, explain the warfare described in *The Iliad*. Thales also accurately predicted an eclipse and calculated, mathematically, the height of the pyramids in Egypt. Perhaps more importantly, he initiated the Greek tradition of free discussion of ideas in the marketplace and other public areas. Intellectual exchange was no longer limited to an educated elite or a priestly class.

Empedocles of Acragas (ca. 490–430 BCE) introduced the four elements—fire, earth, air, water—and used their relationship to describe natural phenomena and human behavior. A cyclical pattern of elements combining (through love and peace) or separating (by strife and war) explained how creatures as well as nations were born, grew, decayed, and died. Anaxagoras of Clazomenae (ca. 500–428 BCE) postulated an infinite number of small particles that, however small they might be, always contained a dominant substance (for example, bone or water) as

well as stray bits of other substances in lesser quantities. Unity in nature, Anaxagoras claimed, came from the force of reason.

The Presocratic philosopher who had the greatest influence on later philosophical thought was Pythagoras (ca. 570–500 to 490 BCE). He left his birthplace on the Aegean island of Sámos for political reasons and settled in Croton, a Greek colony in southern Italy, where he founded his own school of philosophy. It became quite an exclusive, rigidly controlled, and secretive brotherhood: he required his followers to lead chaste and devout lives and to uphold morality and the ideals of order and harmony as forces in the universe. Disagreement between Pythagoras's sect, which was politically active, and the people of Croton over local governance turned violent, leading to the deaths of many followers. Pythagoras himself fled and spent the last years of his life in another city.

It is difficult to know which of the principles of Pythagoreanism can be directly attributed to Pythagoras and which were later added by his disciples. His chief religious doctrines seem to have been belief in the transmigration of souls and in the kinship of all living things—teachings that led to the development of a religious cult that bore his name. As a philosopher, Pythagoras taught that the universe was harmonious, and as a mathematician (a familiar geometrical theorem bears his name), he taught that all things in the universe could be placed in sequence, ordered, and counted. He discovered the numerical ratios of frequencies that comprise the musical scale. Our modern musical scale, consisting of an **octave** (a span of eight tones) divided into its constituent parts, derives ultimately from his theoretical research. Inspired by this discovery, Pythagoras went on to claim that mathematical relationships represented the underlying principle of the universe and of morality, the so-called harmony of the spheres. Even today, physicists continue the search for a theory of everything, a single principle or theory that will unify that which they see operating on a grand scale—among the galaxies and energies that make up the universe at large—with that which operates on the smallest scale—among the particles and forces that make up atoms. Albert Einstein searched for it with some frustration for nearly 60 years.

In contrast to Pythagoras's belief in universal harmony, the *Dualists* claimed that there existed two separate universes: the world around us, which was subject to constant change, and another ideal world, perfect and unchanging, which could be realized only through the intellect. The chief proponent of this school was Heraclitus of Ephesus (ca. 540–480 BCE), who summed up the unpredictable, and therefore unknowable, quality of nature in the oft-quoted saying, "It is not possible to step twice into the same river." In other words, the river flows and is filled with life such that the molecules of water, drifting plants, and darting fish change their character from moment to moment; at the same time, the river retains its identity or sameness despite change. Heraclitus believed that permanence was an illusion and that the only constant was change. On the other hand, he did not see change as random. He thought that change was determined by a cosmic order that he called *Logos*.

Unlike his predecessors, who tried to understand the fundamental nature of matter, Heraclitus drew attention, then,

to the process whereby matter changed; he proposed that the basic element is fire because of the way in which it ceaselessly changes:

> This world, which is always the same for all men, neither god nor man made; it has always been, it is, and always shall be: an everlasting fire rhythmically dying and flaring up again.[5]

Parmenides of Elea (ca. born 510 BCE), on the other hand, went so far as to claim that true reality can only be apprehended by reason and is all-perfect and unchanging, without time or motion. Our mistaken impressions come from our senses, which are flawed and subject to error. As a result, the world we perceive through them, including the processes of time and change, is a sham and a delusion. Parmenides laid out his ideas in a poem divided into three parts: the Prologue, the Way of Truth (one of the longest of all Presocratic text fragments to have survived), and the Way of Opinion:

READING 2.16 PARMENIDES

From "The Way of Truth"

Now I shall show you—do you listen well and mark my words—the only roads of inquiry which lead to knowledge. The first is that of him who says, "That which exists is real; that it should not exist is impossible." This is the reasonable road, for Truth herself makes it straight. The other road is his who says, "There are, of necessity, things which do not exist,"—and this, I tell you, is a fantastic and impossible path. For how could you know about something which does not exist? A sheer impossibility. You could not even talk about it, for thought and existence are the same.

There remains only to tell of the way of him who maintains that Being does exist; and on this road there are many signs that Being is without beginning or end. It is the only thing that is; it is all-inclusive and immoveable, without an end. It has no past and no future; its only time is *now*, for it is one continuous whole. What sort of creation could you find for it? From what could it have grown, and how? I cannot let you say or think that it came from nothing, for we cannot say or think that something which does not exist actually does so [i.e., if we say that Being comes from Not-being, we imply that Not-being exists, which is self-contradictory]. What necessity could have roused up existence from nothingness? And, if it had done so, why at one time rather than at another? No; we must either admit that Being exists completely, or that it does not exist at all. Moreover, the force of my argument makes us grant that nothing can arise from Being except Being. Thus iron Law does not relax to allow creation and destruction, but holds all things firm in her grasp.

5. Douglas J. Soccio, *Archetypes of Wisdom*, ninth edition. Belmont, CA: Thomson/Wadsworth, 2015.

Parmenides's pupil Zeno (ca. 495–430 BCE) devised several difficult paradoxes, or philosophical problems, in support of Parmenides's doctrines; Zeno's paradoxes were later discussed by Plato and Aristotle.

The last—and perhaps most important—school of Presocratic philosophy was that of the *Atomists*, led by Leucippus and his student Democritus (ca. 460–370 BCE). They both believed that the ultimate, unchangeable reality consisted of atoms—small, imperceptible, and indivisible particles—and the void, or nothingness, in which these particles moved freely. (The word *atom*, in use today, has not changed from the original Greek, *atomos*, meaning "undivided." We know now, however, that atoms can indeed be divided into many particles, forces, and other things yet to be discovered.) They further considered atoms to be eternal and uncreated—always there. Atoms made up objects by combining with one another in various ways—an ingenious notion foretelling the discovery of molecules. Atomism survived into Roman times in the later philosophy of Epicureanism and into the 19th century in the early atomic theory of John Dalton. In 1905, Albert Einstein conducted experiments that provided the crucial evidence for the existence of molecules; more recently, the physicist Werner Heisenberg (1901–1976), who astonished the world of science with his discoveries in quantum mechanics, derived his initial inspiration from the Greek Atomists.

Presocratic ideas survive only in fragments of text, but in their focus on the human rather than the divine, their influence reached across the chronological spectrum from Classical Athens to the Renaissance in Europe and the 18th-century Age of Reason. This contribution to the evolution of human thought is summed up in a well-known statement attributed to Protagoras (ca. 485–415 BCE), a Presocratic philosopher who lived during the Golden Age of Greece and whom we will encounter in the next chapter: "Man is the measure of all things, of the existence of those that exist, and of the nonexistence of those that do not."

Herodotus: The First Greek Historian

At the beginning of the fifth century BCE, the Greeks faced the greatest threat to their civilization. Their success in meeting the challenge precipitated a decisive break with the world of Archaic culture.

In 499 BCE, the Greek cities of Asia Minor, with Athenian support, rebelled against their Persian rulers. The Persian king Darius I succeeded in checking this revolt; he then launched a punitive military expedition against the mainland Greek cities that had sent help to the eastern cities. In 490 BCE, he led a massive army into Greece; to everyone's surprise, the Persians were defeated by the Athenians at the Battle of Marathon. After Darius's death in 486 BCE, his son Xerxes I launched an even larger and more aggressive campaign in 480 BCE. Xerxes defeated the Spartans at Thermopylae and then attacked and sacked Athens. While the city was falling, the Athenians took to their ships, obeying an oracle that had enjoined them to "trust to their wooden walls." Eventually they inflicted a crushing defeat on the

Persian navy at nearby Salamis. In 479 BCE, after being bested on land and at sea, at Plataea and Mycale, the Persians returned home, completely beaten.

Herodotus (484–420 BCE), once called "the father of history," left us in his nine-book *Histories* a detailed account of the wars with Persia during the closing years of the Archaic period. Controversies about his methods and contributions abound, but this much is certain: he was the first writer in the Western tradition to devote himself entirely to historical writing; he was systematic about collecting information; and he was a great storyteller, with the ability to sustain the reader's interest in the main narrative with frequent and entertaining digressions.

Herodotus was not a scientific historian in our terms—he had definite weaknesses. He never really understood the finer points of military strategy. He almost always interpreted events in terms of personalities, showing little interest in underlying political or economic causes. His strengths, however, were many. Although his subject involved conflict between Greeks and foreigners, he remained remarkably impartial and free of nationalist prejudice. His natural curiosity about the world around him and about his fellow human beings was buttressed by acute powers of observation. Above all, he recorded as much information as possible, even when versions conflicted. He also tried to provide a reasonable evaluation of the reliability of his sources so later readers could form their own opinions.

Herodotus's analysis of the Greek victory over the Persians was based on an unwavering philosophical, indeed theological, belief that the enemy was defeated because they were morally in the wrong. Their fault was **hubris**—pride, excessive ambition, and behavior that humiliates or shames a protagonist's victim. The Greeks' victory was, at the same time, an example of right over might and a demonstration that the gods would guarantee the triumph of justice. In Book 7 of Herodotus's account, Artabanus, the uncle of the Persian king Xerxes, warns him in 480 BCE not to invade Greece (see Reading 2.17).

In another reckless exhibition of hubris, Herodotus tells us, Xerxes gave orders to mutilate the body of Leonidas, the Spartan leader of Greeks in the seminal battle at Thermopylae. Leonidas's men, however, retrieved his body before this could happen.

Both moral and political lessons were to be learned from the Greeks' ultimate defeat of the Persians. Right may have explained some of it, but the Greeks were successful, in part, because for once they had managed to unite in the face of a common enemy. The Battle of Thermopylae took place in August of 480 BCE; Leonidas commanded a force of 300 of his own Spartan warriors and thousands from other city-states defending a pass at that city. When the Persians attacked the Greeks, Leonidas and his troops held the pass for six days; it is estimated that some 20,000 Persians, along with about 2500 Greeks, died during that short time. When Leonidas became aware of a sneak attack from the rear by the Persians, he sent all but the Spartans and a couple of thousand of other warriors away; he famously perished with his 300 in a bitter, bloody fight to the last man.

Subsequent victories over the Persians in decisive naval battles inaugurated the greatest period in Greek history—the Classical, or Golden, Age.

READING 2.17 HERODOTUS

Histories, Book 7

For four days Xerxes waited, in constant expectation that the Greeks would make good their escape; then, on the fifth, when still they had made no move and their continued presence seemed mere impudent and reckless folly, he was seized with rage and sent forward the Medes and Cissians with orders to take them alive and bring them into his presence. The Medes charged, and in the struggle which ensued many fell; but others took their places, and in spite of terrible losses refused to be beaten off. They made it plain enough to anyone, and not least to the king himself, that he had in his army many men, indeed, but few soldiers. All day the battle continued; the Medes, after their rough handling, were at length withdrawn and their place was taken by Hydarnes and his picked Persian troops—the King's—Immortals who advanced to the attack in full confidence of bringing the business to a quick and easy end. But, once engaged, they were no more successful than the Medes had been; all went as before, the two armies fighting in a confined space, the Persians using shorter spears than the Greeks and having no advantage from their numbers.

On the Spartan side it was a memorable fight; they were men who understood war pitted against an inexperienced enemy, and amongst the feints they employed was to turn their backs in a body and pretend to be retreating in confusion, whereupon the enemy would come on with a great clatter and roar, supposing the battle won; but the Spartans, just as the Persians were on them, would wheel and face them and inflict in the new struggle innumerable casualties. The Spartans had their losses too, but not many. At last the Persians, finding that their assaults upon the pass, whether by divisions or by any other way they could think of, were all useless, broke off the engagement and withdrew. Xerxes was watching the battle from where he sat; and it is said that in the course of the attacks three times, in terror for his army, he leapt to his feet.

Next day the fighting began again, but with no better success for the Persians, who renewed their onslaught in the hope that the Greeks, being so few in number, might be badly enough disabled by wounds to prevent further resistance. But the Greeks never slackened....

In the morning Xerxes poured a libation to the rising sun, and then waited till about the time of the filling of the marketplace, when he began to move forward.... As the Persian army advanced to the assault, the Greeks under Leonidas, knowing that the fight would be their last, pressed forward into the wider part of the pass much farther than they had done before; in the previous days' fighting they had been holding the wall and making sorties from behind it into the narrow neck, but now they left the confined space and battle was joined on more open ground. Many of the invaders fell; behind them the company commanders plied their whips, driving the men remorselessly on. Many fell into the sea and were drowned, and still more were trampled to death by their friends. No one could count the number of the dead. The Greeks, who knew that the enemy were on their way round by the mountain track and that death was inevitable, fought with reckless desperation, exerting every ounce of strength that was in them against the invader. By this time most of their spears were broken, and they were killing Persians with their swords.

In the course of that fight Leonidas fell, having fought like a man indeed. Many distinguished Spartans were killed at his side—their names, like the names of all the three hundred, I have made myself acquainted with, because they deserve to be remembered. Amongst the Persian dead, too, were many men of high distinction—for instance, two brothers of Xerxes, Habrocomes and Hyperanthes, both of them sons of Darius by Artanes' daughter Phratagune.

There was a bitter struggle over the body of Leonidas; four times the Greeks drove the enemy off, and at last by their valor succeeded in dragging it away. So it went on, until the fresh troops with Ephialtes were close at hand; and then, when the Greeks knew that they had come, the character of the fighting changed. They withdrew again into the narrow neck of the pass, behind the walls, and took up a position in a single compact body—all except the Thebans—on the little hill at the entrance to the pass, where the stone lion in memory of Leonidas stands today. Here they resisted to the last, with their swords, if they had them, and, if not, with their hands and teeth, until the Persians, coming on from the front over the ruins of the wall and closing in from behind, finally overwhelmed them.

Of all the Spartans and Thespians who fought so valiantly on that day, the most signal proof of courage was given by the Spartan Dieneces. It is said that before the battle he was told by a native of Trachis that, when the Persians shot their arrows, there were so many of them that they hid the sun. Dieneces, however, quite unmoved by the thought of the terrible strength of the Persian army, merely remarked: "This is pleasant news that the stranger from Trachis brings us: for if the Persians hide the sun, we shall have our battle in the shade." He is said to have left on record other sayings, too, of a similar kind, by which he will be remembered. After Dieneces the greatest distinction was won by the two Spartan brothers, Alpheus and Maron, the sons of Orsiphantus; and of the Thespians the man to gain the highest glory was a certain Dithyrambus, the son of Harmatides.

The dead were buried where they fell, and with them the men who had been killed before those dismissed by Leonidas left the pass. Over them is this inscription, in honor of the whole force:

Four thousand here from Pelops' land
Against three million once did stand.
The Spartans have a special epitaph; it runs:
Go tell the Spartans, you who read:
We took their orders, and are dead.
For the seer Megistias there is the following:
I was Megistias once, who died
When the Mede passed Spercheius' tide.
I knew death near, yet would not save
Myself, but share the Spartans' grave.

GLOSSARY

Aulos (p. 73) A double-reed musical instrument similar to the modern oboe.

Black-figure technique (p. 69) A Greek vase-painting technique in which only the figural elements are applied using a mixture of fine clay and water (see **slip**); kiln firings produce the combination of a reddish clay pot with black figures. Details are added to the figures with a fine-pointed implement that scratches away some of the black paint.

Cella (p. 70) The small inner room of a Greek temple, used to house the statue of the god or goddess to whom the temple was dedicated; located behind solid masonry walls, the cella was accessible only to temple priests.

Dactylic hexameter (p. 56) A poetic meter or rhythm consisting of six feet or units of *dactyls*. A dactyl contains three syllables, the first of which is long *ir* stressed, and the following two of which are shorter or unstressed.

Dithyramb (p. 73) A choral hymn sung in honor of the god Dionysus; often wild or violent in character.

Ekphrasis (p. 65) A literary device in which a work of art is described in such detail that a clear visual picture emerges.

Epithet (p. 53) A descriptive word or phrase that refers to a particular quality in a person or thing

Ethos (p. 73) Literally "character"; used by Greeks to describe the ideals or values that characterize or guide a community.

Heroic verse (p. 56) The meter or rhythm used in epic poetry, primarily in Greek and Latin.

Hubris (p. 78) Extreme pride or arrogance, as shown in actions that humiliate a victim for the gratification of the abuser.

In medias res (p. 57) Literally, "in the middle of things"; a phrase used to describe a narrative technique in which the reader encounters the action in the middle of the story rather than at the beginning.

Kithara (p. 73) A seven-stringed lyre.

Kore (p. 66) Literally, "girl"; a clothed female figure as represented in the sculpture of the Archaic period of Greek art, often carved with intricate detail. A counterpart to the kouros (plural *korai*).

Kouros (p. 66) Literally, "boy"; a male figure as represented in the sculpture of the Geometric and Archaic periods of Greek art (plural *kouroi*).

Krater (p. 62) A wide-mouthed ceramic vessel used for mixing wine and water.

Meander (p. 62) A continuous band of interlocking geometric designs.

Monophonic (p. 73) Having a single melodic line.

Naturalism (p. 66) Representation that strives to imitate appearances in the natural world.

Nostos (p. 59) Literally, "homecoming"; the theme of the heroes' journeys homeward in the Homeric epics (plural *nostoi*).

Octave (p. 76) The interval of eight degrees between two musical pitches whose frequencies have a ratio of 2:1; originated from Pythagorean ideas about harmony.

Order (p. 71) An architectural style as described, primarily, by the design of the columns and frieze.

Orientalizing period (p. 64) The early phase of Archaic Greek art, so named for the adoption of motifs from Egypt and the Near East.

Peplos (p. 68) A body-length garment worn by women in Greece prior to 500 BCE.

Peripteral (p. 70) Referring to a Greek temple design that has a colonnade around the entire cella and its porches.

Polis (p. 52) A self-governing Greek city-state (plural *poleis*).

Red-figure technique (p. 70) A Greek vase-painting technique in which everything *but* the figural elements is covered with a mixture of fine clay and water (see **slip**); kiln firings produce a combination of a black pot with reddish figures.

Relief sculpture (p. 68) Sculpture in which figures project from a background; often used to decorate architecture or furniture. *High relief* sculpture projects from its background by at least half its natural depth. *Low relief* sculpture projects only slightly from its background.

Slip (p. 69) In ceramics, clay that is thinned to the consistency of cream; used in the decoration of Greek vases (**see black-figure technique** and **red-figure technique**).

Spondee (p. 56) A foot of poetry consisting of two syllables, both of which are stressed.

Trochee (p. 56) A foot of poetry consisting of two syllables, in which the first syllable is stressed and the second is unstressed.

THE BIG PICTURE THE RISE OF GREECE

Language and Literature

— The poet Homer lived during the eighth century BCE. His epic narratives on the Trojan War—*The Iliad* and *The Odyssey*—were composed centuries after the actual event and were recited by generations of bards until they were written down sometime in the sixth century BCE.

— Hesiod's *Works and Days* captures Greek agrarian values as well as the trials, tribulations, and rewards of the life of a farmer. Hesiod also wrote the *Theogony*, a poetic account of the origins of the world.

— The Greeks adopted the Phoenician alphabet ca. 700 BCE.

— Lyric verse replaced Homeric heroic verse during the Archaic period; Sappho of Lésbos was the first woman to leave a literary record that reflects her own personal experiences.

— Herodotus (484–420 BCE), who has been called the "father of history," wrote the *Histories* in nine volumes.

Art, Architecture, and Music

— By the eighth century BCE, Greeks returned to the representation of the human figure, first in painting on pottery, then in small bronze sculptures. Because of the prevalence of abstract motifs in vase painting, this period is called the Geometric period.

— Contact with cultures of the Near East brought Eastern artifacts to Greece; motifs and styles borrowed from Mesopotamia and Egypt are seen in the Orientalizing period of Greek art.

— The earliest life-size Greek stone sculptures coincided with the first Greek settlement in Egypt, around the mid-seventh century BCE, and markedly resembled Egyptian cult statues.

— During the Archaic period, life-size figures of the nude male appeared and artists began to represent the human form in a way that was true to nature; smiles were added to create a more lifelike appearance.

— In architecture, the Archaic period was marked by the construction of several major peripteral temples and the development of the Doric and Ionic orders.

— Athenians developed black-figure vase painting by the mid-sixth century BCE, with Exekias as its unparalleled master; red-figure vase painting is traced back to ca. 530 BCE.

— The introduction of contrapposto in the *Kritios Boy*, along with the sideward glance of the head, separate the Archaic period from the Classical period of Greek art.

— Greek music was composed using a series of distinct modes or scale types; each mode was seen as powerful enough to effect human behavior in a specific way.

— The kithara (a seven-string lyre) and the aulos (a double-reed instrument) were developed ca. 675 BCE and were used, like most musical instruments, to accompany singers; purely instrumental music was introduced at the end of the Archaic period.

— A vast literature on music theory developed; Pythagoras discovered the numerical relationship of music harmonies and our modern musical scales.

Philosophy and Religion

— Greeks sought explanations from their deities for natural phenomena and psychological characteristics that they recognized in themselves.

— Greek mythology offered no central body of information; rather, there were often varying versions of the same basic story. Greek myth and religion consisted of folktales, primitive customs, and traditional rituals.

— It is often said that the Greeks made their gods into men and their men into gods; the difference between gods and human beings was simply that gods were immortal.

— The Presocratic philosophers (who lived and died before Socrates and Plato) were united by their use of logic and theoretical reasoning to solve practical questions about the world and human experience. Presocratic schools of philosophy included Materialism, Pythagoreanism, Dualism, and Atomism.

— Presocratics emphasized the human rather than the divine; Protagoras said, "Man is the measure of all things, of the existence of those that exist, and of the nonexistence of those that do not."

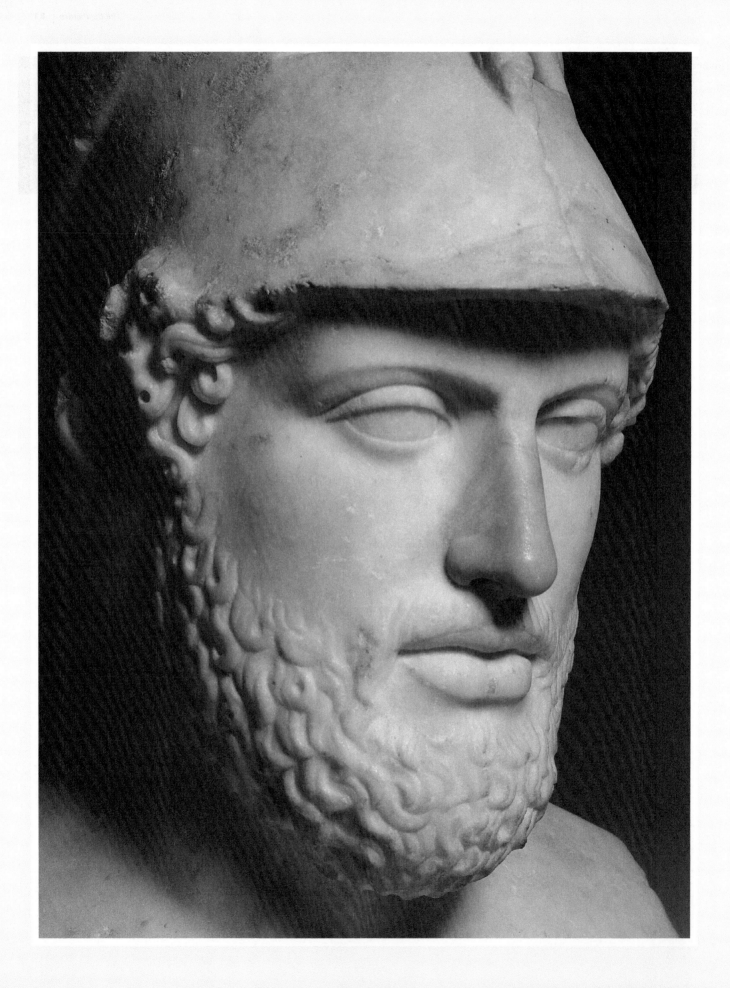

Classical Greece and the Hellenistic Period

3

PREVIEW

By the time Aeschylus took first prize in a drama competition for his renowned *Oresteia* trilogy in 458 BCE, the stories of the Heroic Age from which it sprang were hundreds of years old and as familiar to the Greeks as their own names—stories of King Agamemnon and the divine Achilles, of blood revenge and the wrath of the gods. It was not the first time Aeschylus had won. In 472 BCE he was awarded the same prize for a play whose subject hit much closer to home—*The Persians*. Performed just eight years after the Greeks defeated Xerxes I, it is the earliest surviving play by Aeschylus's hand and the only Greek tragedy we have that describes a historical event that would have occurred in the recent memory of the audience. Herodotus would write his *Histories* three decades later based on information he had gathered from many sources, but Aeschylus had been there. He fought in the Battle of Marathon with his brother, who was killed. And he fought again—10 years later—in the decisive naval battle of Salamis that turned the tide of the prolonged conflict in favor of the Greeks. Like Herodotus in his account of the Persian defeat, Aeschylus—through the voices of characters including the ghost of Xerxes's dead father, Darius—attributes the loss to hubris that unleashed the anger of the gods. (The theme of hubris also would be an undercurrent in *Agamemnon*, the first of the three plays of the *Oresteia*).

As much as it describes the tragic circumstances of war, *The Persians* exalts the strength and spirit of the Greek alliance and glorifies the city-state of Athens—just coming into its Golden Age with a renewed sense of pride and determination to rebuild its temples and reaffirm its democratic values. Spearheading the postwar campaign was the statesman Pericles (Fig. 3.1), under whose leadership Athens reached its peak in the arts, literature, and philosophy. Perhaps significantly, Pericles had been the *chorêgos* for *The Persians*—in effect, the producer. He paid for the chorus preparations and other production expenses that the state did not cover and, in so doing, granted his services to the polis and the people. He was wealthy and could do it; the reward was an honorific that confirmed Pericles's standing among the elite.

Aeschylus died just a few years after the *Oresteia* was performed to great acclaim, but the inscription on his tomb makes no mention of the many accolades bestowed upon him as the Father of Greek Tragedy. Rather, it is the epitaph of a warrior: "Beneath this stone lies Aeschylus, son of Euphorion, the Athenian, who perished in the wheat-bearing land of Gela; of his noble prowess the grove of Marathon can speak, and the long-haired [Persian] knows it well."

◀ **3.1 Cresilas, Pericles, second century BCE. Marble, 23" (58.5 cm) high. British Museum, London, United Kingdom.** This portrait bust of the Athenian statesman Pericles (ca. 490–429 BCE) is said to be from Hadrian's villa at Tivoli, Italy.

CLASSICAL CIVILIZATION IN ANCIENT GREECE

The victories in the Persian Wars produced a new spirit of optimism and unity in Greece. Divine forces, it appeared, had guaranteed the triumph of right over wrong. There seemed to be no limit to the possibilities of human achievement. The accomplishments of the Greeks in the Classical period, which lasted from 479 BCE to the death of Alexander the Great in 323 BCE, do much to justify the Greeks' pride and self-confidence. The period represents an apogee of civilization that has rarely, if ever, been reached since—one that continues to inspire our own culture.

Classical civilization reached its peak in Athens during the last half of the fifth century BCE, a time of unparalleled richness in artistic and intellectual achievement that is often called the Golden Age of Greece. Athenians were pioneers in drama and historiography, town planning and medicine, painting and sculpture, mathematics and government. Their contributions to the development of Western culture not only became the foundation for later achievements but also have endured, and their importance—and exceptionality—is continually validated. Greek tragedies are still read and performed, because the experience of these works is as emotionally intense and intellectually satisfying as anything in the Western dramatic tradition.

The Classical Ideal

The rich legacy that is Greece did not take root amid tranquility; the Athenians of the Golden Age lived not in an environment of calm contemplation but in a world of tension and violence. Their tragic inability to put noble ideals into practice and live in peace with other Greeks—the darker side of their genius—proved fatal to their independence; it led to war with the rest of Greece in 431 BCE and to the fall of Athens in 404 BCE. In this context, the Greek search for order takes on an added significance. The belief that the quest for reason and order could succeed gave a unifying ideal to the immense and varied output of the Classical period. The central principle of this Classical ideal was that existence could be ordered and controlled, that human ability could triumph over the apparent chaos of the natural world and create a balanced society. In order to achieve this equilibrium, individual human beings should try to stay within what seem to be reasonable limits, for those who do not are guilty of hubris—the same hubris of which the Persian leader Xerxes was guilty and for which he paid the price. The aim of life should be a perfect balance: everything in due proportion and nothing in excess. "Nothing too much" was one of the most famous Greek proverbs, and the word *moderation* appears in many texts.

The emphasis that the Classical Greeks placed on order affected their spiritual attitudes. Individuals could achieve order, they believed, by understanding why people act as they do and, above all, by understanding the motives for their own actions. Thus confidence in the power of both human reason and human self-knowledge was as important as belief in the gods. The greatest of all Greek temples of the Classical period—the Parthenon, which crowned the Athenian Acropolis (**Fig. 3.2A** and **Fig. 3.2B**)—was planned not so much to honor the goddess Athena as to glorify Athens and thus human achievement. Even in their darkest days, the Classical Greeks never lost sight of the magnitude of human capability and, perhaps even more important, human potential—a vision that has returned over the centuries to inspire later generations and has certainly not lost its relevance in our own times.

Classical Greece and the Hellenistic Period

500 BCE	450 BCE	404 BCE	323 BCE	146 BCE
	CLASSICAL PERIOD		HELLENISTIC PERIOD	
	Golden Age	Late Classical Period		
The Delian League forms; beginning of Athenian empire	Pericles commissions work on the Acropolis	Athens falls to Sparta 404 BCE	Alexander's successors vie for power	
Pericles comes to prominence at Athens	Pericles is in full control of Athens until his death in 429 BCE from a plague that devastates Athens	The Thirty Tyrants rule Athens r. 404–403 BCE	Pergamum becomes an independent kingdom	
The treasury of the Delian League is moved to Athens	The Peloponnesian War begins 431 BCE	Socrates is executed in 339 BCE	Eomenes II rules Pergamon r. 197–159 BCE	
	Sophocles writes *Oedipus the King*	Thebes ascends	Romans sack Corinth in 146 BCE; Greece becomes a Roman province	
		Phillip II rules Macedon r. 359–336 BCE		

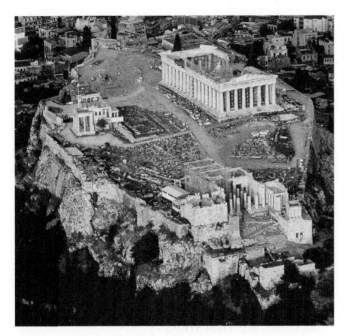

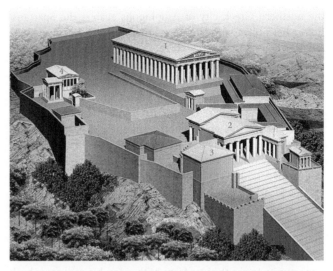

▲ **3.2B Restored View of the Acropolis, Athens, Greece (John Burge).** (1) Parthenon, (2) Propylaia, (3) pinakotheke, (4) Erechtheion, (5) Temple of Athena Nike.

▲ **3.2A The Acropolis. Athens, Greece.** Pericles oversaw the reconstruction of the Acropolis after its sacking by the Persians during their second invasion, in 480 BCE. The Parthenon is at the upper right, and the small Temple of Athena Nike is at the lower right. Note that the Parthenon was not built in the center of the Acropolis, but at its highest point, where it was most visible from below.

The political and cultural center of Greece during the first half of the Classical period was Athens. Here, by the end of the Persian Wars in 479 BCE, the Athenians had emerged as the most powerful people in the Greek world. For one thing, their role in the defeat of the Persians had been decisive. For another, their democratic system of government, first established in the late sixth century BCE, was proving to be both effective and stable. All male Athenian citizens were not only entitled but also required to participate in the running of the state, either as members of the General Assembly, the **Ecclesia** (with its directing council, the **Boule**), or as individual magistrates. They were also eligible to serve on juries.

THE DELIAN LEAGUE In the years immediately following the wars, a defensive organization of Greek city-states was formed to guard against any future outside attack. The money collected from the participating members was kept in a treasury on the island of Delos, sacred to Apollo and politically neutral. This organization became known as the **Delian League**.

Within a short time, several other important city-states, including Thebes, Sparta, and Athens's old trade rival Corinth, began to suspect that the league was serving not so much to protect all of Greece as to strengthen Athenian power. They believed that the Athenians were turning an association of free and independent states into an empire of subject peoples. Their suspicions were confirmed when (in 454 BCE) the funds of the league were transferred from Delos to Athens, and money that should have been spent by the Athenians for the common good of the member states was used instead to finance Athenian

building projects, including the Parthenon. Pericles was the leader of the Athenians and the one responsible for expropriating the funds. (He came to power ca. 461 BCE and was reelected every year until his death in 429 BCE; the period under his leadership is sometimes called the Age of Pericles.) As tensions mounted over the Delian treasury, the spirit of Greek unity began to erode. The Greek states were divided: on one side, Athens and its allies (the cities that remained in the league), and on the other, the rest of Greece. Conflict was inevitable. The Spartans were persuaded to lead the opposition alliance against Athens to check its "imperialistic designs." This war, called the **Peloponnesian War** after the homeland of the Spartans and their supporters, began in 431 BCE and continued indecisively for 10 years until an uneasy peace was signed in 421 BCE. Shortly afterwards, the Athenians made an ill-advised attempt to replenish their treasury by organizing an unprovoked attack on the wealthy Greek cities of Sicily. The expedition proved a total disaster; thousands of Athenians were killed or taken prisoner. When the war began again in 411 BCE, the Athenian forces were fatally weakened. The end came in 404 BCE. After a siege that left many people dying in the streets, Athens surrendered unconditionally to Sparta and its allies.

Following the fall of Athens and the end of the Peloponnesian War, neither Greek politics nor cultural life was dominated by Athens.

THUCYDIDES Our understanding of the Peloponnesian War and its significance owes much to the account of the great historian Thucydides, who lived through its calamitous events. Thucydides did not mean to entertain the reader with digressions and anecdotes (as did Herodotus) but rather to search out the truth and use it to demonstrate universal principles of human behavior. Born around 460 BCE, Thucydides played an active role in Athenian politics in the years before the war. In 424 BCE he was elected general and put in charge of defending

the northern Greek city of Amphipolis against the Spartans. Before he could assume his post, however, the Spartans negotiated terms of surrender with the people of Amphipolis. The Athenian leadership blamed Thucydides for the loss of the city and exiled him from Athens. He did not return until the city was under Spartan control in 404 BCE.

Thucydides intended his *History of the Peloponnesian War* to describe the entire course of the war, but he may have died before completing it; the narrative breaks off at the end of 411 BCE. The work is extremely valuable for its detailed description of events, but Thucydides tried to do more than write about a local war. The history was an attempt to analyze human motives and reactions so that future generations might understand how and why the conflict occurred and, in turn, better understand something about themselves. Writing as an exiled Athenian on the Peloponnesus presented Thucydides with the opportunity to see the war from both sides; his account is both accurate and impartial. In chapter 3, for example, he reports on a meeting of the Congress of the Peloponnesian Confederacy, at which a vote is taken to go to war against Athens. A good part of the chapter is given over to a speech by the Corinthians intended to incite the Lacedaemonians (Spartans) to action, that is, to lead the Peloponnesian states against the Athenians because of their military might. The Corinthian strategy seems to have been to shame the Spartans by comparing them unfavorably to the Athenians:

READING 3.1 THUCYDIDES

From *History of the Peloponnesian War*

The Athenians are addicted to innovation, and their designs are characterized by swiftness alike in conception and execution; you have a genius for keeping what you have got, accompanied by a total want of invention, and when forced to act you never go far enough. Again, they are adventurous beyond their power, and daring beyond their judgment, and in danger they are sanguine; your wont is to attempt less than is justified by your power, to mistrust even what is sanctioned by your judgment, and to fancy that from danger there is no release. Further, there is promptitude on their side against procrastination on yours; they are never at home, you are never from it: for they hope by their absence to extend their acquisitions, you fear by your advance to endanger what you have left behind. . . . Their bodies they spend ungrudgingly in their country's cause; their intellect they jealously husband to be employed in her service. . . . Thus they toil on in trouble and danger all the days of their life, with little opportunity for enjoying, being ever engaged in getting: their only idea of a holiday is to do what the occasion demands, and to them laborious occupation is less of a misfortune than the peace of a quiet life. To describe their character in a word, one might truly say that they were born into the world to take no rest themselves and to give none to others.

Such is Athens, your antagonist. And yet, Lacedaemonians, you still delay, and fail to see that peace stays longest with those who are not more careful to use their power justly than to show their determination not to submit to injustice.

At the time of this meeting, it happens that two Athenian envoys are in town on business. Hearing these exhortations to war, they ask to speak to the assembly, not so much to convince them of Athens's innocence but to ask them to refrain from acting hastily. The envoys remind Sparta and its allies of Athens's contribution to the defeat of the Persians even though they "are rather tired of continually bringing this subject forward." By recounting the heroism of the Athenians, the envoys suggest "what sort of an antagonist she is likely to prove:"

READING 3.2 THUCYDIDES

From *History of the Peloponnesian War*, chapter 3, "Congress of the Peloponnesian Confederacy at Lacedaemon"

We assert that at Marathon we were at the front, and faced the barbarian single-handed. That when he came the second time, unable to cope with him by land we went on board our ships with all our people, and joined in the action at Salamis. This prevented his taking the Peloponnesian states in detail, and ravaging them with his fleet; when the multitude of his vessels would have made any combination for self-defense impossible. The best proof of this was furnished by the invader himself. Defeated at sea, he considered his power to be no longer what it had been, and retired as speedily as possible with the greater part of his army.

Such, then, was the result of the matter, and it was clearly proved that it was on the fleet of Hellas that her cause depended. Well, to this result we contributed three very useful elements, viz., the largest number of ships, the ablest commander, and the most unhesitating patriotism. . . . Receiving no reinforcements from behind, seeing everything in front of us already subjugated, we had the spirit, after abandoning our city, after sacrificing our property (instead of deserting the remainder of the league or depriving them of our services by dispersing), to throw ourselves into our ships and meet the danger, without a thought of resenting your neglect to assist us. We assert, therefore, that we conferred on you quite as much as we received. For you had a stake to fight for; the cities which you had left were still filled with your homes, and you had the prospect of enjoying them again. . . . But we left behind us a city that was a city no longer, and staked our lives for a city that had an existence only in desperate hope, and so bore our full share in your deliverance and in ours.

In the end, the Spartans, the Corinthians, and their allies voted to go to war against Athens. They would be victorious, and Athens would once again be sacked, this time by their own countrymen. But the "city that was a city no longer," the "city that had an existence only in desperate hope" after the Persian Wars, had been resurrected. The hero of Thucydides's account of these years immediately preceding the Peloponnesian War is Pericles, whose funeral oration in honor of the war dead Thucydides also recorded. It stands apart from typical funeral addresses in that Pericles used it as an opportunity to glorify Athens. As the oration was delivered during wartime, it is possible that Pericles's double intent was to praise those who had sacrificed their lives and to remind the living warriors what they were fighting for—home and country:

READING 3.3 THUCYDIDES

History of the Peloponnesian War, Pericles's funeral oration, Book 2

Our form of government does not enter into rivalry with the institutions of others. Our government does not copy our neighbors', but is an example to them. It is true that we are called a democracy, for the administration is in the hands of the many and not of the few. But while there exists equal justice to all and alike in their private disputes, the claim of excellence is also recognized; and when a citizen is in any way distinguished, he is preferred to the public service, not as a matter of privilege, but as the reward of merit. Neither is poverty an obstacle, but a man may benefit his country whatever the obscurity of his condition.... A spirit of reverence pervades our public acts; we are prevented from doing wrong by respect for the authorities and for the laws, having a particular regard to those which are ordained for the protection of the injured as well as those unwritten laws which bring upon the transgressor of them the reprobation of the general sentiment.

And we have not forgotten to provide for our weary spirits many relaxations from toil; we have regular games and sacrifices throughout the year; our homes are beautiful and elegant; and the delight which we daily feel in all these things helps to banish sorrow. Because of the greatness of our city the fruits of the whole earth flow in upon us; so that we enjoy the goods of other countries as freely as our own.

Then, again, our military training is in many respects superior to that of our adversaries. Our city is thrown open to the world, though, and we never expel a foreigner and prevent him from seeing or learning anything of which the secret if revealed to an enemy might profit him.

For we have compelled every land and every sea to open a path for our valor, and have everywhere planted eternal memorials of our friendship and of our enmity. Such is the city for whose sake these men nobly fought and died; they could not bear the thought that she might be taken from them; and every one of us who survive should gladly toil on her behalf.

I have dwelt upon the greatness of Athens because I want to show you that we are contending for a higher prize than those who enjoy none of these privileges, and to establish by manifest proof the merit of these men whom I am now commemorating. Their loftiest praise has been already spoken. For in magnifying the city, I magnify them, and men like them whose virtues made her glorious.

Pericles died, most likely from the plague, in 429 BCE and never lived to see the demise of Athenian power. The Age of Pericles was dominated by the vision of Pericles—to create a glorious city out of the one laid waste by the Persian army.

CULTURE AND SOCIETY

Athens in the Age of Pericles

Area of the city	7 square miles
Population of the city	100,000–125,000
Population of the region (Attica)	200,000–250,000
Political institution	General Assembly, Council of 500, Ten Generals
Economy	Maritime trade; crafts (textiles, pottery); farming (olives, grapes, wheat)
Cultural life	History (Thucydides); drama (Aeschylus, Sophocles, Euripides, Aristophanes); philosophy (Socrates); architecture (Ictinus, Callicrates, Mnesicles); sculpture (Phidias)
Principal buildings	Parthenon, Propylaea (the Erechtheum, the other major building on the Athenian Acropolis, was not begun in Pericles's lifetime)

PERICLES AND THE ATHENIAN ACROPOLIS

The great outcrop of rock that forms the **Acropolis** of Athens—the "high city"—was at the heart of Pericles's postwar building campaign. The sacred (and desecrated) site, which towers above the rest of the city, served as a center for Athenian life since Mycenaean times, when, because of its defensible elevation—the "high ground," as it were—it was the site of a citadel. Throughout the Archaic period, a series of temples was constructed there, the last of which was destroyed by the Persians in 480 BCE. General work on the Acropolis was begun in 449 BCE under the direction of Phidias, the greatest sculptor of his day and a personal friend of Pericles.

The Parthenon (**Fig. 3.3**) was the first building to be constructed under Pericles—the jewel of the restoration of the Acropolis. The word *Parthenon* is generally thought to mean "temple of the virgin goddess"; in this case, Athena. It was built between 447 and 438 BCE; its sculptural decoration was complete by 432 BCE. Even larger than the Temple of Zeus at Olympia—home to the colossal ivory-and-gold sculpture of the god enthroned—the Parthenon became one of the most influential buildings in the history of architecture.

Parthenon Architecture

Constructed by the architects Ictinus and Callicrates, the Parthenon stands as the most accomplished representation of the Doric order, although parts of the building are decorated with a continuous running Ionic frieze. The Parthenon is a **peripteral** temple featuring a single row of **Doric** columns, gracefully proportioned, around a two-roomed **cella** that housed a treasury and a 40-foot-high statue of Athena made of ivory and gold. The proportions of the temple were based on precisely calculated harmonic numeric ratios. There are 17 columns on each of the long sides of the structure and eight columns on the ends. At first glance, the design may appear austere, with its rigid progression of vertical elements crowned by the strong horizontal of its **entablature**. Yet it incorporates refinements intended to prevent any sense of monotony or heaviness and give the building an air of richness and grace. Few of the building's lines are strictly vertical or horizontal. Like earlier Doric columns, those of the Parthenon are thickest at the point one-third from the base and then taper toward the top, a device called **entasis**. In addition, all the columns tilt slightly toward each other (it has been calculated that they would all meet if extended upward for 1.5 miles), and they are not evenly spaced. The columns at the corners are thicker and closer together than the others, and the entablature leans outward. The seemingly flat floor is not flat at all, but convex, higher in the center than it is at the periphery of the temple. The reasons for these variations are not known for certain, but it has been suggested that they are meant to compensate for perceptual distortions that would make straight lines look curved from a distance. All of these refinements are extremely subtle and barely visible to the naked eye. The perfection of their execution is the highest possible tribute to the Classical search for order.

▼ **3.3 Ictinus and Callicrates, the Parthenon, Acropolis, Athens, Greece, 447–438 BCE.** The Parthenon remained almost undamaged until 1687, when Turkish forces occupying Athens had their gunpowder stored inside the building. A cannonball fired by besieging Venetian troops blew up the deposit, and with it the Parthenon. In spite of the damage, the Parthenon remains one of the most influential buildings in Western architectural history.

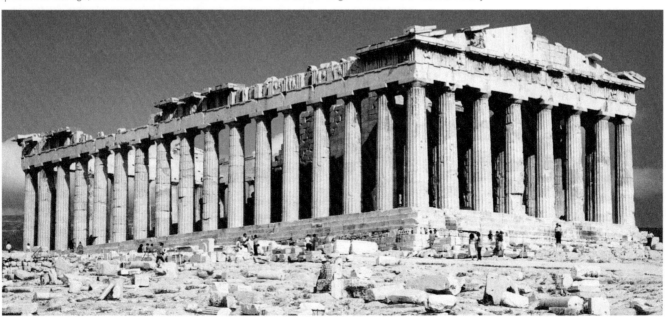

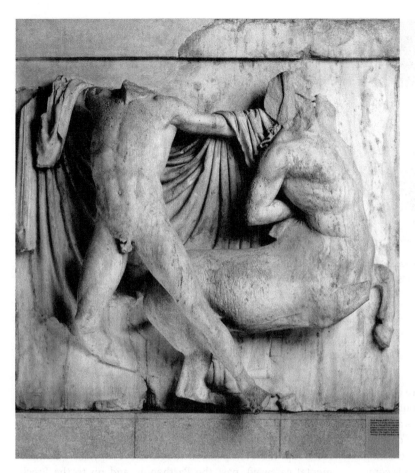

◄ 3.4 **Metope depicting a Lapith battling a centaur, 447–438 BCE. From the south face of the Parthenon, Acropolis, Athens, Greece. Pentelic marble high-relief, 47¼" × 49¼" (120 × 125 cm). British Museum, London, United Kingdom.** The battle between the Lapiths—a legendary people of Ancient Greece—and the centaurs— half man, half horse—occurred after the centaurs, who were invited to a Lapith wedding, got drunk and turned violent, trying to abduct the bride. The victory of the Lapiths over the centaurs, who could be civilized or animal-like, came to symbolize the victories of the Greeks over the Persians.

Parthenon Sculpture

The sculptor Phidias was commissioned by Pericles to oversee the entire sculptural program of the Parthenon. Although he concentrated his own efforts on creating the **chryselephantine** (ivory and gold) statue of Athena, his assistants followed his style closely for the other carved works on the temple. The Phidian style is characterized by delicacy, unparalleled realistic drapery that relates to the form and movement of the body, textural contrasts, a play of light and shade across surfaces owing to variations in the depth of carving, and fluidity of line.

As on other Doric temples, the sculpted ornamentation on the Parthenon was confined to the **friezes** and the **pediments**. The outward-facing frieze is of the Doric order; the inner frieze on the top of the cella wall is Ionic. The subjects of the Doric frieze are epic mythological battles between the Lapiths and the centaurs, the Greeks and the Amazons, and the gods and the giants—metaphors for the Greek battles with the Persians. The square shape of the **metope** sandwiched between **triglyphs** was a somewhat restricted space with which to work, unlike the continuous space that the Ionic frieze provided. One of the most fluid compositions among the metopes is one in which a Lapith man grasps the hair of a centaur as it pulls away from him (**Fig. 3.4**). The figures thrust in opposite directions,

arching outward toward the sides of the square frame. Behind them, the cloak of the Lapith warrior falls in U-shaped folds, carrying the eye from one figure to the other in a pendulum-like motion. Together, the figures form almost a perfect circle with their countermovement, as if they were choreographed to create the perfect balance between motion and restraint.

The sculptural decoration of the Parthenon was created using various carving techniques. The Lapith-and-centaur metope, for example, combines **middle relief** and high relief, with parts that were carved completely in the round. The sculptures for the pediments were also carved in the round; the subject of the east pediment is the birth of the goddess Athena, and the west pediment tells the story of the contest between Athena and Poseidon for the title of patron deity of the city of Athens. Three goddesses (**Fig. 3.5**) present at Athena's birth form a figural group that was placed into the space of one of the outer angles of the east pediment; so accomplished is this portion of the pediment that it is thought to have been designed by Phidias himself and perhaps carved by him, too. The anatomy and the drapery are both carved with meticulous realism, even in places where the details of the workmanship would have been barely visible to the spectator below. The bodies are weighty and well articulated, and the poses and gestures are relaxed and natural. The drapery falls over the bodies in realistic folds, and there is a convincing contrast between the heavier cloth that

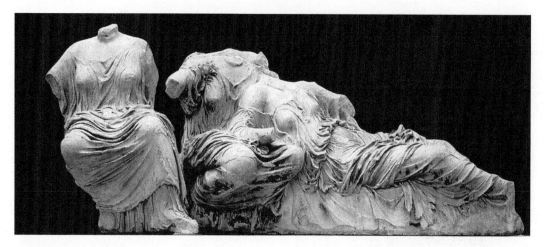

▲ **3.5 The Three Goddesses, ca. 438–432 BCE. From the east pediment of the Parthenon, Acropolis, Athens, Greece. Pentelic marble, ca. 48¾" high × 91¾" long (123 × 233 cm). British Museum, London, United Kingdom.** The sculptor's technical virtuosity can be seen in the extreme realism of the drapery that flows over the bodies and visually unites them. The shape of the sculptural group—a triangle with a long, sloping side—corresponds to the space in the right corner of the Parthenon's east pediment where it was tucked. The goddesses are present to observe the birth of Athena, which was represented in the apex of the pediment triangle.

falls over the legs or wraps around them and the more delicate fabric that clings to the upper torsos, following the contours of the flesh. The intricate play of these linear folds creates a tactile quality not seen in art before. The lines both gently envelop the individual figures and flow from one to another, creating a dynamically flowing composition. This stark realism is combined with a characteristically Classical preoccupation with proportion and balance; the result is a sculptural group that is a perfect blend of idealism and naturalism.

The most extraordinary sculpture on the Parthenon comes from its Ionic frieze—520 running feet of figures carved in relief. Scholars generally agree that the subject is a procession that took place every four years on the occasion of the Panathenaic Festival. The narrative begins on the western end of the temple, where the parade assembles, and continues along the north and south sides, mimicking the length of the parade route up the Acropolis, through the Propylaea (a monumental gateway), past the Parthenon, and on to the Erechtheion, which housed an ancient wooden idol of the goddess Athena. The group—riders on horses, chariots, musicians, animals to be sacrificed—stops and starts along the way as might any large contingent of celebrants (**Fig. 3.6**). On the eastern frieze—in the front of the temple—gods and goddesses and honored guests await the arrival of the procession.

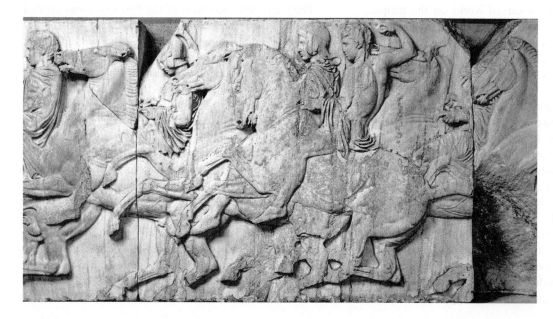

◀ **3.6 Equestrian Group, ca. 438–432 BCE. Detail from the frieze on the north face of the Parthenon, Acropolis, Athens, Greece. Marble relief, 39⅜" (100 cm) high. British Museum, London, United Kingdom.** The Ionic frieze of the Parthenon depicts the Panathenaic procession, part of a festival honoring Athena. The sense of movement—of stopping and of starting—convincingly suggests the erratic flow of a crowded procession.

They gesture to one another as if in conversation; in one segment, Aphrodite points her son Eros's gaze in the direction of the parade—a scene between a parent and child that anyone could imagine. The naturalism of the detail and the fluid movement create a lively, believable scene in which deities have come as spectators—almost like any others—to this human event that honors one of their own. It is interesting to note that, in light of optical effects created with the shapes and placement of the columns and the convex **stylobate**, the relief is not uniformly carved. The upper zone of the frieze is carved in higher relief than the lower. Imagine standing on the ground and looking up at the frieze high on the cella wall; if the depth of carving were uniform, it would be difficult to see the upper part of the figures. The deeper carving of the upper part makes the entire relief more visible.

The Parthenon sculptures are among the most valuable treasures of Greek art—and the most controversial. At the beginning of the 19th century, Lord Elgin, the British ambassador to the Ottoman Empire (which was occupying Greece), removed most of the frieze, together with other parts of the sculptural ornamentation, from the building; these are now in the British Museum and are generally known as the Elgin Marbles. A raging debate about cultural property has swirled around the marbles and whether they should be returned to Greece. The argument has been that Greece was or is incapable of caring properly for the antiquities, which are as much the patrimony of all human civilization as of Greek citizens in particular. Some have contested this position—most notably perhaps, Christopher Hitchens in his article "The Parthenon Marbles: A Case for Reunification"—since the 2009 opening of the new Acropolis Museum in Athens, a structure that was hailed as "one of the most beautiful exhibition spaces in modern architecture." Hitchens believed that, while it is true that the marbles may have been at risk when Greece was unstable and suffered from "repeated wars, occupations, demolitions, and so on," these issues no longer pertain. He insisted that the Greeks have a "natural right" to the Parthenon sculptures. What do you think?

ERECHTHEION The Acropolis was the site of a temple to Athena that was built during the Archaic period and razed by the Persians. The Periclean building program included a new temple, the Erechtheion (**Fig. 3.7**), which would be built on that site but with multifold purposes—it had to commemorate numerous religious events and honor several different deities.

The Erectheion, begun in 421 BCE but not completed until 406 BCE, posed numerous design challenges. The ground level was uneven. The structure had to include multiple shrines; one housed the ancient wooden statue of Athena that was at the center of the Panathenaic Festival depicted on the Parthenon frieze. There were also altars to Poseidon; Erechtheus, an early Athenian king; the legendary Athenian hero Butes; and Hephaestus, the god of the forge. The design also had to incorporate the exact spot where, Athenians believed, Poseidon struck a

▼ **3.7 The Erechtheion with the Temple of Caryatids, Acropolis, Athens, Greece, 421–406** BCE. The Erechtheion, like so many other Acropolis structures, was erected to honor Athena. It housed the wooden statue of the goddess that was part of the ritual of the Panathenaic Festival. The multilevel structure reflects the uneven terrain on which it was built, and its various rooms incorporated tombs, shrines, and other sacred sites.

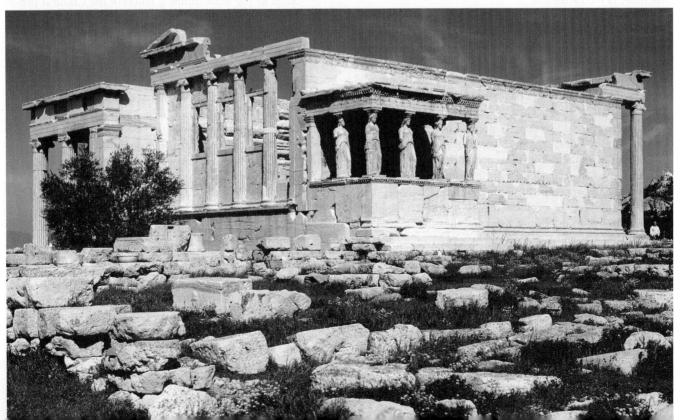

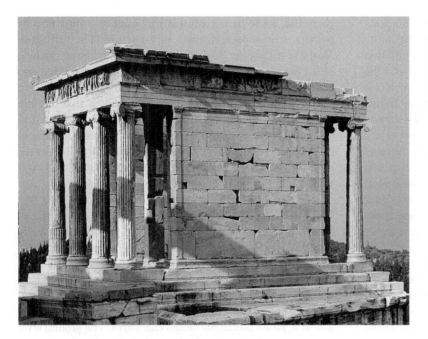

◀ 3.8 **Kallikrates, Temple of Athena Nike (after 2012 restoration), Acropolis, Athens, Greece, ca. 427–424 BCE.** The small Ionic temple at the gateway to the Acropolis honors Athena as the goddess of victory— Nike. Part of the frieze commemorates the defeat of the Persians by Greek forces at Marathon in 490 BCE.

rock and gave birth to a saltwater spring, leaving the marks of his trident. This story is told on the west pediment of the Parthenon. The building also included the grave of another early and probably legendary Athenian king, Cecrops. These criteria, in addition to the irregular topography, called for creative solutions to architectural problems. The building is designed on multiple levels and has four different entrances, one on each side. The asymmetry is striking when compared to the compulsive order of the Parthenon.

The sculptural decoration of the temple is elaborate and delicate, almost fragile. Its most famous feature is the Porch of the Maidens, on the south side of the temple, where **caryatids**, statues of young women, hold up the roof and, by association, the polis. The graceful figures exude an air of dignity and calm, their bodies posed in a **contrapposto** stance with one leg slightly bent at the knee. They are united as a group by their common function—they serve the purpose of columns, and the striations of their drapery even suggest fluting—but the artist has distinguished them from one another through slight variations in body shape and details in their garments. The caryatids represent the most complete attempt until then to conceal the structural functions of a column behind its form. (One of the caryatids is now in the British Museum; the others have been moved to the Acropolis Museum and have been replaced on the actual building by copies.)

Temple of Athena Nike

Perhaps the most beloved of the temples of the Acropolis is the tiny Temple of Athena Nike, only 27 by 19 feet and an exquisite

example of the Ionic order (**Fig. 3.8**). *Nike* means victory (think about the brand of athletic shoes with the same name that channels that theme); one part of the Ionic frieze depicts the Battle of Marathon, one of the most important for the Greeks in their war against the Persians. Four monolithic Ionic columns grace the front and back entrances to the temple, which was erected at the edge of a parapet overlooking the Parthenon and the city beneath the Acropolis.

Some of the most stunning reliefs of the Classical period appear on the Temple of Athena Nike. Callicrates, one of the architects of the Parthenon, was also responsible for the sculpture of the Temple of Athena Nike and the delicate, sensuous carving and play of line across the surfaces. These features are evident, for example, in the Three Goddesses, and can be seen in a relief showing Nike adjusting her sandal (**Fig. 3.9**) as well. The exceptional naturalism can be attributed not only to the carving but also to the subject; the goddess stops for a moment to fasten a sandal that has come loose, a tiny nuisance that any mere mortal has certainly experienced.

THE VISUAL ARTS IN CLASSICAL GREECE

The pursuit of naturalism was at the core of the visual arts during the Classical period. Sculptors in the mid-fifth century BCE continued to explore the possibilities of portraying the body in motion that the sculptor of the Kritios Boy (see Fig. 2.16) introduced. At the same time, they sought ways to perfect the proportions of the human figure, finding a visual counterpart to

Classical Sculpture

The most significant development in Early Classical art was the introduction of implied movement in figurative sculpture. One of the most widely copied works of this period that features this new element is the Diskobolos (**Fig. 3.10**), or Discus Thrower, by the sculptor, Myron. Like most Greek monumental sculpture, it survives only in a marble Roman copy after the bronze original. Bronze was melted down for many purposes (weaponry, coins, and building material, for example); it is through exceptional good luck that we find any bronze works that are completely intact.

▼ **3.10 Myron, Discobolos (Discus Thrower), Roman copy of a bronze statue of ca. 450 BCE. Marble, 61" (155 cm) high. Museo Nazionale Romano–Palazzo Massimo alle Terme, Rome, Italy.** The short, untidy hair and pronounced musculature are typical of the Early Classical period, as is the juxtaposition of physical tension and a calm facial expression. The athlete is caught in action, his torso resembling an arrow about to be shot through the taut bow of his arms.

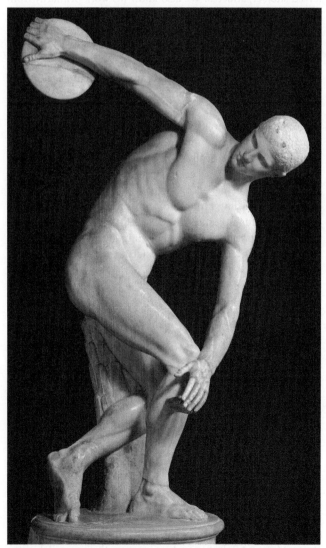

▲ **3.9 Nike Adjusting Her Sandal, ca. 420 BCE. From the south side of the parapet of the Temple of Athena Nike, Acropolis, Athens, Greece, ca. 410 BCE. Marble, relief, 37¾" high × 22" wide × 7⅛" (96 × 56 × 18 cm). Acropolis Museum, Athens, Greece.** The parapet on which the Temple of Athena Nike stands was decorated with reliefs of Nike—winged Victory. This image of Nike captures the goddess in an ordinary, quite human, action, adjusting a sandal that has perhaps come unfastened. The drapery is nearly transparent, suggesting the filmiest of fabrics falling sensuously over the body.

mathematical harmonies and the ideals of moderation, balance, and order. Painters added an array of colors to their palettes to more closely approximate nature and experimented with foreshortening to more realistically portray figures in three-dimensional space. These developments originated with a close observation of the world, the pursuit of underlying, universal harmonies, and the desire to be the most perfect version of the self that was possible.

Myron was considered one of the foremost masters of sculpture in the early years of the Classical period. His life-size *Diskobolos* depicts an event from the Olympic Games—the discus throw. The artist catches the athlete, a young man in his prime, at the moment when his arm stops its backward swing and prepares to sling forward to release the discus. His head faces inward in unbroken concentration, and his muscles are tensed as he reaches for the strength to release it; his torso intersects the arc of his extended arms, resembling an arrow pulled taught on a bow. It is an image of pent-up energy at the moment before release. As in most Classical Greek art, there is a balance between motion and stability, emotion and restraint.

POLYCLITUS AND THE CANON OF PROPORTIONS While Phidias was supervising a team of artists working on his sculptural designs for the Parthenon, his contemporary, Polyclitus of Argos, was devising a formula that could be used to create the perfect, ideal figure—his **canon of proportions**. His favorite medium was bronze and his preferred subject, athletes. We also know his work primarily from Roman copies of lost bronze originals. If Phidias delighted in the appearance of things and the changeability and fluidity of surfaces influenced by the play of light and line, Polyclitus was interested primarily in the core. If Phidias's touch seems more instinctive, Polyclitus's work exudes reason and intellect.

Polyclitus's *Canon*, built on harmonic proportions and codified into a precise mathematical formula, did not come out of nowhere; Pythagoras, as we read in Chapter 2, concluded that harmonic relationships in music could be expressed mathematically. The idea behind the *Canon* was that ideal beauty (perfection) in a sculpture of the human form could be achieved through the exacting application of principles regarding ratios and proportions to all parts of the body. Polyclitus's treatise is lost, but it had been referred to by several important writers, including the historian Pliny the Elder (see Chapter 4) and the physician–philosopher Galen of Pergamum (129–ca. 200 CE).

READING 3.4 GALEN

De placitis Hippocratis et Platonis, 5

[Beauty in art results from] the commensurability of the parts, such as that of finger to finger, and of all the fingers to the palm and the wrist, and of these to the forearm, and of the forearm to the upper arm, and, in fact, of everything to everything else, just as it is written in the *Canon* of Polykleitos.... Polykleitos supported his treatise [by creating] a statue according to the tenets of his treatise, and called the statue, like the work, the Canon.

Polyclitus's most famous work is the Doryphorus (Spear Bearer) (**Fig. 3.11**). Imposing his *Canon* on the figure, Polyclitus

loses some of Phidias's spontaneity, but the result is an almost godlike image of grandeur and strength. As in the *Kritios Boy*, contrapposto, or weight shift, is employed, but in the Doryphorus, Polyclitus goes further to perfect the balance between motion and rest. The figure supports his weight on his right leg, which is firmly planted on the ground. It forms a strong

▼ **3.11** **Polyclitus, Doryphorus (Spear Bearer), Roman copy (from the palaestra of Pompeii, Italy) of a bronze statue of ca. 450–440** BCE. **Marble, 83" (210.8 cm) high. Museo Archeologico Nazionale, Naples, Italy.** Polyclitus devised a canon of proportions in pursuit of the perfect male form, tied to mathematical harmonies. The sculpture epitomizes the control—balance between motion (or emotion) and restraint—that reflected the model human behavior to which Greeks aspired.

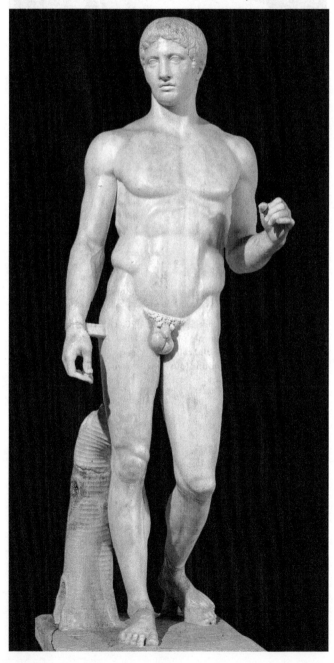

▲ **3.12** Niobid Painter, **Artemis and Apollo Slaying the Children of Niobe**, ca. 450 BCE. Orvieto, Italy. Athenian clay, red-figure (white highlights) calyx krater, 21¼" high × 22" diameter (54 × 56 cm). Musée du Louvre, Paris, France. The figures in the narrative are arranged on different levels, suggesting a naturalistic landscape. The effort to create a sense of three-dimensional space likely reflects the style of contemporary panel paintings, all of which have not survived.

vertical that is echoed in the relaxed arm on the same side of the body. These are counterbalanced by a relaxed left leg bent at the knee and a tensed arm bent at the elbow. Tension and relaxation of the limbs are balanced across the body *diagonally*. The relaxed arm *opposes* the relaxed leg, and the tensed arm *opposes* the tensed, weight-bearing leg. The result is a harmonious balance of opposing parts that creates ease and naturalism belying the rigor of the process of constructing the form.

CONNECTIONS To a large extent, Polyclitus's *Canon* forms the pedagogical foundation of classes in figure drawing. Students are taught to relate one part of the body to another and to be mindful of proportions that are harmonious and accurate relative to the whole. The *Canon* does not correspond to actual body proportions in all their variety, but rather it is strictly a guidepost in the classroom for framing the human figure in a representational style. If the goal, on the other hand, is to evoke an emotional response in the viewer or to dramatize the subject or to emphasize gesture for narrative purposes, ideal proportions may be manipulated, exaggerated, or distorted.

Vase Painting

The goal of naturalism that dominated the visual arts in the Classical period is also present in vase painting. Taking his cue from contemporary panel painting, the Niobid Painter—so named after the **krater** depicting Apollo and Artemis's slaughter of the children of the fertile Niobe after their mother boasted about herself—uses the entire field of the vase to array his narrative (**Fig. 3.12**). Thinly drawn ground lines define the fluctuations in the landscape; figures are placed on or under what appear to be outcroppings of rock. The figures twist and turn in space, and all are engaged in action. This was a noble attempt at naturalism based on optical perception, although the uniform scale of the figures precludes a more developed sense of foreground and background. The ability to arrange figures in space convincingly came later, with the development of perspective.

During the Classical period, white-ground painting was introduced, providing a neutral backdrop for exquisitely drawn images accented with touches of vibrant color. This technique also likely mimicked those of wall and panel painting that have not survived. Because white-ground painting was less durable, it was reserved for pottery that was not utilitarian. Among the most touching works from the period are oil flasks—*lekythoi*—used for funerary offerings and painted with mourning or graveside scenes. A **lekythos** (**Fig. 3.13**) by the so-called Reed Painter illustrates a woman laying her hand upon the tomb of her husband, the fallen warrior who sits before it. The figures are depicted

▲ **3.13** Reed Painter, **Warrior Seated at His Tomb**, 410–400 BCE. Clay, white-ground lekythos, 18¾" (47.8 cm) high, 5⅛" (13 cm) shoulder diameter. National Archaeological Museum, Athens, Greece. In white-ground vase painting, an array of colors are added after firing. Lekythoi were used for libations related to funerary rituals. Here, a warrior who was likely killed in the Peloponnesian War is mourned by his wife.

CULTURE AND SOCIETY

The Women Weavers of Ancient Greece

No works of art by Greek women have survived, and only a scant number of names have been recorded. Yet there is evidence that women did have outlets for creative expression, including ceramics, basketry, and particularly weaving. Noblewomen, commoners, and slaves wove as a pastime or to earn a living. Athena, the most important female god in the Greek pantheon, was best known as the goddess of war and wisdom, but she was also the patron goddess of potters and weavers.

Stories of women weaving come down to us from Homer in *The Iliad* and *The Odyssey*. In Book 3 of *The Iliad*, Helen of Sparta (now Helen of Troy) is visited by the goddess Iris in disguise, who aims to rekindle her love for her abandoned husband, Menelaus:

> And Iris came on Helen in her rooms . . .
> weaving a growing web, a dark red folding robe,
> working into the weft the endless bloody struggles
> stallion-breaking Trojans and Argives armed in bronze
> had suffered all for her at the god of battle's hands.

In Book 22 of *The Iliad*, Hector's wife Andromache has not heard of her husband's death at the hands of Achilles:

> No messenger brought the truth
> of how her husband made his stand outside the gates.
> She was weaving at her loom, deep in the high halls,
> working flowered braiding into a dark red folding robe.

In *The Odyssey*, Penelope, the wife of the wily (and missing-in-action) Odysseus, wards off suitors on the promise that she will choose one of them after she finishes weaving a funeral shroud for her father-in-law. Unbeknownst to them, Penelope spends her days weaving and her nights tearing out her work.

The importance of women weavers is suggested in the subject of a black-figure vase attributed to the Amasis Painter (Fig. 3.14). Its large central panel features a scene of women working on looms and engaged in other aspects of cloth production. Some scholars have posited the even more widespread influence of women's weaving by connecting the patterns of geometric vase painting (see Fig. 2.10) with those of Dorian wool fabrics.

The connection of women to weaving continues throughout the centuries. In the Middle Ages, for example, noblewomen, nuns, and commoners were all taught the skills of weaving and embroidery, and the great tapestries of this era were most certainly created by women (for example, the Bayeux Tapestry; see Fig. 9.22).

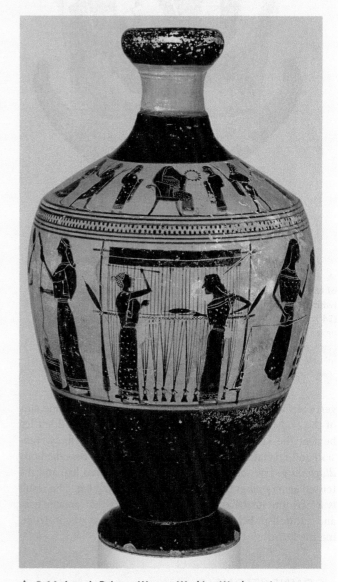

▲ **3.14 Amasis Painter, Women Working Wool on a Loom, ca. 540 BCE. Terra-cotta oil flask, black figure. H: 6¾". The Metropolitan Museum of Art, NY.** The center of the vase shows two women working on an upright loom. Weights are tied to the ends of the warp threads to keep them taut.

with a calm dignity but also with considerable feeling. The warrior appears hopeless and exhausted, a sentiment that would have rung true in the late fifth century BCE as the Greeks became embroiled in the Peloponnesian War and as the toll of human life grew daily. This intimate reaction to death and, in general, a growing concern for the human rather than for aspirations to an ideal characterizes much art of the fifth century BCE.

PHILOSOPHY IN CLASSICAL GREECE

It was in Athens that the Western philosophical tradition was truly forged: from Socrates, who openly questioned traditional values and engaged fellow citizens of the polis in philosophical debate, and Plato his student, who believed that the ideal, the Good, existed in all forms, including the state, and that reality was a reflection of that ideal; to Plato's student Aristotle, who believed that the true essence of things—reality—could be comprehended by observing the material world and deriving truths from observation.

The intellectual and cultural spirit of the new century was foreshadowed in its first year in an event at Athens. In 399 BCE, the philosopher Socrates was charged with impiety and leading youth to question authority, found guilty, and executed. Yet the ideas that Socrates represented—concern with the fate of the individual and questioning traditional values—could not be killed so easily. They had already begun to spread and came to dominate the culture of the fourth century BCE.

Protagoras

As to the gods, I have no means of knowing that they exist or that they do not exist.

—PROTAGORAS

A group of philosophers who came to be called **Sophists** (wise men) visited Athens from time to time. The Sophists shared some of the interests in the workings of nature that occupied the cosmologists, but their principal focus was on the human world. They were concerned with ethics, psychology, political philosophy, and theories of knowledge, such as how people know what they know and whether they can know reality. But the Sophists were also professional teachers who roamed Greece, selling their services as masters of reasoning and rhetoric to wealthy families who wanted to advance the education of their sons.

The most well-known Sophist of the fifth century BCE was Protagoras of Abdera (ca. 485–410 BCE). Although his books no longer exist, some quotations have come down to us through other authors. Protagoras famously said, "Man is the measure of all things." To artists and natural scientists, this remark has been taken to mean that people see themselves as the standard of beauty, or they judge other things as large or small in terms of their own size. The philosopher Plato interpreted it to mean that there is no such thing as absolute knowledge, that one person's views of the world are as valid as those of the next person. Since Plato believed that there was an objective reality (a reality that existed regardless of whether people perceived it), he objected to this idea.

Protagoras boasted that he was so skilled as a debater that he "could make the weaker side defeat the stronger." This statement was alarming because it implied that reliance on rational debate to sift out truth and justice could be undermined by a clever speaker, one who was skilled in sophistic arguments. We might ask whether it is so ourselves. Does the truth always win out in an argument, or does the clever speaker often have the advantage? After all, lawyers are hired to advocate for both sides of arguments and for criminals whom they believe to be guilty. Lawyers are expected to be persuasive even when the facts are against them. Sophistry is alive and well.

Socrates

Socrates is one of the most important figures in Greek history. He is also one of the most difficult to understand. Much of the philosophy of the Greeks and of later ages and cultures has been inspired by his life and teachings. Yet Socrates wrote nothing; most of what we know of him comes from the works of his disciple Plato. Socrates was born around 469 BCE, the son of a sculptor and a midwife; in later life, he claimed to have followed his mother's profession in being a "midwife to ideas." He seems first to have been interested in natural science but soon turned to the problems of human behavior and morality. Unlike the Sophists, he neither took money for teaching nor founded a school. Instead, he went around Athens, to public places such as the markets and the gymnasia and to private gatherings, talking and arguing, testing traditional ideas by subjecting them to a barrage of questions—as he put it, "following the argument wherever it led."

Socrates gradually gained a circle of enthusiastic followers, drawn mainly from the young. At the same time, he acquired many enemies, disturbed by both his challenge to established morality and the uncompromising persistence with which he interrogated those who upheld it. Socrates was no respecter of the pride or dignity of others, and his search for the truth inevitably exposed the ignorance of his opponents. Among Socrates's supporters were some who had taken part in an unpopular and tyrannical political coup at Athens immediately following the Peloponnesian War. The rule of the so-called Thirty Tyrants lasted only from 404 to 403 BCE; it ended with the death or expulsion of its leading figures. The return of democracy gave Socrates's enemies a chance to take advantage of the hostility felt toward those who had "collaborated" with the tyrants; thus in 399 BCE he was put on trial. It seems probable that to some degree the proceedings were intended for show and that those who voted for the death sentence never seriously thought it would be carried out. Socrates was urged by his friends to escape from prison, and the authorities offered him every

opportunity. However, the strength of his own morality and his reverence for the laws of his city prohibited him from doing so. After a final discussion with his friends, he was put to death by the administration of a draft of hemlock.

Socrates had apparently earned many enemies because he challenged the wisdom of those he happened across by asking them about the nature of virtue and of the specific virtues of justice, piety, and courage. Those he met generally believed that they had some wisdom and that their abilities in politics, poetry, or crafts permitted them to expound their opinions about unrelated matters—as is the case today with celebrities endorsing products they know nothing about. At his trial, Socrates spoke of the origins of some of the slanders spoken about him. He told the story of his friend Chaerephon, who journeyed to the oracle at Delphi and asked whether Socrates was, in fact, the wisest man in the world. The oracle replied that "no one was wiser," which, of course, could be read as an acknowledgement of Socrates's special genius or a slur on the entire human species. Since Socrates believed he was not wise, he took the oracle's reply as a riddle to solve. Following are Socrates's words, as recorded by Plato in his *Apology*:

READING 3.5 PLATO

From the *Apology*

Consider now why I tell you this; I am going to explain to you the source of the slander against me. When I had heard the answer of the oracle, I said to myself: "What in the world does the god mean, and what is this riddle? For I realize that I am wise in nothing, great or small; what then does he mean by saying that I am the wisest? Surely, he does not lie; that is not in keeping with his nature." For a long time I was perplexed; then I resorted to this method of inquiry. I went to one of those men who were reputed to be wise, with the idea of disproving the oracle and of showing it: "Here is one wiser than I; but you said that I was the wisest." Well, after observing and talking with him (I don't need to mention his name; but he was a politician), I had this experience: the man seemed in the opinions of many other men, and especially of himself, to be wise; but he really wasn't. And then I tried to show him that he thought he was wise, but really wasn't; so I found myself disliked by him and by many of those present. So I left him, and said to myself: "Well, I am wiser than this man. Probably neither of us knows anything noble; but he thinks he knows, whereas he doesn't, while I neither know nor think I know. So I seem to have this slight advantage over him, that I don't think I know what I don't know." Next I went to another man who was reputed to be even wiser, and in my opinion the result was the same; and I got myself disliked by him and by many others.

After that I went to other men in turn, aware of the dislike that I incurred, and regretting and fearing it; yet I felt that God's word must come first, so that I must go to all who had the reputation of knowing anything, as I inquired into the meaning of the oracle. And by the Dog! gentlemen, for I must

tell you the truth, this is what happened to me in my quest: those who were in greatest repute were just about the most lacking, while others in less repute were better off in respect to wisdom. I really must expound to you my wanderings, my Herculean labors to test the oracle. After the politicians, I went to the poets, tragic, dithyrambic, and the rest, with the expectation that there I should be caught less wise than they. So picking up those of their poems which seemed to me to be particularly elaborated, I asked them what they meant, so that at the same time I might learn something from them. Now I am ashamed to tell you the truth, but it must be spoken; almost every one present could have talked better about the poems than their authors. So presently I came to know that the poets, too, like the seers and the soothsayers, do what they do not through wisdom but through a sort of genius and inspiration; for the poets, like them, say many fine things without understanding what they are saying. And I noticed also that they supposed because of their poetry that they were wisest of men in other matters in which they were not wise. So I left them, too, believing that I had the same advantage over them that I had over the politicians.

Finally I went to the craftsmen; for I knew that I knew hardly anything, but that I should find them knowing many fine things. And I was not deceived in this; they knew things that I did not know, and in this way they were wiser than I. But even good craftsmen seemed to me to have the same failing as the poets; because of his skill in his craft each one supposed that he excelled also in other matters of the greatest importance; and this lapse obscured their wisdom. So I asked myself whether I would prefer to be as I was, without their wisdom and without their ignorance, or to have both their wisdom and their ignorance; and I answered myself and the oracle that I was better off just as I was.

From this inquiry many enmities have arisen against me, both violent and grievous, as well as many slanders and my reputation of being "wise." For those who are present on each occasion suppose that I have the wisdom that I find wanting in others; but the truth is that only God is wise, and by that oracle he means to show that human wisdom is worth little or nothing.

Many of Socrates's disciples tried to preserve his memory by writing accounts of his life and teachings. The works of only two have survived. One of these is the Greek historian Xenophon, whose *Apology*, *Symposium*, and *Memorabilia* are interesting, if superficial. The other is Plato, who, together with his pupil Aristotle, stands at the forefront of the whole intellectual tradition of Western civilization.

Plato

The dialogues of Plato claim to record the teachings of Socrates. In almost all of them Socrates appears, arguing with his opponents and presenting his own ideas. How much of Plato's picture

of Socrates is historical truth and how much is Plato's invention, however, is debatable. The Socratic problem has been almost as much discussed as the identity of Homer. In general, modern opinion supports the view that in the early dialogues, Plato tried to preserve something of his master's views and methods, whereas in the later ones he used Socrates as the spokesman for his own ideas. There can be no doubt that Plato was deeply impressed by Socrates's life and death. Born in 428 BCE, Plato was drawn by other members of his aristocratic family into the Socratic circle. He was present at the trial of Socrates, whose speech in his own defense Plato records in the *Apology*, one of three works that describe Socrates's last days. In the *Crito*, set in prison, Socrates explains why he refuses to escape. The *Phaedo* gives an account of his last day spent discussing with his friends the immortality of the soul and his death.

After Socrates's death, Plato left Athens, horrified by the society that had sanctioned the execution, and spent several years traveling. He returned in 387 BCE and founded the Academy, the first permanent institution in Western civilization devoted to education and research, and thus the forerunner of all our universities. Its curriculum concentrated on mathematics, law, and political theory. Its purpose was to produce experts for the service of the state. Some 20 years later, in 368 BCE, Plato was invited to Sicily to put his political theories into practice by turning Syracuse into a model kingdom and its young ruler, Dionysius II, into a philosopher–king. Predictably, the attempt was a dismal failure, and by 366 BCE, Plato was back in Athens. Apart from a second equally unsuccessful visit to Syracuse in 362 BCE, he seems to have spent the rest of his life in Athens, teaching and writing. He died there in 347 BCE.

Much of Plato's work deals with political theory and the construction of an ideal society. The belief in an ideal is, in fact, characteristic of most of his thinking. It is most clearly expressed in his theory of Forms, according to which in a higher dimension of existence there are perfect Forms, of which all the phenomena we perceive in the world around us represent pale reflections.

To illustrate the limits of, or blinders on, our perceptions, Plato presents the Allegory of the Cave in the *Republic* (**Fig. 3.15** and Reading 3.6). He asks us to picture prisoners chained in an underground cave who can see

nothing their entire lives but shadows cast on a wall by objects backlit by a fire. The only reality the prisoners know is the shadows on the wall, and they think themselves clever if they can guess which is going to appear next. They have little or no imagination and are ruled by the opinion of others. Imagine

▼ **3.15 Plato's Allegory of the Cave.** Plato used his Allegory of the Cave to symbolize human misperceptions of reality that result from superstition and falsehood and to suggest that the philosopher, who thrives in the light of reason and intellect, is uniquely positioned to educate others and liberate them from beliefs that prevent them from acquiring truth.

what would happen if a prisoner were released from the shackles and could wend his way up and out toward the light. His eyes at first might be blinded. He would have to adjust, and he might doubt what he would see. He might be frightened by the new as he is acquiring knowledge through reason, especially if new knowledge is shattering superstition and false ideas, and he might wish he could return to the cave. But eventually he might come to truly see and appreciate the fullness and warmth of the real world that is to be perceived through reason and intelligence. It is the task of the philosopher, who is free from the chains of misperception, to liberate others and educate them in such a way as to set them free from the imprisonment of the senses. Reading 3.6 contains part of the passage of the Allegory of the Cave, presented as a dialogue.

Socrates's death made Plato skeptical about the capacity of democracies to deliver justice. In the *Republic*, he proposes that a state has nourishing needs, protection needs, and ruling needs, which are to be provided by workers, warriors, and philosopher–kings. Either philosophers must become kings or kings must become philosophers, he writes, because a just state requires rulers whose acquaintance with the Forms has bestowed on them the knowledge needed to rule wisely and the virtue necessary to rule in the best interests of the state. How can an individual gain acquaintance with the Forms? Through the careful selection of talented men or women and rigorous education. The few who can complete the process will be qualified to play the role in the state that reason plays in a well-ordered soul. In a well-ordered soul, Plato argues, reason supported by valor rules passions and appetites. Likewise, in a well-ordered

state, philosophers supported by loyal auxiliaries should rule over those who seek material prosperity. Philosophers, unlike politicians, will not rule because they desire to gain power or to promote their own interests. True philosophers would prefer to spend their time contemplating the Forms; they rule because virtue demands their service.

Yet the details of Plato's vision of an ideal society are too authoritarian for most tastes, involving among other restrictions the careful breeding of children, the censorship of music and poetry, and the abolition of private property. In fairness to Plato, however, it must be remembered that his works are intended not as a set of instructions to be followed literally but as a challenge to think seriously about how our lives should be organized. Furthermore, the disadvantages of democratic government had become all too clear during the last years of the fifth century BCE. If Plato's attempt to redress the balance seems to veer excessively in the other direction, it may in part have been inspired by the continuing chaos of fourth-century Greek politics.

Aristotle

Plato's most gifted pupil, Aristotle (384–322 BCE), continued to develop his master's doctrines, at first wholeheartedly and later—for at least 20 years—critically. In 335 BCE, Aristotle founded a school in competition with Plato's Academy, the Lyceum, severing his ties with Plato. Aristotle in effect introduced a rival philosophy—one that has attracted thinking

READING 3.6 PLATO

Republic, Book 7, "The Allegory of the Cave"

"Next, then," I said," take the following parable of education and ignorance as a picture of the condition of our nature. Imagine mankind dwelling in an underground cave with a long entrance open to the light across the whole width of the cave; in this they have been from childhood, with necks and legs fettered, so they have to stay where they are. They can not move their heads round because of the fetters, and they can only look forward, but light comes to them from fire burning behind them higher up at a distance. Between the fire and the prisoners is a road above their level, and along it imagine a low wall has been built, as puppet showmen have screens in front of their people over which they work their puppets."

"I see," he said.

"See, then, bearers carrying along this wall all sorts of articles which they hold projecting above the wall, statues of men and other living things, made of stone or wood and all kinds of stuff, some of the bearers speaking and some silent, as you might expect."

"What a remarkable image," he said, "and what remarkable prisoners!"

"Just like ourselves," I said. "For, first of all, tell me this: What do you think such people would have seen of themselves and each other except their shadows, which the fire cast on the opposite wall of the cave?"

"I don't see how they could see anything else," said he, "if they were compelled to keep their heads unmoving all their lives!"

"Very well, what of the things being carried along? Would not this be the same?"

"Of course it would."

"Suppose the prisoners were able to talk together, don't you think that when they named the shadows which they saw passing they would believe they were naming things?"

"Necessarily."

"Then if their prison had an echo from the opposite wall, whenever one of the passing bearers uttered a sound, would they not suppose that the passing shadow must be making the sound? Don't you think so?"

"Indeed I do," he said.

"If so," said I, "such persons would certainly believe that there were no realities except those shadows of handmade things."

"So it must be," said he.

minds ever since. In the 19th century, the English poet Samuel Taylor Coleridge would comment, with much truth, that one was born either a Platonist or an Aristotelian.

The Lyceum seems to have been organized with typical Aristotelian efficiency. In the morning, Aristotle lectured to the full-time students, many of whom came from other parts of Greece to attend his courses and work on the projects he was directing. In the afternoon, the students pursued their research in the library, museum, and map collection attached to the Lyceum, while Aristotle gave more general lectures to the public. His custom of strolling along the Lyceum's circular walkways, immersed in profound contemplation or discourse, gained his school the name *Peripatetic* (the "walking" school).

As a philosopher, Aristotle was the greatest systematizer. He wrote on every topic of serious study of the time. Many of his classifications have remained valid to this day, although some of the disciplines, such as psychology and physics, have severed their ties with philosophy and become important sciences in their own right. The most complex of Aristotle's works is probably the *Metaphysics*, in which he deals with his chief dispute with Plato, which concerned the theory of Forms. Plato had postulated a higher dimension of existence for the ideal Forms and thereby created a split between the apparent reality that we perceive and a genuine reality that we can only know by philosophical contemplation. Moreover, knowledge of these Forms depended on a theory of remembering them from previous existences.

Aristotle, on the other hand, claimed that the Forms were actually present in the objects we see around us, thereby eliminating the split between the two realities. Elsewhere in the *Metaphysics*, Aristotle discusses the nature of God, whom he describes as "thought thinking of itself" and "the Unmoved Mover." The nature of the physical world ruled over by this supreme being is further explored in the *Physics*, which is concerned with the elements that compose the universe and the laws by which they operate.

In his *Nicomachean Ethics*, Aristotle argues that the ultimate goal of human life is happiness, perhaps better translated as "human flourishing." His concept of happiness is not simply a matter of pleasure or freedom from want. Since people are rational beings, human flourishing requires that actions be guided by reason, but Aristotle understood that humans have needs for friends, family, and material comforts. Aristotle believed that humans are political as well as rational beings and that a fully human life is possible only within a political community. He calls political science the master science, since without the benefits of political order the human condition is worse than the condition of beasts. He remarks: "For man when perfected is the best of animals, but, when separated from law and justice . . . is the most unholy and savage of animals and the most full of lust and gluttony."

In the following passage from the *Nicomachean Ethics*, Aristotle describes the nature of happiness as he sees it. In the passage, you may notice the familiar saying, "One swallow does not make it spring."

READING 3.7 ARISTOTLE

Nicomachean Ethics, Book 7, "The Nature of Happiness"

The nature of happiness is connected with the nature of man. No doubt, however, to say that happiness is the greatest good seems merely obvious, and what is wanted is a still clearer statement of what it is. It may be possible to achieve this by considering the function of man. As with a flute player or sculptor or any artisan, or generally those who have a function and an activity, the good and good performance seem to lie in the performance of function, so it would appear to be with a man, if there is any function of man. Are there actions and a function peculiar to a carpenter and a shoemaker, but not to man? Is he functionless? Or as there appears to be a function of the eye and the foot and generally of every part of him, could one also post some function of man aside from all these? What would this be? Life he shares even with plants, so that we must leave out the life of nourishment and growth. The next in order would be a kind of sentient life, but this seems to be shared by horse and cow and all the animals. There remains an active life of a being with reason. This can be understood in two senses: as pertaining to obedience to reason and as pertaining to the possession of reason and the use of intelligence; and since the latter as well is spoken of in two senses, we must take the one which has to do with action, for this seems to be regarded as higher.

If the function of man is an activity of the soul according to reason or not without reason, and we say that the function of a thing and of a good thing are generically the same, as of a lyre-player and a good lyre-player, and the same way with all other cases, the superiority of virtue being attributed to the function—that of a lyre-player being to play, that of a good one being to play well—if this is so, the good for man becomes an activity of the soul in accordance with virtue, and if there are more virtues one, in accordance with the best and most perfect. And further, in a complete life; for one swallow does not make it spring, nor one day, and so a single day or a short time does not make a man blessed and happy.

Other important works by Aristotle include the *Rhetoric*, which prescribes the ideal model of oratory, and the *Poetics*, which does the same for poetry and includes the famous definition of tragedy mentioned earlier. Briefly, Aristotle's formula for tragedy is as follows: The tragic hero, who must be noble, through some undetected tragic flaw in character meets with a bad end involving the reversal of fortune and, sometimes, death. The audience, through various emotional and intellectual relations with this tragic figure, undergoes a cleansing or purgation of the soul, called **catharsis**. Critics of this analysis sometimes complain that Aristotle was trying to read his own subjective formulas into the Greek tragedies of the time. This critique, however, may not be entirely justified, because Aristotle was probably writing for future tragedians, prescribing what ought to be rather than what was.

Aristotle's influence on later ages was vast, although not continuous. Philip of Macedon employed him to tutor the young Alexander, but the effect on the conqueror-to-be was probably minimal. Thereafter, Aristotle's works were lost and not recovered until the first century BCE, when they were used by the Roman statesman and thinker Cicero (106–43 BCE). During the Middle Ages, they were translated into Latin and Arabic and became a philosophical basis for Christian theology. Thomas Aquinas's synthesis of Aristotelian philosophy and Christian doctrine still remains the official philosophical position of the Roman Catholic Church. In philosophy, theology, and scientific and intellectual thought as a whole, many of the distinctions first applied by Aristotle were rediscovered in the early Renaissance and remain valid today. No recounting such as this can begin to do justice to one described by Dante as "the master of those who know." In the more than 2000 years since Aristotle's death, only Leonardo da Vinci has come near to equaling his creative range.

MUSIC IN CLASSICAL GREECE

Pythagoras connected harmonic chords in music with similar harmonies found in nature and construed a mathematical formula to explain the relationship. The word *harmony* is Greek in origin, coming from a word that literally means a "joining together." In a musical context, the Greeks used harmony to describe various kinds of scales, but there is no evidence that Greek music featured harmony in the more modern sense of the word—that is, the use of pitches (tones and notes) or chords (groups of notes) sounded simultaneously.

Both Plato and Aristotle found a place for music in their ideal states, owing principally to the link that they saw between music and moral development. As a mathematician, Aristotle believed that numerical relationships, which linked the various pitches in music, could be used by musicians to compose works that imitated the highest state of reason, and thus virtue—just as Polyclitus believed that he could create the ideal human figure through harmonic principles derived from reason and the intellect. Aristotle also believed in the doctrine of ethos, whereby music had the power to influence human behavior. As such, he saw the study of music as vital to Greek life and education:

READING 3.8 ARISTOTLE

Politics, Book 8, Part 5

Rhythm and melody supply imitations of anger and gentleness, and also of courage and temperance, and of all the qualities contrary to these, and of the other qualities of character, ... for in listening to such strains our souls undergo a change. ... Enough has been said to show that music has a power of forming the character, and should therefore be introduced into the education of the young.

Similarly, Plato held the view that participation in musical activities molded the character for worse (which is why he suggested banning certain kinds of music) and for better:

READING 3.9 PLATO

Protagoras, 326a

Teachers of the kithara...cultivate moderation and aim to prevent the young from doing anything evil. Moreover, whenever [students] learn to play the kithara, [they are taught] the poems of morally good poets, setting them to the music of the kithara and compel rhythms and harmonies to dwell in the souls of the boys to make them more civilized, more orderly, and more harmonious, so that they will be good in speech and action.

For all its importance in Greek life and thought, the actual sound of Greek music and the principles whereby it was composed are neither easily reconstructed nor completely understood. The numerical relationship of notes to one another established by Pythagoras was used to divide the basic unit of an octave (series of eight notes) into smaller intervals named after their positions relative to the lowest note in the octave. The interval known as a **fourth**, for example, represents the distance between the lowest note and the fourth note up the octave. The intervals were then combined to form a series of scales, or **modes**. Each mode was associated with a particular emotional characteristic: the Dorian mode was serious and warlike, the Phrygian exciting and emotional, and the Mixolydian plaintive and melancholic.

The unit around which Greek music was composed was the **tetrachord**, a group of four pitches: the two outer ones a perfect fourth interval apart and the inner ones variably spaced. The combination of two tetrachords formed a mode. The Dorian mode, for example, consisted of the following two tetrachords.

The Lydian mode was composed of two different tetrachords.

The origin of the modes and their relationship to one another is uncertain; it was disputed even in ancient times. The search for these origins is further clouded by the fact that medieval church music adopted the same system of mathematical construction—and even some of the names of the Greek modes—although they used these names for entirely different modes.

Throughout the fifth century BCE, while music played an important part in dramatic performances, it was generally subordinated to verse. Musical rhythms accompanied words or dance steps and were tied to them. Special instruments such as cymbals and tambourines were used to mark the rhythmic patterns, and Greek writers on music often discussed the specific challenges for composers that the Greek language and its accents presented. As it expanded beyond accompaniment, instrumental music became especially popular.

Although few traces have survived, a system of notation was used to write down musical compositions; it probably was borrowed from the Phoenicians, as was the Greek alphabet. Originally used for lyre music, the notation used symbols to mark the position of fingers on the lyre strings, rather like modern guitar notation (tablature). The system was then adapted for vocal music and for nonstring instruments, such as the aulos. The oldest of the few surviving examples of musical notation dates to ca. 250 BCE.

THEATER IN CLASSICAL GREECE

The tumultuous years of the fifth century BCE, passing from the spirit of euphoria that followed the end of the Persian Wars to the mood of self-doubt and self-questioning of 404 BCE, may seem unlikely to have produced the kind of intellectual concentration characteristic of Classical Greek drama. Yet in the plays written specifically for performance in the theater of Dionysus at Athens in these years, Classical literature reached its most elevated heights. The tragedies of the three great masters—Aeschylus, Sophocles, and Euripides—not only illustrate the development of contemporary thought but also contain some of the most memorable scenes in the history of the theater.

The Drama Festivals of Dionysus

Tragic drama did not begin in the fifth century BCE. It had evolved over the preceding century from choral hymns—**dithyrambs** sung in honor of the god Dionysus, and the religious nature of its origins was still present in its fully developed form. (Like the Egyptian god Osiris, Dionysus died and was reborn, and the festivals held in his honor may be related to earlier ceremonies developed in Egypt.) To go to the theater was to take part in a religious ritual; the theaters were regarded as sacred ground. The plays that have survived from the Classical period in Athens were all written for performance at one of the two annual festivals sacred to Dionysus before an audience consisting of the entire population of the city. Breathtakingly large **theaters** were designed to accommodate throngs of people; the one at Epidaurus (**Fig. 3.16**) could seat some 12,000 spectators in 55 rows. The architect was Polyclitus the Younger, who some historians believe was the nephew of the sculptor renowned for his *Canon*. The wedges of the roughly semicircular, cone-shaped structure taper at ground level and envelop a circular stage for the actors; a building tangential to the circle, called the *skene*, was used for dressing rooms and as a backdrop for the play.

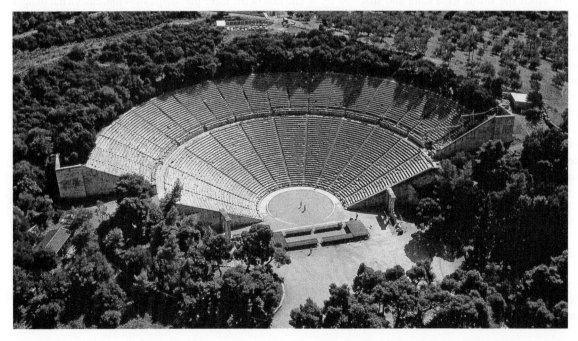

◀ **3.16 Polyclitus the Younger, Theater of Epidaurus, Greece, ca. 350 BCE.** The Greeks built their theaters into hillsides to support the tiers of stone seats that overlooked the circular stages. The theater at Epidaurus seated an audience of 12,000.

Each playwright participating in the festival submitted four plays to be performed consecutively on a single day—three tragedies, or a **trilogy**, and a more lighthearted piece called a **satyr play** (a satyr was a mythological figure: a man with an animal's ears and tail). The trilogies sometimes consisted of three parts of a single narrative, although more often the three works were based on different stories connected to a common theme. The plots, generally drawn from mythology, often dealt with the relationship between humans and deities. The style of performance was serious, lofty, and dignified. The actors, who in a sense served as priests of Dionysus, wore masks, elaborate costumes, and platform shoes. At the end of each festival, the plays were judged and a prize awarded to the winning author.

THE GREEK CHORUS: FROM DITHYRAMB TO DRAMA The **chorus**, whose sacred dithyrambic hymns had been the starting point for the development of tragedy, retained an important role in Classical Greek theater. In earlier plays, like those written by Aeschylus, the chorus is centrally involved in the action; later, as in Sophocles's *Oedipus the King*, the chorus does not participate directly in the events on stage but rather assumes the role of the spectator, commenting on the actions of the principal characters and reducing to more human terms their larger-than-life circumstances and emotions. Later still, in the time of Euripides when dramatic confrontation took the place of extended poetic or philosophical musings, the chorus retained an important function that reflected its theatrical roots: that of punctuating the action and dividing the play into separate episodes with lyric odes, the subjects of which were sometimes only indirectly related to the play's narrative.

The text of the surviving Classical tragedies, then, represents only a small part of the total experience of the original performances. The words (or at least some of them) have survived, but the music to which the words were sung and that accompanied much of the action, the elaborate choreography to which the chorus moved, and the whole grandiose spectacle performed out of doors in theaters located in sites of extreme natural beauty before an audience of thousands—all of this can only be recaptured in the imagination. It is interesting to note that, almost 2000 years after the Classical era, Florentine humanists interested in reviving classical drama in all of its dimensions—music, acting, dance—would wind up creating opera. In the 19th century, German composer Richard Wagner would coin the concept of the *Gesamtkunstwerk* (literally "total work of art"), combining all of the arts into one in his dramatic operas.

The Athenian Tragic Dramatists

Even if some the surviving Greek dramas are lost, we do have the words. The differing worldviews of the authors of these works vividly illustrate the changing fate of Athens in the fifth century BCE.

AESCHYLUS The earliest of the playwrights, Aeschylus (525–456 BCE), died before the lofty aspirations of the early years of the Classical period could be shaken by contemporary events. His work shows a deep awareness of human weakness and the dangers of power (as noted earlier, he had fought at the Battle of Marathon in 490 BCE) but retains an enduring belief that, in the end, right—and reason—will triumph. In Aeschylus's plays, the process of recognizing and doing what is moral is painful. Progress and self-knowledge come only through suffering and are achieved by the will of Zeus. In the opening scene of *Agamemnon*, the chorus tells us as much:

READING 3.10 AESCHYLUS

Agamemnon, lines 250–255

Justice turns the balance scales,
sees that we suffer
and we suffer and we learn.
And we will know the future when it comes.
Greet it too early, weep too soon.
It all comes clear in the light of day.

The essential optimism of Aeschylus's philosophy must be kept in mind because the actual course of the events he describes is often violent and bloody. Perhaps his most impressive plays are the three that form the *Oresteia* trilogy. This trilogy, the only complete one that has survived, won first prize in the festival of 458 BCE at Athens. The subject of the trilogy is nothing less than the growth of civilization, represented by the gradual transition from the primitive justice of *vendetta* ("blood for blood") to a legal system of justice guiding a rational, civilized society.

The first of the three plays, *Agamemnon*, casts a harsh light on blood justice and bloodguilt. King Agamemnon returns to his homeland, Argos, after leading the Greeks to victory at Troy. Ten years earlier, before the launch of his expedition, he had been forced to make a choiceless choice: to abandon the campaign because of unfavorable tides or to obtain easy passage by sacrificing his daughter Iphigenia. (The situation may seem contrived, but it clearly symbolized the conflict between public and personal responsibilities.) After considerable hesitation and self-doubt, Agamemnon makes the decision to sacrifice his daughter. The chorus describes the violence and, further, alludes to what lies in store for Agamemnon:

READING 3.11 AESCHYLUS

Agamemnon, lines 218–226

Once he slipped his neck in the strap of Fate,
his spirit veering black, impure, unholy,
once he turned he stopped at nothing,
seized with the frenzy

blinding, driving to outrage—
wretched frenzy, cause of all our grief!
Yes, he had the heart
to sacrifice his daughter! —
to bless the war that avenged a woman's loss,
a bridal rite that sped the men-of-war.

Upon his return home at the end of the Trojan War, he pays the price: his wife Clytemnestra and her lover Aegisthus murder him. Her ostensible motive is vengeance, but an equally powerful, if less noble, one is her desire to replace Agamemnon, both as husband and king, with Aegisthus. Aeschylus shows us, however, that "a life for a life" has its domino effect: The punishment of one crime creates in turn another crime to be punished. If Agamemnon's murder of his daughter merits vengeance, then so does Clytemnestra's sacrifice of her husband. Violence breeds violence.

The second play, *The Libation Bearers*, shows us the effects of the operation of this principle on the son of Agamemnon and Clytemnestra, Orestes. After spending years in exile, Orestes returns to Argos to avenge his father's death by killing his mother. Although a further murder can accomplish nothing except the transfer of bloodguilt to Orestes, the ancient and primitive code of vendetta requires him to act. With the encouragement of his sister Electra, he kills Clytemnestra. His punishment follows immediately. He is driven mad by the Furies, the implacable goddesses of vengeance, who hound him from his home.

The Furies are transformed into *The Eumenides* ("the Kindly Ones") at the conclusion of the third play, to which they give their name. In his resolution of the tragedy of Orestes and his family, Aeschylus makes it clear that violence can only be brought to an end by the power of reason and persuasion (Athena says, "I am in my glory! Yes, I love Persuasion."). After a period of tormented wandering, Orestes comes finally to Athens, where he stands trial for the murder of his mother before a jury of Athenians, presided over by Athena. Orestes describes his motive for revenge and submits himself to justice:

READING 3.12 AESCHYLUS

The Eumenides, lines 473–485

What an ignoble death he died
When he came home—Ai! My blackhearted mother
Cut him down, enveloped him in her handsome net—
It still attests his murder in the bath.
But I came back, my years of exile weathered—
Killed the one who bore me, I won't deny it,
Killed her in revenge. I loved my father,
Fiercely.
 And Apollo shares the guilt—
He spurred me on, he warned of the pains I'd feel

Unless I acted, brought the guilty down.
But were we just or not? Judge us now.
My fate is in your hands. Stand or fall
I shall accept your verdict.

The Furies insist on his condemnation on the principle of blood for blood, but Apollo, the god of reason, who would ultimately win an acquittal, defends Orestes. Orestes's fellow mortals comprise a jury of his peers and deliver a tied verdict. Athena casts the final vote in favor of Orestes. Thus, the long blood feud is brought to an end, and the apparently inevitable violence and despair of the earlier plays is finally dispelled by the power of persuasion and human reason, which—with the help of Athena and Apollo—have managed to bring civilization and order to primeval chaos: from then on, homicide cases were to be tried by the Athenian court system, as Athena tells all gathered:

READING 3.13 AESCHYLUS

The Eumenides, lines 693–697

And now
If you would hear my law, you men of Greece,
you who will judge the first trial of bloodshed.
Now and forever more, for Aegeus' people
This will be the court where judges reign.

Despite all the horror of the earlier plays, therefore, the *Oresteia* ends on a positive note. Aeschylus affirms his belief that progress can be achieved by reason and order. This gradual transition from darkness to light is handled throughout the three plays with unfailing skill. Aeschylus matches the grandeur of his conception with majestic language. His rugged style makes him sometimes difficult to understand, but all the verbal effects are used to dramatic purpose. The layering of images and complexity of expression produce an emotional tension that is unsurpassed.

SOPHOCLES The life of Sophocles (496–406 BCE) spanned both the glories and the disasters of the fifth century BCE. Of the three great tragic poets, Sophocles was the most prosperous and successful; he was a personal friend of Pericles. He is said to have written 123 plays, but only 7 have survived, all of which date from the end of his career. They all express a much less positive vision of life than those of Aeschylus. His philosophy is not easy to extract from his work, because he is more concerned with exploring and developing the individual characters in his dramas than with expounding a point of view; in general, Sophocles seems to combine an awareness of the tragic consequences of individual mistakes with a belief in the collective ability and dignity of the human race.

CULTURE AND SOCIETY

Civic Pride

Aristotle's comment that "man is a creature who lives in a city," sometimes translated as "man is a political animal," summarizes the Greeks' attitude toward their polis (city). The focus of political, religious, and cultural life, and most other aspects as well—sport, entertainment, justice—the polis came to represent the central force in the life of each individual citizen.

The Greeks saw the importance of their city-states as the fundamental difference between their culture and that of the "barbarians," because it enabled them to participate in their community's affairs as responsible individuals. This participation was limited to adult male citizens; female citizens played little significant role in public life, and slaves and resident foreigners were completely excluded.

If the polis was responsible for many of the highest achievements of Greek culture, the notion of civic pride produced in the end a series of destructive rivalries that ended

Greek independence. The unity forged in the threat of the Persian invasions soon collapsed in the buildup to the Peloponnesian War. Even in the face of the campaigns of Philip of Macedon, the Greek cities continued to feud among themselves, unable to form a common front in the face of the danger of conquest.

The notion of the individual city as the focus of political and cultural life returned in the Italian Renaissance. Renaissance Florence, Siena, Milan, Venice, and Verona saw themselves as separate city-states, with their own styles of art and society. Even a small community such as Urbino became an independent political and artistic unit, modeled consciously on the city-states of Classical Greece. As in Greek times, civic pride led to strife between rivals and left the Italians helpless in the face of invasions by French forces or those of the Holy Roman Emperor.

The consequences of human error are vividly depicted in his play *Antigone*, first performed ca. 440 BCE. Thebes has been attacked by forces under the leadership of Polyneices, the son of Oedipus; the attack is beaten off and Polyneices is killed. In the aftermath, Creon, now king of Thebes, declares the dead warrior a traitor and forbids anyone to bury him on pain of death. Antigone, Polyneices's sister, disobeys, claiming that her religious and family obligations override those to the state. Creon angrily condemns her to death, but she stands firm and proud in her decision, further accusing Creon of tyranny:

READING 3.14 SOPHOCLES

Antigone, lines 555–573

Antigone: Creon, what more do you want
Than my arrest and execution?
Creon: Nothing. Then I have it all.
Antigone: Then why delay? Your moralizing repels me,
every word you say—pray god it always will.
So naturally all I say repels you too.
 Enough.
Give me glory! What greater glory could I win
than to give my own brother decent burial?
These citizens here would all agree,
[*To the* Chorus]
they would praise me too

if their lips weren't locked in fear.
[*Pointing to* Creon]
Lucky tyrants—the perquisites of power!
Ruthless power to do and say whatever pleases *them*.
Creon: You alone, of all the people in Thebes,
see things that way.
 Antigone: They see it just that way
but defer to you and keep their tongues in leash.
Creon: And you, aren't you ashamed to differ so from them?
So disloyal!
Antigone: Not ashamed for a moment,
not to honor my brother, my own flesh and blood.

Creon subsequently reverses his position, but too late: Antigone, his son (who is betrothed to Antigone), and his wife have all committed suicide. Creon's stubbornness and bad judgment thus result in tragedy for him as well as for Antigone. Creon laments over the body of his son:

READING 3.15 SOPHOCLES

Antigone, lines 1392–1400 and 1466–1470

 Ohhh,
so senseless, so insane . . . my crimes,
my stubborn, deadly—

Look at us, the killer, the killed,
father and son, the same blood—the misery!
My plans, my mad fanatic heart,
my son, cut off so young!
Ai, dead, lost to the world,
not through your stupidity, no my own.

After these words, a messenger comes to Creon with news of more death—this one his wife's. He is in anguish, but the messenger does nothing to console him. On the contrary, he reaffirms Creon's guilt. Creon prays for his own death, but the chorus leader tells him that there is no cure for his misery:

Creon: [*Kneeling in prayer*]
Come, let it come—that best of fates for me
that brings the final day, best fate of all.
Oh quickly, now—
so I never have to see another sunrise.
Leader: That will come when it comes;
we must deal with all that lies before us.
The future rests with the ones who tend the future.
Creon: That prayer—I poured my heart into that prayer!
Leader: No more prayers now. For mortal men
there is no escape from the doom we must endure.

Creon asks "where to lean for support." He laments that "whatever [he] touch[es] goes wrong" and that "a crushing fate's come down upon [his] head." The chorus responds to him, closing the play with these lines:

Wisdom is by far the greatest part of joy,
and reverence toward the gods must be safeguarded.
The mighty words of the proud are paid in full
with mighty blows of fate, and at long last
those blows will teach us wisdom.

More than any of his contemporaries, Sophocles emphasizes how much lies outside our own control, in the hands of destiny or the gods. His insistence that we respect and revere the forces that we cannot see or understand makes him the most traditionally religious of the tragedians. These ambiguities appear in his best known play, *Oedipus the King*, which has stood ever since Classical times as a symbol of Greek tragic drama. A century after it was first performed (ca. 429 BCE), Aristotle used it as his model when, in the *Poetics*, he discussed the nature of tragedy. Its unities of time, place, and action, the inexorable drive of the story with its inevitable yet profoundly tragic conclusion, the beauty of its poetry—all have made *Oedipus the King* a classic, in all senses.

Oedipus is the king of Thebes. The scope of his incalculable tragedy—his murder of his father and marriage to his mother—is revealed to him over the course of the play as he pursues truth and blood justice, but the audience already knows it well. When he appears on stage at the beginning of the play,

Oedipus is grappling with what to do about a plague that has devastated his city. He consults with the oracle, who warns that things will not be set right until the murder of his predecessor, Laius, is avenged. Oedipus tells his people that he will do what he must to bring the criminal to justice. The words that Oedipus speaks have particular meaning to the audience, even though Oedipus is unaware of their significance; this literary technique is known as **dramatic irony**. When the play opens, Oedipus, unbeknownst to him, has already committed the crimes that will bring about his downfall. In this passage, he speaks to the chorus, who represent the citizens of Thebes, ordering them to provide any information they might have so that the killer might be apprehended:

READING 3.16 SOPHOCLES

Oedipus the King, lines 254–287

If any one of you knows who murdered Laius,
the son of Labdacus, I order him to reveal
the whole truth to me. Nothing to fear,
even if he must denounce himself,
let him speak up
and so escape the brunt of the charge—
he will suffer no unbearable punishment,
nothing worse than exile, totally unharmed.
[Oedipus *pauses, waiting for a reply.*]
　　　Next,
if anyone knows the murderer is a stranger,
a man from alien soil, come, speak up.
I will give him a handsome reward, and lay up
gratitude in my heart for him besides.
[*Silence again, no reply.*]
But if you keep silent, if anyone panicking,
trying to shield himself or friend or kin,
rejects my offer, then hear what I will do.
I order you, every citizen of the state
where I hold throne and power: banish this man—
whoever he may be—never shelter him, never
speak a word to him, never make him partner
to your prayers, your victims burned to the gods.
Never let the holy water touch his hands,
Drive him out, each of you, from every home.
He is the plague, the heart of our corruption,
as Apollo's oracle has just revealed to me.
So I honor my obligations:
I fight for the god and for the murdered man.
Now my curse on the murderer. Whoever he is,
a lone man unknown in his crime
or one among many, let that man drag out
his life in agony, step by painful step—
I curse myself as well . . . if by any chance
he proves to be an intimate of our house,
here at my hearth, with my full knowledge,
may the curse I just called down on him strike me!

CULTURE AND SOCIETY

Theater of War

*"Friends—this was the thing I came to ask of you—
won't you come in and help us, if you can?
Men like him will listen to their friends."*
 Tecmessa, from Sophocles's *Ajax*

At the time Sophocles premiered his tragedy, *Ajax*, sometime between 450 and 430 BCE, the audience would have included scores of veterans of the Greeks' many hard-fought military campaigns. Heirs to the inspirational epic narratives—*The Iliad* and *The Odyssey*—that glorified conflict, individual heroism, and collective struggle, and the endurance of body and spirit; these veterans would have seen, in Sophocles's play, something different: an empathic portrayal of the private, postwar torments and anxieties that may have followed them, too, from the battlefield to the home front. The story of Ajax, the Achaeans' most skilled and valiant warrior next to Achilles, may be a story of post-traumatic stress disorder (PTSD).

The Iliad ends with the burial of Hector, and *The Odyssey* begins with Odysseus already in the throes of his arduous journey back home. What comes between are the deaths of Achilles and Ajax—Achilles at the hands of Paris, who struck him with a poison arrow guided by Apollo, and Ajax by his own hand, falling on the same sword given to him by Hector

▲ **3.17 Attic Red-Figured Kylix, showing Ajax impaled on his own sword. Attributed to the Brygos Painter (Greek [Attic]), active ca. 490–470 BCE). Terra-cotta, 4⁷⁄₁₆" × 12³⁄₈". The Getty Center, Los Angeles.**

after their hand-to-hand combat in *The Iliad* ended in a draw.

What could have happened that would lead Ajax to commit suicide—a man whose bravery was virtually unmatched and who, himself, carried the body of the slain Achilles away from Troy? Tecmessa, Ajax's concubine and the mother of his infant son, tells us "Madness has seized our noble Ajax . . ." The details of Ajax's actions and anguish are recounted in Sophocles's play. After Achilles's death, the fallen hero's armor was to be awarded to the greatest warrior among the Achaeans. Ajax was certain he would be awarded the honor, but the soldiers voted in favor of Odysseus. The outcome drove Ajax to the edge, and he turned his murderous rage on the Greek army. It was Athena who intervened with a "god-sent sickness," leading Ajax to believe that he was slaughtering his comrades when, in fact, he was slaughtering animals. When Ajax came to realize what he had done, his unbearable feelings of humiliation led him to commit suicide (**Fig. 3.17**).

In ancient times, scenes of Sophocles's *Ajax* doubtless would have struck a chord with at least some members of the audience. The effects of battle-induced psychological trauma, feelings of abandonment and hopelessness, and the emotional toll they take on war veterans and their loved ones—these are themes that rang familiar and continue to ring familiar today, in our own war-torn, war-weary society.

The audience knows that the future will mark Oedipus's words, that the fate he draws for this murderer will be his own. It is Oedipus who is clueless, and it is painful to watch. Again, in an interchange with Tiresias, the blind **soothsayer**, allusions are made to the events that will transpire. Tiresias speaks to Oedipus:

READING 3.17 SOPHOCLES

Oedipus the King, lines 469–479

 So,
you mock my blindness? Let me tell you this.
You with your precious eyes,
you're blind to the corruption of your life,
to the house you live in, those you live with—

who are your parents? Do you know? All unknowing
you are the scourge of your own flesh and blood,
the dead below the earth and the living here above,
and the double lash of your mother and your father's curse
will whip you from this land one day, their footfall
treading you down in terror, darkness, shrouding
your eyes that now can see the light!

When Oedipus finds out who his parents are, that he was left to die by his mother who was fearful of prophecies that the child would grow to kill his parents, and that he killed his father unknowingly and then came to marry the same woman who thought he was dead—Oedipus gouges his eyes:

Just as Sophocles—himself a general in the Greek army—may have recognized the value of dramatic literature, particularly tragedy, as a vehicle for recognizing and overcoming—or at least easing—mental suffering among veterans, so too did Brian Doerries, a translator of Greek and Roman drama, believe that experiences dramatized in Greek tragedies might help military personnel cope with the psychological toll of war. *The Philoctetes Project* (named for another play by Sophocles in which the protagonist, Philoctetes, is abandoned by his comrades when he is injured) was developed by Doerries as a way to "increase awareness of post-deployment psychological health issues, disseminate information regarding available resources, and foster greater family, community, and troop resilience."* Theater of War has united screen and stage actors including David Strathairn, Paul Giamatti, Jake Gyllenhaal, and Adam Driver (a former Marine and costar of *Star Wars: The Force Awakens*) in readings of scenes from two of Sophocles's plays, *Ajax* and *Philoctetes*. More than 300 performances have taken place worldwide before military and civilian audiences in the United States, Europe, and Japan at venues including VA hospitals, homeless shelters, high school auditoriums, theaters, museums, and churches (**Fig. 3.18**). It is estimated that more than 60,000 individuals have attended the readings and participated in "town-hall" audience discussions afterward, led by fellow service members and including veterans, their spouses, and mental health professionals or clergy members.

The painter Gustav Klimt said, "Art is a line around your thoughts." Theater of War has created a context for individuals affected by war and its aftermath to give shape to—give voice to—the oftentimes unspoken things that have deeply affected them:

▲ 3.18 Actors David Strathairn, Jake Gyllenhaal, and Reg E. Cathey performing a reading of Sophocles's *Ajax* at the Brooklyn Academy of Music for the Theater of War project.

By presenting these plays to military and civilian audiences, our hope is to de-stigmatize psychological injury, increase awareness of post-deployment psychological health issues, disseminate information regarding available resources, and foster greater family, community, and troop resilience. Using Sophocles' plays to forge a common vocabulary for openly discussing the impact of war on individuals, families, and communities, these events *[are]* aimed at generating compassion and understanding between diverse audiences.**

* "Theater of War," *Outside the Wire*, accessed February 9, 2016, http://www.outsidethewirellc.com/projects/theater-of-war/overview.

** "Theater of War," *Outside the Wire*, accessed February 9, 2016, http://www.outsidethewirellc.com/projects/theater-of-war/overview.

READING 3.18 SOPHOCLES

Oedipus the King, lines 1306–1310

> O god—
> all come true, all burst to light!
> O light—now let me look my last on you!
> I stand revealed at last—
> cursed in my birth, cursed in marriage,
> cursed in the lives I cut down with these hands!

Oedipus's story is extreme, idiosyncratic. Yet the universal admiration of the play—and its relevance—may have something to do with the fact that even though Oedipus is a king

whose actions break societal taboos, we have sympathy for him; he is a tragic hero. Like any human being, he has good qualities and bad ones. In spite of the trajectory of his life toward ruin, he is hopeful. He is confident and intelligent, but in the end, these things are not enough. Given Oedipus's situation, rather than condemning him, the audience finds itself asking, "What would I have done under the circumstances?" As the play closes, Oedipus goes into exile and Creon tells him, "Here your power ends. None of your power follows you through life." Yet somehow we do not believe it. We do not believe that Oedipus will wander and wallow in the disaster that has befallen him; rather, we have hope that he will pick up the pieces of his life and assemble something better from them. In the play that follows, *Oedipus at Colonus*, he has done just that. The ill-fated king whom we meet in the opening lines of *Oedipus the King*—the one who

says, "Here I am myself—you all know me, the world knows my fame: I am Oedipus," for whom knowledge bred suffering and who would gain self-knowledge through that suffering, returns as a wise and magnificent ruler.

Why does Oedipus, though, deserve to suffer for his actions? Certainly he does not knowingly kill his father nor knowingly marry his mother. The events that unfold have been prophesied; fate simply plays out. The play seems to be saying, in part, that humans cannot avoid destiny, although we are responsible for our own conduct as this destiny is met. The end may be predetermined, but how we journey toward it reveals our true character. *Oedipus the King*, for all of its suspense and spellbinding details, is also a psychological profile of one man who, as it happened, made some mistakes.

Artistotle writes on plot and character in the *Poetics*, his analysis of the nature of tragedy and the tragic hero. He theorizes that pity and fear are aroused in the audience when it recognizes that the unfortunate plight of the character is universal—that it could befall anyone, not "through vice or depravity, but . . . because of some great error or frailty in character."

READING 3.19 ARISTOTLE

From *Poetics*, 14

The plot ought to be so constructed that, even without the aid of the eye, he who hears the tale told will thrill with horror and melt to pity at what takes place. This is the impression we should receive from hearing the story of Oedipus.

Aristotle makes the point that the downfall of a tragic figure is the result of a character flaw or an intellectual miscalculation (the Greek word is *hamartia*). Does Sophocles see tragic flaws in his character of Oedipus? Oedipus's pride and stubborn insistence on discovering the truth, and the anger he shows in the process, lead to his destruction—the final, disastrous revelation. These flaws, or weaknesses, in his character overcome his assets—his intelligence, civic devotion, persistence, hopefulness. His personality is multidimensional, and it is the sum total of his personality that accounts for the situation in which he finds himself. In the end, however, some aspects of existence are beyond his—and human—understanding and control, aspects that operate by principles outside the range of human experience. And so Sophocles addresses the relationship between character and fate.

EURIPIDES The significance for the Athenians of Oedipus's fall from greatness emerges in full force in the work of Euripides (ca. 484–406 BCE). Although only slightly younger than Sophocles, Euripides expresses all the weariness and disillusionment of the war-torn years at the end of the fifth century BCE. Of all the tragedians, the outlook of Euripides is perhaps the closest to that of our own time, with his concern for realism and his determination to expose social, political, and religious injustices.

Although Euripides admits the existence of irrational forces in the universe that can be personified in the forms of gods and goddesses, he certainly does not regard them as worthy of respect and worship. This skepticism won him the charge of impiety. His plays show characters frequently pushed to the limits of endurance; their reactions show a new concern for psychological truth. In particular, Euripides exhibits a profound sympathy and understanding for the problems of women who live in a society dominated by men. Characters like Medea and Phaedra challenged many of the basic premises of Athenian society.

Euripides's deepest hatred is reserved for war and its senseless misery. Like the other dramatists, he draws the subject matter of his plays from traditional myths, but the lines delivered by the actors must have sounded in their listener's ears with a terrible relevance. *The Suppliant Women* was probably written in 421 BCE, when 10 years of indecisive fighting had produced nothing but an uneasy truce. Its subject is the recovery by Theseus, ruler of Athens, of the bodies of seven chiefs killed fighting at Thebes, in order to return them to their families for burial. His first response to the families' request is no, but his own mother reminds him of what is right:

READING 3.20 EURIPIDES

The Suppliant Women, lines 293–319

Aethra: Ah, poor, poor women!
Theseus: Mother, you are not one of them!
You do not share their fate.
Aethra: My son, shall I say something which will give you and our city some honor?
Theseus: Yes, do. Women can offer much wise council.
Aethra: But, I'm a little hesitant to utter what is in my mind.
Theseus: That's a shame, mother. Keeping wise words from your dear son!
Aethra: No, I won't stay silent now so as to have this silence punish me some time in the future. Nor will I hold back something that needs to be said through fear that speech making is unbecoming to women.

. . .

This is an insult to all the Greeks. It is a violation of the laws of the heavens, laws respected highly by all of Hellas. With no respect for the laws, there is no respect for the communities of men.
And then, if you will not act upon this, people will say that it was due to cowardice on your behalf. That you have failed to deliver the garland of glory to our city through lack of courage. They will say that you have once shown courage by fighting a wild boar but you now show cowardice when you need to fight against spears and helmets. Courage in the face of a trifling errant but cowardice in the face of a noble task.
You are my son, Theseus, so you should not act like that.

Theseus comes to understand that what his mother says honors the men, the gods, their families, and the state. He agrees to go to Thebes and bring the bodies of the dead warriors home, even at risk to his own safety, but he tells his mother that he will have to bring the matter to a vote, as the people ought to decide whether they want to put their warriors, their sons, in harm's way:

READING 3.21 EURIPIDES

The Suppliant Women, lines 339–355

But you're right. It's not in my character to run away from dangerous tasks and by my many deeds of virtue in the past, I have already exhibited to the Greeks my willingness to punish those who perform evil deeds.

No, it is not possible for me to refuse a task simply because it's difficult. What would my enemies say if they found out that the person who has asked me to perform it was you, mother, the very person who bore me and the very person whose heart trembles for my safety?

I will do this, mother. I will go and persuade the Thebans to release the corpses of the fallen men. I will try using words first but if words fail to persuade them, then I will use force. The gods will not go against us for such a purpose.

I also want the city to vote on this and I am sure they will agree with me, not only because I wish it but because they, too want it even more than I do.

In any case, I have made the citizens of this city its rulers, by giving them freedom and the equal rights to vote as they wish.

Euripedes uses *The Suppliant Women* as a pulpit from which to preach the glories of Greek democracy. A debate ensues between Theseus and a messenger from Thebes, who has come to bring Creon's position on the return of the dead to their mothers and on which city and government is superior—one ruled by a king or one ruled by the people. Theseus feels that he has the upper hand in the argument:

READING 3.22 EURIPIDES

The Suppliant Women, lines 430–454

To begin with, a city like that has no laws that are equal to all of its citizens. It can't. It is a place where one man holds all the laws of the city in his own hands and dictates them as he wants. What then of equality?

Written laws, however, give this equal treatment to all, rich and poor. If a poor man is insulted by a rich one, then that poor man has every right to use the same words against that rich man.

The poor can win against the rich if justice is on his side.

The essence of freedom is in these words: "He who has a good idea for the city let him bring it before its citizens."

You see? This way, he who has a good idea for the city will gain praise. The others are free to stay silent.

Is there a greater exhibition of fairness than this?

No, where the people hold the power, they can watch with great enjoyment the youth of their city thrive.

Not so when there is a single ruler. He hates that. The moment he sees someone who stands out in some way, he becomes afraid of losing his crown and so he kills him.

So how could a city possibly flourish like that? How could it grow in strength when someone goes about culling its bright youth like a farmer goes about cutting off the highest tips of his wheat during Spring?

Who would anyone want to bother with wealth and livelihood for his boys if it will all end up in the ruler's hands? Or his girls. Why bother raising sweet daughters in your house if they, too, will end up with the ruler, whenever he wants them, leaving you with tears of sorrow? I'd rather die than have my daughters dragged against their will into a wedding bed!

Theseus does wind up embattled with Theban warriors, but he brings the fallen soldiers home, and those he does not return to their families, he buries with honor. A significant portion of the play thereafter continues the lament over the loss of Greek children, the future of the country, cementing Euripides's play as a bold antiwar statement. It concludes with a stirring and painful plea from Iphis, the king of Argos, whose men were the ones who were lost in Thebes:

READING 3.23 EURIPIDES

The Suppliant Women, lines 1080–1090

Ah!

How I wish!

How I wish that mortals could live their youth twice and twice their old age, too!

When we make mistakes in our homes, we think about them again and the second time around, we correct them; but not with life.

If we could live as youths twice and twice as old men, we could also correct the mistakes we made in our first life, during our second.

I used to see people around me have children and it made me wish to have children of my own but it was that very wish that has destroyed me. But if I had suffered this present destruction back then, and if by being a father like all the others, had learnt what a terrible thing it is to lose your children, I would have never had to endure this evil destruction!

When the play premiered, Euripedes's audience would have had little need to be reminded of the grief of wives and mothers or of the kind of political processes that produced years of futile fighting in the Peloponnesian War.

If Aeschylus's belief in human progress is nobler, Euripides is certainly more realistic. Although unpopular in his own time, he later became the most widely read of the three tragedians. As a result, more of his plays have been preserved (19 in all), works with a wide range of emotional expression. They extend from romantic comedies like *Helen* and *Iphigenia in Tauris* to the profoundly disturbing *Bacchae*, his last completed play, in which Euripides the rationalist explores the inadequacy of reason as the sole approach to life. In this acknowledgment of the power of emotion to overwhelm the order and balance so typical of the Classical ideal, he is most clearly speaking for his time.

Aristophanes and Greek Comedy

Euripides was not the only poet–playwright to bring a laser-like focus to the futility of war. The plays of Aristophanes (ca. 450–385 BCE), the greatest comic poet of fifth-century-BCE Athens, combine political satire with unforgiving caricature, along with a strong dose of scatological humor and sexual innuendo.

In *The Birds*, produced in 414 BCE, two Athenians who are tired of war and paying taxes decide to leave home to find a better place to live. They join forces with the birds and build a new city in midair called Cloud-cuckoo-land, which cuts off contact between gods and humans by blocking the path of the smoke rising from sacrifices. The gods are forced to come to terms with the new city, and Zeus hands over his scepter of authority to the birds.

This is comedic escapism, but *Lysistrata*, written a few years later in 411 BCE, brings a humorous twist to a serious subject—the prolonged war and the inability of the men in conflict to come up with a solution to end it. Aristophanes brings out Athenian women as a secret weapon. With Lysistrata inciting them to action, they mean to bring the war to an end by using their bodies as weapons. She comes up with abstinence as the cure and presents the idea to her friends, who are not sure, at first, whether they are fond of the idea:

READING 3.24 ARISTOPHANES

Lysistrata, lines 124–127, 129–134, 138–140, and 152–161

> Lysistrata: We can force our
> husbands to negotiate Peace,
> Ladies, by exercising steadfast Self-Control—
> By Total Abstinence . . .
> [*A pause.*]
> Kleonike: From WHAT?
>
> . . .

> Lysistrata: Total Abstinence
> From SEX!
> [*The cluster of women dissolves.*]
> —Why are you turning away? Where are you going?
> [*Moving among the women.*]
> —What's this? Such stricken expressions!
> Such gloomy gestures!
> —Why so pale?
> —Whence these tears?
> —What IS this?
> Kleonike: Afraid I can't make it. Sorry.
> On with the War!
> Myrrhine: Me neither. Sorry.
> On with the War!
>
> . . .
>
> Kleonike: [*Breaking in between* Lysistrata *and* Myrrhine.]
> Try something else. Try anything. If you say so,
> I'm willing to walk through fire barefoot.
> But not
> to give up SEX—there's nothing like it, Lysistrata!
>
> . . .
>
> Kleonike: Well, just suppose we *did*
> as much as possible, abstain from . . . what you said,
> you know—not that we *would*—could something like
> that bring Peace any sooner?
> Lysistrata: Certainly. Here's how it works:
> We'll paint, powder, and pluck ourselves to the last
> detail, and stay inside, wearing those filmy
> tunics that set off everything we *have*—
> and then
> slink up to the men. They'll snap to attention, go
> absolutely *mad* to love us—
> but we won't let them. We'll Abstain.
> —I imagine they'll conclude a treaty rather quickly.

In addition to the sex strike, the Athenian women seize the Acropolis treasury, thus depriving their men of what they crave and must have—women and money to keep the war going. The action spreads, and women all over Greece refuse to make love with their husbands until peace is negotiated. The Athenian men, teased and frustrated, finally give in, and envoys are summoned from Sparta. The play ends with the Athenians and Spartans dancing together for joy at the new peace. Aristophanes suggests, perhaps, that war is, for men, a substitute for sex, and therefore sex can be a substitute for war.

THE LATE CLASSICAL PERIOD

When the Peloponnesian War came to an end with the defeat of Athens, Greece came under the leadership first of the victorious Spartans and then of the rulers of Thebes (home of

Oedipus, Creon, and Antigone). It would not be long, however, until outsiders again threatened the city-states—this time the Macedonians under King Philip II (359–336 BCE). They could not rally this time, and Greece went down to defeat, coming under the control of Philip followed by his son Alexander III (336–323 BCE), known as Alexander the Great.

In the aftermath of the Peloponnesian War, the ideals in which the Athenians so steadfastly believed must have seemed to crumble as cold reality set in. This is reflected in the art: the Classical ideal, the perfect human form, gave way to an art that looked to the real world rather than a set of abstract principles. The result was a remarkable realism, in terms of both appearance and the expression of human emotion.

Late Classical Sculpture

The Late Classical period, then, brought a more humanizing and naturalistic style, one that emphasized expression. A more languid sensuality and graceful proportions replaced the stocky muscularity of the Polyclitan ideal. One of the major proponents of this style was Praxiteles. His works show a lively spirit that was lacking in some of the more austere sculptures of the Classical period.

Praxiteles's Hermes Carrying the Infant Dionysus (**Fig. 3.19**) from the Temple of Hera in the Greek city of Olympia, is the only undisputed original work we have by a Greek sculptor dating back to this era. Praxiteles's ability to transform harsh stone surfaces into subtly modeled flesh was unsurpassed. We need only compare this with the Doryphorus to witness the changes that had taken place since the Classical period. Hermes is delicately carved, and his musculature is realistically depicted, suggesting the preference of nature as a model over adherence to a rigid, predefined canon. The messenger god holds the infant Dionysus, the god of wine, in his left arm, which is propped up by a tree trunk covered with a drape. His right arm is broken above the elbow but reaches out in front of him. It has been suggested that Hermes once held a bunch of grapes toward which the infant was reaching.

Praxiteles's skill in depicting variations in texture was extraordinary. Note, for example, the differences between the solid, toned muscles of the man and the soft, cuddly flesh of the child; or rough, curly hair against the flawless skin; or the deeply carved, billowing drapery alongside the subtly modeled flesh. The easy grace of Hermes's body is a result of the shift of weight from the right leg to the left arm which, in turn, rests on the tree trunk. This position causes a sway that is called an **S curve**, because the contours of the body form an S shape around an imaginary vertical axis.

Perhaps most remarkable is the emotional content of the sculpture. The aloof quality of Classical statuary is replaced with a touching scene between the two gods. Hermes's facial expression as he teases the child is one of pride and amusement. Dionysus, on the other hand, exhibits typical infant behavior—he is all hands and reaching impatiently for something to eat.

▲ 3.19 **Praxiteles, Hermes Carrying the Infant Dionysus, ca. 330–270 BCE. Copy from the Temple of Hera, Olympia, Greece, sculpted by a son or grandson of Praxiteles. Parian marble, 84½" (215 cm) high. Archaeological Museum, Olympia, Greece.** The long, lean proportions and pronounced sway of Praxiteles's statue differ markedly from the canon and contrapposto of Polyclitus's figures.

There remains a certain restraint to the movement and to the expressiveness, but it is definitely on the wane. In the Hellenistic period, that Classical balance will no longer pertain, and the emotion present in Praxiteles's sculpture will reach new peaks.

The most important and innovative sculptor to follow Praxiteles was Lysippus. He introduced a new canon of proportions that resulted in more slender and graceful figures, departing from the stockiness of Polyclitus and assuming the fluidity of Praxiteles. Most important, however, was his new concept of the motion of figure in space. All of the sculptures that we have seen so far have had a two-dimensional perspective. That is, the whole of the work can be viewed from a single point of view, standing in front of the sculpture. This is not the case in works

▲ **3.20** Lysippus, **Apoxyomenos (Scraper)**, Roman copy of a bronze statue of ca. 330 BCE. Marble, 80 ¾" (205 cm) high. Musei Vaticani, Vatican City State, Italy. The Apoxyomenos illustrates an athlete scraping sweat and dirt off his body with a strigil, or blunt, knifelike implement.

In fact, Lysippus's work was so widely admired that Alexander the Great—the Macedonian king who conquered Persia and Egypt and spread Greek culture throughout the Near East—chose him as his court sculptor. It is said that Lysippus was the only sculptor permitted to execute portraits of Alexander (**Fig. 3.21**).

The Hellenistic Period

When Alexander died in the summer of 323 BCE, the division of his empire into separate independent kingdoms spread Greek culture even more widely. The kingdoms of the Seleucids in Syria and the Ptolemies in Egypt were the true successors to Periclean Athens. Even as far away as India, sculptors and town planners were influenced by ideas developed by Athenians of the fifth and fourth centuries BCE. In due course, the cultural achievement of Classical Greece was absorbed and reborn in Rome, as we will see in Chapter 4. Meanwhile, in the Hellenistic period, which lasted from the death of Alexander to the Roman conquest of Greece in 146 BCE, that achievement took a new turn.

The inability of Alexander's generals to agree on a single successor after his death made the division of the Macedonian Empire inevitable. The four most important kingdoms that split off—Syria (the kingdom of the Seleucids), Egypt, Pergamun, and Macedonia—were soon at loggerheads, and remained so until they were finally conquered by Rome. Each of these, however, in its own way continued the spread of Greek culture, as the name of the period implies (it is derived from the verb *hellenize*, or "spread Greek influence").

The greatest of all centers of Greek learning was in the Egyptian city of Alexandria, where King Ptolemy, Alexander's former personal staff officer and bodyguard, planned a large institute for scholarship known as the Temple of the Muses, or the Museum. The library at the Museum contained everything of importance ever written in Greek, up to 700,000 separate works, according to contemporary authorities. Its destruction by fire when Julius Caesar besieged the city in 47 BCE must

such as the Apoxyomenos (**Fig. 3.20**) by Lysippus. The figure's arms envelop the surrounding space. The athlete is scraping oil and grime from his body with a dull, knifelike implement. This stance forces the viewer to walk around the sculpture to appreciate its details. Rather than adhere to a single plane, as even the S curve figure of Hermes does, the Apoxyomenos seems to spiral around a vertical axis.

Lysippus's reputation was almost unsurpassed. Years after the Apoxyomenos was created, it was still seen as a magnificent work of art. Pliny, a Roman writer on the arts, recounted an amusing story about the sculpture.

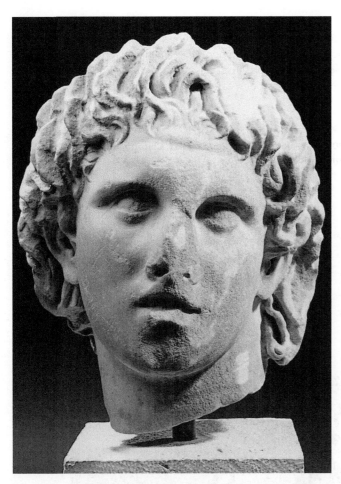

▲ **3.21 Head of Alexander the Great, third century BCE. Marble, 12" (30 cm) high. Archaeological Museum, Pella, Greece.** The thick, tousled hair and angle of the head correspond with contemporary descriptions of a lost full-length sculpture of Alexander that was attributed to Lysippus.

surely be one of the great intellectual disasters in the history of Western culture.

In Asia Minor and farther east in Syria, the Hellenistic rulers of the new kingdoms fostered Greek art and literature as one means of holding foreign influences at bay. Libraries were built at Pergamum and the Syrian capital of Antioch, and philosophers from Greece were encouraged to visit the new centers of learning and lecture there. In this way Greek ideas not only retained their hold but also began to make an impression on more remote peoples even farther east. The first Buddhist monumental sculpture, called Gandharan after the Indian province of Gandhara where it developed, used Greek styles and techniques. There is even a classic Buddhist religious work called *The Questions of King Milinda* in which a local Greek ruler, probably called Menander, is described as exchanging ideas with a Buddhist sage, ending with the ruler's conversion to Buddhism—one example of the failure of Greek ideas to convince those exposed to them.

Yet however much literature and philosophy could do to maintain the importance of Greek culture, Hellenistic rulers turned primarily to the visual arts. In so doing, they inaugurated the last great period of Greek art. The most powerful influence on the period immediately following Alexander's death was the memory of his life. The daring and immensity of his conquests, his heroic personality, the new world he had sought to create— all combined to produce a spirit of adventure and experiment.

The all-pervading spirit of the Classical age had been order. Now artists began to discover the delights of freedom. Classical art was calm and restrained, but Hellenistic art was emotional and expressive. Classical artists sought clarity and balance even in depicting scenes of violence, but Hellenistic artists allowed themselves to portray riotous confusion involving strong contrasts of light and shade and the appearance of perpetual motion. It is not surprising that the term *baroque*, originally used to describe the extravagant European art of the 17th century CE, is often applied to the art of the Hellenistic period.

The artists responsible for these innovations created their works for a new kind of patron. Most of the great works of the Classical period had been produced for the state, with the result that the principal themes and inspirations were religious and political. But following the disintegration of the Macedonian Empire and the establishment of prosperous kingdoms at Pergamon, Antioch, and elsewhere, there developed a group of powerful rulers and wealthy businessmen who commissioned works either to provide lavish decoration for their cities or to adorn their private palaces and villas. Artists were no longer responsible to humanity and to the gods, but to whoever paid for the work. Their patrons encouraged them to develop new techniques and surpass the achievements of rivals. At the same time, the change in the artist's social role produced a change in the function of the work. Whereas in the Classical period architects had devoted themselves to the construction of temples and religious sanctuaries, the Hellenistic age is notable for its marketplaces and theaters, as well as for scientific and technical buildings like the Tower of the Winds at Athens (a combination sundial, clock tower, and wind vane) and the Lighthouse at Alexandria (450 feet high and destroyed in an earthquake). Among the rich cities of Hellenistic Asia, none was wealthier than Pergamum, ruled by a dynasty of kings known as the Attalids. Pergamum was founded in the early third century BCE and reached the high point of its greatness in the reign of Eumenes II (197–159 BCE). The Upper City—or Upper Acropolis—was inspired by the Athenian Acropolis, although the site included much more than sacred temples: royal residences, an agora or marketplace, a library of some 200,000 volumes, a theater that seated 10,000 spectators on the steepest-rising seats in ancient times, and more. Embedded among these buildings, but on an elevated platform of great prominence, was the chief religious shrine of Pergamon—the altar of Zeus (see Fig. 3.22).

Eumenes II erected the altar ca. 180 BCE to commemorate the victories of his father, Attalus I, over the Gauls. Its base is decorated with a colossal frieze depicting the battle of the gods and giants. The triumphant figure of Zeus stands presumably

CONNECTIONS Contemporary German photographer, Thomas Struth, began work on his most well-known series, *Museum Photographs*, in 1989. His photographs of the Pergamon Altar at the Pergamon Museum in Berlin, taken between 1996 and 2001 (**Fig. 3.22**), are his first dedicated to a single museum's collections from classical antiquity. Though it appears to be a candid shot of museum-goers milling about the space, the crowd has been carefully positioned and choreographed by the artist.

▼ **3.22 Thomas Struth, *Pergamon Museum I, Berlin* (2001), Museum of Contemporary Art, Chicago. Chromogenic development print, 77¾" × 97⅞". Altar of Zeus dated to ca. 175 BCE.** The altar stood on an elevated platform, framed by an Ionic colonnade. Around the platform is a nearly 400-foot-long frieze depicting the battle of gods and giants and alluding to the victory of King Attalus I over the Gauls.

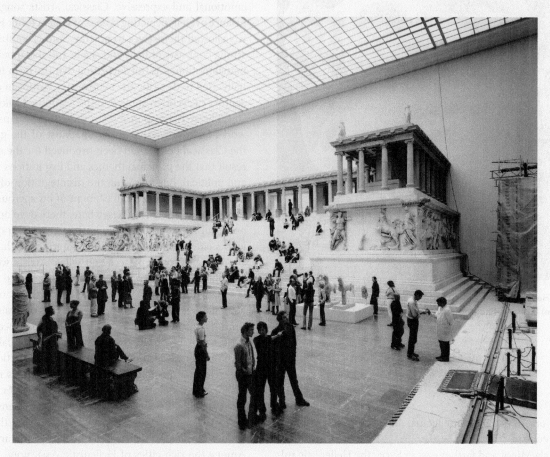

as a symbol for the victorious king of Pergamon. The drama and violence of the battle find perfect expression in the tangled, writhing bodies, which leap out of the frieze in high relief, and in the intensity of the gestures and facial expressions (**Fig. 3.23**). The immense emotional impact of the scenes may prevent us from appreciating the remarkable skill of the artists, some of whom were brought from Athens to work on the project. However, the movement of the figures is far from random, and the surface of the stone has been carefully worked to reproduce the texture of hair, skin, fabric, metal, and so on.

The altar of Zeus represents the most complete illustration of the principles and practice of Hellenistic art. It is, of course, a work on a grand, even grandiose, scale, intended to impress

a wide public. But many of its characteristics can also be seen in other works by Pergamene sculptors. The statue of a dying Gaul (**Fig. 3.24**), part of a figural group depicting the bravery of barbaric foes in the face of defeat, features many details that contribute to an emotional narrative. Bleeding from a large wound in his side, the fallen warrior, exhausted, head hanging hopelessly, can barely support his weight on a weakened right arm. Collapsed on a shield that might as well be a funeral bier, all of his strength seems to leave him even as we watch. The artist has taken pains to signify his "otherness" (the coarse, disheveled hair and mustache of a barbarian and the rope-like torque around his neck) but approaches his subject as a noble, gallant foe.

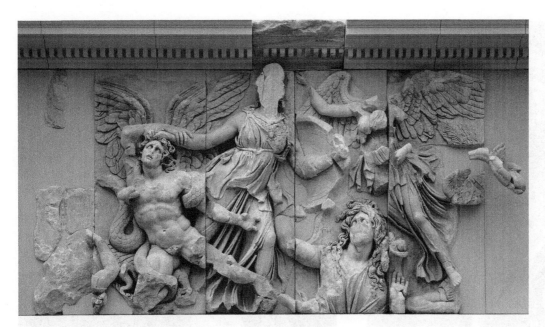

◀ **3.23** **Athena Battling Alcyoneus,** ca. 180 BCE. Detail of the frieze on the Altar of Zeus, from Pergamon, Turkey. Proconnesian marble relief, 90½" high × ca. 361' total length (2.3 × 110 m). Antikensammlung, Staatliche Museen, Berlin, Germany. The reliefs of the altar of Zeus contain battle scenes characterized by extreme physical violence and anguish. Athena is shown here grasping the giant Alcyoneus by the hair, the source of his strength, to lift him off the ground. His mother—Gaea, the earth goddess—looks on despairingly from below.

There is considerable variation in terms of subject and style within Hellenistic art, although one common denominator may be "extremes." The Hellenistic artist pushed emotion to the extreme, pushed realism to the extreme, pushed the limits of their material to the extreme. How else to describe the tactile drapery, the sense of motion, and a weightlessness that defies the gravity of stone in the *Nike of Samothrace* (**Fig. 3.25**)? Archaeologists believe that this Hellenistic Greek statue of Nike, the goddess of victory—which was found in pieces on a small island in the northern part of the Aegean Sea—may have been carved to commemorate the triumphant outcome of a naval battle. Originally part of a fountain carved into a rocky niche, Nike alights on the prow of a warship, bracing herself against the wind and spray of the sea, her wings still fluttering and her water-soaked garments billowing and clinging sensuously to her torso. Her dynamic forward stance—and what we imagine to be the swelling and pitching of the sea and the ship—are equalized by the steadying force of the goddess's outstretched wings.

▶ **3.24** **Epigonos (?), Dying Gaul.** Roman copy of a bronze statue, ca. 230–220 BCE. Marble, 3' ½" high. Museo Capitolino, Rome, Italy. The mortally wounded battle trumpeter falls to the ground on his shield, his instrument at his feet. The artist took pains to represent the distinct physical characteristics of the enemy barbarian but rendered the subject with great sympathy.

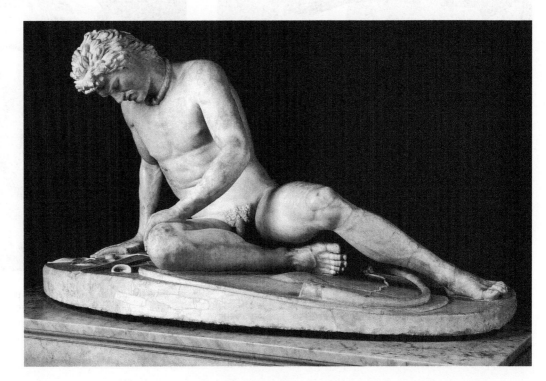

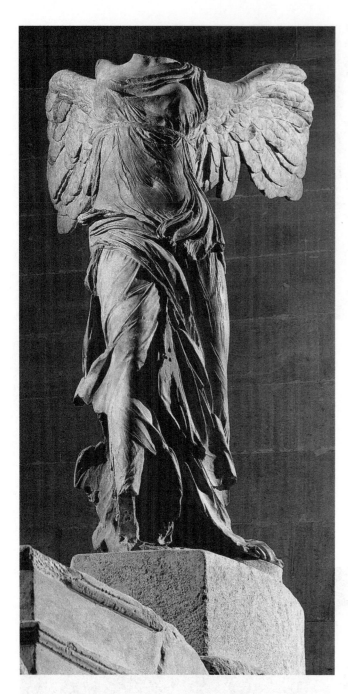

▲ **3.25 Nike alighting on a warship (*Nike of Samothrace*), from Samothrace, Greece, ca. 190 BCE. Marble, Nike 8' 1" high. Musée du Louvre, Paris, France.** The statue of Nike, perched on a pedestal in the shape of a ship's prow, may have been carved to commemorate the triumphant outcome of a naval battle.

Two of the most well-known and influential works of Hellenistic art are, at once, on different ends of the stylistic spectrum. The first is an approximate contemporary of the *Nike of Samothrace*—a statue of Aphrodite that is better known as the famed *Venus de Milo* (Fig. 3.26). In the midst of the theatricality of Hellenistic art, like an oasis of calm in a storm, another trend appeared that reflected the simplicity and idealism of the

Classical period. The realism, emotionalism, and dynamism of works like the dying Gaul or the Louvre's *Nike* could not be farther in spirit from the serene and idealized form of this beloved Aphrodite. It owes more to the artistic legacy of Praxiteles than, say, to the Pergamene sculptors.

The other, carved more than 100–150 years later, in the first century CE, depicts the gruesome strangling deaths of the Trojan priest, Laocoön, and his sons by serpents (Fig. 3.27). Laocoön was punished by the gods for his attempt to expose the ruse of the Greek's infamous wooden horse that led to the slaughter of the Trojans within their city walls. The "who's who" of the protagonists and the "what's what" of the plot line are conflicting; both Sophocles and Virgil, in his *Aeneid* (we will read some excerpts in the next chapter on Rome), tell the story

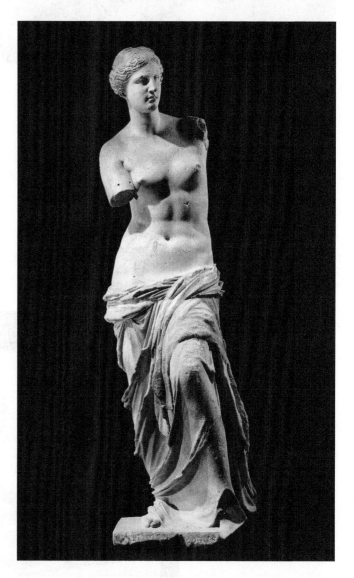

▲ **3.26 Alexandros of Antioch-on-the-Meander, Aphrodite (*Venus de Milo*), from Melos, Greece, ca. 150–125 BCE. Marble, 6' 7" high. Musée du Louvre, Paris, France.** In this version of Aphrodite, the artist depicts the goddess as an object of sexual desire. Although the figure is serene overall, it is charged with eroticism. The deliberate arrangement of drapery so that it slips down off her hips was intended to titillate the viewer.

but with different twists and turns. The large piece is superbly composed along a strong diagonal, with the three figures pushing and pulling against the sinuous curves of the serpents that bind them together. Laocoön's tortured position recalls one figure in particular from Athena's battle on the Pergamon altar (see Fig. 3.23). One can hardly think of a subject more appropriate to the expressive Hellenistic style, or a style more suited to such a subject.

The gradual conquest of the Hellenistic kingdoms by Rome and their absorption into the Roman Empire produced a new artistic synthesis in which the achievements of Classical and Hellenistic Greece fused with native Italian culture and set the stage for a history of Roman art.

CONNECTIONS In the year 1939, as the world began to brace itself for war, museums braced themselves for its impact on art treasures. At the Louvre museum in Paris, antique sculptures were rounded up and stored in the basement and paintings were removed from their frames and sent to chateaus in the French countryside for safekeeping. In the middle of the night on September 3rd, the *Nike of Samothrace*—hoisted by a system of ropes and pulleys—made its way from the top of a staircase down specially constructed wooden ramps and was shipped off to spend the war years at the Chateau de Valencay in the French province of Berry.

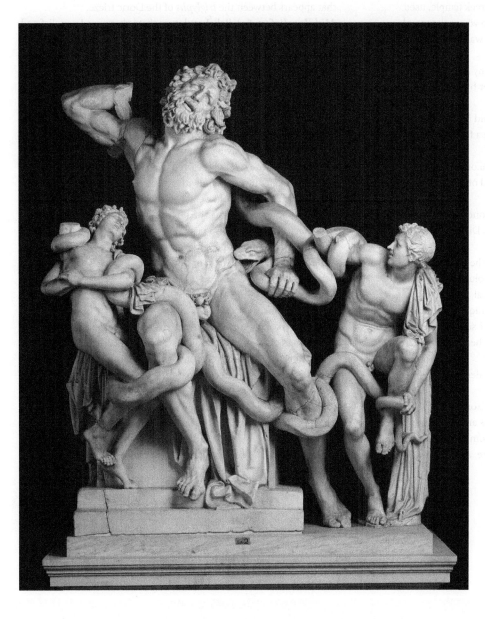

◄ **3.27 Athenadorus, Agesander, and Polydorus of Rhodes, Laocoön and His Sons, early first century CE. Roman copy, marble, 82¾" (210 cm) high. Musei Vaticani, Vatican City State, Italy.** From an incident described in Virgil's *Aeneid*, sea serpents strangle the Trojan priest Laocoön and his sons in retaliation for their telling the Trojans to be wary of the gift of the Trojan horse. The figures writhe in agony, futilely attempting to free themselves from the death grip of the serpents. Stylistic similarities between Laocoön and the struggling Alcyoneus in the frieze on the altar of Zeus (Fig. 3.23) have been noted by scholars.

GLOSSARY

Acropolis (p. 88) Literally "high city"; the flat-topped rock in Athens that rises 490 feet above sea level and has buildings that were erected during the Golden Age, including the Parthenon.

Boule (p. 85) The ruling council of the Athenian Ecclesia.

Canon of proportions (p. 94) A set of rules (or formula) governing what are considered to be the perfect proportions of the human body or correct proportions in architecture.

Caryatid (p. 92) A stone sculpture of a draped female figure used as a supporting column in a Greek-style building.

Catharsis (p. 101) A cleansing of the soul, or release of pent-up emotions.

Cella (p. 88) The small inner room of a Greek temple, used to house the statue of the god or goddess to whom the temple is dedicated; located behind solid masonry walls, the cella was accessible only to the temple priests.

Chorus (p. 104) In Greek drama, a company or group of actors who comment on the action in a play, either by speaking or singing in unison.

Chryselephantine (p. 89) Made of gold and ivory.

Contrapposto (p. 92) A position in which a figure is obliquely balanced around a central vertical axis.

Delian League (p. 85) A politically neutral organization of Greek city-states that kept a treasury on the island of Delos to fund military defenses in case of an attack.

Dithyramb (p. 103) A frenzied or impassioned choral hymn of ancient Greece, especially one dedicated to Dionysus, the god of wine.

Doric (p. 88) The earliest and simplest of the Greek architectural styles, consisting of relatively short, squat columns, sometimes unfluted, and a simple, square-shaped capital.

Dramatic irony (p. 107) The literary technique in which the words spoken by a character have particular significance for the audience although the character himself or herself is unaware of their meaning.

Ecclesia (p. 85) The main assembly of the democracy of Athens during its golden age.

Entablature (p. 88) In architecture, a horizontal structure supported by columns that in turn supports any other element, such as a pediment, that is placed above; from top to bottom, the entablature consists of a *cornice*, a **frieze**, and an *architrave*.

Entasis (p. 88) In architecture, a slight convex curvature of a column, which provides the illusion of continuity of thickness as the column rises.

Fourth (p. 102) In music, the distance between the lowest note and the fourth note up an octave.

Frieze (p. 89) In architecture, a horizontal band between the *architrave* and the *cornice* that is often decorated with sculpture.

Krater (p. 95) A wide-mouthed ceramic vessel used for mixing wine and water.

Lekythos (p. 95) An oil flask used for funerary offerings and painted with mourning or graveside scenes (plural *lekythoi*).

Metope (p. 89) In architecture, a panel containing *relief sculpture* that appears between the *triglyphs* of the Doric frieze.

Middle relief (p. 89) Relief sculpture that is between low relief and high relief in its projection from a surface.

Mode (p. 102) In music, the combination of two *tetrachords*.

Pediment (p. 89) In architecture, any triangular shape surrounded by *cornices*, especially one that surmounts the *entablature* of the *portico façade* of a Greek temple.

Peloponnesian War (p. 85) The war between Athens and its allies and the rest of Greece, led by the Spartans.

Peripteral (p. 88) Having columns on all sides.

Satyr play (p. 104) A lighthearted play; named for the satyr, a mythological figure of a man with an animal's ears and tail.

S curve (p. 113) A double weight shift in Classical sculpture in which the body and posture of a figure form an S shape around an imaginary vertical axis or pole.

Soothsayer (p. 108) A person who can foresee the future.

Sophist (p. 97) A wise man or philosopher, especially one skilled in debating.

Stylobate (p. 91) A continuous base or platform that supports a row of columns.

Theaters (p. 103) A round or oval structure, typically unroofed, having tiers of seats rising gradually from a center stage or arena.

Tetrachord (p. 102) A group of four pitches, the two outer ones a perfect fourth interval apart and the inner ones variably spaced.

Triglyph (p. 89) In architecture, a panel incised with vertical grooves (usually three, hence *tri-*) that serve to divide the scenes in a *Doric* **frieze**.

Trilogy (p. 104) A series of three tragedies.

THE BIG PICTURE CLASSICAL GREECE AND THE HELLENISTIC PERIOD

Language and Literature

- Aeschylus, author of the *Oresteia* trilogy, was awarded the first prize in the drama festival of Dionysus in 458 BCE.
- Sophocles's *Antigone* is performed in 440 BCE.
- Sophocles wrote *Oedipus the King* ca. 429 BCE.
- Euripides wrote *The Suppliant Women* ca. 421 BCE.
- Thucydides wrote the *History of the Peloponnesian War* ca. 420–ca. 399 BCE.
- Aristophanes wrote *The Birds* in 414 BCE.
- Aristophanes wrote *Lysistrata* in 411 BCE.

Art, Architecture, and Music

- The introduction of contrapposto in the Kritios Boy, along with the sideward glance of the head, separate the Archaic period from the Classical period of Greek art.
- Myron sculpted the Discobolos (Discus Thrower) ca. 450 BCE.
- Ictinus and Callicrates designed and erected the Parthenon 448 BCE–432 BCE; Phidias completed the Parthenon sculptures.
- Polyclitus created his canon of proportions for statuary, and Ictinus applied mathematical formulas to achieve harmonious temple design. Polyclitus sculpted the Doryphorus ca. 440 BCE.
- Following a sacking by the Persians, Pericles rebuilt the Acropolis.
- Corinthian capitals were introduced in architecture.
- Music dominated dramatic performances ca. 400 BCE. Instrumental music became popular in the fourth century BCE.
- Late Classical sculptors created more realistic portraits of deities and heroes.
- Hellenistic sculpture became yet more realistic, often choosing common people as subjects and portraying violence and emotion. Laocoön and His Sons was sculpted ca. 150 BCE.

Philosophy and Religion

- Socrates (ca. 469 BCE–399 BCE) introduced his dialectic method of inquiry to examine central moral concepts such as the good and justice. He posed a series of questions to help people understand their underlying beliefs and challenge them.
- Socrates questioned the apparent Athenian belief that might made right and spoke positively of Athens's enemy Sparta; he was tried and executed in 399 BCE.
- Plato published the *Republic* before 387 BCE; it is a Socratic dialogue that examines the concept of justice and lauds the rule of the philosopher–king.
- Plato founded his Academy in 387 BCE.
- Xenophon chronicled the teachings of Socrates ca. 385 BCE.
- Aristotle (ca. 384–ca. 322 BCE) studied and taught at Plato's Academy
- Aristotle wrote the *Poetics* and *Metaphysics*.
- Aristotle tutored King Philip II's son, Alexander.
- Aristotle founded the Lyceum in 335 BCE.

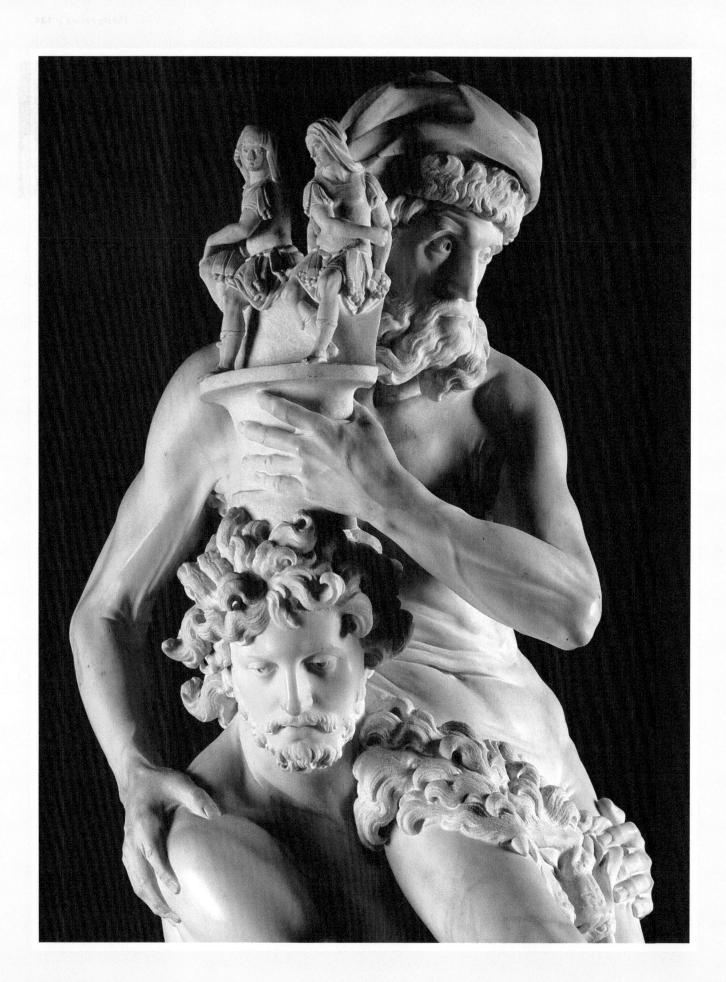

Rome

4

PREVIEW

So much of Greek culture was a point of departure for that of Rome. The Greek gods and their temples, art and architecture, drama and poetry all provided a springboard for Roman synthesis, creativity, and innovation. While the legacy of Greece offered precedents, it did not define limits. Rome was unmistakably Roman.

When the poet Virgil undertook his epic on the founding of Rome, he had ample models from ancient Greece to consider, not the least of which were Homer's own epic narratives—*The Iliad* and *The Odyssey*. In some ways, Virgil's *Aeneid* reflects the themes of those two stories. Aeneas, Virgil's protagonist, was a Trojan prince and warrior who escaped the burning city—after the deadly ruse of the Trojan horse—to face any number of obstacles between him and his goal: the founding of a city that would become the centerpiece of a Roman state. But he is neither like Achilles, the brooding hero, nor Odysseus, the long-suffering survivor who prevails in his quest to reach home against all odds. Aeneas, it turns out, is archetypically Roman. His heroism lies not in sacrifices he makes for himself, but in those he makes for the greater good of the generations that will follow him. In the end, he loses almost everything—his home, wife, father, lover, and ultimately his life. Aeneas makes choices that he would prefer not to make, ever mindful of his duty to the gods who have ordained his mission and his responsibility to the future—to something bigger than himself.

In the early 17th century, the Italian sculptor Gian Lorenzo Bernini carved the figural group *Aeneas, Anchises, and Ascanius* (Fig. 4.1) for his patron, Scipione Cardinal Borghese. Forced to flee the destruction that is Troy, Aeneas carries his aged father Anchises on his broad shoulders while Anchises protectively clutches the household gods. The scene from the *Aeneid*, here faithfully depicted, symbolizes the Roman ideal of devotion to the gods, family, and duty. In Aeneas we find the embodiment of Roman virtues: *gravitas*, a seriousness of purpose and sense of responsibility; *pietas*, a dutifulness and devotion to others; *dignitas*, a sense of self-worth; and *virtus*, manliness, courage, and character.

◄ 4.1 Gian Lorenzo Bernini, detail of *Aeneas, Anchises, and Ascanius*, 1618–1619. Marble, 86⅝" (220.0 cm). Galleria Borghese, Rome, Italy.

The origins of our Western heritage date back to the Greeks and, less directly, to the peoples of Egypt and the Near East, but Rome was responsible for the spread of Western civilization for thousands of miles in the direction of every point on the compass. In language, law, politics, religion, art, and more, Roman culture continues to affect our lives. The road network of modern Europe is based on one planned and built by the Romans some 2000 years ago; the alphabet we use is the Roman alphabet; and the division of the year into 12 months of unequal length is a modified form of the calendar introduced by Julius Caesar in 45 BCE. Even after the fall of the Roman Empire, the city of Rome stood for centuries as the symbol of civilization; later empires deliberately shaped themselves on the Roman model.

The enormous impact of Rome on our culture is partly the result of the industrious and determined character of the Romans, who early in their history saw themselves as the divinely appointed rulers of the world. In the course of fulfilling their mission, they spread Roman culture from Britain in the north to Africa in the south, from Spain in the west to Asia in the east (see **Map 4.1**). This Romanization of the entire known world permitted the Romans to disseminate ideas drawn from other cultures. Greek art and literature were handed down and incorporated into the Western tradition through the Romans, not the Greeks. The rapid spread of Christianity in the fourth century CE was a result of the decision by the Roman emperors to adopt it as the official religion of the Roman Empire.

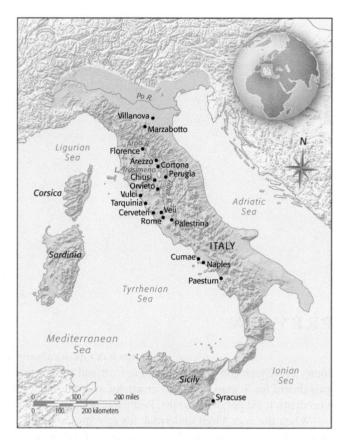

▲ **MAP 4.1 Italy in Etruscan times.**

Rome

700 BCE	509 BCE	27 BCE	337 CE

THE ETRUSCANS	REPUBLICAN ROME	IMPERIAL ROME

THE ETRUSCANS

The Etruscans emerge as a culture distinct from the rest of the Italian peninsula, Greece, and the Near East

Etruscan Kings rule the region until the Roman Republic is established in 509 BCE

Etruscans dominate sea trade in the Mediterranean, exchanging metals and finely painted ceramic ware for foreign goods

REPUBLICAN ROME

The legend of Romulus and Remus places the founding date of Rome at 753 BCE

Roman Republic established in 509 BCE; beginning of a constitutional government

Arts and ideas of various cultures, particularly Greece, impact Roman art and architecture

Single, unified code of civil law (jus civile) implemented under Julius Caesar

The republic collapses after a civil war that begins with the assassination of Julius Caesar in 44 BCE

Octavian defeats forces of Mark Antony and Egypt's Queen Cleopatra; Egypt becomes a Roman province

IMPERIAL ROME

Roman Senate bestows on Octavian the title of Augustus and powers of emperor; Imperial period begins

Augustus establishes a citizen army of half a million soldiers

A nexus of roads bring freedom of travel and trade, expanding the economy of the empire

The Pax Romana—a period of relative peace—lasts over 200 years, from the time of Augustus to the death of Marcus Aurelius in 180 BCE

Mount Vesuvius erupts in 79 CE; Pompeii and Herculaneum buried in volcanic ash

Struggles for imperial power and external threats weaken the empire

Military spending leads to a decline in the quality of life for Roman citizens

Roman art and literature absorbed and assimilated influences from conquered lands and beyond, and created from them something typically Roman. The **lyric poetry** of first-century-BCE writers such as Catullus was inspired by the works of Sappho, Alcaeus, and other Greek poets of the sixth century BCE, but nothing could be more Roman in spirit than Catullus's poems. And while Greece most certainly provided models for Roman buildings and sculptures, Roman engineering and design expanded their architectural vocabulary to create one of the most impressive of our legacies from the ancient world. The study of Roman art, architecture, and drama examines the influences upon them while also recognizing the creative and unexpected ways in which the Romans absorbed and combined the ideas of other cultures.

Rome's history was a long one, beginning with the foundation of the city in the eighth century BCE. For the first two and one-half centuries, Rome was ruled by kings. The rest of the vast span of Roman history is divided into two periods: Republican Rome (509–27 BCE), during which time democratic government was developed and then allowed to collapse, and Imperial Rome (27 BCE–476 CE), during which the Roman world was ruled, at least in theory, by one man—the emperor. The date 476 CE marks the deposition of the last Roman emperor in the West.

Shortly after the foundation of the Roman Republic, the Romans began their conquest of neighboring peoples, first in Italy, then throughout Europe, Asia, and North Africa. As their territory grew, their civilization developed as well, assimilating the cultures that fell under Roman domination.

THE ETRUSCANS (CA. 700 BCE–89 BCE)

The late eighth century BCE was a time of great activity in Italy. The Greeks had reached the south coast and Sicily. In the valley of the Tiber, farmers and herdsmen of a group of tribes known as the Latins (the origin of the name of the language spoken by the Romans) were establishing small settlements, one of which was to become the future imperial city of Rome. But in central Italy—in a region named after them called Tuscany—the Etruscan culture was flourishing.

The Etruscans are among the most intriguing of ancient peoples; ever since early Roman times, scholars have argued about who they were, where they came from, and what language they spoke. Even today, despite the discoveries of modern archaeologists, we still know little about the origins of the Etruscans. The ancient Greeks and Romans thought that the Etruscans had come to Italy from the east, perhaps from an ancient kingdom in Asia Minor. Indeed, some aspects of their life and art have pronounced Eastern characteristics. Their language has not yet been deciphered fully, although we know that the Etruscans spoke a non-European language that was written in a script derived from Greek. The longest extant text is the *Liber Linteus* (the *Linen Book*). It survived because it was cut into strips by Egyptians and used to wrap a mummy.

Etruscan Art and Architecture

The commercial contacts of the Etruscans extended over most of the Western Mediterranean; in Italy, Etruscan cities such as Cerveteri and Tarquinia developed rich artistic traditions. Etruscan art is sophisticated in technique and exciting and energetic in appearance. Life-size terra-cotta sculptures, finely crafted bronze objects, and sumptuous gold treasures buried in Etruscan tombs all point to superb craftsmanship and material prosperity.

A sense of confidence that one can imagine prevailed among the Etruscans at the peak of their power is exuded in the painted terra-cotta sculpture of the god Apulu known to us as the Apollo of Veii (**Fig. 4.2**). He features several stylistic details that we saw in Archaic Greek art—the zig-zag folds of drapery, slight smile, thick-lidded eyes, and eyebrows that come down to form the bridge of the nose—but his gesturing arms and vigorous stride set him apart from the static bodies of the Greek sculptures. We know that the Apollo of Veii would have occupied a prominent place on the rooftop of an Etruscan temple, although none of these structures have survived beyond their foundations, because they were constructed of impermanent materials such as wood and mudbrick.

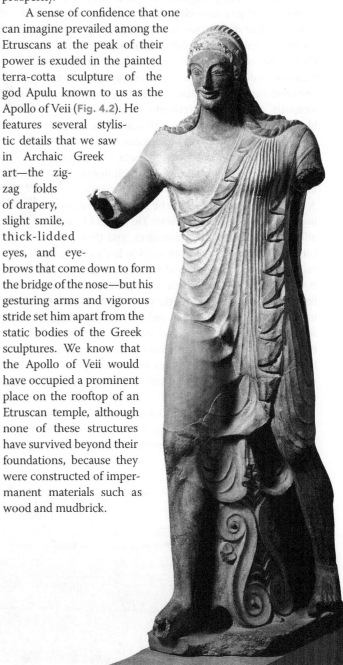

▲ 4.2 Apollo of Veii, ca. 510–500 BCE. From the roof of the Portonaccio Temple, Veii, Italy. Painted terra-cotta, 69" (175 cm) high. National Etruscan Museum of Villa Giulia, Rome, Italy.

How, then, do we know what an Etruscan temple looked like? First, the existing foundations allow us to perceive the floor plans (see Figure 4.16). Second, the Roman architect Vitruvius, who wrote on the architecture of his day, provided detailed information about the construction and style of Etruscan temples. The model in (Fig. 4.3) is based on Vitruvius's notes.

Just as we can pick out a few similarities between Greek and Etruscan sculpture, Etruscan tombs might appear to us as a throwback to ancient Egypt. At a time when the Greeks were burying their dead in simple shaft graves, the Etruscans were constructing elaborate tombs that simulated their earthly environments. Carved out of bedrock, the walls of underground tombs were covered with hundreds of everyday items carved in low relief, including kitchen utensils, mirrors, pillows, weapons, and shields. Networks of rooms resemble actual houses, complete with seating on which terra-cotta sculptures of the deceased may have perched. It is as if someone lived there. Completing this picture is a **sarcophagus** with a reclining couple, found in a cemetery in Cerveteri, Italy (Fig. 4.4). A husband and wife appear to be at a banquet enjoying the evening's entertainment. He places his arm affectionately around her shoulders, and their gestures suggest that they are engaged in lively conversation. The sarcophagus, which contained ashes of the cremated deceased, is unprecedented in the ancient world. And while we do find banquet scenes on Greek pottery, which the Etruscans eagerly imported, we do not see men and women dining together. The sarcophagus bears the unique characteristics of Etruscan sculpture and also suggests the position of Etruscan women relative to other ancient societies: They were participants. They also were more literate and independent, and enjoyed higher legal status.

The vivaciousness of the Etruscan culture can also be seen in vibrant frescoes (Fig. 4.5) found on tomb walls. The subject matter, again, references life: scenes of banquets, hunting and fishing, music and dancing, and all sorts of sports and athletic competitions. The

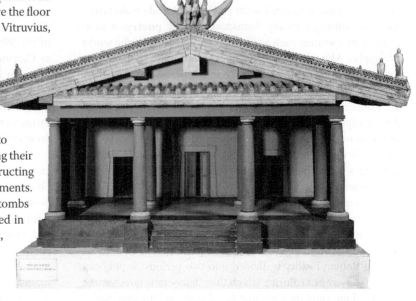

▲ **4.3 Model of a typical Etruscan temple of the sixth century** BCE, **as described by Vitruvius. Plastic. Istituto di Etruscologia e di Antichità Italiche, Università di Roma, Rome, Italy.** Etruscan temples resembled Greek temples but had widely spaced wood columns in the front only, brick walls, and a staircase in the center of the façade.

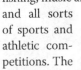

▲ **4.4 Sarcophagus, ca. 520** BCE **(Etruscan). Cerveteri, Italy. Terra-cotta, 44⅞" high × 27¼" wide × 74⅜" long (114 × 134 × 190 cm). National Etruscan Museum of Villa Giulia, Rome, Italy.** Sarcophagi in the form of a husband and wife on a dining couch have no parallel in ancient Greece. The artist's focus on the upper half of the figures and the emphatic gestures are Etruscan hallmarks.

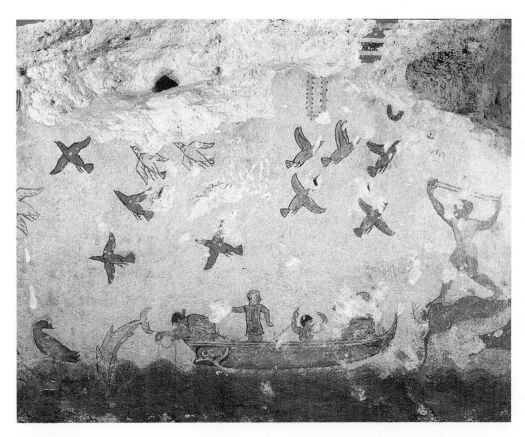

▲ **4.5 Etruscan scene of fishing and fowling, ca. 520 BCE. Detail, fresco, 66" (167.6 cm) high. Tomb of Hunting and Fishing, Tarquinia, Italy.** Men, fish, and birds are all rendered naturalistically, with acute observation.

sheer joyousness of Etruscan art in the heyday of their rule and influence can be contrasted with an Etruscan bronze sculpture, the Capitoline Wolf (**Fig. 4.6**), probably created after the last of the Etruscan kings who ruled Rome was driven from the city in 509 BCE. It became a symbol of the new republic. Even now—as it assuredly did then—the animal's taut muscles, lowered head, piercing eyes, and tooth-bearing grin convey power and fearlessness.

The Capitoline Wolf traditionally has been interpreted as an image of the defiant and protective she-wolf said to have nurtured the abandoned twins Romulus and Remus (the two little suckling babies, however, were created during the Renaissance). One of Rome's foundation myths (the other is the story of Aeneas) holds that Romulus, who killed his brother, went on to found Rome and become its first king in 753 BCE. In actual fact, for a good part of the period

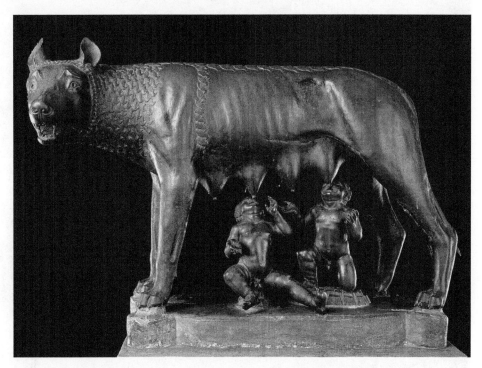

▲ **4.6 Capitoline Wolf, ca. 500–480 BCE. Rome, Italy. Bronze, 31 ½" (80 cm) high. Musei Capitolini, Rome, Italy.** An Etruscan sculptor cast this bronze statue of the she-wolf that nursed the infants Romulus and Remus, founders of Rome. The animal has a tense, gaunt body and an unforgettable psychic intensity.

between this date and 509 BCE, Rome was little more than a small country town on the Capitoline Hill living under Etruscan rule. The Romans' own grandiose picture of their early days was intended to glamorize its origins, but it was only with the arrival of the Etruscans that it developed into an urban center. Etruscan engineers drained a large marshy area, previously uninhabitable, that became the community's center—the future Roman **Forum**. They built infrastructure—sewers, roads, and bridges—as well as temples, including an enormous one called the Temple of Jupiter Optimus Maximus on the Capitoline Hill.

The Etruscans exerted a strong influence on the development of civilization in Rome and the rest of Italy. Under their rule, the Romans found themselves, for the first time, in contact with the larger world. No longer simple villagers in a small community governed by tribal chiefs, they became part of a large cultural unit with links throughout Italy and abroad. By 509 BCE, they had assimilated Etruscan culture; absorbed Etruscan technology; grown powerful enough to overthrow Tarquinius Superbus, the last of the Etruscan kings;

and established their own constitutional government—their republic. What followed was the conquering of one Etruscan city after the next and, with those military victories, the appropriation of more and more territory on the Italian peninsula. By 89 BCE, all of Italy was under the control of the Romans. Etruscans were granted Roman citizenship and were assimilated into the Roman state.

By the reign of the emperor Constantine in the fourth century CE, the roots of the city of Rome would be unrecognizable. A model of the city (**Fig. 4.7**) shows a dense urban landscape that gives the appearance of mostly haphazard growth. The cluster of huts that once occupied the Palatine Hill (no. 1) and overlooked swampland have been replaced with imposing buildings that seem to preside over the social and religious life of the city and the political affairs of an empire. From this aerial perspective, we can pick out temples here and there that seem at least to have been inspired by Greek architecture (no. 2, for example). We can see what appear to be two sports facilities not unlike ones in or near our cities today—the *Colosseum* (no. 3 and Fig. 4.28, site of the infamous gladiator games) and

▼ **4.7 Model of Rome during the early fourth century CE. Museo della Civiltà Romana, Rome, Italy.**
(1) Palatine Hill, (2) Temple of Venus and Roma, (3) Colosseum, (4) Circus Maximus, (5) Forum of Trajan, (6) Forum of Julius Caesar, (7) Forum of Augustus, (8) Forum Romanum, (9) Markets of Trajan, (10) Arch of Titus, (11) Arch of Constantine.

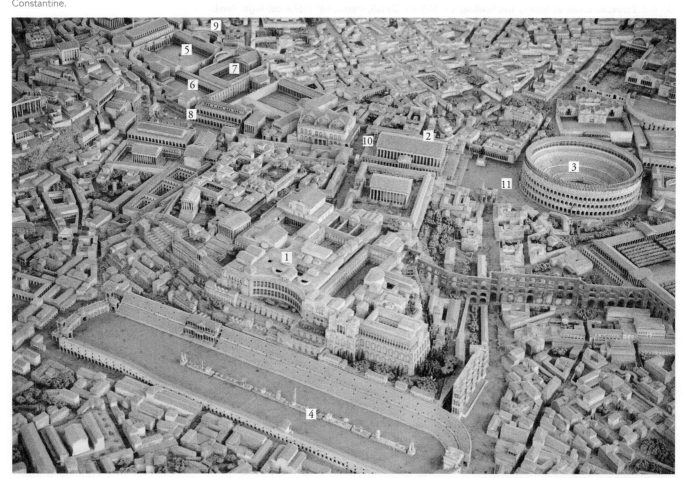

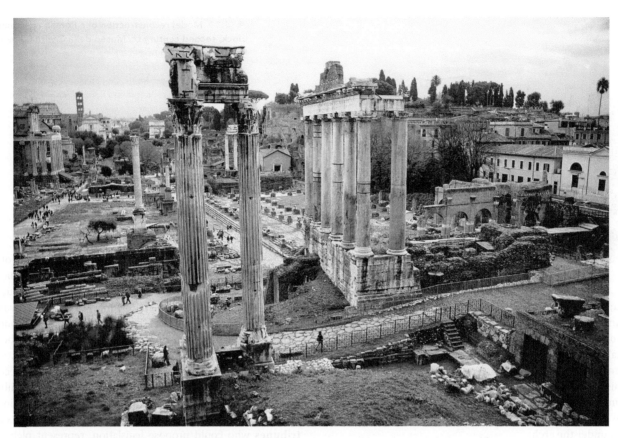

▲ **4.8 Ruins of the Roman Forum, Italy.** As the center of the evolving political, economic, and religious life of the Roman world, the Forum's buildings were constructed over a period of more than 1000 years.

the Circus Maximus (no. 4, a chariot-racing stadium that looks a bit like a present-day racetrack); large rectangular spaces for public gathering (fora; singular, *forum*) that were the centers of Roman life, politics, and commerce (nos. 5, 6, 7, and 8; **Fig. 4.8** and Fig. 4.35); and the *Markets of Trajan* (no. 9; and **Fig. 4.9**),

the equivalent of a mall that had offices and shops on several floors. We can imagine this marketplace teeming with people who dwelled in the crowded city, some in multistory apartment buildings that, like today, made the most of dwindling patches of available land (**Fig. 4.10**).

Imagine also the celebrated homecomings of victorious generals who led courageous campaigns to vanquish Rome's enemies, secure the peace, and expand the empire. A main road, the Via Sacra, ran from the Capitoline Hill down into the forum area and was, among other things, the traditional parade route of the Roman Triumph, an annual ceremony that honored military successes—particularly ones in foreign lands. Monuments such as the *Arch of Titus* (no. 10; and **Fig. 4.11**) were constructed along the Via Sacra. This **triumphal arch** glorified Titus's conquest of

◄ **4.9 Apollodorus of Damascus, interior of the great hall, Markets of Trajan, ca. 100–112 CE. Rome, Italy.** The great hall of Trajan's Markets resembles a modern shopping mall. It housed two floors of shops, with the upper ones set back and lit by skylights. Concrete groin vaults cover the central space.

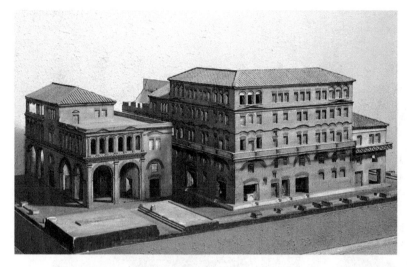

◀ **4.10 Model reconstruction of a Roman apartment block, second century CE. Museo della Civiltà Romana, Rome, Italy.** Shown here is a reconstruction of an *insula*—a multistory, brick-faced, concrete apartment house in Ostia, the seaport of ancient Rome. As can be seen from the size of the windows, the ground floor, which was intended for shops, was more spacious, with higher ceilings. The apartments on the floors above were cramped; few had private toilet facilities.

REPUBLICAN ROME (509 BCE–27 BCE)

Rome initially constituted itself as a republic, governed by the people somewhat along the lines of the Greek city-states. Two chief magistrates, or *consuls*, were elected for a one-year term by all male citizens, but the principal assembly, the Senate, drew most of its members from Roman aristocratic families. Therefore, power was concentrated in the hands of the upper class, the **patricians**, although a lower class of free Roman citizens, called **plebeians**, were permitted to form their own assembly. Plebeians could become influential and wealthy but for many years were prohibited from intermarrying with patricians. They also served in the military, and once elected to the Plebeian Council, they became **tribunes** who could propose legislation, represent plebeians' interests, and protect themselves and other plebeians from state officials who treated them unjustly. The meeting place for both the Senate and the assembly of the people was the forum.

Judaea; relief sculptures on the inside of the archway depict his armies carrying spoils from Jerusalem to Rome—including a *menorah*, a sacred Jewish candelabra. The design of the triumphal arch inspired many imitators, including the French emperor Napoléon Bonaparte, who in the early 19th century commissioned a triumphal arch in Paris to honor those who died in the French Revolution and the Napoleonic Wars. Before Napoléon's remains were placed in a tomb, they were carried under the arch.

The model of the city transports us to Rome in the fourth century CE, but the story of Rome as its own republic begins about eight centuries earlier.

From the founding of the Roman Republic to its bloody end in the civil wars following the assassination of Julius Caesar (44 BCE), Rome's history was dominated by agitation for political equality. Yet the first major confrontation—the conflict between patricians and plebeians—never seriously endangered political stability in Rome or military campaigns abroad. Both sides showed flexibility and a spirit of compromise that produced gradual growth in plebeian power while avoiding dissension great enough to interrupt Rome's expansion throughout the Italian peninsula. The final plebeian victory came in 287 BCE, with passage of a law that made the decisions of the plebeian assembly binding on the entire Senate and Roman people.

Increasing power brought new problems. In the third and second centuries BCE, Rome began to build its empire abroad. Rome came into conflict with the city of Carthage, which was founded by the Phoenicians around 800 BCE and by the third century had become the independent ruler of territories in North Africa, Spain, and Sicily. The Romans defeated the

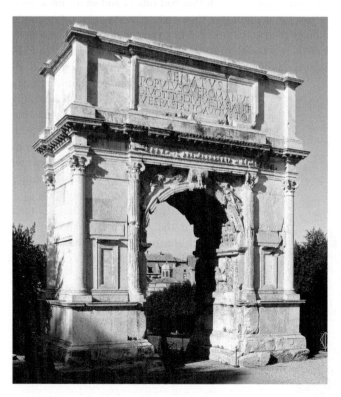

◀ **4.11 Arch of Titus, 81 CE. Rome, Italy.** Roman arches commemorated victories by successful generals. This arch celebrates the victory of Titus, son of the reigning emperor Vespasian, over the Jews in 70 CE—a victory that saw the destruction of Solomon's Temple when Titus's army captured the city of Jerusalem. While early Imperial arches resembled this one, those built later generally had a large central arch flanked by two smaller ones.

Carthaginians in the Punic Wars (after the Roman name for the Phoenicians, *Poeni*) and confiscated their territories. By the first century BCE, the entire Hellenistic world was in Roman hands. From Spain to the Near East stretched a vast territory consisting of subject provinces, protectorates, and nominally free kingdoms, all of which depended on Roman goodwill and administrative efficiency.

It turned out that the Romans were better at expanding their empire than governing it. Provincial administration could be incompetent and corrupt. The long series of wars had hardened the Roman character, leading to insensitivity and, frequently, brutality in the treatment of conquered peoples. Chaos abroad was to some degree mirrored in growing political instability at home. The balance of power struck between the patricians and plebeians was increasingly disrupted by the rise of a middle class, the *equites*, many of whom were plebeians who had made their fortunes in the wars. Against this backdrop, bitter struggles eventually led to the collapse of the republic.

The political system that had been devised for a thriving but small city 500 years earlier was inadequate for a vast empire. Discontent among Rome's Italian allies led to open revolt. Although the Romans were victorious in the Social War of 90–88 BCE, the cost in lives and economic stability was significant. The ineffectuality of the Senate and the frustration of the Roman people led to struggles among statesmen for power. These struggles culminated in a series of civil wars leading to the emergence of Julius Caesar as dictator in 45 BCE, only to be assassinated a year later on the Ides of March (March 15), 44 BCE. Another series of civil wars that followed Caesar's death led to the end of the republic and the beginning of the empire.

Republican Literature

The Republican era is characterized by a diversity of literary genres, from historical commentaries and narratives to treatises on Roman values; from comedic farces to poems of love.

JULIUS CAESAR Julius Caesar (100–44 BCE)—brilliant politician, skilled general, expert administrator and organizer—wrote the history of his military campaigns in his *Commentaries*. His style is straightforward but gripping, and some of his one-liners have become iconic: "Veni, vidi, vici" ("I came, I saw, I conquered") is Caesar's succinct summation of a victory following a battle that lasted only four hours. That battle was only one in a protracted series of civil wars. A few years before Caesar became dictator of Rome, he warred with his political-partner-turned-rival, Pompey (Gnaeus Pompeius). In early passages describing the campaign, Caesar writes that the success of his forces is thwarted by his opponent's treachery and by natural obstacles such as floods. But passages 61–72 describe a fast-paced turnaround in 49 BCE, with Pompey's army retreating. Note how Caesar refers to himself in the third person, as "Caesar" and "he," not as "I":

READING 4.1 JULIUS CAESAR

Commentaries on the Civil Wars (De bello civili), Book 1, passage 64 (45 BCE)

At break of day, it was perceived from the rising grounds which joined Caesar's camp, that their rear was vigorously pressed by our horse; that the last line sometimes halted and was broken; at other times, that they joined battle and that our men were beaten back by a general charge of their cohorts, and, in their turn, pursued them when they wheeled about: but through the whole camp the soldiers gathered in parties, and declared their chagrin that the enemy had been suffered to escape from their hands and that the war had been unnecessarily protracted. They applied to their tribunes and centurions, and entreated them to inform Caesar that he need not spare their labor or consider their danger; that they were ready and able, and would venture to ford the river where the horse had crossed. Caesar, encouraged by their zeal and importunity, though he felt reluctant to expose his army to a river so exceedingly large, yet judged it prudent to attempt it and make a trial. Accordingly, he ordered all the weaker soldiers, whose spirit or strength seemed unequal to the fatigue, to be selected from each century, and left them, with one legion besides, to guard the camp: the rest of the legions he drew out without any baggage, and, having disposed of a great number of horses in the river, above and below the ford, he led his army over. A few of his soldiers being carried away by the force of the current were stopped by the horse and taken up, and not a man perished. His army being safe on the opposite bank, he drew out his forces and resolved to lead them forward in three battalions: and so great was the ardor of the soldiers that, notwithstanding the addition of a circuit of six miles and a considerable delay in fording the river, before the ninth hour of the day they came up with those who had set out at the third watch.

CICERO Marcus Tullius Cicero (106–43 BCE) is one of the late republic's most controversial figures. A political powerhouse who first made his reputation as a lawyer, he is certainly one of the high-profile individuals from this period about whom we know the most. In 63 BCE, when he was serving as consul, he famously put down a populist plot against the government led by the Roman Senator, Lucius Sergius Catilina, also known as Catiline (something that Cicero never tired of reminding everyone). The severity with which he went about it—capturing and executing several of the alleged accomplices without a court trial—earned him a short period in exile. Cicero did return to Rome, however, and once again became involved in power and politics. He took the side of Pompey in the struggle for power between him and Caesar—ultimately the wrong bet, although Caesar seemed to have forgiven him. In spite of

Cicero's admiration for Caesar's abilities, he seems never really to have trusted him.

Cicero is best known to history as one of its greatest orators, although he preferred to be remembered for his accomplishments in the political realm. He even went so far as to ask a historian to write a trumped-up biography, although the writer passed on the request. Cicero himself was a writer; *On Duties* comprises several books of letters that reflect on individual character and the responsibility of citizens to each other and the state:

READING 4.2 CICERO

On Duties, Book 3, passages 5 and 6

Hercules denied himself and underwent toil and tribulation for the world, and, out of gratitude for his services, popular belief has given him a place in the council of the gods. The better and more noble, therefore, the character with which a man is endowed, the more does he prefer the life of service to the life of pleasure. Whence it follows that man, if he is obedient to Nature, cannot do harm to his fellow-man. Finally, if a man wrongs his neighbor to gain some advantage for himself he must either imagine that he is not acting in defiance of Nature or he must believe that death, poverty, pain, or even the loss of children, kinsmen, or friends, is more to be shunned than an act of injustice against another. If he thinks he is not violating the laws of Nature, when he wrongs his fellow-men, how is one to argue with the individual who takes away from man all that makes him man? But if he believes that, while such a course should be avoided, the other alternatives are much worse—namely, death, poverty, pain—he is mistaken in thinking that any ills affecting either his person or his property are more serious than those affecting his soul. This, then, ought to be the chief end of all men, to make the interest of each individual and of the whole body politic identical. For, if the individual appropriates to selfish ends what should be devoted to the common good, all human fellowship will be destroyed.

From letters such as these, we can derive a vivid picture of Cicero and of Rome, its ideas, and ideals. Almost 900 letters were published, mostly after his death. While they reveal Cicero's human frailties—his vanity, indecisiveness, and stubbornness—they also project humanity, sensitivity, and a sense of justice.

Conquest brought the Romans into contact with myriad cultures, the most influential of which was Greece. Roman dramatic literature followed that of the Greeks in form and content as far back as the third century BCE. Ennius (239–169 BCE), who was later described as the father of Roman poetry, appears to have adapted Greek models for his tragedies, although almost all of his works are lost. His *Annals*, an epic chronicle of the history of Rome, represents the first time a Greek metrical scheme was used in Latin verse.

CONNECTIONS The Norwegian playwright and poet, Henrik Ibsen, is perhaps best known for his play, *A Doll's House*. But his first attempt at dramatic literature, written during the winter of 1848–1849, was *Cataline*—a work based on Cicero's speeches against his accused conspirator. Written shortly after widespread revolutions rocked Europe, Ibsen's Cataline character is pictured as a revolutionary taking on the corruption and fraud in the patrician world around him.

When educated Romans of the late republic stopped to think about something other than history and politics, it was likely to be laughs and love. The first Roman works to have survived in quantity were written by two comic playwrights—Plautus (ca. 254–184 BCE) and Terence (ca. 195/185–159 BCE). Their plays are adaptations of Greek comedies; whereas the Greek originals are comic satires, the Roman versions turn human foibles into almost slapstick comedy. Plautus, the more boisterous of the two, is known for humorous songs and farcical intrigues. Terence's style is more balanced and refined, and his characters are more realistic. It says something about the taste of the Roman public, however, that Plautus was by far the more successful of the two. Both authors were fond of elaborate, convoluted plots built around nonsense, like mass confusion caused by mistaken identities that eventually sorted themselves out.

CATULLUS Roman lyric poetry featured romantic themes such as the love affair charted by Rome's first great lyric poet, Catullus (ca. 84–54 BCE). Inspired by Sappho of Lésbos, Catullus's poem "Lesbia" is one of 25 short poems describing the course of his ill-fated relationship, ranging from the ecstasy of its early stages to the disillusionment and despair of the final breakup. The clarity of his style is the perfect counterpart to the direct expression of his emotions. These poems, personal though they are, are not simply an outpouring of feelings. Catullus makes his own experiences universal. However trivial one man's unhappy love affair may seem in the context of the grim world of the late republic, Lesbia's inconstancy has achieved a timelessness unequaled by many more serious events:

READING 4.3 CATULLUS

Lyrics to his lover Lesbia

Lyric 5

My sweetest Lesbia, let us live and love;
And though the sager sort our deeds reprove,
Let us not weigh them. Heaven's great lamps do dive
Into their west, and straight again revive,
But soon as once is set our little light,
Then must we sleep one ever-during night.

Give me a thousand kisses, then a hundred.
Then, another thousand, and a second hundred.
Then, yet another thousand, and a hundred.
Then, when we have counted up many thousands,
Let us shake the abacus, so that no one may know the
 number,
And become jealous when they see
How many kisses we have shared.

But then Lesbia rejects Catullus, and he undergoes fits of frustration and indignation, which he variously describes as the tragedy of his soul or the history of his heart. There are some 20 Lesbia poems, and through them the reader can follow Catullus's initial homage and rapture through to his doubts—can love be lost? —and ultimate repulsion. In Lyric 8, the poet calls on himself to admit that the affair is over. Catullus would later write an epigram which illuminates the struggle within between his old feelings of love and his newly developing emotion of hate:

Can Love breed hate, Hate love? Ah, who shall say?
And yet I feel it…and have torment aye.

Roman Philosophy

Stoicism, which originated in ancient Greece, was the most important school of philosophy in Rome. It was founded by the Greek philosopher Zeno (ca. 335–263 BCE) who met with his followers in **stoas** (hence the name *Stoicism*). Noted Roman Stoics include Cicero, Seneca (ca. 4 BCE–65 CE), Epictetus (ca. 55–135 CE), and Marcus Aurelius (121–180 CE). Stoicism was appealing to Romans because it advocated acceptance of all situations, including hardships, thus reinforcing the Roman virtues of manliness and courage.

The Stoics taught that the universe was ordered by the gods, which gave it its *Logos*—that is, its moving spirit or meaning. Stoics believed that they could not change the course of tragic events, but they could psychologically distance themselves from them by controlling their attitudes toward them. Politically, providence and natural law meant that the Roman Empire was destined to spread throughout the world by means of assimilation or conquest. The loss of individual lives in that conquest was for the greater good and to be accepted as inevitable. Foot soldiers, farmers, philosophers, and emperors all contributed to the empire in their own way. All were part of the whole.

Epicureanism was also popular, although not as agreeable to the Roman palate as Stoicism. It spread from Greece to Rome, where it survived into the latter part of the second century CE. Epicureanism was appealing because of its recognition that natural desires must be satisfied to lead a pleasant life. The Epicureans looked upon death as being a passing event without great meaning, a view that was also voiced by

many philosophers in Rome, including, as we shall see, Lucretius, a follower of atomic theory, and an emperor, Marcus Aurelius.

Another school of thought, **Neo-Platonism**, came into being in places in the empire in the century following Marcus Aurelius. Many of its concepts would pave the way for the further development of Judaism, Christianity, and Islam.

EPICUREANISM According to Epicurus (341–271 BCE), the founder of the school named after him, the correct goal and principle of human actions is pleasure. However, Epicurus is commonly misunderstood. He believed that it is wise to seek pleasure and avoid pain, but reason is also required. We must sometimes endure pain to achieve happiness, and at other times, the pleasures of the moment can lead to prolonged suffering.

Although Epicureanism stresses moderation and prudence in the pursuit of pleasure, many Romans thought of the philosophy as a "typically Greek" enthusiasm for self-indulgence and debauchery. As a result, Epicureanism never really gained many followers, despite the efforts of the Roman poet Lucretius (99–55 BCE), who described its doctrines in his poem *On the Nature of Things* (*De rerum natura*), a remarkable synthesis of poetry and philosophy. Lucretius emphasized the intellectual and rational aspects of Epicureanism. As we see in the following passage, Reading 4.4, the principal teaching of Epicureanism was that the gods, if they exist, play no part in human affairs or in the phenomena of nature:

READING 4.4 LUCRETIUS

On the Nature of Things (50 BCE), from Book V

Thou canst ne'er
Believe the sacred seats of gods are here
In any regions of this mundane world;
Indeed, the nature of the gods, so subtle,
So far removed from these our senses, scarce
Is seen even by intelligence of mind.
And since they've ever eluded touch and thrust
Of human hands, they cannot reach to grasp
Aught tangible to us. For what may not
Itself be touched in turn can never touch.

We can therefore live our lives free from superstitious fear of the unknown and the threat of divine retribution. The Epicurean theory of matter explains the world in physical terms. It describes the universe as made up of small particles of matter, or atoms, and empty space. So far it sounds consistent with modern science. But Lucretius also believed that atoms are solid and can be neither split nor destroyed. We now know that atoms themselves consist mostly of space and that they can be split, as in nuclear fission. Epicureans taught that atoms coalesced to form complex structures (we would call them

molecules) as a result of random swerving in space, without interference from the gods. As a result, human life can be lived in complete freedom; we can face the challenges of existence and even natural disasters like earthquakes or plagues with serenity, because their occurrence is beyond our control. According to Epicurus, at death the atoms that compose our bodies separate such that body, mind, and soul are lost. Because we are not immortal, we should have no fear of death; death offers no threat of punishment in a future world but brings, rather, only the ending of sensation.

STOICISM The Stoics taught that the world was governed by Reason, and that Divine Providence watched over the virtuous, never allowing them to suffer evil. The key to virtue lay in willing or desiring only that which was under one's own control. Thus riches, power, even physical health—all subject to the whims of Fortune—were excluded as objects of desire.

Although Stoicism had already won a following at Rome by the first century BCE and was discussed by Cicero in his philosophical writings, its chief literary exponents came slightly later. The philosophy of the Stoic Lucius Annaeus Seneca (ca. 4 BCE–65 CE), known as Seneca the Younger, is encapsulated in his many proverbs, such as "It is not because things are difficult that we do not dare, it is because we do not dare that they are difficult" or "Calamity is virtue's opportunity." Seneca was born in southern Spain, the son of a wealthy rhetorician, but was educated in Rome, where he would become a dramatist, essayist, philosopher, and powerful statesman. He counseled that in order to achieve peace of mind, human beings should avoid burdens and anxieties, remain of modest means, and essentially take in stride whatever comes along. He sets down his views in his dialogue *On the Tranquility of Mind*:

CONNECTIONS One of the basic principles of Stoicism, founded by the Greek philosopher Zeno and expounded by Seneca, Epictetus, and Marcus Aurelius, is that death is a natural event and nothing to be feared. In Shakespeare's *Julius Caesar*, a seer's warning, "Beware the ides of March" (March 15th—the day Caesar would be slain) goes unheeded. In Act 2, Scene 2, Caesar's dismissive response to a cluster of omens suggests that Shakespeare saw the character of Caesar

▲ **4.12 Denarius with portrait of Julius Caesar, 44 BCE.**

as one who was "stoic" when it came to human fear and the matter of life and death:

> Of all the wonders that I yet have heard,
> It seems to me most strange that men should fear;
> Seeing that death, a necessary end,
> Will come when it will come.

READING 4.5 SENECA

On the Tranquility of Mind

All life is bondage. Man must therefore habituate himself to his condition, complain of it as little as possible, and grasp whatever good lies within his reach. No situation is so harsh that a dispassionate mind cannot find some consolation in it. If a man lays even a very small area out skillfully it will provide ample space for many uses, and even a foothold can be made livable by deft arrangement. Apply good sense to your problems; the hard can be softened, the narrow widened, and the heavy made lighter by the skillful bearer.

Despite this Stoic wisdom, Seneca himself became deeply involved in political intrigues and grew fabulously wealthy. He was implicated in a plot to kill the emperor Nero—his former student—and ordered by Nero to kill himself. A bitter irony, one of Seneca's most well-known proverbs reads: "There has never been any great genius without a spice of madness" (Latin: *Nullum magnum ingenium sine mixtura dementiae fuit*; *On the Tranquility of Mind*, 17.10).

The writings of the Stoic philosopher Epictetus—a Greek slave born in present-day Turkey who obtained his freedom and taught philosophy in Rome—would have a significant impact on the emperor Marcus Aurelius. He embraced the teachings of Epictetus and, as we shall see, incorporated the tenets of Stoicism in his own writings. An excerpt from Epictetus's *Encheiridion* explains his basic Stoic ideas, namely that there are things subject to our power (such as judgment, desire, and impulse) and those things that are not (such as health). Humans differ from other creatures in that we can make judgments as to what to seek and what to avoid. However, good and evil reside in our judgment only, not in external things. The student who grasps these principles can find a serene state of mind—fulfillment and contentment—that reflects the predetermined and fixed order of the universe:

READING 4.6 EPICTETUS

Enchiridion

It is not the things themselves that disturb men, but their judgments about these things. For example, death is nothing dreadful, or else Socrates too would have thought so, but the judgment that death is dreadful, this is the dreadful thing. When, therefore, we are hindered, or disturbed, or grieved, let us never blame anyone but ourselves, that means, our own judgments.

Shakespeare would later have Hamlet say, "for there is nothing either good or bad, but thinking makes it so" (*Hamlet*, 2.2).

Marcus Aurelius, whose full name was Marcus Aurelius Antoninus Augustus, occupies a unique place in history as a Roman soldier and emperor and as a Stoic philosopher. He wrote his powerful *Meditations* while on one of the seemingly endless military campaigns that defined his reign, from 170–180 CE. It is a spiritual guide to self-improvement inscribed by a man who believed that death was final:

READING 4.7 MARCUS AURELIUS

Meditations

Book 2, Part 5

5. Concentrate every minute like a Roman...on doing what's in front of you with precise and genuine seriousness, tenderly, willingly, with justice. And on freeing yourself from all other distractions. Yes, you can—if you do everything as if it were the last thing you were doing in your life,...

Book 3, Part 3

Hippocrates cured many illnesses—and then fell ill and died....Alexander, Pompey, Caesar—who utterly destroyed so many cities, cut down so many thousand foot and horse in battle—they too departed this life....Democritus was killed by ordinary vermin, Socrates by the human kind.

And?

You boarded, you set sail, you've made the passage. Time to disembark. If it's for another life, well, nowhere without gods on that side either. If to nothingness, then you no longer have to put up with pain and pleasure, or go on dancing attendance on this battered crate, your body—so much inferior to that which serves it.

One is mind and spirit; the other earth and garbage.

The *Meditations* has been described as an infinitely tender work written by a professional, hardened soldier who never asked why events were as ugly as they were or whether it was right that there should be such pain in the world. The world was as it was; it had always been that way, and one could only choose one's attitude toward it. "A cucumber is bitter," he wrote. "Throw it away. There are briars in the road. Turn aside from them. This is enough. Do not add, 'And why were such things made in the world?'"

NEO-PLATONISM In the century following the life of Marcus Aurelius, there gathered in Rome a school of religious and mystical philosophers—including the Egyptian Plotinus (ca. 205–270 CE)—who called themselves Platonists. Although they saw themselves as following in the footsteps of Plato, they diverged sufficiently enough from their source that they are now more appropriately called Neo-Platonists. The teachings of Plotinus, the father of Neo-Platonism, are found in his six *Enneads*, assembled by a pupil who also penned the philosopher's biography.

Neo-Platonists adopted the concept of the One as defined in Plato's *Timaeus*. Plotinus taught that the One was a transcendent and unknowable being who had created life and, unlike Greek and Roman gods who were capable of whimsical and amoral behavior, was good. Neo-Platonists taught that humans had a soul (Plotinus spoke of being ashamed that his immortal soul had been born into a mortal body) that returned to the One—the source—upon death. But the Neo-Platonists had no universally agreed-upon description of the One. When it came to what happens to the soul after the death of the body, some imagined something akin to a heaven, others spoke of reincarnation, and still others spoke of spending eternity with the ancient Greek heroes in Hades (the ideal of Socrates) or of suffering eternal punishment in a hell. Later, Neo-Platonic philosophers set the stage for divine or semidivine creatures such as angels and demons that mediate between the One and human beings. Neo-Platonic philosophy had a profound influence on Christian thinkers such as Augustine, Islamic scholars such as al-Farabi, and Jewish philosophers such as Maimonides.

Roman Law

Among the most lasting achievements of Julius Caesar's dictatorship and of Roman culture in general was the creation of a single unified code of civil law: the **jus civile**. The science of law is one of the few original creations of Roman literature. The earliest legal code of the republic was the so-called Law of the Twelve Tables of 451–450 BCE. By the time of Caesar, however, most of this law had become either irrelevant or outdated and had been replaced by a mass of later legislation, much of it contradictory and confusing. Caesar's jus civile, produced with the help of eminent legal experts of the day, served as the model for later times, receiving its final form in 533 CE when it was collected, edited, and published by the Byzantine emperor Justinian (482–565 CE).

Justinian's Corpus Juris Civilis remained in use in many parts of Europe for centuries and profoundly influenced the

development of modern legal systems. Today, many millions of people live in countries whose legal systems derive from that of ancient Rome; one eminent British judge has observed of Roman law that "there is not a problem of jurisprudence which it does not touch: there is scarcely a corner of political science on which its light has not fallen."[1] According to the great Roman lawyer Ulpian (died 228 CE), "Law is the art of the good and the fair."

The Romans developed this art over the centuries during which they built an empire of widely diverse peoples. Roman law was international, adapting Roman notions of law and order to local conditions, and changing and developing in the process. Many of the jurists responsible for establishing legal principles had practical administrative experience from serving in the provinces. Legal experts were in great demand in Rome; the state encouraged public service, and problems of home and provincial government frequently occupied the best minds of the day. Many of these jurists acquired widespread reputations for wisdom and integrity. Emperor Augustus gave to some of them the right to issue "authoritative opinions," while a century or so later, Emperor Hadrian formed a judicial council to guide him in matters of law. Their general aim was to equate human law with that of Nature by developing an objective system of natural justice. By using this system, the emperor could fulfill his duty to serve his subjects as benefactor and bring all peoples together under a single government.

Thus, over the centuries, the Romans built up a body of legal opinion that was comprehensive, concerned with absolute and eternal values, and valid for all times and places; at its heart lay the principle of "equity"—equality for all. By the time Justinian produced his codification, he was able to draw on a millennium of practical wisdom.

1. Viscount James Bryce, *Studies in History and Jurisprudence, Vol. II*. New York: Oxford University Press, 1901, p. 896.

Roman Religion

Rome was home to a religion resplendent with a multitude of gods bequeathed by numerous cultures, among them the Etruscans and the Greeks. According to Roman mythology, a king of Rome purchased books of prophecies from the Cumaean sibyl, who was consulted by Aeneas before he descended to the underworld (*The Aeneid*, Book 6, lines 9–10).

The Sibylline Books were written in Greek hexameter and kept in the temple of Jupiter Capitolinus (that is, on the Capitol Hill in Rome). The books were consulted at times of great peril, such as plague or invasion. Directed by the prophecies in the volumes, Romans made sacrifices to ward off disaster. Such was the nature of superstition among the Romans, most of whom believed that events were preordained and that it was necessary for humans to placate gods who could be as changeable in mood as the weather.

The Romans devoured the Greek gods along with Greek literature, sculpture, and architecture. It was a cultural and religious feeding frenzy. In religion, the Romans may have imported the Greek gods from Mount Olympus, but they constructed temples for them everywhere. The Greeks could never have imagined the building boom they inspired throughout the empire and how their gods would be integrated with dozens of lesser ones, along with emperors who were deified after death. The Romans also worshipped household deities (we saw that Anchises carried statues of his household gods from Troy to Rome) and ones that would guide and protect them when they went outdoors and into the streets. A festival called the *Compitalia* was celebrated annually in honor of the gods of the crossroads—that is, intersections—because in Roman times, such meetings were symbolic of many possibilities, of positive prospects and dangers alike.

The Romans had so many gods and goddesses that in some instances they might even forget why they were worshipping them at all. By the time of Julius Caesar, for example, no one could remember who the goddess Furrina was or why she was celebrated or petitioned for advice or favors. This lapse of communal memory, however, did not prevent the Romans from holding a festival in her honor. The Roman calendar was filled with festivals. Life had its problems, but Romans knew how to have a good time.

RELIGION

Etruscan, Greek, and Roman Counterparts of Gods and Heroes

ETRUSCAN	GREEK	ROMAN
Tinia	Zeus	Jupiter
Uni	Hera	Juno
Menrva	Athena	Minerva
Apulu	Apollo	Apollo
Artumes	Artemis	Diana
Laran	Ares	Mars
Sethlans	Hephaestus	Vulcan
Aita	Hades	Pluto
Turms	Hermes	Mercury
Nethuns	Poseidon	Neptune
Turan	Aphrodite	Venus
Hercle	Herakles	Hercules

For centuries, the Romans were tolerant of the local religions of the peoples whom they conquered or otherwise brought into the empire. In the case of Christianity, a period of persecution was followed by the emperor Constantine's conversion and Christianity's becoming the official religion of Rome. The Romans were generally tolerant for practical reasons. Running a far-flung empire was a spotty business; as long as the locals paid tribute, provided soldiers for the Roman army, and stirred up no trouble, Rome was usually—but not always—content. For example, at the trial of Jesus, the Roman governor of Judaea, Pontius Pilate, may have been as concerned with smothering political instability as with religious differences.

Roman notions of an afterlife varied, from the Greek-style view of an underworld ruled by Pluto to a pre-Christian view of body–soul dualism.

Republican Art and Architecture

During the Republican period, the visual arts and architecture bore the marks of both the Greek and Etruscan styles. As the Romans pushed beyond Italy in their conquests, their exposure to Greek art in particular broadened their cultural horizons. Greece became a province of Rome in 146 BCE, and all things Greek became fashionable and highly sought after. That said, older Etruscan works also continued to influence Roman artists.

In many respects, portraiture represents Roman art at its most creative and sensitive. It certainly opened up new expressive possibilities, as artists discovered how to use physical appearance to convey something more about the sitter. Many of the best Roman portraits serve as revealing psychological documents; painstaking realistic details convincingly capture outer appearances at the same time that they suggest inner character. In the bust of Cicero (**Fig. 4.13**), we see a balding older man whose furrowed brow and wrinkles around deep-set eyes suggest a certain intensity of personality. The subtly parted lips remind us that Cicero was renowned for his skills as an orator. Romans in the Republican period were fond of this extremely naturalistic style and understood its power to project a carefully crafted self-image. Julius Caesar certainly realized this when he issued silver coins bearing his profile along with the words *dictator perpetua* (dictator for life) positioned to either side of his head like a victory wreath (see Fig. 4.12). Shortly after the coins were issued, Caesar was assassinated.

The Republican-period Temple of Portunus (also known as the Temple of Fortuna Virilis; **Fig. 4.14**) can be linked to both Greek and Etruscan precedents, as seen through a comparison of temple plans in **Fig. 4.15**. From the Etruscans the

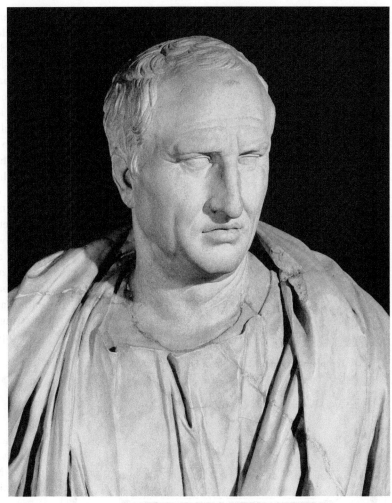

▲ **4.13 Bust of Cicero, first century BCE. Marble, 36½" (93 cm). Museo Capitolino, Rome, Italy.** This portrait of one of the leading figures of the late republic suggests the ability of Roman sculptors of the period to capture both likeness and character. Cicero is portrayed as thoughtful and preoccupied.

Romans took the elevated podium, columned porch, and single flight of stairs in front leading to the cella. From the Greeks they took the Ionic order for the frieze and the columns, as well as the suggestion of a peripheral temple, even though freestanding columns are used only on the porch. Instead, engaged (half) columns are attached to the exterior walls of the cella. We can see these influences on the design of the Temple of Portunus, but the novel synthesis of these elements gives the building its telltale Roman character.

Roman Music

Roman music was intended mainly for performance at religious events such as weddings and funerals, and as a background for social occasions. Musicians were often brought into aristocratic homes to provide after-dinner entertainment at a

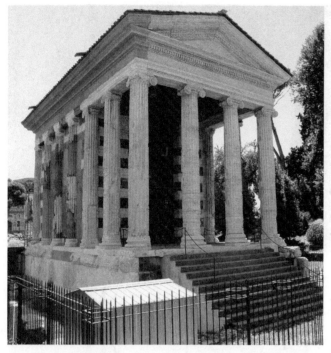

▲ **4.14 Temple of Portunus (Temple of Fortuna Virilis), ca. 75 BCE. Rome, Italy.** Republican temples combined Etruscan plans and Greek elevations. This temple, made of stone, adopts the Ionic order, but it has a staircase and freestanding columns only at the front.

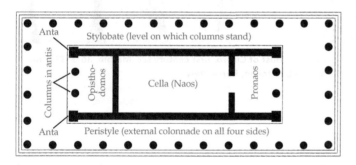

a. Greek Temple Plan

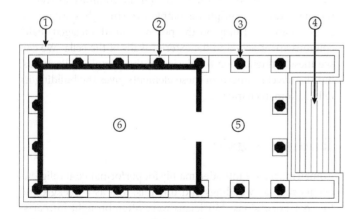

c. Roman Temple Plan

party, and individual performers, frequently women, would play before small groups in a domestic setting. Small bands of traveling musicians (**Fig. 4.16**), playing on pipes and such percussion instruments as cymbals and tambourines, provided background music for the acrobats and jugglers who performed in public squares and during gladiatorial contests. For the Romans, music did not have the intellectual and philosophical significance it bore for the Greeks, and Roman writers who mentioned musical performances often complained about the noise. The Romans lengthened the Greek trumpet, producing a longer and louder bronze instrument called a tuba. It was used at public occasions like games and processions; an especially powerful version of the instrument—some four feet long—was used to signal attacks and retreats. The sound was anything but pleasant. Roman music lovers— mainly aristocrats—seemed content with the Greek music played on Greek instruments that grew in popularity with the spread of Greek culture. The emperor Nero was one such enthusiast, although his public performances on the kithara (a string instrument resembling a lute) were decried by his contemporaries, including Tacitus and Juvenal.

IMPERIAL ROME (27 BCE–337 CE)

With the assassination of Julius Caesar in 44 BCE, a brief respite from civil war was followed by further turmoil. Caesar's lieutenant, Mark Antony, led the campaign to avenge his death and punish the conspirators. He was joined in this endeavor by

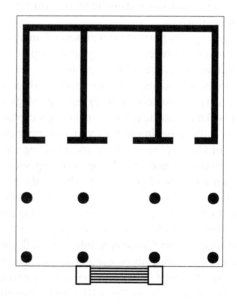

b. Etruscan Temple Plan

▲ **4.15 Typical Greek, Etruscan, and Roman temple plans.**
(a) Greek temple plan; (b) Etruscan temple plan; (c) Roman temple plan showing (1) podium or base, (2) engaged column, (3) freestanding column, (4) entrance steps, (5) porch, and (6) cella.

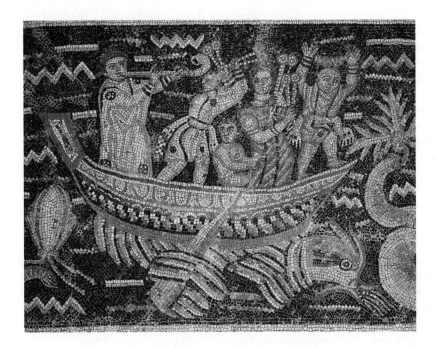

◀ **4.16** Musicians in a boat, early third century CE. Border detail of a stone mosaic of a bestiary in the House of Bacchus, Archaeological Museum of Djemila, Algeria.

Augustus's (Octavian's) cultural achievement was astonishing but could only have been accomplished in a world at peace. In order to achieve this, it was necessary to build a new political order. The Republican system had shown itself to be inadequate for a vast and multiethnic empire. Augustus tactfully, if misleadingly, claimed that he "replaced the state in the hands of the Senate and Roman people." He in fact did the reverse: while maintaining the appearance of a reborn republic, Augustus took all effective power into his own hands and those of his imperial staff.

From the time of Augustus, the emperor and his bureaucracy controlled virtually all decisions. A huge civil service developed, with various career paths. A typical middle-class Roman might begin his career with a period of military service, move on to a post as fiscal agent in one of the provinces, then serve in a governmental department back in Rome, and end up as a senior official in the imperial postal service or the police.

Augustus also began the reform of the army, which the central government had been unable to control during the final chaotic decades of the republic. Its principal function now became guarding the frontiers. It was made up of some 250,000 Roman citizens and about the same number of local recruits. The commanders of these half a million soldiers looked directly to the emperor as their commander-in-chief. The troops did far more than fight: They served as engineers, building roads and bridges. They sowed crops and harvested them. They surveyed the countryside and helped police it. In the process, they won widespread respect and gratitude from Rome's provincial subjects.

Protected by the army and administered by the civil service, the empire expanded economically. With freedom of travel and trade, goods circulated with no tariffs or customs duties; traders only had to pay harbor fees. From the time of Augustus, the Roman road system carried increasing numbers of travelers—traders, officials, students, wandering philosophers, the couriers of banks and shipping agencies—between the great urban centers. Cities such as Alexandria or Antioch were self-governing to some degree, with municipal charters giving them constitutions based on the Roman model.

Not all later emperors were as diligent or successful as Augustus. Caligula, Nero, and some others have become notorious as monsters of depravity. Yet the imperial system that Augustus founded was to last for almost 500 years.

Approximately a century after the empire was born, there occurred one of the greatest natural disasters in human history.

Caesar's young great-nephew Octavius, who had been named by Caesar as his heir and who had recently arrived in Rome from the provinces. It soon became apparent that Antony and Octavius (or Octavian, to use the name he then adopted) were unlikely to coexist happily, even though Antony married Octavian's sister, Octavia. After the final defeat of the conspirators (42 BCE), a temporary peace was obtained by putting Octavian in charge of the western provinces and sending Antony to the east. A final confrontation could not be long delayed, and Antony's fatal involvement with Cleopatra alienated much of his support in Rome. The end came in 31 BCE at the Battle of Actium. The forces of Antony, reinforced by those of Cleopatra, were routed, and the couple committed suicide in 30 BCE. Octavian was left as sole ruler of the Roman world, which lay in ruins. His victory marked the end of the Roman Republic.

When Octavian took supreme control after the Battle of Actium, Rome had been continuously involved in civil and foreign wars for the better part of a century. The political and cultural institutions of Roman life were beyond repair, the economy was wrecked, and parts of Italy were in turmoil. By the time of Octavian's death (14 CE), Rome had achieved a peace and prosperity unequaled in its history—before or after. The art and literature created during and following his reign represent the peak of Roman culture. To the Romans of Octavian's time, it seemed that a new Golden Age had dawned, and for centuries afterward his memory was revered. As the first Roman emperor, Octavian inaugurated the second great period in Roman history—the empire, which lasted technically from 27 BCE, when he assumed the title Augustus, until 476 CE, when the last Roman emperor was overthrown. However, we can also place the end date at 337 CE, when Constantine founded the eastern empire in Byzantium. In many ways, however, the period began with the Battle of Actium and continued in the subsequent western and Byzantine empires.

POMPEII One day in the year 79 CE, Mount Vesuvius—a volcano above the Bay of Naples—erupted, spewing a column

of ash and pumice more than 20 miles into the air. Then scorching materials rained on Pompeii, Herculaneum, and other towns in the region (Fig. 4.17), blanketing Pompeii with eight feet of pumice. Roofs and floors collapsed, rendering the area uninhabitable. Some 20,000 inhabitants of Pompeii fled during these hours, which proved to be wise, if frightening and painful. During the phase of the eruption to follow, an avalanche of superheated gas and dust poured down the sides of the volcano, killing everything and everyone in its path. The haunting remains of the some 2000 victims unearthed in Pompeian excavations show that most probably died during the second phase of the eruption, as they were found on top

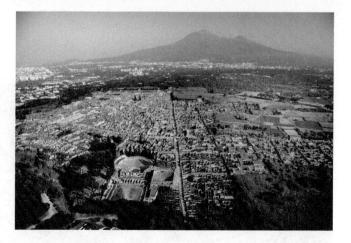

▲ 4.17 Aerial view of Pompeii and Mount Vesuvius looking down to the amphitheater and the theater (lower left foreground).

CONNECTIONS The event has lost none of its fascination and intrigue, though it happened almost 2000 years ago. Sometime in the late summer or fall of 79 CE, a volcano located not far from Naples, Italy—Mount Vesuvius—erupted after being dormant for, some say, 1500 years. The plumes reached into the stratosphere— literally—spewing pumice and poisonous gas over 20 miles into the sky above the volcano's vent. On another day, the wind might have blown the cloud of stones and ash out to sea, but, that day, the wind was blowing southeast—in the direction of Pompeii. Another city, Herculaneum, nestled on the western face of the mountain, suffered little immediate damage, but in the days that followed, the city would be buried under some 75 feet of ash. Most of the inhabitants, luckily, had already evacuated. The picture we have in our minds of a volcano is likely one in which rivers of molten lava cascade down the sides of the mountain, burning and burying everything in their wake. Not so with Vesuvius. The eruption of 79 CE, and others like it, which we now call Plinian eruptions, are marked by columns of ash and gas that reach high into the stratosphere as described in a letter to Tacitus by Pliny the Younger (see Reading 4.8).

Archaeological excavation of the two stricken cities began a couple of hundred years ago, yielding, among the ruins of buildings, hollow human-shaped cavities formed after the remains of the deceased had decayed. These cavities were filled with plaster that, when hardened, produced three-dimensional forms. The seemingly frozen gestures have

given the impression that people were literally stopped in their tracks or had died in torment—begging, crawling, trying to climb out of the morass. Most recent theories, however, suggest that the extreme heat of the volcanic explosion likely killed most of the inhabitants virtually in seconds.

To a large degree, the history of Pompeii and Herculaneum has been framed by the drama of their destruction and the terror of how the inhabitants perished. But an interdisciplinary team, including forensic researchers and anthropologists, is trying to steer us beyond death— away from the romanticized lore of the cities' demise—and toward life—the lives of the cities' inhabitants: who they were, what they ate, who they were related to, how old they were when the eruption took their lives. To try to arrive at some answers, the team is employing equipment such as a computerized tomography (CT) scanner to study the plaster casts in minute detail, using the scans to re-form three-dimensional skeletons. They are performing DNA testing on scraps of remaining human tissue. Early interpretations of the data have been fascinating in their mundaneness. One early finding: the victims tested thus far had all of their teeth, indicating a healthy, low-sugar diet. DNA testing is also being used to determine whether genetic relationships accounted for the proximity of some of the bodies of the deceased, such as the two girls found in Pompeii who seem to be hugging each other. Regardless, anthropologist Estelle Lazar, a team member, noted that while it had been assumed that the victims largely represented those who could not escape the breath of the volcano—the elderly, the very young, the disabled—this was not so. Rather, the deceased represent more of a random sample of the residents of Pompeii. Lazar suggested that disasters such as volcanic disruptions do not discriminate; they destroy everyone in their path.[2]

2. Elisabetta Poveledo, "Scientists hope to learn how Pompeians lived, before the big day." The *New York Times*, October 5, 2015, p. A9.

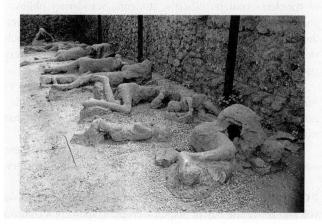

◄ 4.18 **Plaster casts of Vesuvius victims, 79 CE.** Plaster casts such as these, formed from the hollows of the remains of several adults and a child who perished in a garden, are being analyzed at a field laboratory in Pompeii. Specialists are using computerized tomography (CT) scanners to study the victims.

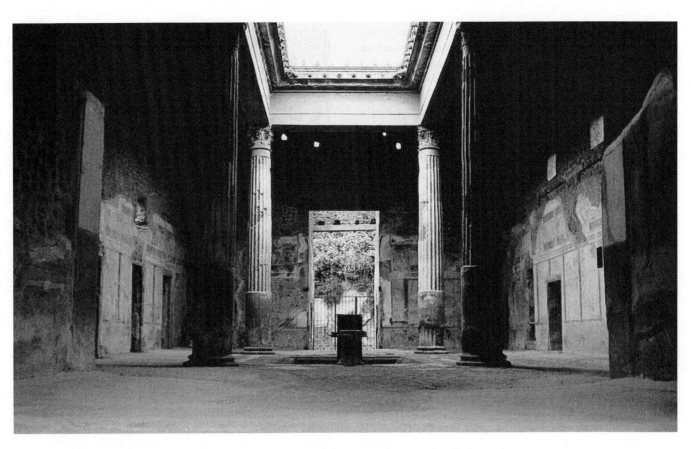

▲ **4.19 Atrium, House of the Silver Wedding, first century CE. Pompeii, Italy.** The open plan of substantial houses such as this helped keep the interior cool in summer. The adjoining rooms were closed off in the winter by folding doors.

of a layer of pumice. Excavation of Pompeii began more than 200 years ago. The finds preserved by the volcanic debris give us a rich and vivid impression of the way of life in a provincial town of the early Roman Empire—from the temples in which the Pompeians worshiped and the baths in which they cleansed themselves to the food they prepared.

Scientists have classified geological events that match those of the first phase of the Vesuvius eruption as *plinian*, after the Roman politician and literary figure Pliny the Younger (ca. 61–112 CE), who bequeathed to history his eyewitness report on the destruction in a letter (see Reading 4.8 on pp. 142–143) written to the historian Tacitus (ca. 56–117 CE). Pliny the Younger was so called to distinguish him from his uncle, Pliny the Elder (23–79 CE). Pliny the Elder, who authored a *Natural History* in 37 volumes, wanted to investigate for himself the nature of the explosion and made his way toward Vesuvius. On his way across the Bay of Naples, a friend in need of rescue sent Pliny a message, whereupon he changed course and headed in the direction of evacuations underway along the shore. The men with him on his ship reported the circumstances of his death—which they attributed to toxic fumes from the eruption—to Pliny the Younger, who had remained behind with his mother at a town named Misenum.

Excavations of cities around Mount Vesuvius, in addition to yielding a large cache of artworks, have revealed how their inhabitants lived, worked, and played. The general picture is impressive. Cool, comfortable houses, remote from the noise of busy streets, were designed around an open space—an atrium— and were decorated with elaborate frescoes, mosaics, fountains, and gardens (**Fig. 4.19**). Household silver and other domestic ornaments found among the ruins of houses were often of high quality. Although the population of Pompeii was only 20,000, there were several public baths, a theater, a concert hall, an amphitheater large enough to seat the entire population, and a significant representation of brothels. The forum was closed to traffic, and the major public buildings arranged around it include a splendid basilica or large hall that housed both the stock exchange and the courts of law. For those with money, life appeared to have been extremely comfortable at Pompeii. Although only a small part of Herculaneum has been excavated, some mansions found there surpass the houses of Pompeii.

In terms of technical virtuosity, some of Pompeii's most impressive works of art are its mosaics—wall or floor decorations created with pieces of glass or tile embedded into surfaces coated with cement. The House of the Tragic Poet (also called the Homeric House, **Fig. 4.20**) was named by archaeologists

for one of its mosaics featuring a group of actors preparing backstage for a performance. They are gathered around an older man who supervises the rehearsal. One actor warms up on a musical instrument while another changes into costume. A box of masks in the style of those worn by Greek actors sits on the floor in the center of the room. This and other decorative works in the house that feature themes from Greek mythology and the Homeric epics suggest that the owner desired to present himself as a educated man with a love of Greek culture.

The actors mosaic was the inspiration for an epic-style poem by the 20th-century Czech poet Vladimír Janovic entitled *House of the Tragic Poet*. Although focused on the actors and director of the satyr play about to be performed, the poem reconstructs life in Pompeii on the eve of the eruption. Janovic is but one among many writers inspired by Pompeii and its ruins. Johann Wolfgang von Goethe (1749–1832) visited the buried city in 1787 and wrote "of all the disasters there have been in this world, few have provided so much delight to posterity." Johann Winckelmann (1717–1768), sometimes called the father of archaeology and art history, discussed the excavations at Pompeii in his *History of Ancient Art*. Artists such as Ingres, David, and Canova were influenced by Pompeian paintings and sculpture; even Wedgwood china designs were based on Pompeian motifs.

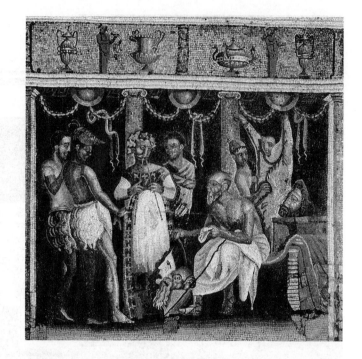

▲ **4.20 Choreographer and actors, House of the Tragic Poet, late first century CE. Pompeii, Italy. Stone mosaic. Museo Archeologico Nazionale, Naples, Italy.**

READING 4.8 PLINY THE YOUNGER

Letter to Tacitus on the eruption of Vesuvius

Though my mind shudders to remember, I shall begin. After my uncle departed I spent the rest of the day on my studies; it was for that purpose I had stayed. Then I took a bath, ate dinner, and went to bed; but my sleep was restless and brief. For a number of days before this there had been a quivering of the ground, not so fearful because it was common in Campania. On that night, however, it became so violent that everything seemed not so much to move as to be overturned.

My mother came rushing into my bedroom; I was just getting up, intending in my turn to arouse her if she were asleep. We sat down in the rather narrow courtyard of the house lying between the sea and the buildings. I don't know whether I should call it iron nerves or folly—I was only seventeen: I called for a book of Titus Livy and as if at ease I read it and even copied some passages, as I had been doing. Then one of my uncle's friends, who had recently come from Spain to visit him, when he saw my mother and me sitting there, and me actually reading a book, rebuked her apathy and my unconcern. But I was as intent on my book as ever.

It was now the first hour of day, but the light was still faint and doubtful. The adjacent buildings now began to collapse, and there was great, indeed inevitable, danger of being involved in the ruins; for though the place was open, it was narrow. Then at last we decided to leave the town. The dismayed crowd came after us; it preferred following someone else's decision rather than its own; in panic that is practically the same as wisdom. So as we went off we were crowded and shoved along by a huge mob of followers. When we got out beyond the buildings we halted. We saw many strange fearful sights there. For the carriages we had ordered brought for us, though on perfectly level ground, kept rolling back and forth; even when the wheels were checked with stones they would not stand still. Moreover the sea appeared to be sucked back and to be repelled by the vibration of the earth; the shoreline was much farther out than usual, and many specimens of marine life were caught on the dry sands. On the other side a black and frightful cloud, rent by twisting and quivering paths of fire, gaped open in huge patterns of flames; it was like sheet lightning, but far worse. Then indeed that friend from Spain whom I have mentioned spoke to us more sharply and insistently: "If your brother and uncle still lives, he wants you to be saved; if he has died, his wish was that you should survive him; so why do you delay to make your escape?" We replied that we would not allow ourselves to think of our own safety while still uncertain of his. Without waiting any longer he rushed off and left the danger behind at top speed.

Soon thereafter the cloud I have described began to descend to the earth and to cover the sea; it had encircled Capri and hidden it from view, and had blotted out the promontory

Imperial Literature

Augustus actively supported and encouraged the writers and artists of his day, and many of their works echo the chief themes of Augustan politics: the return of peace, the importance of the land and agriculture, the putting aside of ostentation and luxury in favor of a simple life, and above all the belief in Rome's destiny as world ruler. Some of the greatest works of Roman sculpture commemorate Augustus and his deeds; Horace and Virgil sing his praises in their poems. It is sometimes said that much of this art was propaganda, organized by the emperor to present the most favorable picture possible of his reign. The greatest works of the time do relate in some way or other to the Augustan worldview, and it is difficult to imagine a poet whose philosophy differed radically from that of the emperor being able to give voice to it. But we have no reason to doubt the sincerity of the gratitude felt toward Augustus or the strength of what seems to have been an almost universal feeling that at last a new era had dawned. In any case, from the time of Augustus, art in Rome became largely official. Most of Roman architecture and sculpture of the period was public, commissioned by the state, and served state purposes.

VIRGIL Virgil (Publius Vergilius Maro; 70–19 BCE), the most renowned of Roman poets, devoted the last 10 years of his life to the composition of an epic poem intended to honor Rome and, by implication, Augustus. *The Aeneid* is one of history's greatest and most influential poems. A succession of poets including Dante, Tasso, and Milton regarded him as their master. Probably no work of literature in the entire tradition of Western culture has been more loved and revered than *The Aeneid*—described by T. S. Eliot as the classic of Western society—yet its significance is complex and by no means universally agreed upon. As the Homerian epics, *The Aeneid* was written in **dactylic hexameter**.

The Aeneid was not Virgil's first poem. The earliest authentic works that have survived are 10 short pastoral poems known as the *Eclogues* (sometimes called the *Bucolics*), which deal with the joys and sorrows of the country and the shepherds and herdsmen who live there. Virgil was the son of a farmer; his deep love of the land emerges also in his next work, the four books of the *Georgics* (29 BCE). Their most obvious purpose is to serve as a practical guide to farming—they offer helpful advice on such subjects as cattle breeding and beekeeping as well as a deep conviction that the strength of Italy lies in its agricultural richness. In a passage in Book 2, Virgil hails the "ancient earth, great mother of crops and men." He does not disguise the hardships of the farmer's life, the poverty, hard work, and frequent disappointments, but still feels that only life in the country brings true peace and contentment.

of Misenum. Then my mother began to plead, urge, and order me to make my escape as best I could, for I could, being young; she, weighed down with years and weakness, would die happy if she had not been the cause of death to me. I replied that I would not find safety except in her company; then I took her hand and made her walk faster. She obeyed with difficulty and scolded herself for slowing me. Now ashes, though thin as yet, began to fall. I looked back; a dense fog was looming up behind us; it poured over the ground like a river as it followed. "Let us turn aside," said I, "lest, if we should fall on the road, we should be trampled in the darkness by the throng of those going our way." We barely had time to consider the thought, when night was upon us, not such a night as when there is no moon or there are clouds, but such as in a closed place with the lights put out. One could hear the wailing of women, the crying of children, the shouting of men; they called each other, some their parents, others their children, still others their mates, and sought to recognize each other by their voices. Some lamented their own fate, others the fate of their loved ones. There were even those who in fear of death prayed for death. Many raised their hands to the gods; more held that there were nowhere gods any more and that this was that eternal and final night of the universe. Nor were those lacking who exaggerated real dangers with feigned and lying terrors. Men appeared who reported that part of Misenum was buried in ruins, and part of it in flames; it was false, but found credulous listeners.

It lightened a little; this seemed to us not daylight but a sign of approaching fire. But the fire stopped some distance away; darkness came on again, again ashes, thick and heavy. We got up repeatedly to shake these off; otherwise we would have been buried and crushed by the weight. I might boast that not a groan, not a cowardly word, escaped from my lips in the midst of such dangers, were it not that I believed I was perishing along with everything else, and everything else along with me; a wretched and yet a real consolation for having to die. At last the fog dissipated into smoke or mist, and then vanished; soon there was real daylight; the sun even shone, though wanly, as when there is an eclipse. Our still trembling eyes found everything changed, buried in deep ashes as if in snow. We returned to Misenum and attended to our physical needs as best we could; then we spent a night in suspense between hope and fear. Fear was the stronger, for the trembling of the earth continued, and many, crazed by their sufferings, were mocking their own woes and others' by awful predictions. But as for us, though we had suffered dangers and anticipated others, we had not even then any thought of going away until we should have word of my uncle.

You will read this account, far from worthy of history, without any intention of incorporating it; and you must blame yourself, since you insisted on having it, if it shall seem not even worthy of a letter.

The spirit of the *Georgics* matched Augustus's plans for an agricultural revival. The emperor probably commissioned Virgil to write an epic poem that would be to Roman literature what *The Iliad* and *The Odyssey* were for Greek literature: a national epic. The task was immense. Virgil had to find a subject that would do appropriate honor to Rome and its past as well as commemorate the achievements of Augustus. *The Aeneid* is not a perfect poem (on his deathbed, Virgil ordered his friends to destroy it), but in some ways it surpasses even the high expectations Augustus must have had for it. Virgil succeeded in providing Rome with its national epic and stands as a worthy successor to Homer. At the same time, he created a profoundly moving study of the nature of human destiny and personal responsibility.

The Aeneid is divided into 12 books. Its hero is a Trojan prince, Aeneas, who flees from the ruins of burning Troy and sails west to Italy to found a new city, the predecessor of Rome. Virgil's choice was significant: Aeneas's Trojan birth establishes connections with the world of Homer; his arrival in Italy involves the origins of Rome; and the theme of a fresh beginning born, as it were, out of the ashes of the past corresponds perfectly to the Augustan mood of revival. We first meet Aeneas and his followers in the middle of their journey from Troy to Italy, caught in a storm that casts them upon the coast of North Africa. They make their way to the city of Carthage, where they are given shelter by the Carthaginian ruler, Queen Dido. At a dinner in his honor, Aeneas describes the fall of Troy (Book 2) and his wanderings from Troy to Carthage (Book 3), in the course of which his father Anchises died. Dido is struck by Aeneas's manliness and his tales of battle (his *virtus*).

In Book 4, perhaps the best known, the action resumes where it had broken off at the end of Book 1. The tragic love that develops between Dido and Aeneas tempts Aeneas to stay in Carthage and thereby abandon his mission to found a new home in Italy. Mercury, the divine messenger of the gods, is sent to remind Aeneas of his responsibilities. He leaves after an agonizing encounter with Dido, and the distraught queen commits suicide; "the blade aflush with red blood drenched her hands" (lines 888–889).[3] During the encounter, Dido confronts Aeneas about his preparations to leave her and Carthage. He had not been forthright with her about them:

READING 4.9 VIRGIL

The Aeneid, Book 4, lines 306–316

"And so, betrayer,
You hoped to hide your wickedness, go sneaking
Out of my land without a word? Our love
Means nothing to you, our exchange of vows,
And even the death of Dido could not hold you.
The season is dead of winter, and you labor
Over the fleet; the northern gales are nothing—

3. Sarah Lawall & Maynard Mack (Eds.). *The Norton Anthology of World Literature*, Second Edition, Volume A. New York: W. W. Norton & Company. Translated by Robert Fitzgerald.

You must be cruel, must you not? Why, even,
If ancient Troy remained, and you were seeking
Not unknown homes and lands, but Troy again,
Would you be venturing Troyward in this weather?"

Despite his love for Dido, "Jove bade him keep/Affection from his eyes, and grief in his heart/With never a sign" (lines 338–340). Aeneas sees himself as bound to fulfill his destiny elsewhere:

READING 4.10 VIRGIL

The Aeneid, Book 4, lines 419–426

And good Aeneas, longing
To ease her grief with comfort, to say something
To turn her pain and hurt away, sighs often,
His heart being moved by this great love, most deeply,
And still—the gods give orders, he obeys them;
He goes back to the fleet. And then the Trojans
Bend, really, to their work, launching the vessels
All down the shore.

Book 5 brings the Trojans to Italy. In Book 6, Aeneas journeys to the underworld to hear from the spirit of his father the destiny of Rome. However, he also comes upon Dido in her "dim form":

READING 4.11 VIRGIL

The Aeneid, Book 6, lines 478–497

"Unhappy Dido, so they told me truly
That your own hand had brought you death. Was I—
Alas!—the cause? I swear by all the stars,
By the world above, by everything held sacred
Here under the earth, unwillingly, O queen,
I left your kingdom. But the gods' commands,
Driving me now through these forsaken places,
This utter night, compelled me on. I could not
Believe my loss would cause so great a sorrow.
Linger a moment, do not leave me; whither,
Whom, are you fleeing? I am permitted only
This last word with you."
　　　　　But the queen, unmoving
As flint or marble, turned away, her eyes
Fixed on the ground: the tears were vain, the words,
Meant to be soothing, foolish; she turned away,
His enemy forever, to the shadows
Where Sychaeus, her former husband, took her
With love for love, and sorrow for her sorrow.
And still Aeneas wept for her, being troubled
By the injustice of her doom; his pity
Followed her going.

This visit to the underworld also marks the turning point of the poem. Before it we see Aeneas, and he sees himself, as a man prone to human weaknesses and subject to personal feelings. But the shade of his father, Anchises, sets Aeneas's eyes upon his own destiny and the far future of Rome, which he will not live to see in the world above:

READING 4.12 VIRGIL

The Aeneid, Book 6, lines 822–828

"Turn the eyes now this way; behold the Romans,
Your very own. These are Iulus' children,[4]
The race to come. One promise you have heard
Over and over: here is its fulfillment,
The son of a god, Augustus Caesar, founder
Of a new age of gold, in lands where Saturn
Ruled long ago;[5] he will extend his empire…"

Anchises's revelations fortify Aeneas's sense of mission, and the weary, suffering Trojan exile becomes transformed into a "man of destiny."

In Books 7 and 8, the Trojans arrive at the Tiber River, and Aeneas visits the future site of Rome while the Italian peoples prepare to resist the Trojan invaders. In Book 8, Aeneas's mother, the goddess Venus, appears before him with gifts, including a shield forged by her husband, Vulcan, that he will use in battle:

READING 4.13 VIRGIL

The Aeneid, Book 8, lines 623–628 and 643–646

And the bright goddess[6] through the clouds of heaven
Came bringing gifts, seeing her son alone
By the cold river in the quiet valley,
And spoke to him:—"Behold, the gifts made ready
By Vulcan's[7] promised skill. Fear not, my son,
To face the wars with Turnus and the Latins!"

On the shield is written the future of Rome. Among other things:

"Here
In Mars' green cave the she-wolf gives her udders
To the twin boys, turning half around to lick them,
And neither is afraid, and both are playing."

The last four books describe the war between the Trojans and the Latins, in the course of which there are losses on both sides. *The Aeneid* ends with the death of Turnus—the king of an Italic people allied with the Latins—and the final victory of Aeneas.

It is tempting to see Aeneas as the archetype of Augustus; certainly Virgil must have intended for us to draw some parallels. Yet the protagonist of *The Aeneid* represents a far more complex view of his character than we might expect. And Virgil goes further yet. If greatness can be acquired only by sacrificing individuals, he may be subtly asking, is it worth the price? Does the future glory of Rome excuse the cruel treatment of Dido? Readers will provide their own answers. Virgil's response might have been that the sacrifices were probably worth it, but barely. Much depends on individual views of the nature and purpose of existence, and for Virgil there is no doubt that life is essentially tragic. The prevailing mood of the poem is one of melancholy regret for the sadness of human lives.

SULPICIA The poet Sulpicia was a contemporary of Augustus and Virgil, although the precise dates of her life are unknown. She was the daughter of Servius Sulpicius (ca. 106–43 BCE), a jurist and one of the assassins of Julius Caesar; and probably the niece of Messala, a patrician who fought against Mark Antony at the Battle of Actium. We have only six poems from Sulpicia, a total of 40 lines, and they were once attributed to a male poet, Tibullus, with whose works they were found. Her poems have nothing to do with politics, philosophy, history, mythology, or the destiny of Rome. Rather, they tell of her passion for a young man she identifies as Cerinthus,[8] which is likely to be a pseudonym. Nor do her poems reflect the styles of her era. They are lively, fresh, and spontaneous, and may well have been circulated among her uncle's glitterati friends. The following poem speaks of a love that was apparently more than "platonic"; the "joys" and "joining" of which Sulpicia writes are apparently physical:

READING 4.14 SULPICIA

"Love has come at last"

Love has come at last, and such a love as I
should be more shamed to hide than to reveal.
Cytherea,[9] yielding to my Muse's prayers,
has brought him here and laid him in my arms.
Venus has kept her promise. Let people talk, who never
themselves have found such joys as now are mine.
I wish that I could send my tablets to my love
unsealed, not caring who might read them first.
The sin is sweet, to mask it for fear of shame is bitter.
I'm proud we've joined, each worthy of the other.

4. Iulus, Aeneas's son, was regarded as the progenitor of the Julian clan of Virgil's time, and thus of the line of Caesars.

5. Augustus was "son of a god" because Julius Caesar, of whom Augustus was the adopted son, was deified at his death. [The god] Saturn, after being deposed by his son Jupiter, was supposed to have reigned in Italy during the mythical Age of Gold.

6. Venus.

7. The Roman god Vulcan is the equivalent of the Greek god Hephaestus.

8. A word for the gum of the juniper, which tastes sweet, similar to honey.

9. A poetic alternate name for the goddess Venus.

VALUES

Roman Ideals as Seen Through the Prism of *The Aeneid*

Following the death of Julius Caesar, Rome was ruled by the triumvirate of Octavian (who would become Augustus Caesar), Marcus Antonius (Mark Antony), and Marcus Aemilius Lepidus. Octavian ruled the western provinces, Antony the eastern, and Lepidus ruled Hispania and Africa. Lepidus was expelled after attempting to usurp power from Octavian. Despite being married to Octavian's sister, Antony lived openly with Cleopatra of Egypt, fathering three children with her. Octavian convinced the Senate to declare war on Egypt, and after their defeat, Antony and Cleopatra committed suicide. From the perspective of Octavian—now Augustus—Antony had subordinated his duty to Rome to the love of a woman.

Is it coincidence that Aeneas, Virgil's protagonist in *The Aeneid*, leaves his Carthaginian lover, Queen Dido, to pursue his duty and his destiny to found Rome across the Mediterranean in the Italian peninsula? We noted that unlike the Greek warrior Achilles, who is besotted with his egoistic vision of immortal fame, Aeneas, the ideal Roman, sacrifices not for personal gain but for the greater good of generations yet to be born. Unlike the Trojan prince Paris, he does not place his country in jeopardy for the love of a woman. Unlike Mark Antony, he does not dally in an idyllic land. Rather, he sets sail against brutal winds into the unknown, leaving despair behind and willing to experience

more. It would have been easier for him to stay in Carthage or settle somewhere else along the way, rather than press onward under harsh circumstances into a hostile foreign land.

While Achilles seeks personal glory, while Paris looks at Helen's beauty and not ahead, while Antony lets Rome slip into more wars, Aeneas devotes himself to duty and family. Aeneas carries not only his father on his back but also the future of civilization. Whereas so many warriors of yesteryear concern themselves with the self, Aeneas practices self-denial. He weeps in the underworld when the shade of Dido turns from him. He hurts. Yet he embodies all the virtues valued by Romans: seriousness (gravitas), duty and devotion to others (pietas), self-possession (dignitas), and courage (virtus).

Augustus Caesar himself likely had some sort of hand in the creation of *The Aeneid*. He and the poet had met. Aeneas's mother was Venus, and Augustus and his uncle, Julius Caesar, had claimed Venus in their ancestry. The poem was written just following social and political upheavals, when the general belief in the greatness of Rome and its destiny were in danger of faltering. *The Aeneid* reasserted the traditional values of Rome—the holy journey to a better place, not for personal gain but for the future of one's people.

HORACE Horace (Quintus Horatius Flaccus; 65–8 BCE) was the son of a freed slave, but like many patricians, he was educated in Athens. He rose to become the poet laureate of Augustus and a friend of Virgil. Many of his poems are satirical, using humor and wit to mock human frailties such as vanity and ambition. He even turned a satirical eye on patriotism and war. However, as a Stoic, he also believed that wishing would not remove the stings from life or change its ending. People could only distance themselves from the outcomes by seizing the pleasures of the day. Hence Horace's ode "Carpe Diem" (Seize the Day):

READING 4.15 HORACE

"Carpe Diem" (Seize the Day)

Ask not, Leuconoë (we cannot know), what end the gods have set for me, for thee, nor make trial of the Babylonian tables! How much better to endure whatever comes, whether Jupiter

allots us added winters or whether this is last, which now wears out the Tuscan Sea upon the barrier of the cliffs! Show wisdom! Busy thyself with household tasks; and since life is brief, cut short far-reaching hopes! Even while we speak, envious Time has sped. Reap the harvest of today [*carpe diem*], putting as little trust as may be in the morrow!

JUVENAL Comics and satirists can have a reputation for being nasty and vulgar, even bitter. The tradition was as alive in ancient Rome as it is today, and Juvenal (Decimus Junius Juvenalis, ca. 55/60–127 CE) was perhaps the most renowned satirist of his time. Life in Rome had many of the problems of big-city living today; noise, traffic jams, dirty streets, and overcrowding were constant sources of complaint—by Juvenal as well as much of the populace. Born in the provinces, Juvenal came to Rome, where he served as a magistrate and irritated his emperor, Domitian—not a difficult task. After a period of exile, probably in Egypt, he returned to Rome and lived in considerable

poverty. Toward the end of his life, however, his circumstances improved. His 16 Satires make it clear that Juvenal liked neither Rome nor Romans. He tells us that he writes out of fierce outrage at the congestion of the city, the corruption and decadence, the depraved aristocracy, and the general greed and meanness. "At such a time who could not write satire?" Despite his own meanness, Juvenal is among the greatest satirical poets in Western literature, and he strongly influenced many of his successors, including Jonathan Swift:

READING 4.16 JUVENAL

From Satire 3, lines 376–399

Translated by John Dryden, 1693, from Dryden's complete satires of Juvenal and Persius. There are many translations of Juvenal; this one is made interesting because it is written by an accomplished 17th-century British poet.

"'Tis frequent here, for want of sleep, to die,
Which fumes of undigested feasts deny,
And, with imperfect heat, in languid stomachs fry.
What house secure from noise the poor can keep,
When even the rich can scarce afford to sleep? [380]
So dear it costs to purchase rest in Rome,
And hence the sources of diseases come.
The drover,[10] who his fellow-drover meets
In narrow passages of winding streets;
The wagoners, that curse their standing teams, [385]
Would wake even drowsy Drusus[11] from his dreams.
And yet the wealthy will not brook delay,
But sweep above our heads, and make their way,
In lofty litters borne, and read and write,
Or sleep at ease, the shutters make it night; [390]
Yet still he reaches first the public place.
The press before him stops the client's pace;
The crowd that follows crush his panting sides,
And trip his heels; he walks not, but he rides.
One elbows him, one jostles in the shole, [395]
A rafter breaks his head, or chairman's[12] pole;
Stockinged with loads of fat town-dirt he goes,
And some rogue-soldier, with his hobnailed shoes,
Indents his legs behind in bloody rows.

OVID The poet Ovid (Publius Ovidius Naso, 43 BCE–17 CE) produced collections of erotic poetry, including *Amores* (*Love Affairs*) and a sex manual called *Ars amatoria* (*The Art of Love*), that serve as evidence of his romantic obsession with women. A couplet from *Amores* reads, "Offered a sexless heaven, I'd

10. A driver of sheep or cattle.
11. The emperor Claudius, who had a reputation for being sleepy.
12. A person who carries a chair.

say *No thank you*, women are such sweet hell." These texts are so explicit that they may have been the reason Augustus exiled Ovid to what is now Romania. It may be no surprise that the more common reading from Ovid assigned to students is his *Metamorphoses* (*Changes of Shape or Form*), a poem that recounts mythological tales from the creation of the world and the gods to the death of Julius Caesar. Caesar was assassinated about half a century before Ovid penned this work.

Metamorphoses remains a key source of information about Greek and Roman mythology, and some of the tales therein found their way into literature and drama throughout the ages. In Book 10, we find the story of Pygmalion, the sculptor of Cyprus, who became enamored of a statue he had created, and Venus taking pity on him brings the statue to life. Pygmalion has served as the inspiration for the musical *My Fair Lady*, among other interpretations. In Ovid's story of the young lovers Pyramus and Thisbe, the families of the ill-fated couple, rivals, forbid them to marry. Pyramus commits suicide and Thisbe, finding his body, kills herself as well. The story has its counterpart in *Romeo and Juliet* (and *West Side Story*).

The following excerpts from "The Tale of Pyramus and Thisbe" describe the passion of the couple's forbidden love and Thisbe's final request:

READING 4.17 OVID

"The Tale of Pyramus and Thisbe," *Metamorphoses*, Book 4

What parents could not hinder, they forbad.
For with fierce flames young Pyramus still burn'd,
And grateful Thisbe flames as fierce return'd.
Aloud in words their thoughts they dare not break,
But silent stand; and silent looks can speak.
The fire of love the more it is supprest,
The more it glows, and rages in the breast.

Before Thisbe joins Pyramus in death, she has a final request for their parents.

"Now, both our cruel parents, hear my pray'r;
My pray'r to offer for us both I dare;
Oh! see our ashes in one urn confin'd,
Whom love at first, and fate at last has join'd.
The bliss, you envy'd, is not our request;
Lovers, when dead, may sure together rest."

The Art of Imperial Rome

At around the same time that Virgil wrote the *Georgics*, his exaltation of agriculture and nature found expression in one of the most stunningly beautiful frescoes of ancient Rome—a gardenscape from a villa that belonged to Livia, the wife of Augustus (**Fig. 4.21**). The walls of the setting must have seemed to melt

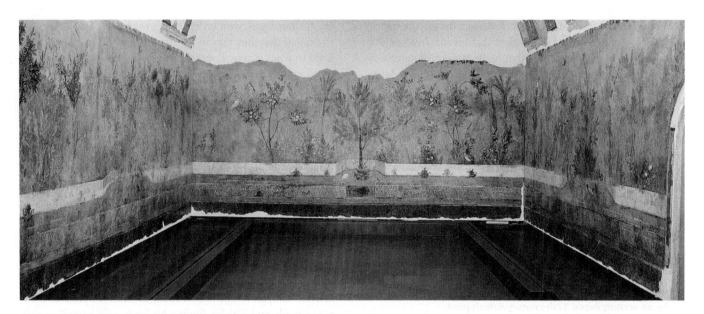

▲ **4.21** Gardenscape, Villa of Livia, Primaporta, Italy, ca. 30–20 BCE (Second style). Fresco, overall size 8'11" high × 38'5" long (2.72 × 11.7 m). **Museo Nazionale Romano (Palazzo Massimo alle Terme), Rome, Italy.** Livia's gardenscape is perhaps the ultimate example of a painted Roman picture window. The painter suggests depth by attempting linear perspective in the fence surrounding the tree in the center and by using atmospheric perspective—intentionally blurring the more distant objects.

away under the spell of masterful illusion—a crisp blue sky alive with the songs of birds, the feel of lush foliage underfoot, and the sweet scent of flowering trees. The garden fresco represents one of four styles of Roman wall painting created between the second century BCE and 79 CE; many of the best—and best-preserved—examples were found among the ruins of Pompeii.

Lines of Virgil's poetry also find their visual counterpart in a relief carving depicting Aeneas (**Fig. 4.22**) on the front of the *Ara Pacis* (Altar of Peace), one of the most important works commissioned by Augustus and perhaps the single most comprehensive statement of how he wanted his contemporaries and future generations to view his reign (**Fig. 4.23**). Aeneas, shown in the manner of a Classical Greek god, performs a sacrifice on his arrival in Italy before a small shrine that contains the two sacred images brought from Troy. Virgil glorified Aeneas, who was the son of a goddess, and Augustus who constructed a divine lineage by tracing his ancestry to Aeneas and, therefore, to Venus. Yet the Ara Pacis was not dedicated to any one god but to Livia, his wife, symbolizing the continuity of generations and reinforcing the ideal of stability of family and thus of state. Just as significantly, the reliefs of the Ara Pacis—with its allegorical figures of peace and fertility and luxuriously intertwined fruits and flowers—symbolize the abundance of nature and the flourishing of society made possible by the peace Augustus secured.

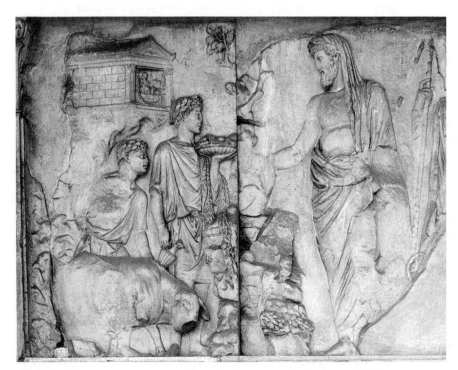

◀ **4.22** Aeneas performs a sacrifice, 13–9 BCE. **Detail from the Ara Pacis Augustae, Rome, Italy. Marble, 63" (160.0 cm) high. Museo dell'Ara Pacis, Rome, Italy.** Aeneas (right) is shown in the manner of a classical Greek god. The landscape and elaborate relief detail are typical of late Hellenistic art.

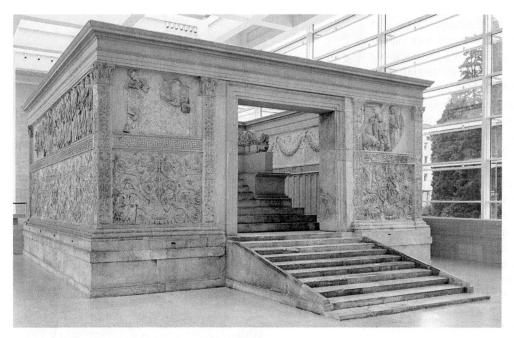

◀ **4.23 Ara Pacis Augustae (Altar of Augustan Peace), 13–9 BCE. Marble, rectangular stone wall surrounding a stone altar; wall, 34' 5" long × 38' wide × 23' high (10.5 × 11.6 × 7 m). Museo dell'Ara Pacis, Rome, Italy.** The central doorway, through which the altar is just visible, is flanked by reliefs showing Romulus and Remus, and Aeneas. On the right side is the procession of the imperial family, led by Augustus. The altar originally stood on Rome's ancient Via Flaminia. Fragments were discovered in the 16th century; the remaining pieces were located in 1937 and 1938, and the structure was reconstructed near the mausoleum of Augustus.

The relief of Aeneas and, across from it, one depicting Romulus and Remus together serve as a reminder of Rome's glorious beginnings. Scenes at the back of the altar show a female figure—the earth mother or an allegory of peace—and the goddess of war, emphasizing both the abundance of nature and the need for vigilance. The rich vegetation of the lower panels is a constant reference to the rewards of agriculture that can be enjoyed in an era of flourishing peace. Reliefs on the long sides of the Ara Pacis capture a celebratory procession. On one side, Augustus leads the way, accompanied by priests and followed by members of his family. Augustus is shown as the first among equals rather than supreme ruler. Although he leads the procession, he is marked by no special richness of dress. The presence of Augustus's family indicates that he intends his successor to be drawn from among them and that they have a special role

to play in public affairs. On the other side (**Fig. 4.24**), senators and dignitaries march, some of them holding the hands of small children who fidget and talk—as children are wont to do when they are bored. But don't let this charming realism and seeming spontaneity fool you. Just as Republican portraits played an important role in the construction of personal image and in propaganda, so was the scene of family men on the Ara Pacis intended to send a message. Members of the Roman nobility—here depicted—were not having many children; to encourage them otherwise, Augustus enacted laws to promote the institution of marriage and to support larger families. The linchpin, symbolized by the dedication of the Ara Pacis to his wife, was Augustus's call for fidelity. The fact that Augustus had divorced his first wife to marry his pregnant mistress Livia seems a distant memory.

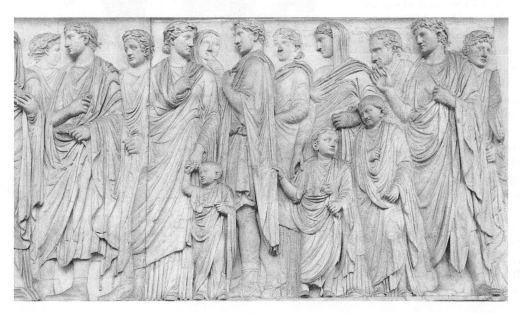

◀ **4.24 Procession of the imperial family, detail of south frieze of the Ara Pacis Augustae, 13–9 BCE. Marble, 63" (160.0 cm) high. Museo dell'Ara Pacis, Rome, Italy.** Although inspired by the frieze of the Parthenon, the Ara Pacis processions depict recognizable individuals, including children. Augustus promoted marriage and childbearing.

The detailed political and social message of the Ara Pacis is expressed without pretentiousness and with superb workmanship. The style is deliberately and self-consciously classical, based on works such as the Parthenon frieze (see Chapter 3). To depict the new Golden Age of Augustus, his sculptors chose the artistic language of the Golden Age of Athens, although with a characteristic Roman twist.

The elaborate message of the Ara Pacis echoes that of the Augustus of Primaporta (Fig. 4.25). This best-preserved statue of the emperor was named for the location of the imperial villa (Livia's) at which the sculpture was excavated. The sculpture was probably carved close to the time of the emperor's death, yet he is shown in the full vigor of life—young, handsome, calm, and determined, with a stance of quiet authority. The carefully constructed and idealized image *was* Augustus in the minds of the people, who only saw their emperor in art and on coins.

Augustus's ornately carved breastplate recalls an important event of his reign. In 20 BCE, he defeated the Parthians, an eastern tribe, and recaptured Roman standards that had been lost in battle in 53 BCE, The cupid on a dolphin at Augustus's feet is a symbol of the goddess Venus, connecting Augustus and his family with Aeneas (whose mother was Venus) and thereby with the origins of Rome. But the toddler may also represent Augustus's grandson Gaius, who was born in the year of the victory over the Parthians and was at one time considered a possible successor to the throne.

Augustus never managed to resolve the problem of naming a satisfactory successor. The deaths of desirable candidates forced him to fall back upon his unpopular stepson Tiberius. The succession problem would recur throughout the long history of the empire, because no effective mechanism was devised to guarantee a peaceful transition.

Imperial Architecture

Augustus and his successors also used architecture to express authority. In Imperial Rome, public buildings, civic architecture, temples, monuments, and private houses were constructed in numbers and on a scale that remains impressive by any standard. Roman achievements in both architecture and engineering had a lasting effect on the development of later architectural styles. The *arch*, *vault*, and *dome*—some versions of which we have seen in earlier cultures—appear as regulars in Roman architecture, but with a twist of engineering that upped the game: the invention of *concrete* (Fig. 4.26).

Arches and vaults were used to construct roofs over structures of increasing size and complexity. Greek and Republican Roman temples had been relatively small, partly because of the difficulty of roofing a large space without numerous supports. With the invention of concrete in the first century BCE and an increased understanding of the principles of stress and counterstress, Roman architects were able to experiment with new forms that—like the **barrel vault** and the **dome**—would enrich the Western architectural tradition.

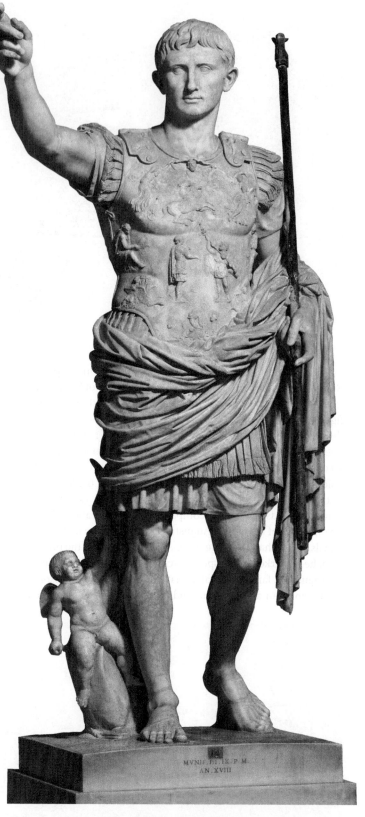

▲ **4.25 Augustus of Prima Porta, ca. 20 BCE. Marble. 80"
(203.2 cm) high. Musei Vaticani, Vatican City State, Italy.** Found in the imperial villa of Prima Porta, the statue shows Augustus about to deliver a speech. The small cupid at his feet connects the emperor to the legendary founder of Rome, Aeneas, who, like Cupid, was a child of the goddess Venus.

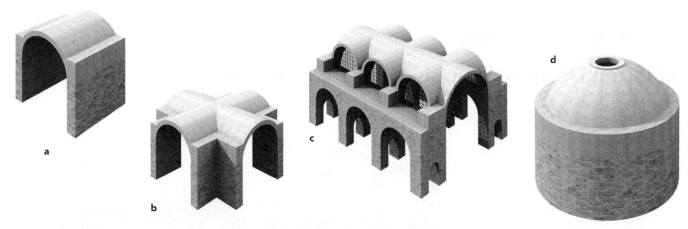

▲ **4.26 Roman construction using concrete. (a) A barrel vault; (b) a groin vault; (c) a fenestrated sequence of groin vaults; (d) a hemispherical dome with an oculus.** Concrete vaults and domes permitted Roman architects to create revolutionary designs. Artwork by John Burge.

The Greeks rarely built arches, but the Etruscans used them as early as the fifth century BCE. The Romans used arches regularly for civic projects such as bridges and aqueducts. The Pont du Gard (Fig. 4.27), an aqueduct-bridge that spans the Gard River in southern France, carried water more than 30 miles and furnished each inhabitant of the colonial city of Nîmes with some 100 gallons per day. Constructed of three levels of masonry arches, the largest of which spans about 82 feet, the aqueduct is about 900 feet long (a regulation football field is 360 feet long) and 160 feet high (approximately the height of a 16-story building). Gravity brought the water from the source to its destination: the aqueduct sloped gradually over the long distance and water flowed in a channel along the top. The two lower stories of wide arches functionally and visually anchor the weighty structure to the earth, whereas the quickened pace of the smaller arches complements the rush of water in the upper tier. The grandeur and simplicity of the Pont du Gard illustrate the principle, enunciated by modern architects, that *form follows function*.

The system of aqueducts throughout the empire, one of the most impressive feats of Roman engineering, had immense public-relations value. It was a way to assert the beneficence of the emperor, who provided the citizens of Rome with a basic necessity of life: water. A vast network of pipes brought millions of gallons of water a day into the city of Rome itself, distributing it

▼ **4.27 Pont du Gard, ca. 16 CE. Near Nîmes (ancient Nemausus), France. Stone block, 902' long × 161' (275 × 49 m) high; each large arch spans 82' (25 m).** Note the precise three-for-one positioning of the top row of arches. The entire aqueduct was 25 miles long. This section carried water over the canyon of the Gard River in what is today the south of France.

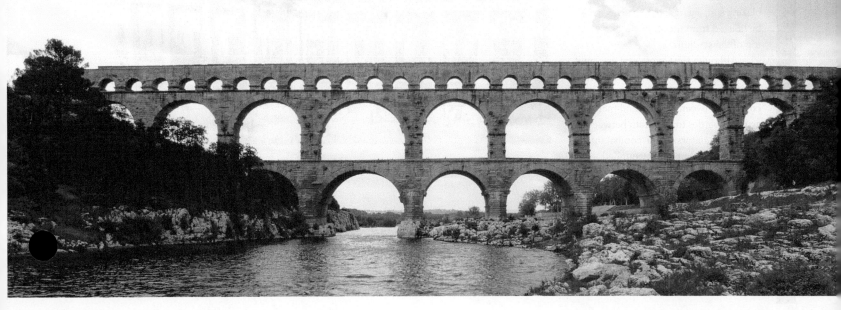

COMPARE + CONTRAST

Stadium Designs: Thumbs-Up or Thumbs-Down?

The sports stadium has become an inextricable part of our global landscape and our global culture. A city's bid for host of the Olympic Games can hinge entirely on the stadium it has to offer. These megastructures are not only functional—housing anticipated thousands—but they tend to become symbols of the cities, the teams, or now the corporations that fund them. There is something about a space like this. The passion of friends and strangers and "fors"and "againsts" alike creates an odd sense of uniformity regardless of diversity. This observation has led some of history's political leaders to use—and abuse— the phenomenon of the stadium for their own propagandistic purposes.

The Colosseum (**Fig. 4.28**) represented Rome at its best, but it also stood for Rome at its worst. A major feat of architectural engineering coupled with practical design, this vast stadium accommodated as many as 55,000 spectators who—thanks to 80 numbered entrances and stairways—could get from the street to their designated seats within 10 minutes. In rain or under a blazing sun, a gargantuan canvas could be hoisted from the arena up over the top of the stadium.

Although the Colosseum was built for entertainment and festivals, its most notorious events ranged from sadistic contests between animals and men to grueling battles to the death between pairs of gladiators. If one combatant emerged alive but badly wounded, survival might depend on whether the emperor (or the crowd) gave the thumbs-up or the thumbs-down.

As in much architecture, form can follow function and reflect and create meaning. In 1936, Adolf Hitler commissioned Germany's Olympic Stadium in Berlin (**Fig. 4.29**). Intended to

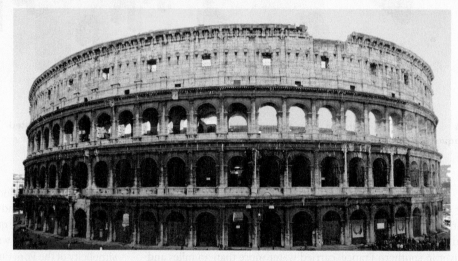

▲ **4.28** Colosseum, ca. 70–80 CE (Early Empire). Rome, Italy. Concrete (originally faced with marble).

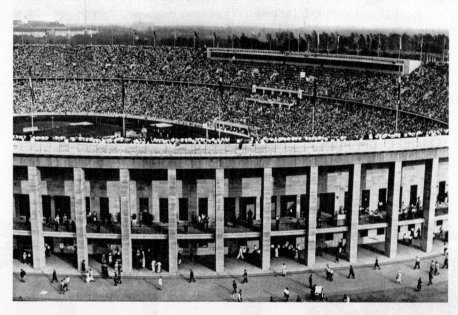

▲ **4.29** Werner March, Olympic Stadium, 1936. Berlin, Germany.

showcase Aryan superiority (even though Jesse Owens, an African American, took four gold medals in track and field as Hitler watched), architect Werner March's stadium is the

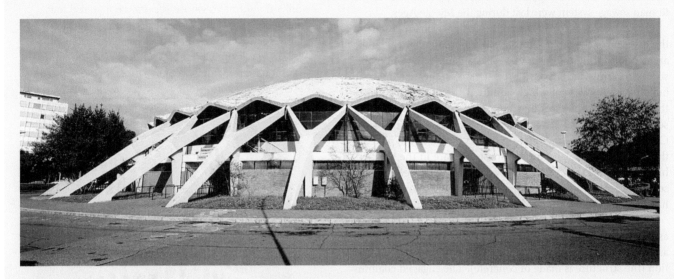

▲ 4.30 Pier Luigi Nervi, Palazzo dello Sport, 1960. Rome, Italy.

physical embodiment of Nazi ideals: order, authority, and the no-nonsense power of the state.

How different the message, noted critic Nicolai Ouroussoff, when an architect uses design to cast off the shackles of "nationalist pretensions" and "notions of social conformity" in an effort to imbue the structure—and the country—with a sense of the future. Created by Pier Luigi Nervi in 1957 for the 1960 Olympics, the Palazzo dello Sport (**Fig 4.30**) in Rome symbolized an emerging internationalism in the wake of World War II. The unadorned and unforgiving pillars of March's Berlin stadium seem of a distant and rejected past. Nervi's innovative, interlacing concrete roof beams define delicacy and seem to defy gravity.

In 2008, China hosted the Olympic Games in the city of Beijing. A doughnut-shaped shell crisscrossed with lines of steel as if it were a precious package wrapped in string, the stadium (**Fig. 4.31**)—dubbed by many the Bird's Nest—housed 100,000 spectators and came with a price tag in excess of $500 million. But beyond these staggering numbers, and like the Colosseum

and the Berlin Stadium, it stands as a symbol of the transformation of its city—and its country—into a major political and cultural force of its time.

▼ 4.31 Herzog and de Meuron, Beijing National Stadium, 2005. Beijing, China.

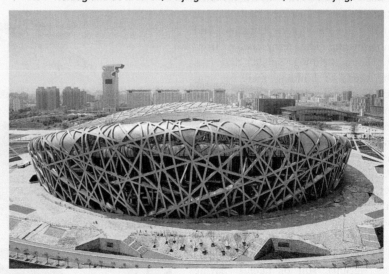

to drinking and display fountains, to public baths, and to the private villas of the wealthy. At the same time, a system of covered street drains was built, eliminating the unpleasantness and health risks of open sewers. With the passage of time, most of the aqueducts that supplied ancient Roman cities and towns collapsed or were demolished. The engineering skills for projects such as the Roman sewage system were lost during the Middle Ages.

The arch is also the principal design element used on the exterior of the Colosseum (Fig. 4.28), the infamous public arena built during the reign of Vespasian and dedicated by his successor, Titus, in 80 CE. Three tiers of arches encircle the building, the lowest of which admitted throngs of spectators through numbered gates and into corridors that led to their seats above the oval-shaped arena. In today's versions of the Colosseum—sports stadiums—the seats closer to the field are the most expensive and the cheapest ones are in the top tiers high above the athletes. In the days of ancient Rome, the good seats were reserved for the upper classes and the lower classes had to climb.

The architect of the Colosseum was as design-conscious as the one who built the Pont du Gard, if not more so, for the arches around the façade served only as a decorative function (the structure is made of concrete). The engaged columns between the arches pay homage to three architectural orders: the lowest level features the Tuscan order, a variation on the Doric order of the Greeks; the columns in the second tier are Ionic; and the third tier boasts the Corinthian order. As we progress from the ground level up toward the top and the most solid of the four bands, the column styles grow more delicate and lighter in appearance.

The Colosseum is a spectacular sight, even in a state of ruin. Much of the work of Roman architects was destroyed during the Barbarian invasions of the fifth and sixth centuries CE, and yet more was wrecked during the Renaissance by popes who, in effect, used Roman sites as quarries for brick and marble for their own buildings and monuments. The term *spolia*, from the Latin meaning "spoils," describes the reuse of building materials and sculpture in the construction and ornamentation of new structures and monuments. By great good fortune, one of the most superb of all imperial structures has been preserved almost intact. The Pantheon (**Fig. 4.33**) was built around 126 CE during the reign of Hadrian (117–138 CE), even though a prominent inscription on a frieze above the entrance reads "M.AGRIPPA.L.F.COS. TERTIUM.FECIT" (meaning "Marcus Agrippa, son of Lucius, having been consul three times, built it"). For a very long time, archaeologists and

CONNECTIONS In 1935, when Benito Mussolini, the Fascist dictator of Italy, initiated plans for the world exhibition to be held in Rome, he chose the Roman Colosseum as a model for the architectural centerpiece of the fair—an ancient building whose monumentality signified might and whose reputation inspired fear. As much a salutation to the structure as a symbol of Mussolini's rule, the Palazzo della Civiltà Italiana, also known as the Colosseo Quadrato (or Square Colosseum), remains one of the most iconic works of Fascist architecture.

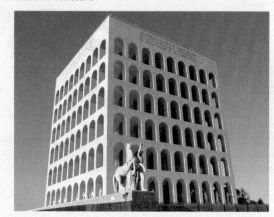

▲ **4.32** **Palazzo della Civiltà Italiana, designed by Guerrini, La Padula, and Romano, Rome, Italy, 1935.**

▼ **4.33** **Pantheon, 118–125 CE (Early Empire). Rome, Italy. Exterior view.** The Pantheon's traditional façade masked its revolutionary cylindrical drum and huge hemispherical dome. The interior symbolized both the orb of the earth and the vault of the heavens.

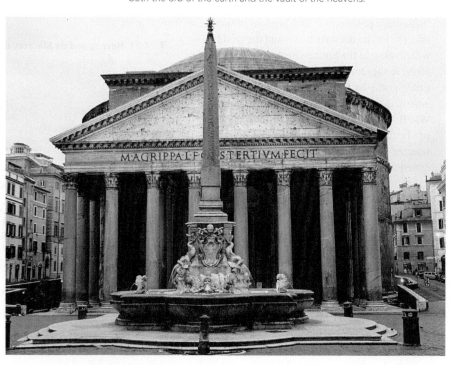

art historians thus believed that the Pantheon, dedicated to all of the gods (*pan* is a prefix meaning "all," and *theon* comes from the Latin *theologia*, referring to religion) was constructed under the reign of Marcus Agrippa. However, excavations revealed that the concrete in the Pantheon was of a type used only after Agrippa's reign. Why, then, did Hadrian put Agrippa's name on a building that he made possible? We know this: even though Hadrian is responsible for the construction or rebuilding of architectural monuments throughout the city of Rome, he wished for only one work to be attributed to him—

the Temple of the Deified Trajan, the emperor who preceded him and named Hadrian his successor just before his death.

The Pantheon's design combines the simple geometric shapes of a cylinder and a circle (**Fig. 4.34**). An austere and majestic exterior portico, supported by freestanding granite columns with Corinthian capitals, leads to the central rotunda—a domed space that is 142 feet high at its center and measures the same distance across. The dome rests on a concrete cylinder pierced with deep, vaulted niches that accept the downward thrust of the dome and distribute its weight to the cylinder's 20-foot-thick wall. These deep niches alternate with shallow ones along the inside perimeter of the rotunda in which statues were placed. While the cylinder wall was constructed of concrete mixed according to a recipe that would provide the greatest strength, the concrete used in the dome was much lighter. The concrete is thickest at the point where the dome begins to rise off its cylindrical base and is thinnest at the very top, where it culminates in a circular opening—an **oculus** (after the Latin word meaning "eye") that frames a patch of sky and allows entry of the only natural light in the space. The actual weight of the dome—as well as its visual massiveness—was alleviated with *coffering*, the carving of squares within squares in a regular pattern across its surface. In ancient times, the innermost squares may have contained gold-gilded bronze rosettes and, if so, were among the decorative elements decried by Pope Boniface IV as "pagan filth" when he converted the Pantheon into a Christian church in the early seventh century CE.

The Pantheon was dwarfed by the enormous complex of open spaces, buildings, and monuments that made up the imperial fora, among which was the Forum of Trajan (**Fig. 4.35**). One of the most original and stunning monuments in the forum, at a height of 128 feet, is Trajan's Column (**Fig. 4.36**). The entire surface of the column is carved in low

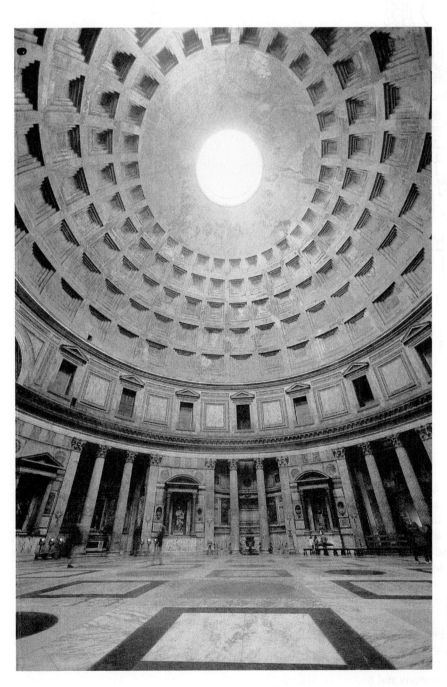

◀ **4.34 Pantheon, 118–125 CE (Early Empire). Rome, Italy. Interior view.** The coffered dome of the Pantheon is 142' (43m) in diameter and 142' high. Light entering through its oculus forms a circular beam that moves across the dome as the sun moves across the sky.

▲ **4.35 Imperial fora. Rome, Italy.** Unlike the Republican forum, which served as a public meeting place, the imperial fora were huge complexes constructed as monuments to the emperors who commissioned them. Note the Forum of Trajan (Forum Traiani), one of the largest, in the upper portion.

relief with scenes from Trajan's military campaign against the Dacians. The spiral band on which these adventures are carved, if unwound, would measure over 600 feet in length. The ascending spiral forced the spectator to move around the column, thus mimicking the Roman funerary ritual of circumambulation. Trajan's body was cremated upon his death on August 8, 117 CE, and his ashes placed in a chamber in the column. **Map 4.2** shows the extent of the Roman Empire at the time of Trajan's passing.

Elsewhere in the city, baths, theaters, temples, racetracks, and libraries catered to the needs and fancies of an ever-expanding urban population. Architects continued to mix Greek and Roman styles in new and different contexts and to

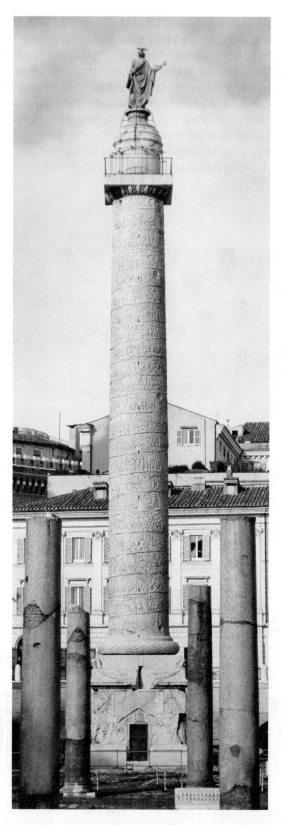

▲ **4.36 Column of Trajan, dedicated 112 CE.** Forum of Trajan, Rome, Italy. Carrara marble shaft ca. 98' (30 m) high, 11' (3.7 m) diameter on 27' (8 m) pedestal. The spiral frieze of Trajan's Column tells the story of the Dacian Wars in 150 episodes. The reliefs depict all aspects of the campaigns, from battles to sacrifices to road and fort construction.

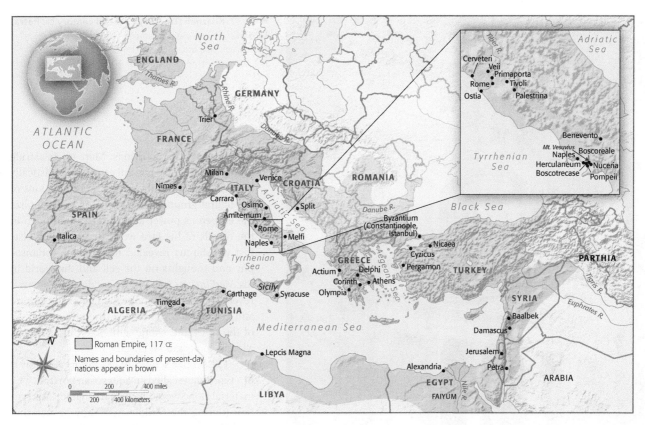

▲ **MAP 4.2 The Roman Empire at the death of Trajan in 117 CE.**

experiment with new techniques of construction. Roman design and engineering principles were applied throughout the empire from Spain to the Middle East.

The influence of Roman architecture and urban planning can be seen in two examples in the far-flung empire: Timgad, a colony in present-day Algeria (**Fig. 4.37**), and the façade of an elaborate rose-colored rock-cut tomb in Petra, Jordan (**Fig. 4.38**). The aerial view of Timgad reveals a hyperplanned community in which a large square of land is divided first by two wide roads that intersect to form four main quadrants. The quadrants, in turn, are divided into smaller blocks by a grid of narrower streets. The centerpiece of the city is a forum, reflecting the importance of the Roman fora as centers of city life. The tidiness of the plan couldn't look more different from Rome's haphazard cityscape (see again Fig. 4.7). Timgad

▶ **4.37 Satellite view of Timgad, Algeria, founded 100 CE.** The plan of Trajan's new colony of Timgad in North Africa features a strict grid scheme, with the forum at the intersection of the two main thoroughfares, the *cardo* and the *decumanus*.

◀ **4.38 Khaznah (Treasury), second century CE. Petra, Jordan.** This rock-cut tomb façade is a prime example of Roman baroque architecture. The designer used Greek architectural elements in a purely ornamental fashion and with a studied disregard for classical rules.

of the canon of proportions. Marcus sits astride a horse that is, by any measure, unrealistically small in relation to its rider. The proportions of the figural group are manipulated to symbolize the emperor's power and authority, although in the details of his face we read something else. Just as Marcus revealed his personal philosophy and thoughts on the self and the world in his *Meditations* (see p. 135), so does his portrait reveal his concerns about the fate of the empire and the burden of wearing the crown. For all of the spirit and energy embodied in his horse, Marcus looks sad and tired.

The bronze sculpture of Marcus Aurelius is of a type that is called an equestrian portrait. The material alone would have marked it for destruction (during the Middle Ages, any bronze that could be seized was melted down for other uses), were it not for a case of mistaken identity. The statue of Marcus Aurelius was spared because it was believed to have portrayed Constantine, the first Christian emperor of Rome.

The End of the Roman Empire

is a signature example of the template used for Roman settlements, wherever in the world they might be.

If Timgad reveals an almost militaristic approach to town planning in its extreme regularity and precision, the tomb in Petra (known as the *Khaznah* or "Treasury") reveals the Roman love for mixing and matching architectural styles. What *isn't* going on in this façade? We see two pediments (one broken, one not); an entrance that is flanked by unevenly spaced columns; something that looks like a cylindrical mini-temple in the second story; deep, shadowy recesses; and delicately carved reliefs. This suggestion of a split personality when it comes to Roman art and design calls to mind a quote by the 19th-century American poet Walt Whitman: "Do I contradict myself? Very well, then I contradict myself. I am large, I contain multitudes."

Back in Rome, artists and their patrons were departing—at long last—from some of the strict conventions of Classical Greece. Consider the portrait of the emperor Marcus Aurelius (Fig. 4.39) and how far the artist has come from the mandate

Few historical subjects have been as much discussed as the fall of the Roman Empire. It is not even possible to agree on when it fell, let alone why. The traditional date—476 CE—marks the deposition of the last Roman emperor, Romulus Augustulus. By that time, however, the political unity of the empire had already disintegrated. Perhaps the beginning of the end came in 330 CE, when Constantine moved the capital of the empire from Rome to a new city on the Bosporus and named it Constantinople. But his transfer of the seat of the empire may have represented a new development as much as a conclusion. One could even argue that Constantine's successors in the east, the Byzantine emperors, were heirs to Augustus, and that the imperial traditions begun in 31 BCE continued until the fall of Constantinople in 1453 CE.

Fascinating though the question may be, it is in a sense theoretical rather than practical. The Roman Empire did not fall overnight. Many of the causes for its long decline are obvious. One factor was the growing power and changing character of the army. The larger it became, the more necessary it was to recruit troops from the more distant provinces—Germans,

Illyrians, and others, the very people the army was supposed to be holding in check. Most of these soldiers had never been anywhere near Rome. They felt no loyalty to the empire and had no reason to defend Roman interests. A succession of emperors had to buy their support by raising their pay and promising gifts of land. At the same time, the army came to play an increasingly prominent part in the choice of a new emperor, and because the army was largely non-Roman, so were many of the emperors chosen. Rulers of the third and fourth centuries included

Africans, Thracians, a Syrian, and an Arab—men unlikely to feel any strong reason to place the interests of Rome over those of themselves and their own men.

Throughout this late period, the empire was increasingly threatened from outside. To the west, barbarian tribes such as the Huns, the Goths, and the Alemanni began to penetrate farther and farther into the empire's defenses and even to sack Rome. Meanwhile, in the east, Roman armies were continually involved in resisting the growing power of the Persians. In many parts of the empire, it became clear that Rome could provide no help against invaders, and some of the provinces set themselves up as independent states with their own armies.

Problems such as these inevitably had a devastating effect on the economy. Taxes increased, and the value of money depreciated. The constant threat of invasion or civil war made trade impossible. What funds there were went for the support of the army, and the general standard of living suffered a steady decline. The eastern provinces, the old Hellenistic kingdoms, suffered rather less than the rest of the empire, because they were protected in part by wealth accumulated over the centuries and by their long tradition of civilization. As a result, Italy sank to the level of a province rather than remaining the center of the imperial administration.

Total collapse was prevented by the efforts of two emperors: Diocletian, who ruled from 284 to 305 CE, and Constantine, who ruled from 306 to 337 CE. Both men were masterful organizers who realized that the only way to save the empire was to impose stringent controls on every aspect of life—social, administrative, and economic. In 301 CE, the Edict of Diocletian was passed, establishing fixed maximums for the sale of goods and for wages. A vast bureaucracy was set up to collect taxes and administer the provinces. The emperor became once again the focal point of the empire, but to protect himself from the dangers of coups and assassinations, he never appeared in public. As a result, an elaborate court with complex rituals developed, and the emperor's claim to semidivine status invested him with a new religious authority.

◀ **4.39 Equestrian statue of Marcus Aurelius, ca. 175 CE. Rome, Italy. Bronze, 138" (350.5 cm) high. Musei Capitolini–Palazzo dei Conservatori, Rome, Italy.** In this equestrian portrait of Marcus Aurelius as omnipotent conqueror, the emperor stretches out his arm in a gesture of clemency. An enemy once cowered beneath the horse's raised foreleg.

▼ **4.40 Ruins of the Basilica Nova, 306–315 CE. Forum Romanum, Rome, Italy.** The last great imperial building in Rome, the basilica was begun in 306 CE by Maxentius and completed by Constantine after 315 CE. Only the northern side still stands; the central nave and south aisle collapsed in antiquity. The brickwork visible today was originally hidden behind marble panels, both inside and out. Top: restored cutaway view (John Burge).

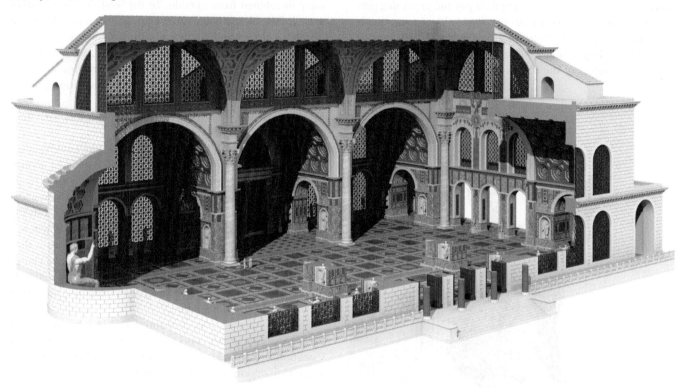

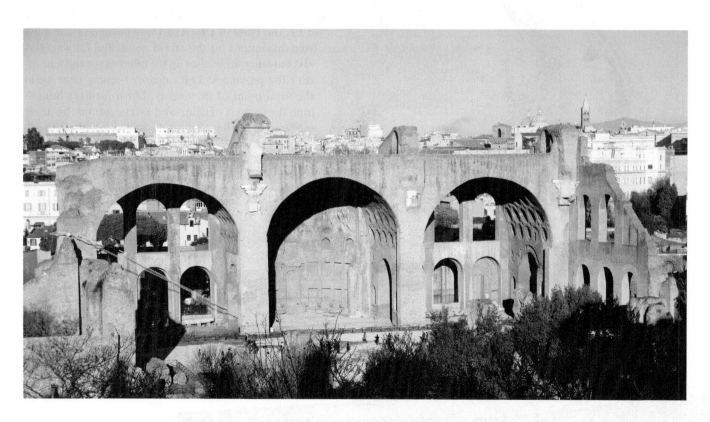

Late Roman Art and Architecture

Even if the emperor did not show himself to his subjects, he could impress them in other ways, and the reigns of Diocletian and Constantine marked the last great age of Roman architecture. The immense Basilica Nova (Fig. 4.40) was begun by the emperor Maxentius and completed by Constantine. Though it now lies in ruins, it must have been a powerful reminder of the emperor's authority, with its scale—300 feet long (the size of a football field without the end zones), 215 feet wide (55 feet wider than a football field)—and enormous barrel vaults in aisles that supported a groin-vaulted ceiling over a central *nave* that rose to a height of 100 feet. In ancient Rome, basilicas were large public meeting halls that were usually built around or near fora (you can see a few of them in Figure 4.35). The Basilica Nova was that and more. It was the setting for a colossal sculpture of a seated Constantine that featured a wooden torso sheathed in bronze and a head and limbs carved of marble. The head alone (Fig. 4.41) is eight and one-half feet tall. Thinking back to the realism of Republican portraits—including the profile of an aging Julius Caesar on a silver coin—and the idealism of the head of Augustus on the Primaporta portrait, the head of Constantine is something altogether different. His austere, emotionless expression and thick-lidded, wide-staring eyes exude an aura of uncompromising authority.

The appearance and eventual triumph of Christianity is outside the scope of this account, but its emergence as the official religion of the empire played a final and decisive part in ending the Classical era. Pagan art, pagan literature, and pagan culture as a whole represented forces and ideals that Christianity strongly rejected, and the art of the early Christians is fundamentally different in its inspiration. Yet even the fathers of the early church, implacable opponents of paganism, could not fail to be moved by the end of so great a cultural tradition.

The memory of Rome's greatness lived on through the succeeding ages of turmoil and achievement, and the Classical spirit survived to be reborn triumphantly in the Renaissance.

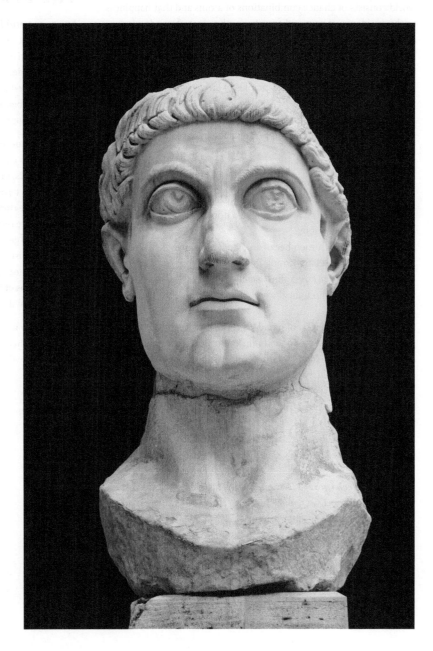

▶ **4.41 Colossal head of Constantine, ca. 315–330 CE. Basilica Nova, Rome, Italy. Marble, 102" (259 cm) high. Musei Capitolini—Palazzo dei Conservatori, Rome, Italy.** Constantine's portraits revive the Augustan image of an eternally youthful ruler. The colossal head is one fragment of an enthroned Jupiter-like statue of the emperor holding the orb of world power.

GLOSSARY

Barrel vault (p. 150) A continuous arch or vault that looks like a semicircle in cross-section (also called a *tunnel vault*).

Dactylic hexameter (p. 143) The rhythmic scheme used in epic poetry by Homer and Virgil; each line consists of six dactyls. A dactyl is a long syllable followed by two short syllables.

Dome (p. 150) A vaulted roof usually having a circular base and shaped like half a sphere.

Epicureanism (p. 133) A school of philosophy that argues that the world consists of chance combinations of atoms and that happiness or the avoidance of pain and anxiety are the greatest goods, although pleasure is to be enjoyed in moderation.

Forum (p. 128) An open public space in the center of a Roman city (plural *fora*).

Jus civile (p. 135) Rules and principles of law as derived from the laws and customs of Rome.

Lyric poetry (p. 125) A form or genre of poetry characterized by the expression of emotions and personal feelings; so called because such poetry was sung to a lyre.

Neo-Platonism (p. 133) The school of philosophy that developed Plato's concept of the One, the source of all life, which is transcendent and unknowable through reasoning.

Oculus (p. 155) A circular opening in a dome that allows the entry of natural light from above.

Patrician (p. 130) A member of an elite family in ancient Rome.

Plebeian (p. 130) A landowning Roman citizen, but not a patrician.

Sarcophagus (p. 126) A coffin; usually cut or carved from stone, although Etruscan sarcophagi were made of terra-cotta (plural *sarcophagi*).

Stoa (p. 133) A covered colonnade; a roofed structure, like a porch, that is supported by a row of columns opposite a back wall.

Stoicism (p. 133) A school of philosophy with the view that the universe was ordered by the gods and that people could not change the course of events; people could, however, psychologically distance themselves from tragic events by controlling their attitudes toward them.

Tribune (p. 130) The title given elected officials in Rome; they could convene the Plebeian Council and the Senate and propose legislation.

Triumphal arch (p. 129) A monumental structure that takes the form of one or more arched passageways, often spanning a road, and commemorates a military victory.

THE BIG PICTURE ROME

THE ETRUSCANS (CA. 700–89 BCE)

Language and Literature

- Etruscans spoke a non-European language that was written in a script derived from Greek. Some texts have survived, but they are not fully deciphered.
- The longest extant text is the *Liber Linteus* (the *Linen Book*), which survived because it was cut into strips by Egyptians and used to wrap a mummy.

Art, Architecture, and Music

- Etruscans were admirers of Greek art, but not imitators. Unlike the Greeks, they built their temples of wood and mudbrick and preferred terra-cotta as a medium for their life-size statues.
- While the rippling drapery and enigmatic smiles of Etruscan statues are reminiscent of the Archaic Greek style, the movement, animated gestures, and lively facial expressions are telltale Etruscan characteristics.
- Subterranean tombs, carved from bedrock limestone, reflect the floor plans of Etruscan houses and feature interiors decorated with reliefs that depict household utensils and status symbols.

Philosophy and Religion

- The pantheon of Etruscan gods has its equivalents in Greek and Roman mythology.

REPUBLICAN ROME (509–27 BCE)

Language and Literature

— The Romans spoke Latin, an Indo-European language. So-called Classical Latin was a literate form of the language that was in usage by the late years of the Republic. As Rome expanded, the various dialects of conquered peoples mixed with Latin.

— Roman poetry and plays followed Greek models in form and content. Subjects ranged from pure comedy to love.

— Insights into Roman life and military campaigns come to us in the form of written commentaries and letters.

Art, Architecture, and Music

— Roman temples are hybrids of Greek and Etruscan architectural styles.

— Portrait sculpture is characterized by *verism*, or a superrealistic style, and is often used to project a specific, constructed self-image.

— Wall painting emerged as a complex art form.

— Music consisted mainly of performance at religious events—from marriages to funerals—and entertainment—from private dinner parties to public gladiator contests.

Philosophy and Religion

— Two main schools of philosophy—*Epicureanism* and *Stoicism*—were "imported" from Greece.

— The pantheon of Roman gods assimilated the deities of the Greeks and Etruscans.

IMPERIAL ROME (27 BCE–337 CE)

Language and Literature

— Literary works from epics to odes related to the Augustan worldview: peace, the importance of the land and agriculture, the merits of the simple life, and Rome's destiny as ruler of the world.

— Satirical verse appears, along with poetry about love and sex that flies in the face of Augustus's call for a family-oriented lifestyle.

— Historical narratives provide insight into the reigns of Roman emperors and the catastrophe of the eruption of Vesuvius.

Art, Architecture, and Music

— Imperial sculpture and architecture mimic the Classical style of Periclean Athens.

— Buildings and monuments were constructed using Roman techniques and innovations: the arch, the vault, the dome, and bold use of concrete.

— Wall paintings and intricate mosaics decorate Roman houses and gardens, many of which were preserved in the volcanic ash spewed by Vesuvius.

— Forums, constructed in Rome's city center, are sites for temples, basilicas, monuments, and markets.

— Form and function merge in the design of public works, most notably aqueducts that carried water from the outskirts of Rome into the heart of the city, and in the apartment blocks constructed to alleviate overcrowding.

— In the waning days of the empire, classical ideals were abandoned; portraits of emperors revealed the anxiety of the age.

Philosophy and Religion

— Neo-Platonism developed. Interest in Epicureanism and Stoicism was replaced with an enthusiasm for Eastern religious cults, including Christianity.

Early Civilizations of South Asia, China, and Japan

5

PREVIEW

It is 566 BCE and the Panathenaic Games have been inaugurated in Athens. There would be athletic competitions, to be sure, but prizes would also be awarded for poetry and music and the best recitation of Homer. The full texts of *The Iliad* and *The Odyssey* would be read at the games. In the Near East, the vast Persian Empire was just beginning to take shape; by the time Darius the Great took over as ruler, the empire already included parts of northeast Africa, Anatolia (Turkey), Mesopotamia, and the Aegean coast. Egypt followed, only a few years before Darius became king in 522 BCE. Greece would have been next, but Darius's son, Xerxes, ultimately was defeated in 490 BCE. The outcome of the Persian Wars with Greece would determine the course of Western civilization. But at the same time, in other places, there were other civilizations, other outcomes.

In 1922, the German novelist Hermann Hesse penned his story of a young man whose life overlapped this era, many miles to the east of Persia. Born into wealth and insulated from human suffering, he fled his life of privilege to experience both the ordinary beauty and the extraordinary horror of the world beyond his palatial realm. His adventures ran the gamut between asceticism and hedonism. Rejecting both, he settled into the uneventful life of a ferryman, which, nevertheless, brought about a certain awareness.

> Tenderly, he looked into the rushing water, into the transparent green, into the crystal lines of its drawing, so rich in secrets. Bright pearls he saw rising from the deep, quiet bubbles of air floating on the reflecting surface, the blue of the sky being depicted in it. With a thousand eyes, the river looked at him, with green ones, with white ones, with crystal ones, with sky-blue ones. How did he love this water, how did it delight him, how grateful was he to it! In his heart he heard the voice talking, which was newly awaking, and it told him: Love this water! Stay near it! Learn from it! Oh yes, he wanted to learn from it, he wanted to listen to it. He who would understand this water and its secrets, so it seemed to him, would also understand many other things, many secrets, all secrets.[1]

The scene takes place in ancient India and is a fictionalized account of the spiritual awakening of a man called Siddhartha—in **Sanskrit**, "he who has achieved his goals" or "he who has found the meaning of life"—who lived during the time of the Buddha, Siddhartha Gautama. In reality, Gautama Buddha was likely born into a royal family in Nepal. According to popular biographical narrative,

◀ **5.1 Funerary urn (*hunping*), ca. third century CE (Western Jin dynasty, 265–317 CE). Earthenware with green glaze, 17⅞" × 11¾" (45.4 × 30.3 cm). Metropolitan Museum of Art, New York, New York.** The urn has a rich gathering of figures and architecture, organized in tiers. Around the waist of the urn sits a row of Buddhas with lotus petals on lion thrones. It was intended that the soul of the departed individual would return to dwell in the urn.

1. Hermann Hesse, *Siddhartha*, trans. Hilda Rosner (1922; trans. New York: New Directions Publishing Corporation, 1951), p. 101.

he abandoned his life of luxury and sought enlightenment through meditation. After 49 days spent under a sacred fig tree, Gautama achieved enlightenment and thereafter was called the Buddha (that is, the "awakened one") by his followers. Gautama's teachings were passed down orally for some four centuries and finally committed to writing at about the time that Julius Caesar was assassinated in Rome. Buddhism, a religion and philosophy that traveled eastward from South Asia to China and beyond, is based on the teachings of Siddhartha Gautama.

Of the many religions of South Asia, China, and Japan, Buddhism is the one that is common to all three cultures. The *hunping* (soul jar), a glazed ceramic funerary urn from around the third century CE, features what may be the earliest images of the Buddha in China (**Fig. 5.1**). Found in a region south of the Yangtze River, it is of a type that was often placed in Han-dynasty tombs. Intricately modeled animals and birds gather around the base of a pagoda-style structure, all perched on a ring of Buddhas, who are meditating on the petals of lotus flowers. As in Egyptian and Etruscan tombs, the urn would have been one of many objects intended for use by the deceased in the afterlife. The Metropolitan Museum of Art in New York, where the hunping now resides, suggests that the birds and beasts are auspicious (they are there to promise success) and that, together with the Buddhas, they can guide the soul of the deceased to rebirth in paradise.

SOUTH ASIA

At roughly the same time as Western civilization began in the fertile lands around the Nile and Tigris and Euphrates rivers, the earliest South Asian cities developed in the Sindh region of the Indus River Valley, near the Arabian Sea in what is now Pakistan. South Asia includes the cultures of modern day Pakistan, India, Bangladesh, and nearby lands (see **Map 5.1**).

The word *India* derives from the Sindhi, an ethnic group who lived in this region. What we know of ancient India comes from archaeological evidence, although it is only imperfectly understood. They possessed a written language based on picture signs that has yet to be deciphered. Like the other river civilizations, theirs was an agrarian society (they were probably the first people to cultivate cotton), but they also had large, significant urban centers, notably Harappā and Mohenjo-daro. Stone and ceramic artifacts suggest a highly developed religion, of which we know little, and some carved objects seem to indicate that, as on Crete, the bull may have been important. These ancient peoples also used standardized weights and measures, likely for trade purposes. They created a drainage system, and the close examination of pottery shows that some centralized agency handled the distribution of goods.

Ancient Civilizations of India and China

3000 BCE	1500 BCE	200 CE	600 CE	1300 CE
Earliest South Asian cities develop in the Indus River Valley (modern day Pakistan)	Indian Emperor Ashoka (r. 272–231 BCE) converts from Brahmanism to Buddhism and facilitates the spread of the religion	Gupta Empire establishes a period of economic stability, religious tolerance, and cultural achievements in India	The Tang dynasty (r. 618–906 CE) emerges after centuries of confusion in China	
Mohenjo-daro designed with a grid plan of streets, central marketplace, public bath, and sewage system	Shang dynasty of China (ca. 1520–1027 BCE) develops an urban civilization based on trade and commerce	Guptas build universities in which subjects such as mechanics, medicine, and mathematics are taught	Heian (later Kyoto) becomes capital of Japan in 780 CE	
Aryan people settle in the Indus Valley and introduce a caste system	Zhou dynasty (ca. 1046–221 BCE) replaces the Shang dynasty and coordinates separate kingdoms	Indian scholars invent what we now call Arabic numerals and develop decimals, quadratic equations, and other mathematical concepts	Song dynasty in China (r. 960–1279 CE)	
The Longshan culture establishes cities along the Yellow River in China	The Qin dynasty, from which China derives its name, is founded in 221 BCE; a single writing system and standard weights and measures are imposed		Period of feudal rule in Japan (begins 1185 CE)	
Jomon pottery is the earliest form of art in Japan	The Han dynasty (r. 202–220 BCE) is established in China		Sultan of Delhi establishes seat of Muslim power in India in 1192 CE	
			Mongol invasions of Japan in 1274 CE and 1281 CE	
			Mongol invasion of China in 1279 CE	

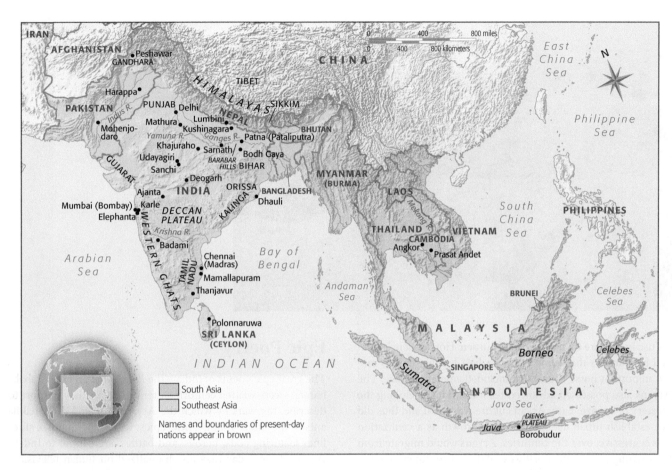

▲ **MAP 5.1 South and Southeast Asia before 1200.**

The Indus Valley Civilization

Mohenjo-daro was the largest and oldest center of Indus Valley civilization, and its urban plan and engineering finesse are impressive: a grid plan of streets with fired-brick rectilinear buildings, a central marketplace with a public well, a public bath waterproofed with bitumen, and a sewage system, to name but a few of its features. The size of the city (at its peak, it housed 35,000 inhabitants), its fortifications, and its variety of structures indicate that it was a city of great importance, perhaps the civilization's administrative center. Excavation of Mohenjo-daro began in the 1920s, and today the ruins are designated as a UNESCO World Heritage site (**Fig. 5.2**).

Artisans of the Indus River Valley were highly skilled in bronze and stone sculpture, as a limestone male figure (**Fig. 5.3**) from Mohenjo-daro attests. Carefully crafted detail—the clover-leaf pattern of the delicately carved robe, head and arm bands accented with matching circular symbols, a neatly trimmed beard—suggests that this is an individual of high status. The serene expression, enhanced by his placid lips and only slightly opened eyelids, may indicate that he is a ruler or member of a priestly hierarchy.

Around the time of the New Kingdom in Egypt, 1550 BCE, the Indus Valley civilization began to decline. The area was struck by a series of floods, the soil was exhausted, and the woodlands had been overused. In the maelstrom of these ecological disasters, apparent in the archaeological record, a new threat appeared: invasions from the northwest by the **Aryans**. The disintegration of the older Indus Valley culture was so complete that archaeologists have failed to find any significant artworks from the period between its decline and the much later emergence in the area of Buddhist culture.

The Aryans

The Aryans had settled in the Indus Valley by around 1500 BCE, but who they were and where they came from remains unclear. Some scholars have suggested that they came from the area of the Russian steppes—grassland plains—but the full picture of their migration into the Indian subcontinent is not completely understood. Agriculture was a common way of life, but it was not as prestigious as cattle breeding and herding. Cattle were traded as a medium of currency. Aryans also bred horses, more

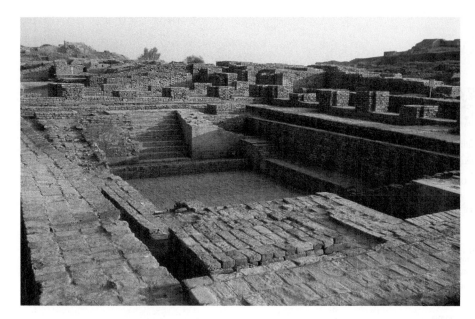

◀ **5.2 Citadel ruins, ca. 2500** BCE.
Mohenjo-daro (modern Pakistan). The ruins
of the residential quarter lead to the citadel,
which houses ritual baths and is thought to
have been the site of other religious rituals.
Mohenjo-daro, meaning "mounds of the
dead," was once the largest city of the Indus
civilization and probably the capital.

for use in warfare than as beasts of burden. Horses were so valued by warriors that some of the earliest hymns refer to rare but important horse rituals that included animal sacrifice. The Aryans also possessed advanced technical skills, including the mastery of bronze. Early Aryan culture was tribal and thus did not establish urban centers. Yet their growth as a civilization was aggressive; over the centuries, Aryans would migrate from their strongholds in the northwest of the subcontinent into the southern reaches of India.

The material evidence mapping the spread of the Aryan peoples is at best spotty. What we do know (mainly from later historical texts) is that they spoke the language we call Sanskrit, a branch of Indo-European language groups and the ancestor of Indo-Aryan and Latin, from which Romance languages developed. The connection of these languages can be seen in some words: *yoga* (yoke for an animal; later: discipline)—*jugum* (Latin: yoke)—*yoke* (English); *Agni* (God of fire)—*ignis* (Latin: fire)—*ignition* (English).

▲ **5.3 Robed male figure, ca. 2000–1900 BCE. Mohenjo-daro (modern Pakistan). Limestone, 6⅞" (17.5 cm) high. National Museum of Pakistan, Karachi, Pakistan.**

Epic Poetry

The great epic poems of India—the *Ramayana* and the Mahabharata—were written centuries after the events they purport to describe: the wars by which the Aryans subdued the inhabitants of the Indus Valley. These epics, with their complex story lines featuring gods, heroes, and battles, are central to Indian culture. Even today they are dramatized on Indian television. But they are more than simply stories. The Ramayana influenced the Sanskrit poetry to follow and set forth the teachings of what were even then "ancient" Hindu sages, having religious and philosophical features.

THE MAHABHARATA The **Mahabharata**, was probably begun sometime between the eighth and ninth centuries BCE, although the preserved texts date no farther back than about 400 BCE. It achieved its final form ca. 400 CE. It is attributed to Krishna Dvaipayana Vyasa and is the longest epic ever written, comprised of some 100,000 verses organized into 18 books. It is written in a meter based on the *length* of syllables—short and long—rather than on the arrangement of accented and unaccented syllables, as is typical in English verse.

The epic recalls a number of events that were believed to have occurred during the wars between two branches of the Indo-Aryan Kuru clan—the Kauravas and the Pandavas—over the succession to the kingdom of the Kurus (Kuruksetra) in the Ganges River Valley in north India. Like *The Iliad* and *The Odyssey*, some of the story may be based on actual historical events, but they are embellished by fanciful interactions between gods and humans. In the first book of the Mahabharata, the tale is told of the birth of one of the epic's heroic protagonists, Karna. Kunti, a virtuous, beautiful, but infertile woman, is given a magic spell by a sage which, he says, will enable her to bear children. She tries the spell, which invokes the sun god—the "light of the universe"—he impregnates her with a son who becomes the "foremost of warriors." Karna was born wearing armor and

CONNECTIONS Like the Homeric epics, the *Ramayana* and the Mahabharata, as well as the Vedas, were written down only after they had been transmitted orally for many generations. Like their Greek counterparts, they were compilations of different parts and versions added over time. The epic poems of India, as *The Iliad* and *The Odyssey*, recounted events that took place centuries before their telling and featured heroic battles and divine machinations that defined the ancestry and consciousness of a people. Just as in Homer's poems, the Vedas include a multitude of gods; Indra, the Storm-god, is the head deity of the Hindu pantheon and, like Zeus, "wields the thunderbolt."

earrings. As Achilles, Karna was the offspring of a divine parent and a mortal. Without a father to be seen, Kunti hid her "transgression" by throwing Karna into the Ganges River, whereupon he was plucked to safety by a Kuru charioteer who raised him as his own son. Karna grows up as a Kaurava, not realizing that he has brothers who are Pandavas. Thus, Karna winds up in battle against his own kin. Interestingly, in the Hebrew Bible, Moses—the prophet and leader of the Hebrews—was similarly placed in a basket in the Nile River by his mother, who feared that Egyptians would otherwise kill him. Moses was discovered and raised in the court of the pharaoh, and, as such, at first oppressed his own people—the Hebrews—who were enslaved by the Egyptians.

The epic is hailed as teaching universal truths and values, but much of the detail is devoted to the rituals and violence of war in the ancient world of the heroic age. Early on, in Book 2, we meet the wrathful Bhima, the second brother of the Pandavas who has been insulted by the Kaurava warrior Duhsasana and vows revenge. In Book 8, we find Karna and Bhima on the same battlefield:

READING 5.1 KRISHNA DVAIPAYANA VYASA

The Mahabharata, Book 8, passage 48

During the fighting on that day there was a dreadful and thrilling battle between Karna and the Pandavas which increased the domain of the god of Death. After that terrible and gory combat only a few of the brave Samsaptakas survived. Then Dhrstadyumna and the rest of the Pandavas rushed towards Karna and attacked him. As a mountain receives heavy rainfall, so Karna received those warriors in battle. Elsewhere on the battlefield Duhsasana boldly went up to Bhima and shot many arrows at him. Bhima lept like a lion attacking a deer, and hurried towards him. The struggle that took place between those two, incensed against each other and careless of life, was truly superhuman.

Fighting fiercely, Prince Duhsasana achieved many difficult feats in that duel. With a single shaft he cut off Bhima's bow; with six shafts he pierced Bhima's [chariot] driver. Then,

without losing a moment he pierced Bhima himelf with many shafts discharged with great speed and power, while Bhima hurled his mace at the prince. With that weapon, from a distance of ten bow-lengths, Bhima forcibly dislodged Duhsasana from his car. Struck by the mace, and thrown to the ground, Duhsasana began to tremble. His charioteer and all his steeds were slain, and his car too was smashed to pieces by Bhima's weapon.

Then Bhima remembered all the hostile acts of Duhsasana towards the Pandavas. Jumping down from his car, he stood on the ground, looking steadily on his fallen foe. Drawing his keen-edged sword, and trembling with rage, he placed his foot upon the throat of Duhsasana and, ripping open the breast of his enemy, drank his warm lifeblood, little by little. Then, looking at him with wrathful eyes, he said, "I consider the taste of this blood superior to that of my mother's milk, or honey, or ghee[2], or wine, or excellent water, or milk, or curds, or buttermilk."

All those who stood around Bhima and saw him drink the blood of Duhsasana fled in terror, saying to each other, "This one is no human being!" Bhima then said, in the hearing of all those heroes, "O wretch among men, here I drink your lifeblood. Abuse us once more now, 'Beast, beast,' as you did before."

The Mahabharata is the ancestral narrative of the Indian people, but within it is one of their most well-known religious and philosophical texts—the Bhagavad Gita. Much of what the West knows about Hinduism—the religion of the majority of Indians today—comes from this text.

Aryan culture had brought to the Indus Valley strict societal class distinctions between the nobility and the common people. Over time, this distinction developed into a **caste system** that separated society into distinct strata and went hand in hand with religious beliefs. Societal rank was hereditary, and movement from one rank to a higher one (or lower one) was believed to be connected to good or bad deeds during one's lifetime. In the next life, one might be better—or worse—off. The caste system was also endogamous, meaning that one could marry only within one's caste. At the top level were the *Brahmins* (priests), followed by *Kshatriyas* (warriors), *Vaishyas* (merchants and landowners), and *Kshudras* (commoners, peasants, and servants), and finally the *Dalit*, the "untouchables" who did all the lowest-level work and were subordinate to all other castes. The untouchables, also called the *outcasts* (literally, out of caste), performed menial tasks that other castes shunned (cleaning latrines or sweeping streets, for example). The caste system was one of the shaping social forces in India, reinforced by many laws concerning ritual purity, marriage, and even who could eat with whom.

2. A substance having the consistency of clarified butter.

The Birth of Two Religions

Hinduism and Buddhism—two of the world's major religions—began in South Asia. Hinduism is generally thought to be the world's oldest organized religion (dating in some form to about 1500 BCE); today it is the third largest after Christianity and Islam. Buddhism is the fourth largest, but it only has about one-third as many followers. Hinduism emerged from the Aryan religion, while Buddhism traces its roots to one founder—the Buddha. Both religions believe in the cycle of birth, death, and rebirth; escape from this cycle (or cessation, from the word *cease*) is called "moksha" by Hindus and "nirvana" by Buddhists.

Unlike Judaism, Christianity, and Islam, Hinduism and Buddhism are not monotheistic religions.

Hinduism

The word *Hindu* derives from a Persian term meaning "those who live beyond the Indus River" (in Sanskrit, the Sindhu River). The Hindu religion, which was an outgrowth of the elaborate Aryan religious system, combined a highly ritualized worship of a vast pantheon of gods with a strong speculative tradition that tries to grasp the ultimate meaning of the cosmos and those who dwell in it. Indian religion, in short, is a religion of the priest and the temple, as well as a religion of solitary meditation and study.

The three most important Hindu deities are the gods **Vishnu**, **Shiva**, and **Brahma**. Vishnu is regarded as the preserver of the universe. Shiva is known as the Lord of Lords and god of creation and destruction, which in Hindu philosophy are one and the same (see **Fig. 5.4**). In the Bhagavad Gita, Shiva says, "Now I am become Death, the destroyer of worlds." (J. Robert Oppenheimer, an American physicist and so-called "Father of the Atomic Bomb," said he thought of Shiva's words after he witnessed the world's first test of the weapon in 1945.) Brahma, the god of creation, is also portrayed as the goddess Devi or Deva, whose name means "shining one." The goddess Devi was seen as gentle and approachable, sometimes as "Mother of the Universe."

Most Indian homes to this day have a small altar for a god or goddess, in order for the family to show respect and worship in the home. The fundamental aim of Indian religion, however, is to find the path that leads one to correct knowledge of ultimate reality, which, when known, leads one to be liberated from the illusory world of empirical reality and be absorbed into the one true reality, *brahman*.

Broadly speaking, three paths have been proposed for attaining such knowledge:

Asceticism The path or discipline (that is, yoga) of asceticism (fasting, nonpossession, bodily discipline, and so on), in which one lives so that the material world becomes accidental and that person becomes enlightened. This is the hardest path of all, which, if at all undertaken, usually comes after one has had a normal life as a householder.

Karma The path or discipline of **karma**, in which one does one's duty according to one's caste obligations (for example, priests should sacrifice, warriors fight) and not out of greed or ambition—motives that cloud the mind.

The *Brihad-Aranyaka Upanishad* (ca. 8th century BCE), speaks of karma in the Supreme Teaching:

> According as a man acts and walks in the path of life, so he becomes. He that does good becomes good; he that does evil becomes evil. By pure actions he becomes pure; by evil actions he becomes evil.
>
> And they say in truth that a man is made of desire. As his desire is, so is his faith. As his faith is, so are his works. As his works are, so he becomes. It was said in this verse: A man comes with his actions to the end of the determination.
>
> Reaching the end of the journey begun by his works on earth, from that world a man returns to this world of human action.
>
> Thus far for the man who lives under desire.

Devotion The path of devotion, in which all people refer all of their deeds as an act of devotion to the gods or to the one god to whom a person has a special devotion. By doing everything out of devotion, one does not fall into the trap of greed or self-centeredness.

THE BHAGAVAD GITA The **Bhagavad Gita** ("Song of the Lord") is a Sanskrit poem of 700 verses organized into 18 chapters. It is hailed as the great scripture of the Hindu religion. It is said to have inspired the contemporary Indian leader Mahatma Gandhi (1869–1948), who advocated civil disobedience rather than force to counter the occupying British, and it is well known in the West. The Bhagavad Gita may originally have been an independent philosophical poem, but it was placed in the sixth book of the Mahabharata, at the beginning of hostilities. Its tone is completely different from that of the warfare that follows.

Reading 5.2 (see page 172) recounts a dialogue between Arjuna, a champion of the Pandavas, and his charioteer, Krishna. Arjuna is reluctant to bring his weapons to bear against his kinsmen, who, after all, include relatives and teachers, and he halts his chariot between the opposing forces. Krishna, however, who is actually an incarnation of the preserver god Vishnu, will tell Arjuna that it is his sacred duty (dharma) to fight, because action performed as a sacred obligation will lead to the emancipation of his spirit and release him from the dreaded cycle of karma and rebirth.

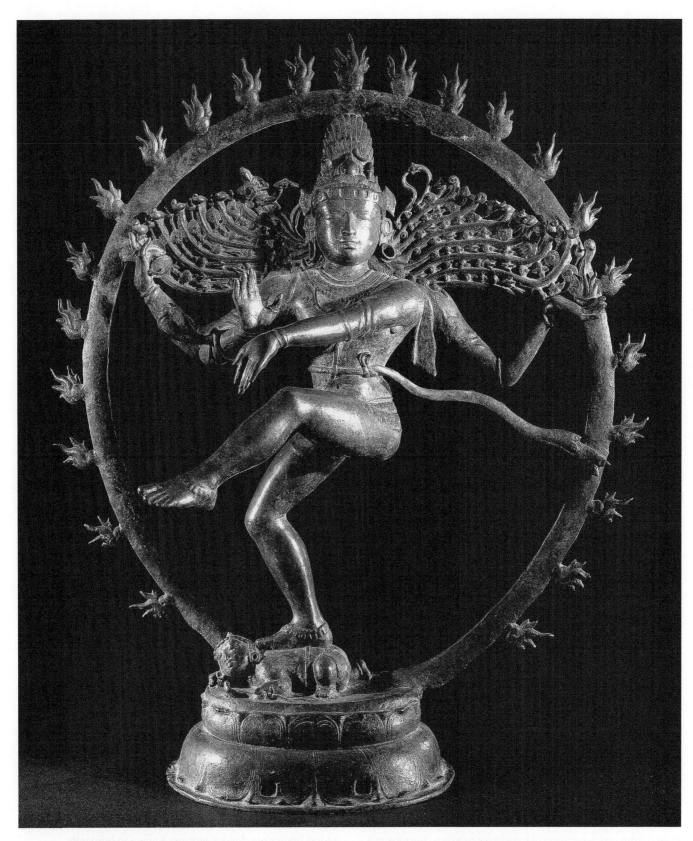

▲ **5.4 Shiva as Nataraja, the King of Dance, from Tamil Nadu, India, c. 1100. Bronze, 2' 11¼" high.**
British Museum, London. With one foot on the Demon of Ignorance, Shiva dances within a fiery aura. His
periodic dance destroys the universe, which is then reborn. Thus, in Hindu belief, the human spirit is reborn after
death, its new form reflecting the sum of the virtues of its previous existences.

READING 5.2 THE BHAGAVAD GITA

From the First Teaching

Arjuna saw them standing there:
fathers, grandfathers, teachers,
uncles, brothers, sons,
grandsons, and friends.

He surveyed his elders
and companions in both armies,
all his kinsmen
assembled together.

Dejected, filled with strange pity,
he said this:
 "Krishna, I see my kinsmen
gathered here, wanting war.
My limbs sink,
 my mouth is parched,
 my body trembles,
 the hair bristles on my flesh.

The magic bow[3] slips
from my hand, my skin burns,
I cannot stand still,
 my mind reels.

I see omens of chaos,
Krishna: I see no good
in killing my kinsmen
in battle.

Krishna, I see no victory,
or kingship or pleasures.
What use to us are kingship,
delights, or life itself?
. . .
They are teachers, fathers, sons,
and grandfathers, uncles, grandsons,
fathers and brothers of wives,
and other men of our family.
. . .
How can we ignore the wisdom
of turning from this evil
when we see the sin
of family destruction, Krishna?"

From the Second Teaching
Lord Krishna (speaks):

"You [Arjuna] grieve for those beyond grief,
and you speak words of insight;
but learned men do not grieve
for the dead or the living.
Never have I not existed,[4]
nor you, nor these kings;
and never in the future
shall we cease to exist.

Just as the embodied self
enters childhood, youth, and old age,
so does it enter another body;
this does not confound a steadfast man.

Contacts with matter make us feel
heat and cold, pleasure and pain.
Arjuna, you must learn to endure
fleeting things–they come and go!
. . .
Our bodies are known to end,
but the embodied self is enduring,
indestructible, and immeasurable;
therefore, Arjuna, fight the battle!
. . .
Look to your own duty (dharma);
do not tremble before it;
nothing is better for a warrior[5]
than a battle of sacred duty."

The elaborate religious system of the Aryan culture placed enormous emphasis on ritual sacrifice to the pantheon of gods. The fact that the priests had the highest place in the caste system was a result of their responsibility in carrying out the religious ceremonies in honor of the gods. Highly complex in their detail, the rituals had to be carried out exactly according to tradition in order for the ceremonies to attain their goal (for example, the fertility of the soil, the arrival of the rains, and so on). These ceremonies and their companions—hymns and gestures—were passed from one generation of hereditary priests to the next in a fixed oral form beginning at around 1500 BCE to 1200 BCE. It was only around 300 BCE that these texts were committed to writing in a compilation that is now known as the Vedas, with the best-known of these compilations called the *Rig-Veda*. The Vedas represent the oldest strain of Indian religious literature and are still chanted by Hindus at all important moments in Indian religious life: at birth, naming ceremonies, rites of passage to adulthood, in sickness, and at death. They also form the core text of Hindu temple worship. The Vedas, in fact, represent one of the oldest bodies of religious writings known to humanity.

3. A bow he won from the fire god.

4. Krishna is a god, but he is also referring to reincarnation, as we shall see.

5. Fighting is not a choice for Arjuna; he belongs to the warrior class.

THE *RIG-VEDA* The **Rig-Veda** comprises a collection of 1028 hymns to the gods written in verses. Some were meant for use during religious ceremonies; some were meant to address deep philosophical and religious questions, such as the origins of the universe and of the social order. Hymn 129 from Book 10 of the *Rig-Veda*, containing seven verses, addresses the creation of the universe and tries to approach certain philosophical questions: If something cannot emerge from nothing, what was the first something, the "prime mover"? And how could we hope to explain the origin of such a creator, and how and when a creator came into being?

say what might have happened? There is even questioning as to whether God created the universe or whether even God—who is unknowable—can understand how things came to be.

We saw that the Aryans brought a caste system to India, which divided society into castes of priests, warriors, laborers, and serfs (workers who were attached to the land and sold or bought by a feudal lord as part of a property). A hymn from the *Rig-Veda* that has come down to us as "The Sacrifice of the Primal Man" reinforces the religious belief in sacrifice as a creative event and justifies the social order. In this myth, the primal man is sacrificed to become the world, and the several castes emanate from different parts of his body:

READING 5.3 THE *RIG-VEDA*

"In the beginning"

1 Then neither Being nor Not-Being was,
 Nor atmosphere, nor firmament, nor what is beyond.
 What did it encompass? Where? In whose protection?
 What was the water, the deep, unfathomable?

2 Neither death nor immortality was there then, no sign of night or day.
 That One breathed, windless, by its own energy:
 Nought else existed then.

3 In the beginning was darkness swathed in darkness;
 All this was but unmanifested water.
 Whatever was, that One, coming into being,
 Hidden by the void,
 Was generated by the power of heat.

4 In the beginning this [One] evolved,
 Became desire, first seed of mind.
 Wise seers, searching within their hearts,
 Found the bond of Being in Not-being.

5 Their cord was extended athwart:
 Was there a below? Was there an above?
 Casters of seed there were, and powers;
 Beneath was energy, above was impulse.

6 Who knows truly? Who can here declare it?
 Whence it was born, whence this emanation.
 By the emanation of this the gods
 Only later [came to be].
 Who then knows whence it has arisen?

7 Whence this emanation hath arisen,
 Whether [God] disposed it, or whether he did not,—
 Only he who is its overseer in highest heaven knows.
 [He only knows,] or perhaps even he knows not!

READING 5.4 THE *RIG-VEDA*

From "The Sacrifice of the Primal Man"

1 A thousand heads had [primal] Man,
 A thousand eyes, a thousand feet:
 Encompassing the earth on every side,
 He exceeded it by ten fingers' [breadth].

2 [That] Man is this whole universe,
 What was and what is yet to be,
 The Lord of immortality
 Which he outgrows by [eating] food.

 . . .

3 With three-quarters Man rose up on high,[6]
 A quarter of him came to be again [down] here:[7]
 From this he spread in all directions,
 Into all that eats and does not eat.

 . . .

4 When with Man as their oblation[8]
 The gods performed their sacrifice,
 Spring was the melted butter,
 Summer the fuel, and the autumn the oblation.

 . . .

8 From this sacrifice completely offered
 The clotted ghee was gathered up:
 From this he fashioned beasts and birds,
 Creatures of the woods and creatures of the village.

 . . .

10 From this were horses born, all creatures
 That have teeth in either jaw;
 From this were cattle born,
 From this sprang goats and sheep.

11 When they divided [primal] Man,
 Into how many parts did they divide him?
 What was his mouth? What his arms?
 What are his thighs called? What his feet?

Many scholars have compared these verses to the book of Genesis. In both we begin with nothing. We have concepts of darkness and of the deep, the unfathomable. In both, something that cannot be understood by the human mind—here referred to as "that One" or "this One"—somehow breathed and created the world. But there is a questioning in the *Rig-Veda* version that we find nowhere in Genesis. Can humans truly imagine or

6. Three-quarters of primal man became divine beings who dwell in heaven.
7. One-quarter of primal man became beings on the earth.
8. The act of making an offering.

12	The Brahman[9] was his mouth,
	The arms were made the Prince,
	His thighs the common people,
	And from his feet the serf was born.
13	From his mind the moon was born,
	And from his eye the sun,
	And from his mouth Indra[10] and the fire,
	From his breath the wind was born.
14	From his navel arose the atmosphere,
	From his head the sky evolved,
	From his feet the earth, and from his ear
	The cardinal points of the compass:
	So did they fashion forth these worlds.

THE UPANISHADS Shortly after the composition of the *Rig-Veda*, a new kind of literature came into being. The sages of India were interested in the large questions of what we would call philosophical issues, for example: What caused the cosmos to be? How did human beings arise? Why is human life short? Why do people suffer? What is the deep meaning behind the priestly rituals and sacrifices? The responses to these and similar questions are treated in a series of classical Indian texts known as the **Upanishads** (meaning a "session," that is, from a learned person). We possess more than 100 Upanishadic texts, which vary in length and sophistication. Some deal with the allegorical meaning of ritual, whereas others are more philosophical in nature. They even memorialized an early view of dreams as a form of wish fulfillment:

READING 5.5 DREAMS

The *Brihad-Aranyaka Upanishad* (8th–7th century BCE), the Supreme Teaching

When the Spirit of man retires to rest, he takes with him materials from this all-containing world, and he creates and destroys in his own glory and radiance. Then the Spirit of man shines in his own light.

In that land there are no chariots, no teams of horses, nor roads; but he creates his own chariots, his teams of horses, and roads. There are no joys in that region, and no pleasures nor delights; but he creates his own joys, his own pleasures and delights. In that land there are no lakes, no lotus ponds, nor streams; but he creates his own lakes, his lotus ponds, and streams. For the Spirit of man is Creator.

According to the Upanishads, the ultimate reality is an impersonal reality called **brahman**. Everything else is a manifestation of this underlying reality. Each individual person has brahman within the self, which, in a person, is called **atman**.

The secret of life is to come to the knowledge that brahman is the ultimate reality (that is, one's inner self is part of this fundamental reality) and everything else is, in a certain fashion, permeable and unreal. This fundamental assertion is summed up in a classical Sanskrit expression *Tat tvam asi*: "You (the individual) are that (the eternal essence or brahman)."

Unlike Judaism, Christianity, and Islam—and unlike India's other major religion, Buddhism—the Hindu religion has no founder, no prophet.

Buddhism

Siddhartha Gautauma, the person who came to be called Buddha, was born to the ruling class of a clan in the foothills of the Himalayas in what is present-day Nepal. Most historians give his dates as about 563-483 BCE, although they are not known for certain. Raised in luxury, he married young and fathered a son. When he was not yet 30, he traveled outside his palatial quarters and witnessed the human misery (beggars, a corpse, a sick person, and a wandering, begging ascetic) that led to his contemplation of the inevitability of suffering and death, and to his wandering life as an ascetic practitioner of meditation and self-denial. According to Buddhist tradition, he visited learned men, undertook meditation, and practiced fasting and self-deprivation. At age 35, frustrated by his lack of insight, he sat under the shade of a Bodhi tree until he intuited the truth about existence. At the climax of this long vigil, he received the illumination that led to his title, Enlightened One (Buddha). He left his spot and went to the Deer Park at Sarnath, near what is present-day Benares (Varanasi), to preach his new doctrine in his first sermon outlining the "Middle Way" between extreme asceticism and self-indulgence.

These milestones in the life of Buddha are captured in a very early pictorial narrative from the Gandhara region of India (**Fig. 5.5**). Viewing the work from left to right, Buddha appears four times. In the first section, he is a newborn infant who has just emerged from the hip of his mother, Queen Maya. We next see him as an adult sitting beneath the leafy branches of a tree in Bodh Gaya in a pose that will become typical. From there, we move to another image of the Buddha sitting on a pedestal bearing an image of the Wheel of the Law under a leafy canopy in the Deer Park. It is from here that he preaches his first sermon on the Four Noble Truths, as we see in the Religion feature on page 176.

Buddhism preaches liberation through knowledge, and typical figures that represent Buddha make this point forcefully: As in the Gandhara relief, Buddha typically sits in a meditative pose with eyes half-closed and a slight smile, signifying the discovery within himself of the ultimate truth that has enlightened him. Buddha does not look up to the heavens to a god or kneel in worship. Truth comes from within.

THE EMPEROR ASHOKA When Buddha died around 483 BCE, his religious tradition was one of many that circulated within India. That situation was to change through the efforts of

9. The eternal ultimate reality, incapable of being understood by humans.
10. A chief Vedic god associated with rain and thunder.

◀ **5.5** **The life and death of the Buddha, frieze from Gandhara, Pakistan, second century CE. Schist, 2' 2⅜" × 9' 6⅛". Freer Gallery of Art, Washington, DC.**
Top: The Buddha's birth and enlightenment at Bodh Gaya.
Bottom: The first panel on the left shows the Buddha delivering the First Sermon at Samath. The last panel of the relief shows Buddha as he lay dying amidst his followers, in a state of paranirvana, or nirvana-after death.

perhaps the greatest emperor of ancient India: Ashoka. He was a superb and ruthless ruler who unified India (including such faraway places as Afghanistan and Baluchistan) around 261 BCE. However, Ashoka was appalled by the suffering and bloodshed he had caused in this enterprise. Out of remorse, he converted from traditional Hinduism to Buddhism and, out of his Buddhist conviction, began to preach the doctrine of nonviolence in his empire. Although tolerant of all religious traditions, he established Buddhism as the religion of the state. He mitigated the harsh laws of the empire, regulated the slaughter of animals, founded and sustained Buddhist monasteries (called **sanghas**), and erected many **stupas**—those characteristic domed buildings found in Buddhist lands.

After his death, Buddha's cremated remains were reportedly placed in stupas in eight different locations in India. These sites became places of worship and devotion for his followers. The Great Stupa at Sanchi (**Fig. 5.6**) was completed in the first century CE. The stupa is crowned by a large dome

▲ **5.6** **Great Stupa, third century BCE–early first century CE. Sanchi, India. 65' (19.8 m) high.** The shape of the stupa develops from the ancient practice of building a hemispherical mound atop the remains of the deceased. It is believed that eight such stupas serve as reliquaries for Buddha. They may also be repositories of Buddhist texts.

that symbolizes the sky. The dome is visually separated from the base of the structure by a stone railing or fence—known as the *vedika*—echoing the separation of the heavenly and earthly

RELIGION

The Four Noble Truths of Buddhism

Prince Siddhartha Gautama was born to wealth. His father, a king, sought to protect him from the miseries of the world and kept him cloistered. He married a beautiful woman and had a son. But then he came upon the world outside and witnessed suffering in the forms of poverty, hunger, violence, and disability.

Gautama left the chains of comfort to search for enlightenment as to why suffering existed and how it could be ended. He tried conventional forms of meditation and they accomplished nothing. He tried asceticism. He and five followers starved themselves on the banks of the Nairanjana River for six years, but then he discovered that austerity would not lead to wisdom. His followers were disgusted by his apparent failure and deserted him.

He moved toward the village of Senani, where he was offered milk by a Brahmin girl and a mat from a grass cutter. The Buddha-to-be seated himself beneath a pipal tree, where he resolved to remain until he found enlightenment—from within. His body might shrivel, he declared. His skin, flesh, and bones might dissolve. But he would not move.

Myth would have it that Māra, the Lord of Illusion, was threatened by Gautama's imminent enlightenment and sought to distract him. Gautama touched the earth, calling upon it to bear witness to the countless cycles of death and rebirth—*reincarnation*—that had led him to this place. The earth shook to confirm his assertion, and Māra unleashed demons. An epic battle ensued, during which Gautama finally saw through illusion and perceived truth. The weapons of the demons were transformed into flowers, and Māra fled.

There was no claim of revelation or divine inspiration as in Western religions. For Gautama, now the Buddha (the Enlightened One), four noble truths had come from within:

One: Life is suffering (**dukkha**). We may feel happy for a while, but happiness is transitory. At some point, we experience pain, decay, and all-pervasive suffering. Death is not a cure because of **reincarnation**: we will be born into a different body, but that body will also suffer.

Two: The causes of suffering are attachment, anger, and ignorance. We are attached to sweets, to life itself. Harming others will recoil into harming ourselves. Ignorance? Reality is not as it seems, and realization of ultimate truth is difficult.

Three: Suffering can end if we enter **nirvana**, a state beyond suffering. Suffering is dependent on the state of the mind; by changing the way one perceives the world and the self, one can end suffering.

Four: One can help others and end suffering via the eightfold path:

By avoiding jealousy, the desire to harm others, and wrong views (right thought)

By avoiding lying, harsh speech, and gossip (right speech)

By avoiding killing, stealing, and sexual transgressions (right actions)

By making a living without hurting others, lying, or committing crimes (right livelihood)

By developing wisdom (right understanding)

By persevering in our endeavors (right effort)

By focusing on the "here and now," not what was or what might be (right mindfulness), and

By maintaining a calm, attentive state of mind (right concentration)

spheres. Pilgrims circumnavigate the mound in a clockwise direction, as if tracing the path of the sun across the sky. The worshippers' relationship to the monument concentrates on the exterior rather than the interior as, for example, in the case of the Christian church.

The bracket figure (**Fig. 5.7**) on a gateway to the Great Stupa is a **yakshi**, a pre-Buddhist goddess who was believed to embody the generative forces of nature. She appears to be nude, but a hemline reveals that she wears a diaphanous garment. Her ample breasts and sex organs symbolize the force of her productive powers. The voluptuousness of such figures stands in contrast to the often ascetic figures we find in Western religious art.

In addition to stupas, Ashoka erected pillars and towers with his decrees carved on them, some of which exist to this day. Finally, Ashoka is credited with calling a vast Buddhist convocation to fix the canon of sacred books for Buddhism (that is, the authoritative list of writings that are the measure or canon of Buddhist belief and practice).

Perhaps Ashoka's most important contribution to the spread of Buddhism was sending Buddhist monks as missionaries throughout India and beyond to share Buddhist

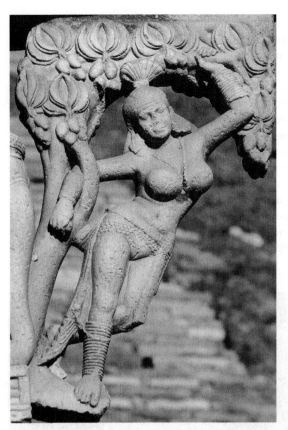

◀ **5.7 *Yakshi* sculpture on the east *torana* (gateway) at the Great Stupa, Sanchi, India.** In Indian mythology, yakshis were a class of benevolent nature spirits who guard treasures hidden in the earth and among the roots of trees. This yakshi is intended to secure favorable conditions at the site of the stupa. Four such gateways face the four directions around the building. This yakshi figure is a tree spirit who was believed to usher in spring by kicking the trunk of a tree while breaking a branch off, thereby stimulating the tree to blossom. The yakshi and the elephants symbolize the passageway from the profane world outside the stupa to the sacred space within.

wisdom. There is evidence that his missionaries went as far as Syria, Egypt, and Greece. One of his most important missions was sending a blood relative (perhaps a son or a brother) to Ceylon (present-day Sri Lanka), where the Buddhist doctrine took root and then spread to other parts of Asia (see **Map 5.2**). Although Buddhism—like all major religions of the world—has a variety of forms and different cultural expressions, at its core is the code enshrined in the Buddha's Four Noble Truths. It is one of the small ironies of history that Ashoka, the emperor of all of India, spread Buddhism all over the East, while in his native India, Buddhism would shrink in time to a small minority, which is the situation at present.

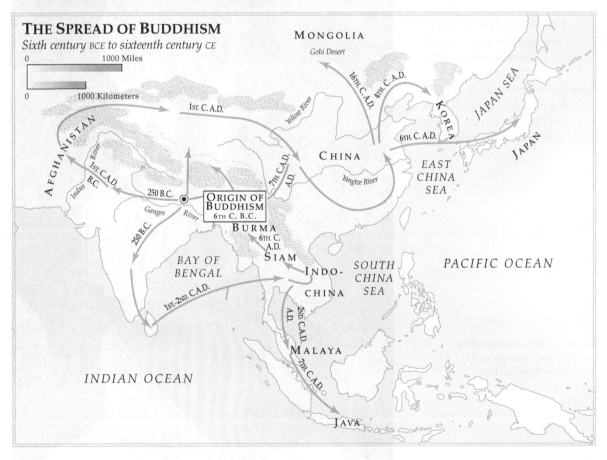

THE SPREAD OF BUDDHISM
Sixth century BCE *to sixteenth century* CE

▲ **MAP 5.2 The Spread of Buddhism.**

Hindu and Buddhist Art

There is little evidence for artistic production in the period following the disappearance of the Indus Valley people. Only with the reign of Ashoka does a tradition of large-scale sculpture and architecture begin to appear, probably influenced by developments to the west, in Persia. Ashoka erected large monolithic pillars, 30 to 40 feet high, each carved from a single piece of stone. They were planted deep in the ground so as to connect the earth and the sky and create an "axis of the universe" that would become a key theme in Buddhist architecture. The pillars stood along pilgrimage routes to meaningful sites in Buddhism. The pillars were capped with embellished capitals which, like the columns themselves, were carved from single blocks of stone. A pillar was erected at Sarnath, where the Buddha delivered his first sermon (Fig. 5.8). Although the style of the pillar resembles similar works found at Persepolis, the capital of Persia, its symbolism is Buddhist. Two pairs of lions stand back to back, facing the four cardinal directions of the world. Their open mouths would appear to trumpet the message of the Buddha.

Both Hindu and Buddhist art are overwhelmingly religious in spirit. The great statues and sculptural reliefs that decorate the temples are narrative, telling the stories of the Hindu deities and the life of Buddha to their worshippers. The difference between the two styles of art reflects the differing characteristics of the two faiths.

Hindu temples are considered to be the dwelling places of the gods, not houses of worship. The proportions of the Vishvanatha Temple at Khajuraho (Figs. 5.9A and 5.9B) symbolize

cosmic rhythms. The gradual unfolding of spaces within is highlighted by the sculptural procession of exterior forms. The organic, natural shapes of the multiple roofs are in most sections separated from the horizontal registers of the base by sweeping cornices. The main tower is an abstracted mountain peak, reached visually by ascending what appear to be architectural and natural hurdles. All of this can be seen as representing human paths to oneness with the universe. Much of Hindu art is openly erotic, reflecting the belief of pious Hindus that sexual union represents union with their gods; the registers of the base of the temple are populated by high reliefs of gods, allegorical scenes, and idealized men and women in erotic positions (Fig. 5.10).

Scenes from the Mahabarata and other great Hindu epics combined elements of naturalism and eroticism, as in *Krishna*

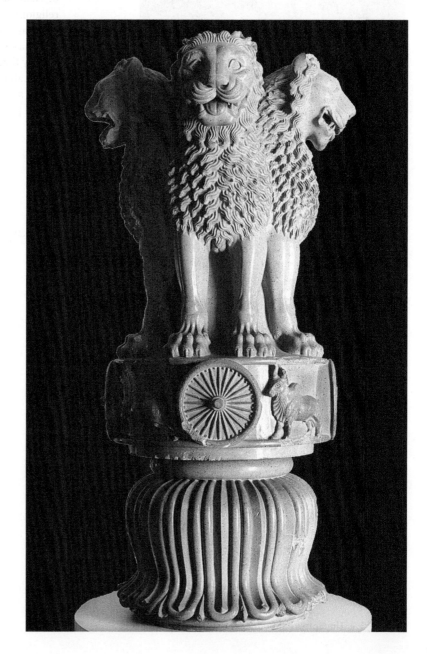

▶ **5.8 Lion capital, from a column erected by Ashoka, 242–232 BCE. Polished sandstone, 84" (213 cm). Sarnath Museum, Uttar Pradesh, India.** One of a series of columns set up during Ashoka's reign, this capital comes from Sarnath, where Buddha preached his first important sermon. The wheel on the base represents the Wheel of the Law, and the four small animals (one is visible here) symbolize the four corners of the earth. The lions crowning the column originally bore a wheel on their backs.

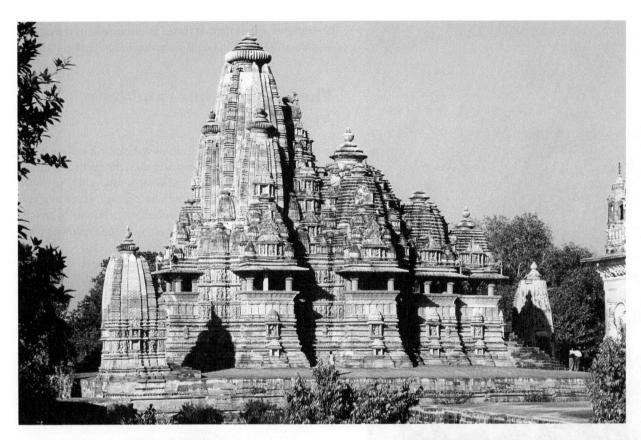

▲ **5.9A Vishvanatha Temple, ca. 1000 CE. Khajuraho, India.** This type of temple is characteristic of Hindu temples in northern India. The organically shaped towers of ascending height symbolize the way in which the foothills of the Himalayas rise gradually to their peak, the home of the god Shiva. Vishvanatha is another name for Shiva.

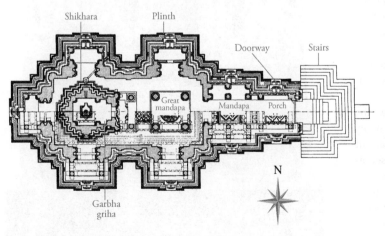

▲ **5.9B Plan of the Vishvanatha Temple, Khajuraho, India, ca. 1000.** Beneath the shikara is the cave-like garbha griha, which contains an image of the deity. Only priests are permitted to enter this inner sanctuary.

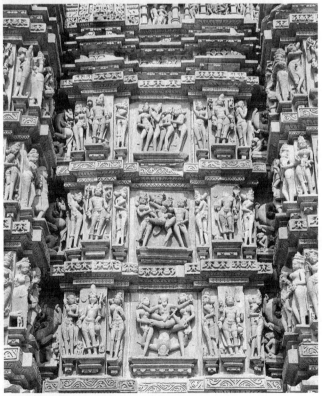

▲ **5.10 Reliefs, detail of the north side of the Vishvanatha Temple, ca. 1000 CE. Khajuraho, India.** The openly erotic subjects of many of these reliefs illustrate the close link for the Hindu culture between amorous and religious ecstasy. These and similar sculptures were always placed on the outside walls of the temples.

▲ **5.11 Krishna and Radha on a Canopy, 1825. Indian miniature, gouache on paper, 9" × 7" (22.8 × 18.0 cm). Musée national des arts asiatiques Guimet, Paris, France.** In this scene from the Mahabharata, Krishna, who is regarded by the followers of Vishnu as another incarnation of the god, is easily recognizable by the blue color of his skin.

face exhibits a pleasant cast that is as inscrutable as the expression of La Gioconda in Leonardo's *Mona Lisa* (see Fig. 13.4).

The Gupta Empire and Its Aftermath

In the years following the death of Ashoka, his empire began to fall apart, and a series of invaders from the north established small kingdoms in the Indus and Ganges valleys. These northerners never penetrated the southern regions, where numbers of small independent states flourished economically by trading with Southeast Asia and, to the west, with the expanding commercial power of the Roman Empire.

Only in 320 CE did Chandra Gupta I lay the foundations of a new large-scale kingdom, known as the Gupta Empire, which reached its zenith under his grandson, Chandra Gupta II (ruled ca. 380–415 CE). Known as "The Sun of Power," Chandra Gupta's reign was famous for its cultural achievements, economic stability, and religious tolerance. As a Buddhist monk noted, "The people vie with each other in the practice of benevolence

and Radha on a Canopy (**Fig. 5.11**). Here, Krishna, who is regarded as one of the many incarnations (**avatars**) of the supreme Hindu spirit, Vishnu, is easily recognized by the blue color of his skin. Other incarnations include fish, tortoise, and boar avatars, illustrating the Hindu sense of the unity of all forms of life. Interestingly, one of the 10 principle incarnations of Vishnu is Buddha, illustrating a mutual tolerance of religious differences.

In contrast to Hindu art, Buddhist art emphasizes the spiritual, even austere nature of Buddhist doctrines. For many hundreds of years, there were no images of the Buddha, but sculptures such as the Gandhara relief and other representations began to appear in the second century CE. Buddha and his many saints are shown as calm, often transcendent figures, inviting prayer and meditation. Some statues of Buddha display a Greco-Roman influence that can be traced to the conquest of northwestern India by Alexander the Great in 327 BCE. Others have a sensuous, rounded look that recalls the ancient seals and is decidedly Indian. The slender chlorite Buddha (**Fig. 5.12**) shows delicate fingers and gauzelike, revealing drapery. The

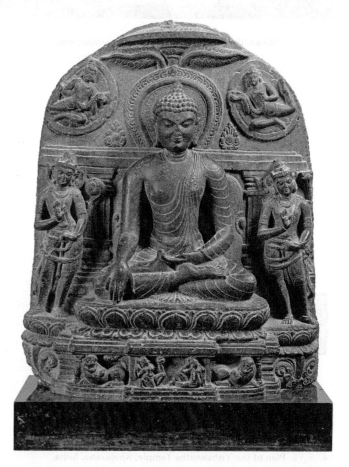

▲ **5.12 Buddha calling on earth to witness, 10th century CE (Pala period, 750–1197 CE). Bihar, India. Basalt, 18⅞" (48 cm) high. Musée national des arts asiatiques Guimet, Paris, France.**

and righteousness." Despite this general tolerance, however, the Gupta period saw the rapid decline of Buddhism in India and a return to the traditions of Hinduism.

GUPTA LITERATURE AND SCIENCE Literary skills assumed vast importance at the Gupta court, where poets competed with one another to win fame. The language they used was ancient Sanskrit, that of the old Hindu Vedas, which served as the literary language of the period; it was no longer spoken by the general population. The most famous of all classical Indian writers was Kalidasa (active ca. 400), who wrote plays, epics, and lyric poetry. His best-known work was the play *Sakuntala*, which describes the happy marriage of the beautiful Shakuntala to King Dushyanta, the marriage's collapse as a result of a curse pronounced by an irascible holy man, and the couple's eventual triumphant reunion. By contrast to the classical dramas of the Greek tradition, with their analysis of profound moral dilemmas, Kalidasa's play has the spirit of a fairy tale with a happy ending. The work of another author of the same period, Shudraka, is more realistic. Among the characters in his play *The Little Clay Cart* are a nobleman, a penniless Brahmin, a prostitute, and a thief who at one point offers a vivid description of his technique of housebreaking.

Under the Guptas, many important scientific discoveries were made possible by the foundation of large universities. The most important, at Nalanda, had some 5000 students who came from various parts of Asia. Among the subjects taught were mechanics, medicine, and mathematics. In this latter field, Indian scholars continued to make important advances. The system of so-called Arabic numerals, which only became widespread in Western Europe in the Renaissance (15th and 16th centuries), had first been invented in India in the late third century BCE. By the time of the Gupta Empire, Indian mathematicians were using a form of decimal notation, and the concept of zero may have been first employed at this time. Among their work in algebra were quadratic equations and the use of the square root of 2.

THE COLLAPSE OF GUPTA RULE The decline of the Gupta Empire, which began with the death of Chandra Gupta II, escalated with a series of invasions around 480–500 CE by the White Huns, a people related to the Huns and other Central Asian tribes. Around the same time, other related tribes moved westward from Central Asia and sacked Rome in 476 CE, thereby effectively ending the Roman Empire. The White Huns never managed to establish a secure power base in India, however, and over the following centuries, innumerable local princely states fought both among themselves and against foreign invaders. In part, the difficulty in constructing a central government and a lasting peace was caused by the powerful Hindu priestly class, who were unwilling to surrender conflicting religious interests to an overall secular, political settlement. When a new united Indian Empire did begin to develop in the 15th and 16th centuries, its rulers were Muslim, not Hindu.

CONNECTIONS Buddhism was one of Afghanistan's major religions prior to the arrival of Islam, having arrived in 305 BCE as a result of an alliance between the Maurya Empire (322–185 BCE) of India and the Greek Seleucid Empire (312–63 BCE). What resulted from this connection is what is called *Greco-Buddhism*, a hybrid of Buddhism and Hellenistic Greek culture that flourished in the Gandhara region of what is today northern Pakistan. The art that emerged from this hybrid culture blends Buddhist subjects with stylistic characteristics found in Greek statuary: the idealism of the Classical period and the sensuousness of the Hellenistic period. The monumental Buddhas of Bamiyan, a sixth-century site for Buddhist learning and pilgrimage in central Afghanistan, were a fine example. Carved into the area's sandstone cliffs in the first half of the sixth century CE, the details of the two bodies—one smaller, one larger—were modeled from a mixture of mud, straw, and stucco and painted in vibrant colors. The Buddhas were destroyed in March of 2001 after being declared "idols" by the Taliban government.

In June of 2015, a Chinese couple—Zhang Xinyu and Liang Hong—acquired permission from UNESCO and the Afghan government to fill the gaping niches with holograms of the destroyed statues using 3D light projection technology.*

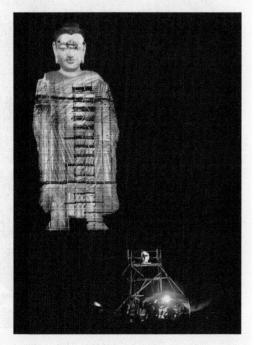

▲ 5.13 Holographic projections of one of the two Bamiyan Buddhas destroyed by the Taliban in 2001.

*Emily Chan, "Rebirth of the Buddha of Bamiyan," *Daily Mail*, accessed 2/16/16. http://www.dailymail.co.uk/news/peoplesdaily/article-3124580/Chinese-millionaires-create-amazing-175-foot-3-D-hologram-Afghan-Buddha-statue-destroyed-Taliban-bomb-blast.html.

COMPARE + CONTRAST

Ganesh, the Hindu Deity: Don't Leave Home Without Him

In Hinduism's vast pantheon of gods, one of the more familiar and beloved is the elephant-headed Ganesh. Also known as Ganesha or Ganapati, he is the son of Shiva, the most powerful of the Hindu deities, and Parvati, the goddess of power who gives energy to all beings. Ganesh is the Lord of Success—and the destroyer of evils and obstacles. He is also worshipped as the god of knowledge, wisdom, and wealth. Hindus interpret dreams of elephants as messages of transformation and divine power—the emergence of one's highest self from the collective unconscious mind.

▲ 5.15 **Statuettes sold during the Ganesh festival. Maharashtra, India.**

The distinctive form of Ganesh is seen in temple carvings, sculptures, miniature paintings, and any number and variety of small statuettes purchased by Hindus as votives. Ganesh is always visualized as a man with a pot belly, an elephant head with one tusk (the other is broken), and multiple arms (typically four) holding attributes that vary from one representation to another, including: a goad (a pointed instrument) used to prod humans toward proper goals, his broken tusk, prayer beads, an ax, a mace, a noose, a lotus flower, a seashell, a small water vessel, and more. He is also shown in many incarnations, as in an 11th-century stone sculpture (**Fig. 5.14**) in which he is dancing on a mouse, a tiny creature seen frequently in Ganesh iconography.

The immense popularity and importance of Ganesh, who is invoked at the start of any undertaking, is evidenced by the Hindu calendar's 10-day-long festival to the deity known as the Ganesh Chathurhi. In many places in India (and elsewhere throughout the world), elaborate celebrations include parades, performances, cultural events, and community activities centered around charitable giving. Thousands of plaster statues of Ganesh in all shapes and sizes (**Fig. 5.15**) are displayed and purchased for the decoration of public spaces and individual homes and, at the end of the festival, they are immersed in water—any water, whether a river, sea, or small bucketful (**Fig. 5.16**). Originally, Ganesh icons had been made of clay, which dissolved in water and symbolized the natural life cycle of birth and death. However, in this day and age, the celebratory practice has led to environmental problems like water pollution caused from toxic plaster and paint, as well as unsightly

▲ 5.14 **Dancing Ganesh (Ganesha), 11th century CE. North Bengal, India. Slate, 22⅛" × 9⅞" (56.5 × 25 cm). Museum für Asiatische Kunst, Berlin, Germany.**

◀ **5.16** Lord Ganesh idol being immersed in the sea at Girgaum Chowpatty, Mumbai, Maharashtra, India.

accumulations of nonbiodegradable plastic used for accessories to adorn the Ganesh icons.

The clash of age-old traditions with the perils and strains of contemporary life is also evoked in a painting (**Fig. 5.17**) by Prajakta Palav Aher from her Ganpati Series. Aher's is not an iconic representation of the deity such as might be found in a temple or shrine. Rather, Ganesh rides a well-worn commuter train—like anyone else shuttling to the city for a day's work—accompanying those who petition him for success and good fortune. In what may be interpreted as an allusion to the "rat race" to economic success in today's world, Ganesh has an air of exhaustion, as if he has just plopped down in his seat with all of the tools of his trade at the end of a long, long day. In a true manifestation of globalization, the Destroyer of Obstacles may be returning from the realm of outsourced troubleshooters managing worldwide software glitches and catching his breath before moving on to the next.

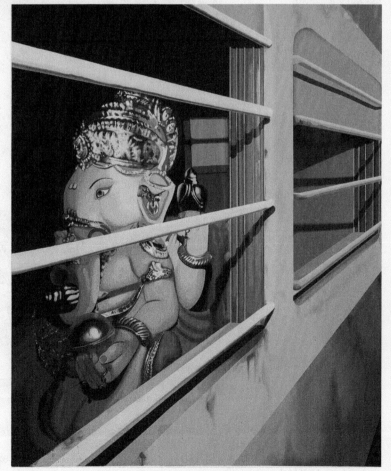

▶ **5.17** Prajakta Palav Aher, *Untitled I*, 2007 (Ganpati Series). Acrylic on canvas, 96" × 72" (243.8 × 182.9 cm).

SOUTHEAST ASIA

Hinduism and Buddhism—along with Indian culture—spread via trade from the South Asian subcontinent to another peninsula whose land mass is contiguous with China (present-day Myanmar, Laos, Thailand, Cambodia, and Vietnam), as well as to islands to the southeast comprising the modern nation of Indonesia (including Sumatra, Borneo, and Java; see Map 5.1). While the influence of India on Southeast Asian art and traditions is evident, the peoples of these areas combined them in interesting ways to achieve an idiosyncratic mode of expression.

Java

One of the most spectacular sites in Southeast Asia is found on the island of Java. The Buddhist monument, Borobudur

(Fig. 5.18), comprised of nine terraces ascending 98 feet to a large stupa, looks from the air like a three-dimensional **mandala** of colossal proportions. More than 500 life-sized statues of Buddha, twice as many relief sculptures, and more than 1500 stupas populate the harmonious, symmetrical structure that scholars believe was designed to be circumambulated and ascended by worshipping pilgrims.

It is not entirely clear what the function of the structure may have been, and there are no prototypes for it in either Hindu or Buddhist art in India, reinforcing the point that the peoples of Southeast Asia reinvented their assimilated traditions in imaginative ways.

Cambodia

As early as the seventh century, the Khmer people of Cambodia produced works of art that were influenced by Hindu and

▲ **5.18 Aerial view of Borobudur, Magelang, Central Java, Indonesia, ca. 750–825, approximately 400' each side and 98' high in the center.** The Buddhist structure has nine stacked platforms that take the form of a cosmic mountain. There are 1500 stupas.

▲ 5.19 Aerial view of Angkor Wat, Angkor, Cambodia, 9th–11th centuries. Rectangular; sides approximately 5000' × 4000'.

Buddhist imagery in Indian art. In 802, Jayavarman II (r. 802–850), a Khmer king, established the Angkor dynasty and for four centuries thereafter, a succession of Khmer rulers constructed palaces, temple complexes, and monasteries in Angkor—"Holy City"—the capital and cultural center of the empire. The most breathtaking of these is certainly Angkor Wat (**Fig. 5.19**), built by Suryavarman II (r. 1113–1150) to associate himself with his personal god, Vishnu, who (along with the king) is glorified in the vast sculptural program throughout. It is the largest religious structure in the world.

Set within a grid, Angkor Wat features perimeter and inner walls—both comprised of towers and galleries—surrounding a tall tower and four somewhat shorter ones that anchor the four corners of the central block. The five towers represent the peaks of the sacred Mount Meru—the center of the physical and spiritual universes. Many consider Angkor Wat to be the most magnificent architectural feat on the planet.

CHINA

In the late Neolithic period, the Longshan culture developed along the Yellow River in China, overlapping chronologically with both the Egyptian Old Kingdom and the Sumerian civilization of Mesopotamia. Excavations in China have revealed numerous settlements, along with pictographic carvings that some scholars have tied to early written language. As with other river civilizations, the Longshan is marked by the establishment of urban centers and the development of technology and the arts. Of particular interest are examples of finely wrought pottery, some of which was wheel-thrown. The distinctive black vessels were exceptionally thin walled, highly polished, and often decorated with elaborate patterns of incised lines (**Fig. 5.20**).

▶ 5.20 Black eggshell pottery, 3000–2000 BCE (Longshan culture). High-stemmed cup, 10⅜" (26.5 cm) high. Shandong Museum, Jinan, Shandong, China.

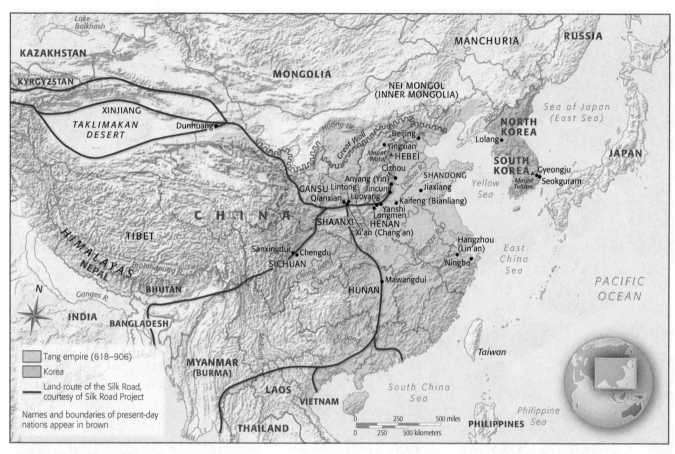

▲ **MAP 5.3 China during the Tang dynasty.**

During the years that the Shang dynasty (ca. 1520–1027 BCE; see **Map 5.3**) ruled China, Tutankhamen became pharaoh, the Mycenaeans lived in their fortified cities, and the Minoans decorated their elaborate palaces with brilliant frescos. The Shang dynasty, too, was a Bronze Age urban civilization ruled by kings who, as in Egypt, inherited their positions and who, like the pharaohs, claimed their authority from the divine. Trade and commerce began to develop. The Shang culture is known for its accomplished metalwork, including bronze weaponry, fittings for chariots, and sophisticated ceremonial vessels such as the one in **Figure 5.21**, which was discovered in a royal tomb. The two-headed fantastic animal is embellished with elaborate, stylized, linear detail that complements the curving shapes of the vessel. The casting technique perfected by Shang artisans consisted of pouring molten bronze into piece molds and, after casting, assembling the individual parts into a cohesively designed whole. The Shang royal tombs, as in Egypt and Mesopotamia, were filled with precious objects such as these.

The Zhou Dynasty

Around 1100 BCE, a new dynasty replaced the Shang—the Zhou (ca. 1046–221 BCE). Zhou rulers did not provide a strong central government but served as the coordinators of a series of separate kingdoms, each with its own local lord. The relationship of these local rulers with the Zhou emperors was often unstable. In times of trouble, they could supply the Zhou with military aid, but they frequently feuded with both the central authority and each other. Over time, Zhou influence began to diminish; the last period of their dynasty is known as the Warring States period (475–221 BCE). During these centuries of increasing crisis, the foundations of Chinese thought and culture were laid.

Confucianism and Daoism

Confucius (ca. 551–479 BCE) and Laozi (active ca. 570 BCE) founded the two chief schools of Chinese philosophy. Born in humble circumstances in central China at a time when local wars were raging, Confucius's chief aim was to restore the peace of earlier times by encouraging the wise and virtuous to enter government service. A state run by a wise ruling class, he believed, would produce similar characteristics in its people. To achieve this he traveled throughout China in search of pupils (**Fig. 5.22**).

and passivity. Its central concept is that of "the Way" (*dao*). According to this principle, one should follow one's own nature, not distinguishing between good and bad, but accepting both as part of the Way. The traditional founder of this school of philosophy, Laozi, an obscure, even legendary figure, is said to have lived around the time of Confucius. Many modern scholars, however, believe that the book that sets forth Laozi's teachings, *The Classic of the Way and Its Power* (*Daodejing*), was written two or more centuries after the death of Confucius, at some point in the third century BCE.

The followers of Daoism often expressed their ideas in obscure and frequently contradictory language. Their overriding concept is perhaps best illustrated by one of the central images of Daoist art: water. As it flows, water gives way to the rocks in its path, yet over time "the soft yield of water cleaves the obstinate stone." Humans should, in the same way, avoid participating in society or culture or seeking actively to change them. Far from sharing Confucius's mission to reform the world, the Daoists preached passivity and resignation. Worst of all was war, for "every victory celebration is a funeral rite."

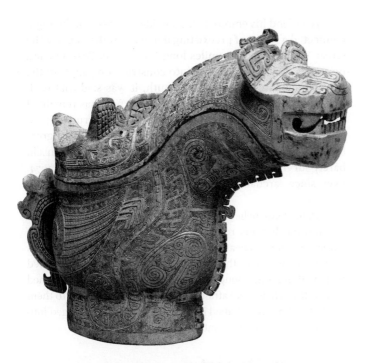

▲ 5.21 Ceremonial vessel (*guang*), 12th century BCE. Covered pouring vessel with tiger and owl decoration, cast bronze with green patina, 9¾" × 12⅜" × 4⅛" (25 × 31.5 × 10.6 cm). Arthur M. Sackler Museum, Harvard University Art Museums, Cambridge, Massachusetts.

According to the central dogma of Confucianism, the morally superior person should possess five inner virtues and acquire another two external ones. The five with which each virtuous person is born are righteousness, inner integrity, love of humanity, altruism, and loyalty. Those with these natural gifts should also acquire culture (education) and a sense of decorum or ritual. If individuals with these qualities served their rulers in government, they would be loyal and unconcerned with material rewards, yet fearlessly critical of their masters.

Traditional religion played no part in Confucius's teachings. He refused to speculate about the gods or the possibility of life after death; he is said to have commented, "Not yet understanding life, how can we understand death?" Confucius was a revolutionary figure in that he defended the rights of the people and believed that the state existed for the benefit of the people, rather than the reverse. At the same time, however, he strongly endorsed strict authority and discipline, within both the state and the individual family—devotion to parents, worship of ancestors, respect for elders, and loyalty to rulers were all crucial to the Confucian system. In the centuries following his death, many totalitarian regimes in China abused the innate conservatism of Confucius's teaching, using it to justify their assaults on the freedom of individuals.

If the central principle of Confucianism is the possibility of creating a new, virtuous social order, Daoism emphasized the limitations of human perceptions and encouraged withdrawal

▲ 5.22 Portrait of Confucius, ca. third century BCE. This image of Confucius is stylized rather than realistic. The wise old sage with a long beard and hands peacefully folded symbolizes the nature of Confucian teaching. There is no evidence of realistic portraiture from this period.

Both Confucianism and Daoism can be seen as reactions—albeit opposing ones—to the increasingly chaotic struggles of the later Zhou period. They were to remain powerful sources of inspiration over the succeeding centuries, and the tension between them played a large part in the evolution of Chinese civilization.

The Qin Dynasty

In the struggle for power in the last years of the Zhou period, one state emerged victorious. In 221 BCE, the king of the state of Qin succeeded in conquering all of his rivals and ruling them by means of a centralized government, thereby establishing the Qin dynasty—from which the word *China* is derived. He took the name of Shihuangdi ("First Emperor") and was remembered by later generations for the brutality of his conquests as much as the brilliant skill with which he organized his new empire.

He ordered the building of a magnificent capital city, Xian-yang (near modern Xi'an), and instructed leading noble families from the former independent kingdoms to move there, where they would be under his direct control and thus unable to lead revolts. No private citizen was allowed to possess weapons, and it was left to the imperial army to maintain order. The emperor divided his territory into 36 provinces and imposed a single writing system and standardized weights and measures. In order to check criticism, he ordered the destruction of all philosophical writings, the so-called Burning of the Books—including, of course, the works of Confucius—an action that his successors bitterly condemned.

To defend his empire from outside invaders, Shihuangdi connected a series of preexisting defensive walls to make the Great Wall, some 5500 miles long (**Fig. 5.23**). Peasants and prisoners of war were forced into construction gangs. In the extreme climates of north and south, it was said that each stone cost the life of a worker. The Great Wall has remained visible to this day; it is one of the few human structures on earth that can be seen from space. The emperor's other great building project, the massive tomb he designed for himself, barely survived his death and was only rediscovered in 1974. Ever since, archaeologists have been exploring its riches (**Fig. 5.24**).

Shihuangdi believed that he was creating an empire to last forever, but his ruthless methods ensured that his rule barely survived his death. One contemporary described him as "a monster who had the heart of a tiger and a wolf. He killed men as though he thought he could never finish, he punished men as though he were afraid he would never get round to them all." When Shihuangdi died in 210 BCE, the empire plunged into chaos as nobles and peasants alike ran riot.

The Han Dynasty

By 202 BCE, a new dynasty had established itself—the Han. It would rule China for the next four centuries. The first Han emperor, Gaozu (256–195 BCE), returned a degree of power to the local rulers but maintained the Qin system of provinces, with governors appointed by the central authority. In order to strengthen the imperial administration, Gaozu and his successors created an elaborate central bureaucracy. To reinforce their authority, the early Han emperors lifted the ban on philosophical works and encouraged scholars to reconstruct the writings of Confucius and others from the few surviving texts or from memory. With the emperor's encouragement, many of these reconstructions emphasized the need for loyalty to the emperor and a central bureaucracy, and omitted Confucius's emphasis on constructive criticism by virtuous observers.

◀ **5.23 The Great Wall of China, Qin dynasty. Roughly 5500 miles (8850 km) long, averaging 16–20' (4.9–6.1 m) wide × 16–26' (4.9–7.9 m) high, plus 13' (3.9 cm) at the watchtowers.** Wide enough for horsemen to ride along it, the Great Wall has been extended, repaired, and rebuilt many times since its first construction in the late 3rd century BCE.

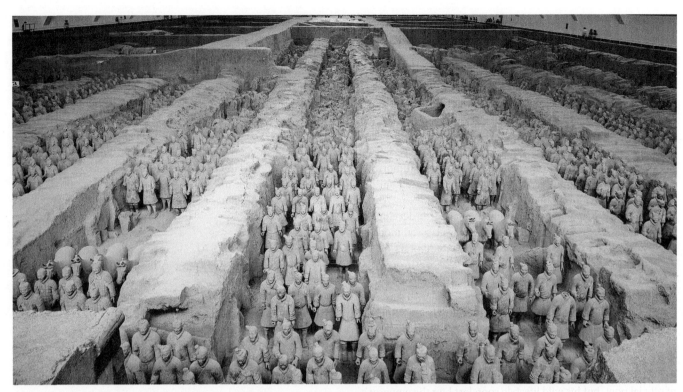

▲ **5.24 Army of Shihuangdi (First Emperor) in pits next to his burial mound, ca. 210 BCE (Qin dynasty). Painted terra-cotta, average figure height: 71" (180.34 cm). Lintong, China.** There are more than 8000 life-size clay warriors and horses, as well as bronze chariots and horses, in the excavation. The parts of the bodies (arms, torsos, legs) were made from a limited number of molds, but they were put together in many different combinations, with the result that no two figures are identical. The emperor's burial chamber has been located but remains unexcavated: Chinese archaeologists do not want to disturb it until they have developed more sophisticated archaeological techniques.

The Tang Dynasty

By the second century CE, the central government gradually lost its control over the provinces. The great aristocratic families began to take control, as successive emperors became paralyzed by internal feuding and plotting. In the ensuing civil war, the last Han emperor finally abdicated in 220 CE, only to plunge China into another extended period of confusion. Finally, in the early seventh century, the Tang dynasty (618–906 CE) managed to reunite China. The political and economic stability it created made possible a period of cultural achievement known as China's golden age.

The Song Dynasty

The Song dynasty reigned from 960 to 1279. Song emperors, interestingly, discontinued much of the practice of populating important government positions with hereditary ministers; instead, they instituted the equivalent of the modern civil-service examination to create a meritocracy. Ability and education therefore became as important as birthright. Perhaps as a result of the meritocracy, the Song dynasty became the technological trailblazer of the world—creating printing with moveable type

centuries before Gutenberg in Germany, gunpowder (which was eagerly adopted by Western visitors), and magnetic compasses as travel aids, particularly at sea when the stars were occluded by cloudy skies.

Classical Chinese Literature

With the notable exception of the period of Qin rule, literature played an important part in Chinese culture. As early as the Zhou period, standard texts known as the *Five Classics* circulated widely—Confucius may have been partly responsible for editing them. They included history, political documents such as speeches, and descriptions of ceremonies. The *Classic of Songs* contained more than 300 poems dealing with private life (love, the family) and public affairs. Because the Chinese language uses pitch and stress (inflections; the meanings of words and/or phrases change according to the way they are pronounced), poetry became especially popular, and any educated Chinese person was expected to memorize and recite classical verse.

Later generations drew inspiration from these classical texts, developing their themes and expressing new ideas based on familiar concepts. The introduction of Buddhism into China

during the Han dynasty provided a new subject for philosophical writing; during the years of chaos following the fall of the Han rulers, Buddhist texts provided consolation for suffering by offering eventual release from pain. The two main strains of Buddhism were *Mahayana*, the "Great Vehicle," and *Hinayana*, the "Lesser Vehicle." The first of these was less ascetic and more worldly than the second, and thus appealed more to those influenced by Confucianism. It also met with more favor in the eyes of the ruling class, although when the Buddhist monasteries began to grow in wealth and influence, the central authorities started to limit the number of monasteries permitted and to control the ordination of monks and priests.

During the Tang dynasty, a new literary form developed: the short story. Unlike the works inspired by classical models, these tales often provide a vivid picture of contemporary life.

LI BAI Many lovers of Chinese poetry consider Li Bai (701–762 CE) a leading Chinese poet of premodern times. He was famous in his day for his unique rapport with nature and his love of wine. He grew up in Sichuan province. After spending a few years as a hermit, he trained himself in the arts of the "wandering knight," protecting the weak and avenging injustices.

In 742, he was summoned to the emperor's court as a kind of official poet, but his wild lifestyle soon lost him the emperor's favor. He took to wandering, accompanied by a following of singing girls. For a while, he became involved with a rival to the imperial throne and was exiled, but he was then reprieved. He was married four times, but, as a contemporary remarked, "none detained him for very long."

His addiction to wine was legendary, celebrated in many of his poems. Like the Roman poet Horace, he also advised seizing the day:

> ### READING 5.6 LI BAI
>
> From "Bring the Wine"
>
> Have you never seen
> The Yellow River waters descending from the sky,
> Racing restless toward the ocean, never to return?
> Have you never seen
> Bright mirrors in high halls, the white-haired ones lamenting,
> Their black silk of morning by evening turned to snow?
> If life is to have meaning, seize every joy you can;
> Do not let the golden cask sit idle in the moonlight!
> Heaven gave me talents, and meant them to be used;
> Gold scattered by the thousand comes home to me again.
> Boil the mutton, roast the ox—we will be merry,
> At one bout no less than three hundred cups.

He was also interested in alchemy and what he called "spiritual journeys." He impressed his admirers with his spontaneous genius and his personal appearance: they called him the "banished immortal." For all the ups and downs of his career, he was not given to bitterness or despair; on the whole,

his poetry is calm and even sunny. His search for spiritual freedom and communion with nature were united with a deep sensitivity to the beauties of language. Today, the Chinese praise him for his "positive romanticism."

Inspired by Daoism, Li Bai preferred simple language and ignored the rules of the classical style. Impressing his contemporaries as much by his charisma and personal appearance as by his writings, he could produce poems of all kinds and lengths, and his unconventional lifestyle provided him with unlimited subject matter. Many of his best-loved poems describe scenes from nature, often involving rivers or waterfalls—images central to Daoist thought:

> ### READING 5.7 LI BAI
>
> "Autumn Cove"
>
> At autumn cove, so many white monkeys
> Bounding, leaping up like snowflakes in flight!
> They coax and pull their young ones down from the branches
> To drink and frolic with the water-borne moon.

LI QINGZHAO A woman poet, Li Qingzhao (ca. 1084–1155 CE), was born into a family of scholars and government officials. She was well educated by her patrician family, and, like the Roman poet Sulpicia, her poetry was known within elite circles while she was still a teenager. She married at the age of 18, and she and her husband shared interests in collecting art and books. Her husband's work required travel, and they would write each other love poems when apart.

Some hundred of her poems survive. Most of her poetry is in *ci* form, a sort of Chinese lyric poetry that was originally intended to be sung according to key words in the title—with specific rhythms, rhyme, and tempo. **Ci poetry** was generally used to comment on relationships:

> ### READING 5.8 LI QINGZHAO
>
> "Like a Dream" (*Re meng ling*)
>
> I will always recall that day at dusk,
> the pavilion by the creek,
> and I was so drunk I couldn't tell
> the way home. My mood left me,
> it was late when I turned back in my boat
> and I strayed deep among lotuses—
> how to get through?
> how to get through?
> and I startled to flight a whole shoal
> of egrets and gulls.

Li's husband died when she was still young, and she spent her last years alone.

◀ **5.25 Pendant in the form of a dragon, 403–221 BCE (Warring States period). China. Perforated, green jade, 7 ¼" × 3 ½" (18.5 × 9.0 cm). Musée national des arts asiatiques Guimet, Paris, France.** Jade, an extremely hard stone, was commonly used for objects to be buried with the dead. The perforated dragon, seen here in a characteristic spiral pose, was doubly symbolic. The ancient Chinese believed that dragons flew between earth and sky, bringing rain. They thus represented fertility and, at the same time, the power of Chinese rulers to influence the weather.

Visual Arts

In the visual arts, traditional styles were combined with new ones. A jade pendant from the end of the Zhou dynasty (**Fig. 5.25**) depicting a dragon is reminiscent of the Shang bronzes of centuries earlier, whereas a bronze horse from a little later shows much greater realism (**Fig. 5.26**).

THE SIX CANONS OF CHINESE PAINTING China has a rich history in the theory, history, and criticism of art. In the sixth century CE, a man versed in these three areas, Xie He, set down six points to consider when critiquing a painting in the preface of his book, *The Record of the Classification of Painters of Old.* The date was about 550 CE, and to Xie He, that was "today."

The six canons or points[11] are:

Engender a sense of movement through spirit consonance.

Use the brush with the bone method.

Respond to things, depict their forms.

According to kind, describe appearances (with color).

Divide and plan, position and arrange.

Transmit and convey earlier models through copying and transcribing.

The sense of movement in canon 1 means creating a sense of life through merging the painter's inner self with that of the subject. The bone method is a way of handling the brush in writing—**calligraphy**—as well as painting. Depicting the forms of things means painting from nature rather than from the mind of the artist or from the use of conventional forms. Describing appearances is depicting what things truly look like.

Canon 5 refers to what we call composition—the organization of the visual elements in a work of art. Canon 6 means learning from artists of the past, imitating their strengths and bringing their works up to date. But most important—number 1—was to communicate the vitality of the subject.

▼ **5.26 Flying horse, from the tomb of Governor-General Zhang, late second century CE (Han dynasty). Wuwei, China. Bronze, 13 ½" × 1 ½" (34.5 × 3.8 cm). Gansu Provincial Museum, Lanzhou, China.** The only horses native to China were small and slow animals. The Han emperors, learning that the peoples of Central Asia used much faster animals as warhorses, sent a series of missions to try to import Central Asian horses into China. So great was the delight that the Chinese took in their new warhorses—one of which is shown here with one leg resting on a swallow—that they called them heavenly horses.

11. James Cahill, "The Six Laws and How to Read Them," *Ars Orientalis* 4 (1961): 372–381.

CONNECTIONS The sixth canon of Chinese painting, set forth by China's Xie He in the sixth century, speaks to the importance—in fact, necessity—of "copying and transcribing" earlier works of art in the training of the young artist. More than eight centuries later, in a different part of the world, Cennino Cennini—an Italian painter who was greatly influenced by Giotto's style as a result of copying his works as an apprentice in a Florentine studio—wrote of the benefits to the young artist of copying the works of older masters:

> Having first practiced drawing for a while,... take pains and pleasure in constantly copying the best things which you can find done by the hands of great masters. And if you are in a place where many good masters have been, so much the better for you. But I give you this advice: take care to select the best one every time, and the one who has the greatest reputation. And, as you go on from day to day, it will be against nature if you do not get some grasp of his style and of his spirit.*

*Cennino Cennini, from *Il Libro dell'arte (The Handbook of Art)*. [Trans. Daniel V. Thompson, Jr., *Cennino Cennini: The Craftsman's Handbook (Il Libro dell'Arte)* (New York: Dover Publications, 1960; reprint of 1933 edition), pp. 14–15.

Figure 5.27 suggests mastery of the six canons of painting. It is a vital picture of a horse by Han Gan, who lived in the eighth century CE. The work brings the spirit of the animal to life with calligraphic brushstrokes and contour lines that breathe life into the work. The red-orange stamps on the work were the seals of artists and scholars who left their "comments" over the centuries. They are literal "stamps of approval."

A painting of Tang ladies at a feast shows elegant ladies of the palace court enjoying dinner and music (**Fig. 5.28**). Figures higher in the picture are farther from the viewer, but note that they are the

▼ **5.27 Han Gan,** *Night Shining White***, ca. 750 CE. Handscroll, ink on paper, image 12⅛" × 13⅜" (30.8 × 34 cm); overall with mounting, 14" × 37' 5¼" (35.4 cm × 11.4 m). Metropolitan Museum of Art, New York, New York.** This spirited horse was painted by a master of the six canons of painting who lived during the Tang dynasty.

◀ **5.28 A palace concert, 10th century CE. Hanging scroll, ink and colors on silk, 19¼" × 27⅜" (48.7 × 69.5 cm). National Palace Museum, Taipei, Taiwan.** The Tang dynasty is often known as the golden age of Chinese figure painting. This typical example, showing elegant ladies of the imperial court enjoying a feast and music, has no background setting but convincingly places the figures in space. The forms of the bodies are visible beneath the simple, dignified lines of the drapery, and the faces portray the individual feelings of these court ladies with considerable subtlety. Note the dog, a household pet, beneath the table.

same size as the lower figures, which are closer to the picture plane. The artist apparently had no knowledge of linear perspective, a method of representing depth in two-dimensional media such that objects grow smaller as they recede from the viewer.

With the coming of Buddhism, Chinese devotees began to construct shrines and decorate them with monumental carvings. Many of these show the influence of similar relief sculptures in India, particularly in the treatment of drapery (**Fig. 5.29**).

▼ **5.29 Fengxian Temple. Longmen grottoes, Luoyang, Henan, China. Limestone grotto, 136' (41 m) long × 118' (36 m) deep.** The Buddhist sculptures were begun in the sixth century CE and greatly extended around 690, when Luoyang became the new Tang capital. The central figure of the Vairochana Buddha (the Buddha of Illumination) is 56' 3" (17.4 m) high; to either side stand monks, bodhisattvas, and guardian figures. The simplicity of the folds of the Buddha's robe adds to the grandeur of the figure.

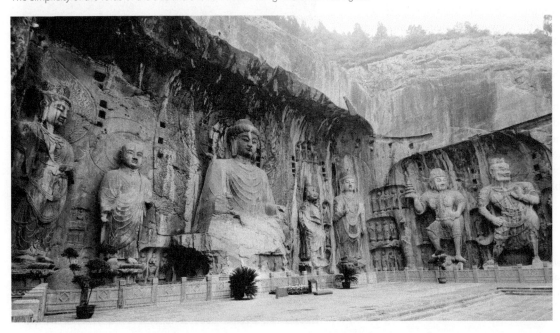

▲ **5.30** Huang Tingjian, Biographies of Lian Po and Lin Xiangru, ca. 1095 CE. Hand scroll, ink on paper, image: 13¼" × 60' 4½" (33.7 × 1840.2 cm), overall with mounting: 13½" × 71' 5⅝" (34.3 × 2178.4 cm). **Metropolitan Museum of Art, New York, New York.** The biographies comprise a hand scroll that is nearly 60 feet long and contains some 1200 cursive characters. The writing shows a spontaneity and exuberance that reflects the style of the "mad monk" Huaisu, with whose work the calligrapher was familiar.

Writing also became an art, as rabbit hair and other materials were collected into fine brushes and dipped into ink. Examples of fine handwriting—calligraphy—were as prized as works made of precious material. **Figure 5.30** shows a segment of a calligraphic scroll that set down the biographies of two rival officials who had served the same king some 1200 years earlier.

Many consider the Song dynasty to be the height of landscape painting. Fan Kuan (ca. 960–1030) was born at the beginning of the dynasty and spent much of his life as a recluse, studying nature rather than the works of other artists. His *Travelers Among Mountains and Streams* (**Fig. 5.31**) was painted on a silk scroll during the early 11th century. Although Fan was an ardent observer of nature, the work reveals an escape into the landscapes of the imagination that constitute the so-called Monumental Style. This style was often used to create a "perfection" that was meant to praise the supposed flawlessness of the Song government. The highest peak in such landscapes is often meant to represent the Song emperor.

Rocks in the foreground of the Fan Kuan scroll create a visual barrier that prevents the viewer from being drawn suddenly into the painting. But once the viewer is "in," his or her eye is lifted upward in a sort of mystical journey. Rounded forms rise in an orderly, rhythmic fashion from foreground through background. Sharp brushstrokes clearly delineate conifers, deciduous trees, and small temples on the cliff in the middle ground. The waterfall down the high cliffs to the right is balanced by the cleft to the left. A high contrast in **values**—dark and light—picks out the waterfall from the cliffs. The distance to the mountains is ambiguous, and possibly infinite; the remote and possibly unreachable mountains dwarf the human figures

▶ **5.31** Fan Kuan, *Travelers Among Mountains and Streams*, ca. 1000 CE. Hanging scroll, ink and colors on silk, 81¼" × 40¾" (206.3 × 103.3 cm). **National Palace Museum, Taipei, Taiwan, Republic of China.** The scroll was painted in the Monumental style, which was used to create a sense of perfection that symbolized the supposedly flawless rule of the Song dynasty.

in the foreground. Those figures usually represent the governed masses in works such as these. In contrast to the perspective typical of Western landscapes, there is no single vanishing point or set of vanishing points. The perspective shifts, offering the viewer a freer journey back across the many paths and bridges.

About a century later, Zhou Jichang painted *Lohans Bestowing Alms on Suffering Human Beings* (**Fig. 5.32**), which

represented a traditional Buddhist theme. Lohans were viewed as having obtained nirvana—freedom from the endless cycle of rebirth—through their reverence for the teaching of the Buddha. The scroll has a vertical organization, as does *Travelers Among Mountains and Streams* (see Fig. 5.31), but there the similarity ends. In using perspective, artists typically portray figures and objects higher in the picture as farther from the viewer. Observation of nature would also dictate that more distant figures be smaller than those in the foreground, and perhaps less distinctly delineated. But Zhou's scroll places large, clearly defined, and colorful figures in the center of the scroll, in conflict with their apparent greater remoteness from the picture plane than the figures at the bottom. It is all quite symbolic. The lohans are presented as being more important, given their spiritual attainments, than the beggars beneath them. They are shown as dwelling at a higher level of existence than the peasants—who scramble below for the descending coins—which explains the devices used to attract the eye, including the unnatural brightness of the colors.

JAPAN

Archaeological excavations in Japan—an island country off the eastern coast of Asia (see **Map 5.4**)—have yielded what may be the most ancient pottery fragments in the world, dating to before 10,000 BCE. What does this tell us about the culture that produced these ceramics? It tells us that these people—called

▲ **5.32** Zhou Jichang, *Lohans Bestowing Alms on Suffering Human Beings*, ca. 1178 (Southern Song period). Hanging scroll mounted as panel, ink, and color on silk, 43⅞" × 20⅞" (111.5 × 53.1 cm). Museum of Fine Arts, Boston, Massachusetts.

▲ **MAP 5.4** Japan before 1333.

the Jomon—who were hunter-gatherers, stayed in one place long enough to establish the technology needed to create pottery (*jomon* means "cord markings" and refers to their ceramics technique). The Jomon period dates from 10,500 BCE (the Neolithic period) to 300 BCE (roughly the same time that the Greek sculptor Praxiteles was working).

The islands comprising Japan were formed from porous volcanic rock, and thus they are devoid of hard stone; Japan's early art objects were created in clay and bronze. Pottery from the Middle Jomon period (2500–1500 BCE) is unlike any from the early civilizations in the West. So-called flame-style vessels (**Fig. 5.33**) were hand-built (rather than wheel-thrown) from clay coils that were then smoothed over with a wooden paddle and decorated with incised lines or additional thin clay coils pressed onto the surface in swirling patterns. Their unique and most visually interesting characteristic is the flame-like projections along the rim of the vessel that were shaped with the fingertips. Most often, pottery from this early era was functional, that is, created for storing food or cooking or sometimes to house the cremated remains of the deceased. The ostentatious ornamentation of flame-style ceramics, it seems, would have rendered them impractical for common use, suggesting that they may have been used for ritual purposes.

Archaeological evidence suggests that fortified agricultural communities sustained by wet-rice farming had developed by

▼ **5.33** Flame-style vessel, from Nigata Prefecture, Japan, Middle Jomon period, ca. 2500 BCE. Earthenware, 2' high. Cleveland Museum of Art, Cleveland, Ohio.

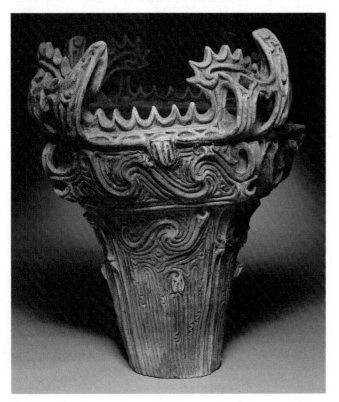

200 CE. Each community had a tribal chief and its own god, thought of as an ancestor. By the fourth century CE, the Japanese islands had had significant contact with China and Korea; indeed, in one community, Korean scribes were brought in to keep records because no system of writing as yet had been developed. Among the most notable archaeological finds from this period are burial mounds (*tumuli*) for the wealthy and powerful, the largest of which is the tomb of Emperor Nintoku in Osaka. Nintoku's tumulus invites comparison with other ancient royal tombs. Like those of the Egyptian pharaohs, his was filled with objects—some useful, some luxurious—that might be valuable in the afterlife; like the tomb of Shihuangdi ("First Emperor") of China's Qin dynasty, Nintoku's tomb was accompanied by an army of hollow, unglazed clay statues of warriors—around 20,000 of them in all.

Japan's first imperial capital was Nara, laid out in 706 CE in imitation of Chinese urban design; it served as the seat of power from 710 to 794. Less than a century later, however, the various settlements, now much expanded, came together in a new capital, Kyoto (then known as Heian), which remained a center of stable government and economic growth until 1185.

Buddhist Japan

By the beginning of the seventh century, Buddhism had spread to Japan from China and had been established as the state religion in Japan. Many sculptors produced wooden and bronze effigies of the Buddha, and Buddhist temples, such as Phoenix Hall (**Fig. 5.34**) reflected the influence of Chinese architectural style. Phoenix Hall is the main Buddhist temple erected within the Byōdō-in monastery, located in the Kyoto metropolitan area. With its gracefully upward-moving, overhanging roofs and its slender wooden columns at ground level, the temple appears to be weightless, floating on the pond before it—creating a Buddhist heaven on earth. The temple derives its name from its shape, which resembles a bird with its wings outspread, as the mythical phoenix. The main bedroom faced south to open upon the sunlight reflected from a pond within a garden. Originally a royal country palace, the hall was converted to a temple to house a gilded statue of the Buddha Amida, who Japanese Buddhists believed had promised salvation for people from all social strata. Smaller images of Buddha are presented as playing musical instruments, heralding worshippers on the path upward.

Shintoism, the native religion of Japan, teaches love of nature and the existence of many beneficent gods, who are never symbolized in art or any other visual form. Shintoism involved worship of the spirits of nature—including the all-important rice god—a complex series of rituals, and the imperial cult; that is, the ruling emperor and his ancestors were worshipped as divine. The tension between Shintoism and the influence of Chinese Buddhism always remained an important factor in Japanese religious life. The move from Nara to Heian (present-day Kyoto) was in part to escape from the domination of Nara's Buddhist priests.

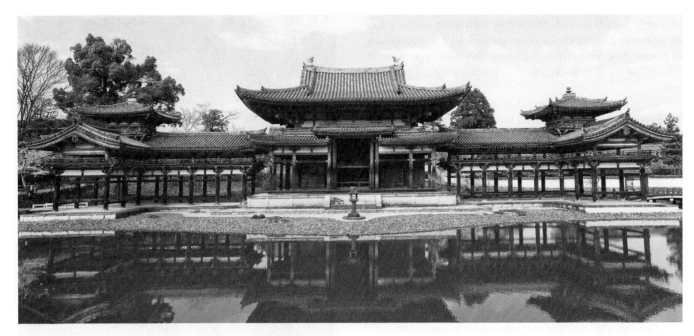

▲ **5.34 Phoenix Hall (looking west), Byōdō-in, Uji, Kyoto Prefecture, Japan. Heian period, completed 1053 CE.**

During this period, the Japanese developed their own writing system, partly based on the Chinese system. Poetry was popular, and as urban centers grew, various forms of theater became common. Perhaps the best known is the **Noh** play, in which dancers enact dramatic stories combined with ritual and slapstick (**Fig. 5.35**). The most famous literary work of the age was *The Tale of Genji*, written by Lady Murasaki Shikibu (ca. 973–ca. 1014–1025). Murasaki lived during the so-called Fujiwara period, one dominated by members of that family; the most important, Fujiwara Michinaga, ruled as regent from 1017 to 1028.

Murasaki's father held a minor position at court. She married and had children, but when her husband died and her father was transferred to the provinces, Murasaki took a position in the service of Empress Akiko. The diary she wrote during her years at court gives precious insight into life there. Basically serious-minded, Murasaki had little time for the frivolity of many of her contemporaries. By a remarkable chance, another diary of the same period has also survived, kept by Sei Shonagon (active ca. 1000).

Sei Shonagon's work takes the form of a **pillow book**—a collection of notes and observations on the day's events that are often malicious and sometimes indelicate, forming an interesting contrast to the more straitlaced Murasaki.

Murasaki's enduring fame is based on her novel *The Tale of Genji*. One of the great achievements of Japanese literature, the book describes the amorous adventures of Prince Genji, set against a court background very similar to that in which

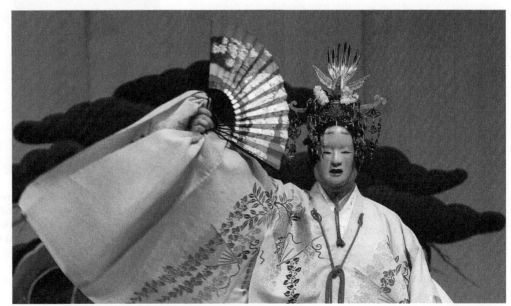

▲ **5.35 An actor in a Japanese Noh play.** The pinned hairstyle suggests the actor is playing a female role. All performers in Noh plays are traditionally male; as here, they use traditional wooden masks. The plays combine speech, singing, dance, and mime.

Murasaki herself moved. She writes with great delicacy and an underlying melancholy, often underlined by descriptions of nature. The autumnal winds, swift-flowing rivers, snow in winter—all serve as background to the book's more poignant scenes.

Genji is married to a somewhat older woman who dwells in a mansion at Sanjo. Yet he longs for his father's most beautiful consort, Fujitsubo, who resembles his own mother, who died years earlier:

READING 5.9 MURASAKI SHIKIBU

From *The Tale of Genji*, chapter 1

Constantly at his father's side, Genji spent little time at the Sanjō mansion of his bride. Fujitsubo was for him a vision of sublime beauty. If he could have someone like her—but in fact there was no one really like her. His bride too was beautiful, and she had had the advantage of every luxury; but he was not at all sure that they were meant for each other. The yearning in his young heart for the other lady was agony. Now that he had come of age, he no longer had his father's permission to go behind her curtains. On evenings when there was music, he would play the flute to her koto[12] and so communicate something of his longing, and take some comfort from her voice, soft through the curtains. Life at court was for him much preferable to life at Sanjō. Two or three days at Sanjō would be followed by five or six days at court. For the minister [his bride's father], youth seemed sufficient excuse for this neglect. He continued to be delighted with his son-in-law.

The minister selected the handsomest and most accomplished of ladies to wait upon the young pair and planned the sort of diversions that were most likely to interest Genji. At the palace the emperor [Genji's father] assigned him the apartments that had been his mother's and took care that her retinue was not dispersed. Orders were handed down to the offices of repairs and fittings to remodel the house that had belonged to the lady's family. The results were magnificent. The plantings and the artificial hills had always been remarkably tasteful, and the grounds now swarmed with workmen widening the lake. If only, thought Genji, he could have with him the lady he yearned for.

One of the unintentional effects of Murasaki's psychological subtlety is to reveal the gulf between the aesthetic sensibilities of the aristocratic elite at court and the lives of the peasants, the overwhelming majority of the population. It seems that life at court consisted of music and love affairs, poetry recitations, and apt quotations from the classics.

12. A Japanese stringed instrument resembling a zither, having a rectangular wooden sounding board and typically 13 strings made of silk. It is usually plucked with the fingers.

▲ **5.36** *The Three Sacred Shrines at Kumano: Kumano Mandala*, ca. 1300. Japan, Kamakura period (1185–1333). **Hanging scroll; ink and color on silk, 53¾" × 24⅜" (134 × 62 cm). The Cleveland Museum of Art, John L. Severance Fund 1953.16, Cleveland, Ohio.** A mandala is an object to encourage meditation. The shrines in the scroll are miles apart, but the artist chose to collapse the space between them so that the viewer would be able to make a visual pilgrimage from one to the next.

The Period of Feudal Rule

As the increasingly remote court life of Kyoto led to internal rivalry, in 1185 a new, more aggressive center developed at Kakamura. The emperor now combined legal and administrative duties with military command, creating a new office—**samurai-dokoro**—which gave him control of all of Japan's warriors (**samurai** is the Japanese name for a professional warrior). His title was *seii taishogun* ("barbarian-suppressing commander-in-chief"), later shortened to **shogun**. This newly enhanced warrior class dominated Japanese culture sufficiently to defeat two waves of Mongol invaders (in 1274 and 1281). Bands of warriors followed their aristocratic leader, who was in turn bound to the emperor—a system not unlike the feudal system developing independently in Western Europe around the same period.

The landscapes, portraits, and narrative scrolls produced by the Japanese during the late 12th through the early 14th centuries are highly original and Japanese in character. Some of them express the contemplative life of Buddhism, others express the active life of the warrior, and still others express the aesthetic life made possible by love of nature.

The Three Sacred Shrines at Kumano: Kumano Mandala (**Fig. 5.36**), a scroll executed at the beginning of the 14th century, represents three Shinto shrines. For nearly 2000 years, wooden Shinto shrines such as those shown in the scroll have been razed every 20 years and replaced by duplicates. The shrines in the mandala are actually several miles apart in mountainous terrain, but the artist collapsed the space between them to permit the viewer an easier visual pilgrimage. The scroll pays homage to the unique Japanese landscape in its vivid color and rich detail. The several small figures of the seated Buddha portrayed within testify to the Japanese reconciliation of disparate spiritual influences. The repetition of forms within the shrines and the procession of the shrines afford the composition a wonderful rhythm and unity. A mandala is a religious symbol of the design of the universe. It seems as though the universe of the shrines of *The Three Sacred Shrines at Kumano: Kumano Mandala* must carry on forever—as indeed it did in the minds of the Japanese.

The feudal period also gave rise to an extraordinary realism, as in the 13th-century wood sculpture *The Sage Kuya Invoking the Amida Buddha* (**Fig. 5.37**). From the stance of the figure and the keen observation of every drapery fold to the crystal used to create the illusion of actual eyes, this sculptor's effort to reproduce reality knew no bounds. The artist even went as far as to attempt to render speech: six tiny images of the Buddha come forth from the sage's mouth, representing the syllables of a prayer that repeats the name of the Buddha. A remarkable balance between the earthly and the spiritual is achieved through the use of extreme realism to portray a subject that refers to religion.

At the same time that the Buddha was preaching the doctrines of his new faith in India, Jewish communities in Egypt and Babylon were following another faith based on a covenant between God and their biblical patriarch, Abraham.

▲ **5.37** *The Sage Kuya Invoking the Amida Buddha*, **13th century. Painted wood, ca. 46¼" (117.5 cm) high. Rokuharamitsu-ji Temple, Kyoto, Japan.** The artist spared no effort in the attempt to render the sage realistically. There is even a representation of speech in tiny Buddhas emerging from the statue's mouth.

GLOSSARY

Aryan (p. 167) A member of one of the peoples supposedly descended from Indo-Europeans; particularly, a speaker of an Iranian or Indian language in ancient times.

Atman (p. 174) The basic principle of life; the individual self, known after enlightenment to be identical with Brahman.

Avatar (p. 180) An incarnation of an animal or a human.

Bhagavad Gita (p. 170) A section of the Mahabharata; considered a great scripture of the Hindu religion.

Brahma (p. 170) The Hindu god of creation.

Brahman (p. 174) In Hinduism, the one true reality, which cannot be fully understood by humans.

Calligraphy (p. 191) A stylized form of elegant handwriting.

Caste system (p. 169) A system of rigid social stratification characterized by being heritable and limiting of marriage prospects to a member of one's own caste.

Ci poetry (p. 190) A form of Chinese lyric poetry meant to be sung and usually expressing desire.

Dukkha (p. 176) Suffering.

Karma (p. 170) The path according to which one carries out one's duty according to his or her caste.

Mahabharata (p. 168) The Mahabharata (ca. 400 BCE–400 CE), attributed to Krishna Dvaipayana Vyasa, is an epic poem that embellishes probable events of India's heroic age.

Mandala (p. 184) A geometric Hindu and Buddhist symbol that represents the universe.

Nirvana (p. 176) A state characterized by the absence of suffering.

Noh (p. 197) A type of Japanese drama in which actors wear wooden masks.

Pillow book (p. 197) Generally, a book of observations and musings, which reveal a period in a person's life.

Reincarnation (p. 176) One's rebirth into another body, according to one's karma.

Rig-Veda (p. 173) A collection of 1028 hymns to the Hindu gods.

Samurai (p. 199) Japanese professional warriors in medieval times.

Samurai-dokoro (p. 199) The official in feudal Japan who led legal and military affairs.

Sangha (p. 175) A Buddhist monastery.

Sanskrit (p. 165) An ancient Indo-Aryan language; the classical language of India and Hinduism.

Shintoism (p. 196) The native Japanese religion, which teaches of many beneficent gods and love of nature.

Shiva (p. 170) The Hindu god of creation and destruction; the "destroyer of worlds."

Shogun (p. 199) Another term for the **samurai-dokoro**.

Stupa (p. 175) A dome-shaped reliquary of the Buddha, possibly also of Buddhist texts.

Upanishads (p. 174) A series of classical Indian teaching texts addressing issues such as karma, death, and dreams.

Value (p. 194) In art, the relative lightness or darkness of a color.

Vishnu (p. 170) A Hindu god; the preserver of the universe.

Yakshi (p. 176) A pre-Buddhist voluptuous goddess who was believed to embody the generative forces of nature.

THE BIG PICTURE EARLY CIVILIZATIONS

SOUTH ASIA

Language and Literature

– The Aryans bring the Sanskrit language to the Indus Valley region.

– India's epic poems, such as the *Ramayana* and the Mahabharata, reflect the "heroic age" when Aryans subdued the native people.

– The Bhagavad Gita, which is part of the Mahabharata, displays the importance of altruism but places foremost emphasis on acceptance of one's duty in one's social class.

– The *Rig-Veda* contains 1028 hymns to the gods and addresses matters such as the creation of the universe and the origins of the social caste system.

– The Upanishads present the view that the ultimate reality is brahman, which can be found within and is called atman within the individual. The Upanishads address matters from death to karma to dreams.

– During the Gupta Empire, Kalidasa writes plays, epics, and lyric poetry.

Art, Architecture, and Music

– Hindu temples are built with organic shapes that reflect cosmic rhythms and foothills ascending into mountains. Their exterior walls are decorated with erotic reliefs, indicating that within Hindus, sexual pleasure is one path to nirvana, a state that breaks the cycle of endless rebirth.

– The emperor Ashoka builds domed stupas to house relics of Buddha and possibly religious texts. Ashoka also erects immense pillars and towers that hold his decrees and exalt Buddhism.

– Buddhist art emphasizes the spiritual, austere nature of Buddhist doctrines. Images of the Buddha begin to appear in the second century CE and tend to support the meditative life and the renunciation of worldly pleasures.

– Khmer kings build temples and palaces from the 9th through the 15th centuries, culminating in Angkor Wat.

Philosophy and Religion

– Early epic poems laud heroism and piety.

– The Bhagavad Gita supports the concepts of duty (dharma) and gradual development into an enlightened state through karma and reincarnation.

– The pantheon of Aryan gods develops into the Hindu religion, with the three main gods Brahma, Vishnu, and Krishna.

– Buddhism develops as a path to enlightenment and the end of suffering via the Four Noble Truths and the Eightfold Path.

– Whereas Hinduism acknowledges sexual pleasure and the enjoyment of erotic imagery, Buddhism tends to renounce worldly pleasures and value the meditative life.

OF SOUTH ASIA, CHINA, AND JAPAN

CHINA

Language and Literature

- The book that sets forth Laozi's teachings, *The Classic of the Way and Its Power* (*Daodejing*), is written in the third century BCE.
- Early Han emperors (after 202 BCE) lift the ban on philosophical works and encourage scholars to reconstruct the writings of Confucius.
- Beginning in the Zhou period, the *Five Classics* circulate widely—addressing history, political documents such as speeches, and descriptions of ceremonies. The *Classic of Songs* contains poems dealing with private life (love, the family) and public affairs.
- Because the meanings of Chinese words and phrases change according to their pronunciation, poetry becomes especially popular. Li Bai writes poetry lauding wine and nature.
- The short story develops during the Tang dynasty.
- Li Qingzhao writes *Ci* poetry.
- Calligraphy becomes a form of fine art, as on lengthy scrolls.

Art, Architecture, and Music

- To defend his empire, Shihuangdi, the first Qin emperor, connects existing defensive walls into the Great Wall of China, 1400 miles long.
- In about 550 CE, Xie He set down the six canons of Chinese painting.
- Painters chose many courtly subjects and nature.
- Chinese Buddhists build shrines and decorate them with monumental carvings.
- Calligraphy becomes a form of fine art.

Philosophy and Religion

- Confucius and Laozi founded Confucianism and Daoism.
- Confucianism taught that the morally superior individual should possess five inner virtues and acquire another two. The five were righteousness, integrity, love of humanity, altruism, and loyalty. Those to be acquired were culture (education) and a sense of decorum or ritual. Confucius would not speculate about the possibility of gods or an afterlife. He argued that the state should exist for the benefit of the people, rather than the reverse.
- Daoism preaches that people should follow their own nature, not distinguishing between good and bad. Daoism taught passivity and resignation, particularly avoiding war because "every victory is a funeral rite."
- After Shihuangdi's Burning of the Books, Han emperors lift the ban on philosophical works and encourage scholars to reconstruct the writings of Confucius.
- Buddhism is introduced into China during the Han dynasty. Following the collapse of the Han rulers, Buddhist monasteries grow in wealth and power.

JAPAN

Language and Literature

- Ca. 400 CE, a Japanese community imported Korean scribes because Japan did not yet have a system of writing of its own.
- The Japanese developed their own writing system, partly based on the Chinese, before 1185.
- The Japanese developed the Noh play ca. 1185.
- *The Tale of Genji* was the best-known literary work of 11th century Japan.
- Sei Shonagon kept a noted pillow book early in the 11th century.

Art, Architecture, and Music

- Ceramic figures and vessels date to the fourth millennium BCE.
- In the fifth and sixth centuries CE, the Japanese produced hollow ceramic figures—haniwa—from slabs of clay and placed them around burial plots.
- The Buddhist temple Phoenix Hall was erected in the 11th century in the Chinese style.
- Japanese produced highly original landscapes, portraits, and narrative scrolls during the late 12th through early 14th centuries.

Philosophy and Religion

- Buddhism was established as the state religion of Japan by the early seventh century.
- Shintoism, the native religion of Japan, developed in the seventh and eighth centuries.

The Rise of the Biblical Tradition

<div style="text-align: right">6</div>

PREVIEW

In Italy, at the very start of the 15th century, guild officials in the city of Florence announced a competition for a high-profile sculpture commission—a set of bronze doors for the small, octagonal baptistery that faced the entrance to the city's spectacular cathedral. The commission would secure for the winning artist many years of employment as well as recognition and fame. To level the field for the participants—seven in all—the sample panel that was to be submitted for consideration had to meet certain criteria: it had to be made of bronze; the imagery had to be placed within an elaborate frame embellished by curves and triangles; and all of the artists had to depict the same subject—the sacrifice of Isaac (Fig. 6.1). Following the description of the event in the Old Testament, or Hebrew Bible, the content of the trial panels was specified further: each had to include Abraham, Isaac, two servants and a donkey, an altar, an angel, a sheep, and the suggestion of the setting of Mount Moriah.

The book of Genesis contains the passage in which these details are found. God tests Abraham, who will ultimately become the father of the Hebrew people and a great prophet, by telling him to make of his son Isaac a burnt offering. Abraham saddles a donkey and leaves home with Isaac and two young men. When he arrives at the place that God has specified for the sacrifice, Abraham binds Isaac to an altar and is about to slay him with a knife when, at the last moment, God, assured of Abraham's loyalty, sends an angel to stay his hand. The burnt offering to God in Isaac's place is a ram that Abraham spots in a nearby thicket.

Lorenzo Ghiberti (1378–1455) was awarded the commission and worked on the project for 21 years. Shortly after the commission for the east-baptistery doors had gone out, the city of Florence came under the assault of the forces of the Duke of Milan, Gian Galeazzo Visconti. Florence was most certainly the underdog in this fight; most thought that the Milanese would prevail. But at the last moment, Gian Galeazzo contracted a fever, and a month later he was dead. The biblical story of the sacrifice of Isaac resonated with the Florentines. The weaker of the two powers, it would seem that their "deliverance" had a convincing parallel in God's deliverance of Isaac.

◄ 6.1 Lorenzo Ghiberti, *Sacrifice of Isaac*, 1401–1402. Gilt bronze, 21" × 17½" (53.3 × 44.5 cm). Museo Nazionale del Bargello, Florence, Italy.

ABRAHAM

The story of Abraham begins in the 12th chapter of the book of Genesis in the Hebrew Bible, when God commands him to leave Ur, his country, and his relatives, to go to a land that God will show him. God promises Abraham: "I will make of you a great nation and I will bless you and make your name great." This land that God will show Abraham is the promised land—the land of Canaan. The next 13 chapters tell Abraham's story, including two of the most wrenching and perplexing: his near sacrifice of his son Isaac and his abandonment of another son, Ishmael.

In the 15th chapter of Genesis, God tells Abraham to look at the sky and to count the stars—so innumerable would be his descendants. The three great monotheistic religions—Judaism, Christianity, and Islam—are often called the Abrahamic religions because they consider this ancient patriarch to be their common ancestor. Abraham is considered the father of the Jewish people. Jesus of Nazareth, who was born a Jew, calls God the "God of Abraham," and in a Christian epistle to the Hebrews, Abraham is praised as a model of faith:

> By faith, Abraham obeyed when he was called to set out for a place that he was to receive as an inheritance; and he set out. By faith he stayed a long time in the land he had been promised as in a foreign land, living in tents, as did Isaac and Jacob, who were heirs with him of the same promise.... Therefore from one person...descendants were born, as many as the stars of the heaven and the innumerable grains by the seashore. (Heb. 11:8–12)

Muslims also count themselves among the descendants of Abraham (*Ibrahim*, in Arabic) and call him the Father of the Arabs. Abraham is honored as one of Islam's revered prophets and bears the title *hanif*—a revealer of belief in one God. Muslims believe that Abraham built the *Ka'bah*, a shrine in Mecca to which devout Muslims make a pilgrimage at least once in their lifetimes (see Chapter 8). They believe that, in their journey, they follow the footsteps of Abraham, Ishmael, and Ishmael's mother, Hagar.

Isaac and Ishmael, then, both sons of Abraham but by different mothers, went on to found these separate nations—the Hebrew and the Arab nations. Ishmael was the older of the two brothers, fathered by Abraham with an Egyptian servant, Hagar, when it was thought that Abraham's wife, Sarah, would not be able to conceive. After many years—when Sarah was in her old age and Abraham himself was 100, we are told—Sarah gave birth to Isaac, whose name in Hebrew means "he will laugh." In Genesis 21:6–7, Sarah says, "God has brought me laughter, and everybody who hears about this will laugh with me.... Who would have said to Abraham that Sarah would nurse children? Yet I have borne him a son in his old age." After Isaac is born, Sarah worries that Ishmael may wish to share in her son's inheritance and tells Abraham to turn out "that slave woman and her son." In Genesis 21:11, Abraham complies. He gives Hagar and Ishmael a bit of food and water, takes them out into the desert, and leaves them there. Abraham has some trepidation, but God assures him that Ishmael will survive and that God will make his descendants, too, "into a nation." When the exiles run out of water, God does indeed provide for them, and Ishmael goes on to fulfill his destiny.

When Ishmael was sent from his father's house, Isaac was a very small child, but when his own story with Abraham unfolds, he is probably at least 12 and maybe quite a bit older. We know from the passage that he is old enough to walk for three days to Mount Moriah and to carry wood for the burnt offering:

The Rise of the Biblical Tradition

2000 BCE	1260 BCE	1000 BCE	922 BCE	587 BCE	63 BCE	381 CE
Age of Hebrew Patriarchs Abraham, Isaac, Jacob (r. 1800–1600 BCE) Hebrews in Egypt until Exodus in 1280 BCE	Hebrews begin to penetrate land of Canaan Reign of Saul, first king of Israel 1040–1000 BCE	Reign of King David 1000–961 BCE Reign of King Solomon 961–922 BCE; height of ancient Israel's cultural power	Civil war after Solomon's death splits Israel; prophetic period begins Northern Israeli kingdom destroyed by Assyria in 721 BCE	Jews driven into captivity in Babylonia in 587 BCE King Cyrus allows Jews to return to Jerusalem in 539 BCE Dedication of Second Temple in 516 BCE Conquest by Alexander the Great in 332 BCE	Rome conquers Jerusalem in 63 BCE Reign of King Herod 37–4 BCE Birth of Jesus ca. 6 CE Titus sacks Jerusalem in 70 CE Reign of Emperor Constantine, 307–327 CE	Edict of Milan 313 CE Founding of Constantinople Christianity declared state religion

READING 6.1 THE HEBREW BIBLE

Genesis 22:1–17

[1]After these things God tested Abraham, and said to him, "Abraham!" And he said, "Here am I." [2]He said, "Take your son, your only son Isaac, whom you love, and go to the land of Mori'ah, and offer him there as a burnt offering upon one of the mountains of which I shall tell you." [3]So Abraham rose early in the morning, saddled his ass, and took two of his young men with him, and his son Isaac; and he cut the wood for the burnt offering, and arose and went to the place of which God had told him. [4]On the third day Abraham lifted up his eyes and saw the place afar off. [5]Then Abraham said to his young men, "Stay here with the ass; I and the lad will go yonder and worship, and come again to you." [6]And Abraham took the wood of the burnt offering, and laid it on Isaac his son; and he took in his hand the fire and the knife. So they went both of them together. [7]And Isaac said to his father Abraham, "My father!" And he said, "Here am I, my son." [8]He said, "Behold, the fire and the wood; but where is the lamb for a burnt offering?" Abraham said, "God will provide himself the lamb for a burnt offering, my son." So they went both of them together.

[9]When they came to the place of which God had told him, Abraham built an altar there, and laid the wood in order, and bound Isaac his son, and laid him on the altar, upon the wood. [10]Then Abraham put forth his hand, and took the knife to slay his son. [11]But the angel of the LORD called to him from heaven, and said, "Abraham, Abraham!" And he said, "Here am I." [12]He said, "Do not lay your hand on the lad or do anything to him; for now I know that you fear God, seeing you have not withheld your son, your only son, from me." [13]And Abraham lifted up his eyes and looked, and behold, behind him was a ram, caught in a thicket by his horns; and Abraham went and took the ram, and offered it up as a burnt offering instead of his son. [14]So Abraham called the name of that place The LORD will provide; as it is said to this day, "On the mount of the LORD it shall be provided."

[15]And the angel of the LORD called to Abraham a second time from heaven, and said, "By myself I have sworn, says the LORD, because you have done this, and have not withheld your son, your only son, [16]I will indeed bless you, and I will multiply your descendants as the stars of heaven and as the sand which is on the seashore. And your descendants shall possess the gate of their enemies, [17]and by your descendants shall all the nations of the earth bless themselves, because you have obeyed my voice."

to faith. God will challenge Abraham's faith and loyalty again when God tells him to sacrifice his son Isaac. Commentators have asked why God would test Abraham in this heartless way and have wondered why Abraham would have carried out God's will with no objection. Søren Kierkegaard, the 19th-century Danish philosopher, pondered the anguish he assumed Abraham must have felt and concludes that his ultimate complicity was a "leap to faith." In *Fear and Trembling*, Kierkegaard postulates that "infinite resignation is the last stage before faith, so anyone who has not made this movement does not have faith, for only in infinite resignation does an individual become conscious of his eternal validity, and only then can one speak of grasping existence by virtue of faith."[1]

JUDAISM AND EARLY CHRISTIANITY

More than 3000 years ago in the Middle East, a small tribe-turned-nation became one of the central sources for the development of Western civilization: the marriage of the biblical tradition and Graeco-Roman culture.

We have very little of the art, music, or philosophy—other than the religious precepts—of these ancient people. Some commentators have attributed the scarcity of art to the second of the Ten Commandments: "You shall not make for yourself a graven image, or any likeness of anything that is in heaven above, or that is in the earth beneath, or that is in the water under the earth; you shall not bow down to them or serve them; for I the Lord your God am a jealous God" (Exod. 20:4–5). But other commentators emphasize that this commandment is given in the context of idol worship; it has most often been interpreted as a warning to the Hebrews not to make idols of wood, stone, or metal and worship them. If this is so, the commandment does not proscribe the visual arts in general.[2] We do have the texts of the Hebrews' hymns, canticles, and psalms, but we can only speculate how they were sung and how they were accompanied instrumentally. The major gift bequeathed to us is a book; more precisely, the collection of books Jews call the Hebrew Bible, or *Tanakh*, and Christians often refer to as the Old Testament.

These people called themselves the Children of Israel or Israelites. At a later time, they became known as the Jews, from the area around Jerusalem known as Judaea. In the Bible, they are called Hebrews (most often by their neighbors), which is the name now most commonly used to describe these biblical people.

In the story of Abraham, Hagar, and Ishmael, we are told that Abraham grieved over his abandonment of his son but was reassured in his faith that God would provide for them. Abraham resigns himself to his situation and releases himself

1. Søren Kierkegaard, *Fear and Trembling*, in *Kierkegaard's Writings*, ed. and trans. Howard V. Hong and Edna H. Hong, vol. 6, *Fear and Trembling/Repetition* (Princeton, NJ: Princeton University Press, 1983; original copyright 1843).
2. See, for example, John Williams, ed., *Imaging the Early Medieval Bible* (University Park: Pennsylvania State University, 1999).

Biblical History

The history of the Hebrew people is long and complex, but the stages of their growth can be outlined as follows:

- *The period of the patriarchs.* According to the Bible, the Hebrew people had their origin in Abraham, the father (**patriarch**) of a tribe who took his people from ancient Mesopotamia to the land of Canaan on the east coast of the Mediterranean about 2000 BCE. After settling in this land, divided into 12 tribal areas, they eventually went to Egypt at the behest of Joseph, who had risen to high office in Egypt after his enslavement there.
- *The period of the Exodus.* The Egyptians eventually enslaved the Hebrews (perhaps around 1750 BCE), but the Hebrews were led out of Egypt under the leadership of Moses. This going out (**exodus**) is one of the central themes of the Bible; this great event also gives its name to one of the books of the Bible.
- *The period of the conquest.* The biblical books of Joshua and Judges relate the struggles of the Hebrews to conquer the land of Canaan as they fought against the native peoples of that area and the competing "sea people" (the Philistines who came down from the north).
- *The united monarchy.* The high point of Hebrew political power came with the consolidation of Canaan and the rise of a monarchy. There were three kings: Saul, David, and Solomon. An ambitious flurry of building during the reign of Solomon (ca. 961–922 BCE) culminated in the construction of the great temple in Jerusalem (**Fig. 6.2**).
- *Divided kingdom and exile.* After the death of Solomon, a rift over the succession resulted in the separation of the northern kingdom (Israel) and the southern kingdom (Judah), the center of which was Jerusalem. Both were vulnerable to pressure from the surrounding great powers. Israel was destroyed by the Assyrians in the eighth century BCE, and its inhabitants (the so-called Lost Tribes of Israel) were swept away by death or exile. In 587 BCE, the Babylonians conquered the southern kingdom, destroyed Solomon's temple in Jerusalem, and carried the Hebrew people into an exile known to history as the Babylonian Captivity.
- *The return.* The Hebrews returned from exile about 520 BCE to rebuild their shattered temple and to resume their religious life. Their subsequent history was marked by a series of foreign (Greek, Egyptian, and Syrian) rulers, one brief period of political independence (ca. 165 BCE), and, finally, rule by Rome after the conquest of 63 BCE. In 70 CE, after a Jewish revolt, the Romans destroyed Jerusalem and razed the rebuilt temple. A small band of Jewish rebels that held off the Romans for two years at a mountain fortress called Masada was defeated in 73 CE. Except for pockets of Jews who lived there over the centuries, not until 1948, when the state of Israel was established, would Jews hold political power in their ancestral home.

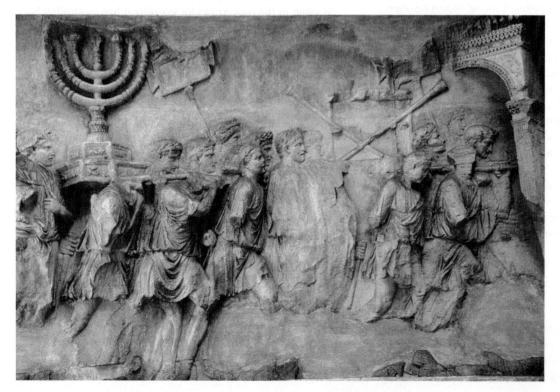

◀ **6.2 Spoils of Jerusalem (detail of the Arch of Titus), 81 CE. Rome, Italy.** This honorific arch was erected in the Roman Forum to commemorate Titus's victory over the Hebrews in 70 CE. The left inner relief shows soldiers carrying off a menorah and other spoils from the Temple of Jerusalem.

The Hebrew Bible and Its Message

The English word *bible* comes from the Greek name for the ancient city of Gebal (Byblos), from which the papyrus reed used to make books was exported. The Bible is a collection of books that took its present shape over a long period.

The ancient Hebrews divided the books of their Bible into three large groupings: the Law, the Prophets, and the Writings. The Law referred specifically to the first five books of the Bible, called the **Torah** (from the Hebrew word for "instruction" or "teaching"). The Prophets consist of writings attributed to the great moral teachers of the Hebrews, who were called **prophets** because they spoke with the authority of God (*prophet* derives from a Greek word for "one who speaks for another"). The Writings contain the wisdom of the Hebrew Bible, in prose, poetry (like the book of Psalms), or a mixture of the two, as in the book of Job (see Religion feature below, and Reading 6.4).

The list of books contained in the modern Bible—the **canon**—was not established until 90 CE, when an assembly of rabbis agreed upon it, although its main outline had been known for centuries. The Christians in turn accepted this canon and added the 27 books that make up what we know as the Christian New Testament. Roman Catholics and Orthodox Christians also accept as canonical some books of the Hebrew Bible that are not in the Hebrew canon but are found in an ancient Greek version of the Hebrew scriptures known as the **Septuagint** (a version of the Bible widely used in the ancient world).

One fundamental issue about the Bible must be emphasized: Both ancient Israel, subsequent Jewish history, and the Christian world have made the Bible *the* central document not only for worship and the rule of faith but also as a moral guide and anchor for ethical and religious stability. The Bible, directly and indirectly, has shaped our law, literature, language, ethics, and social outlook. It permeates our culture. To cite one single example: At Solomon's temple, the people sang hymns of praise (**psalms**) to God, just as they are sung in Jewish synagogues today. Those same psalms were sung by Jesus and his followers in their time, just as they are sung and recited in Christian churches in every part of the world. That ancient formulation is, in a deep sense, part of our common religious culture.

RELIGION

Books of the Hebrew and Christian Bibles

HEBREW BIBLE	CHRISTIAN BIBLE
Genesis	**Gospels**
Exodus	Matthew
Leviticus	Mark
Numbers	Luke
Deuteronomy	John
Joshua	
Judges	**Acts of the Apostles**
Ruth	
1 and 2 Samuel	*Letters of Paul*
1 and 2 Kings	Romans
1 and 2 Chronicles	1 and 2 Corinthians
Ezra	Galatians
Nehemiah	Ephesians
Esther	Philippians
Job	Colossians
Psalms	1 and 2 Thessalonians
Proverbs	1 and 2 Timothy
Ecclesiastes	Titus
Song of Songs	Philemon
Isiah	Hebrews
Jeremiah	
Lamentations	
Ezekiel	

	Letters of James
Daniel	1 and 2 Peter
Hosea	1, 2, and 3 John
Joel	Jude
Amox	
Obadiah	**Revelation (also called the Apocalypse)**
Jonah	
Micah	
Nahum	
Habakkuk	
Zephaniah	
Haggai	
Zechariah	
Malachi	

The Deuterocanonical Books of the Bible

Tobit
Judith
Wisdom of Solomon
Ecclesiasticus (also known as the *Wisdom of Ben Sira*)
Baruch (containing the Letter of *Jeremiah*)
I and II Maccabees
Some additional chapters of Esther and Daniel
Orthodox Christian
First Esdras
Prayer of Manasseh
Psalm 151

The Bible is not a philosophical treatise; it is a sacred book. It is, nonetheless, a book that contains ideas; those ideas have enormously influenced the way we think and the way we look at the world. Some of the basic motifs of the Bible have been so influential in our culture that they should be considered in some detail. Let us consider four of them.

BIBLICAL MONOTHEISM A central conviction of biblical religion is that there is one God, that this God is good, and, crucially, that this God is involved in the arena of human history. God is conceived of as a person and not as some impersonal force in the world of nature. **Monotheism** (the belief in one god) can thus be distinguished both from **henotheism** (the belief that there may be other gods, although only one is singled out for worship) and **polytheism** (the belief that there are many gods).

The opening pages of the Hebrew Bible—the book of Genesis—set out a creation story: a story that addresses the creation of the universe ("the heavens and the earth") and the creation of humans (see Reading 6.2).

The creation story of Genesis provides us with a rather complete vision of what the Bible teaches about God. The story makes three basic assertions about God. First, God exists before the world and called it into existence by the simple act of utterance. God, unlike the gods and goddesses of the Hebrews' ancient neighbors, is not born out of the chaos that existed before the world. Second, God pronounces each part of creation, and creation as a whole as "good." Thus, the book of Genesis does not present the material universe as evil or, as certain Eastern religions teach, an illusory world that conceals the true nature of reality. Finally, God creates human beings as the apex and crown of creation. The material world is a gift from God, and human beings are obliged to care for it and be grateful for it. A basic motif of biblical prayer is gratitude to God for the gift of creation.

Biblical monotheism must not be thought of as a theory that simply sees God as the starting point or originator of all things after the fashion of a craftsperson who makes a chair and then forgets about it. The precise character of biblical

READING 6.2 THE HEBREW BIBLE

Genesis 1:1–31 and 2:1–25

1

[1]In the beginning God created the heavens and the earth. [2]The earth was without form and void, and darkness was upon the face of the deep; and the Spirit of God was moving over the face of the waters. [3]And God said, "Let there be light"; and there was light. [4]And God saw that the light was good; and God separated the light from the darkness. [5]God called the light Day, and the darkness he called Night. And there was evening and there was morning, one day.

[6]And God said, "Let there be a firmament in the midst of the waters, and let it separate the waters from the waters." [7]And God made the firmament and separated the waters which were under the firmament from the waters which were above the firmament. And it was so. [8]And God called the firmament Heaven. And there was evening and there was morning, a second day.

[9]And God said, "Let the waters under the heavens be gathered together into one place, and let the dry land appear." And it was so. [10]God called the dry land Earth, and the waters that were gathered together he called Seas. And God saw that it was good. [11]And God said, "Let the earth put forth vegetation, plants yielding seed, and fruit trees bearing fruit in which is their seed, each according to its kind, upon the earth." And it was so. [12]The earth brought forth vegetation, plants yielding seed according to their own kinds, and trees bearing fruit in which is their seed, each according to its kind. And God saw that it was good. [13]And there was evening and there was morning, a third day.

[14]And God said, "Let there be lights in the firmament of the heavens to separate the day from the night; and let them be

for signs and for seasons and for days and years, [15]and let them be lights in the firmament of the heavens to give light upon the earth." And it was so. [16]And God made the two great lights, the greater light to rule the day, and the lesser light to rule the night; he made the stars also. [17]And God set them in the firmament of the heavens to give light upon the earth, [18]to rule over the day and over the night, and to separate the light from the darkness. And God saw that it was good. [19]And there was evening and there was morning, a fourth day.

[20]And God said, "Let the waters bring forth swarms of living creatures, and let birds fly above the earth across the firmament of the heavens." [21]So God created the great sea monsters and every living creature that moves, with which the waters swarm, according to their kinds, and every winged bird according to its kind. And God saw that it was good. [22]And God blessed them, saying, "Be fruitful and multiply and fill the waters in the seas, and let birds multiply on the earth." [23]And there was evening and there was morning, a fifth day.

[24]And God said, "Let the earth bring forth living creatures according to their kinds: cattle and creeping things and beasts of the earth according to their kinds." And it was so. [25]And God made the beasts of the earth according to their kinds and the cattle according to their kinds, and everything that creeps upon the ground according to its kind. And God saw that it was good.

[26]Then God said, "Let us make man in our image, after our likeness; and let them have dominion over the fish of the sea, and over the birds of the air, and over the cattle, and over all the earth, and over every creeping thing that creeps upon the earth." [27]So God created man in his own image, in the image of God he created him; male and female he created them. [28]And God blessed them, and God said to them, "Be fruitful and multiply, and fill the earth and subdue it; and have dominion over the fish of the sea and over the birds of the air

monotheism is its conviction that God creates and sustains the world in general and chose a particular people to be both vehicle and sign of divine presence in the world. The exact nature of that relationship can be found in the biblical notion of covenant.

THE COVENANT Covenant is the crucial concept for setting out the relationship between God and the Hebrew people. The covenant can be summed up in the simple biblical phrase, "I will be your God; you will be my people." In Hebrew history, the Bible insists, God has always been faithful to that covenant that was made with the people of Israel, whereas the people must learn and relearn how to be faithful to it. Scholars have pointed out that the biblical covenant may be based on the language of ancient marriage covenants (for example, "I will be your husband; you will be my wife"). If that is true, it gives us an even deeper understanding of the term: the relationship of God and Israel is as close as the relationship of husband and wife.

This strong portrait of a single, deeply involved God who is beyond image or portrayal has had a profound impact on

the shape of the Judeo-Christian worldview. The notion of covenant religion not only gave form to Hebrew religion, but the idea of a renewed covenant became the central claim of Christianity. (Another word for covenant is **testament**; hence the split between Old and New Testaments that Christianity insists upon.) The idea has even spilled over from synagogues and churches into our national civil religion, where we affirm a belief in "one nation under God" and "In God we trust"—both sentiments rooted in the idea of a covenant.

ETHICS The Bible is not primarily an ethical treatise; it is a theological one, even though it does set out a moral code of behavior both for individuals and for society. The Bible has many rules for worship and ritual, but its fundamental ethical worldview lies in the idea that humans are created in "the image" and "likeness" of God (Gen. 1:26). The more detailed formulation of that link between God and individual and social relationships is contained in the Ten Commandments—also known as the **Decalogue**—which the Bible depicts as being

and over every living thing that moves upon the earth." ²⁹And God said, "Behold, I have given you every plant yielding seed which is upon the face of all the earth, and every tree with seed in its fruit; you shall have them for food. ³⁰And to every beast of the earth, and to every bird of the air, and to everything that creeps on the earth, everything that has the breath of life, I have given every green plant for food." And it was so. ³¹And God saw everything that he had made, and behold, it was very good. And there was evening and there was morning, a sixth day.

2

¹Thus the heavens and the earth were finished, and all the host of them. ²And on the seventh day God finished his work which he had done, and he rested on the seventh day from all his work which he had done. ³So God blessed the seventh day and hallowed it, because on it God rested from all his work which he had done in creation.

⁴These are the generations of the heavens and the earth when they were created.

In the day that the LORD God made the earth and the heavens, ⁵when no plant of the field was yet in the earth and no herb of the field had yet sprung up—for the LORD God had not caused it to rain upon the earth, and there was no man to till the ground; ⁶but a mist went up from the earth and watered the whole face of the ground—⁷then the LORD God formed man of dust from the ground, and breathed into his nostrils the breath of life; and man became a living being. ⁸And the LORD God planted a garden in Eden, in the east; and there he put the man whom he had formed. ⁹And out of the ground the LORD God made to grow every tree that is pleasant to the sight and good for food, the tree of life also in the midst of the garden, and the tree of the knowledge of good and evil.

¹⁰A river flowed out of Eden to water the garden, and there it divided and became four rivers. ¹¹The name of the first is Pishon; it is the one which flows around the whole land of Havilah, where there is gold; ¹²and the gold of that land is good; bdellium and onyx stone are there. ¹³The name of the second river is Gihon; it is the one which flows around the whole land of Cush. ¹⁴And the name of the third river is Tigris, which flows east of Assyria. And the fourth river is the Euphrates.

¹⁵The LORD God took the man and put him in the garden of Eden to till it and keep it. ¹⁶And the LORD God commanded the man, saying, "You may freely eat of every tree of the garden; ¹⁷but of the tree of the knowledge of good and evil you shall not eat, for in the day that you eat of it you shall die."

¹⁸Then the LORD God said, "It is not good that the man should be alone; I will make him a helper fit for him." ¹⁹So out of the ground the LORD God formed every beast of the field and every bird of the air, and brought them to the man to see what he would call them; and whatever the man called every living creature, that was its name. ²⁰The man gave names to all cattle, and to the birds of the air, and to every beast of the field; but for the man there was not found a helper fit for him. ²¹So the LORD God caused a deep sleep to fall upon the man, and while he slept took one of his ribs and closed up its place with flesh; ²²and the rib which the LORD God had taken from the man he made into a woman and brought her to the man. ²³Then the man said, "This at last is bone of my bones and flesh of my flesh; she shall be called Woman, because she was taken out of Man."

²⁴Therefore a man leaves his father and his mother and cleaves to his wife, and they become one flesh. ²⁵And the man and his wife were both naked, and were not ashamed.

given by God to Moses after the latter brings the people out of the bondage of Egypt and before they reach the Promised Land (see Reading 6.3).

The commandments, consisting of both prohibitions (against murder, theft, idolatry, and so on) and positive commands (for worship, honoring of parents, and so on), are part of the larger ethical commands of all civilizations. The peculiarly monotheistic parts of the code appear in the first cluster, with the positive command to worship God alone and the prohibition of graven images and their worship.

Ancient Israel's ethics take on a more specific character in the writings of the prophets. The prophet (Hebrew *nabi*) speaks with God's authority. In the Hebrew religion, the prophet was not primarily concerned with the future (prophet and seer are thus not the same thing), even though the prophets do speak of a coming of peace and justice in the age of the **messiah** (the Hebrew word meaning "anointed one"). The main prophetic task was to call people back to the observance of the covenant and to warn them about the ways in which they had failed that covenant. The great eighth-century prophets who flourished in both the north and the south after the period of the monarchy left a great literature. They insisted that worship of God, for example, in the worship of the temple, was insufficient if that worship did not come from the heart and include love and compassion for others. The prophets were radical critics of social injustice and defenders of the poor. They linked worship with a deep concern for ethics. They envisioned God as a god of all people and insisted on the connection between worship of God and righteous living.

Prophets were "called" to preach. In many instances, they even resisted that call and expressed reluctance to undertake the prophetic task. The fact that they had an unpopular message explains both why many of them suffered a violent end and why some were reluctant to undertake the task of preaching.

The prophetic element in religion was one of Israel's most enduring contributions to the religious sensibility of the world. The idea that certain people are called directly by God to preach peace and justice in the context of religious faith would continue beyond the biblical period in Judaism and Christianity. It is not accidental, to cite one modern example, that the civil-rights leader Martin Luther King, Jr. (1929–1968) often cited the biblical prophets as exemplars for his own struggle on behalf of African Americans. That King died a violent death by assassination in 1968 is an all too ready example of how disquieting the prophetic message can be.

MODELS AND TYPES Until modern times, relatively few Jews or Christians actually read the Bible on an individual basis. Literacy was rare, books expensive, and leisure at a premium. Bibles were read to people most frequently in public gatherings of worship in synagogues or churches. The one time that the New Testament reports Jesus as reading is from a copy of the prophet Isaiah kept in a synagogue (Luke 4:16). The biblical stories were read over the centuries in a familial setting (as at the Jewish Passover) or in formal worship on the Sabbath. The basic point, however, is that for more than 3000 years, the stories and (equally important) the people in these stories have been etched in the Western imagination. The faith of Abraham, the guidance of Moses, the wisdom of Solomon, the sufferings of Job, and the fidelity of Ruth have become proverbial in our culture.

READING 6.3 THE HEBREW BIBLE

Exodus 20:1–31 (the Decalogue)

¹And God spoke all these words, saying,
²"I am the LORD your God, who brought you out of the land of Egypt, out of the
³house of bondage.
⁴"You shall have no other gods before me.
⁵"You shall not make for yourself a graven image, or any likeness of anything that
⁶is in heaven above, or that is in the earth beneath, or that is in the water under the
⁷earth;
⁸you shall not bow down to them or serve them; for I the LORD your God am a
⁹jealous God, visiting the iniquity of the fathers upon the children to the third and
¹⁰the fourth generation of those who hate me,
¹¹but showing steadfast love to thousands of those who love me and keep my
¹²commandments.
¹³"You shall not take the name of the LORD your God in vain; for the LORD will
¹⁴not hold him guiltless who takes his name in vain.

¹⁵"Remember the sabbath day, to keep it holy.
¹⁶Six days you shall labor, and do all your work;
¹⁷but the seventh day is a sabbath to the LORD your God; in it you shall not do any
¹⁸work, you, or your son, or your daughter, your manservant, or your maidservant,
¹⁹or your cattle, or the sojourner who is within your gates;
²⁰for in six days the LORD made heaven and earth, the sea, and all that is in them,
²¹and rested the seventh day; therefore the LORD blessed the sabbath day and
²²hallowed it.
²³"Honor your father and your mother, that your days may be long in the land
²⁴which the LORD your God gives you.
²⁵"You shall not kill.
²⁶"You shall not commit adultery.
²⁷"You shall not steal.
²⁸"You shall not bear false witness against your neighbor.
²⁹"You shall not covet your neighbor's house; you shall not covet your neighbor's
³⁰wife, or his manservant, or his maidservant, or his ox, or his ass, or anything that
³¹is your neighbor's."

THE BOOK OF JOB As noted in the discussion of Abraham and the sacrifice of Isaac, belief in God, or belief that God is benevolent, has been a challenge for Jews at many times in history—for instance, during the Spanish Inquisition, which began in the same year that Columbus sailed into the New World, and as recently as the mid-20th century, in the devastation of the **Holocaust**. The question for Jews—and indeed for peoples all over the world, regardless of their religion—is why bad things happen to good people. The book of Job deals with that painful question (see Reading 6.4).

It relates the story of a righteous man—Job (rhyming with *lobe*). God and Satan discuss Job's piety, and Satan cynically contends that Job is observant only because God has protected him and blessed him with prosperity and a large family. Should God strike Job's possessions, Job would curse God. God permits Satan to put Job's righteousness to the test, and all of Job's possessions

READING 6.4 THE HEBREW BIBLE

From Job 38 and 40

38

¹Then the LORD answered Job out of the whirlwind:
²"Who is this that darkens counsel by words without knowledge?
³Gird up your loins like a man,
I will question you, and you shall declare to me.
⁴"Where were you when I laid the foundation of the earth?
Tell me, if you have understanding.
⁵Who determined its measurements—surely you know!
Or who stretched the line upon it?
⁶On what were its bases sunk,
or who laid its cornerstone,
⁷when the morning stars sang together,
and all the sons of God shouted for joy?
⁸"Or who shut in the sea with doors,
when it burst forth from the womb;
⁹when I made clouds its garment,
and thick darkness its swaddling band,
¹⁰and prescribed bounds for it,
and set bars and doors,
¹¹and said, `Thus far shall you come, and no farther,
and here shall your proud waves be stayed'?
¹²"Have you commanded the morning since your days began,
and caused the dawn to know its place,
¹³that it might take hold of the skirts of the earth,
and the wicked be shaken out of it?
¹⁴It is changed like clay under the seal,
and it is dyed like a garment.
¹⁵From the wicked their light is withheld,
and their uplifted arm is broken.
¹⁶"Have you entered into the springs of the sea,
or walked in the recesses of the deep?
¹⁷Have the gates of death been revealed to you,
or have you seen the gates of deep darkness?
¹⁸Have you comprehended the expanse of the earth?
Declare, if you know all this.
¹⁹"Where is the way to the dwelling of light,
and where is the place of darkness,
²⁰that you may take it to its territory
and that you may discern the paths to its home?
²¹You know, for you were born then,
and the number of your days is great!

²²"Have you entered the storehouses of the snow,
or have you seen the storehouses of the hail,
²³which I have reserved for the time of trouble,
for the day of battle and war?
²⁴What is the way to the place where the light is distributed,
or where the east wind is scattered upon the earth?
²⁵"Who has cleft a channel for the torrents of rain,
and a way for the thunderbolt,
²⁶to bring rain on a land where no man is,
on the desert in which there is no man;
²⁷to satisfy the waste and desolate land,
and to make the ground put forth grass?
²⁸"Has the rain a father,
or who has begotten the drops of dew?
²⁹From whose womb did the ice come forth,
and who has given birth to the hoarfrost of heaven?
³⁰The waters become hard like stone,
and the face of the deep is frozen.

40

¹And the LORD said to Job:
²"Shall a faultfinder contend with the Almighty?
He who argues with God, let him answer it."
³Then Job answered the LORD:
⁴"Behold, I am of small account; what shall I answer thee?
I lay my hand on my mouth.
⁵I have spoken once, and I will not answer;
twice, but I will proceed no further."
⁶Then the LORD answered Job out of the whirlwind:
⁷"Gird up your loins like a man;
I will question you, and you declare to me.
⁸Will you even put me in the wrong?
Will you condemn me that you may be justified?
⁹Have you an arm like God,
and can you thunder with a voice like his?
¹⁰"Deck yourself with majesty and dignity;
clothe yourself with glory and splendor.
¹¹Pour forth the overflowings of your anger,
and look on every one that is proud, and abase him.
¹²Look on every one that is proud, and bring him low;
and tread down the wicked where they stand.
¹³Hide them all in the dust together;
bind their faces in the world below.
¹⁴Then will I also acknowledge to you,
that your own right hand can give you victory.

and livestock are soon obliterated or stolen. His offspring are killed. But instead of cursing God, Job prays, "Naked I came from my mother's womb, and naked shall I return; the Lord has given, and the Lord has taken away; blessed be the name of Lord" (Job 1:21). Satan is then permitted by God to afflict Job's body but not take his life. Job is assaulted with an excruciating case of boils, which he tries to manage by scraping his skin with shards of pottery. Job's wife prompts him to curse God at this point, but Job answers, "Shall we receive good from God and not receive evil?" (Job 2:10). Nevertheless, he finally curses the day he was born.

In one of the most poetic, though mystifying, passages in the Bible, God answers Job (see Reading 6.4). But God does not directly explain why the righteous suffer. Rather, He paints the magnificence of His creation and of His own power. Is the point that the sufferings of one man matter little in the grand scheme? Some readers will find the "answer" less than satisfying, but the writing soars. It evokes a line from John Milton's *Paradise Lost*, which we shall see in Chapter 15; Milton declares that he wrote his poem to "justify the ways of God to men."

At the end of the story, Job's health has been restored. He has a new family and is again rich in livestock. But again, readers may ask whether one child is the same as another, and whether one can simply replace one's children such that one's pain is relieved. And what of the children who were killed?

These events and stories from the Bible are models of instruction and illumination; they have taken on a meaning far beyond their original significance. The events described in the book of

CONNECTIONS William Blake's watercolor drawings and engraved Illustrations of the book of Job, ironically, represent one of his few commercial and critical successes. The late 18th- to early 19th-century poet, who went penniless and unrecognized during his lifetime, identified himself with the righteous biblical wretch, Job. Scholars have noted that the book of Job had a significant influence on Blake's writing and art.

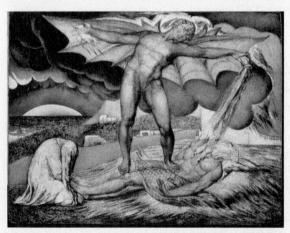

▲ 6.3 **William Blake, *Satan Smiting Job with Sore Boils*, ca. 1826** CE. Pen and ink and tempera on mahogany, 32.6 × 43.2 cm. Tate Gallery, London, Great Britain.

Exodus, for example, are often invoked to justify a desire for freedom from oppression and slavery. It is not accidental that Benjamin Franklin suggested depicting the crossing of the Reed Sea (not the Red Sea, as is often said) by the Children of Israel as the centerpiece of the Great Seal of the United States. Long before Franklin's day, the Pilgrims saw themselves as the new Children of Israel who had fled the oppression of Europe (read: Egypt) to find freedom in the land "flowing with milk and honey" that was America. At a later period in history, slaves in this country saw themselves as the oppressed Israelites in bondage. The desire of African Americans for freedom was couched in the language of the Bible as they sang "Go down, Moses.... Tell old Pharaoh: Let my people go!"

Dura-Europos

An archeological find in the 1930s provides evidence of the diversity and coexistence of religions in the Roman Empire of the third and fourth centuries, and is one of the few repositories of ancient Jewish art and architecture. The site is the Syrian town of Dura-Europos, which was destroyed by Persian armies in 256 CE and cloaked by desert sands for nearly 1700 years. From the perspectives of archaeology and art history, it is a wonder that buildings from this era and this place survived at all, much less so well preserved. After an erratic history of shifting control of the town, the population of Dura-Europos left once and for all in 256 CE. It is as if they just closed the doors behind them and walked away. Among the collection of buildings are pagan temples and homes, one of which had been converted into an early Christian meeting house, and a synagogue replete with glorious frescoes.

The synagogue in Dura-Europos (**Fig. 6.4**) belies the assumption that Jews, following the proscriptions of the Ten Commandments, did not create images associated with the worship of their god. The walls of the synagogue, divided into picture-like spaces, are covered with scenes from biblical stories and Jewish history. Stone benches line the walls of the meeting space, and on one wall is a niche with a projecting arch and two columns that housed the Torah scroll.

In one fresco, the figure of Moses dominates a scene depicting the parting of the Red Sea and the Exodus from Egypt under the protective, outstretched arms of the Hebrew God (**Fig. 6.5**). Although God's face is never represented in the frescoes, a guiding hand along the upper edge of a painting sometimes suggests His presence. In terms of style, Moses might look familiar to you. The frescoes of Dura-Europos owe much to Roman prototypes, in terms of both the overall historical narrative and stylistic details. The emotionless expression on the face of Moses, for example, recalls the stoicism of Marcus Aurelius.

It is impossible to ignore the impact of the biblical tradition on our common culture. Our literature echoes it; our art is saturated with it; our social institutions are shaped by it. Writers in the Middle Ages said that all knowledge came from God in the form of two great books: the book of nature and the book called the Bible. We have enlarged that understanding today but nonetheless have absorbed much of the Hebrew scriptures into the texture of our culture.

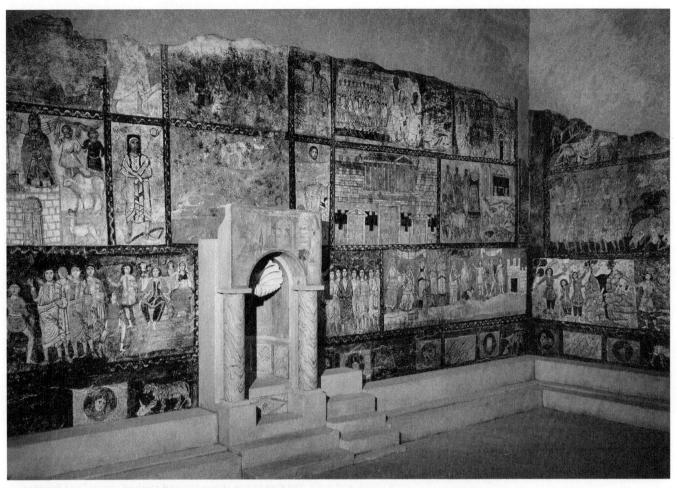

▲ **6.4 Interior of the synagogue, Dura-Europos, Syria, with wall paintings of themes from the Hebrew Bible, ca. 245–256 CE. Tempera on plaster. Reconstruction in the National Museum, Damascus, Syria.**

▼ **6.5 Moses and the Exodus, ca. 245–256 CE. Fresco detail from the Dura-Europos synagogue. Reconstruction in the National Museum, Damascus, Syria.** Moses (staff in hand), his brother Aaron, and the Israelites are pursued by Egyptian armies across the Red Sea. Egyptians are shown drowning on the right.

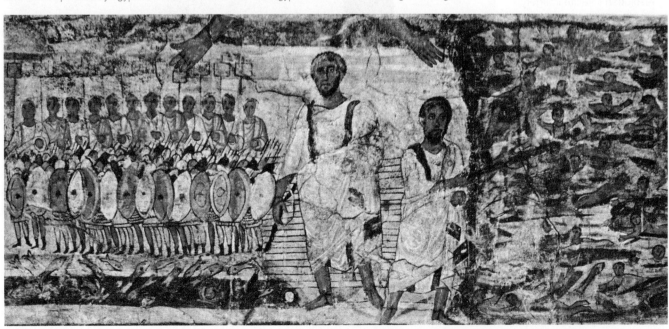

CONNECTIONS At one point in history, Dura-Europos was a great city sitting squarely at the crossroads of ancient empires. Nicknamed the "Pompeii of the desert," archaeological excavations were giving credence to the idea that Dura-Europos was much more than just an outpost on the east-west caravan route. Remains of temples dedicated to Sumerian, Syrian, Greek, and Palmyran deities as well as a synagogue and Early Christian meetinghouse attested to the growing opinion that this was a place where people from widely divergent cultural traditions intermingled and coexisted. The past tense you may have noticed in these sentences is deliberate. All we might have known about Dura-Europos we now will never know. The entire site has been utterly demolished by the Islamic State in Iraq and Syria (ISIS), the brutal Islamic militants in control of parts of Iraq and Syria who were determined—through death, destruction, enslavement, and repression—to establish a worldwide caliphate.

Dura-Europos is but one site of many to have fallen victim to the Islamic State's deliberate campaign to eradicate the cultural heritage—museums, historic buildings, archaeological sites—of both Iraq and Syria. Information about these losses have been reported by numerous sources ranging from news and social media to UNESCO, a branch of the United Nations that oversees and protects World Heritage Sites around the world. The most complete assessment of the extent of the damage to these sites, however, has been undertaken by the American Association for the Advancement of Science (AAAS), using high-resolution satellite imagery.

The disturbing photographs in **Figures 6.6A** and **6.6B** show the looting and destruction that took place at Dura-Europos over roughly a three-year period between August 4, 2011 and April 2, 2014. The first satellite image shows the site smooth and undisturbed, having been delicately excavated by archaeologists. The second image shows the same site within the same parameters riddled with thousands of looting pits—holes dug in the ground in pursuit of treasure that could be turned for profit. The areas highlighted by red circles on the satellite image, when enlarged, show the presence of vehicles within the walls of the site. Additional photographs, taken on the ground and in secret, corroborate the pillaging. The cratered site looks like the surface of the moon.

As your book was being revised for its current edition, ISIS destroyed the Temple of Baal Shamin in Palmyra, Syria, a UNESCO World Heritage monument (**Figure 6.7**).

▲ **6.6A** and **6.6B** The first image shows the undisturbed site of Dura-Europos. The second image shows it riddled with pits resulting from looting. The red circles show vehicles on the grounds.

▲ **6.7** The destruction of the Temple of Baal Shamin by the Islamic State in Iraq and Syria, Palmyra, Syria, August 2015. The temple formed the center of religious life in Palmyra and was dedicated in 32 CE. Its ruins were among the best preserved at Palmyra, but they were destroyed by ISIS in August 2015.

RELIGION

Revelation

One deep theme that runs through the Bible is the concept of revelation. Revelation means a disclosure or "making plain" (literally, "pulling back the veils"). The Bible has the strong conviction that God reveals himself in the act of creation but also, more important, through the process of human history. The Old Testament makes clear the Hebrew conviction that God actually chose a people, exercised his care for them (providence), prompted prophets to speak, and inspired people to write. Christians accepted this divine intervention and expanded it with the conviction that God's final revelation to humanity came in the person of Jesus of Nazareth.

Several consequences derive from the doctrine of revelation. First is the idea that God gives shape to history and is most deeply revealed through history. Second, biblical religion conceived of God not as a distant figure separated from people but as one who guided, encouraged, and finally shaped the destiny of a particular people (the Jews) and eventually the whole human race. The concept of revelation is intimately connected to the idea of covenant, which is discussed in the text.

It should also be noted that Islam, in continuity with biblical religion, also focuses on the idea of revelation. Islam teaches respect for the Hebrew patriarchs, prophets, and the person of Jesus, but it insists that Muhammad receives the final unveiling of God's purposes for the human race.

THE BEGINNINGS OF CHRISTIANITY

The fundamental fact to remember when studying the life of Jesus is that he was a Jew, born during the reign of Roman Emperor Augustus in the Roman-occupied land of Judaea (see **Map 6.1**, "Israel at the Time of Jesus"). What we know about him, apart from a few glancing references in pagan and Jewish literature, comes from the four gospels (**gospel** derives from an Anglo-Saxon word meaning "good news") attributed to Matthew, Mark, Luke, and John. The Gospels began to appear more than a generation after the death of Jesus, which probably occurred in 30 CE. The Gospels are religious documents, not biographies, but they contain historical data about Jesus as well as theological reflections about the meaning of his life and the significance of his deeds.

Jesus must also be understood in light of the Jewish prophetic tradition. He preached the coming of God's kingdom, which would be a reign of justice and mercy. Israel's enemies would be overcome. Until that kingdom arrived, Jesus insisted on a life of repentance; an abandonment of earthly concerns; love of God and neighbor; and compassion for the poor, downcast, and marginalized. He set forth his own life as an example. His identification with the poor and powerless antagonized his enemies—who included the leaders of his own religion and the governing authorities of the ruling Romans. Perhaps the most characteristic expression of the teachings of Jesus is to be found in his parables and in the moral code he expressed in what is variously called the Beatitudes or the Sermon on the Mount.

The Sermon on the Mount (see Reading 6.5) is among the most familiar passages in the New Testament. It promises heaven for the righteous. There are many expressions that have become part of common speech: "salt of the earth," "a city set on a hill," "the light of the world." It is in the sermon that we find the Roman Catholic prohibition of divorce, the concept of turning the other cheek when assaulted, and the command to love one's enemies. But make no mistake: there is also the repeated threat of hellfire for transgressors.

ISRAEL AT THE TIME OF JESUS

◀ MAP 6.1 Israel at the time of Jesus.

This area coincides more or less with the kingdom known in the time of King David.

READING 6.5 THE CHRISTIAN BIBLE, NEW TESTAMENT

Matthew 5:1–48

[1]Seeing the crowds, he went up on the mountain, and when he sat down his disciples came to him.

[2]And he opened his mouth and taught them, saying:

[3]"Blessed are the poor in spirit, for theirs is the kingdom of heaven.

[4]"Blessed are those who mourn, for they shall be comforted.

[5]"Blessed are the meek, for they shall inherit the earth.

[6]"Blessed are those who hunger and thirst for righteousness, for they shall be satisfied.

[7]"Blessed are the merciful, for they shall obtain mercy.

[8]"Blessed are the pure in heart, for they shall see God.

[9]"Blessed are the peacemakers, for they shall be called sons of God.

[10]"Blessed are those who are persecuted for righteousness' sake, for theirs is the kingdom of heaven.

[11]"Blessed are you when men revile you and persecute you and utter all kinds of evil against you falsely on my account.

[12]Rejoice and be glad, for your reward is great in heaven, for so men persecuted the prophets who were before you.

[13]"You are the salt of the earth; but if salt has lost its taste, how shall its saltness be restored? It is no longer good for anything except to be thrown out and trodden under foot by men.

[14]"You are the light of the world. A city set on a hill cannot be hid.

[15]Nor do men light a lamp and put it under a bushel, but on a stand, and it gives light to all in the house.

[16]Let your light so shine before men, that they may see your good works and give glory to your Father who is in heaven.

[17]"Think not that I have come to abolish the law and the prophets; I have come not to abolish them but to fulfill them.

[18]For truly, I say to you, till heaven and earth pass away, not an iota, not a dot, will pass from the law until all is accomplished.

[19]Whoever then relaxes one of the least of these commandments and teaches men so, shall be called least in the kingdom of heaven; but he who does them and teaches them shall be called great in the kingdom of heaven.

[20]For I tell you, unless your righteousness exceeds that of the scribes and Pharisees, you will never enter the kingdom of heaven.

[21]"You have heard that it was said to the men of old, 'You shall not kill; and whoever kills shall be liable to judgment.'

[22]But I say to you that every one who is angry with his brother shall be liable to judgment; whoever insults his brother shall be liable to the council, and whoever says, 'You fool!' shall be liable to the hell of fire.

[23]So if you are offering your gift at the altar, and there remember that your brother has something against you,

[24]leave your gift there before the altar and go; first be reconciled to your brother, and then come and offer your gift.

[25]Make friends quickly with your accuser, while you are going with him to court, lest your accuser hand you over to the judge, and the judge to the guard, and you be put in prison;

[26]truly, I say to you, you will never get out till you have paid the last penny.

[27]"You have heard that it was said, 'You shall not commit adultery.'

[28]But I say to you that every one who looks at a woman lustfully has already committed adultery with her in his heart.

[29]If your right eye causes you to sin, pluck it out and throw it away; it is better that you lose one of your members than that your whole body be thrown into hell.

[30]And if your right hand causes you to sin, cut it off and throw it away; it is better that you lose one of your members than that your whole body go into hell.

[31]"It was also said, 'Whoever divorces his wife, let him give her a certificate of divorce.'

[32]But I say to you that every one who divorces his wife, except on the ground of unchastity, makes her an adulteress; and whoever marries a divorced woman commits adultery.

[33]"Again you have heard that it was said to the men of old, 'You shall not swear falsely, but shall perform to the Lord what you have sworn.'

[34]But I say to you, Do not swear at all, either by heaven, for it is the throne of God,

[35]or by the earth, for it is his footstool, or by Jerusalem, for it is the city of the great King.

[36]And do not swear by your head, for you cannot make one hair white or black.

[37]Let what you say be simply 'Yes' or 'No'; anything more than this comes from evil.

[38]"You have heard that it was said, 'An eye for an eye and a tooth for a tooth.'

[39]But I say to you, Do not resist one who is evil. But if any one strikes you on the right cheek, turn to him the other also;

[40]and if any one would sue you and take your coat, let him have your cloak as well;

[41]and if any one forces you to go one mile, go with him two miles.

[42]Give to him who begs from you, and do not refuse him who would borrow from you.

[43]"You have heard that it was said, 'You shall love your neighbor and hate your enemy.'

[44]But I say to you, Love your enemies and pray for those who persecute you,

[45]so that you may be sons of your Father who is in heaven; for he makes his sun rise on the evil and on the good, and sends rain on the just and on the unjust.

[46]For if you love those who love you, what reward have you? Do not even the tax collectors do the same?

[47]And if you salute only your brethren, what more are you doing than others? Do not even the Gentiles do the same?

[48]You, therefore, must be perfect, as your heavenly Father is perfect."

Matthew 6 (see Reading 6.6) communicates some essentials of Christian life and worship. First, there is a prohibition against praying for show—that is, for the approval of other people. Prayer should be sincere, and for that reason, it is well to pray in private. (In Chapter 15, we will meet Tartuffe, a character in a French comedy of the same name by Molière. Tartuffe calls for his servant to put away his hair shirt and his whip—two means used to mortify the flesh. However, he does so loudly and in the view of others, revealing his hypocrisy.) Matthew 6 is also the origin of the familiar phrase, "do not let your left hand know what your right hand is doing," whose meaning is often lost when it is used in the present day. Lines 9–15 contain "The Lord's Prayer."

The teachings of Jesus reflect a profound grasp of the piety and wisdom of the Jewish traditions, but the Gospels make a further claim for Jesus, depicting him as the **Christ** (a Greek translation of the Hebrew *messiah*, "anointed one")—the savior promised by the ancient biblical prophets who would bring about God's kingdom. His tragic death by crucifixion (a punishment so painful and degrading that it was reserved for slaves, foreigners, vile criminals, and revolutionaries) would seem to have ended the public career of Jesus. The early Christian church, however, insisted that Jesus overcame death by rising from the tomb three days after his death. This belief in the resurrection became a centerpiece of Christian faith and preaching and the basis on which early Christianity proclaimed Jesus as the Christ.

The Spread of Christianity

The slow growth of the Christian movement was given an early boost by the conversion of a Jewish zealot, Saul of Tarsus, around the year 35 CE near Damascus, Syria. Paul (his postconversion name) won a crucial battle in the early Christian church, insisting that non-Jewish converts to the movement would not have to adhere to all Jewish religious customs, especially male circumcision. Paul's victory was to change Christianity from a religious movement within Judaism to a religious tradition that could embrace the non-Jewish world of the Roman Empire. One dramatic example of Paul's approach to this pagan world was a public sermon he gave in the city of Athens, in which he used the language of Greek culture to speak to the Athenians with the message of the Christian movement (see Acts 17:16–34).

Paul was a tireless missionary. He made at least three long journeys through the cities on the northern shore of the Mediterranean (and may once have gotten as far as Spain). On his final journey, he reached Rome, where he met his death at the hands of a Roman executioner around the year 62 CE. In many of the cities he visited, he left small communities of believers. Some of his letters (to the Romans, Galatians, Corinthians, and so on) are addressed to believers in these places and provide details of his theological and pastoral concerns.

The letter of Paul seen in Reading 6.7 addresses the meaning and power of love. "Seeing with a mirror dimly" may strike you as a familiar phrase.

READING 6.6 THE CHRISTIAN BIBLE, NEW TESTAMENT

Matthew 6:1–15

[1]"Beware of practicing your piety before men in order to be seen by them; for then you will have no reward from your Father who is in heaven.

[2]"Thus, when you give alms, sound no trumpet before you, as the hypocrites do in the synagogues and in the streets, that they may be praised by men. Truly, I say to you, they have received their reward.

[3]But when you give alms, do not let your left hand know what your right hand is doing,

[4]so that your alms may be in secret; and your Father who sees in secret will reward you.

[5]"And when you pray, you must not be like the hypocrites; for they love to stand and pray in the synagogues and at the street corners, that they may be seen by men. Truly, I say to you, they have received their reward.

[6]But when you pray, go into your room and shut the door and pray to your Father who is in secret; and your Father who sees in secret will reward you.

[7]"And in praying do not heap up empty phrases as the Gentiles do; for they think that they will be heard for their many words.

[8]Do not be like them, for your Father knows what you need before you ask him.

[9]Pray then like this: Our Father who art in heaven, Hallowed be thy name.

[10]Thy kingdom come.
Thy will be done,
On earth as it is in heaven.

[11]Give us this day our daily bread;

[12]And forgive us our debts,
As we also have forgiven our debtors;

[13]And lead us not into temptation,
But deliver us from evil.

[14]For if you forgive men their trespasses, your heavenly Father also will forgive you;

[15]but if you do not forgive men their trespasses, neither will your Father forgive your trespasses.

EARLY MARTYRS By the end of the first century CE, communities of Christian believers existed in most of the cities of the vast Roman Empire. Their numbers were sufficient that, in 64 CE, Emperor Nero could make Christians scapegoats for a fire that destroyed the city of Rome (probably set by the emperor's own agents). As we see in Reading 6.8, the Roman writer Tacitus provides a vivid description of the tortures meted out to the Christians.

THE GROWTH OF CHRISTIANITY Why were the Christians successful in spreading their religion? Why did they become the object of persecution at the hands of the Romans?

Several social factors aided the growth of Christianity: There was peace in the Roman Empire; a good system of safe

READING 6.7 THE CHRISTIAN BIBLE, NEW TESTAMENT

[1]If I speak in the tongues of men and of angels, but have not love, I am a noisy gong or a clanging cymbal.
[2]And if I have prophetic powers, and understand all mysteries and all knowledge, and if I have all faith, so as to remove mountains, but have not love, I am nothing.
[3]If I give away all I have, and if I deliver my body to be burned, but have not love, I gain nothing.
[4]Love is patient and kind; love is not jealous or boastful;
[5]it is not arrogant or rude. Love does not insist on its own way; it is not irritable or resentful;
[6]it does not rejoice at wrong, but rejoices in the right.

[7]Love bears all things, believes all things, hopes all things, endures all things.
[8]Love never ends; as for prophecies, they will pass away; as for tongues, they will cease; as for knowledge, it will pass away.
[9]For our knowledge is imperfect and our prophecy is imperfect;
[10]but when the perfect comes, the imperfect will pass away.
[11]When I was a child, I spoke like a child, I thought like a child, I reasoned like a child; when I became a man, I gave up childish ways.
[12]For now we see in a mirror dimly, but then face to face. Now I know in part; then I shall understand fully, even as I have been fully understood.
[13]So faith, hope, love abide, these three; but the greatest of these is love.

roads made travel easy; there was a common language in the empire (a form of common Greek called Koine, the language of the New Testament); and Christianity was first preached in a network of Jewish centers. Scholars have also offered some religious reasons: the growing interest of pagans in monotheism; the strong Christian emphasis on salvation and freedom from sin; the Christian custom of offering mutual aid and charity for its members; and its relative freedom from class distinctions. Paul wrote that in this faith there was "neither Jew nor Gentile; male nor female; slave nor free person."

This new religion met a good deal of resistance. The first martyrs died before the movement spread outside Jerusalem because of the resistance of the Jewish establishment. Very quickly, too, the Christians earned the enmity of the Romans. Even before Nero's persecution in 64 CE, the Christians had been expelled from the city of Rome by Emperor Claudius. From those early days until the third century, there were sporadic outbreaks of persecutions. In 250 CE, under Emperor Decius, there was an empire-wide persecution, with two others coming in 257 (under Emperor Valerian) and in 303 (under Emperor Diocletian). Finally, in 312 CE, Emperor Constantine issued a decree in Milan to tolerate Christianity.

What was the basis for this long history of persecution? The reasons are complex. Ordinarily, Rome had little interest in the religious beliefs of its subjects so long as these beliefs did not threaten public order. The Christian communities seemed secretive; they had their own network of communication in the empire; they kept away from active life in the political realm; most telling of all, they refused to pay homage to the state gods and goddesses. A common charge made against them was that they were atheists: they denied the existence of the Roman gods. Romans conceived of their society as bound together in a web of *pietas*, a virtue that meant a combination of duty and devotion to others. The Romans felt that one should express pietas to the parents of a family, the family should express pietas toward the state, and the state in turn owed pietas to the gods. That brought everything into harmony, and the state would flourish. The Christian refusal to express pietas to the gods seemed to the Romans to strike at the heart of civic order. The Christians, in short, were traitors to the state.

APOLOGISTS Christian writers of the second century tried to answer these charges by insisting that the Christians wished

READING 6.8 TACITUS

From *Annals 15*

Nero charged, and viciously punished, people called Christians who were despised on account of their wicked practices. The founder of the sect, Christus, was executed by the procurator Pontius Pilate during the reign of Tiberius. The evil superstition was suppressed for a time but soon broke out afresh not only in Judea where it started but also in Rome where every filthy outrage arrives and prospers. First, those who confessed were seized and then, on their witness, a huge

number was convicted, less for arson than for their hatred of the human race.

In their death they were mocked. Some were sewn in animal skins and worried to death by dogs; others were crucified or burned so that, when daylight was over, they could serve as torches in the evening. Nero provided his own gardens for this show and made it into a circus. He mingled with the crowd dressed as a charioteer or posed in his chariot. As a result, the sufferers guilty and worthy of punishment although they were, did arouse the pity of the mob who saw their suffering resulted from the viciousness of one man and not because of some need for the common good.

to be good citizens and could be. These writers (called apologists) wrote about the moral code of Christianity, about their beliefs and the reasons they could not worship the Roman deities. Their radical monotheism, inherited from Judaism, forbade such worship. Furthermore, they protested their roles as ready scapegoats for every ill—real or imagined—in society. The acid-tongued North African Christian writer Tertullian (ca. 155/160–225 CE) provided a sharp statement concerning the Christian grievance about such treatment: "If the Tiber floods its banks or the Nile doesn't flood; if the heavens stand still or the earth shakes, if there is hunger or drought, quickly the cry goes up, 'Christians to the lions!'"

One of the most important of the early Christian apologists was Justin Martyr. Born around 100 CE in Palestine, he converted to Christianity and taught, first at Ephesus and later in Rome. While in Rome, he wrote two lengthy apologies to the emperors asking for toleration and attempting to explain the Christian religion. These early writings are important because they provide a window onto early Christian life and Christian attitudes toward both Roman and Jewish culture. Justin's writings did not, however, receive the audience for which he had hoped. In 165 CE, he was scourged and beheaded in Rome under the anti-Christian laws.

notions, these underground galleries, hollowed out or hewn from the soft rock known as *tufa*, were never hiding places for Christians during the times of persecution; neither were they secret places for worship. Also contrary to popular belief, only a small number of tombs contained the remains of martyrs of the Christian faith. None do today, in fact, because martyrs were reburied inside the walls of the city of Rome in the early Middle Ages.

These underground cemeteries are important, however, because they provide us with some visual evidence of early Christian beliefs and customs.

Frescoes

A number of **frescoes** (wall paintings on wet plaster) have survived in the catacombs, one of the most accomplished of which was found in the Catacomb of Saints Pietro and Marcellino (**Fig. 6.8**). Jesus stands within a perfect circle, represented as a young shepherd who carries one of his rescued sheep over his shoulders. Four arms in the shape of a cross extend outward from the circle, culminating in semicircular frames depicting scenes from the biblical story of Jonah and the whale.

EARLY CHRISTIAN ART

Very little Christian art or architecture dates from before the fourth century because before the Edict of Milan and the declaration of tolerance for Christianity, followers were forbidden to establish places for worship. They did so clandestinely. We do have art from cemeteries and some cities that were maintained by Christian communities. These cemeteries, which were outside the Roman limits, consisted of an extensive network of galleries and burial chambers for thousands of Christians. They are called **catacombs**, from the word *catacumbas*, which means "in the hollows." Contrary to romantic

▶ 6.8 *The Good Shepherd*, early fourth century CE. Catacomb of Saints Pietro and Marcellino, Rome, Italy.

The meaning and style of the fresco illustrate a convergence of three traditions: Christian, Jewish, and Roman. The reference to Christ as a shepherd is traced to his own words, according to the Gospel of John.

> I am the good shepherd; I know my sheep and my sheep know me—just as the Father knows me and I know the Father—and I lay down my life for the sheep. I have other sheep that are not of this sheep pen. I must bring them also. They too will listen to my voice, and there shall be one flock and one shepherd." (John 10:11–18)

For Christians, the image of the shepherd and his flock symbolized Jesus and his followers, his loyalty and sacrifice. The symbolism of Jonah provided an important connection between the Christian (New Testament) and the Hebrew (Old Testament) Bibles: early Christians saw the miracle of Jonah's deliverance after three days from the belly of the monster that swallowed him as a prefiguration of Christ's resurrection three days after his crucifixion. And though the image of the good shepherd proved to be one of the most enduring in Christian iconography, it likely did not originate among Jesus's followers. It may be possible to draw a connection between sacrificial animals in Greek ritual and biblical references to a Lamb of God (the Messiah) who would be sacrificed to save humanity. In addition, the style of the figures in the Good Shepherd fresco is more generally reminiscent of those found in vase and wall paintings from Greece and Rome. The poses and proportions are realistic, and the drapery falls over the body in natural folds. Early Christians shared the art and culture of Rome, even if not its religion. There were bound to be similarities in style.

Other subjects reflect the Christian hope of salvation and eternal life. Jesus's raising of Lazarus from the dead, for example, alluded to the belief that all of the dead would be raised at the end of time. Another common theme was Jesus's communion meal during the Last Supper; it anticipated the heavenly banquet that awaited all believers in the next life. These frescoes herald the beginnings of artistic themes and images that would continue down through the centuries of Christian art.

Tombs in the catacombs were covered by slabs of marble cemented in place and inscribed with the name and death date of the deceased. Frequently, the slabs also featured symbols that alluded to Jesus Christ, his followers, or the promise of faith. Among them are the anchor (hope) and the dove with an olive branch (peace). One of them most common symbols was a fish (**Fig. 6.9**); the letters that spell the Greek word for "fish" were considered an anagram for the phrase "Jesus Christ, Son of God and Savior." The fish symbol became a stenographic way of confessing faith. Another enduring symbol of Christ is the overlapping Greek letters, *chi* and *rho*—the first two letters of the Greek word *christos*. The other Greek letters in the diagram—*alpha* and *omega*—are the first and last letters of the Greek alphabet respectively. They are a shorthand symbol for a phrase attributed

▲ **6.9 Anchor with entwined fish, fourth century CE. Mosaic from the Catacombs of Hermes, Sousse, Tunisia.** A symbol of Jesus and his followers, the anchor motif was a hidden reference to the cross, which was rarely depicted before the fourth century.

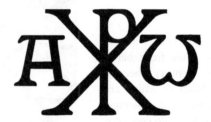

▲ **6.10 The Chi-rho symbol along with the alpha and omega are seen together in Early Christian sites such as the Catacombs of Domatilla in Rome, part of an extensive network of underground burial places.**

to Jesus from the book of Revelation: "I am the alpha and the omega," meaning, "I am the beginning and the end." The Greek letters used in the following symbol are alpha (α or A), rho (ρ), chi (χ), and omega (ω) (**Fig. 6.10**).

Sculpture

Sculpture with Christian imagery was particularly rare, and despite their connection to Roman culture, Christians did not populate their houses of worship with an equivalent of a cult statue. The few examples that do exist pick up on Graeco-Roman modes of representation, as in the statue of Christ as the Good Shepherd (**Fig. 6.11**). The artist depicts

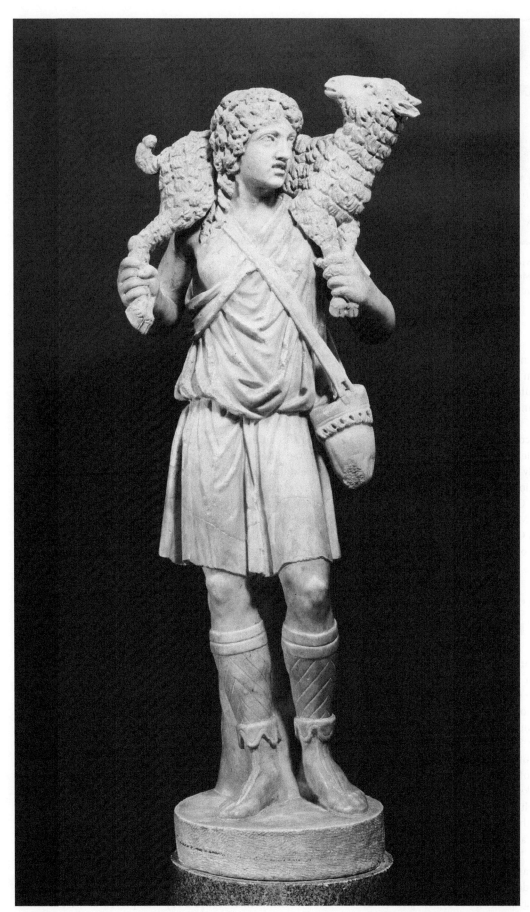

◄ **6.11** *The Good Shepherd,* ca. 300 CE. **Marble, 39"** **(99 cm) high. Museo Pio** **Cristiano, Vatican Museums,** **Vatican City State, Italy.** This depiction of Christ, borrowed from Graeco-Roman models, is common in early Christian art, although sculptural examples are rather rare.

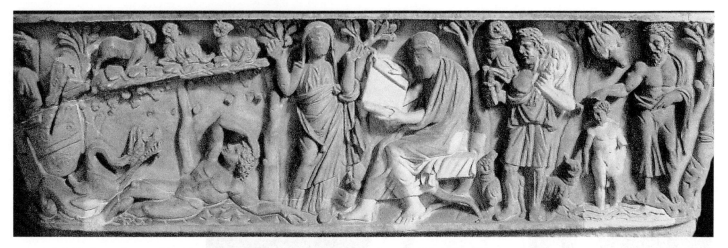

▲ 6.12 **Sarcophagus with philosopher, orant, and scenes from the Hebrew and Christian Bibles, ca. 270. Marble, 1' 11¼" × 7' 2". Santa Maria Antiqua, Rome.** The sarcophagus portrays the salvation of Jonah, Christ as the Good Shepherd, and the baptism of Christ.

Jesus as a beardless young man in a contrapposto stance, with his weight shifting from one leg to the other as he balances the sheep over his shoulders. His drilled, curly hair and slightly parted lips are distinctly Classical, as is the subtle draping of his tunic.

Wealthy Christians also commissioned carved sarcophagi, and imagery found in the reliefs is consonant with the themes depicted in painting. The Early Christian sarcophagus shown in **Figure 6.12** depicts the salvation of Jonah, Christ as the Good Shepherd, and the baptism of Christ. As in the fresco from the Catacomb of Saints Pietro and Marcellino, the artist creates a harmonious blend of Hebrew and Christian Bible scenes, emphasizing the common denominator of an afterlife.

EARLY CHRISTIAN ARCHITECTURE

Two of the most famous Christian churches are associated with the reign of the Emperor Constantine (306–337 CE): Old Saint Peter's Basilica and the Church of the Holy Sepulcher. Old Saint Peter's was erected on the site where it was believed that Saint Peter was buried, and it was dedicated by Constantine in 326 CE. (The present Saint Peter's in Vatican City in Rome rests on the remains of the old **basilica**.) We do not have a fully articulated plan of that church, but its main outlines are clear—the plan looks to the past and to the future. The scale of the building, including many of its parts, reflects those of Roman basilicas. Both have wide, long, central **naves** flanked by two narrower side aisles, framing the main congregational space. Unlike many Roman basilicas, however, Old Saint Peter's (see **Fig. 6.13**) was entered from one of the short sides, rather than the long sides of the rectangular plan. The faithful would enter through a kind of gateway into an **atrium**

(an open courtyard surrounded by an arcade), cross the open space, and then pass through a vestibule called the **narthex** into the wide nave and the church proper. On the opposite end of the 300-foot-long structure was the **transept**, an aisle that crossed over and was perpendicular to the nave and side aisles and that separated the congregational space from the altar. The transept often extended beyond the boundaries of the side aisles so that it resembled the arms of a cross. The altar, the focus of ritual and ceremony, was placed in a semicircular space called the **apse**, another holdover from Roman basilicas. This plan is called a **Latin cross plan** or, because of the length of the nave and the orientation of the plan along a single dominant axis, a **longitudinal plan**. The roof of the structure was pitched, with wooden trusses, and supported by the outer walls and the columned interiors.

The walls that flanked the nave consisted, on the lowest level, of a colonnade and, in the upper reaches, just below the ceiling, a series of small arched windows called a **clerestory**; these windows provided most of the interior illumination. This basilican plan became a model from which many of the features of later church architecture evolved.

Old Saint Peter's was decorated lavishly with inlaid marble and mosaics, none of which survive. In fact, no early Christian churches except for one escaped destruction by fire, in large part because their roofs were constructed of wood. The art of mosaic, much of it Classical in style, was adopted from the Romans and comprised most of the ornamentation in these churches.

Constantine also ordered the construction of the Church of the Holy Sepulcher within the walls of the city of Jerusalem (**Fig. 6.14**), on the site of a demolished temple to Venus. The plan included two connected churches that contained important Christian sites: Calvary (also known as Golgotha), the place where Jesus was crucified, and a rock-cut tomb believed to be the one into which Jesus's body was placed and from which

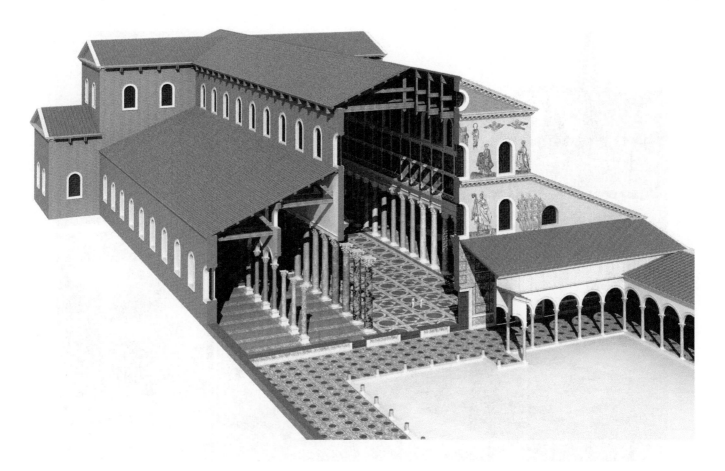

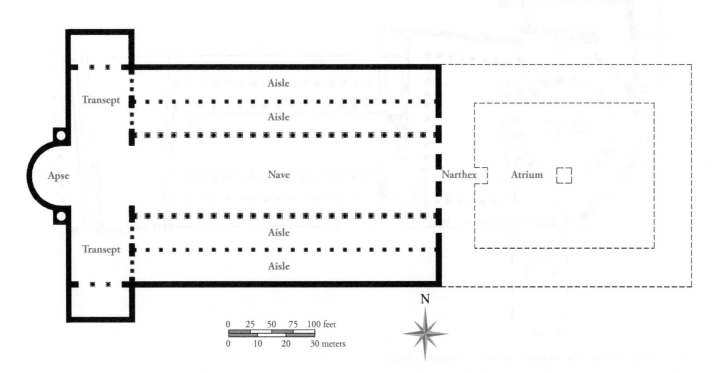

▲ **6.13 Old Saint Peter's Basilica, begun ca. 319** CE. **Rome, Italy. 835' (254.5 m) long (grand axis) ×
295' (90 m) wide (transept).** Restored cutaway view and plan. This kind of basilica floor plan would be common
in the West until the rise of the Romanesque period. Artwork by John Burge.

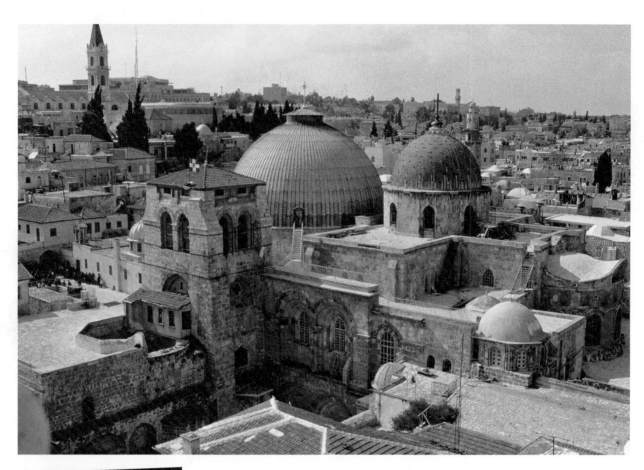

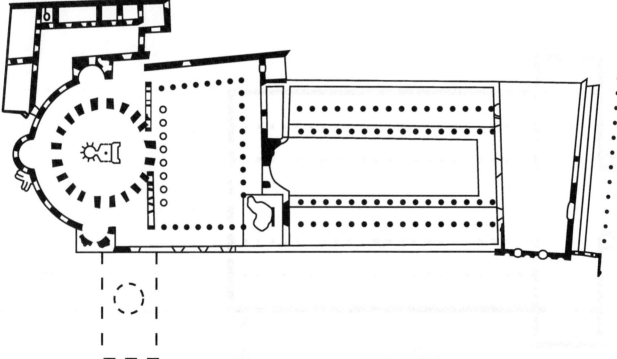

▲ **6.14 Church of the Holy Sepulcher, ca. 345 CE. Jerusalem, Israel.** (Top) Today the church is nestled in among other buildings in the Old City of Jerusalem. It was erected on the site of the hill of Calvary (also known as Golgotha), where Christians believe that Jesus was crucified. It also encompasses the tomb from which Jesus was resurrected. (Bottom) The floor plan of the original church as built by the emperor Constantine and his mother, Saint Helena.

he was resurrected three days later. Even though the structure today is not from Constantine's era (it was destroyed, rebuilt, expanded, and embellished), one can still see the parts of the church that owe their design to Roman architectural models: a basilica plan is combined with a domed space that recalls the Pantheon in Rome.

EARLY CHRISTIAN MUSIC

If the visual arts of early Christianity turned to Graeco-Roman models for inspiration, the music of the early church drew on Jewish sources. The tradition of singing (or, rather, chanting) sacred texts at religious services was an ancient Jewish custom that appears to go back to Mesopotamian sources. What little we know of Jewish music, in fact, suggests that it was influenced strongly by the various peoples with whom the Jews came into contact. The lyre used by Jewish musicians was a common Mesopotamian instrument, whereas the harp for which King David was famous came to the Jews from Assyria by way of Egypt (**Fig. 6.15**).

By early Christian times, Jewish religious services consisted of a standardized series of prayers and scriptural readings organized to create a cycle that fit the Jewish calendar. Many of these readings were taken over by early Christian congregations, particularly those where the number of converted Jews was high. In chanting the psalms, the style of execution often depended on how well they were known by the congregation. Where the Jewish component of the congregation was strong, the congregation would join in the chant. Increasingly, however, the singing was left to trained choruses, with the other congregants joining in only for the standard response of "amen" or "alleluia." As the music fell more into the hands of professionals, it became increasingly complex.

This professionalization proved unpopular with church authorities, who feared that the choirs were more concerned with performance than with worship. In 361 CE, a provincial council of the Christian church in Laodicea ordered that there should be only one paid performer (**cantor**) for each congregation. In Rome, the authorities discouraged poetic elaboration on the liturgical texts, a practice common among the Jews and the Christians of the East.

Part of the early Christian suspicion of music, in the West at least, was a reaction against the Greek doctrine of *ethos*[3] in music, which claimed that music could have a profound effect on human behavior. The possibility that music might induce moods of passion or violence, or might even yield agreeable sensations in itself, was not likely to appeal

▲ **6.15** King David plays the lyre, surrounded by other musicians. 12th century psalter. Municipal Library, Mantua, Italy.

to a church that required the ethos of its music to express religious truth alone. For this reason, instrumental music was rejected as unsuitable for the Christian liturgy. Such instrumentation was, in the minds of many Christians, too reminiscent of pagan customs.

By the fourth century, then, the standard form of music in Christian churches was either **responsorial singing**, with a cantor intoning lines from the Psalms and the congregation responding with a simple repeated refrain, or **antiphonal singing**, with parts of the congregation (or the cantor and the congregation) alternating verses of a psalm in a simple chant tone. By the beginning of the fifth century, there is evidence of nonscriptural hymns being composed. Apart from some rare fragments, we have no illustration of music texts with notation before the ninth century.

3. The spirit or beliefs of a culture or a community.

GLOSSARY

Apse (p. 222) A semicircular or polygonal projection of a building with a semicircular dome, especially on the east end of a church.

Antiphonal singing (p. 225) A form of religious singing in which segments of a congregation chant alternating verses of a psalm.

Atrium (p. 222) A courtyard, especially as surrounded by a colonnaded arcade.

Basilica (p. 222) A large oblong building or hall with colonnades and an apse; used for public functions, such as a court of law, or as a church.

Canon (p. 207) A code of law, an honored list, or an ecclesiastical regulation enacted by a religious council; as in a canon of "great works of literature" or a canon of writings that belong in a bible.

Cantor (p. 225) A singer, especially a person who takes a special role in singing or leading songs at a ceremony or at synagogue and church services.

Catacomb (p. 219) An underground cemetery consisting of tunnels or chambers that have recesses for coffins and tombs.

Christ (p. 217) The Messiah, or savior, as prophesied in the Hebrew Bible; Jesus of Nazareth, held by Christians to be the fulfillment of the prophecy.

Clerestory (p. 222) High windows permitting light to enter a building but not enabling people to look in or out.

Covenant (p. 209) Agreement; referring to the "special relationship" between God and the Israelites.

Decalogue (p. 209) Another term for the Ten Commandments, as set forth in the book of Exodus.

Exodus (p. 206) Going out.

Fresco (p. 219) A type of painting in which pigments are applied to a fresh, wet plaster surface or wall and thereby become part of the surface or wall (from Italian for "fresh").

Gospel (p. 215) The teachings of Jesus and the apostles, especially as described in the first four books of the New Testament; also conceived as "good news" in that redemption has become possible.

Henotheism (p. 208) The belief that there are many gods but only one is chosen for worship.

Holocaust (p. 211) Mass slaughter or destruction, as by fire or nuclear war; the name given to the Nazi slaughter of Jews during World War II.

Latin cross plan (p. 222) A cross-shaped church design in which the nave is longer than the transept.

Longitudinal plan (p. 222) A church design in which the nave is longer than the transept and in which parts are symmetrical against an axis.

Messiah (p. 210) Savior; from the Hebrew for "anointed one."

Monotheism (p. 208) The belief in one god.

Narthex (p. 222) A vestibule leading from an atrium into a church.

Nave (p. 222) The central part of a church, constructed for the congregation at large; usually flanked by aisles with less height and width.

Patriarch (p. 206) The male head of a family or a tribe.

Polytheism (p. 208) Belief in many gods.

Prophet (p. 207) A person who speaks with the authority of God, either to predict the future or to call people to observance.

Psalm (p. 207) A song, hymn, or prayer from the book of Psalms; used in Jewish and Christian worship.

Responsorial singing (p. 225) A form of religious singing in which a cantor intones lines from psalms and the congregation responds with a simple refrain.

Septuagint (p. 207) An ancient Greek version of the Hebrew scriptures that was originally made for Greek-speaking Jews in Egypt.

Testament (p. 209) Originally, a covenant between God and humans; now referring more often to either of the two main divisions of the Bible: the Hebrew Bible (Old Testament) and the Christian Bible (New Testament).

Torah (p. 207) A Hebrew word meaning "teaching" or "law" and used to refer to the first five books of the Hebrew Bible; also known as the *Pentateuch*.

Transept (p. 222) The crossing part of a church built in the shape of a cross.

THE BIG PICTURE THE RISE OF THE BIBLICAL TRADITION

Language and Literature

- The first five books of the Hebrew scriptures (the Torah) are put into writing ca. 600–400 BCE.
- The book of Psalms is written ca. 950 BCE.
- The books of Kings, Isaiah, Jeremiah, Ezekiel, Amos, and Job are set down in writing ca. the 10th–5th centuries BCE.
- "The Sermon on the Mount" is set down in the Gospel of Saint Matthew ca. 70 CE.
- Justin Martyr writes *Apology* ca. 150 CE.

Art, Architecture, and Music

- Depiction of divinity is prohibited in the Jewish religion ca. 1000 BCE.
- The Temple of Solomon is built ca. 961–922 BCE.
- Musical instruments—drums, reed instruments, lyres, harps, and horns—often accompany psalms.
- Solomon's Temple is destroyed by the Babylonians in 587 BCE.
- Herod begins rebuilding the Temple of Solomon in 19 CE; it is destroyed by Titus under Emperor Vespasian in 70 CE.
- Frescoes embellish Christian catacombs ca. 250 CE.
- A Jewish synagogue and art are made at Dura-Europos in the third century CE.
- Christian sculpture appears ca. 300 CE.
- Inscriptions, particularly chi-rho, decorate Christian tombs in the fourth century CE.
- Old Saint Peter's Basilica is built in Rome ca. 333 CE.
- The Church of the Holy Sepulcher is built in Jerusalem ca. 326–345 CE.

Philosophy and Religion

- The age of the Hebrew patriarchs—Abraham, Isaac, and Jacob—lasts from 1800 BCE to 1600 BCE.
- Jesus is born ca. 6 BCE.
- The death of Jesus occurs ca. 30 CE.
- The age of persecution of Christians begins in 64 CE and ends with the Edict of Milan, which grants Christians freedom of religion, in 313 CE.
- Christianity is made the state religion of the Roman Empire in 381 CE.

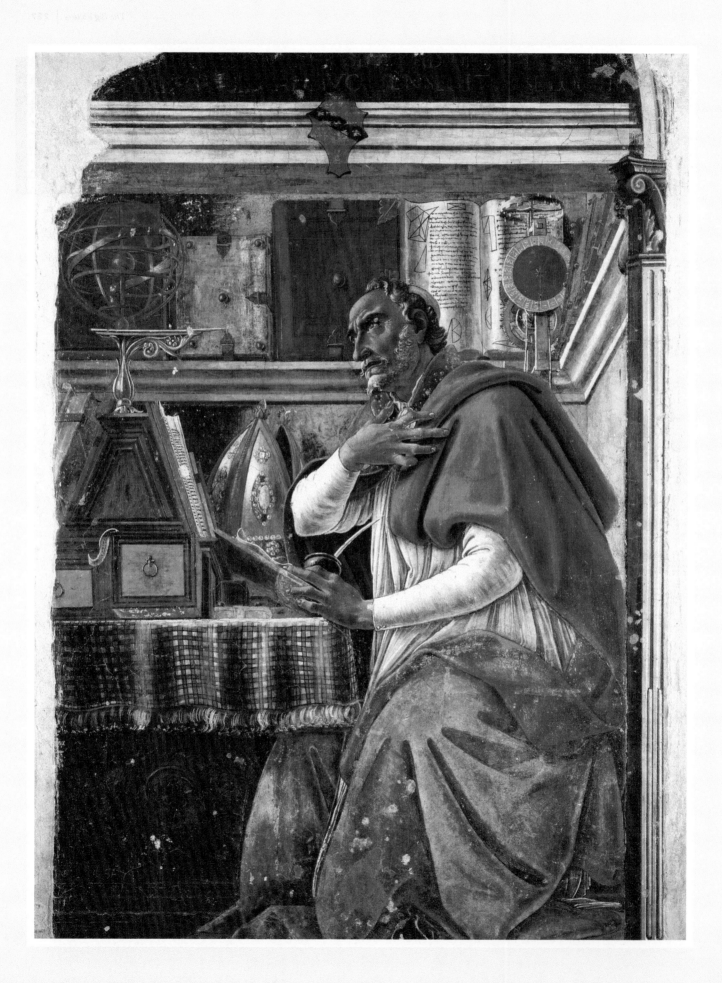

Early Christianity: Ravenna and Byzantium

7

PREVIEW

In 1480, Sandro Botticelli painted an image of Saint Augustine for the Church of Ognissanti in Florence, Italy (Fig. 7.1). The saint sits at a cloth-draped desk surrounded by books and objects that create the effect of a scholar's cluttered study. Pen, ink, and writing tablet in hand, he pauses to look up from his work. He draws his right hand to his heart; his brow is furrowed, and his eyes look misty.

This is Augustine of Hippo—philosopher, rhetorician, theologian, bishop, canonized saint, and doctor of the Roman Catholic Church, called the "first medieval man and the last classical man." His influential writings bridge the Graeco-Roman philosophical traditions with Judeo-Christian beliefs and scripture. A towering figure of medieval philosophy, Augustine filled his writings with reflections on the absolute majesty of God, the immutability of God's will, and the flawed state of the human condition. They also include reflections on pagan wisdom and Neo-Platonist philosophy.

Saint Augustine lived during the era of the Byzantine Empire. He was born and died in North Africa but spent a few transformational years in Rome and Milan. His father was pagan and his mother Christian, and Augustine himself did not convert to Christianity until he was 33 years old. In his *Confessions*, viewed as the first self-reflective writing in the West, Augustine documented his journey toward his newfound faith, as well as the extreme spiritual conflict it generated within him. Is it this personal struggle that is the subject of Botticelli's painting? Art historian Richard Stapleford believes it is.[1]

One of the challenges in the discipline of art history concerns the decipherment of symbols and narratives that have been lost or confused over time. Numerous artists had portrayed the subject of Augustine in his study by the time Botticelli came to the task, and he most certainly would have been aware of the precedents. The long-standing interpretation of Botticelli's painting, based on comments by the Renaissance writer Giorgio Vasari, was that it was paradigmatic of "profound meditation and subtle perception characteristic of men of wisdom who ponder continuously on difficult and elevated matters." As such, Botticelli's painting was read *not* as the portrayal of a specific event in the saint's life but rather as a work that reflected the big ideas of the artist's era—the revival of classical philosophy, its emphasis on intellectualism, and the reconciliation of pagan philosophy, humanism, and Christianity. Yet Stapleford argues that the imagery within the painting is connected to passages from the *Confessions* in which Augustine describes the torment he experiences as he comes to the point of conversion: "I now found myself driven by the tumult in my breast to take refuge in this garden, where no one could interrupt that fierce struggle in which

◀ **7.1** Sandro Botticelli, *Saint Augustine in His Study*, ca. 1480. Fresco, 59¾" × 44" (152 × 112 cm). Church of Ognissanti, Florence, Italy.

1. Richard Stapleford, "Intellect and Intuition in Botticelli's *Saint Augustine*," *Art Bulletin* 76, no. 1 (March 1994): 69–80.

I was my own contestant, until it came to its conclusion.... I was beside myself with madness that would bring me sanity. I was dying a death that would bring me life. I knew that evil that was in me, but the good that was soon to be born in me I did not know." Augustine ends this profound passage with the statement that, after he came to this realization, he went out into a garden.

Botticelli's Saint Augustine is surrounded by the trappings of a scholarly man—richly bound texts; a clock; an armillary sphere that is used to plot the movements of the sun, moon, and planets. On a shelf are three volumes: the blue one has been identified as a sacred book, the red one in the middle a book of poetry, and the open one above the saint's shoulder a mathematics text whose pages are filled with writing. Could the text offer a clue to the meaning of the painting? Most of it, Stapleford notes, is illegible—the sort of fill-in pseudoscript often seen in works of art. However, three lines of actual words, in Italian, appear on the painted page: "Dove sant agostino a d[eus] a sp[er]ato e dov'e andato a fuor dela porta al prato" ("Where Saint Augustine put his trust in God, and where he went outside to the meadow"). Botticelli's narrative is inspired by that very moment, described in *Confessions*, when Augustine turned to God. Stapleford poignantly concludes that the artist "has presented us with the spiritual pain of a person of reason, a man of thought and feeling, faced with apparently irreconcilable choices. Augustine is Botticelli's Everyman."

THE TRANSFORMATION OF ROME

By the early fourth century, the Roman Empire already had severe economic, political, and social problems. In 330, Emperor Constantine dedicated a Greek trading town on the Bosporus as his eastern capital, changing its name from Byzantium to Constantinople. It was to be a new Rome.

Constantinople had some obvious advantages for a major city: It straddled the most prominent land route between Asia and Europe. It had a deepwater port with natural shelter. It guarded the passage between the Mediterranean and the Black Seas. The surrounding countryside was rich in forests and water. The neighboring areas of Europe (Thrace) and Asia (Bithynia) were rich agricultural areas that could supply the city's food needs.

Because of the tumultuous conditions, the emperors spent less time in Rome. At the beginning of the fifth century (in 402), Emperor Honorius moved the capital of the Western Roman Empire to the northern Italian city of Ravenna, on the Adriatic coast. Seventy-four years later, in 476, the last Roman emperor in the West would abdicate the throne. Goths would occupy Ravenna, only to be defeated in turn by the imperial forces from Constantinople in 540 (see Map 7.1).

While Rome declined in the waning decades of the fourth and fifth centuries, Christianity flourished. It continued to grow and expand in influence, and would eventually become the religion of those who destroyed the empire in the West. During that period, in far different places, two writers would live who saw the decline of the West: Augustine in Roman North Africa and Boethius in the city of Ravenna. Their writings were to have an enormous impact on the culture of Europe.

The Council of Nicaea

He sat on a chair of gold "like some heavenly angel of God, his bright mantle shedding luster like beams of light, shining with the fiery radiance of a purple robe, and decorated with the dazzling brilliance of gold and precious stones." Those who were

Early Christianity: Ravenna and Byzantium

64 CE	313 CE	395 CE	565 CE	1453 CE
EARLY CHRISTIAN ERA			**BYZANTINE ERA**	
Period of Persecution	**Period of Recognition**	**Growth of Empire**	**Decline and Fall**	
Christians are persecuted under the Roman emperor Decius The Roman Empire is divided into Eastern and Western Empires, and the capital of the West is moved from Rome to Milan Reign of Constantine, the first Christian emperor 307–327	Edict of Milan in 313 grants Christians freedom of worship Constantine founds city of Constantinople Council of Nicaea in 325 upholds the doctrine of the Holy Trinity Ostrogoths accept Christianity Capital of the Western Empire is moved from Milan to Ravenna in 402	Visigoths sack Rome in 410 Vandals sack Rome in 455 The last Western Roman emperor abdicates in 476; the Ostrogoths take over rule in Italy Justinian reigns as Eastern Roman emperor 527–565 Ravenna comes under the rule of Justinian in 540	Muhammad born in Mecca in 570 Pope Leo III bans representations of the divine; era of iconoclasm 726–843 Russians accept Christianity Constantinople falls to the Ottoman Turks in 1453, bringing an end to the Byzantine Empire	

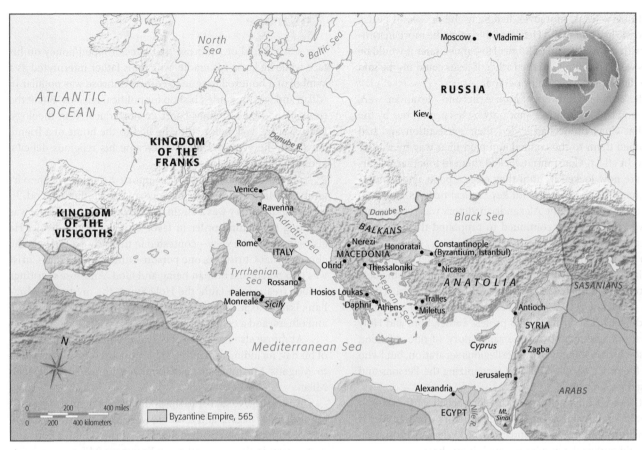

▲ **MAP 7.1 Justinian's Empire.**

called before him were "stunned and amazed at the sight—like children who have seen a frightening apparition."[2]

So did the emperor Constantine—the first Christian emperor of Rome—preside over the bishops at the Council of Nicaea, which was held in modern-day Turkey in the year 325 CE. Only a year earlier, as Augustus of the Eastern Roman Empire, he had seized control of the entire Roman Empire from Licinius, who was forced to cede the Western states. It was a scant dozen years since he and Licinius had inscribed the Edict of Milan, which sought to end religious clashes and the persecution of Christians within the empire by proclaiming tolerance throughout: "No one whatsoever should be denied freedom to devote himself either to the cult of the Christians or to such religion as he deems best suited for himself." As emperor, Constantine demanded order, yet now he found conflict, often bloody, between Christian groups who held disparate beliefs. According to a participant at the council, the bishop Eusebius, "The bishop of one city was attacking the bishop of another.... [Populations] were rising up against each other,...so that desperate men, out of their minds, were committing sacrilegious acts, even daring to insult the images of the emperors."[3]

Constantine was in no mood to brook dissension in his empire or minor squabbling among his guests. They had been embroiled in the so-called **Arian controversy**, which concerned the true nature of Jesus, for years. **Orthodox Christians**—including a Greek named Alexander, the bishop of Alexandria—believed that Jesus the Son was divine and fully a part of the Godhead, equal and unified with God the Father and the Holy Spirit. Arius, another Greek and an elder in Alexandria, held another view. He and others argued that Jesus, as the created Son, was distinct from God the Father, who was eternal. The Arians could point to the Gospels in arguing their cause. In Mark 10:18, Jesus says, "Why do you call me good? No one is good but God alone." Matthew 26:39 records Jesus's agony at Gethsemane: "My father, if possible, let this cup pass me by. Nevertheless, let it be as you, not I, would have it." Arians viewed Jesus as being sent to earth not so much to save helpless humanity as to inspire ordinary women and men to develop their own godlike potential by imitating him.[4]

Constantine apparently had no patience for the Arian view. Perhaps he feared that construing Christ as human or even a divine being of some sort—but less than God the Father—might sow further seeds of disruption in the empire. Jesus, after all, had been crucified because Rome viewed him as a threat, a

2. Eusebius, *Life of Constantine*, ed. and trans. Averill Cameron and Stuart Hall (Oxford: Oxford University Press, 1999), p. 125.
3. Quoted in Charles Freeman, *The Closing of the Western Mind* (New York: Knopf, 2003), p. 163.
4. Richard E. Rubenstein, *When Jesus Became God* (New York: Harcourt, 1999).

revolutionary. Jesus, moreover, had sung the praises of peace, and the warlike god of the Hebrew Bible might be more in sympathy with the militarism of Rome. How much safer it would be if Jesus were one with God the Father, if Jesus could not be said to be a different yet admirable person.

The bishops, followers of both Arius and Alexander, were spellbound by Constantine—not only by his person but by the facts that Constantine had ended their persecution and had summoned them to the council and paid their way by ship or donkey. In effect, Constantine locked them in together, as cardinals are now locked in until they elect a pope, and admonished them not to emerge until key clerical matters had been put to rest. In the end, the Alexandrian victory was resounding. However, many Arians continued to propound their views at the local level.

In 381, the emperor Theodosius held another council on Christian doctrine, the Council of Constantinople, and the outcome reinforced the teachings of the Council of Nicaea. Theodosius proclaimed, "We now order that all churches are to be handed over to the bishops who profess Father, Son, and Holy Spirit of a single majesty, of the same glory, of one splendor, who establish no difference by sacrilegious separation, but [who avow] the order of the Trinity by recognizing the Persons and uniting the Godhead."[5]

At these councils, many of the core beliefs of the church were enumerated and affirmed. The emperors who supported them helped reinforce the foundations of a religious institution that would outlive the empire in which it was born.

LITERATURE, PHILOSOPHY, AND RELIGION

Four important **Latin fathers** of the church were philosophers and theologians:

- Saint Ambrose of Milan (ca. 338–397 CE), bishop of Milan
- Saint Jerome of Stridon (ca. 347–420 CE), who translated the Bible from Hebrew and Greek into Latin
- Saint Augustine of Hippo (354–430 CE), who, as we will see, developed the idea of the church as the City of God, apparently as an eternal bulwark against the disintegrating City of Man (Rome)
- Pope Gregory I (the Great; ca. 540–604 CE), who may have had the greatest influence on the early medieval church

Because of their teachings, these four are also called **doctors of the church**.

Ambrose

The story is told of Ambrose that bees dropped honey on his face while he lay in his cradle, which his father interpreted as a symbol of a honeyed tongue to come. Ambrose was popular in Milan and was appointed bishop for political reasons. But at the time, he had been neither baptized nor educated in theology. Fearful of the task before him, he fled to the home of a friend. Yet finally he ventured forth, overcame his religious deficits, and rose to the occasion.

As a theologian, Ambrose supported the idea of the virginity of Mary and her importance as the Mother of God. In believing that Mary was a virgin, Ambrose admitted that he was rejecting the natural order in favor of belief in the divine. He also supported the view—contested in the early centuries of the church—that Christ was one person. Others argued that Christ was two persons: a human being and God. Ambrose's writings include treatises on faith, the Holy Spirit, the mysteries, Abraham, Isaac, Noah, and virgins. We also have letters to emperors and others, and a collection of hymns.

Ambrose also navigated the political and military currents of his day, including remaining at his post after the loss of Milan to Magnus Maximus of Gaul (France). Rome later regained Milan.

Ambrose gave succor to the poor but vehemently expressed his disdain for pagans and Jews. He was also a mentor of Augustine of Hippo. Ambrose died a natural death, and his body lies in the crypt in the Sant'Ambrogio Basilica in Milan.

Augustine of Hippo

In the year 386 CE, a 32-year-old man from North Africa wrote one of the most famous prayers in history: "Grant me chastity and continence,[6] but not yet" (*da mihi castitatem et continentiam, sed noli modo*). Although this man would come to teach that lust was sinful, even in marriage, his own life in his early years reveled in lust.

His name was Augustine, and he was from Hippo, a North African town on the Mediterranean Sea west of Carthage. Augustine was of Berber descent and spent most of his life in what is now Algeria. His mother was a devout Roman Catholic, but his father was a pagan. At school, he came under pagan influences but also became immersed in Latin literature. At the age of 17, a sponsor arranged to support his studies in Carthage, where "a cauldron of illicit loves leapt and boiled"[7] about him (*Confessions*, 3.51). At this time, he was attracted to the polytheistic Manichaean religion, which had originated in Persia and spread as far as Rome to the west and China to the east. That stern religion taught that the material world—the world of

5. Quoted in Richard P. C. Hanson, *The Search for the Christian Doctrine of God: The Arian Controversy, 318–381* A.D. (Edinburgh, Scotland: T. & T. Clark, 1988), p. 215.

6. Self-restraint; moderation, especially in sexual matters.
7. Saint Augustine, *Confessions*. ed. Michael P. Foley, trans. F. J. Sheed (Indianapolis: Hackett Publishing Company, Inc., 1992), p. 37.

greed and lust—was one of darkness, while the spiritual world was one of light. But Augustine was also attracted to a hedonistic lifestyle. In Book 3, chapter 51 of one of his two great works, *Confessions*, he recounts, "I was not yet in love, but I loved the idea of love." Regardless of any momentary flings, he took a young woman as a concubine. Of her, he wrote, "It was a sweet thing to be loved, and sweeter still when I was able to enjoy the body of a woman."[8]

At the time, marriage was precisely regulated under Roman law. It had nothing to do with love, and sex was incidental although necessary to extend the lineage and thereby channel the property of the family. It was essentially an alliance between families. Marriage between people of different classes, such as between nobility and freed men, or between freed men and slaves, was forbidden. Concubinage was usually stable and monogamous, but it did not come with property rights. Augustine lived with his concubine for more than 13 years, during which time they had a son. But if they had lived together for a century, there would still have been no common-law marriage between them. His concubine would have had no right to alimony.

Augustine moved to Rome and then to Milan, where he converted to Christianity in 387—partly due to the influence of Ambrose, the bishop there. He chronicled his spiritual journey in *Confessions*. But it is thought that Manichaeism helped shape his views on the nature of good and evil, hell, predestination, and his eventual hostility toward the flesh and sexual activity. Following his conversion and his denunciation of the flesh, Augustine became a priest and then a bishop back in Hippo, and eventually one of the Latin fathers of the church. He developed the concepts of original sin and just war. He wrote that humans are depraved—perhaps as he was depraved in his earlier years—and could not become righteous without the grace of God.

When the Visigoths sacked Rome in 410, the pagan world was aghast, and many blamed the rise of Christianity for it. Partially as a response to this charge, Augustine framed the concept of the church as an eternal spiritual City of God in his book *The City of God* (*De civitate Dei*). The City of God was distinct from the material and flawed City of Man. *The City of God* asserts that history has a direction willed by God and that in the end all will be made right as the City of Man gives way to the City of God. The City of God, of course, is closely identified with the church and Rome, and survives regardless of invasions—as have the writings of Augustine of Hippo, the young man who swam in a hot cauldron of passion but would eventually become Saint Augustine.

Augustine of Hippo's intellectual impact on the subsequent cultural history of the West is difficult to overestimate. His influence within Christianity is without parallel. Until Thomas Aquinas in the 13th century, all Christian theologians in the West started from explicitly Augustinian premises. Even Thomas did not shake off his debt to Augustine, although he replaced Augustine's strong Platonic orientation with a more empirical Aristotelian one. Augustine emphasized the absolute majesty of God, the immutability of God's will, and the flawed state of the human condition (notions derived from the Apostle Paul). These tenets received a powerful reformulation in the Reformation by Martin Luther (who, as a Catholic friar, had lived under the rule of Saint Augustine) and by John Calvin, a profound student of Augustine's theological writings.

THE *CONFESSIONS* Augustine invented the genre of self-reflective writing in the West. "I would know myself that I might know Thee," he writes to God in the *Confessions*. Before Augustine's time, memoirs related a life in terms of social, political, or military affairs (as did, for example, Caesar's *De bello civili*), but Augustine's intimate self-scrutiny and inquiry into the significance of life were new in Western culture. There would be no other work like the *Confessions* until Petrarch, an indefatigable student of Augustine, wrote his "Letter to Posterity" in the mid-14th century. The Renaissance writers, extremely self-conscious, were devoted students of Augustine's stately Latin prose; even the great later autobiographies of Gibbon, Mill, and Newman are literary and spiritual descendants of Augustine.

Augustine's *Confessions* is a compelling analysis of his spiritual and intellectual development from his youth until the time of his conversion to Christianity and his readiness to return to his native Africa. The title can be understood in a triple sense—a confession of sin, an act of faith in God, and a confession of praise.

The following passage recounts Augustine's conversion experience in 387 in his garden in Milan, Italy:

READING 7.1 SAINT AUGUSTINE

From *Confessions*, Book 8, chapter 12

I felt that I was still the captive of my sins, and in my misery I kept crying "How long shall I go on saying 'tomorrow, tomorrow'? Why not now? Why not make an end of my ugly sins at this moment?"

I was asking myself these questions, weeping all the while with the most bitter sorrow in my heart, when all at once I heard the sing-song voice of a child in a nearby house. Whether it was the voice of a boy or a girl I cannot say, but again and again it repeated the refrain "Take it and read, take it and read." At this I looked up, thinking hard whether there was any kind of game in which children used to chant words like these, but I could not remember ever hearing them before. I stemmed the flood of tears and stood up, telling myself that this could only be a divine command to open my book of Scripture and read the first passage on which my eyes should fall.

. . .

So I hurried back to the place where Alypius[9] was sitting, for when I stood up to move away I had put down the book

8. Ibid., p. 37.

9. A friend.

containing Paul's Epistles. I seized it and opened it, and in silence I read the first passage on which my eyes fell: *Not in revelling and drunkenness, not in lust and wantonness, not in quarrels and rivalries. Rather, arm yourself with the Lord Jesus Christ; spend no more thought on nature and nature's appetites.* I had no wish to read more and no need to do so. For in an instant, as I came to the end of the sentence, it was as though the light of confidence flooded into my heart and all the darkness of doubt was dispelled.

Although strongly autobiographical, the *Confessions* is also a meditation on the hidden grace of God as Augustine's life is shaped toward its appointed end. Augustine confesses to God (and the reader) how his early drive for fame as a teacher of rhetoric, his flirtation with the Manichaean sect and its belief in gods of evil and good, his liaison with a woman that resulted in the birth of a son, and his restless movement from North Africa to Rome and Milan were all part of a web of circumstance that made up an individual life. Interspersed in the narrative line of his early life are Augustine's reflections on the most basic philosophical and theological questions of the day, always linked to his own experience.

THE CITY OF GOD Augustine made a notable impact beyond theology. *The City of God,* begun about 412, was an attempt to formulate a coherent and all-embracing philosophy of history, the first such attempt in the West. For Augustine, history moves on a straight line in a direction from its origin in God until it ends, again in God, at a consummation in the Last Judgment. Augustine rejects the older pagan notion that history repeats itself in endless cycles. His reading of the Bible convinced him that humanity had an origin, plays out its story, and will terminate. The City of Man will be judged, and the City of God will be saved. Subsequent philosophers of history have secularized this view but, with a few exceptions (the 17th-century Italian philosopher Giambattista Vico, for example), have maintained the outlines of Augustine's framework to some extent. "A bright future," "an atomic wasteland of the future," and "a classless society" are all statements about the end of history, all statements that echo, however quietly, the worldview of Augustine.

In Readings 7.2 and 7.3 from *The City of God,* Augustine ponders a perennial subject for all people: the character of peace in both its personal and its social context. These reflections on peace are all the more compelling because they were written against the backdrop of the barbarian invasions of Europe and Roman North Africa as well as Augustine's own shock at the sack of the city of Rome—the occasion for his writing the book in the first place.

Augustine's philosophical treatment of the concept of time remains popular today. According to Augustine, time did not exist prior to the creation because time is perceived in terms of space and motion. Within the creation, time exists in the mind, and there is only the present; the past is memory in the present, and the future is expectation in the present. As an aside, one view of the current Big Bang theory of the origin of the universe also holds that time and space were born then, although the theory does not propose an intelligent process of creation.

READING 7.2 SAINT AUGUSTINE

The City of God, Book 19, chapter 7

Figure 7. Human society divided by differences of language. The misery of war, even when just

After the city or town comes the world, which the philosophers reckon as the third level of human society. They begin with the household, proceed to the city, and then arrive at the world. Now the world, being like a confluence of waters, is obviously more full of danger than the other communities by reason of its greater size. To begin with, on this level the diversity of languages separates man from man. For if two men meet, and are forced by some compelling reason not to pass on but to stay in company, then if neither knows the other's language, it is easier for dumb animals, even of different kinds, to associate together than these men, although both are human beings. For when men cannot communicate their thoughts to each other, simply because of difference of language, all the similarity of their common human nature is of no avail to unite them in fellowship. So true is this that a man would be more cheerful with his dog for company than with a foreigner. I shall be told that the Imperial City has been at pains to impose on conquered peoples not only her yoke but her language also, as a bond of peace and fellowship, so that there should be no lack of interpreters but even a profusion of them. True; but think of the cost of this achievement! Consider the scale of those wars, with all that slaughter of human beings, all the human blood that was shed!

In chapter 12 of that same book, Augustine argues that all people wish for peace, even if they resort to war to achieve it (see Reading 7.3). Certainly there are many warlike individuals who may fit within the confines of his argument, but the current obsession with violence in the media—in novels, films, television shows, and video games—might leave one wondering whether Augustine was overly optimistic about human nature.

READING 7.3 SAINT AUGUSTINE

The City of God, Book 19, chapter 12

12. Peace is the instinctive aim of all creatures, and is even the ultimate purpose of war

Anyone who joins me in an examination, however slight, of human affairs, and the human nature we all share, recognizes

that just as there is no man who does not wish for joy, so there is no man who does not wish for peace. Indeed, even when men choose war, their only wish is for victory; which shows that their desire in fighting is for peace with glory. For what is victory but the conquest of the opposing side? And when this is achieved, there will be peace. Even wars, then, are waged with peace as their object, even when they are waged by those who are concerned to exercise their warlike prowess, either in command or in the actual fighting. Hence it is an established fact that peace is the desired end of war. For every man is in quest of peace, even in waging war, whereas no one is in quest of war when making peace. In fact, even when men wish a present state of peace to be disturbed they do so not because they hate peace, but because they desire the present peace to be exchanged for one that suits their wishes. Thus their desire is not that there should not be peace but that it should be the kind of peace they wish for. Even in the extreme case when they have separated themselves from others by sedition, they cannot achieve their aim unless they maintain some sort of semblance of peace with their confederates in conspiracy. Moreover, even robbers, to ensure greater efficiency and security in their assaults on the peace of the rest of mankind, desire to preserve peace with their associates.

Scientists aver that the Big Bang occurred some 13.7 billion years ago, whereas some readers of the Bible contend that the universe has existed for only 6000 years. In *The Literal Interpretation of Genesis*, Augustine warns against taking the Bible literally if it flies in the face of reason and observation (see Reading 7.4). The Hebrew Bible speaks of six days of creation followed by a day of rest, but as we see in Reading 7.4, Augustine was concerned that biblical accounts that defy reason could be harmful to Christianity.

READING 7.4 SAINT AUGUSTINE

From *The Literal Meaning of Genesis*, chapter 19

Usually, even a non-Christian knows something about the earth, the heavens, and the other elements of this world, about the motion and orbit of the stars and even their size and relative positions, about the predictable eclipses of the sun and moon, the cycles of the years and the seasons, about the kinds of animals, shrubs, stones, and so forth, and this knowledge he holds to as being certain from reason and experience. Now, it is a disgraceful and dangerous thing for an infidel to hear a Christian, presumably giving the meaning of Holy Scripture, talking

nonsense on these topics; and we should take all means to prevent such an embarrassing situation, in which people show up vast ignorance in a Christian and laugh it to scorn. The shame is not so much that an ignorant individual is derided, but that people outside the household of the faith think our sacred writers held such opinions, and, to the great loss of those for whose salvation we toil, the writers of our Scripture are criticized and rejected as unlearned men. If they find a Christian mistaken in a field which they themselves know well and hear him maintaining his foolish opinions about our books, how are they going to believe those books in matters concerning the resurrection of the dead, the hope of eternal life, and the kingdom of heaven, when they think their pages are full of falsehoods on facts which they themselves have learnt from experience and the light of reason?

On the other hand, Augustine believed he understood why the Bible was written as it was. He rationalized it this way: "It must be said that our authors knew the truth about the nature of the skies, but it was not the intention of the Spirit of God, who spoke through them, to teach men anything that would not be of use to them for their salvation." He believed that God created everything in the universe at once, not in six days; the six days found in Genesis were intended to provide a conceptual rather than a physical framework for describing creation.

Augustine wrote that original sin, the guilt of Adam for eating the forbidden fruit, is inherited by all humans. Humans are depraved and incapable of doing good without divine grace. Augustine believed in predestination, the doctrine that God has foreordained who will be saved. Yet there is free will, and people can choose to live so that they are saved. The Eastern Orthodox Church split from the Roman Catholic Church in 1054, partly because of differences in doctrine such as that of original sin. The Eastern Orthodox Church does not follow the Augustinian descriptions of original sin as a moral and spiritual stain upon the soul and of the inheritance of guilt. The Eastern Orthodox Church sees original sin as a break in the human communion with God; a loss of grace; the introduction of disease, decay, and death; and weakened resistance to temptation. Both churches agree that Christ has made salvation possible.

Augustine wrote that war can be just when it is fought for a good purpose and not for personal gain or power. A just war can only be waged by a proper authority, such as the state, and even though war is violent, the motive of a just war is love.

Augustine came to associate sexual desire with original sin. He did not see the sexual act itself as evil but rather the lustful emotions that can accompany it. To virgins raped during the sack of Rome, he wrote, "Another's lust cannot pollute thee."

CONNECTIONS Augustine of Hippo, in a brief essay from his writing on *The Literal Meaning of Genesis*, warned uninformed Christians against speaking about theoretical scientific matters, in this case the notion that God's creation of the universe took place over the six days described in the Bible. Augustine's own view was that God created everything in the same instant, but his larger point was that if non-Christians heard Christians speaking against generally held views, they would be discredited and thus dismissed when it came to promulgating Christian beliefs and arguing Church dogma.

Augustine is considered one of the four fathers of the Catholic Church, but despite his cautionary words to resist making scientific issues into issues of faith and vice versa, the Church enforced its views on the

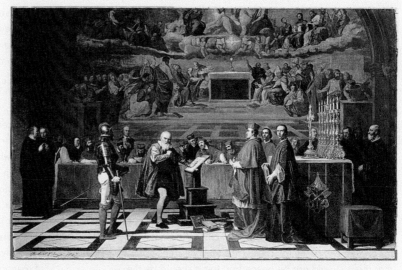

▲ 7.2 **Joseph Nicolas Robert-Fleury,** *Galileo before the Holy Office of the Vatican.* **Oil on canvas, 196 × 308 cm. The Louvre, Paris. France.**

structure of the universe for centuries. In 1633, Galileo Galilei was sentenced to prison after being charged with heresy for his heliocentric view—his view that the sun lay at the center of the solar system—as set forth in his *Dialogue Concerning the Two Chief World Systems*. The Church subscribed to a geocentric view in line with its interpretation of Scripture, but Galileo argued that something could be true *even if* the Church claimed that it contradicted the Bible.

It was not until 1757 that Pope Benedict XIV, based on the work of Sir Isaac Newton on the physical laws that govern planetary motion, suspended the ban on heliocentric scholarship. In 1822, Pope Pius VII allowed the publication of heliocentric books in Rome. But it was not until 1979 that Pope John Paul II declared that the Church had misinterpreted the Bible and that it was wrong in its treatment of Galileo.

In 2014, Pope Francis publicly supported the roles of observation and reason, stating, for example, that the big bang theory—which places the age of the universe at 13.7 billion years—and the concept of evolution "were not inconsistent" with the teachings of the church. Rather, he said, they afforded more knowledge of the workings of the hand of God in creation.

On the other hand, virtue is lost when a person intends to sin, even if the act is not carried out.

Augustine condemned the practice of abortion, as did other church fathers. Yet the seriousness of abortion depends on the ensoulment status of the fetus—that is, whether or not it has received its soul at the time. Augustine believed, along with the Greek philosopher Aristotle (384–322 BCE), that male fetuses receive a soul at 40 days of gestation and female fetuses at 90 days.[10]

Boethius

In the twilight period in Ravenna, between the death of the last Roman emperor and the arrival of the troops of Justinian,

who ruled the Eastern Roman Empire, an important figure who bridged the gap between classical paganism and Christianity lived and died. Anicius Manlius Severinus Boethius was a highly educated Roman who entered the service of the Gothic king Theodoric in 522. Imprisoned in the city of Pavia for reasons that are not clear, Boethius wrote a treatise called *Consolation of Philosophy* while awaiting his probable execution. Cast as a dialogue between Lady Philosophy and the author on the philosophical and religious basis for human freedom, the work blends the spirit of the biblical book of Job with Roman Stoicism. Attempting to console him in his sad state of disgrace and imprisonment, Lady Philosophy demands that the author avoid self-pity and face his troubles with serenity and hope. Insisting that a provident God overcomes all evil, Philosophy insists that blind fate has no control over humanity. She explains that human freedom exists along with an all-knowing God and that good will triumph.

In the following reading, Boethius describes how Lady Philosophy visits him in his prison cell. As *Consolation* goes on, it becomes clear that his dialogue with the lady is a dialogue with

10. Paul A. B. Clarke and Andrew Linzey, *Dictionary of Ethics, Theology, and Society* (New York: Routledge, 1996); Odd Magne Bakke, *When Children Became People: The Birth of Childhood in Early Christianity*, trans. Brian McNeil (Minneapolis, MN: Augsburg Fortress, 2005).

himself. *Consolation* is an early example of the manner in which writers create characters who embody parts—often conflicting parts—of themselves. Lady Philosophy convinces Boethius of things he is likely attempting to convince himself are true:

READING 7.5 BOETHIUS

From *Consolation of Philosophy*, Book 1, chapter 1

While I was thus mutely pondering within myself, and recording my sorrowful complainings with my pen, it seemed to me that there appeared above my head a woman of a countenance exceeding venerable. Her eyes were bright as fire, and of a more than human keenness; her complexion was lively, her vigour showed no trace of enfeeblement; and yet her years were right full, and she plainly seemed not of our age and time. Her stature was difficult to judge. At one moment it exceeded not the common height, at another her forehead seemed to strike the sky; and whenever she raised her head higher, she began to pierce within the very heavens, and to baffle the eyes of them that looked upon her. Her garments were of an imperishable fabric, wrought with the finest threads and of the most delicate workmanship; and these, as her own lips afterwards assured me, she had herself woven with her own hands.

Consolation of Philosophy was one of the most widely read and influential works of the Middle Ages and Elizabethan England. Geoffrey Chaucer made a Middle English translation of it from an already existing French version, and Queen Elizabeth I translated the work into modern English. Its message of hope and faith was quoted liberally by every major medieval thinker from Thomas Aquinas to Dante Alighieri.

Boethius sets out a basic problem and provides an answer that would become normative Christian thought for subsequent centuries. In *Consolation*, he asks how one can reconcile human freedom with the notion of an all-knowing God.

Put another way: if God knows what we do before we do it, how can we be said to be free agents who must accept responsibility for personal acts? The answer, Boethius insists through Lady Philosophy, is to look at the problem from the point of view of God, not from the human vantage point. God lives in eternity. Eternity does not mean a long time with a past and a future; it means no time: God lives in an eternal moment that for him is a now. In that sense, God does not foresee the future—there is no future for God. He sees everything in one simple moment that is only past, present, and future from the human point of view. Boethius says that God does not exercise *praevidentia* (seeing things before they happen) but *providence* (seeing all things in the simultaneity of their happening). Thus God, in a single eternal, ineffable moment, grasps all activity, which exists for us as a long sequence of events. More specifically, in that moment, God sees our choices, the events that follow from them, and the ultimate consequences of those choices.

The consolation for Boethius, as Lady Philosophy explains it, rests in the fact that people do act with freedom, that they are not in the hands of an indifferent fate, and that the ultimate meaning of life rests with the all-seeing presence of God, not a blind force. Lady Philosophy sums up her discussion with Boethius by offering him this consolation. It is her assurance that his life, even while he is awaiting execution in a prison cell, is not the product of a blind fate or an uncaring force in the universe.

The language of Boethius, with its discussion of time, eternity, free will, and the nature of God, echoes the great philosophical tradition of Plato and Aristotle (Boethius had translated the latter's works), as well as the Stoicism of Cicero and the theological reflections of Augustine. It is a fitting apex to the intellectual tradition of the late Roman Empire in the West.

RAVENNA

As the Western Roman Empire tried to adjust to changing conditions, the capital was moved from Rome to Milan in 286, and from Milan to Ravenna in 402. Ravenna today is a repository of monuments that reflect its late Roman, Gothic, and Byzantine history. The Mausoleum ("burial chapel") of Galla Placidia (who reigned as regent from 430 to 450) was built at the end of the Roman period of the city's history (Fig. 7.3). Once thought to be the tomb of the empress (hence its name), it is more likely a **votive chapel** to Saint Lawrence originally attached to the nearby Church of the Holy Cross. This small chapel in the shape of a cross, very plain on the outside, shows the architectural tendency to combine the basilica-style nave with the structure of a dome (it even uses

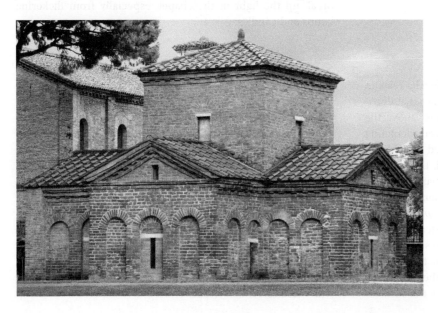

◀ **7.3 Mausoleum of Galla Placidia, early fifth century. Ravenna, Italy.** The building has sunk more than 3' (1 m) into the marshy soil, thus making it rather squat in appearance.

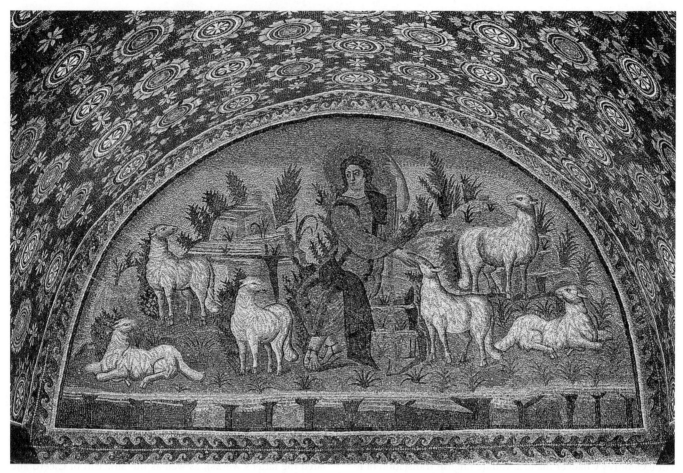

▲ **7.4 Christ as the Good Shepherd, fifth century. Lunette mosaic, Mausoleum of Galla Placidia, Ravenna, Italy.** Symbolizing the heavens, the motif of stylized gold sunbursts and stars set in a deep-blue ground can be seen in the vault. Note the beardless Christ dressed in a Roman toga.

a modified pendentive form) used later in monumental structures like the Hagia Sophia.

Mosaics

The importance of the Mausoleum of Galla Placidia rests in the complete and breathtakingly beautiful mosaics that decorate the walls and ceiling. The north niche, just above the entrance, has a *lunette* (small arched space) mosaic depicting Christ as the Good Shepherd (**Fig. 7.4**). Clothed in gold and royal purple, and with a gold staff in his hand, the figure of Christ has a courtly, almost languid elegance that refines the more rustic depictions of the Good Shepherd theme in earlier Roman Christian art. The vaulting of both the *apse* (the altar end of the church) and the dome is covered with a deep-blue mosaic interspersed with stylized sunbursts and stars in gold. This "Persian rug" motif symbolizes the heavens, the dwelling place of God. Because the *tesserae* (the small cubes that make up the mosaic) are not set fully flush in the wall, the surfaces

of the mosaic are irregular. These surfaces thus refract and break up the light in the chapel, especially from flickering lamps and candles.

Sant'Apollinare Nuovo

Theodoric, the king of the Goths who executed Boethius and reigned over all of the Italian Peninsula from 493 to 526, was buried in a massive mausoleum that may still be seen on the outskirts of Ravenna. The cap of the mausoleum is a huge stone that measures 36 feet by 10 feet (11 m × 3 m). Aside from this mausoleum, the most famous extant monument of Theodoric's reign is the Church of Sant'Apollinare Nuovo (originally called the Church of the Redeemer), Theodoric's palace church (**Fig. 7.5**). This church is constructed in the severe basilican style: a wide nave with two side aisles partitioned off from the nave by double columns of marble. The apse decorations have been destroyed, but the walls of the basilica, richly ornamented with mosaics, remain visible.

CULTURE AND SOCIETY

Autocracy and Divine Right

The Byzantine Empire was characterized by its acceptance of the belief that the emperor was God's representative on earth, the sole ruler of the empire from whom all social and political good for the empire flowed. This view of the political order is called *autocracy*, which means, in essence, that the imperial power is unlimited, and whatever power others may have (for example, in the military or in the state bureaucracy) flows from the unlimited power of the emperor. In this case and many others throughout history, it was also claimed that the emperor held his position by divine right. The emperor was both the civil and religious ruler of the empire.

In the actual political order, of course, emperors were overthrown or manipulated by political intrigue. Even so, autocracy was generally accepted as the divinely ordered nature of things. Symbolic reinforcement of the divinely sanctioned autocratic power of the emperor (visually represented in the Ravenna mosaics of Justinian and Theodora) came through various symbolic means. The emperor alone dressed in the purple and gold once reserved for the semidivine pagan emperors. He lived in a palace with a rigid protocol of ceremony. When participating in the public worship of the church (the liturgy), he was given a special place and special recognition within that liturgy. Public insignia and other artifacts like coins recognized his authority as coming from God. It was commonplace in the literature of the time to see the emperor as the regent of God on earth, with his role compared to the sun, which brings light and warmth to his subjects.

Many autocracies (from the Egyptian pharaohs to the French kings just before the Revolution) claimed such a relationship to the divine. The Byzantine Empire not only built itself on this idea but also maintained an intimate bond between the human and the divine in the person of the emperor. This concept would last almost a millennium in Constantinople and be replicated in Russia with the tsar until modern times.

The mosaics are of two different dates and reflect in one building both the Roman and Byzantine styles of art. At the level of the clerestory windows are scenes from the New Testament—the miracles of Christ on one side (**Fig. 7.6**) and scenes from his passion on the other. These mosaics are very different in style from the procession of sainted martyrs on the lower level. The Gospel sequence is more Roman in inspiration: severe and simple. Certain themes of earlier Roman Christian

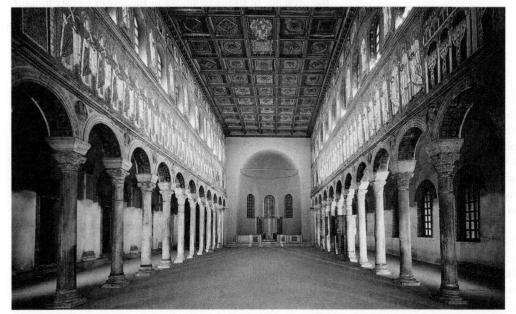

◀ **7.5 Church of Sant'Apollinare Nuovo, ca. 493–526. Ravenna, Italy.** There are three registers of mosaics above the arched colonnades, showing Hebrew prophets and scenes from the life of Christ. The church was originally dedicated to "our Lord Jesus Christ" but was rededicated in the ninth century when the relics of Apollinaris were acquired. Bishop Apollinaris, a second-century apologist for Christianity, had defended his faith in a treatise addressed to Emperor Marcus Aurelius.

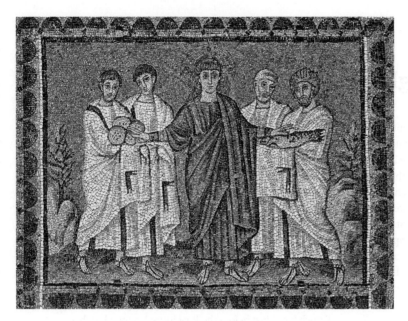

◀ **7.6** *Miracle of the loaves and fishes.* **Mosaic from the uppermost register of the nave wall, above the clerestory windows, Church of Sant'Apollinare Nuovo, Ravenna, Italy.** There is no blue sky, as in Figure 7.4; instead, we have "heavenly" gold.

iconography are evident. The procession of saints, most likely erected by artists from a Constantinople studio, is much more lush, reverent, and static in tone.

BYZANTIUM

The city of Byzantium is said to have been founded in 667 BCE, 67 years before the beginning of the Archaic period in Greece. Legend would have it that the Greek king Nisos consulted the oracle at Delphi to learn where his son, Byzas, should found his own city. The oracle instructed him to settle where, as it turned out, Constantine would later seat his Eastern Roman Empire. The city would be renamed Constantinople, but the entirety of the Eastern Roman Empire would be referred to as Byzantium in centuries to come.

Constantinople

The city of Constantinople in present-day Turkey became the center of imperial life in the early fifth century and reached its highest expression of power in the early sixth century with the ascension of Justinian to the throne in 527. Justinian's stated intention was to restore the empire to a condition of grandeur. In this project, he was aided by his wife Theodora. A former dancer and prostitute, Theodora was a tough-minded and capable woman who added strength and resolve to the grandiose plans of the emperor. She was Justinian's equal, and perhaps more.

The reign of Justinian and Theodora was impressive, if profligate, by any standard. The emperor encouraged Persian monks residing in China to bring back silkworms for the introduction of the silk industry into the West. Because the silk industry of China was a fiercely guarded monopoly, the monks accomplished this

rather dangerous mission by smuggling silkworm eggs out of the country in hollow tubes, and within a decade, the silk industry in the Western world rivaled that of China.

Justinian also revised and codified Roman law, a gigantic undertaking of scholarship and research. Roman law had evolved over a 1000-year period; by Justinian's time, it was a vast jumble of disorganized and often contradictory decisions, decrees, statutes, opinions, and legal codes. Under the aegis of the emperor, a legal scholar named Tribonian produced order out of this chaos. First a code that summarized all imperial decrees from the time of Hadrian (in the second century) to the time of Justinian was published. The code was followed by the Pandects ("Digest"), which synthesized a vast quantity of legal opinion and scholarship from the past. Finally came the Institutes, a legal collection broken down into four categories by which the laws concerning persons, things, actions, and personal wrongs (in other words, criminal law) were set forth. The body of this legal revision became the basis for the law courts of the empire and, in later centuries, the basis for the use of Roman law in the West.

Justinian and Theodora were fiercely partisan Christians who took a keen interest in theology and ecclesiastical governance. Justinian's fanatical devotion prompted him to shut down the last surviving Platonic academy in the world on the grounds that its paganism was inimical to the true religion. His own personal life—despite evidences of cruelty and capriciousness—was austere and abstemious, influenced by the presence of so many monks in the city of Constantinople. His generosity to the church was great, with his largesse shown most clearly in openhanded patronage of church building. The Hagia Sophia, his most famous project, has become legendary for the beauty and opulence of its decoration.

THE NIKA RIOTS In January of 532, Justinian was nearly deposed and, were it not for Theodora's resolve, he easily might have been. There were two opposing religious/political factions in Jusinian's time—Orthodox Christians (the Blues) and Monophysites (the Greens), and each took opposing sides in the popular chariot races held in Constantinople's Hippodrome. The Blues supported the Orthodox view that the person of Christ was both human and divine, part of the Godhead. The Monophysites held that Christ could not be both human and divine. He had to be one or the other. Broadly speaking, the Blues were Byzantium's wealthiest citizens and the Greens were what me might call "the party of the people." Outbreaks of bloody violence were not unheard of between these fiercely partisan groups, but nothing would compare to the slaughter of some 30,000 people—Greens

and Blues—that took place during the so-called Nika riots (after *nike*, the Greek word for victory chanted by the rioters). What touched it off? Taxes on the rich and poor alike.

At the races on January 10th, there was an outbreak of fighting that precipitated arrests on Justinian's order. Seven of those seen responsible for fomenting the rioting were to be executed by hanging, although two (a "Green" and a "Blue") escaped into the crowd when a scaffold broke. At the next race, both groups turned against Justinian (who had been a supporter of the Blues), chanting for the removal of the emperor and his tax administrator. The rioters left the Hippodrome and began to set the city aflame. Things were out of control for five days, when the rioters brought Hypatius—a nephew of a previous ruler—to the Hippodrome and placed him on the emperor's throne. It was then that Justinian was about to flee the city until, by most accounts, Theodora shamed him into staying and fighting.

CONNECTIONS

Born in the hovel,
bred in the hippodrome,
Theodora graced the throne.

On December 26, 1884, Sarah Bernhardt, the world's most celebrated actress, took the stage in the title role of *Theodora*. The most spectacular production that Paris had ever seen, the dramatist Victorien Sardou's work of historical fiction, panned by scholars, not only shaped the public's consciousness and image of the bygone Byzantine Empire but also influenced the contemporary discourse of Byzantine studies.

Elena Boeck begins her chapter-long essay entitled "Archaeology of Decadence: Uncovering Byzantium in Victorian Sardou's Theodora"[*] with these provocative lines describing Justinian's wife, the Empress Theodora. The "hovel" and "hippodrome" refer to Theodora's life before Justinian: She was the daughter of a bear trainer in Constantinople's Hippodrome and a woman who was a dancer and an actress. According to Procopius's *Secret History* (a scathing, tell-all exposé on Justinian and Theodora published more than 1000 years after the author's death), Theodora had worked in a brothel at an early age; more recent scholars suppose that as a performer she would have earned a living from some combination of theatrical skills and sexual services.[†] Theodora already "graces the throne," however, when we enter the play. "Although [she] is an empress," Boeck writes, "she has not forgotten her adventurous and colorful roots."

Perhaps Theodora's checkered past is what drew Bernhardt to what was supposedly her favorite role. Boeck calls this the "Sarah/Theodora nexus," noting that "The character of the courtesan-empress was quite close to Sarah Bernhardt's own humble origins (as a daughter of a prostitute and a kept woman herself earlier in life), and triumphant rise to thespian power." In an early example of what is now known as "method acting," Bernhardt traveled to Justinian's chapel, San Vitale, in Ravenna and made sketches of the mosaics. Bedecked in costumes that were over the top in splendor, she "literally morphed into a jeweled idol"[‡] in her imperial role.

There can be no doubt that the public's beguilement with Berhardt contributed to the astounding response

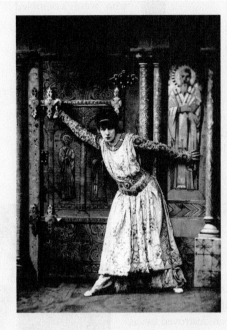

◀ **7.7 Sarah Bernhardt as Theodora, 1884. Photograph by Nadar.** Victorien Sardou familiarized himself with Byzantine art and architecture to create an undeniable authenticity for his stage sets.

to *Theodora*, but 19th-century Parisians were a captive audience for historicism and eroticism—particularly portrayals of what they saw as the blatant sexuality and decadence of the Near East. *Theodora* came along at the right time: "Rome was not new, Egypt was no longer fresh, and Byzantium offered an opportunity for a new kind of spectacle and a bit of Parisian introspection."[§]

The glow of Sardou's "dazzling, decadent Byzantium" remained long after Bernhardt's unprecedented 257 consecutive performances of the role of *Theodora*. Boeck cites examples of the subsequent, decades-long popularity of the Theodora character in art, print culture, film, as well as social gatherings of aristocrats and elites: In a letter dated December 11, 1897, Winston Churchill asked his mother for a photograph of her as Theodora taken at a fancy-dress party, and Sigmund Freud kept a photo of Bernhardt's Theodora in his office.

[*] Roland Betancourt and Maria Taroutina, eds., *Byzantium/Modernism: The Byzantine as Method in Modernity*, Visualizing the Middle Ages, book 12 (Leiden, The Netherlands: Brill Academic Publishing; Lam edition, 2015).
[†] Lynda Garland, *Byzantine Empresses: Women and Power in Byzantium, AD 527–1204* (London, Routledge, 1999).
[‡] Ibid., p. 121.
[§] Ibid., p. 108.

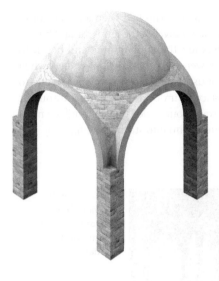

◀ **7.8 Dome on Pendentives.**

That is when the bloodbath occurred. The Greens and Blues, who were assembled in the Hippodrome, were prevented from escaping by the Imperial Bodyguard, and Belisarius, Justinian's renowned general, along with his troops, slayed them—the guilty and innocent alike. After the Nika riots, Justinian and Theodora reestablished control of the city. The event marked the end of chariot racing in Byzantium.

The Hagia Sophia: Monument and Symbol

The Hagia Sophia (Greek for "Holy Wisdom") was the principal church of Constantinople. It had been destroyed twice, once by fire and once—during Justinian's reign—by the Nika revolt. Soon afterward, Justinian decided to rebuild the church using the plans of two architects: Anthemius of Tralles and Isidorus of Miletus. Work began in 532, and the new edifice was solemnly dedicated five years later in the presence of Justinian and Theodora.

The Hagia Sophia was a stunning architectural achievement that combined the longitudinal shape of the Roman basilica with a domed central plan. Two centuries earlier, Constantine had used both the dome and basilica shapes in the Church of the Holy Sepulcher in Jerusalem, but he had not joined them into a unity. In still earlier domed buildings in the Roman world, such as the Pantheon, the dome rested on a circular drum. This gave the dome solidity but limited its height and expansiveness. Anthemius and Isidorus solved this problem by the use of **pendentives** (Fig. 7.8), triangular masonry devices that carry the weight of the dome on massive piers rather than straight down from the drum.

In the Hagia Sophia, the central dome is abutted by two half domes, so that a person looking down at the building from above might see a nave in the form of an oval instead of a quadrangle (Fig. 7.9). The church—at 184 feet high, 41 feet higher than the Pantheon—retains a hint of the old basilican style as a result of the columned side aisles and the gallery for female worshippers in the triforium—the space above the arches of the side aisles—but the overwhelming visual impression comes from the massive dome. Because the pendentives reduce the weight of the dome, the area between drum and dome could be pierced by 40 windows that make the dome seem to hang in space. Light streams into the church from the windows and refracts off the rich mosaics and colored marbles that cover the interior (Fig. 7.10).

Light, in fact, was a key theoretical element behind the entire conception of the Hagia Sophia. It is the symbol of divine wisdom in the philosophy of Plato and in the New Testament. A common metaphor in pagan and biblical wisdom had the sun

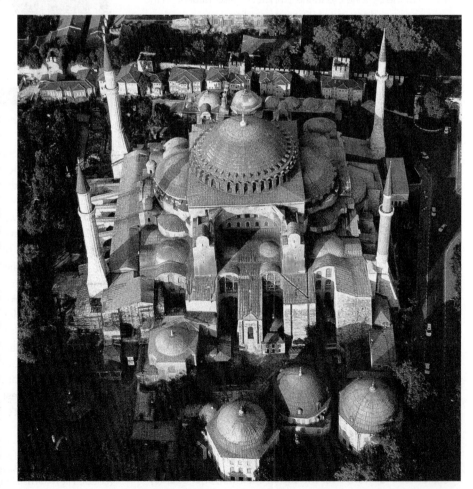

▲ **7.9 Hagia Sophia, 532–537. Constantinople (Istanbul), Turkey.** Exterior view from the southeast. The minarets, of Turkish origin, are a later addition. Justinian built or restored at least 30 churches in Constantinople and others elsewhere.

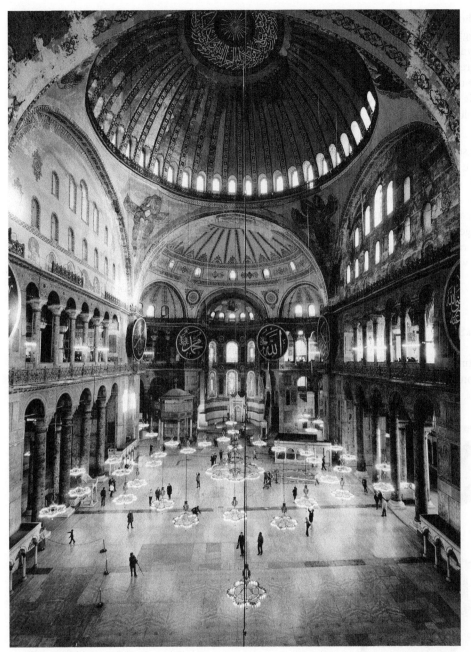

and its rays represent the eternity of God and his illumination of mortals. The suffusion of light was an element in the Hagia Sophia that went far beyond the functional need to illuminate the interior of the church. Light refracting in the church created a spiritual ambience analogous to that of heaven, where believers would be bathed in the actual light of God.

WORSHIP IN THE HAGIA SOPHIA The sequence of the various parts of the worship service at Constantinople—the **liturgy**—was developed from the inspiration of Saint John Chrysostom (347–407), patriarch of the city in the century before Justinian. The official liturgy of Byzantine Christianity is still the Divine Liturgy of Saint John Chrysostom, modified and added to over the centuries. In that liturgy, the worshipping community visualizes itself as standing in the forecourt of heaven when it worships in the church. Amid the swirling incense, the glittering light, and the stately chants of the clergy and people comes a sense of participation with the household of heaven standing before God. A fragment from the liturgy—added during the reign of Justinian's successor Justin II (565–578)—underscores the point dramatically. Note the characteristic cry of "Wisdom!" and the description of the congregation as mystically present in heaven.

Priest	Wisdom! That ever being guarded by Thy power, we may give glory to Thee, Father, Son, and Holy Spirit, now and forevermore.

Congregation Amen. Let us here who represent the mystic Cherubim in singing the thrice holy hymn to the life-giving Trinity now lay aside every earthly care so that we may welcome the King of the universe who comes escorted by invisible armies of angels. Alleluia. Alleluia. Alleluia.

The Hagia Sophia was enriched by subsequent emperors, and after repairs were made to the dome in 989, new mosaics were added to the church. After the fall of Constantinople in 1453, the Turks turned the church into a mosque; the mosaics were whitewashed or plastered over because the Qur'an (also spelled *Koran*) prohibited the use of images. When the mosque was converted to a museum by the modern Turkish state, some of the mosaics were uncovered, so today we can get some sense of the splendor of the original interior.

Other Churches in Constantinople

Other monuments bear the mark of Justinian's creative efforts. His Church of the Holy Apostles, built on the site of an earlier

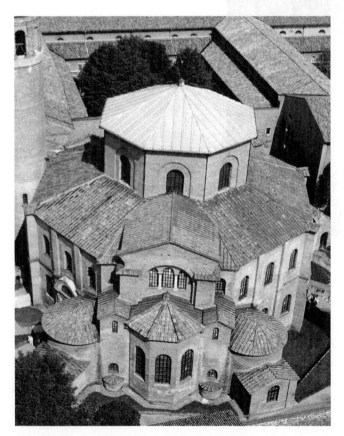

▲ **7.11 Church of San Vitale, ca. 526–547. Ravenna, Italy.** This complex building, the inspiration for Charlemagne's church at Aachen (see Figure 9.12), gives little exterior evidence that it is constructed in the basilica style. The church honors Saint Vitalis, a second-century martyr.

church of the same name, destroyed by an earthquake, did not survive the fall of the city in 1453 but did serve as a model for the San Marco Basilica in Venice. Near the Hagia Sophia is the Hagia Eirene ("Holy Peace"), now a mosque, whose architecture also shows the combination of basilica and dome. The church, dedicated to the martyr saints Sergius and Bacchus and begun in 527, was a preliminary study for the later Hagia Sophia. In all, Justinian built more than 25 churches and convents in Constantinople. His program of secular architecture included an impressive water-conduit system that still exists.

San Vitale

The Church of San Vitale most clearly testifies to the presence of Justinian in Ravenna (**Fig. 7.11**). Dedicated by Bishop Maximian in 547, it had been begun by Bishop Ecclesius in 526, the year Justinian came to the throne while the Goths still ruled Ravenna. The Church of San Vitale is octagonal, with only the barest hint of basilican length. The octagon has another octagon within it. This interior octagon, supported by columned arches and containing a second-story women's gallery, is the structural basis for the dome. The dome is supported on the octagonal walls by small vaults called *squinches* that cut across the angles of each part of the octagon.

The most arresting characteristic of San Vitale, apart from its intricate and not fully understood architectural design, is its stunning program of mosaics. In the apse is a great mosaic of Christ the Pantocrator, the one who sustains all things in his hands (**Fig. 7.12**). He is portrayed as a beardless young man, clothed in royal purple; in his left hand, he holds a book with seven seals (a reference to the book of Revelation), and with his right hand, he offers the crown of martyrdom to Saint Vitalis. Flanked by the two archangels Michael and Gabriel, Christ is offered a model of the church by Bishop Ecclesius, who laid its foundations. Above the figures are symbolic representations of the four rivers of paradise.

Mosaics to the left and right of the apse mosaic represent the royal couple as regents of Christ on earth. On the left wall of the sanctuary is a mosaic depicting Justinian and his attendants (**Fig. 7.13**). It is no mere accident or exercise of simple piety that the soldiers carry a shield with the **chi-rho** (the first letters in the Greek name of Christ) or that the figure of the emperor divides clergy and laity. The emperor considered himself the regent of Christ, an attitude summed up in the iconographic, or symbolic, program: Justinian represents Christ on earth, and his power balances both church and state. The only figure identified in the mosaic is Bishop (later Archbishop) Maximian, flanked by his clergy, who include a deacon with a jeweled gospel and a subdeacon with a chained incense pot.

The figures form a strong friezelike horizontal band that communicates unity. Although they are placed in groups, some slightly in front of the others, the heads present as points in a single line. Thickly lidded eyes stare outward. The heavily draped bodies have no evident substance, as if garments hang on invisible

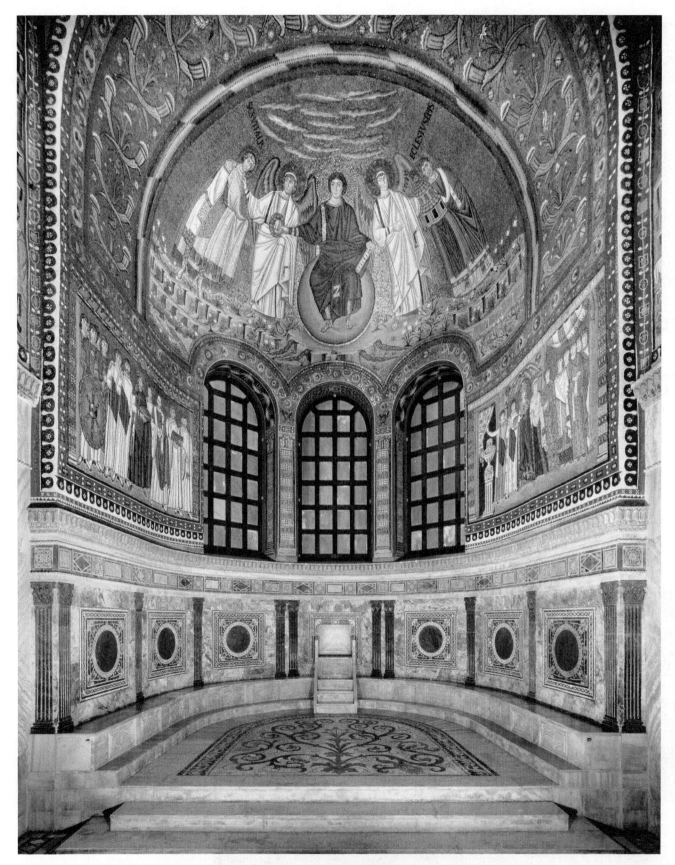

▲ 7.12 **View of the Apse with mosaic of Christ enthroned, Surrounded by Angels, Saint Vitalis, and Bishop Ecclesius, ca. 530. Ceiling mosaic, Church of San Vitale, Ravenna, Italy.** At the extreme right of the mosaic, the bishop holds a model of the church, while Christ hands the crown of martyrdom to the saint on the left.

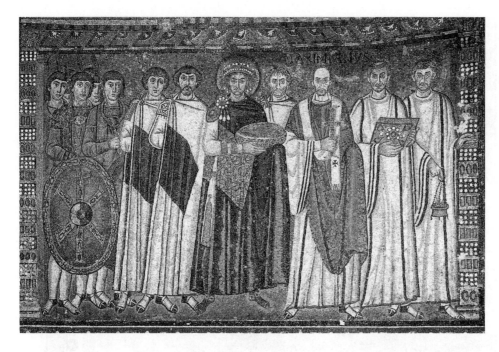

◀ **7.13 Emperor Justinian and courtiers, ca. 547. Mosaic, north wall of the apse, Church of San Vitale, Ravenna, Italy.** The church authorities stand at the emperor's left; the civil authorities are at the right. Note the chi-rho on the shield of the soldier.

frames, and the physical gestures of the men are unnatural. Space is tentatively suggested by a grassy ground line, but the placement of the figures on this line and within this space is uncertain. The feet seem to hover rather than support the bodies to which they are attached. These characteristics contrast strongly with the Classicism of Early Christian art and point the way toward a manner of representation in which the corporeality of the body is less significant than the soul.

Opposite the emperor's retinue, Empress Theodora and her attendants look across at the imperial group (**Fig. 7.14**). Theodora holds a chalice to complement the *paten* (bread basket) held by

the emperor. At the hem of Theodora's gown is a small scene of the Magi bringing gifts to the Christ child. Scholars disagree whether the two mosaics represent the royal couple bringing the Eucharistic gifts for the celebration of the liturgy or the donation of the sacred vessels for the church. It was customary for rulers to give such gifts to the more important churches of their realm. The fact that the empress seems to be leaving her palace (two male functionaries of the court are ushering her out) makes the latter interpretation more probable. The women at Theodora's left are striking; those to the extreme left are stereotyped, but the two closest to the empress appear more individualized, leading

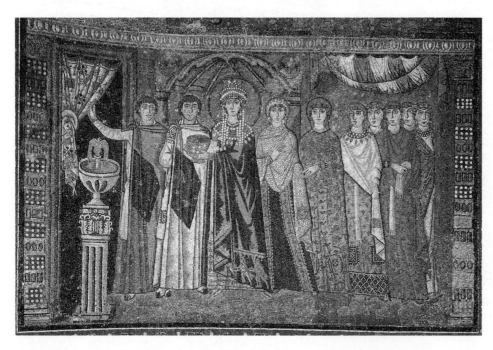

◀ **7.14 Empress Theodora and retinue, ca. 547. Mosaic, south wall of the apse, Church of San Vitale, Ravenna, Italy.** Note the Magi on the hem of the empress's gown.

The entire ensemble of San Vitale, with its pierced capitals typical of the Byzantine style, its elaborate mosaic portraits of saints and prophets, its lunette mosaics of Old Testament prefigurations of the Eucharist, and monumental mosaic scenes, is a living testimony to the rich fusion of imperial Roman, Christian, and Middle Eastern cultural impulses. San Vitale is a microcosm of the sociopolitical vision of Byzantium fused with the religious worldview of early Christianity.

Saint Catherine's Monastery at Mount Sinai, Egypt

Justinian is remembered not only in Constantinople and Ravenna but also in the Near East, where he founded a monastery that is still in use some 1500 years later—a living link back to the Byzantine world.

In her *Peregrinatio*, that wonderfully tireless traveler of the fourth century, Etheria, describes a visit to the forbidding Sinai Desert to pray at the site where God appeared to Moses in a burning bush (which, Etheria assures us, "is still alive to this day and throws out shoots") and to climb the mountain where the law was given to Moses. She says that there was a church at the spot of the burning bush, with some hermits living nearby to tend it and see to the needs of pilgrims. More than a century later, Emperor Justinian built a monastery fortress at the foot of Mount Sinai and some pilgrimage chapels on the slopes of the mountain (Fig. 7.16). An Arabic inscription over one of the gates tells the story:

▲ **7.15** Bishop's cathedra ("throne") of Maximian, ca. 546–556. Ivory panels on wood frame, 22" (55.9 cm) wide × 59" (150 cm) high. Museo Arcivescovile, Ravenna, Italy.

some art historians to suggest that they are idealized portraits of two of Theodora's closest friends: the wife and daughter of Belisarius, the conqueror of Ravenna.

MAXIMIAN'S THRONE The royal generosity did not extend only to the building and decoration of the Church of San Vitale. An ivory throne, now preserved in the episcopal museum of Ravenna, was a gift from the emperor to Bishop Maximian (Fig. 7.15). A close stylistic analysis of the carving on the throne has led scholars to see the work of at least four different artists on the panels, all probably from Constantinople. The front of the throne bears portraits of John the Baptist and the four evangelists, while the back has scenes from the New Testament, with sides showing episodes from the life of Joseph in the Old Testament. The purely decorative elements of trailing vines and animals show the style of a different hand, probably Syrian. The bishop's throne (*cathedra* in Latin; a cathedral is a church where a bishop presides) bears a small monogram: "Maximian, Bishop."

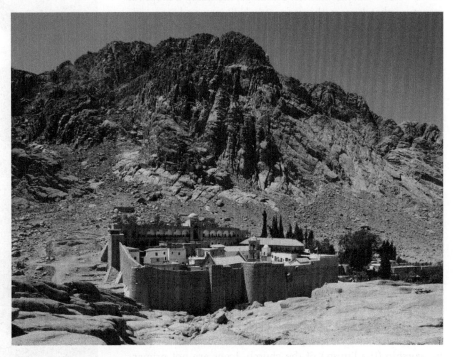

▲ **7.16** **Fortress of Saint Catherine's Monastery, sixth century. Sinai Desert, Egypt.** Constructed by order of Emperor Justinian between 527 and 565 at the foot of Mount Sinai, the fortress surrounds the monastery and its church, which was built over what is thought to be Moses's burning bush. The church can be seen flanked by a bell tower in the lower center of the walled enclosure. The formal name of the monastery is the Monastery of the Transfiguration.

The pious king Justinian, of the Greek Church, in the expectation of divine assistance and in the hope of divine promises, built the monastery of Mount Sinai and the Church of the Colloquy [a church over the spot where Moses spoke to God in the burning bush] to his eternal memory and that of his wife, Theodora, so that all the earth and all its inhabitants should become the heritage of God; for the Lord is the best of masters. The building was finished in the thirtieth year of his reign and he gave the monastery a superior named Dukhas. This took place in the 6021st year after Adam, the 527th year [by the calendar] of the era of Christ the Savior.

Because of several factors—most important being its extreme isolation and the very dry weather—the monastery is an immense repository of ancient Byzantine art and culture. It preserves some of Justinian's architecture and also some of the oldest icons in Christianity. The monastery is also famous as the site of the rediscovery of the earliest Greek **codex** of the New Testament hitherto found. Called the *Codex Sinaiticus*, it was discovered in the monastery by the German scholar Konstantin von Tischendorf in the 19th century. The codex, from the middle of the fourth century, was given by the monks to the tsar of Russia. In 1933, the Soviet government sold it for 100,000 pounds to the British Museum, where it remains today—a precious document.

The monastery is surrounded by heavy, fortified walls, the main part of which dates from before Justinian's time. Within those walls are some modern buildings, including a fireproof structure that houses the monastery's library and icon collections. The major church of the monastery dates from the time of Justinian, as recently discovered inscriptions carved into the wooden trusses in the ceiling of the church prove. Even the name of the architect, Stephanos, was uncovered. This church thus is unique: signed sixth-century ecclesiastical architecture.

ICONS One of the more spectacular holdings of the monastery is its vast collection of religious **icons**. Because of the **iconoclastic controversies** of the eighth and ninth centuries in the Byzantine Empire, repealed in 1843, almost no pictorial art remains from the period before the eighth century. Sinai survived the purges of the iconoclasts that engulfed the rest of the Byzantine world because of its extreme isolation. At Sinai, a range of icons (the Greek word *eikōn* means "image") that date from Justinian's time to the modern period can be seen. In a real sense, the icons of the monastery of Saint Catherine show the entire evolution of icon painting.

In the Byzantine Christian tradition, an icon is a painting of a religious figure or a religious scene that is used in the public worship (the liturgy) of the church. Icons are not primarily decorative, and they are didactic only in a secondary sense: for Orthodox Christians, the icon is a window into the world of the sacred. Just as Jesus Christ was in the flesh but imaged God in eternity, so the icon is a thing but permits a glimpse

into the timeless world of religious mystery. One stands before the icon and speaks through its image to the reality beyond it. This explains why the figures in an icon are usually portrayed in full front with no shadow or sense of three-dimensionality. The figures "speak" directly and frontally to the viewer against a hieratic background of gold.

This iconic style becomes clear from an examination of an icon of Christ that may well have been sent to the new monastery by Justinian himself (**Fig. 7.17**). The icon is done using the *encaustic* method of painting (a technique common

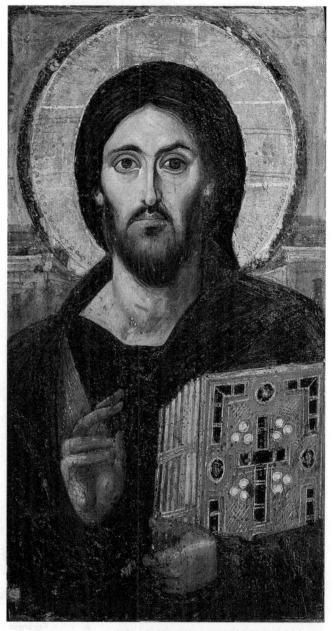

▲ **7.17** **Christ Pantocrator, ca. 500–530. Encaustic on wood panel, 32" × 27" (84 × 46 cm). Saint Catherine's Monastery, Sinai, Egypt.** The book is a complex symbol of the Bible, Christ as the Word of God, and the record of human secrets that will be opened on the last day.

in the Roman world for funerary portraits): painting with molten wax that has been colored by pigments. Christ, looking directly at the viewer, is robed in royal purple; in his left hand, he holds a jeweled codex, and with his right hand, he blesses the viewer.

THE LEGACY OF BYZANTINE CULTURE

It is simplistic to describe Byzantine art as unchanging—it underwent regional, intellectual, social, and iconographic changes—but a person who visits a modern Greek or Russian Orthodox church is struck more by the similarities than by the dissimilarities with the art of early medieval Constantinople. Furthermore, the immediately recognizable Byzantine style can be found in the history of art in areas as geographically diverse as Sicily in southern Italy and the far eastern reaches of Russia. What explains this basic persistence of style and outlook?

Russia

Until it fell to the Turks in 1453, Constantinople exerted an extraordinary cultural influence over the rest of the Eastern Christian world. Russian emissaries sent to Constantinople in the late 10th century to inquire about religion brought back to Russia both favorable reports about Byzantine Christianity and a taste for the Byzantine style of religious art. Services in the Hagia Sophia most impressed the delegates of Prince Vladimir, the first Christian ruler in Russia. Although art in Christian Russia was to develop its own regional variations, it was still closely tied to the art of Constantinople; Russian onion-domed churches, for example, are native adaptations of the central-domed churches of Byzantium.

Russia, in fact, accepted Christianity about 150 years after the ban on icons was lifted in Constantinople in 843. By this time, the second golden age of Byzantine art was well under way. In the 11th century, Byzantine artists were working in Russia and had even established schools of icon painting in such centers as Kiev. By the end of the century, these schools had passed into the hands of Russian monks, but their stylistic roots remained the artistic ideas of Byzantium. Even after the Mongol invasions of Russia in 1240, Russian religious art continued to have close ties to the Greek world—although less with Constantinople than with the monastic centers of Mount Athos and Salonika in Greece.

Italy

Byzantine influence was also strong in Italy. We have already seen the influence of Justinian's court on Ravenna. Although northern Italy fell to Lombard rule in the eighth century, Byzantine influence continued in the south of Italy for the next 500 years. During the iconoclastic controversy in the East, many Greek artisans went into exile in Italy, where their work is still to be seen. Even while the kingdom of Sicily was under Norman rule in the 12th century, Byzantine artisans were still active, as the great mosaics of Monreale, Cefalù, and Palermo testify. In northern Italy, especially in Venice, the trade routes to the east and the effects of the Crusades permitted a strong presence of Byzantine art, as the mosaics of the San Marco Basilica and the cathedral on the nearby island of Torcello attest (as well as Byzantine art looted when the crusaders entered Constantinople in 1204). We shall see in later chapters the impact of this artistic presence on panel painting in Italy. Until the revolutionary changes by Cimabue and Giotto at the end of the 13th century, the pervasive influence of this style was so great that Italian painting up to that time is often characterized as Italo-Byzantine.

Byzantine Art

There is another reason that Byzantine aesthetics seem so changeless over the centuries. From the time of Justinian (and even more so after controversies of the eighth and ninth centuries), Byzantine art was intimately tied to the theology and liturgical practices of the Orthodox church. The use of icons, for example, is not merely a pious practice but a deep-rooted part of the faith, celebrated annually by the Feast of the Triumph of Orthodoxy.

Art, then, is tied to theological doctrine and liturgical practice. Because of the innate conservatism of the theological tradition, innovation either in theology or in art was discouraged. The ideal of the artists was not to try something new but to infuse their work with a spirit of deep spirituality and unwavering reverence. This art, while extremely conservative, was never stagnant. The artists strove for fidelity to the past as their aesthetic criterion. As the art historian André Grabar has noted, "Their role can be compared to that of musical performers in our day, who do not feel that their importance is diminished by the fact that they limit their talent to the interpretation of other people's work, since each interpretation contains original nuances."[11]

This attitude of theological conservatism and aesthetic stability helps explain why, for example, the art of icon painting is considered a holy occupation in the Eastern Orthodox Church. Today, when a new Orthodox church is built, the congregation may commission from a monk or icon painter the necessary icons for the interior of the church. The modern scholars who went on expeditions to Saint Catherine's Monastery to study the treasures there recall the sadness they felt at the funeral of a monk, Father Demetrios, in 1958. The last icon painter in the monastery, he marked the end of a tradition that stretched back nearly 1500 years.

11. Andre Grabar, *Byzantine Art in the Middle Ages*, trans. Betty Forster (New York: Greystone Press, 1967).

The Literary, Philosophical, and Theological Aspects of Byzantine Culture

Byzantine culture was not confined to artistic concerns. We have already seen that Justinian made an important contribution to legal studies. Constantinople also had a literary, philosophical, and theological culture. Although Justinian closed the pagan academies, later Byzantine emperors encouraged humanistic and theological studies. Even though the links between Constantinople and the West were strained over the centuries, they did remain intact. At first, a good deal of Greek learning came into the West (after having been lost in the early Middle Ages) through the agency of Arabic sources. The philosophical writings of Aristotle became available to Westerners in the late 12th and early 13th centuries in the forms of Latin or Arabic translations of the Greek: Aristotle came to the University of Paris from the Muslim centers of learning in Spain and northern Africa. Even in the 14th century, Petrarch and Boccaccio had a difficult time finding anyone to teach them Greek; the language was not yet widely known in the West. By the 15th century, this situation had changed. One factor contributing to the Renaissance love for the classics was the presence in Italy of Greek-speaking scholars from Constantinople.

The importance of this reinfusion of Greek culture can be seen easily enough by looking at the great libraries of 15th-century Italy. Of the nearly 4000 books listed in a catalog of the Vatican library in 1484, 1000 were in Greek, most of them from Constantinople. The core of the great library of the San Marco Basilica in Venice was Cardinal Bessarion's collection of Greek books, brought from the East when he went to the Council of Ferrara–Florence in 1438 to discuss the union of the Greek and Latin churches. Bessarion brought with him, in addition to his books, the noted Platonic scholar Gemistus Plethon, who lectured on Platonic philosophy for the delighted Florentines. This event prompted Cosimo de' Medici to subsidize the collection, translation, and study of Plato's philosophy under the direction of Marsilio Ficino. Ficino's Platonic Academy, supported by Medici money, became a rallying point for the study of philosophical ideas.

The fall of Constantinople to the Turks in 1453 brought a flood of émigré Greek scholars to the West, in particular to Italy. The presence of these scholars enhanced the already considerable interest in Greek studies. Greek refugee scholars soon held chairs at the various **studia** ("schools") of the leading Italian cities. These scholars taught language, edited texts, wrote commentaries, and fostered an interest not only in Greek pagan learning but also in the literature of the Greek fathers of the church. By the end of the 15th century, the famous Aldine Press in Venice was publishing a whole series of Greek classics to meet the great demand for such works. This new source of learning and scholarship spread rapidly throughout Western Europe so that by the early 16th century, the study of Greek was an ordinary but central part of both humanistic and theological education.

The cultural worldview of Justinian's Constantinople is preserved directly in the conservative traditionalism of Orthodox religious art and indirectly in Constantinople's gift of Greek learning to Europe during the Renaissance. Although the seat of power of the Byzantine Empire ended in the 15th century, its cultural offshoots remain very much with us.

GLOSSARY

Arian controversy (p. 231) The dispute as to whether Jesus was divine and unified with God the Father and the Holy Spirit (the Orthodox Christian view) or whether Jesus, as the created Son, was distinct from the eternal God the Father (the view held by Arius).

Chi-rho (p. 244) A symbol for Christ, consisting of the first two letters of the Greek word *christos*.

Codex (p. 248) Manuscript pages held together by stitching; an early form of a book.

Doctor of the church (p. 232) A title given by the Roman Catholic Church to 33 eminent saints, including Augustine, who distinguished themselves by soundly developing and explaining church doctrine.

Icon (p. 248) An image or symbol.

Iconoclastic controversy (p. 248) The dispute as to whether or not it was blasphemous to use images or icons in art, based on the second of the Ten Commandments, in which God forbids the creation and worship of "graven images"; the Greek word *iconoclasm* translates as "image breaking" and refers to the destruction of religious icons within a culture.

Latin fathers (p. 232) The early and influential theologians of Christianity.

Liturgy (p. 243) The arrangement of the elements or parts of a religious service.

Orthodox Christians (p. 231) Christians who believe in the divinity of Christ and the unity of Jesus, God the Father, and the Holy Spirit.

Pendentive (p. 242) A triangular section of vaulting between the rim of a dome and each adjacent pair of the arches that support it.

Studia (p. 250) Schools.

Votive chapel (p. 237) A chapel that is consecrated or dedicated to a certain purpose.

THE BIG PICTURE EARLY CHRISTIANITY: RAVENNA AND BYZANTIUM

Language and Literature

– Saint Ambrose, bishop of Milan and a Latin father of the church, wrote theological treatises such as *On Faith*, letters, and a collection of hymns ca. the 380s.

– Saint Jerome, another father of the church, translated the Bible into Latin in 386.

– Saint Augustine of Hippo, another father of the church, wrote his *Confessions*, recounting his early unchaste years and his conversion to Christianity.

– As the Roman Empire in the West was declining, Saint Augustine wrote *The City of God*—about an eternal city to be contrasted with the City of Man.

– Procopius wrote the *History of the Wars*, *The Buildings*, and a *Secret History* of the reign of Justinian (ca. 550–562).

Art, Architecture, and Music

– Saint Ambrose began the use of hymns in church services.

– Mosaics, including one of Christ as the Good Shepherd, were created at the Mausoleum of Galla Placidia in Ravenna, which had become the capital of the Roman Empire in the West.

– A dome mosaic with floral designs, the apostles, and a depiction of the baptism of Christ was created in the Bapistery of the Orthodox at Ravenna.

– The Church of Sant'Apollinare Nuovo was constructed in Ravenna, with a wide nave and side aisles partitioned off by double columns of marble.

– The octagonal Church of San Vitale, which was later adorned with its mosaic of Christ the Pantocrator, was constructed in Ravenna.

– The monastery at Mount Sinai was founded by Justinian; Saint Catherine's preserves Justinian's architecture and some of the oldest Christian icons.

– The Hagia Sophia, combining the longitudinal shape of the Roman basilica with a domed central plan, was constructed in Constantinople.

– Emperor Justinian of Byzantium gave an ivory throne to Archbishop Maximian.

– During the iconoclastic controversy (740–843), the creation of religious imagery was banned, based on an interpretation of the second commandment that prohibited the creation and worship of "graven images."

– Following the Islamic Turskish capture of Constantinople in 1453, the Hagia Sophia was converted into a mosque.

Philosophy and Religion

– Christians were persecuted under Decius ca. 250.

– The final but extreme persecution of Christians occurred ca. 303 under Diocletian.

– The Edict of Milan granted Christians (and other peoples throughout the Byzantine Empire) religious freedom in 313.

– The Council of Nicaea, convened by Constantine, proclaimed in 325 that Jesus was divine, equal to, and unified with God the Father and the Holy Spirit.

– Saint Ambrose supported the idea of the virginity of Mary and her importance as the Mother of God.

– Saint Augustine proclaimed that all humans inherit the original sin of eating the forbidden fruit and are depraved—capable of being saved solely by Jesus.

– Christianity became the state religion in 381, unifying church and state.

– Boethius wrote *Consolation of Philosophy* ca. 522–524 while awaiting his probable execution in a prison cell.

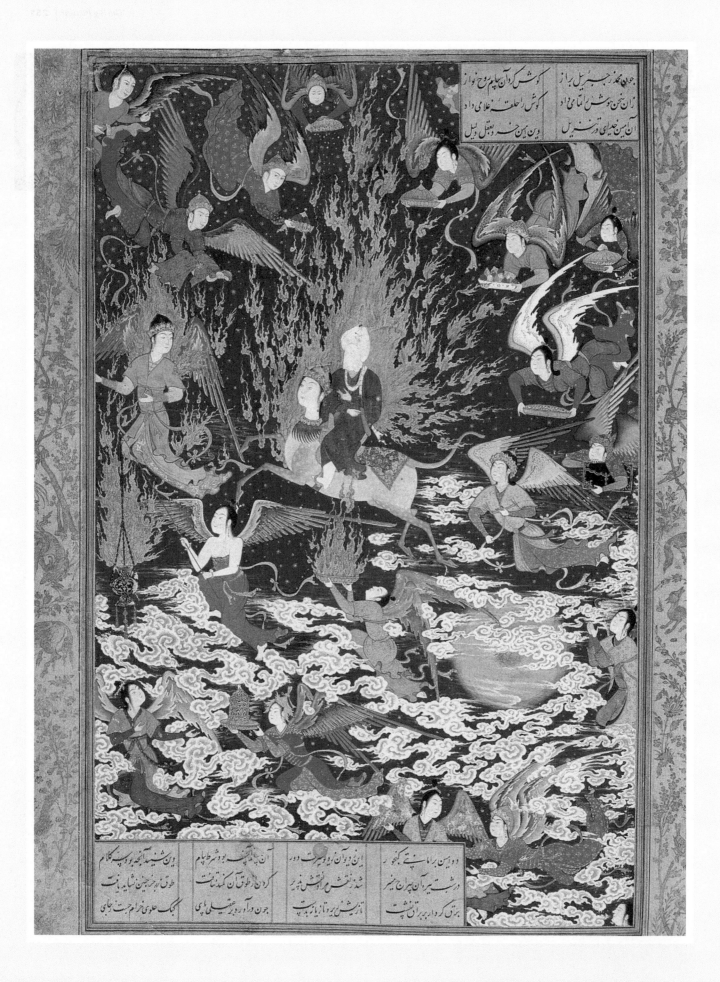

The Islamic World

8

PREVIEW

Five times a day, from minarets all over the world, a call goes out to the followers of the prophet Muhammad to uphold the Second Pillar of the Islamic faith—to recite the *salah*, the ritual prayer. Between first light and sunrise, after the sun has passed the middle of the sky, between midafternoon and sunset, between sunset and the last light of day, and between darkness and midnight, practicing Muslims, wherever they may be—in a mosque, an airport, or a corporate office—pause in the course of everyday life to unfurl their prayer mats, prostrate themselves, and pray in the direction of Mecca, directly to the one God of the Bible, *Allah* in Arabic.

Salah has its origins in the texts of the *Qur'an*—the word of Allah as given directly to his prophet Muhammad—and *Hadith*, the repository of writings about Muhammad's life. Allah gave instructions for obligatory prayer, according to Islamic tradition, to Muhammad during a physical and spiritual journey that took place over a single night in the year 621. The story of the two-part Night Journey—the *Isra* and the *Mi'raj*—is briefly mentioned in a chapter in the Qur'an.

The Night Journey begins with Muhammad at prayer in the Ka'bah—a sacred building in Mecca. There he is visited by the archangel Gabriel (*Jibril* in Arabic), who brings with him a white, winged steed—Buraq—that flies faster than the wind and whose single stride stretches farther than the eye can see (Fig. 8.1).

Muhammad mounts Buraq and is carried to many places, including the "farthest mosque," the *masjid al-aqsa*, which some Muslims believe is the present-day Al-Aqsa Mosque on the Temple Mount (also the site of two destroyed Hebrew temples) in the Old City of Jerusalem. It is there that Muhammad meets prophets who preceded him—Adam (*Adem* in Arabic), Moses (*Musa* in Arabic), and Jesus (*Isa* in Arabic)—and leads them in prayer. It is on the Temple Mount that the Prophet ascended into heaven from the same rock on which, according to Hebrew tradition, Abraham was about to sacrifice his son Isaac before an angel of God stayed his hand.

In the second part of the Night Journey, Muhammad travels through the seven circles of heaven and once again meets earlier prophets. It is in this realm that Allah instructs him regarding the nature and number of obligatory prayers. At first, Allah tells him that believers must worship 50 times each day, but on the advice of Moses, Muhammad beseeches God to reduce the number so that the obligation is more manageable. After some negotiation, Allah finally assents to five times a day, the pattern for prayer that Muslims follow to this day.

◄ 8.1 "Muhammad's ascent into heaven on Buraq, guided by Gabriel and escorted by angels, during his Night Journey," 1539–1543, Iran. Folio 195 recto, illuminated miniature, from Nizami's Khamsa (Five Poems). British Library, London, United Kingdom.

"THE LAMPS ARE DIFFERENT, BUT THE LIGHT IS THE SAME"

"The lamps are different, but the Light is the same:
it comes from Beyond."

—FROM "THE ONE TRUE LIGHT," JALAL AL-DIN RUMI

When the Sufi mystic and poet Rumi was writing in the 1200s CE, Islam was in its golden age, Christianity was in the High Middle Ages, and it had been more than two millennia since the Hebrews drafted the tenets of their faith after, according to their belief, Moses received the Ten Commandments at Mount Sinai. Judaism, Christianity, and Islam—three "lamps" representing three of the world's most influential religions—have things in common: their "light" comes from a single God, and all are built on the belief in divine revelation from beyond. Jews believe that God, whom the ancient Hebrews called Yahweh, spoke directly to Abraham and to Moses, establishing a covenant with their generations as his chosen people. Christians believe that the same God spoke to Jesus at his baptism, calling him his beloved Son. And Muslims believe that the same God, whom they call **Allah**, revealed their holy book—the **Qur'an**—to the prophet Muhammad. Rumi referred to a single God as "the kernel of Existence" but acknowledged the perspectives of many religions.

MUHAMMAD AND THE BIRTH OF ISLAM

Muhammad, the founder of Islam, was born in 570 in the Arabian city of Mecca. Orphaned as a child and reared in poverty, while still young he married a rich widow who would bear him a daughter, Fatima. Fatima would later marry the first imam (authoritative religious leader) of the Shiites. An ancestor of followers of Islam, Fatima is highly venerated by Muslims as a model of piety and purity. Muhammad's deep religious nature led him to ponder the reasons for his good fortune, and he began to retreat into caves in the neighboring mountains to meditate. Muslims believe that at about the age of 40, he began receiving revelations from God through the agency of the angel Gabriel. When he began to speak publicly about his ideas of religious reform, Muhammad soon encountered severe opposition from the citizens of Mecca, who had little patience with his sermons against the city's polytheism and idolatry and with his insistence on the worship of one god.

As Muhammad preached and the numbers of his followers grew, a number of them were tortured and killed. A slave named Sumayya bint Khubbat, considered Islam's first martyr, was killed by her master when she refused to renounce her faith. People kicked stones at Muhammad when he was praying, and it is said that he ran away with bleeding feet. The antagonism between Muhammad and local clansmen became so great that Muhammad had to flee the city to a desert oasis—now called Medina ("City of the Prophet")—in 622 CE. This date marks the beginning of Islam and the first year in the Islamic calendar.

Muhammad returned to Mecca in 630 CE, eight years later, with several thousand soldiers. He defeated the polytheists, converted the population to Islam, removed the idols of Arabian tribal gods that were housed in a small cubical building—called the **Ka'bah**, or "cube" in Arabic—and rededicated it as an Islamic house of worship. On pilgrimages to Mecca today, Muslims circle the Ka'bah, which is the spiritual center of their world (see Fig. 8.4). From this beginning, Islam has grown to be the world's second largest religion, after Christianity, with nearly one and a half billion adherents. Islam today stretches from communities in Europe throughout North Africa, the Middle East, much of South Asia, and Indonesia. Muslims once swept

The Islamic World

570 CE	632 CE	1099 CE	1258 CE	1492 CE
Muhammad born in Mecca in 570	Muslims capture Jerusalem in 638	Christian Crusaders capture Jerusalem in 1099	Mongols sack Baghdad in 1258, ending Abbasid Caliphate	
Spread of Islam to Arabia, Egypt, Iraq, Northern Africa, and southern Spain	The Umayyad Caliphate r. 661–750	Saladin, the Sultan of Egypt, retakes Jerusalem in 1187	Ottoman Empire is founded in 1281	
Muhammad flees to Medina in 622—an event called "the Hejira"; 622 becomes Year 1 in the Islamic calendar	Charles Martel stems Muslim expansion at Tours, France, in 732	The Third Crusade pits Richard the Lion-Hearted against Saladin in 1189	Constantinople falls to the Ottoman Turks in 1453, ending the Byzantine Empire	
Muhammad captures Mecca in 630	The Abbasid Caliphate begins in 750	Richard and Saladin agree to a truce in 1192	Muslims are driven from Spain in the "Reconquista" in 1492	
Muhammad dies in 632				

RELIGION
The Five Pillars of Islam

The fundamental principle of the faith of Islam is a bedrock **monotheism**. This belief was a conscious rejection of not only the polytheism that Muhammad found throughout the Arabian peninsula but also of the Christian doctrine of the Trinity of persons in God. Muhammad articulated the so-called Five Pillars—the core values—of Islam:

- Recitation of the Muslim act of faith that there is one God and that Muhammad is his messenger.
- The obligation to pray five times a day in a direction that points to the Ka'bah in Mecca. Soon there was added the obligation to participate in Friday prayers as a community and hear a sermon.
- Donation of a portion of the surplus of one's wealth to charity.
- Observance of a fast during the holy month of **Ramadan**—abstinence from all food and drink from sunrise to sunset.
- The duty to make a pilgrimage to Mecca (called a hajj) at least once in a lifetime.

That latter obligation was performed by Muhammad around the purified and restored Ka'bah in 632, which was the same year he died in the arms of his wife. The pilgrimage to Mecca today draws millions of Muslims.

In addition to these core practices, there are other characteristic practices of Islam: Like Jews, Muslims do not eat pork products. Unlike Jews and Christians, Muslims are forbidden to consume alcoholic beverages. Again, as with Jews, Muslim males are circumcised. Polygamy is permitted under Islamic law but not practiced universally. The taking of interest on loans or lending for interest (usury) is forbidden by Islamic law, as it was at one point by Christian law. (Today, of course, Christian nations and most Islamic nations participate in international banking systems.) Over the course of time, a cycle of feast days and observances developed (for example, the birthday of the Prophet).

into and took control of the Iberian Peninsula but were eventually pushed back by Christians. In the Middle Ages, Christians also fought Muslims to reclaim the "Holy Land," which is now Israel and the Palestinian Territories.

The word *Islam* means "submission"—surrender of the self to the will of Allah. A follower of Islam is called a Muslim, an etymologically related word meaning "one who has submitted to Allah." Muslims believe that their holy book, the Qur'an (also spelled *Koran* in English), was revealed to Muhammad by the angel Gabriel. The Qur'an and Muhammad's life, words, and deeds, as recorded in the *Sunnah* and **Hadith**, constitute the basic texts of Islam. Muslims worship God directly, without any hierarchy of rabbis, priests, pastors, or saints. In Islam, there is unity of church and state; the state is to be ruled by Islamic law, or **Shariah**, as revealed in the basic texts. The proper ruler is both a religious and secular leader, a successor to Muhammad known as a **caliph**.

Islam, like Judaism, has an unbending teaching about the oneness of God; the Islamic statement of faith begins, "There is but One God, Allah. . . ." To grasp this belief in radical monotheism is to understand a whole variety of issues connected to Islam. The revelation of Allah is seen as final and definitive; Islam sees the reality of God beyond the revelation of the God of the Jewish scriptures and is explicitly resistant to the Trinitarian faith of Christianity. Jesus is honored as a prophet, but the idea of Jesus as divine is denied in the pages of the Qur'an. Islamic society usually refers to an individual as a person's son to clarify paternity; and the Christian Gospels describe Jesus as the Son of God to solidify his place in the Trinity. However, the Qur'an repeatedly refers to Jesus as the son of Mary, reinforcing Mary's particular importance in the history of the Abrahamic religions and at the same time

denying that Jesus is the Son of God. In this way, Muslims see the revelations to Muhammad as returning the monotheism of Moses back from the Trinity to its original meaning.

Consider verse 116 of the fifth **sura** (chapter) of the Qur'an:

> And when Allah saith: O Jesus, Son of Mary! Didst thou say unto mankind: Take me and my mother for two gods beside Allah? He [Jesus] saith: Be glorified! It was not mine to utter that to which I had no right. If I used to say it, then Thou knewest it. Thou knowest what is in my mind, and I know not what is in Thy mind. Lo! Thou, only Thou are the knower of things hidden.

Just as Christian scholars have done, Muslim scholars have debated theological issues such as whether the attributes of God, or Allah, allow for free will. A close reading of the Qur'an suggests that people are probably seen as having free will, because Allah is repeatedly warning them to choose not to engage in wrongdoing or evil.

Islam, like Christianity, has a tradition of missionary expansion. The omnipotent will of God is for all humanity to submit to Him; if people are not aware of that fact, they are not living according to His will. Hence, the devout are encouraged to teach people this fundamental truth.

Sunni, Shia, Sufi

Islam was beset by internal strife almost from its beginning. The Muslim denominations of Sunni and Shia were born from

COMPARE + CONTRAST

Journeys of Faith

The journey to sites deemed holy by followers of the three Abrahamic religions—Judaism, Christianity, and Islam—can be traced to the earliest years of each faith. The practice of such journeying—of the pilgrimage—takes its name from the Latin word *peregrination*, meaning a trip undertaken by a traveler over a long distance. The earliest religious pilgrims traversed extraordinary distances to visit spiritual touchstones and, in some cases, to bring back relics or mementos that would continue their connection to the sites and the protections of the holy figures associated with them.

The holiest site in the Judaic faith was the Temple in Jerusalem where the Ark of the Covenant (the tablets of stone with the Ten Commandments) had been housed; Jews were obligated to worship there once a year. Today, pilgrims of the Jewish faith and others visit the remnants of a wall that Jews believe surrounded the courtyard of the Second Temple, built in Jerusalem around 19 BCE. The Western Wall, in Hebrew the *Kotel*, is also referred to as the Wailing Wall, based on the Arabic description of the wall as el-Makba—the "Place of Weeping." Pilgrims pray at the site (**Fig. 8.2**), and some press small pieces of paper inscribed with prayers or petitions into the cracks between the stones. In a curious adaptation to the times in which we live, "virtual pilgrims" can use the Twitter social networking service to "tweet" their prayers to the Western Wall, which are then printed out and placed between the stones.

Jerusalem also became a pilgrimage destination for Christians as early as the second century CE, when followers began to visit sites such as the Holy Sepulcher (see Fig. 6.13) where they believed Jesus was buried. Beginning during the reign of Constantine, other sanctuaries were built in Jerusalem and throughout Palestine that eventually became points of interest on the pilgrim's map. In the towns in which the sanctuaries were

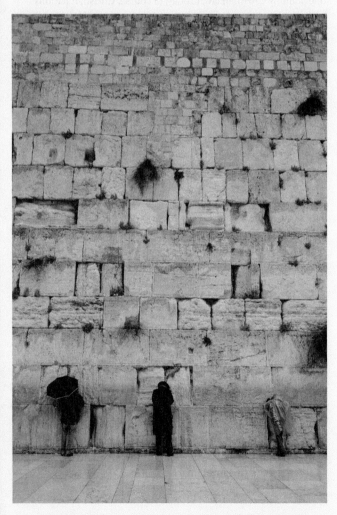

▲ 8.2 **Wailing Wall, 19** BCE **to mid-first century** CE. Limestone retaining wall on the western side of Temple Mount, entire wall 1600' (488 m) long, exposed height 62' (19 m). Jerusalem, Israel.

▲ 8.3 **Cathedral of Santiago de Compostela, 1075–1211.** Western façade (Obradoiro Square), 1738–1750, architect Fernando Casas y Nóvoa. Granite. Santiago de Compostela, Spain.

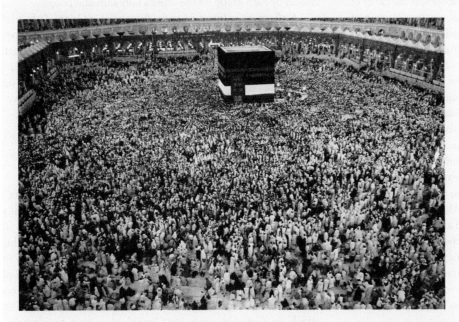

◀ **8.4 Muslim pilgrims circumnavigating the Ka'bah during a hajj (pilgrimage). Mecca, Saudi Arabia.** Pious pilgrims believe they can see the footprints of Abraham upon the stone. Near the Ka'bah is the tomb of Ishmael, from whom Muslims trace their descent. Muslims believe that heaven is directly above the Ka'bah.

located (such as Bethlehem, the birthplace of Jesus according to Christians), places for worship were constructed and many businesses were created to accommodate pilgrims.

The most famous Christian pilgrimage route in Europe honors Saint James, an apostle of Jesus who, it is believed, left Palestine to spread the Christian faith in Galicia in northwestern Spain. His martyred remains were believed to be buried on the site of what is now the city of Santiago de Compostela. The pilgrimage is over 1000 years old and still attracts pilgrims who traverse different routes to the shrine. Every year on July 25th—Saint James's Day—Santiago de Compostela holds an outsized festival that includes pyrotechnic displays and concerts. When July 25th falls on a Sunday, a Holy Year is declared, and pilgrims are welcomed with parties, parades, and pop music. (Past jubilee years have featured performers such as David Bowie, Bob Dylan, Bruce Springsteen, and The Rolling Stones.) During the jubilee celebrations, churches in the city exhibit rare treasures typically not on view, and a massive incense burner is lifted by a group of priests during masses. Pilgrims to the Cathedral of Saint James (**Fig. 8.3**) who are marking the end of a 60-mile journey enter the church through the Door of Pardon, kiss the silver statue of Saint James behind the high altar, and are absolved of sin.

Santiago de Compostela was named a UNESCO World Heritage Site in 1985, but it is only recently (2012) that the Friday mosque—the Masjed-e Jame' of Isfahan—was so designated. This important monument is seen as a prototype for later mosques in Central Asia, adapting the courtyard layout of secular palaces to Islamic religious architecture; this plan can also be seen in the Umayyad Mosque of Damascus (see Fig. 8.7), a World Heritage Site connected to Islamic pilgrimages.

The most sacred journey in the Islamic faith, however, is the pilgrimage to Mecca in Saudi Arabia—the Hajj. One of the Five Pillars of Islam, it is each Muslim's duty to undertake the pilgrimage at least one time in their life if health and finances permit. The destination is connected with the Prophet Muhammad, but in fact, the tradition of pilgrimage to Mecca goes back to ancient times, perhaps even to the time of Abraham. Muhammad himself performed the Hajj, leading his followers to Mecca from Medina in 631 CE. The pilgrimage is held once a year in the 12th month of the Islamic calendar from the 8th to the 12th day.

Today's Muslim pilgrims—hundreds of thousands strong—engage in traditional preparations and rituals associated with the Hajj. All male pilgrims don the Ihram, a white garment of unhemmed cloth secured by a sash, and wear sandals. Women wear the hijab, a veil or scarf that covers the head, but are not permitted to cover their faces. These stipulations, among others, are intended to create oneness before Allah, with no one Muslim different from or above another. The pilgrims converge on Mecca from all points and distances to the Ka'bah, a black, cube-shaped shrine in the center of the Great Mosque. It is in the direction of this sacred spot that Muslims around the world orient themselves five times a day to pray. During the Hajj, the pilgrim is required to circumambulate (walk around) the Ka'bah seven times and to touch or kiss its stone surfaces (**Fig. 8.4**). With each circuit, the takbir or Islamic phrase, "God is Great," is recited. The sacred pilgrimage to Mecca reinforces the bonds of the Muslim community of believers and demonstrates the practice of Islam—an individual's submission to God and to Muhammad as His chief and last prophet.

dissension. **Sunnis**, whose name means "tradition" or "well-trodden path," believe that Muhammad's rightful successor was the father of his wife, Abu Bakr, and that the Qur'an endorses the selection of caliphs according to the consensus of the Muslim community (also called the **ummah**). The lands and peoples ruled by the caliph are called the *caliphate*. At first, only members of Muhammad's tribe were eligible to become caliphs, but then the ummah allowed for the choice of any qualified leader. Both Sunnis and Shia believe that some day the **Mahdi**, the redeemer of Islam, will come. Some believe that the Mahdi will rule for several years before the Day of Judgment in order to rid the world of error and injustice.

Shia believe that Muhammad, as commanded by Allah, ordained his son-in-law, Ali, as the next caliph, and that legitimate successors must be drawn from the descendants of Muhammad and Ali. Shia believe that Ali, like Muhammad, had special spiritual qualities. Muhammad and Ali are imams—without sin and capable of interpreting the Qur'an. So-called Twelvers believe that the Mahdi will be the twelfth imam, that he exists but is hidden by Allah for the time being. Shia—as in Iran—maintain the interesting Muslim practice of "temporary marriage," which permits people to express affection without a permanent commitment.[1]

Some 85–90 percent of Muslims are Sunnis, and 10–15 percent are Shia. Sunnis comprise the majority of Muslims in most countries with large Muslim populations throughout the Arab world, Asia, and Africa. Shia are in the majority in Iran, Iraq, Azerbaijan, Bahrain, and Lebanon. The first Islamic religious civil

1. Elaine Sciolono, "Love Finds a Way in Iran: 'Temporary Marriage,'" *New York Times*, October 4, 2000.

war occurred in 657 CE; Sunni–Shia violence continues today with attacks by each group on the other's holy sites and people.

Sufism is the inner, mystical dimension of Islam. Sufis may be either Sunnis or Shia, and their quest is to purify the inner self and turn away from all but Allah. All Muslims believe that, if they live justly, they will become close to Allah in paradise, but Sufis believe that it is possible to draw closer to Allah on earth by arriving at a mystical state in which one's sole motivation is love of Allah.

THE GROWTH OF ISLAM

The simplicity of the original Islamic teaching—its emphasis on submission to the will of the one God, insistence on daily prayer, appeal for charity, and demand for some asceticism in life—all help explain the phenomenal and rapid spread of this new religion coming out of the deserts of Arabia. In less than 10 years after the death of the Prophet, Islam had spread to all of Arabia, Egypt, Syria, Iraq, and parts of North Africa. A generation after the Prophet's death, the first (unsuccessful) Muslim attack on Constantinople was launched; within two generations, Muslims constituted a forceful majority in the holy city of Jerusalem. By the eighth century, Islam had spread to all of North Africa (modern-day Libya, Morocco, Tunisia, and Algeria) and had crossed the Mediterranean near Gibraltar with the creation of a kingdom in southern Spain. Islam also spread eastward, throughout southern Asia. Toward the end of the 15th century, Christians had retaken Spain, as shown in **Map 8.1**, but Islam had also taken Constantinople (present-day Istanbul).

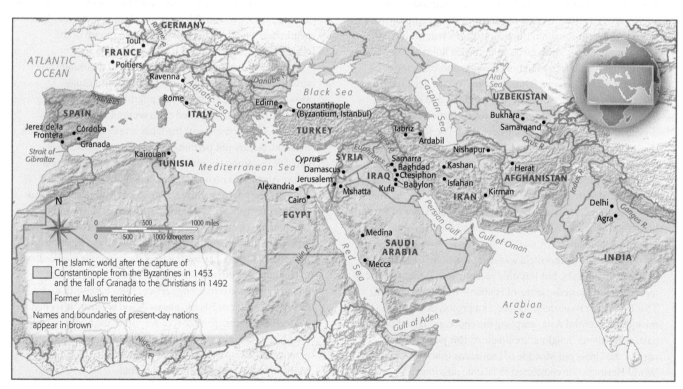

▲ MAP 8.1 **The Islamic world toward the end of the 15th century.**

The Umayyad Caliphate

Following the death of Muhammad in 632 CE, disputes arose over who would succeed him. A series of civil wars and assassinations eventually led to the founding of the Umayyad Caliphate (661–750 CE). At its largest, the caliphate extended Islamic rule north into Persia, east into South Asia (modern-day Afghanistan, Pakistan, and adjacent regions), west across the north of Africa (to present-day Morocco), and, from there, across what is now the Strait of Gibraltar to the Iberian Peninsula (now Portugal and Spain) and the south of present-day France. The Umayyads were overthrown by the Abbasid Caliphate and moved into what is now Spain, where they founded the caliphate of Córdoba, which they ruled until 1031.

Architecture

Islam has a 1500-year history. Its communities are found in every part of the world. In that long history, it has made its buildings suitable to the circumstances in which it finds itself, even though the basic needs of the **mosque** remain fairly constant: a large covered space for the faithful to pray, especially when the community gathers for Friday prayers. Typically, the gathering area is covered with rugs; except for the steps leading up to a **minbar** (pulpit), there is no furniture in a mosque. A niche in the wall called a **mihrab** indicates the direction of Mecca so that the congregation at prayer are accurately oriented. In traditional Friday mosques, there is also usually some type of fountain so that worshippers may ritually cleanse their hands, feet, and mouth before prayer. Adjacent to the mosque is a tower or minaret so that the **muezzin** may call the faithful to prayer five times a day. Visitors to Islamic countries soon become accustomed to the muezzin's predawn call, "Wake up! Wake up! It is better to pray than to sleep."

Although primarily designed to shelter Muslims at prayer, the mosque serves a larger community function in Islam. It is a community gathering center; it is a place where scholars meet to study and debate; courtroom proceedings can be held there; leisurely conversations can be held in its courtyards, and people can escape the heat of the sun in its covered areas. As scholars have noted, the mosque is to Islamic countries what the Roman forum or the precincts of the medieval cathedral or the town square were to other cultures: a gathering place for the community to express itself. The simple requirements for the mosque leave much for the ingenuity and genius of the individual architect to develop. As a result, the history of Islamic architecture provides extraordinary examples of art.

THE DOME OF THE ROCK The Dome of the Rock in Jerusalem is the earliest and one of the most spectacular achievements of Islamic architecture (**Fig. 8.5**). Built toward the end of the seventh century by Caliph Abd al-Malik of Damascus on Jerusalem's *al-Haram al-Sharif* ("the Noble Sanctuary"), known by Jews as the Temple Mount, it is an elevated space that was once the site of the second Jewish temple, which was destroyed in 70 CE. The Dome of the Rock is an octagonal building capped by a golden dome, which sits on a heavy drum supported by four immense piers and twelve columns. The interior is decorated lavishly with **mosaics**, as was the outside of the building until, in the late Middle Ages, the mosaics were replaced by tiles. The building owes a clear debt to Roman and Byzantine architecture, but the Qur'anic verses on its inside make it clear that it was intended to serve an Islamic function.

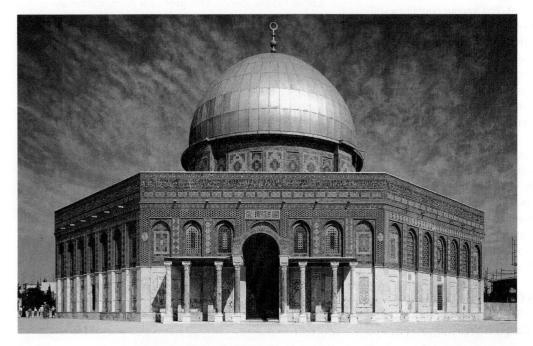

◀ **8.5 The Dome of the Rock, 687–692. Jerusalem, Israel.** The blue decoration in the upper registers is made of tile. The tile work replaces earlier mosaic work that probably was done by Byzantine artisans, who were acknowledged experts in that art.

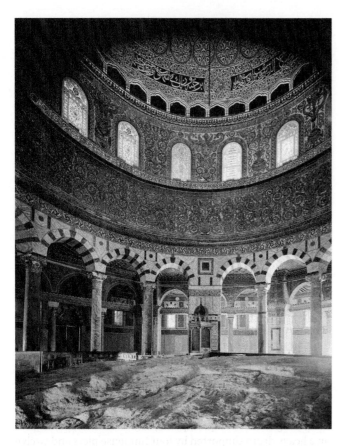

▲ **8.6 The Dome of the Rock (interior), 687–692. Jerusalem, Israel.** The original mosaics inside the dome remain reasonably intact. The rocky outcropping in the center has been believed to be the burial place of Adam, the rock upon which Abraham prepared to sacrifice his son, and the place from which Muhammad ascended to heaven during his Night Journey.

The original mosaics decorating the interior of the Dome of the Rock are largely intact (**Fig. 8.6**). The interior contains a still-visible rock outcropping that is of great significance in the Abrahamic tradition. The Dome of the Rock may have been erected to serve as a counterpoint to the Church of the Holy Sepulcher in Jerusalem, acting as a rebuff in stone to Christianity and making the artistic argument (as does the Qur'an itself) that Islam is a worthy successor to Judaism and Christianity. Scholars do not agree on the building's original purpose (some have even argued that it was built as a rival to the Ka'bah in Mecca), but they are unanimous that it is a splendid example of Islamic architecture.

The rock outcropping itself, shown in the lower extreme foreground of this photograph, is believed by many to be the site of Adam's grave. Many Jews, Christians, and Muslims alike believe that this is the rock upon which Abraham was prepared to sacrifice his son, Isaac, although at the last minute an angel stayed his sword. A ninth-century story speaks of it as the place from which the Prophet traveled to heaven during his Night Journey.

THE GREAT MOSQUE AT DAMASCUS, SYRIA The Great Mosque in Damascus, Syria (**Fig. 8.8**), built by Abd al-Malik's son—the Umayyad Caliph al-Walid (r. 705–715)—on

the site of a Byzantine church that had formerly been a Roman temple, incorporated the foundations of the ancient precinct walls and building materials culled from both of the earlier structures; the three minarets rise from the remains of Roman towers. An aerial view shows that the main prayer hall stands higher than the rest of the mosque complex, becoming the focal point of the courtyard. The first-story arcades, pediment above the main entrance to the prayer hall, and the octagonal-based dome all invoke Roman architectural prototypes, and the mosaic decoration further displays the influence of Roman and Byzantine art. These are combined with features that would become standard in mosque architecture: the *qibla* wall (which faces Mecca), a *mihrab* (a semicircular niche in the qibla wall), a *minbar* (pulpit on which the *imam*—the worship leader—stands), and minarets (towers from which the faithful are called to worship five times a day). The caliph's palace, now gone, was adjacent to the mosque so that the ruler could pass easily from one to the other.

As with the Dome of the Rock, the interior of the Great Mosque was decorated lavishly, with marble columns and walls covered with glass mosaics depicting, perhaps, the imagined splendor of Paradise—grand palaces, luxurious vegetation, and abundant, flowing water.

CONNECTIONS Amidst the columns and arches of the prayer hall of the Umayyad Great Mosque in Damascus is a green-domed shrine—and reliquary within—that contains what some believe to be the head of John the Baptist. The mosque was built on the site of a Christian basilica that was dedicated to John the Baptist, and the shrine was constructed upon the discovery of a coffin with human remains beneath the basilica floor. Christians venerate John, Jesus's maternal cousin, as a prophet as well as the preacher who baptized Christ; his life, deeds, and death are recounted in all four Christian gospel narratives. John the Baptist is also honored by Muslims as the prophet, Yahya, the son of Zecariah and exalted by God. His lineage is also recounted in the Qur'an.

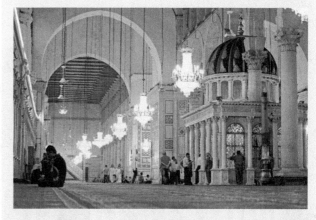

▲ **8.7 The Shrine of John the Baptist in the Great Mosque in Damascus.**

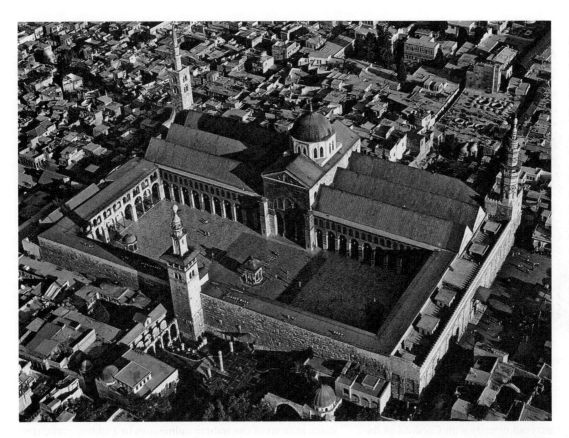

◄ **8.8 The Great Mosque of Damascus, Syria, 706–715** CE. Worshippers at Friday prayers would spill over from the mosque to gather in the courtyard. The mosque incorporates a former Christian church, details of which (for example, the façade, laterals, and dome) can be detected in the present-day architecture. Congregants use the domed fountain in the courtyard to refresh themselves and to bathe their hands and feet before prayers.

THE GREAT MOSQUE AT SAMARRA, IRAQ In 750, the Umayyad caliphs were overthrown by the Abbasids, who traced their lineage to an uncle of Muhammad named Abbas. The Abbasids moved the capital of their caliphate from Damascus in Syria to Baghdad in Iraq where al-Mansur (r. 754–775) established Medina al-Salam, the City of Peace. Under a succession of powerful caliphs, Baghdad remained the center of Islamic culture in the Middle East for three centuries. The Abassids nurtured the arts and sciences and sponsored the translation of many ancient Greek texts into Arabic.

A century after al-Mansur created his capital in Baghdad, the Abbasid caliph al-Mutawakkil constructed what was, at that time, the largest mosque in the world in Samarra, just north of Baghdad on the Tigris River. In style, it was simple, but in scale it was remarkable—800 feet long and 520 feet wide. Like the Great Mosque at Damascus, it had a vast open courtyard, and its interior walls were covered with glass mosaics. All that remains of the mosque is its outer wall and its famous spiral minaret (**Fig. 8.9**) called the *Malwiya* (the Arabic word for "snail shell") that once linked to it by a bridge. This photograph was taken before insurgents damaged the top of the minaret in 2006, during the Iraq War.

THE MOSQUE AT CÓRDOBA In 750, when the Abbasids deposed and murdered the Umayyads, Prince Abd-al-Rahman I —the sole survivor of his family—escaped to Spain. There, among Arabs who had been in Spain since they conquered the Christian Visigoths in 711, Abd-al-Rahman I (r. 764–788)

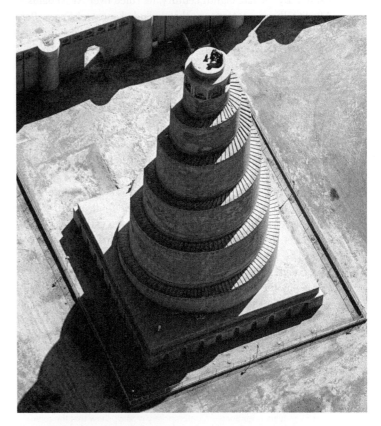

▲ **8.9 The Malwiyah minaret of the Great Mosque of Samarra, Iraq, 848–852** CE. The immense expanse of the prayer hall is a simple wooden structure. The mosque is renowned for its spiral-shaped minaret.

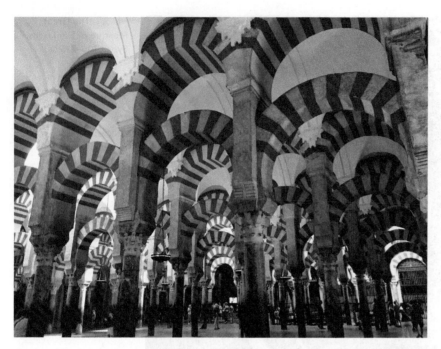

▲ **8.10 The hypostyle prayer hall of the Great Mosque of Córdoba, Spain, 8th–10th century CE.** Córdoba was the Spanish capital of the Umayyad Caliphate. The horseshoe-shaped arches in the city's Great Mosque are supported by 514 columns.

columns from Roman and Visigothic Christian buildings, Corinthian capitals that trace back to the architectural orders of antiquity, and the "horseshoe" arch, also from the Visigoth period. It is widely viewed as one of the most exhilarating experiences of architectural space that a traveler can have.

The focal point of the vast hall is the elaborate qibla wall and mihrab, put in place by al-Hakam II (r. 961–976), the first Umayyad caliph, who used his position to hark back to the splendor of the Umayyad reign in Damascus to legitimize and elevate the Spanish Caliphate. Particularly noteworthy in its richly carved and mosaic ornamentation is the mosque's *maqsura*, a space reserved for the caliph and accessed by a corridor that leads from his palace to a door in the qibla wall. Al-Hakam brought in Byzantine artisans, renowned for their techniques, to decorate the interior of the mosque which was completed, according to an inscription, in 965. The mihrab is framed by a horseshoe arch whose wedge-shaped, mosaic-encrusted **voussoirs** gleam like sunrays (**Fig. 8.11**); the high, narrow space in front of the mihrab culminates in a ribbed dome covered in equally dazzling mosaic work.

established the Spanish Umayyad dynasty with Córdoba as its capital. By the late eighth century, he ruled over Al-Andalus—Muslim Iberia—a territory that included most of Spain, Portugal, and even a part of southern France. Abd-al-Rahman I recreated the grandeur of the Umayyads in a new place, rivaling that of the Abbasids.

Just as al-Walid in Damascus built his Great Mosque on the site of a Byzantine church, so did Abd-al-Rahman I construct a Great Mosque on a holy site—a Christian Visigothic church that had been converted to a mosque after the Muslim conquest in 711. This first structure, the Mezquita, was the core of what would become, after numerous additions over time, the largest mosque in the West.

The first iteration of the Great Mosque of Córdoba (in Spanish, the *Mezquita*, meaning "mosque") featured a large courtyard framed by colonnades and planted with orange trees, a minaret, and a sprawling hypostyle prayer hall (**Fig. 8.10**). The hypostyle system enabled expansion of the hall in any direction as a congregation grew, and the Mezquita's hall was enlarged twice—in the 9th and and 10th centuries. The prayer hall, with its 36 piers, 514 columns, and red-and-white-patterned double-tiered aches, is a creative amalgamation of the essentials of mosque architecture and elements—both structural and stylistic—from different cultures: recycled many-colored

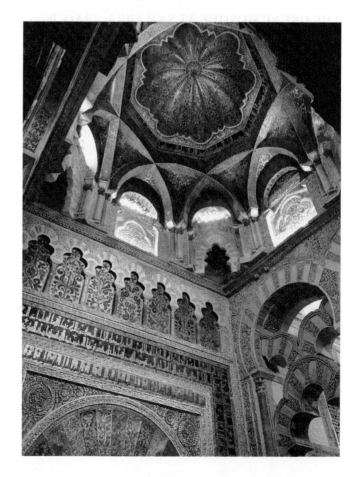

▶ **8.11 Central dome of the Great Mosque of Córdoba, Spain, mid-10th century.** The decoration of the mosque, done a century after its construction, is elaborate. Contemporary records show that the ruler of Córdoba imported 30,000 mosaic tesserae as well as workmen from Constantinople to execute the lavish decoration. This dome covers the mihrab, which points toward the Ka'bah in Mecca.

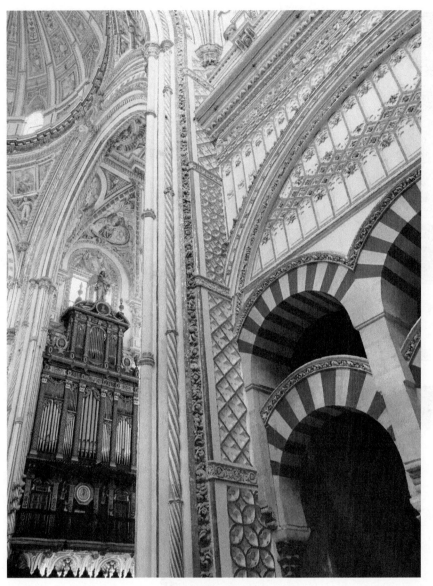

illuminated manuscripts. For both Islam in the Middle East and Islam in the West, the period marks a high point in the search for and preservation of knowledge in all disciplines.

Baghdad and Samarra under the Abbasids became the intellectual, cultural, and commercial capitals of the Islamic world. Trends in art and architecture spread from there to other parts of the Muslim world—including Spain. A form of capitalism and free markets was established, and relations with foreign powers were cultivated. Citrus fruits were imported from China, and rice, cotton, and sugarcane were brought in from India and trained to grow in Islamic lands. The scientific method was instituted, in which hypotheses are tested through experimentation. Muslim astronomers considered the possibility that the sun was the center of the solar system and that the earth spun on an axis. Algebra and trigonometry were invented, and the concepts of inertia and momentum, later adopted by Newton, were discovered. In Baghdad, the caliph Harun al-Rashid (r. 786–809) established the "House of Wisdom," an important educational institute that we will discuss later. Under his son, Ma'mun (r. 813–833), astronomical observatories were constructed, texts were preserved through Arabic translations, and the largest collection of books in the world was amassed.

During the same period in Spain, the Umayyad Caliphate, too, patronized the arts, humanities, and sciences and nurtured scholars of all disciplines and all cultural traditions. Among these was the Jewish philosopher, scientist, and physician, Moshe ben Maimon (1135 or 1138–1204; Moses Maimonides, also known as Rambam), who attended an Islamic medical school. Of course, it is during this era that the Great Mosque of Córdoba was begun.

The Umayyad Caliphate began to unravel with the death of al-Hakam II in 976 and ultimately collapsed in 1031 when it splintered into small, independent kingdoms. Berbers from North Africa ruled southern Spain for a couple of centuries until Christian forces captured the city of Córdoba in 1236. At roughly the same time, the Abbasid Caliphate came to an end after the Mongols of East-Central Asia sacked Baghdad in 1258 and Damascus in 1260.

The Mezquita survived the destruction of Islamic buildings when the Christians drove the Muslims out of Spain in 1492—the period known as the *Reconquista*. In the early 16th century, King Charles V granted permission for a cathedral to be constructed inside the Mezquita, a clear indication of the high esteem in which the architecture of the mosque was held. It is still possible to see the literal intersection of Islam and Christianity in parts of the Mezquita-Catedral (Fig. 8.12).

The Golden Age of Islam

The Great Mosque at Samarra and the Great Mosque at Córdoba were constructed during the period known as the Golden Age of Islam. In the years between the 8th and 13th centuries, both the Abbassids and the Umayyads sponsored extraordinary works of architecture; luxury arts like silk carpets and cushions and objects of ivory and inlaid metals; painted ceramics and

THE ALHAMBRA The last Muslim dynasty to rule territory in Spain was established in 1232 by Mohammed I ibn Nasr. The Nasrids, whose center of government was in Granada, continued their reign until January 2, 1492, when Muhammad XII surrendered to the Catholic Monarchs, Isabella I of Castile and Ferdinand II of Aragon (the same monarchs who funded Christopher Columbus's 1492 expedition) after a decade of military campaigns.

The Alhambra (from the Arabic *al-Hamra* meaning "the red one"), a rose-colored fortress-palace complex on a hill at the edge of the city of Granada, was built on an existing 10th-century Arab fortress and expanded by a succession of Nasrid sultans in the 13th and 14th centuries. At its peak, 40,000 people lived within its walls. Only two of the royal residences of the Alhambra survive, having been preserved by the very Christians who destroyed the rest of the complex. As paltry as this is, enough remains to convey a sense of the opulent surroundings of Nasrid courtly life.

The constructions within the Alhambra that we see today are the work of Yusuf I (1333–1353), who began improvements on the complex, and his son, Mohammed V (1353–1391), who brought to fruition

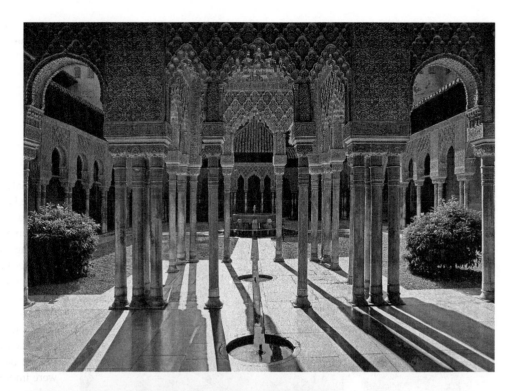

▲ **8.13 Court of the Lions in the Alhambra, Granada, Spain, ca. 1391.** Above: The delicacy of the architecture of the interior rooms of the court is striking. Note the multiple columns, the waterways, and the fountains at floor level. The court takes its name from the lions that support the fountain basin in the center. Below: Sturdy lions ring the base of the great fountain.

some of the most extraordinary examples of late Islamic art and architecture. Among these is the Court (or Patio) of the Lions (**Fig. 8.13**), the main courtyard of the Palace of the Lions. The centerpiece of the rectangular patio—framed by arcades embellished with elaborate carved stucco detail—is a fountain basin resting on 12 lion statues. The shady cloister-like gallery around the patio offers respite from the brilliant sunlight and serves as a transition from the outdoors to the more intimate chambers of the palace, not unlike what we see in ancient Roman villas. The mild Spanish winters make possible the full integration of the palace with its environment through a stately progression of spaces.

The walls of the chambers, too, are sheathed with intricately carved stucco decoration—abstract shapes, vegetal

motifs, and calligraphic inscriptions—and the domed ceilings are covered with *muqarnas*—stalactite-like ornamentations that conceal the vault's structure and etherealize its weight with delicate prismatic shapes that capture and reflect light. The muqarnas vault (sometimes called honeycomb vaulting) of the Hall of the Abencerrajes (**Fig. 8.14**) symbolizes the dome of heaven, and verses describing paradise, composed by one of the Alhambra's court poets, Ibn Zamrak, are inscribed on the walls.

Poetry plays a significant role in the experience of the Alhambra, some of which is presented from the point of view of the palace speaking to the inhabitants. In the Hall of the Two Sisters, walls to either side of a tile-trimmed *mirador* (a lookout onto a garden below, **Fig. 8.15**) are inscribed with such verses as:

▲ 8.14 **Muqarnas dome, Hall of the Abencerrajes, Palace of the Lions, Alhambra, Granada, Spain, 1354–1391.**

I am a garden adorned by beauty:
my being will know whether you look at my beauty.
Oh, Mohammed, my king, I try to equal
The noblest thing that has ever existed or will ever exist.
Sublime work of art, fate wants me to outshine every other
 moment in history.
How much delight for the eyes!
The noble one renews his desires here.
The Pleiads serve as his amulet;
the breeze defends it with its magic.
A gleaming vault shines in a unique way,
with apparent and hidden beauties....
The columns are so beautiful in every way,
that their success flies from mouth to ear:
the marble throws its clear light, which invades
the black corner that blackens the shadow;
its highlights iridesce, and one would say that
they are, in spite of their size, pearls.
We have never seen such a blooming garden,
with a sweeter harvest and more scent....

The Holy Roman Emperor Charles V, who approved of a plan to insert a Christian church within the walls of the Mezquita in Córdoba, inserted his own Renaissance-style

palace within the fortification walls of the Alhambra in 1527. Over the centuries, the complex was left to deteriorate, occupied by squatters—including 19th-century "literary squatters," the most famous of which was Washington Irving. The Alhambra joined the ranks of UNESCO World Heritage Sites in 1994.

THE CONVERSION OF THE HAGIA SOPHIA The Mongols who remained in Islamic lands converted to Islam over the following century, as did Turks, who had also come in from the east. The Ottoman Empire emerged in the 13th and 14th centuries and was centered in present-day Turkey. The Hagia Sophia was the cathedral of Constantinople—renamed as Istanbul—from its dedication in 360 CE to the 1453 conquest by the Ottoman Turks, who had the building converted into a mosque. The cathedral's bells, altar, and religious figures were removed; a mihrab and the four minarets we see outside the structure today were installed (**Fig. 8.17**). The Ottoman Empire was defeated during World War I, in 1918; 17 years later, in 1935, the Republic of Turkey made the Hagia Sophia into a museum—ending the Christian–Muslim conflict over the building.

▲ 8.15 **A *mirador* in the Hall of the Two Sisters, Alhambra, Granada, Spain.** Miradors are typically constructed to frame exterior landscapes—in this case, a garden below.

CONNECTIONS In 1829, the American author Washington Irving—best known for his story "The Legend of Sleepy Hollow" with the Headless Horseman—moved into the Alhambra. He was "determined to linger" until he got "some writings under way connected with the place." His *Tales of the Alhambra* was published three years later—a blend of history, legend, and fiction that bore the marks of early 19th-century European Romanticism: "Such is the Alhambra—a Moslem pile in the midst of a Christian land, an Oriental palace amidst the Gothic edifices of the West, an elegant memento of a brave, intelligent, and graceful people who conquered, ruled and passed away." At the same time, the Scottish artist David Roberts visited Spain, recording in arresting detail the complex ornamental schemes of the Alhambra palace chambers. The people in the drawing are in Spanish dress, calling attention to the "missing" Muslims and, with that, the fate of a people. In this sense, the perspectives of Irving and Roberts are the same.

◄ **8.16** David Roberts, *In the Alhambra Palace, Granada* (1832–1833). Bodycolor, pencil, and watercolor on woven paper.

▲ **8.17** Anthemius of Tralles and Isodorus of Miletus, the Hagia Sophia, 532–537. Istanbul, Turkey. Minarets added in the 15th century.

ISLAMIC LITERATURE

Islamic literature is rich with religious writings, stories—some of which are fantastic tales—and poetry. Foremost among religious writings is the Islamic holy book—the Qur'an. The Qur'an consists of the revelations of Allah to Muhammad. Other writings—Hadith—are the sayings of Muhammad or reports of things he is supposed to have done. Muslims consider the Qur'an to be infallible, but questions are sometimes raised as to how certain material might have entered Hadith.

The Qur'an

Evidently, many of the revelations received by the Prophet during his life at both Mecca and Medina were maintained orally, but soon after his death, followers began to write down the revelations as they had received them from him. Within a generation, a serious attempt was made to collate the various oral revelations with a view of producing a uniform edition of the revelations received both at Medina and Mecca. The net result of these long editorial efforts resulted in the central sacred text of Islam, the Qur'an (the word is Arabic for "recitation").

The Qur'an is roughly as long as the Christian New Testament. The book is divided into 114 chapters (suras). There is an opening chapter in the form of a short prayer invoking the name of God, followed by 113 chapters arranged by length, with the second chapter being the longest and the final one, only a line or two long. Muslims have devised ways of dividing these chapters—for example, into 30 parts of near-equal length so that one can complete reciting the entire book during the 30 days of the sacred month of Ramadan, which is a time of intense devotion accompanying the annual fast.

The language of the Qur'an is Arabic. Like all Semitic languages (for example, Hebrew and Syriac), the text is written and read from right to left. Because Muslims believe that the Qur'an came as a result of divine dictation, it cannot be translated into other languages. Although many vernacular versions of the Qur'an exist, they are considered to be paraphrases or glosses. The result of this conviction is that no matter where Muslims live, they will hear the Qur'an recited only in Arabic. Although Arabs (contrary to popular belief) make up only a relatively small proportion of the total Muslim population of the world, the Qur'an serves as a source of unification for all Muslims. Reverence for the Qur'an, further, means that it is believed to be God's word to the people and as such is held in the highest respect. Committing the entire Qur'an to memory is a sign of devotion, and the capacity to chant it aloud is a much-admired gift, because the beauty and care of such recitation is deemed an act of religious piety in its own right. Today, public competitions of recitations of the Qur'an are a regular feature on radio and television in Islamic countries. In cities having a Muslim majority, it is not uncommon to find radio stations that feature reading of the Qur'an 24 hours a day.

The Qur'an is the central text of Islam, but the Hadith has also shaped Islamic religion and culture. From this living stream of sacred text and tradition, Islamic sages and jurists have developed Sharia. When Islamic countries are described as adopting Islamic law for their governance, that refers to Sharia. Sharia is traditional and conservative, yet adaptable to the needs and circumstances of time.

The following selections from the Qur'an are taken from a Muslim scholar who called his work an "explanatory translation," because, again, humans are not supposed to be capable of translating the words of Allah spoken to the prophet Muhammad:

READING 8.1 THE QUR'AN

Sura 1, The Opening, revealed at Mecca

In the name of Allah, the Beneficent, the Merciful.
Praise be to Allah, Lord of the Worlds,
The Beneficent, the Merciful.
Owner of the Day of Judgment,
Thee (alone) we worship; Thee (alone) we ask for help.
Show us the straight path,
The path of those whom Thou hast favored;
Not (the path) of those who earn Thine anger nor of those who go astray.

Verses from sura 5 recount some history concerning Jews and Christians, according to the Qur'an:

READING 8.2 THE QUR'AN

Sura 5, The Table Spread, revealed at al-Madı-nah [Medina]

44. Lo! We[2] did reveal the Torah, wherein is guidance and a light, by which the Prophets who surrendered (unto Allah) judged the Jews, and the rabbis and the priests (judged) by such of Allah's Scripture as they were bidden to observe, and thereunto were they witnesses. So fear not mankind, but fear Me. And barter not My revelations for a little gain. Whoso judgeth not by that which Allah hath revealed; such are disbelievers.

45. And We prescribed for them therein: The life for the life; and the eye for the eye, and the nose for the nose, and the ear for the ear, and the tooth for the tooth, and for wounds retaliation. But whoso forgoeth it (in the way of charity), it shall be expiation for him. Whoso judgeth not by that which Allah hath revealed; such are wrong-doers.

46. And We caused Jesus, son of Mary, to follow in their footsteps, confirming that which was (revealed) before him, and We bestowed on him the Gospel wherein is guidance and a light, confirming that which was (revealed) before it in the Torah—a guidance and an admonition unto those who ward off (evil).

2. Allah.

The Thousand and One Nights

Aside from the Qur'an, *The Thousand and One Nights*, compiled between the 9th and 14th centuries, is the most widely read and beloved work of Islamic and Arabic culture. The stories differ, and critics have questioned whether they were ever meant to be joined together. However, their constant frame is the story of King Shahryar and his bride Shahrazad, although her name may be more familiar in English as Scheherazade, as in the hauntingly pulsating symphonic suite of the same name composed by the Russian Nikolay Rimsky-Korsakov in the latter part of the 19th century.

The king was embittered by the adulterous betrayal of his queen, and he sought to express his enmity toward women by wedding them, bedding them for a night, then having them executed in the morning. Shahrazad, daughter of the king's vizier, decides to try to end the king's practice by offering herself to him and nightly telling him tales of such wonder, pausing as the dawn approached, that he would forgo executing her to hear the conclusion.

Many of the tales are highly erotic, even edgy. Yet they are composed in a luxurious prose and lyric poetry that elevates them to the level of literature. Following is an extract from "The Tale of the Porter and the Young Girls":

READING 8.3 THE THOUSAND AND ONE NIGHTS

From "The Tale of the Porter and the Young Girls"

There were vases and carved seats, curtains.... and in the middle a marble couch, inlaid with pearl and diamond, covered with a red satin quilt. On the bed lay a third girl who exceeded all the marvel that a girl can be. Her eyes were Babylonian, for all witchcraft has its seat in Babylon. Her body was slim as the letter alif,[3] her face so fair as to confuse the bright sun. She was a star among the shining of the stars, a true Arabian woman, as the poet says:
Who sings your slender body is a reed
His simile a little misses,
Reeds must be naked to be fair indeed
While your sweet garments are but added blisses.

As the tales draw to an end, the king is no longer thinking of killing Shahrazad, or indeed any woman:

READING 8.4 THE THOUSAND AND ONE NIGHTS

From "Conclusion"

Then she fell silent, and King Shahryar cried: "O Shahrazad, that was a noble and admirable story! O wise and subtle one, you have taught me many lessons, letting me see that every man is at the call of Fate; you have made me consider the

words of kings and peoples passed away; you have told me some things which were strange, and many that were worthy of reflection. I have listened to you for a thousand nights and one night, and now my soul is changed and joyful, it beats with an appetite for life. I give thanks to Him Who has perfumed your mouth with so much eloquence and has set wisdom to be a seal upon your brow!"

. . .

King Shahryar and Queen Shahrazad, . . . and Shahrazad's three small sons, lived year after year in all delight, knowing days each more admirable than the last and nights whiter than days, until they were visited by the Separator of friends, the Destroyer, the Builder of tombs, the Inexorable, the Inevitable.

Such are the excellent tales called *The Thousand Nights and One Nights*, together with all that is in them of wonder and instruction, prodigy and marvel, astonishment and beauty.

But Allah knows all! He alone can distinguish between the true and the false. He knows all!

Omar Khayyam

The Persian Omar Khayyam (1048–1131) was versed in many disciplines: philosophy, mathematics, astronomy, mechanics, mineralogy, climatology, and music. He was also a poet, whose brief works have come down to us from the world of Islam. The tenets of Islam would seem to demand as austere a life as do the more conservative views within Judaism and Christianity: Taste the pleasures of the flesh with caution. The reward for a proper, pious life is paradise. And for many believers, hell gapes open for those who would seize the day. Yet surprisingly, Khayyam's *rubaiyat*—that is, his quatrains (four-line poems)— appear to preach precisely that we should make the most of time. They are filled with doubt about the value of waiting for the final reward.

Khayyam's verses are some of the most beloved of the Eastern poetry that has found its way to the West. Many of his phrasings, as translated by Edward Fitzgerald,[4] may sound very familiar: "the bird is on the wing," "a jug of wine, a loaf of bread, and thou," "the rumble of a distant drum," "the Moving Finger writes: and, having writ, / Moves on."

READING 8.5 OMAR KHAYYAM

From *The Rubáiyát of Omar Khayyám*

7 Come, fill the Cup, and in the Fire of Spring
 The Winter Garment of Repentance fling:
 The Bird of Time has but a little way
 To fly–and Lo! the Bird is on the Wing.
12 A Book of Verses underneath the Bough,
 A Jug of Wine, a Loaf of Bread—and Thou

3. The first letter of the Arabic alphabet, which looks like a lowercase L.

4. *The Rubaiyat of Omar Khayyám*, trans. Edward Fitzgerald, 5th ed. (London: Bernard Quaritch, 1889).

Beside me singing in the Wilderness—
Oh, Wilderness were Paradise enow!

13 Some for the Glories of This World; and some
Sigh for the Prophet's Paradise to come;
Ah, take the Cash, and let the Credit go,
Nor heed the rumble of a distant Drum!

63 Oh, threats of Hell and Hopes of Paradise!
One thing at least is certain–This Life flies;
One thing is certain and the rest is Lies;
The Flower that once has blown for ever dies.

71 The Moving Finger writes: and, having writ,
Moves on: nor all your Piety nor Wit
Shall lure it back to cancel half a Line,
Nor all your Tears wash out a Word of it.

We also see that Khayyam openly challenged Islamic—or any religious—views of the creation of the universe and of humankind's place within it. That was the scientist within him speaking, the skeptic, as well as the poet:

READING 8.6 OMAR KHAYYAM

"Into this Universe, and Why not knowing"

29 Into this Universe, and Why not knowing
Nor Whence, like Water willy-nilly flowing;
And out of it, as Wind along the Waste,
I know not Whither, willy-nilly blowing.

Sufi Writings

From the perspective of literature, one of the most influential Islamic traditions is Sufism. The name *Sufi* most likely derives from the Arabic word for unbleached wool—the simple clothing many Sufis adopted. Sufi *tariqas* (communities) are to be found in various Islamic lands, with a significant presence in North Africa and Egypt.

Sufism describes a complex group of communities or small groups of teachers with religious authority, called *sheiks*, and their disciples. Like most mystical movements in a religious tradition, Sufism was sometimes embraced with enthusiasm by religious and civil authorities. During other periods, its practices and followers were viewed through the prism of suspicion or hostility. Sufi mystics tended to live a life of retirement in poverty, preaching piety and repentance.

Westerners have expressed a keen interest in Sufi practices, with most large bookstores stocking translations of Sufi texts. Two representative Sufi writers might provide us with some sense of the range of Sufi thought and expression.

RABI'AH AL-ADAWIYAH AL-QAYSIYYA Rabi'ah (717–801), or Rabia, was a Sufi mystic who believed that a highly developed love of God was the key to union with him. Kidnapped and sold into slavery as a child, she became convinced that she was one of God's chosen ones after being granted freedom by her master. Rabia expressed her philosophy of divine love in a series of aphorisms, poems, and meditations inspired by verses in the Qur'an that spoke of Allah's concern for his people and the corresponding love that they should have for him. Like many mystics (and others meditating on the meaning of God's love), Rabia expressed her feelings in the form of poetry. She believed that with Allah as the central focus in one's life, nothing else mattered, not even fear of damnation or hope of paradise: "The best thing in the whole world is to possess nothing in this world or the next world except Allah":

READING 8.7 RABI'AH AL-ADAWIYAH AL-QAYSIYYA

1 I carry a torch in one hand
And a bucket of water in the other:
With these things I am going to set fire to Heaven
And put out the flames of Hell
So that voyagers to God can rip the veils
And see the real goal.

2 O my Lord,
if I worship you
from fear of hell, burn me in hell.
If I worship you
from hope of Paradise, bar me from its gates.
But if I worship you
for yourself alone, grant me then the beauty of your
Face.

3 O my Lord,
the stars glitter
and the eyes of men are closed.
Kings have locked their doors
and each lover is alone with his love.
Here, I am alone with you.

JALAL AD-DIN MUHAMMAD RUMI Perhaps the most famous of the Sufi mystic poets was the 13th-century writer known as Rumi (1207–1273). Born in what is now Afghanistan, Rumi moved with his family to what is present-day Turkey. A prolific writer of religious verse in a form developed by earlier Sufis that used rhyming **couplets**, Rumi, writing mostly in the Persian language, composed more than 3000 poems while also leaving behind 70 long discourses on mystical experience. His poetic corpus is extensive and so powerfully expressed that some have called his body of work the Qur'an in Persian. He was most admired for his capacity to take almost any ordinary thing and turn his observance of it into a poem of religious praise. One of Rumi's best-known works is an homage to religious tolerance (see Reading 8.8).

◀ **8.18** **"Whirling" dervishes.** As part of their religious devotions, many Sufi orders perform ecstatic dancing to the accompaniment of musical instruments. The practice, not universally admired by Muslims, may represent the souls of the just whirling toward paradise.

Rumi's poem "Only Breath" appears to bring what we call mysticism to another level:

READING 8.9 JALAL AD-DIN MUHAMMAD RUMI

"Only Breath"

Not Christian or Jew or Muslim, not Hindu,
Buddhist, sufi, or zen. Not any religion

or cultural system. I am not from the East
or the West, not out of the ocean or up

from the ground, not natural or ethereal, not
composed of elements at all. I do not exist,

am not an entity in this world or the next,
did not descend from Adam or Eve or any

origin story. My place is placeless, a trace
of the traceless. Neither body or soul.

I belong to the beloved, have seen the two
worlds as one and that one call to and know,

first, last, outer, inner, only that
breath breathing human being.

READING 8.8 JALAL AD-DIN MUHAMMAD RUMI

Three Blind Men and the Elephant

The Sufi mystic Jalal ad-Din Muhammad Rumi (1207–1273 CE) would tell his version of the fable of the three blind men and the elephant as a way of showing that people cannot perceive the features or dimensions of Allah, and therefore as a way of preaching tolerance of different points of view.

The elephant was in a dark house; some Hindus had brought it for exhibition.

In order to see it, many people were going, every one, into that darkness.

As seeing it with the eye was impossible, [each one] was feeling it in the dark with the palm of his hand.

The hand of one fell on its trunk; he said: "This creature is like a water-pipe."

The hand of another touched its ear: to him it appeared to be like a fan.

Since another handled its leg, he said: "I found the elephant's shape to be like a pillar."

Another laid his hand on its back: he said, "Truly, this elephant was like a throne."

Similarly, whenever anyone heard [a description of the elephant], he understood [it only in respect of] the part that he had touched.

On account of the [diverse] place [object] of view, their statements differed: one man titled it "dal,"[5] another "alif."[6] If there had been a candle in each one's hand, the difference would have gone out of their words.

One feature of Rumi's poetry was his practice of reciting his poems while dancing in a formal but ecstatic fashion. Rumi believed that the combination of recitation and movement would focus the devotee's total attention on Allah. He founded a community of these ecstatic dancers (dervishes), whose practitioners continue ecstatic dancing to this day (**Fig. 8.18**).

ISLAMIC ARTS

Islamic arts include mosaics and tile work, pottery, fiber arts, and forms of calligraphy that rival the beauty of ancient Chinese calligraphy.

Calligraphy

Calligraphy was developed to render adequate honor to the written text of the Qur'an. The evolution of Arabic script is a long and highly complex study in its own right, but certain standard forms of writing were developed. One of the most characteristic forms of this writing, although it also admits of many variations, is called **Kufic**.

5. A crooked Arabic letter.
6. A long, straight Arabic letter.

Early Kufic

Eastern Kufic

Foliate Kufic

Knotted Kufic

Square Kufic

▲ **8.19 Kufic styles.** Early Kufic was developed in the seventh and eighth centuries. Eastern Kufic was popular in books, and other styles developed over the following centuries. Square Kufic and foliate Kufic were used frequently on architectural monuments. Knotted Kufic seems to embrace plant life.

Kufic calligraphy is named after the city of Kufah in Iraq, where Arabic script was refined in the seventh and eighth centuries. It contained angular and square lines, as well as bold circular forms. Horizontal strokes tended to be extended. By the latter part of the eighth century, Kufic became the official script for copying the Qur'an. In the 10th century, slender verticals and oblique strokes gave more of an animated quality to earlier Kufic, as in Eastern Kufic (see **Fig. 8.19**), which was popular on ceramics. Foliated Kufic and square Kufic became used on architectural monuments, with square Kufic sometimes used to cover entire buildings.

The stylized Arabic from a leaf of the Qur'an drawn around the middle of the Golden Age (Fig. 8.20) shows rounded letters that serve as counterpoint to the angular script. The colored marks are aids that help the reader pronounce the script, but for those who are not readers of Arabic, the whole can have something of a pictographic quality created by the strong, measured strokes. Calligraphic skills were brought to bear not only on the text of the Qur'an but also as decorative features of public buildings, including mosques, and of ceramics.

◀ **8.20 Page from the Qur'an, 9th–10th century. From Iraq or Syria. 8" × 13" (20.3 × 33 cm). Museum für Islamische Kunst Berlin, Germany.** The highly stylized calligraphy is known as Kufic script; it is one of the earliest and most beautiful of Arabic calligraphy styles. Arabic, like Hebrew, is written from right to left.

Ceramics

Potters during the Golden Age were turning out simple, elegant glazed works frequently decorated with calligraphy. A dish from the 11th or 12th century Iran (**Fig. 8.22**) shows Kufic text around the rim that achieves an abstract, painterly quality. Elongated letters are extended in horizontal and vertical directions to embrace the full width of the rim. The Arabic is translated into English as follows: "Science has first a bitter taste, but at the end it tastes sweeter than honey. Good health [to the owner]."

Fiber Arts

The Ardabil carpet (**Fig. 8.24**), created during the Islamic Golden Age, is the oldest dated carpet in the history of art. It is huge, covering some 35 feet by 18 feet, and has more than 25 million knots. In the center is a sunburst design that apparently represents the interior of a dome in a mosque or shrine. Although the carpet is not a religious work per se, the field of interlacing flowers and vines likely draws on references to paradise as a garden in the Qur'an.

▲ **8.21 Mihrab from the Madrasa Imami, Isfahan, Iran, ca. 1354 CE. 135" × 113 ¾" (343.1 × 288.8 cm). Metropolitan Museum of Art, New York, New York.** A mosaic of monochrome-glaze tiles on a composite body is set on plaster to create floral and geometric patterns and inscriptions.

Mosaics

Mosaics are used to decorate the exteriors and interiors of Islamic buildings, especially mosques and shrines. We saw them in the Dome of the Rock and in the interior of the dome in front of the mihrab of the Great Mosque in Córdoba. We find another example in the finely detailed mosaics in the mihrab from the Madrasa Imami in Isfahan (**Fig. 8.21**). The pointed arch bears a Kufic inscription from the Qur'an. We also find geometric and floral motifs.

▲ **8.22 Dish with epigraphic decoration, 11th–12th century. Khurasan, Iran. Terra-cotta, white slip ground, and slip underglaze decoration. 14 ¾" (37.5 cm) diameter. Musée du Louvre, Paris, France.** The Kufic inscription reads, "Science has first a bitter taste, but at the end it tastes sweeter than honey. Good health [to the owner]."

CONNECTIONS Imagine a honeycomb rendered in two-dimensions. The hexagonal cells are an example in nature of **tessellation**—patterns of identical, congruent, geometric shapes that fit together without overlaps or gaps. In ceramic mosaic and tiling, tessellation describes a technique whereby a flat surface is covered with pieces of precisely cut glass or ceramic tiles, typically in patterns consisting of multiple variations on a specific set of shapes (such as squares, circles, and polygons) that are repeated and interlaced. In mathematics, such two-dimensional repetitive patterns based on symmetry are called *wallpaper groups* and number 17 possibilities in total. Some art historians have claimed that all 17 wallpaper groups are present in the Alhambra and that the fortress-palace tile decoration represents the pinnacle of the art form in Spain. The Alcázar in Seville (the setting of the Water Gardens of Dorne in season five of HBO's *Game of Thrones*), also a fortified palace, has stunning examples of tessellation.

▲ **8.23** A tessellated wall in the Alcázar, Seville, Spain.

ISLAMIC MUSIC

Islamic music includes many genres and styles, including sacred, secular, and classical music. Muslims were aware of Greek music and musical theory, and adapted them to their own purposes.

Music has a checkered history in Islam. Certainly the calls to prayer of muezzins are melodic. And, over the centuries, music sprang up everywhere. There are a variety of traditional instruments. **Figure 8.25** shows a **rebab**, a long-necked stringed instrument that is usually played with a bow, although it can be plucked. The **dadabwaan** (**Fig. 8.26**) is a traditional drum, this one from the Philippines, which has both Muslim and Christian populations. Wind instruments and gongs have also been in common usage.

There has been a great deal of sacred music and much poetry set to music. **Figure 8.27** (see p. 275) shows the son of a Syrian merchant, Bayad, serenading an erudite young woman, Riyad, in the court of an important official in Iraq. He plays the **oud**, a traditional, short-necked stringed instrument that is plucked, as a guitar. The serenade occurs in a 13th-century illustrated manuscript called *The Story of Bayad and Riyad*. The manuscript

▶ **8.24 Maqsud of Kashan, carpet from the funerary mosque of Shaykh Safi al-Din, Ardabil, Iran, 1540. Wool and silk, 34' 6" × 17' 7" (10.5 × 5.2 m). Victoria and Albert Museum, London, United Kingdom.** The immense carpet is apparently intended to provide the illusion of a golden, heavenly dome surrounded by mosque lamps, as reflected in a pool of floating lotus flowers with interlacing vines. It contains some 25 million knots.

◀ **8.25 Rebab, late 19th century. Algeria or Morocco. Wood, parchment, metal, and ivory, 29½" (74.9 cm) long (bow 13½", 34.3 cm) Metropolitan Museum of Art, New York, New York.** The term *rebab* refers to lutes and lyres used in Islamic lands. The rebab is held across the player's body like a cello or bass fiddle and is played with a bow. It is used only to accompany singing. This example is embellished with a delicate ivory inlay.

▲ **8.26 Dadabwaan, 19th century. Mindanao, Philippines. Wood, mother-of-pearl, and skin, 32⅜" × 24½" (82.2 × 62 cm); head 21" (55.3 cm) across. Metropolitan Museum of Art, New York, New York.** Islamic influences contributed to the name, goblet shape, mother-of-pearl inlay, and leaf decoration of the drum. It was blackened by rubbing oil into the wood, and it is played with two sticks made of rattan.

was written during the latter years of the Islamic Golden Age (ca. 750–1258 CE), when Muslim philosophers and scientists preserved the earlier traditions of their own culture and those of nearby countries, while advancing their own technology and culture. Suffice it to say that music was generally popular.

Despite these varied uses of music, some Muslims over the centuries have argued in favor of vocal music only, and the use of instruments has sometimes been forbidden. There is thus a tradition of a cappella devotional singing. Other Muslims consider all instruments to be lawful as long as they are used for sacred and other forms of acceptable music. Some allow only drums.

At various times, male instrumentalists have been associated with "vices" such as love of poetry, drinking of wine, chess, and homosexuality. Zealots burned musical scores and writings on music. In recent years, the Taliban, a fundamentalist Islamic group comprised mainly of Pashtuns in Afghanistan and Pakistan, forbade music and dancing along with chess, cinema, television, lipstick, clapping at athletic contests, and on and on. Some Muslims have claimed that music is forbidden by both the Qur'an and the Hadith. Muhammad is quoted as having censured music: "There will be among my [followers] people who will regard as permissible adultery, silk, alcohol and musical instruments." But the context of this remark is debated. Some commentators note that Muhammad made this statement at a time when he was converting polytheists who had been using music and musical instruments in their previous modes of worship. In any event, many Muslims have lauded the joy and uses of music. There is no single Islamic view on the uses (or the dangers) of music.

THE CULTURE OF ISLAM AND THE WEST

Harun al-Rashid (r. 786–809 CE) was the fifth and most famous caliph of the Abbasid period. Famous for encouraging music, poetry, art, and science at his court in Baghdad, and an inspiration for *The Thousand and One Nights*, Harun achieved mythic stature. A military leader as well, he waged intermittent war on the Byzantine Empire. But in 798, with his army encamped around Constantinople, he negotiated with the empress Irene to accept an annual tribute of 70,000 pieces of gold in lieu of certain victory. Not until 1453 would Constantinople fall to Islam.

During a reign that marked the high point of the Abbasid dynasty's social and political power, Harun al-Rashid maintained diplomatic ties with countries as far away to the east as China. To the west he conducted a diplomatic correspondence with Charlemagne. Charlemagne's biographers describe negotiations over Christian access to the holy places in Jerusalem. These negotiations were critical to Charlemagne because the Christian West bitterly regretted the loss of Jerusalem in 638—a bitterness that would erupt into the Crusades several centuries later.

As was customary, Charlemagne sent his delegates with gifts for the caliph. Because Harun was a keen equestrian, Charlemagne sent Spanish horses and hunting dogs, as well

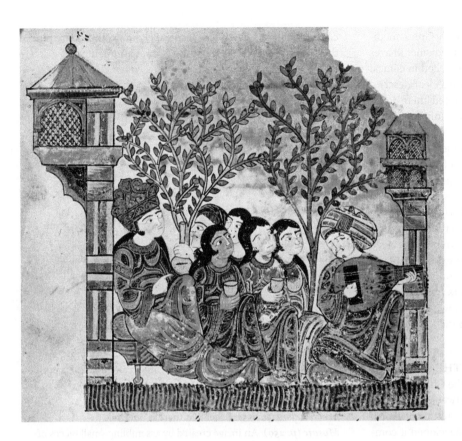

◄ 8.27 "The Story of Bayad and Riyad," 13th century. Manuscript illumination, 6 7/8" × 7 ½" (17.5 × 19.1 cm). Biblioteca Apostolica Vaticana, Vatican City State, Italy. In this tale, the son of a Syrian merchant woos a beautiful and highly educated young woman in the court of a vizier (an important official) in Iraq.

as Frisian woven cloth. In 802, Harun reciprocated, sending—among silks, candelabras, perfumes, ivory chessmen, and slaves—evidence of the technological inventiveness of the Islamic world: a water clock with 12 bronze balls that marked the hour by falling on a cymbal as 12 mechanical knights paraded out of small windows. Implausibly, Harun also sent Charlemagne an elephant named Abul-Abbas. Somehow, the elephant traveled from Baghdad (present-day Iraq) to Aachen (present-day Germany), where it fascinated the populace until 811, when it succumbed to the northern cold.

In Baghdad under the Abbasid dynasty, papermaking was learned from a Chinese prisoner who had learned the process in China, where it had long been commonplace. Baghdad opened its first papermaking factory in 794. It would be some centuries before the process would pass to the West.

The House of Wisdom

Caliph Al-Ma'mun built a library and study center, completed in 833, that was known as the *Bayt al-Hikmah* ("House of Wisdom"). Scholars flocked to that center from all over the Islamic world. A crucial part of the scholarly labors at the House of Wisdom was the translation of texts into Arabic. We owe to this center the preservation of the works of Aristotle, which were translated into Arabic by a team of Greek-speaking Christians who were in the center's employ. It is estimated that every text of Aristotle we know today (except *Politics*) was translated in the House of Wisdom. Additionally, these scholars translated several Platonic texts, the medical texts of Galen, and many treatises of the

Neo-Platonic authors. When scholars (like Thomas Aquinas) read Aristotle in Paris in the 13th century, they did so in Latin versions translated from Arabic manuscripts—the work of the scholars of Baghdad.

AL-KHWARIZMI AND MATHEMATICS The greatest single scholar at the House of Wisdom was the polymath researcher al-Khwarizmi (780–850), who made revolutionary discoveries. He led three expeditions to India and Byzantium in order to gather manuscripts and meet other scholars. As a consequence, al-Khwarizmi had at his disposal much learning from both Indian and Byzantine (Greek) sources. He invented algebra (the word *algebra* derives from the Arabic title of one of his books). Medieval Europeans who knew his writings in Latin gave us another important mathematical term, which is a corruption of his name: *algorithm*.

The most important contribution made by al-Khwarizmi was his adaptation of Hindu notations for numbers that used nine symbols and a placeholder. This simplified numerical system replaced the clumsy Greek and Latin notational system, as any person who has tried to multiply CLXII by LIV instead of 162 by 54 will readily testify. The Hindu placeholder called *sunya* in Sanskrit and *cifra* (from which the English word *cipher* is derived) in Arabic, which came to be called *zero* in some European languages, was now regarded not merely as a placeholder but as a number. One further advance, made in the next century by an otherwise obscure Syrian Muslim named Al-Uqlidisi, was the development of decimal fractions, which then permitted, for example, the computation of a solar year at 365.242199 days.

Although these profound mathematical advances developed rapidly in the Islamic world, their development in the West would be slow. It would take nearly 150 years before these ideas entered the Christian West via translations in those places that had the closest connection to the Islamic world, namely Sicily (not a distant voyage from North Africa) and especially the part of Spain that was Islamic.

SCIENCE AND MEDICINE Mathematics was not the only area in which Islamic scholarship advanced. The Egyptian scientist Alhazen (died 1038) did crucial work in optics and on the technology of grinding and making lenses. Three other scholars

in the Islamic world who had had contact with Greek medicine and other sources shaped the future of medicine. Rhazes (died 932), head of the hospital in Baghdad, excelled in clinical observation, giving the world for the first time a clear description of smallpox and measles that demonstrated them to be two distinct diseases. It was from the observations of Rhazes that other scientists began to understand the nature of infection and the spread of infectious diseases. In the following two centuries, influential writers such as Avicenna (died 1037) and Averröes (died 1198), in addition to their important work in philosophy, wrote influential treatises in medicine. The Jewish philosopher and physician Moses Maimonides (died 1204) was trained in medicine by Muslims in Spain, where he was born, and Morocco. Because of his education, he stressed the need for personal hygiene as a way of avoiding disease (a concept not common in his day) and did influential work on the nature of poisons. The high reputation of Jewish doctors trained in Arabic medicine was such that popes consulted Jewish physicians who lived in the Jewish quarter across from the Vatican right through the Renaissance.

OTHER CONTRIBUTIONS FROM THE ISLAMIC WORLD Despite the antagonism between the Christian West and the Islamic world in the centuries between the Abbasid dynasty in Baghdad and the flourishing culture of North Africa and Islamic Spain, the two cultures developed a common exchange of ideas and goods. The results were widespread. Westerners learned how to make windmills from the Muslims. The sword makers of both Damascus (Syria) and Toledo (Spain) were legendary for the quality of their work. The woven silk of Damascus lingers in our word *damask*. Among the earlier gifts of the Islamic world is coffee. The fruit of the plants, native to tropical Africa, became a common hot beverage when Muslim traders in Ethiopia began to pulverize the beans to brew the drink. So popular was the result that in a short time one could find in Mecca, Damascus, and even in Constantinople an institution popular to this day: the coffeehouse.

English Words from the Islamic World

The exchanges between the Western world and the Islamic world have enriched the English vocabulary. Arabic has given us *algebra, amber, almanac, azimuth, caliph, cotton, hazard, lute, mattress, mosque, saffron,* and *syrup.* From Persian (via Iran) we have gained the words *azure, mummy, scarlet,* and *taffeta,* as well as *chess* and two words from that game: *rook* and *checkmate.*

Finally, Muslim scholars provided not only a great body of Greek philosophical writing but also a vast commentary on it in the High Middle Ages. When al-Ghazali (died 1111) attacked Greek philosophy in a book called *The Incoherence of the Philosophers,* he was answered by Averröes, who wrote a treatise showing how Islam could be reconciled with Greek philosophy. Averröes called his book *The Incoherence of the Incoherence.* Dante regarded Muhammad and Islam with disdain, but a

century after the death of Averröes, Dante would salute him in the *Divine Comedy* as "He of the Great Commentary."

GLOSSARY

Allah (p. 254) The Arabic word for God.

Caliph (p. 255) A spiritual and secular leader of the Islamic world, claiming succession from Muhammad.

Calligraphy (p. 270) A stylized form of elegant handwriting.

Couplet (p. 269) Two successive lines of verse that rhyme.

Dadabwaan (p. 273) A kind of Islamic drum.

Hadith (p. 255) A collection of the sayings of Muhammad and reports of his behavior.

Ka'bah (p. 254) Arabic for "cube"; the cube-shaped building in Mecca, believed by Muslims to have been built by Abraham and to lie directly beneath heaven, which is the holiest site of Islam.

Kufic (p. 270) Styles of calligraphy that were largely developed in the Iraqi city of Kufah.

Mahdi (p. 258) The redeemer of Islam.

Mihrab (p. 259) A niche in the wall of a mosque that indicates the direction of Mecca so that the congregation can direct their prayers in that direction.

Minbar (p. 259) The pulpit in a mosque.

Monotheism (p. 255) Belief that there is one god.

Mosaic (p. 259) An image created by assembling small pieces of materials such as glass, stone, or tile.

Mosque (p. 259) An Islamic house of worship (as a synagogue in Judaism or a church in Christianity).

Muezzin (p. 259) The crier who calls Muslims to prayer five times a day.

Oud (p. 273) A short-necked stringed instrument that is plucked like a guitar; a lute.

Qur'an (p. 254) The Muslim holy book, which is believed to have been revealed by Allah to Muhammad.

Ramadan (p. 255) The ninth month of the Islamic calendar; considered a holy month during which there are limitations on eating, smoking, and sex (alcohol is prohibited at all times).

Rebab (p. 273) A long-necked stringed instrument played with a bow.

Shariah (p. 255) The moral code and religious law of Islam.

Shia (p. 258) The Islamic denomination that believes that Muhammad, as commanded by Allah, ordained his son-in-law, Ali, as the next caliph and that legitimate successors must be drawn from the descendants of Ali.

Sufism (p. 258) The inner, spiritual dimension of Islam.

Sunni (p. 258) The Islamic denomination that believes that Muhammad's rightful successor was his father-in-law, Abu Bakr, and that the Qur'an endorses the selection of leaders according to the consensus of the Muslim community.

Sura (p. 255) A section of the Qur'an; a chapter.

Tessellation (p. 273) Tiling a plane (flat surface) with one or more geometric shapes, called tiles, without overlapping or gaps.

Ummah (p. 258) The Muslim community at large.

Voussoir (p. 262) A wedge-shaped or tapered stone that is used in the construction of an arch.

THE BIG PICTURE THE ISLAMIC WORLD

Language and Literature
- The Qur'an was written in Arabic, a Semitic language. It contains 114 chapters (suras).
- Copies of the Qur'an were made with calligraphy in the so-called Kufic styles. Calligraphy was also used to decorate buildings and pottery.
- *The Thousand and One Nights*, compiled over several centuries, was the most popular secular work in the Arab world.
- Omar Khayyam's four-line verses taught that people should seize the day.
- Sufis such as Rabi'ah al-'Adawiyah al-Qaysiyya (Rabia) and Jalal ad-Din Muhammad Rumi (Rumi) wrote prose and poetry embracing a mystical relationship with Allah.

Art, Architecture, and Music
- The most magnificent Islamic works were architectural—from the Dome of the Rock in Jerusalem to the Alhambra in Spain. Architectural works were frequently decorated with mosaics and calligraphy.
- The interior spaces of mosques were often extended in hypostyle fashion. Mosques have minarets from which muezzins cry to the faithful that it is time for prayer. Mihrabs are focal points in mosques that direct worshippers' prayers in the direction of Mecca.
- Many manuscripts were illuminated (illustrated) with miniature paintings. It was generally forbidden to depict Allah or the face of the prophet Muhammad.
- Various forms of pottery were innovated, and some were decorated with Kufic calligraphy.
- Carpet weaving was a high art, with the famed Ardabil carpet having some 25 million knots.
- The use of music has been quite varied in Islam. In some cases, instruments were forbidden. There is debate as to whether Muhammad opposed music.

Philosophy and Religion
- Islam is a monotheistic religion in the tradition of Abraham. Islam denies the Trinitarianism of Christianity in favor of a single God. The holy book is the Qur'an, and other religious writings are found in the Hadith and the Sunnah.
- Islam numbers Adam, Moses, Jesus, and John the Baptist among its prophets but denies the divinity of Jesus and considers Muhammad to be the final prophet.
- The state is to be ruled according to Islamic law, or Shariah. The caliph is both a spiritual and a secular ruler.
- The holiest site in Islam is the Ka'bah in Mecca, which is believed to have been built by Abraham and to be directly under heaven (paradise).
- The five pillars of Islam are (1) recitation of the Muslim act of faith that there is one God and that Muhammad is his messenger, (2) the obligation to pray five times a day, (3) donation to charity, (4) observance of a fast during the holy month of Ramadan, and (5) the duty to make a pilgrimage to Mecca (hajj) at least once.
- The Sunni and Shia denominations have conflicting views on the rightful successors to Muhammad and his son-in-law, Ali. Sufis seek a direct mystical relationship with Allah.

The Rise of Medieval Culture

<div style="text-align:right">9</div>

PREVIEW

If Hildegard of Bingen had been a man and had lived during the Renaissance, she would have counted among the great thinkers whose achievements defined the *renaissance man*—someone whose spheres of knowledge are many and whose understanding of them is profound. Hildegard was a medieval **polymath**—a Christian mystic and philosopher, a poet and composer. She founded and led two communities of Benedictine nuns as abbess. She authored a compendium on human diseases and another on medicinal practices, and catalogued plants, animals, and chemical elements. She interpreted religious texts and went on speaking tours to monasteries and cathedrals. Her spiritual visions were meticulously described in brilliant manuscript illuminations. Her *Ordo Virtutum* (*Order of the Virtues*), a morality play, is the earliest piece of musical drama that survives with both script and score.

The 14th-century Italian humanist scholar Petrarch labeled the era in which Hildegard lived (the Early Middle Ages) the Dark Ages; he saw it as a period of intellectual and creative stagnation that followed the decline of the Western Roman Empire and the collapse of classical learning. If anything, Hildegard single-handedly defeats that notion.

Hildegard's experiences reveal a great deal about the Early Middle Ages—about the relationship between church and state; the significance of monasteries as centers of learning; the preservation of sacred texts during a prolonged period of barbaric invasions; the inequality of the sexes and the gender ideology of the Christian Church; the presence and influence of learned and powerful women; the intertwined nature of religion, architecture, art, and music; and the essential role of mystery in human life and belief.

Hildegard's output was prodigious. By age 76, she had completed three theological texts describing her mystical visions and expounding on aspects of her faith, the most important of which were *Scivias* and the *De operatione Dei* (*Book of Divine Works*). The visualization of these visions in manuscript illuminations (Fig. 9.1) dates from the 12th century; the original folio of *Scivias* has been missing since World War II.

◄ **9.1** Hildegard of Bingen, "Vision of God's Plan for the Seasons," folio 38 recto from *De operatione Dei* (*On God's Activity*) (also known as *Liber divinorum operum, or Book of Divine Works*) 1163–1174. Illuminated miniature on vellum in mandala form. Biblioteca Statale, Lucca, Italy.

THE MIDDLE AGES

As the power of the Roman Empire declined, warrior lords fought for territory and political authority. Conflicts and competition were fierce among Huns, Vandals, Franks, Merovingians, Goths, and other non-Roman peoples who populated Europe. Once called barbarian tribes, these peoples gained control of parts of Europe.

Migrations

When one of these tribes managed to establish itself in the former center of the Western Empire, Italy, or elsewhere in Europe, another tribe might come crashing across its borders and compel it to move on. Consider the Visigoths, who sacked Rome in 410. They occupied part of Italy and created a kingdom that encompassed part of southern France, but the Franks pressed in, forcing the Visigoths southwest into Spain. The Franks had migrated from the east and crossed the Rhine River, establishing themselves in what is now France, the Netherlands, Switzerland, and parts of Germany. The Ostrogoths, who had become Christian in 383, moved down from eastern Europe into Italy, establishing a kingdom there under Theodoric following the abdication of the last Western Roman emperor in 476. But within a century, the Ostrogoths were forced to move on by the Lombards, a Germanic tribe. Saxons from Germany migrated to Britain and joined with people already living there to form an Anglo-Saxon nation. Celts migrated southward from Ireland and other parts

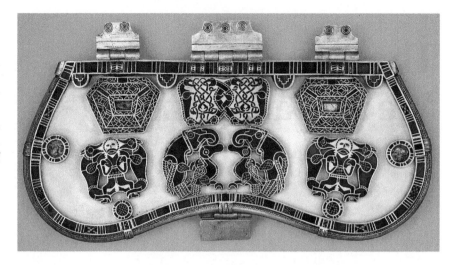

▲ 9.2 Purse cover, ca. 625. Sutton Hoo ship burial, Suffolk, United Kingdom. Gold frame with three gold hinges along a straight top and central projecting gold buckle on the curved lower edge; body of whale-bone ivory (since decayed) set with seven gold-rimmed garnet cloisonné and millefiori glass designs. 7 ½" long × 3 ¼" wide (19 × 8.3 cm) excl. hinges. British Museum, London, United Kingdom.

of the British Isles to inhabit parts of France. Vikings controlled Scandinavia.

Over the centuries of tribal migrations across Eurasia, populations coalesced in what eventually would become the familiar countries of Europe—France, Italy, the nations of Scandinavia, Great Britain, and others. The complexions of the peoples in these places changed literally and figuratively.

Not much in the way of the art and architecture of these migratory tribes remains, although finely wrought ornaments of gold, inlaid stones, and enamelware give us some indication of their artistic capabilities as well as the wealth

The Rise of Medieval Culture

400 CE	800 CE	1200 CE

Monasteries are founded

Warring tribes migrate throughout Europe following the collapse of the Roman Empire

Venerable Bede writes the *Ecclesiastical History of the English Nation*

The Old English epic *Beowulf* is created

Charlemagne battles the Spanish emirate without conclusive results; events give rise to *The Song of Roland*

The feudal system becomes the dominant social structure throughout Europe

Charlemagne, a Frank, is crowned emperor of the new Holy Roman Empire

Charlemagne supports learning, monasteries, and the writing of books

The Ottonian period begins following the death of Charlemagne

William I (William the Conqueror) invades England and becomes England's first Norman king

The Romanesque style of architecture dominates European cathedral construction

CONNECTIONS In the last centuries of the Roman Empire, tribes from the north and the east crushed against its borders. In *How the Irish Saved Civilization*,* Thomas Cahill describes a scene of thousands upon thousands of matted-haired, malodorous "barbarians" attacking helter-skelter across a frozen Rhine River, to be met by well-armed Roman soldiers in military formations. The Romans, in this one battle, slew 20,000 but were still pushed back by the hordes.

Battles like this played out over and over as Rome gradually fell, replaced by a period of cultural darkness that did not yield until the rise of the Byzantine Empire and the subsequent, extraordinary reign of Charlemagne, founder of the Holy Roman Empire. Descended himself from the Franks (one of a similar roaming group of invading Germanic tribes), Charlemagne was unable to write (and some say read) but was responsible for educational reforms that were a vital part of what became known as the Carolingian Renaissance.

During those earlier dark years on the European continent, there was a literal green island of stability to the northwest, nestled among the British Isles: Ireland. Monk–scribes worked away in Irish monasteries dutifully and diligently bending themselves to copying the Hebrew and Greek Bibles as well as classical manuscripts—the histories, plays, and poems we saw in the early chapters of this book.

More than a millennium later, a British Jesuit would describe the Irish as "religious, frank, amorous, ireful, [having] many sorcerers [and] delighted with wars," but still "sharp-witted, lovers of learning, capable of any study whereunto they bend themselves."** Without them, Cahill contends, "Latin literature would almost surely have been lost."

* Thomas Cahill, *How the Irish Saved Civilization*. (New York: Anchor Books, Doubleday, 1995).

** Edmund Campion, in Cahill, page 150, spelling updated.

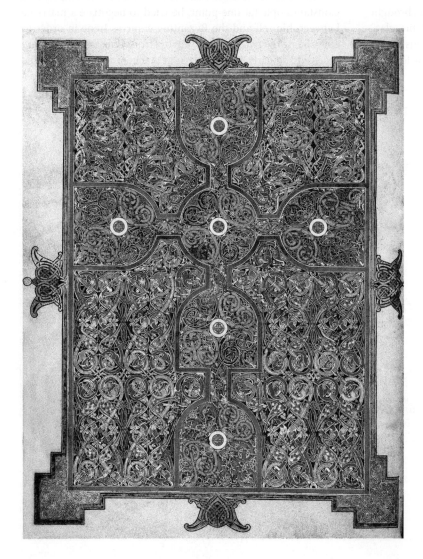

and importance of their leaders. Two cemeteries excavated at Sutton Hoo, England, yielded a large number of ornaments and portable artifacts as well as an entire ship burial dating to the early seventh century CE. One treasure found on the ship is a purse cover made of gold, glass, and semiprecious garnets (**Fig. 9.2**). The surface is completely covered with interlaced decoration, a common stylistic characteristic that suggests the tangled world of mythic monsters in epics such as *Beowulf*.

Many works of Christian art from the Early Middle Ages combine characteristics of the small carvings and metalwork of these warrior tribes with symbols of the Christian faith. A page from the Lindisfarne Gospels, so called for its resemblance to intricately patterned textiles made by these tribes (**Fig. 9.3**), features a stylized cross inscribed with layers of intertwined, multicolored scrolls. The framed space surrounding the

◀ **9.3 Bishop Eadfrith of Lindisfarne attr., folio 72 verso from the Lindisfarne Gospels, ca. 680–720. Illuminated manuscript, ink, pigments, and gold on vellum, 13½" × 9¾" (34.2 × 24.8 cm). British Library, London, United Kingdom.**

cross is similarly filled with repetitive linear patterns that can be decoded as snakes devouring themselves—an animal-interlace motif adapted from the decorative arts of non-Roman peoples.

CHARLEMAGNE

The most important name connected with medieval culture during the period immediately following the migrations is that of a Frank—Charlemagne (Charles the Great, ca. 742–814). This powerful ruler tried to unify the warring factions of Europe under the aegis of Christianity, and modeling his campaign on those of Roman emperors, he succeeded in doing so. In the year 800, on Christmas Day, Charlemagne was crowned Holy Roman emperor by Pope Leo III. It was the first imperial coronation in the West since the late sixth century. The papal coronation was rebellion in the eyes of the Byzantine court, and the emperor in Constantinople considered Charlemagne a usurper, but this coronation, which took place in Rome itself, marked the revival of the Roman Empire in the West.

Charlemagne was an able administrator of lands brought under his subjugation. He modified and adapted the classic Roman administrative machinery to fit the needs of his own kingdom. Charlemagne's rule was essentially a form of **feudalism**—structured in a hierarchical fashion, with lesser rulers bound by acts of fealty to higher ones. Lesser rulers were generally large landowners who derived their right to own and rule their land from their tie to the emperor. Serfs were bound to the land at the lowest rung of society; only slaves ranked beneath serfs. It is estimated that the majority of serfs almost never traveled more than 10 miles from where they were born. They worked in the fields or as artisans in the small villages wholly owned by the manorial lords. A third of what they produced belonged to the manor; the rest sustained them, with precious little left over. If lands worked by serfs were sold, the serfs went to the new owner as well, because they were understood to be part of the land.

Charlemagne also maintained several vassal dependents at his court who acted as counselors at home and as legates to execute and oversee the imperial will abroad. From his palace, the emperor regularly issued legal decrees modeled on old Imperial Roman decrees. These decrees were detailed sets of instructions that touched on a wide variety of secular and religious issues. Those that have survived give us some sense of what life was like in the Early Medieval period. The legates of the emperor carried the decrees to the various regions of the empire and reported back on their acceptance and implementation. This burgeoning bureaucratic system required a class of civil servants with a reasonable level of literacy, an important factor in the cultivation of letters that was so much a part of the so-called Carolingian Renaissance.

The popular view of the Early Middle Ages is that of a period of isolated and ignorant peoples with little contact outside the confines of their own immediate surroundings, and at times, that was indeed the general condition of life. During the Early Middle Ages, the monk–scribes of Ireland helped "save" the civilizations of ancient times by copying Latin manuscripts and others. But by the late eighth and early ninth centuries, Charlemagne ruled over an immense kingdom (all of modern-day France, Germany, the Low Countries, and Italy as far south as Calabria) and had extensive diplomatic contact outside that kingdom (see **Map 9.1**). Charlemagne maintained regular, if somewhat testy, diplomatic relations with the emperor in Constantinople (at one point, he tried to negotiate a marriage between himself and the Byzantine empress Irene in order to consolidate the two empires). Envoys from Constantinople were received regularly in his palace at Aachen, and Charlemagne

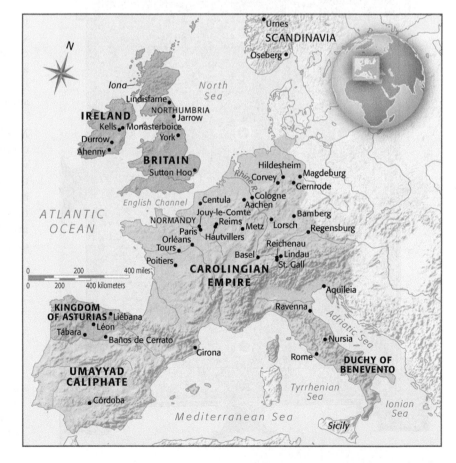

▶ MAP 9.1 **The Carolingian Empire.**

CULTURE AND SOCIETY

Feudalism

The social organization of late **Carolingian** society was based on feudalism, a form of government that had its primary focus on the holding of land. Theoretically, the monarch held all land, with nobles, who swore allegiance to the monarch, possessing it as a gift from the monarch. Under the nobles were people, again pledging allegiance to their noble superiors, who held a smaller piece of land (for example, a manor). The agricultural peasants (serfs) had the use of the land in exchange for fees and for cultivating a certain percentage for the lord above them. The clergy also had the legal right to certain tithes on the production of goods and services. This highly stratified system also affected the system of warfare. Each knight (a small landholder)

pledged loyalty to a higher noble, who in turn pledged loyalty to the crown. Armies could be raised when, for instance, a monarch would call up the nobles pledged to him, and they in turn would call up the knights who had sworn loyalty to them.

Feudal society existed only so long as a country remained rural and without large towns. Italy, with its long history of town life, never had as strong a feudal society as did the Frankish lands of what are today France and Germany. Feudalism was a highly static, hierarchical, and basically agricultural way of organizing life. It would undergo vast changes with the slow emergence of city life and the increased mobility brought on by vigorous trade and such military movements as the Crusades.

learned Greek well enough to understand the envoys speaking their native tongue. Culture flourished.

Charlemagne and Islam

Charlemagne had a mixed relationship with the rulers of Islamic kingdoms. Islam had spread all along the southern Mediterranean coast in the preceding century. Muslim Arabs were in command of all the Middle East, North Africa, and most of the Iberian Peninsula. Charlemagne's grandfather Charles Martel (Charles the Hammer) had defeated the Muslims decisively at Poitiers in 732, thus halting an Islamic challenge from Spain to the rest of Europe. Charlemagne had fought the Muslims of the Umayyad Caliphate on the Franco-Spanish borders; the Battle of Roncesvalles (778) was the historical basis for the epic poem *The Song of Roland.*

Despite his warlike relationship with Muslims in the West, Charlemagne had close diplomatic ties with the great Harun al-Rashid, the caliph of Baghdad. In 787, Charlemagne sent an embassy to the caliph to beg protection for the holy places of the Christians in Muslim-held Palestine. The caliph (who was the inspiration for *The Thousand and One Nights*—see Chapter 8) welcomed the Frankish legates and their gifts (mainly bolts of the much-prized Frisian cloth) and responded by sending an elephant to the emperor as a gesture of friendship. This elephant lived at Aachen for a few years before succumbing to the harsh winter climate. Charlemagne's negotiations were successful. He received the keys to the Church of the Holy Sepulcher and other major Christian shrines, an important symbolic

act that made the emperor the official guardian of the holiest shrines in Christendom.

Charlemagne and Economics

Charlemagne's reign was also conspicuous for its economic developments. He stabilized the currency system of his kingdom. The silver *denier*, struck at the royal mint in Frankfurt after 804, became the standard coin of the time; its presence in archaeological finds from Russia to England testifies to its widespread use and the faith traders had in it.

Trade and commerce were vigorous. There were annual trade fairs at Saint-Denis near Paris, at which English merchants could buy foodstuffs, honey, and wine from the Carolingian estates. A similar fair was held each year at Pavia, an important town of the old Lombard kingdom of northern Italy. Port cities such as Marseilles provided mercantile contracts with the Muslims of Spain and North Africa.

Tolerance of Jews

Although as the Holy Roman emperor Charlemagne was responsible for the welfare of the Christian Church in his dominion, he was tolerant of Jews and welcomed them to his kingdom. Jews in France generally lived where they wished and owned land. In many other European areas, Jews were either unwelcome or compelled to live in Jewish quarters. By the end of the 10th century, Jewish scholars were explicating

biblical texts in French, and Jewish women were taking French names.[1]

Jewish merchants operated as go-betweens in France for markets throughout the Near East. The chief of Charlemagne's mission to Harun al-Rashid's court was a Jew named Isaac who had the linguistic ability and geographic background to make the trip to Baghdad and back—with an elephant—at a time when travel was a risky enterprise. Rivers such as the Rhine and the Moselle were utilized as important trade routes. Among the most sought-after articles from the Frankish kingdom were the iron broadswords produced at forges in and around the city of Cologne and sold to Arabs in the Middle East through Jewish merchants at the port cities. Vivid testimony to these swords' value can be read in the repeated embargoes (imposed under penalty of death) decreed by Charlemagne against their export to the land of the Vikings, who too often put them to effective use against their Frankish manufacturers in coastal raids on North Sea towns and trading posts.

Learning in the Time of Charlemagne

Although he could not write, Charlemagne was an admirer of the arts, Classical culture, and learning. Books were of great importance to him, whether they were of a religious nature or secular. The best known of these, his Coronation Gospels, was written early in the ninth century and has text written in gold. There are numerous manuscript illuminations, four of which show the authors of the Gospels in the midst of writing (see Fig. 9.4).

Charlemagne opened his famous palace school at Aachen— an institution that was a prime factor in initiating what has been called the Carolingian Renaissance. Literacy in Western Europe before the time of Charlemagne was spotty; it existed, but hardly thrived, in certain monastic centers that kept alive the old tradition of humanistic learning taken from ancient Rome. Original scholarship was rare, although monastic copyists did preserve the tradition of literary conservation.

The scholars and teachers Charlemagne brought to Aachen provide some clues about the locales in which early medieval learning had survived. Peter of Pisa and Paul the Deacon (from Lombardy) came to teach grammar and rhetoric at his school because they had had contact with the surviving liberal-arts curriculum in Italy. Theodulf of Orléans was a theologian and poet. He had studied in the surviving Christian kingdom of Spain and was an heir to the encyclopedic tradition of Isidore of Seville and his followers. Finally and importantly, Charlemagne brought an Anglo-Saxon, Alcuin of York, to Aachen after meeting him in Italy in 781. Alcuin had been trained in the English intellectual tradition of the Venerable Bede, the most prominent intellectual

of his day—a monk who had welded together the study of humane letters and biblical scholarship. These scholar–teachers were hired by Charlemagne for several purposes.

First, Charlemagne wished to establish a system of education for the young people of his kingdom. The primary purpose of these schools was to develop literacy; Alcuin of York developed a curriculum for them. He insisted that humane learning should consist of those studies that developed logic and science. From this distinction, later medieval pedagogues developed the two courses of studies for all schooling before the university: the *trivium* (grammar, rhetoric, and dialectic) and the *quadrivium* (arithmetic, geometry, music, and astronomy). These subjects remained at the heart of the school curriculum from the medieval period until modern times. The trivium and quadrivium made up the seven liberal arts that for centuries constituted a classical education and are still discussed in programs in education today.

Carolingian Culture

Few books were available, and people wrote on slates or waxed tablets because parchment was expensive. In grammar, some of the texts of the Latin grammarian Priscian might be studied and then applied to passages from Latin prose writers. In rhetoric, the work of Cicero was studied, or Quintilian's *Institutio oratoria* if it was available. For dialectic, some of the work of Aristotle might be read in the Latin translation of Boethius. In arithmetic, multiplication and division were learned, and perhaps there was some practice on the abacus, because Latin numerals were clumsy to compute with pen and paper. Arithmetic also included some practice in chronology, as students were taught to compute the variable date of Easter. They would finish with a study of the allegorical meaning of numbers. Geometry was based on the study of the Greek mathematician Euclid. Astronomy was derived from the Roman writer Pliny the Elder, with some attention to Bede's work. Music was the theoretical study of scale, proportion, the harmony of the universe, and the "music of the spheres." Music in this period was distinguished from *cantus*, which was the practical knowledge of chants and hymns for church use. In general, all study was based largely on rote mastery of texts.

Beyond the foundation of schools, Charlemagne needed scholars to reform existing texts and to halt their terrible corruption, especially for those used in church worship. Literary revival was closely connected with **liturgical** revival. Part of Charlemagne's educational reform envisioned people who would read aloud and sing in church from decent, reliable texts. Literacy was conceived as a necessary prerequisite for worship.

Alcuin of York mainly worked at revising the liturgical books. He published a book of Old and New Testament passages in Latin for public reading during Mass. He sent for books from Rome in order to publish a *sacramentary*, a book of prayers and rites for the administration of the sacraments of the church. Alcuin's sacramentary was made obligatory for the churches of the Frankish kingdom in 785. Charlemagne made

1. Howard N. Lupovich, *Jews and Judaism in World History* (New York: Routledge, 2010).

the Roman chant (called *Gregorian* after Pope Gregory the Great, who was said to have initiated such chants at the end of the sixth century) obligatory in all churches of his realm. Alcuin also attempted to correct scribal errors in the **Vulgate Bible** (the Latin version of Saint Jerome) by a comparative reading of manuscripts—a gigantic task he never completed.

Beyond the practical need for literacy, there was a further aim of education in this period. It was generally believed that all learning would lead to a better grasp of revealed truth—the Bible. The study of profane letters (by and large, the literature of Rome) was a necessary first step toward the full study of the Bible. The study of grammar would set out the rules of writing, while dialectic would help distinguish true from false propositions. Models for such study were sought in the works of Cicero, Statius, Ovid, Lucan, and Virgil. These principles of correct writing and argumentation could then be applied to the study of the Bible in order to get closer to its truth. The pursuit of analysis, definition, and verbal clarity are the roots from which the scholastic form of philosophy would spring in the High Middle Ages. Scholasticism, which dominated European intellectual life until the eve of the Renaissance, had its beginnings in the educational methodology established by Alcuin and his companions.

These educational enterprises were not centered exclusively at the palace school at Aachen. Under Charlemagne's direction, Alcuin developed a system of schools throughout the empire—schools centered in both monasteries and towns. Attempts were also made to attach them to parish churches in rural areas. The monastic school at Metz became a center for singing and liturgical study; schools at Lyons, Orléans, Mainz, Tours, and Laon had centers for teaching children rudimentary literary skills and offered some opportunity for further study in the liberal arts and the study of scripture. The establishment of these schools was accomplished by a steady stream of decrees and **capitularies** emanating from the Aachen palace. A circular letter written most likely by Alcuin, called *Epistola de litteris colendis (Letter on the Cultivation of Writing)*, encouraged monks to study the Bible and to teach the young to do the same. A decree of 798 insisted that prelates and country clergy alike start schools for children.

This program of renewal in educational matters was an ideal set forth at a time when education was at an ebb in Europe. Charlemagne tried to reverse that trend and in so doing encouraged real hope that there could be an educated class in his time. His efforts were not entirely successful; many of his reforms came to naught in following generations, when Europe slipped back into violence and ignorance.

Most of those who were educated were young men, although there is some evidence of learning among the aristocratic women of Charlemagne's court. The only book written in Charlemagne's time by a Frankish woman who was not a nun was a sort of manual for Christian living, written by Dhuoda for the instruction of her own son. We do, however, know that there had to be a certain level of literacy for nuns, and some evidence also suggests that illuminated manuscripts that have come to us were created by women in convents.

MONASTICISM

Monasticism—from the Greek *monos* ("single")—was an integral part of Christianity from the third century on. Monasticism came into the West from the great Eastern tradition of *asceticism* (self-denial) and *eremitism*[2] (the solitary life). Its development in the West was complex, and we cannot speak of any one form of monasticism as predominant before the time of Charlemagne.

Celtic monasticism in Ireland was characterized by austere living and a lively intellectual tradition. Monasticism in Italy was far more simple and rude. Some of the monasteries of continental Europe were lax, and the region was full of wandering monks. No rule of life predominated in the sixth and seventh centuries. Monastic lifestyles varied not only from country to country but also from monastery to monastery.

The Rule of Saint Benedict

One strain of European monasticism derived from a rule of life written in Italy by Benedict of Nursia (480–547) in the early sixth century. Although it borrowed from earlier monastic rules and was applied only to a small proportion of monasteries for a century after its publication, the Rule of Saint Benedict eventually became the Magna Carta of monasticism in the West. Charlemagne had Alcuin of York bring the rule to his kingdom and impose it on the monasteries to reform them and instill some sense of regular observance. In fact, the earliest copy of the Rule of Saint Benedict we possess today (a ninth-century manuscript preserved in the Swiss monastery of Saint Gall) is a copy of a copy Charlemagne had made in 814 from Saint Benedict's autographed copy, which had been preserved at the Abbey of Montecassino in Italy but is now lost.

The Rule of Saint Benedict consists of a prologue and 73 chapters (some only a few sentences long), which set out the ideal of monastic life. Monks (the brethren) were to live a family life in community under the direction of a freely elected father (the abbot) for the purpose of being schooled in religious perfection. They were to possess nothing of their own (poverty); they were to live in one monastery and not wander (stability); their life was to be one of obedience to the abbot; and they were to remain unmarried (chastity). Their daily life was to be a balance of common prayer, work, and study. Their prayer life centered on duly appointed hours of liturgical praise of God that were to mark the intervals of the day. Called the Divine Office, this liturgy consisted of the public recitation of psalms, hymns, and prayers, with readings from the scriptures. The offices were interspersed throughout the day and were central to the monks' lives. The periods of public liturgical prayer set off the times for reading, study, and the manual labor that was performed for the good of the community and its sustenance. The lifestyle of

2. You may notice that this term and the word *hermit* share a common origin.

COMPARE + CONTRAST

Four Paintings of Saint Matthew

Given Charlemagne's preoccupation with literary culture and his love of Classical art, it should not be surprising that a great deal of artistic effort was expended on the production and illuminations of manuscripts. His own gospel book, called the Coronation Gospels (Fig. 9.4), includes a painting of Saint Matthew, an evangelist who was thought to have written the first gospel. Matthew is represented as an educated Roman writer diligently at work. Only the halo around his head reveals his sacred identity. He does not appear as an otherworldly weightless figure awaiting a bolt of divine inspiration. His attitude is calm, pensive, and deliberate. His body has substance; it is seated firmly, and the drapery of his toga falls naturally over his limbs. The artist uses painterly strokes and contrast of light and shade to define his forms much in the same way that the wall painters of ancient Rome had done.

Although Classicism was preferred by the Holy Roman emperor, it was not the only style during the Carolingian period.

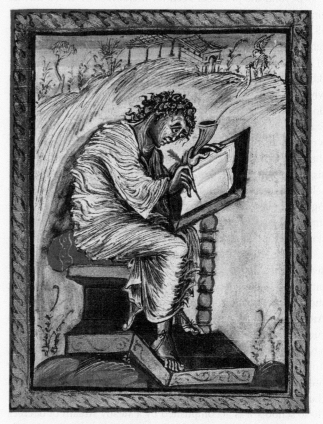

▲ 9.5 "Saint Matthew," folio 18 verso of the Ebbo Gospels (gospel book of Archbishop Ebbo of Reims), ca. 816–835. Ink and tempera on vellum, 10¼" × 8¾" (26 × 22.2 cm). Bibliothèque Municipale, Épernay, France.

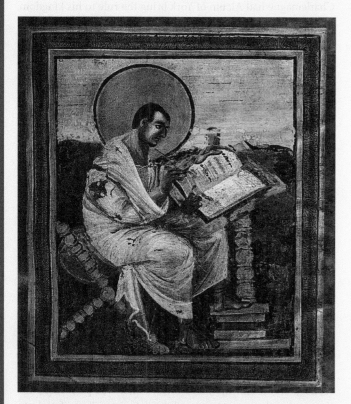

▲ 9.4 "Saint Matthew," folio 15 recto of the Vienna Coronation Gospels (gospel book of Charlemagne), ca. 800–810. Tempera on purple-dyed vellum, 9⅞" × 12¾" (25.1 × 32.2 cm). Schatzkammer, Kunsthistorisches Museum, Vienna, Austria.

The gospel book of Archbishop Ebbo of Reims (Fig. 9.5) was created only five to 10 years after the Coronation Gospels and yet it could not be more different. The sense of rational calm evident in Charlemagne's gospel book stands in marked contrast to the passion and energy overtaking Ebbo's evangelist. In both gospels, Matthew sits at a writing table surrounded by a landscape. Charlemagne's Matthew, however, appears to rely on his own intellect to pen his gospel, whereas Ebbo's evangelist, scroll in hand, seems to rush to jot down every word relayed to him by the angel of God, feverishly trying to keep up. His brow is furrowed, and his hands and feet cramp under the strain of his task.

The mood in the paintings differs dramatically. In the Coronation Gospels, the soft folds of Matthew's garment are echoed in his serene surroundings. He is pensive, dignified,

The differences between the St. Matthews of the Coronation and Ebbo Gospels are revisited, it seems, in the contrast between Rembrandt's version of the saint and Guido Reni's (**Fig. 9.7**). Reni, an Italian Baroque painter whose work was created about 30 years earlier, portrays Matthew with a shock of tousled white hair, his gaze fixed intently on a young boy—the angel—who seems to count off on his small fingers the essential points to be included in the gospel. Matthew grips his journal and balances it in the air, not daring to lift his pen lest he miss something important. He stoops and leans in closely, listening carefully to every word. Matthew's faith in God and devotion to his task are magnified by the almost absurd suggestion that a grown man would be so deferential to a youth. The sense of urgency that permeates Reni's depiction of Matthew has its own symbolism, its own prophetic character; Matthew would become a Christian martyr, slain for the practice of his faith.

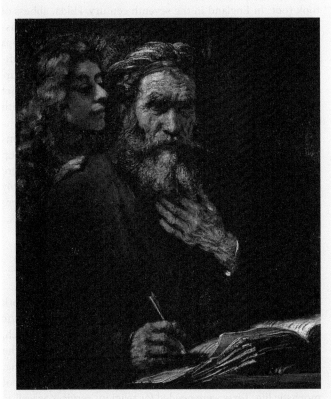

▲ 9.6 **Rembrandt van Rijn,** *Saint Matthew and the Angel,* **1661. Oil on canvas, 34¾ × 31⅞" (96 × 81 cm). Musée du Louvre, Paris, France.**

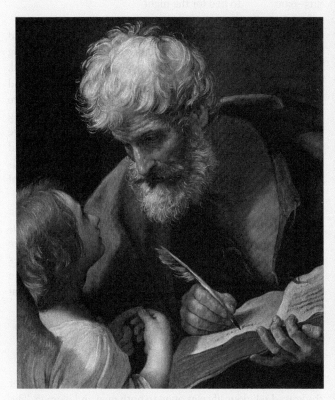

▲ 9.7 **Guido Reni,** *Saint Matthew the Evangelist,* **1635–1640. Oil on canvas, 33½" × 26¾" (85 × 68 cm). Pinacoteca, Vatican Museums, Vatican City State, Italy.**

and scholarly. By contrast, the restless drapery, disheveled hair, facial contortions, and heaving landscape in the Ebbo Gospels convey the sense of a dramatic, highly charged spiritual experience.

The Matthew of the Ebbo Gospels may not be as realistically rendered as the Matthew of the Coronation Gospels, but he does seem more human. Centuries later, the subject of the evangelist and his angel remained popular. Differences in style and pictorial devices reveal very personal perspectives on Matthew. Rembrandt van Rijn, the Dutch master of the 17th century, portrays him as mature man with the wisdom to pen this biography of Christ (**Fig. 9.6**). He pauses, quill in hand, and stares as if lost in thought. He brings his left hand to his heart and twirls the strands of his coarse beard with his fingertips. As if to offer encouragement to continue, an angel lays a hand gently on his shoulder and seems to whisper in his ear.

Benedictine monasticism can be summed up in its motto: "Pray and work." The rule was observed by both men and women.

THE REGULATED DAY IN THE MONASTERY The daily life of a monk was determined by sunrise and sunset (as it was for most people in those days). Here is a typical day—called the *horarium*—in an early medieval monastery. The italicized words designate the names for the liturgical hours of the day.

Horarium Monasticum

2:00 A.M.	Rise
2:10–3:30	*Nocturns* (later called *Matins*; the longest office of the day)
3:30–5:00	Private reading and study
5:00–5:45	*Lauds* (the second office; also called "morning prayer")
5:45–8:15	Private reading and *Prime* (the first of the short offices of the day); at times, there was communal Mass at this time and, in some places, a light breakfast, depending on the season
8:15–2:30	Work punctuated by short offices of *Tierce*, *Sext*, and *None* (literally the third, sixth, and ninth hours)
2:30–3:15	Dinner
3:15–4:15	Reading and private religious exercises
4:15–4:45	*Vespers*—break—*Compline* (night prayers)
5:15–6:00	To bed for the night

This daily regimen changed on feast days (less work and more prayer) and during the summer (rising earlier, working later in the day when the sun was down a bit, eating more food, and so on). Although the schedule now seems harsh, it would not have surprised a person of the time. Benedict would have found it absurd for people to sleep while the sun was shining and then stay up under the glare of artificial light. When we look at the horarium closely, we see that monks prayed and studied eight hours a day, whereas they worked for an additional six hours. The rest of the day was devoted to personal chores, eating, and the like.

The triumph of the Benedictine monastic style of life (the Early Middle Ages have been called the Benedictine centuries by some historians) is to be found in its sensible balance between the extreme asceticism of Eastern monastic practices and the unstructured life of Western monasticism before the Benedictine reforms. There was a balance of prayer, manual labor, and intellectual life.

Women and Monastic Life

We tend to think of monasticism as a masculine enterprise, but the vowed religious life was open to both men and women. The entire early history of Christianity records a flourishing monastic life for women. In the late Roman period, groups of religious women flourished all over the Roman Empire. Benedict's own sister, Scholastica (died ca. 543), was head of a monastery not

far from her brother's establishment at Monte Cassino. Her contemporary, Brigit of Ireland (died ca. 525), was such a powerful figure in the Irish church that legends grew up about her prowess as a miracle worker and teacher. Her reputation as a saint was such that churches dedicated to her dotted Ireland, England, and places on the continent where Irish monasticism took root. In England in the seventh century, Hilda, abbess of Whitby (614–680), not only ruled over a prominent monastery that was a center of learning (many Anglo-Saxon bishops were educated there) but also held a famous episcopal gathering (synod) to determine church policy. Hilda also encouraged lay learning. She fostered the talents of the cowherd poet Caedmon, who produced vernacular poetry concerned with Christian themes.

We possess several edifying lives written by the contemporaries of these women, which laud their decision to give up marriage in order to serve God. These lives of the saints were extremely popular because they served as exemplars of holy living. They were read publicly in churches (hence, they were called *legends*—things read aloud) and privately for devotions.

MUSIC

The main occupation of the monk was the *opus Dei* (work of God)—the liturgical common prayer of the *monastic horarium*—and life revolved around the monastic church, where the monks gathered seven times a day for prayer. The centrality of the liturgy also explains why copying, correcting, and illuminating manuscripts were such important parts of monastic life. Texts were needed for religious services as well as for spiritual reading. The monks were encouraged to study the scriptures as a lifelong occupation. This study was *lectio divina* (divine reading), central to their development as monks. The monastic life encouraged the study of the Bible and such ancillary disciplines (grammar, criticism, and the like) as necessary for the study of scripture. From the seventh century on, monastic scriptoria were busily engaged in copying a wealth of material, both sacred and profane.

The monasteries were also centers for the development of sacred music. We have already seen that Charlemagne was interested in church music. His biographer Einhard tells us that the emperor "made careful reforms in the way in which the psalms were chanted and the lessons read. He was himself an expert at both of these exercises but he never read the lesson in public and he would sing only with the rest of the congregation and then in a low voice." Charlemagne's keen interest in music explains why certain monasteries of his reign—notably those at Metz and Trier—became centers for church music.

Gregorian Chant

Charlemagne brought monks from Rome to stabilize and reform church music in his kingdom as part of his overall plan of liturgical renovation. In the earlier period of Christianity's

growth, diverse traditions of ecclesiastical music developed in various parts of the West. Roman music represented one tradition—later called *Gregorian chant*. Milan had its own musical tradition, known as *Ambrosian* music—in honor of Saint Ambrose, who had been a noted hymn writer, as Saint Augustine attests in the *Confessions*. There was a peculiar regional style of music in Spain known as *Mozarabic* chant, and the Franks also had their own peculiar style of chant. All of these styles derive from earlier models of music that have their roots in Hebrew, Graeco-Roman, and Byzantine styles. Lack of documentation permits only an educated reconstruction of this early music and its original development.

The following listening selection is an early example of Gregorian chant in which every syllable has its own note and the only extended phrases come at the end of each line. Even the final alleluia is simple and unelaborated.

Note that of the three elements that characterize most Western music—melody, harmony, and rhythm—only the first is present. The melody is based entirely on the words of the text. No accompanying line provides harmony, and no repeated rhythm provides musical form: the text dominates the musical structure. The only element of musical variety is the contrast between a single voice and massed voices. The musical content of the listening selection is intended to heighten the significance of the text rather than add any extra element of its own.

GO LISTEN!
ANONYMOUS
"Victimae paschali Laudes"

Gregorian chant as we know it today was not codified until the 11th and 12th centuries, so it is rather difficult to reconstruct precisely the music of Charlemagne's court. It was probably a mixture of Roman and Frankish styles of singing. It was **monophonic** (one or many voices singing a single melodic line) and, ordinarily, would be sung **a cappella** (without instrumental accompaniment) in the monastic churches. Scholars believe that most music consisted of simple chants for the recitation of the psalms at the Divine Office; more elaborate forms were used for the hymns of the office and the Mass chants. The music was simply called *cantus planus* (plainsong or plainchant).

GREGORIAN STYLE As the printed example shows, the written form of the music does not correspond to the modern style, which would not be invented until around 1000 by Guido d'Arezzo. In its elementary form, the chant consisted of a single note for each syllable of a word. The basic symbols used to notate Gregorian chant are called *neumes*. In the Gregorian notational system with its four-line staff, the opening line of Psalm 109, "Dixit Dominus Domino meo, sede a dextris meis" (The Lord said to my Lord: sit on my right hand), would look like the following.

1. Di-xit Dóminus Dómino mé- o : * Séde a déxtris mé- is.

Even in the earliest form of chants, a **cadence** (a rhythmic flow of a sequence of sounds or words) was created by emphasizing the final word of a phrase with the addition of one or two extra notes, as seen in the example. Later, more notes were added to the final words or syllables for elaboration and variation.

The simplicity of syllabic chant should not be regarded as useful only for the monotonous chanting of psalm verses. Very simple yet hauntingly melodic Gregorian compositions still exist that do not use elaborate cadences but rely on simple syllabic notes.

Certain phrases, especially words of acclamation (like *alleluia*) or the word at the end of a line, were musically elaborated beyond the one-to-one correlation between note and syllable in the simple chant. This extensive addition of a chain of intricate notes sung on the vowel sound of a single syllable was called a **melisma**. Thus, for example, a melisma might elaborate the final *a* ("ah") of *alleluia* or the *ie* ("ee-ay") of *kyrie* in the Kyrie Eleison (the Greek "Lord, have mercy on us" retained in the Latin Mass).

The Liturgical Trope

Because books were scarce in the Carolingian period, monks memorized a great deal of liturgical chant. To aid memorization and add variety in the chant, words would be added to the long melismas. These words, **tropes**, were verbal elaborations of, or comments on, the text. Thus, for example, the melismatic Kyrie Eleison might take on such tropes as *sanctus* (holy) and *dominus* (lord), which were sung to the tune of the melisma. The use of tropes grew rapidly and became standard in liturgical music, until they were removed from the liturgy at the time of the Counter-Reformation in the 16th century.

Scholars have pointed to the introduction of tropes into liturgical music as the origin of drama in the Western world. There had been drama in the Classical and Byzantine worlds, but drama in Europe developed from the liturgy of the medieval church after having largely been lost (or suppressed) in the very early Middle Ages.

A ninth-century manuscript (preserved at the monastery of Saint Gall) demonstrates an early trope that was added to the music of the Easter entrance hymn (the Introit) for Mass. It is in the form of a short dialogue and seems to have been sung by either two different singers or two choirs. It is called the *Quem quaeritis* trope, from its opening lines.

De resurrectione Domini	Of the Lord's Resurrection
Int[errogatio]: *Quem quaeritis in* *sepulchro, o Christicolae?*	Question [of the angels]: *Whom seek ye in the* *sepulcher, O followers* *of Christ?*
R[esponsio]: *Jesum Nazarenum* *crucifixum, o coelicolae.*	Answer [of the Marys]: *Jesus of Nazareth,* *which was crucified,* *O celestial ones.*
[Angeli:] *Non est hic; surrexit, sicut,* *praedixerat.* *Ite, nuntiate quia surrexit* *de sepulchro.*	[The angels:] *He is not here; he is risen,* *just as he foretold.* *Go, announce that he is* *risen from the sepulcher.*

Very shortly after the introduction of this trope into the Easter Mass, the short interrogation began to be acted, not at Mass but at the end of the night services preceding Easter dawn. The dialogue of the *Quem quaeritis* (*Whom do you seek* ["in the sepulcher, O Christians"?]) was not greatly enlarged, but the directions for its singing were elaborated into the form of a short play. By the 11th and 12th centuries, the dialogue was elaborated and more people were added. By the 12th century, the stories took on greater complexity.

It was a logical step to remove these plays from the church and perform them in the public square. By the 14th century, sizable cycles of plays were performed in conjunction with various feast days and underwritten by the craft or merchants' guilds. Some of these cycles acted out the major stories of the Bible, from the Creation to the Last Judgment. The repertory also began to include plays about the lives of the saints and allegorical plays about the combats of virtue and vice, such as the 15th-century work *Everyman*. These plays were a staple of public life well into the 16th century; William Shakespeare, for example, may well have seen such plays in his youth.

LITERATURE

Writing continued during the Middle Ages in the West, some of it in Latin, some in Old English, and some in the other languages used throughout Europe. Some of these languages, including English, German, and most of the Nordic tongues, are *Teutonic*. French, Italian, Spanish, Portuguese, and Romanian are *Romance* languages. Arabic was also spoken in the Iberian peninsula. Oral traditions and writings appeared in all these languages.

Venerable Bede

In early medieval England, a monk by the name of Bede—called Saint Bede or the Venerable Bede (ca. 672/673–735)—wrote more than 60 books on religious and secular topics, many of which survive. He wrote in Latin and Old English, and knew some Greek and Hebrew. His topics range from music and mathematics to religious commentaries, and his *Ecclesiastical History of the English Nation* has led scholars to call him the Father of English History. He described the planet Earth as spherical and calculated the passages and phases of the moon. In chapter 2 of Book 1 of his *Ecclesiastical History*, Bede describes Julius Caesar's efforts to conquer the Britons, one of the groups of people occupying present-day England. Caesar sailed to Great Britain with some 80 ships in 60 BCE. His early battles with the Britons did not go well, and he met a violent storm in the English Channel, losing much of his fleet. Caesar returned later with some 600 ships, according to Bede, but many of them were "driven upon the sands" by the weather and destroyed. After numerous battles, Caesar was gaining the upper hand, as described in Reading 9.1:

> **READING 9.1 VENERABLE BEDE**
>
> *The Ecclesiastical History of the English Nation*, Book 1, chapter 2
>
> [Caesar then] proceeded to the river Thames, where an immense multitude of the enemy had posted themselves on the farthest side of the river, under the command of Cassibellaun, and fenced the bank of the river and almost all the ford under water with sharp stakes: the remains of these are to be seen to this day, apparently about the thickness of a man's thigh, and being cased with lead, remain fixed immovably in the bottom of the river. This, being perceived and avoided by the Romans, the barbarians not able to stand the shock of the legions, hid themselves in the woods, whence they grievously galled the Romans with repeated sallies. In the meantime, the strong city of Trinovantum, with its commander Androgeus, surrendered to Caesar, giving him forty hostages. Many other cities, following their example, made a treaty with the Romans.

Caesar left for Gaul—present-day France—and finding himself "beset and distracted with wars and tumults raised against him on every side," did not return to England.

In the *Ecclesiastical History*, Bede also tells of a serf who managed to escape his bondage. According to Bede, the formidable Abbess Hilda of Whitby spotted a swineherd singing. Enchanted by the quality of his voice, and presiding over a men's and women's monastery, she had him brought to the monks to be educated. In Bede's words: "So Caedmon stored up in his memory all that he learned and like one of the clean animals chewing the cud, turned it into such melodious verse that his delightful renderings turned his instructors into listeners" (Book 4, chapter 24).

Only one of his poems has survived, a nine-line piece known as "Caedmon's Hymn" that begins, "Now [we] must honor the guardian of heaven, the might of the architect." The importance of "Caedmon's Hymn" lies in the fact that it is the oldest example we have of a composition in Old English. Caedmon died in 680, but his hymn has immortalized this onetime serf as a pioneer in the history of English poetry.

Beowulf

The origin of *Beowulf* is a mystery. It is an Old English epic poem, written in the **vernacular** rather than in literary Latin, but we do not know whether it was first sung or written. It was created sometime between the 7th and 10th centuries and discovered in England, although it tells a tale of Danes and Swedes beyond the northern sea and is set early in the sixth century. It shows knowledge of the Hebrew Bible, and one may read knowledge of, or at least sensitivity to, Christianity in it.

Its birth does seem to follow the spread of Christianity in northern Europe. It was copied by scribes around the year 1000, then nearly lost in a fire in the 18th century.

Beowulf (the name literally means "bee wolf," or bear) comes to aid the good but grief-stricken king Hrothgar, whose soldiers have been mercilessly slaughtered by the "man-monster" Grendel for the strangest of reasons. Hrothgar has built a wondrous mead[3] hall for his retinue, called Heorot, but the singing and telling of tales in the evening annoys Grendel. It is for Grendel a capital crime:

READING 9.2 *BEOWULF*, LINES 86–98

Then a powerful demon, a prowler through the dark,
nursed a hard grievance. It harrowed him
to hear the din of the loud banquet
every day in the hall, the harp being struck
and the clear song of a skilled poet
telling with mastery of man's beginnings,
how the Almighty had made the earth
a gleaming plain girdled with waters;
in His splendor He set the sun and the moon
to be earth's lamplight, lanterns for men,
and filled the broad lap of the world
with branches and leaves; and quickened life
in every other thing that moved.

The poem is translated into modern English, but as in the lines you have read, there is no rhyme scheme. Rather, there is **alliteration**: consonants are repeated throughout the lines—"dweller in darkness," "made merry with mead." There are also pauses in the lines, providing a rhythm, as if they swing left and right.

One night the murders begin:

READING 9.3 *BEOWULF*, LINES 99–107, 115–125

So times were pleasant for the people there
until finally one, a fiend out of hell,
began to work his evil in the world.
Grendel was the name of this grim demon
haunting the marshes, marauding round the heath
and the desolate fens; he had dwelt for a time
in misery among the banished monsters,
Cain's clan, whom the Creator had outlawed
and condemned as outcasts. . . .
. . . .
So, after nightfall, Grendel set out
for the lofty house, to see how the Ring-Danes

were settling into it after their drink,
and there he came upon them, a company of the best
asleep from their feasting, insensible to pain
and human sorrow. Suddenly then
the God-cursed brute was creating havoc:
greedy and grim, he grabbed thirty men
from their resting places and rushed to his lair,
flushed up and inflamed from the raid,
blundering back with the butchered corpses.

Daylight comes and there are "fits of weeping" and "cries of outrage." Hrothgar beholds the carnage and sinks on his throne. The killing goes on for years, and Horthgar offers a reward for anyone who can rid his kingdom of Grendel.

Beowulf—from a nearby land, "kind to kinfolk," righteous, and "more mighty than any then living"—arrives and presents himself to Hrothgar. Beowulf and Hrothgar talk of a legendary feat at sea in which Beowulf swam against whale-like currents. Beowulf boasts of having the strength and skill to kill Grendel with his bare hands. To make his point, he removes his armor and puts aside his sword when he sets to sleep with Hrothgar's men. Grendel comes that night:

READING 9.4 *BEOWULF*, LINES 736–765, 808–823

 Mighty and canny,
Hygelac's kinsman[4] was keenly watching
for the first move the monster would make.
Nor did the creature keep him waiting
but struck suddenly and started in;
he grabbed and mauled a man on his bench,
bit into his bone-lappings, bolted down his blood
and gorged on him in lumps, leaving the body
utterly lifeless, eaten up
hand and foot. Venturing closer,
his talon was raised to attack Beowulf
where he lay on the bed; he was bearing in
with open claw when the alert hero's
comeback and armlock forestalled him utterly.
The captain of evil discovered himself
in a handgrip harder than anything
he had ever encountered in any man
on the face of the earth. Every bone in his body
quailed and recoiled, but he could not escape.
He was desperate to flee to his den and hide
with the devil's litter, for in all his days
he had never been clamped or cornered like this.
Then Hygelac's trusty retainer recalled
his bedtime speech, sprang to his feet

3. An alcoholic drink made of fermented honey and water.

4. Beowulf.

and got a firm hold. Fingers were bursting,
the monster back-tracking, the man overpowering.
The dread of the land was desperate to escape,
to take a roundabout road and flee
to his lair in the fens. The latching power
in his fingers weakened; it was the worst trip
the terror-monger had taken to Heorot.

. . . .

Then he who had harrowed the hearts of men
With pain and affliction in former times
And had given offence also to God
found that his bodily powers failed him.
Hygelac's kinsman kept him helplessly
locked in a handgrip. As long as either lived,
he was hateful to the other. The monster's whole
body was in pain, a tremendous wound
appeared on his shoulder. Sinews split
and the bone-lappings burst. Beowulf was granted
the glory of winning; Grendel was driven
under the fen-banks, fatally hurt,
to his desolate lair. His days were numbered,
the end of his life was coming over him,
he knew it for certain; and one bloody clash
had fulfilled the wishes of the Danes.

Beowulf's contests are not finished. He will go on to war with, and defeat, Grendel's vengeful mother. Then he will fight with a dragon. He will vanquish the dragon but lose his own life in the process.

The monsters in *Beowulf* are not simply born with instinctive aggressiveness, as are the lion and the wolf; they represent wrath and evil. *Beowulf* was written in the oldest form of English after Nordic peoples—including the Danes and Swedes in the poem—emigrated to the British Isles from their native lands and, presumably, brought their legends and their stories with them. Yet some of those in the epic are actually recorded in the history of the sixth century—although not as having been in conflict with monsters.

Hildegard of Bingen

Because monasticism presumed a certain degree of literacy, it was possible for women to exercise their talents in a way that was not available to them within the confines of the more restricted life of the court or the family. The Benedictine tradition produced great figures such as Hildegard of Bingen (1098–1179), who wrote treatises on prayer, philosophy, medicine, and devotion. Her *Scivias* (*The Way to Knowledge*) includes mystical, cosmic visions symbolizing the structure of a universe created and sustained by God, such as the following one.

Then I saw a huge image, round and shadowy. It was pointed at the top, like an egg. . . . Its outermost layer was

▲ **9.8** Hildegard of Bingen, "Vision of the Ball of Fire," 1141–1151. From *Scivias* ("Know the Ways"). Illuminated miniature on manuscript page 12¾" × 9¼" (32.5 × 23.5 cm). Original destroyed; faithful illuminated copy 1927–1933, Benedictine Abbey of St. Hildegard, Eibingen, Germany.

of bright fire. Within lay a dark membrane. Suspended in the bright flames was a burning ball of fire, so large that the entire image received its light. Three more lights burned in a row above it. They gave it support through their glow, so that the light would never be extinguished[5] (Fig. 9.8).

Hildegard's visions were exceptionally detailed and often described God's call to her to reveal the mysteries embedded in scripture and to preach them, as we see in Reading 9.5:

READING 9.5 HILDEGARD OF BINGEN

Scivias, Vision One: God Enthroned Shows Himself to Hildegard

I saw a great mountain the color of iron, and enthroned on it One of such great glory that it blinded my sight. . . .

5. From *Hildegard of Bingen: Scivias*, translated by Mother Columbia Hart and Jane Bishop, from *The Classics of Western Spirituality*, Copyright © 1990 by the Abbey of Regina: Laudis Benedictine Congregation Regina Laudis of the Strict Observance, Inc., New York/Mahwah, N.J. Used with permission of Paulist Press, www.paulistpress.com

And behold, He Who was enthroned upon that mountain cried out in a strong, loud voice saying, "O human, who are fragile dust of the earth and ashes of ashes! Cry out and speak of the origin of pure salvation until those people are instructed, who, though they see the inmost contents of the Scriptures, do not wish to tell them or preach them, because they are lukewarm and sluggish in serving God's justice. Unlock for them the enclosure of mysteries that they, timid as they are, conceal in a hidden and fruitless field. Burst forth into a fountain of abundance and overflow with mysterious knowledge, until they who now think you contemptible because of Eve's transgression are stirred up by the flood of your irrigation. For you have received your profound insight not from humans, but from the lofty and tremendous judge on high, where this calmness will shine strongly with glorious light among the shining ones.

"Arise therefore, cry out and tell what is shown to you by the strong power of God's help, for He Who rules every creature in might and kindness floods those who fear Him and serve Him in sweet love and humility with the glory of heavenly enlightenment and leads those who persevere in the way of justice to the joys of the Eternal Vision."

Embedded in the passage is an allusion to the church's view of women as culpable for the downfall of humanity, as the descendants of Eve and the inheritors of her transgression. But Hildegard's voice is sanctioned, having received "profound insight" not from members of the church (humans who are "lukewarm and sluggish in serving God's justice") but from God directly.

Between the writing of her visionary books, Hildegard also completed two medical works: *Physica* catalogues, among other things, the medicinal benefits of herbs and other plants; *Causae et Curae* is an encyclopedia of illnesses and their cures as well as an exposition on physiology. *Causae et Curae* was controversial both for its explicit portrayals of sexual acts and its anatomical and physiological assumptions:

READING 9.6 HILDEGARD OF BINGEN

Causae et Curae, Women's Physiology, On Intercourse

When a woman is making love with a man, a sense of heat in her brain, which brings with it sensual delight, communicates the taste of that delight during the act and summons forth the emission of the man's seed. And when the seed has fallen into its place, that vehement heat descending from her brain draws the seed to itself and holds it, and soon the woman's sexual organs contract, and all the parts that are ready to open up during the time of menstruation now close, in the same way as a strong man can hold something enclosed in his fist.

In addition to these more practical works, Hildegard composed a song cycle of hymns and sequences called the *Symphonia* that honored, in particular, the Virgin Mary. Hildegard's musical style has been described as having both monophonic (single melodies without harmonies) and melismatic (consisting of single syllables sung while moving between several successive notes) elements.

The Nonliturgical Drama of Roswitha

At the end of the Early Middle Ages, we also have evidence of plays that did not depend on liturgical worship. Thus, a German poet and nun named Roswitha (or Hrosvitha; the name is spelled variously), who lived at the aristocratic court of Gandersheim and died around the year 1000, has left us a collection of legends written in Latin and six plays modeled on the work of the Roman dramatist Terence. What is interesting about this well-educated woman is the broad range of her learning and her mastery of classical Latin in an age that did not put a high premium on the education of females. Scholars also point out that her prose legend of Theophilus is the first known instance in German literature of the Faust theme—the selling of one's soul to the devil for material gain and public glory.

Roswitha's plays were probably meant to be read aloud by a small circle of literate people, but some internal evidence suggests that they may also have been acted out in some rudimentary fashion. They are heavily moralistic (typically involving a religious conversion or steadfastness in faith during a time of persecution) and didactic. In the play *The Conversion of the Harlot Thaïs*, for example, the holy man Pafnutius begins with a long conversation with his disciples on a liberal education and the rules of musical proportion and harmony. Such a discussion would seem a wild digression to us today, but for Roswitha's audience, it would be not only a way of learning about the liberal arts but also a reminder that the study of them inevitably leads to a consideration of God. That her plays do not have a finished dramatic quality underscores the fact that she was the *first* dramatist writing in Germany (as well as Germany's first female poet). Her model was the ancient drama of Rome as far as style was concerned, but her intention was to use that style to educate and convert. She was a direct heir of the humane learning that developed in the Carolingian and Ottonian periods.

In Reading 9.7 on page 294, taken from scene 3, in the second half of the play, Pafnutius pretends to visit Thaïs for sexual purposes and then undertakes her conversion.

The Morality Play: *Everyman*

Everyman is a 15th-century play that may well be a translation from a much earlier Dutch play. The subject is no longer a redoing of a biblical theme but rather the personification of abstractions representing a theme dear to the medieval heart:

READING 9.7 ROSWITHA

From *The Conversion of the Harlot Thaïs*, scene 3

PAFNUTIUS Are you inside, Thaïs, whom I'm seeking?/

THAÏS Who is the stranger speaking?/

PAFNUTIUS One who loves you.

THAÏS Whoever seeks me in love/ finds me returning his love./

PAFNUTIUS Oh Thaïs, Thaïs, what an arduous journey I took to come to this place/ in order to speak with you and to behold your face./

THAÏS I do not deny you the sight of my face nor my conversation./

PAFNUTIUS The secret nature of our conversation/ necessitates the solitude of a secret location./

THAÏS Look, here is a room well furnished for a pleasant stay./

PAFNUTIUS Isn't there another room, where we can converse more privately, one that is hidden away?/

THAÏS There is one so hidden, so secret, that no one besides me knows its inside except for God./

PAFNUTIUS What God?/

THAÏS The true God./

PAFNUTIUS Do you believe He knows what we do?/

THAÏS I know that nothing is hidden from His view./

PAFNUTIUS Do you believe that He overlooks the deeds of the wicked or that He metes out justice as its due?/

THAÏS I believe that He weighs the merits of each person justly in His scale/ and that, each according to his desserts receives reward or travail./

PAFNUTIUS Oh Christ, how wondrous is the patience, of Thy great mercy! Thou seest that some sin with full cognition,/ yet Thou delay their deserved perdition./

THAÏS Why do you tremble? Why the change of color? Why all these tears?

PAFNUTIUS I shudder at your presumption,/ I bewail your sure perdition/ because you know all this so well,/ and yet you sent many a man's soul to Hell./

THAÏS Woe is me, wretched woman!

PAFNUTIUS You deserve to be damned even more,/ as you offended the Divine Majesty haughtily, knowing of Him before./

THAÏS Alas, alas, what do you do? What calamity do you sketch?/ Why do you threaten me, unfortunate wretch?/

PAFNUTIUS Punishment awaits you in Hell/ if you continue in sin to dwell./

THAÏS Your severe reproach's dart/ pierces the inmost recesses of my heart./

PAFNUTIUS Oh, how I wish you were pierced through all your flesh with pain/ so that you wouldn't dare to give yourself to perilous lust again./

THAÏS How can there be place now for appalling lust in my heart when it is filled entirely with the bitter pangs of sorrow/and the new awareness of guilt, fear, and woe?/

PAFNUTIUS I hope that when the thorns of your vice are destroyed at the root,/ the winestock of penitence may then bring forth fruit./

THAÏS If only you believed/ and the hope conceived/ that I who am so stained,/ with thousands and thousands of sins enchained,/ could expiate my sins or could perform due penance to gain forgiveness!

PAFNUTIUS Show contempt for the world, and flee the company of your lascivious lovers' crew./

THAÏS And then, what am I to do?/

PAFNUTIUS Withdraw yourself to a secret place,/ where you may reflect upon yourself and your former ways/ and lament the enormity of your sins.

THAÏS If you have hopes that I will succeed,/ then I will begin with all due speed./

. . .

PAFNUTIUS Oh how you have changed from your prior condition/ when you burned with illicit passions/ and were inflamed with greed for possessions./

THAÏS Perhaps, God willing,/ I'll be changed into a better being./

PAFNUTIUS It is not difficult for Him, Himself unchangeable, to change things according to His will./

the struggle for the soul. The unprepared reader of *Everyman* will note the heavy-handed allegorizing and moralizing (complete with a doctor who makes a final appearance to point up the moral of the play) with some sense of estrangement, but with a closer reading, students will also note the stark dignity of the play, the earnestness with which it is constructed, and the economy of its structure. *Everyman* is a good example of the transitional play that forms a link between the earlier liturgical drama and the more secular drama that was to come at the end of the English medieval period.

The plot of *Everyman* is simplicity itself; it is summarized by the messenger who opens the play. Everyman must face God in final judgment after death. Yet as we see in Reading 9.8, God, a character in the play, is angry—or at least frustrated—with His creation:

READING 9.8 *EVERYMAN*, LINES 22–35

[GOD SPEAKETH]

GOD: I perceive here in my majesty,
How that all the creatures be to me unkind,
Living without dread in worldly prosperity:
Of ghostly sight the people be so blind,
Drowned in sin, they know me not for their God;
In worldly riches is all their mind,
They fear not my rightwiseness, the sharp rod;
My law that I shewed, when I for them died,
They forget clean, and shedding of my blood red;
I hanged between two, it cannot be denied;

> To get them life I suffered to be dead;
> I healed their feet; with thorns hurt was my head:
> I could do no more than I did truly,
> And now I see the people do clean forsake me.

None of the aids and friends of this life will support Everyman, as the speeches of the allegorical figures of Fellowship and others make clear. The strengths for Everyman come from the aiding virtues of Confession, Good Deeds, and Knowledge. The story, however, is not the central core of this play; the themes that run through the entire play are what should engage our attention. First is the common medieval notion of life as a pilgrimage, which surfaces repeatedly. It is embedded not only in the medieval penchant for pilgrimage but also in the use of the metaphor (as one sees, for example, in Chaucer). Second, the notion of the inevitability of death as the defining action of human life is omnipresent in medieval culture. Everyman has an extremely intense *memento mori* ("Keep death before your eyes!") motif. Finally, medieval theology places great emphasis on the will of the human being in the attainment of salvation. It is not faith (this virtue is presumed) that will save Everyman; his willingness to learn (Knowledge), act (Good Deeds), and convert (Confession) will make the difference between salvation and damnation.

The Messenger says that *Everyman* is "by figure a moral play." It is meant not merely to instruct on the content of religion (as does a mystery play) but to instruct for the purposes of moral conversion. The earlier mystery plays usually point out a moral at the end of the performance. The morality play uses its resources to moralize throughout the play.

The one lingering element from the liturgy in a play like *Everyman* is its pageant quality: the dramatic force of the presentation is enhanced by the solemn wearing of gowns, the stately pace of the speeches, and the seriousness of the message. The play depends less on props and place. Morality plays did not evolve directly out of liturgical drama (they may owe something to the study of earlier plays based on the classics studied in schools), but the liturgical overtones are not totally absent.

The Song of Roland

The memory of Charlemagne and his epoch was kept vividly alive in cycles of epic poems and in tales and memoirs developed, embellished, and disseminated by poets and singers throughout Europe from shortly after his time until the Late Middle Ages. These are the famous *chansons de geste* ("songs of deeds") or, as some were called, *chansons d'histoire* ("songs of history"). Of these songs, the oldest extant—as well as the best known—is *The Song of Roland.*

The Song of Roland was written sometime late in the 11th century, but behind it lay some 300 years of oral tradition and earlier poems celebrating a battle between Charlemagne's army and a Muslim force at the Spanish border. Charlemagne did

campaign against the emirate of Spain in 777 and 778 without conclusive result. In August 778, Charlemagne's rear guard was ambushed by the Basques while making its way through the Pyrenees after the invasion of Spain. The real extent of that battle (later placed, on not too much evidence, at the town of Roncesvalles) is unclear. Some experts maintain that it was a minor skirmish, remembered in the area in local legends that were later told and retold (and considerably embellished in the process) by monks of the monasteries and sanctuaries that were on the pilgrimage routes to the great shrine of Saint James at Santiago de Compostela in Spain. Other historians insist that the battle was a horrendous bloodbath for the army of Charlemagne and that the tale was carried back to the Frankish cities; the legend was transformed as it was repeated by the descendants of the few survivors.

In any event, by the 11th century, the tale was widely known in Europe. Excerpts from *The Song of Roland* were sung to inspire the Norman army of William the Conqueror before the Battle of Hastings in 1066, and in 1096, Pope Urban II cited it in an appeal to French patriotism when he attempted to raise armies for a crusade to retake the Holy Land. Medieval translations of the poem into German, Norse, and Italo-French attest to its widespread popularity outside the French-speaking area.

The Song of Roland is an epic poem; its unknown writer or writers had little interest in historical accuracy or geographic niceties. Its subject matter is the glory of the military campaign, the chivalric nature of the true knight, the constant possibility of human deviousness, and the clash of good and evil. Although the poem is set in the eighth century, it reflects the military values and chivalric code of the 11th century.

The story is simple: Muslims attack the retreating rear portion of Charlemagne's army while it is under the command of Roland, a favorite nephew of the emperor. Roland's army is defeated, but not before he sounds his ivory horn to alert the emperor to the peril. The emperor in turn raises a huge army from throughout Christendom while the Muslims also raise a great force. An epic battle follows; Charlemagne, with divine intervention, is victorious.

The Song of Roland is some 4000 lines long; it is divided into stanzas, and each line contains 10 syllables. It is impossible to reproduce the rhyme in English, because each stanza ends with an **assonance**, so the poem is best read in a blank-verse translation—although that sacrifices the recitative quality of the original.

This poem was meant to be heard, not read. It was recited by wandering minstrels—*jongleurs*—to largely illiterate audiences. This fact explains the verse style, the immediacy of the adjectives describing the characters and situations, and the somewhat repetitive language. The still-unexplained "AOI" at the end of many stanzas may have something to do with the expected reaction of the jongleur as he uttered that particular sound to give emphasis to a stanza. (Some sense of the immediacy of the original may be gained by a reader today who declaims some of these stanzas with gestures and appropriate pauses.)

Certain details of the poem merit particular attention. One portion recounts Charlemagne's arrival on the scene and his victory over the Arabs who are beleaguering the forces commanded by Roland. Most striking is the mixture of military and religious ideals, not an uncommon motif in the medieval period. This mixture is reflected not only in the imagery and in the plot (Charlemagne's prayer keeps the sun from setting in order to allow time for victory, an echo of the biblical siege of Jericho by Joshua) but also in the bellicose Archbishop Turpin. Christian valor is contrasted with Saracen wickedness and treachery; the anti-Muslim bias of the poem is clear. The Muslim Saracens are pagans and idolaters—an odd way to describe the rigidly monotheistic followers of Islam. *The Song of Roland*, like much of the epic tradition from which it springs, is devoted to the martial virtues of courage and strength, the comradeship of the battlefield, and the power of great men as well as the venality of evil ones. Reading 9.9 describes a final episode of heroism as Roland lies dying from his battle wounds.

The Song of Roland was immensely popular in its day. It spawned several other compositions, such as the *Pseudo-Turpin* and *Aspremont*, in order to continue the story or elaborate portions of it. At a much later time in Italy, the story was redone in the telling of the exploits of Orlando (Roland). To this day, children in Sicily visit the traditional puppet shows in which the exploits of brave Roland and his mates are acted out with great clatter and verve. Spectators at those shows witness stories that go back to the beginnings of the medieval period.

VISUAL ARTS

The visual arts progressed significantly throughout medieval Europe. Once life became more settled and predictable, the central role of Christianity swept through the visual arts, from small manuscript illuminations to immense churches and cathedrals. Heavy blocks of stone rose skyward, seeking heaven, as architecture became more sophisticated. Yet, except for the very few who managed to reach the highest rungs of the social ladder, medieval life had its drudgery and drabness. But individuals of every social rank could believe that life on earth was but a test and that an eternal reward awaited those who strived to be righteous, who worked and worshipped for the divine

READING 9.9 *THE SONG OF ROLAND*, LINES 2271–2296 AND 2366–2396

The Death of Roland

169 The hills are high, and very high the trees;
 four massive blocks are there, of gleaming marble;
 upon green grass Count Roland lies unconscious.
 And all the while a Saracen is watching:
 he lies among the others, feigning death;
 he smeared his body and his face with blood.
 He rises to his feet and starts to run—
 a strong, courageous, handsome man he was;
 through pride he enters into mortal folly—
 and pinning Roland's arms against his chest,
 he cries out: "Charles's nephew has been vanquished;
 I'll take this sword back to Arabia."
 And as he pulls, the count revives somewhat.

170 Now Roland feels his sword is being taken
 and, opening his eyes, he says to him:
 "I know for certain you're not one of us!"
 He takes the horn he didn't want to leave
 and strikes him on his jeweled golden casque;
 he smashes through the steel and skull and bones,
 and bursting both his eyeballs from his head,
 he tumbles him down lifeless at his feet
 and says to him: "How dared you, heathen coward,
 lay hands on me, by fair means or by foul?
 Whoever hears of this will think you mad.
 My ivory horn is split across the bell,
 and the crystals and the gold are broken off."

175 Now Roland is aware his time is up:
 he lies upon a steep hill, facing Spain,
 and with one hand he beats upon his chest:
 "Oh God, against Thy power I have sinned,
 because of my transgressions, great and small,
 committed since the hour I was born
 until this day when I have been struck down!"
 He lifted up his right-hand glove to God:
 from Heaven angels came to him down there.

176 Count Roland lay down underneath a pine,
 his face turned so that it would point toward Spain:
 he was caught up in the memory of things—
 of many lands he'd valiantly subdued,
 of sweet France, of the members of his line,
 of Charlemagne, his lord, who brought him up;
 he cannot help but weep and sigh for these.
 But he does not intend to slight himself;
 confessing all his sins, he begs God's mercy:
 "True Father, Who hath never told a lie,
 Who resurrected Lazarus from the dead,
 and Who protected Daniel from the lions,
 protect the soul in me from every peril
 brought on by wrongs I've done throughout my life!"
 He offered up his right-hand glove to God:
 Saint Gabriel removed it from his hand.
 And with his head inclined upon his arm,
 hands clasped together, he has met his end.
 Then God sent down his angel Cherubin
 and Saint Michael of the Sea and of the Peril;
 together with Saint Gabriel they came
 and took the count's soul into Paradise.

intervention of Jesus Christ. Those are the yearnings that the Western visual arts illuminated—beginning in books.

The Utrecht Psalter

The Utrecht Psalter (so called because its present home is the University of Utrecht in the Netherlands) has been called the masterpiece of the Carolingian Renaissance. Executed at Reims sometime around 820 to 840, it contains the whole Psalter, with wonderfully free and playful pen drawings around the text of the psalms. The figures are free from any hieratic stiffness; they are mobile and show a nervous energy. The illustration for Psalm 150, for example, has a scene at the bottom of the page showing various figures praising God with horn and cymbals (**Fig. 9.9**). There are two other interesting aspects of this illustration. One is that the figures are in the act of praising Christ, who stands at the apex of the composition with the symbols of his resurrection (including the staff-like cross in his hand). Although the psalms speak of the praise of God, for the medieval Christian the hidden or true meaning of the scriptures was that they speak in a prefigurative way of Christ. Thus, the psalmist who praises God is a shadow of the church that praises Christ. A second thing to note in this illustration is the bottom-center scene of an organ with two men working the bellows to supply the air for the organ pipes.

The style of the Utrecht Psalter has much in common with early Christian illustration. The lavish purple-and-silver manuscripts show a conscious imitation of Byzantine taste. We have also noted the influence of Irish illustration. Carolingian manuscript art thus had a certain international flavor, and the various styles and borrowings offer ample testimony to the cosmopolitan character of Charlemagne's culture. This internationality diminished in the next century; not until the period of the so-called International Style in the 14th century would such a broad eclecticism again be seen in Europe.

Calligraphy

Another advance in manuscript production during the Carolingian period was in the area of fine handwriting or **calligraphy**. Handwriting before the Carolingian period was cluttered, unformed, and cramped. It was difficult to read because of its erratic flourishes and lack of symmetry. After 780, scribes in Carolingian scriptoria began to develop a precise and rounded form of lettering that became known as the Carolingian minuscule, as opposed to the majuscule or capital letter. This form of lettering was so crisp and legible that it soon became a standard form of manuscript writing. Even in the 15th century, the Florentine humanists preferred minuscule calligraphy for their manuscripts. When printing became popular in the early 16th century, printers soon designed type fonts to conform to Carolingian minuscule. It superseded Gothic type in popularity and is the ancestor of modern standard lettering systems.

Ivory Carving

One other art form that developed from the Carolingian love for the book is ivory carving. This technique was not unique to Charlemagne's time; it was known in the ancient world and highly

▲ **9.9** **Drawing for Psalm 150, detail of folio 83 verso from Utrecht Psalter, ca. 820–840. Bistre (dark brown ink) on vellum, page 13" × 10" (33 × 25.4 cm) University Library, Utrecht, the Netherlands.** This page is typical of the quick, nervous style of the unknown illustrator who did similar symbolic drawings for the entire Psalter of 150 psalms. Note the variety of musical instruments representing those mentioned in Psalm 150: "Praise the LORD . . . with the sound of the trumpet, . . . with the psalter and harp, . . . with tambourine and dance, . . . with stringed instruments and organs, . . . upon the loud cymbals."

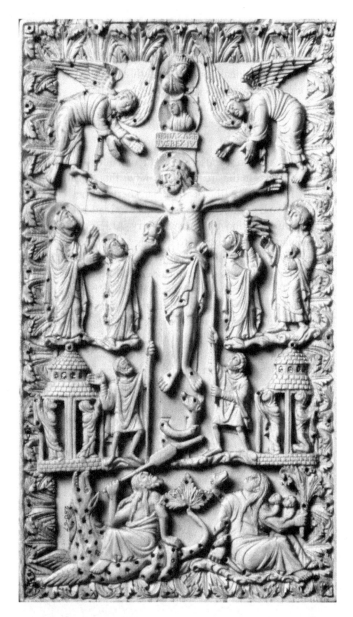

◀ **9.10** **Crucifixion, ca. 860–870. Carved ivory panel, 4⅝" × 8¼" × ¼" (11.8 × 21 × .7 cm). Victoria and Albert Museum, London, United Kingdom.** The crowded scene refers to the saving power of the cross. The figure to the left captures blood from the dying Christ, an allusion to the Eucharist (Mass) of the body and blood of Christ. Such ivories were often used as covers for gospel books and other liturgical works and were frequently produced as gifts for special occasions.

meals—was Augustine's *City of God*. One highly visible way of making this ideal concrete was to build a capital.

Charlemagne built his palace and royal chapel at Aachen, in what is now the Western part of Germany, a few miles from the Belgian border. Except for the chapel, which is incorporated into the present cathedral, all the buildings of Charlemagne's palace have been destroyed. The Aachen city hall (built in the 14th century) covers the palace site. The palace proper was a long one-story building; its main room was the large royal hall, which measured roughly 140 feet by 60 feet. So richly decorated that even the fastidious and sophisticated Byzantine legates were favorably impressed, the room had as its focal point at the western end with the emperor's throne. In front of the palace was an open courtyard, around which were outbuildings and apartments for the imperial retinue. Around the year 800, the courtyard held a great bronze statue of Theodoric—once king of the Ravenna Ostrogoths—that Charlemagne had brought back from Ravenna to adorn his palace. The Ostrogoths were one of the tribes once reviled by the Romans.

The royal hall was joined to Charlemagne's chapel by a long wooden gallery. With 16 exterior walls, it was a central-plan church that was actually based on an octagon (Fig. 9.11). The Western façade, flanking the entry, features two cylindrical towers housing spiral staircases. The model for the chapel was undoubtedly

valued in Byzantium. The ivories that have survived from Charlemagne's time were used for book covers. One beautiful example of the ivory carver's art is a Crucifixion panel made at the palace workshop at Aachen sometime in the early ninth century (Fig. 9.10). Note the crowded scenes that surround the Crucifixion event. The entire ivory is framed with acanthus-leaf floral designs. The composition indicates that the carver had seen some examples of Christian carving, whereas the bearded Christ and the flow of the drapery indicate familiarity with Byzantine art.

Carolingian Architecture

Beyond his immediate commercial, military, and political goals, Charlemagne had an overwhelming desire to model his kingdom on that of the Roman Empire. His coronation in Rome symbolized the fusion of the ancient imperial ideal with the notion of Christian destiny. It was not accidental that Charlemagne's favorite book—he had it read to him frequently at

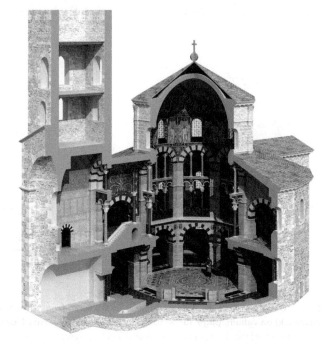

▲ **9.11** **Cutaway view of the Palatine Chapel of Charlemagne, 792–805 (John Burge).** The plan of the chapel is based on the plan of San Vitale (see Fig. 7.11).

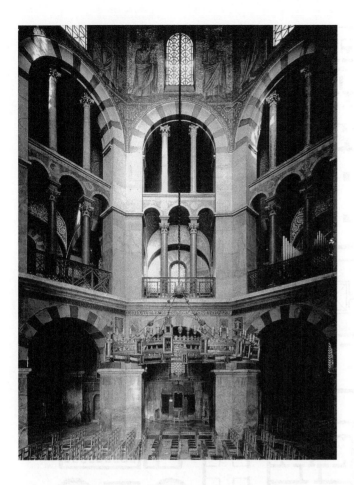

◀ **9.12** **Palatine Chapel (palace chapel of Charlemagne), 792–805. Interior of the rotunda. Aachen Cathedral, Aachen, Germany.**

like his ancient prototype an ambitious builder, a wise lawgiver, and a symbol of national unity. That this analogy was not an idle fancy is proved by a letter to the emperor from Alcuin in anticipation of Alcuin's return to Aachen: "May I soon be allowed to come with palms, accompanied with children singing psalms, to meet your triumphant glory, and to see once more your beloved face in the Jerusalem of our most dear fatherland, wherein is the temple set up to God by this most wise Solomon."

The Carolingian Monastery

In the period between Saint Benedict and Charlemagne, the Benedictine monastery underwent a complex evolution. Originally the monasteries were made up of small communities with fewer than 15 members, who led a life of prayer and work in a rather simple setting. With the decline of city life and the disorder brought on by repeated invasions after the fifth century, the monastery became increasingly a center of life for rural populations. Monasteries not only kept learning alive and worship intact but were also called on to serve as shelters for travelers, rudimentary hospitals for the sick, places of refuge in time of invasion, granaries for farmers, centers of law for both religious and civil courts, and places that could provide agricultural services such as milling and brewing.

This expansion of services, making the monastery into what has been called a miniature civic center, inevitably changed the physical character of the monastery compound. By Charlemagne's time, the monastery was an intricate complex of buildings suitable for the many tasks it was called on to perform (Fig. 9.13). One vivid example of the complexity of the

▼ **9.13** **The Major Parts of the Monastery**

Monastic Church	Site of the major religious services
Chapter House	Ordinary meeting room of the monastic community; the name comes from the custom of reading a chapter of the Rule of Saint Benedict aloud each day to the community
Cloister	Technically, the enclosed part of the monastery; more commonly, the enclosed garden and walkway in the interior of the monastery
Scriptorium	Library and copying area of the monastery
Refectory	Monks' dining hall
Novitiate	Quarters for aspirant monks not yet vowed in the community
Dormitory	Sleeping area for the monks
Infirmary	Resting place for sick, retired, and elderly monks
Guest House	Lodgings for visitors, retreatants, and travelers
Outbuildings	Buildings for the farms and crafts of the monastery; small buildings far from the main monastery that housed farmer monks were called *granges*

the Church of San Vitale in Ravenna, which Charlemagne had visited and admired. The octagon formed the main nave of the church (Fig. 9.12), which was surrounded by **cloisters**. The building was two storied. At the eastern end of the chapel was an altar dedicated to the Savior, with a chapel dedicated to the Virgin directly below it. The central space was crowned with an octagonal cupola, the lower part of which was pierced by windows—the main source of light in the church. The outside of the church was austere, but the inside was richly ornamented with marble brought to Aachen from Ravenna and Rome. The interior of the cupola was decorated with a rich mosaic depicting Christ and the 24 elders of the book of Revelation (now destroyed; the present mosaics in the chapel are modern copies), while the other planes of the interior were covered with frescoes (now also destroyed). The railing of the upper gallery was made from bronze screens that are still in place, wrought in geometrical forms.

The chapel included two objects that emphasized its royal status: the most important relic of the kingdom—Saint Martin of Tours's cape—and a throne. Charlemagne's throne was on the second floor, opposite the Savior chapel. From this vantage point, the emperor could observe the liturgical services being conducted in the Savior chapel and at the same time view the Virgin chapel, with its rich collection of relics.

Charlemagne's throne, with its curved back and armrests, was mounted by six stone steps. This arrangement was taken from King Solomon's throne as described in the Bible (1 Kings 10:18–19). Charlemagne was to be thought of as the new Solomon,

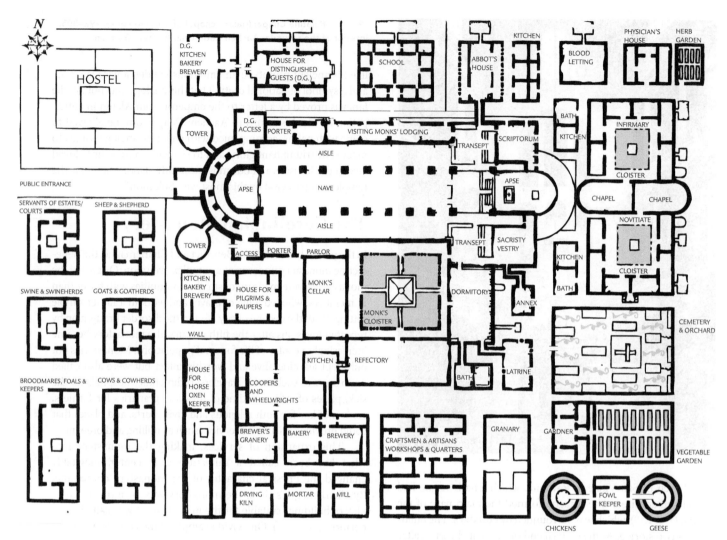

▲ **9.14 Plan for an ideal monastery, ca. 820. Saint Gall, Switzerland. Reconstruction based on original plan (44" across, drawn to scale on vellum) in the Library of the Monastery of Saint Gall, Switzerland.** The monastery site would have been 480' × 640' (146.3 × 195 m) and would have housed 120 monks and 170 serfs. Over the centuries, the Saint Gall Gall plan for future monasteries exerted considerable influence on monastery construction. The areas colored green highlight the gardens within the monastery complex. Reconstruction by Cecilia Cunningham.

Carolingian monastery can be found in a plan for an ideal monastery developed about 820 at the Benedictine abbey of Saint Gall in present-day Switzerland (**Fig. 9.14**).

In the Saint Gall plan, the monastic church dominated the area. Set off with its two round towers, it was a basilica-style church with numerous entrances for the use of the monks. To the south of the church was a rectangular garden space surrounded by a covered walkway (the cloister), from which radiated the monks' dormitory, dining hall (**refectory**), and kitchens. To the north of the church were a copying room (**scriptorium**), a separate house for the abbot, a school for youths and young novices, and a guest house. To the extreme south of the church were ranged workshops, barns, and other utilitarian outbuildings. To the east beyond the church were an infirmary and a separate house for aspirant monks (the *novitiate*), gardens, poultry houses, and the community cemetery.

Ottonian Art

Following Charlemagne's death, internal and external strife threatened the existence of the Holy Roman Empire. It was torn apart on several occasions, only to be consolidated time and again under various rulers. The most significant of these were three German emperors, each named Otto, who succeeded one another in what is now called the Ottonian period. In many respects, their reigns symbolized an extension of Carolingian ideals, including the architectural and artistic styles that dominated Charlemagne's era.

The most important architectural achievement of the Ottonian period was the construction of the Church of Saint Michael in Hildesheim, Germany (**Fig. 9.15**). The Church of Saint Michael offers us our first glimpse at a modified Roman basilican plan that will serve as a basis for **Romanesque** architecture.

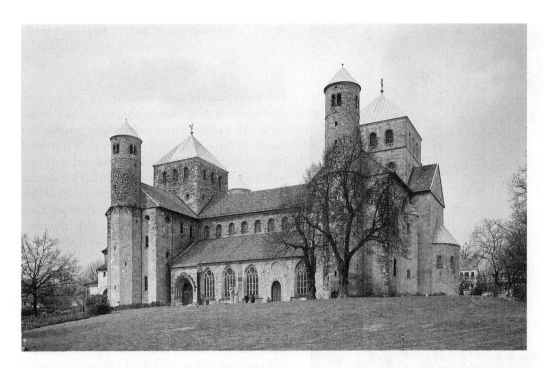

◀ **9.15 Church of Saint Michael (restored exterior), ca. 1001–1031. Hildesheim, Germany.**

The abbey church does not retain the propylaeum (vestibule) or atrium of Old Saint Peter's Basilica, and it reverts to the side entrances of Roman basilicas. But all of the other elements of a typical Christian cathedral are present: **narthex**, **nave**, side aisles, **transept**, and a much enlarged **apse** surrounded by an **ambulatory**. Most significant for the future of Romanesque and Gothic architecture is the use of the **crossing square** as a template for other spaces within the church. The crossing square is the area of overlap formed by the intersection of the nave and the transept. In the plan of the Church of Saint Michael, the nave consists of three consecutive modules that are equal in dimensions to the crossing square and marked off by square pillars.

The Church of Saint Michael also uses an *alternate-support system* in the walls of its nave. In such a system, alternating structural elements (in this case, pillars and columns) bear the weight of the walls and ultimately the load of the ceiling. The alternating elements in the Church of Saint Michael read as pillar–column–column–pillar; its alternate support system is then classified as ABBA in terms of repetition of the supporting elements

(A is assigned to a pillar, and B is assigned to a column). An alternate support system of one kind or another will be a constant in the Romanesque architecture to come.

As with Old Saint Peter's, the exterior of the Church of Saint Michael reflects the character of its interior. Nave, side aisles, and other elements of the plan are clearly articulated in the blocky forms of the exterior. The exterior wall surfaces remain unadorned, as were those of the early Christian and Byzantine churches. However, the art of sculpture, which had not thrived since the fall of Rome, was reborn in the Church of Saint Michael.

Adam and Eve Reproached by the Lord (**Fig. 9.16**), a panel from the bronze doors of Saint Mary's Cathedral in Hildesheim

▶ **9.16** *Adam and Eve Reproached by the Lord*, 1015. Panel of bronze doors, 23" × 43" (58.4 × 109.2 cm). Dom Museum of Saint Mary's Cathedral, Hildesheim, Germany, 1015.

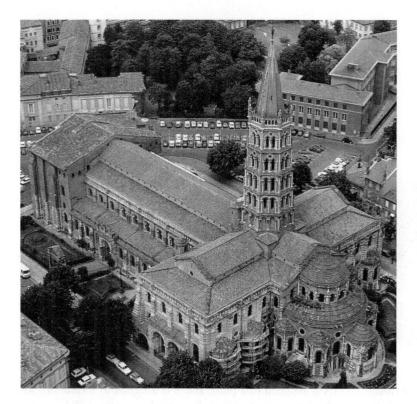

◀ **9.17** Saint Sernin, ca. 1070–1120. Toulouse, France.

architecture are the heavy stone arches and generous exterior decoration, mainly sculpture. The Romanesque style had two obvious advantages. First was that the use of heavy stone and masonry walls permitted larger and more spacious interiors. Second, the heavy walls could support stone arches (mainly the Roman barrel arch), at least in France and Spain, which in turn permitted fireproof stone and masonry roofs. Long experience had shown that basilica-style churches, with their wooden trusses and roofs, were notoriously susceptible to destruction by fire.

SAINT SERNIN The church of Saint Sernin in Toulouse, France, met all of the requirements for a Romanesque cathedral. An aerial view of the exterior (**Fig. 9.17**) shows the blocky forms that outline a nave, side aisles, the narthex to the west, a prominent transept crowned by a multilevel spire above the crossing square, and an apse at the eastern end from whose ambulatory extend five radiating chapels. In the plan of Saint Sernin (**Fig. 9.18**), the outermost side aisle continues around the outer borders of the transept arm and runs into the ambulatory around the apse. Along the eastern face of the transept, and around the ambulatory, a series of chapels radiates, or extends, from the aisle. These spaces provided extra room for the crowds of pilgrims and offered free movement around the church, preventing interference with worship in the nave or the celebration of Mass in the apse.

(originally commissioned in the 11th century for Saint Michael's by Bishop Bernward), represents the first sculpture cast in one piece during the Middle Ages. In mood and style, the imagery closely resembles that seen in manuscript illumination of the period. It is an emotionally charged work, in which God points his finger accusingly at the pathetic figures of Adam and Eve. They, in turn, try to deflect the blame; Adam points to Eve and Eve gestures toward Satan, who is in the guise of a fantastic dragon-like animal crouched on the ground. These are not Classical figures who bear themselves proudly under stress. Rather, they are pitiful, wasted images who cower and try frantically to escape punishment. In this work, as well as in that of the Romanesque period, God is shown as a merciless judge, and human beings as quivering creatures who must beware of his wrath.

Romanesque Art

In the 11th century, after a long period of desolation and warfare, Europe began to stir with new life. Pilgrimages became popular as travel became safe. Pilgrimage routes—in particular to sites in Spain, England, and Italy—crisscrossed Europe. Crusades were mounted to capture the holy places of the Middle East from the Muslims so that pilgrims could journey in peace to their most desired goal: Jerusalem. During this period, monks built and maintained pilgrimage churches and hostels on the major routes of the pilgrims.

The building style of this period (roughly from 1000 to 1200) is called Romanesque, because the architecture was larger and more Roman looking than the work done in the earlier medieval centuries. The two most striking characteristics of this

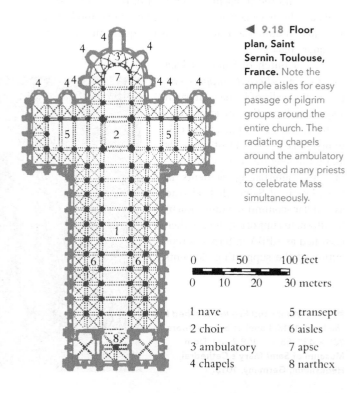

◀ **9.18 Floor plan, Saint Sernin. Toulouse, France.** Note the ample aisles for easy passage of pilgrim groups around the entire church. The radiating chapels around the ambulatory permitted many priests to celebrate Mass simultaneously.

0	50	100 feet
0	10 20	30 meters

1 nave
2 choir
3 ambulatory
4 chapels
5 transept
6 aisles
7 apse
8 narthex

◀ **9.19 Nave, Saint Sernin, ca. 1070–1120. Toulouse, France.** The massive ceiling vaults are called barrel or tunnel vaults. The heavy stonework required heavy walls to support the weight of the vaults. The galleries, with their own vaults, also helped support the cut-stone ceiling vaults. The pulpit to the left is a much later addition to the church.

partly by the nave walls and partly by the side aisles that accept a share of the downward thrust.

Because the barrel vault rests directly on top of the **tribune gallery**, and because **fenestration** would weaken the structure of the vault, there is little light in the interior of the cathedral (**Fig. 9.19**). Lack of light was considered a major problem, and solving it would be the primary concern of future Romanesque architects. The history of Romanesque architecture can be written as the history of vaulting techniques, and the need for light provided the incentive for their development.

SCULPTURE Although we occasionally find freestanding sculpture from the Romanesque period, it was far more common for sculpture to be restricted to architectural decoration around portals. Some of the most important and elaborate sculptural decoration is found in **tympanums**—the semicircular spaces above the doors of cathedrals—such as that of the cathedral at Autun in Burgundy (**Fig. 9.20**). The carved portals of cathedrals bore scenes and

In Saint Sernin, a shift was made from the flat wooden ceiling characteristic of the Roman basilica to a stone vault that was less vulnerable to fire. The ceiling structure, called a **barrel vault**, resembles a semicircular barrel punctuated by arches that spring from **engaged columns** (that is, attached columns) in the nave to define each bay. The massive weight of the vault is supported

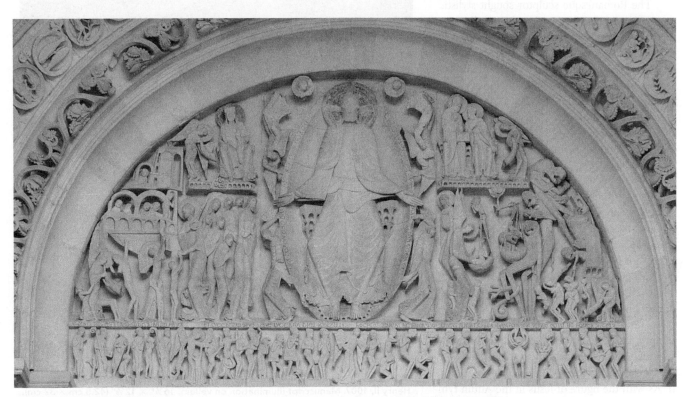

▲ **9.20 Cathedral of Saint-Lazare, west tympanum detail of Last Judgment, ca. 1120–1135. Marble, 21' (640 cm) wide at the base. Autun, France.**

symbols that acted as harsh reminders of fate in the afterlife. They were intended to communicate pictorially a profound message, if not a direct warning, to the primarily illiterate that repentance through prayer and action was necessary for salvation.

At Autun, the scene depicted is that of the Last Judgment. The tympanum rests on a lintel carved with small figures representing the dead. The archangel Michael stands in the center, dividing the horizontal band of figures into two groups. The naked dead on the left gaze upward, hopeful of achieving eternal reward in heaven, while those to the right look downward in despair. Above the lintel, Jesus is depicted as an evenhanded judge. To the left of Jesus, tall, thin figures representing the apostles observe the scene while some angels lift bodies into heaven. To the right of Jesus, by contrast, is a gruesome event. The dead are snatched up from their graves, and their souls are weighed on a scale by an angel on the left and a devil serpent on the right. (In Chapter 1, we noted that the ancient Egyptians believed that upon death, the heart of the deceased would be weighed, and if the deceased were found to have a heart as light as a feather, he or she would be considered worthy of the afterlife.) The devil cheats by adding a little weight, and some of his companions stand ready to grab the souls and fling them into hell. Humankind is shown as pitiful and defenseless, no match for the wiles of Satan. The figures crouch in terror of their surroundings, in strong contrast to the serenity of their impartial judge.

The Romanesque sculptor sought stylistic inspiration in Roman works, the small carvings of the pre-Romanesque era, and especially manuscript illumination. In the early phase of Romanesque art, naturalism was not a concern. Artists turned to art rather than to nature for models, and thus their figures were at least twice, and perhaps a hundred times, removed from the original source. It is no wonder, then, that the figures appear as dolls or marionettes. The figure of Jesus is squashed within a large oval, and his limbs bend in sharp angles in order to fit the frame. Although his drapery seems to correspond broadly to the body beneath, the folds are reduced to stylized patterns of concentric arcs that play across a relatively flat surface. Realism is not the goal. The sculptor is focused on conveying the frightful message with the details and emotions that will have the most dramatic impact on the worshipper or penitent sinner.

The relationship between Romanesque sculpture and manuscript illumination can be seen in "The Annunciation to the Shepherds" (Fig. 9.21), a page from the Lectionary of Henry II. As with the figure of Jesus in the Autun tympanum, the long and gangling limbs of the figures

join their torsos at odd angles. Drapery falls at harsh, unnatural angles. Sent by God, the angel Gabriel alights on a hilltop to announce the birth of the Christ child to shepherds tending their flocks. The angel towers over the rocky mound and appears to be almost twice the size of the shepherds. The shepherds, in turn, are portrayed as unnaturally large in relation to the animals. The animals along the bottom edge of the picture stand little more than ankle high. The use of hierarchical scaling implies that humans are less significant than celestial beings and that animals are lower than humans. The symbols in the scene take precedence over truth; reality fades in their wake.

Toward the end of the Romanesque period, there was a significant increase in naturalism. Drapery falls softly rather than in sharp angles, and the body begins to acquire more substance. The gestures are less frantic, and a balance between emotion and restraint begins to reappear. These elements reached their

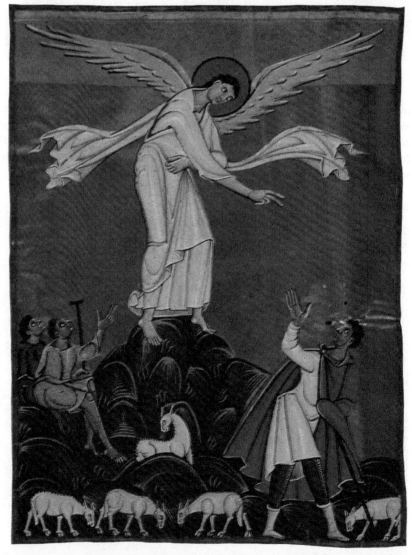

▲ 9.21 "The Annunciation to the Shepherds," folio 8 verso from the Lectionary of Henry II, 1007. Manuscript illumination on vellum, 16¾" × 12⅝" (42.5 cm × 32 cm). Bayerische Staatsbibliothek, Munich, Germany.

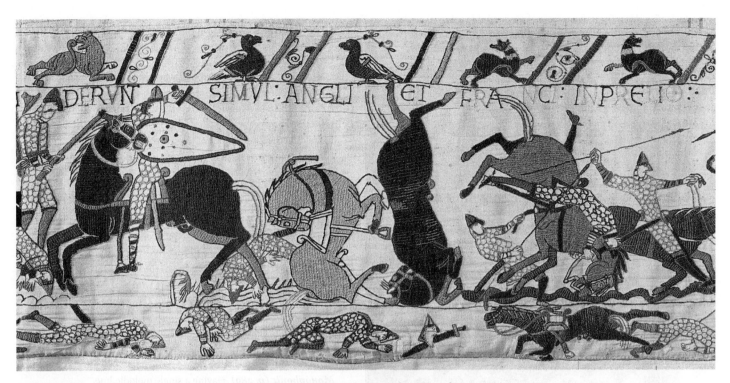

▲ 9.22 **Battle of Hastings, detail of the Bayeux Tapestry, ca. 1070–1080. One of a series of connected panels, embroidered wool on linen, 20" (50.8 cm) high, entire length of fabric 229' (69.8 m). Centre Guillaume le Conquérant, Bayeux, France.**

peak during the Gothic period, as we see in the next chapter, and pointed to a full-scale revival of classicism during the Renaissance of the 15th century.

TAPESTRY Although the tasks of copying sacred texts and embellishing them with manuscript illuminations were sometimes assumed by women, that art form remained primarily a male preserve. Not so with the medium of tapestry. In the Middle Ages, weaving and embroidery were taught to women of all social classes and walks of life. Noblewomen and nuns would weave and decorate elaborate tapestries, clothing, and liturgical vestments, using the finest linens, wools, gold and silver threads, pearls, and other gems.

One of the most famous surviving tapestries, the Bayeux Tapestry (Fig. 9.22), was almost certainly created by a team of women at the commission of Odo, the bishop of Bayeux. The tapestry describes the invasion of England by William I of Normandy in 1066 in a continuous narrative. William, the first Norman king of England, became known as William the Conqueror. Although the tapestry is less than 2 feet in height, it originally measured in excess of 230 feet long and was meant to run clockwise around the entire nave of the Bayeux Cathedral. In this way, the narrative functioned much in the same way as the continuous narrative of the Ionic frieze of the Parthenon.

THE LEGEND OF CHARLEMAGNE

Charlemagne's kingdom did not long survive intact after his death. By the 10th century, the Frankish kingdom was fractured and Europe reduced to a state worthy of being called the Dark Ages. Anarchy, famine, ignorance, war, and factionalism were constants in 10th-century Europe; Charlemagne's era was idealized as a long-vanished golden age. By the 12th century, Charlemagne's reputation was such that he was canonized (in Aachen on December 29, 1165) by the emperor Frederick Barbarossa. The cult of Charlemagne was immensely popular throughout France—especially at the royal abbey of Saint-Denis in Paris, which made many claims of earlier links with the legendary emperor.

A 15th-century oil painting in Aachen depicts an idealized Charlemagne as saint, wearing the crown of the Holy Roman emperor and carrying a model of the church he had built at Aachen. Frederick Barbarossa commemorated the canonization by commissioning a great wrought-bronze candelabra to hang in the Aachen cathedral. He also ordered a gold reliquary (now in the Louvre in Paris) to house the bones of one of his sainted predecessor's arms; another reliquary, in the form of a portrait bust that contains fragments of Charlemagne's skull, is in the cathedral treasury at Aachen (Fig. 9.23).

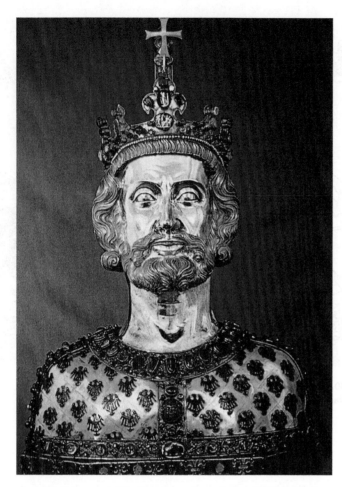

▲ **9.23 Reliquary of Charlemagne, crown before 1349, bust after 1349. Gold, silver, gems, and enamel, 34" (86 cm) high. Aachen Cathedral Treasury, Aachen, Germany.** Reliquaries of this type are containers for a relic of the person depicted by the statue–in this case, the crown of Charlemagne's skull.

GLOSSARY

A cappella (p. 289) Sung without instrumental accompaniment.

Alliteration (p. 291) A form of rhyme characterized by the repetition of consonant sounds in nearby words.

Ambulatory (p. 301) In a church, a continuation of the side aisles into a passageway that extends behind the choir and **apse** and allows traffic to flow to the chapels, which are often placed in this area (from *ambulare*, Latin for "to walk").

Apse (p. 301) A semicircular or polygonal projection of a building with a semicircular dome, especially on the east end of a church.

Assonance (p. 295) A form of rhyme characterized by the repetition of vowel sounds in nearby words.

Barrel vault (p. 303) A roofed-over space or tunnel constructed as an elongated arch.

Cadence (p. 289) A modulation or inflection of the voice.

Calligraphy (p. 297) Decorative handwriting, particularly as produced with a brush or a pen.

Capitulary (p. 285) A royal rule or decree, especially one made by a Frankish king.

Carolingian (p. 283) Of Charlemagne.

Cloister (p. 299) A covered walkway, particularly in a monastery, convent, college, or church, with a wall on one side and a row of columns open to a quadrangle on the other side.

Crossing square (p. 301) The area of overlap in a church plan formed by the intersection of the **nave** and the **transept**.

Engaged column (p. 303) A column embedded in a wall and partly projecting from the surface of the wall.

Fenestration (p. 303) The presence and arrangement or design of windows and doors in a building.

Feudalism (p. 282) The dominant social system in medieval Europe from the 9th through the 15th centuries, in which vassals were granted fiefs—estates or property—by their lords and were required to serve under their lords in the event of war.

Liturgical (p. 284) Relating to public worship.

Melisma (p. 289) A group of notes or tones sung to a single syllable of text.

Monasticism (p. 285) The style of life under religious vows in which a community of people shares an ascetic existence in order to focus on spiritual pursuits.

Monophonic (p. 289) Having a single melodic line.

Narthex (p. 301) A lobby or vestibule that leads to the **nave** of a church.

Nave (p. 301) The central aisle of a church, constructed for use by the congregation at large.

Polymath (p. 279) A person of great learning and achievement in several fields of study, especially unrelated fields such as the arts and the sciences.

Refectory (p. 300) A room used for communal dining, as in a monastery or college.

Romanesque (p. 300) Referring to a style of European art and architecture from the 9th through 12th centuries, descended from Roman styles; in architecture, characterized by heavy masonry, round arches, and relatively simple ornamentation.

Scriptorium (p. 300) A room dedicated to writing.

Transept (p. 301) The side parts of a church plan with a **crossing square**, crossing the **nave** at right angles.

Tribune gallery (p. 303) In architecture, the space between the nave arcade and the clerestory that is used for traffic above the side aisles on the second stage of the elevation.

Trope (p. 289) A literary or rhetorical device, such as the use of metaphor or irony.

Tympanum (p. 303) A semicircular space above the doors of a cathedral.

Vernacular (p. 290) The native dialect or language of a region or country, as contrasted with a literary or foreign language.

Vulgate Bible (p. 285) A late-fourth-century version of the Bible, largely translated into Latin by Saint Jerome.

THE BIG PICTURE THE RISE OF MEDIEVAL CULTURE

Language and Literature

- Scribes wrote mainly on slates and waxed tablets, although some precious works were written on parchment.
- Charlemagne recruited scholars to keep Classical texts alive and to correct errors in texts, especially one that had liturgical uses.
- In England, a monk called the Venerable Bede, who wrote more than 60 books, became known as the Father of English History for writing his *Ecclesiastical History of the English Nation*.
- *Beowulf*, an Old English epic poem, told a fantastic tale of men battling monsters in Scandinavia.
- The nun Hildegard of Bingen was a philosopher, physician, painter, musician, and preacher. Her main literary works are *Scivias*, which recounts her religious visions and their meanings, and the medical treatises *Physica* and *Causae et Curae*.
- A German nun and poet, Roswitha, wrote moralistic plays involving religious conversion, such as *The Conversion of the Harlot Thaïs*, and preaching steadfastness of faith during times of persecution.
- The morality play *Everyman* preached the value of confession, good deeds, and knowledge.
- *The Song of Roland* embellished an actual battle between Charlemagne on the border with Spain (ca. 777 and 778) and used a hero, Roland, to teach the values of patriotism and courage.

Art, Architecture, and Music

- A ship buried in Sutton Hoo, England, held treasures such as a 7th-century purse cover made of gold, glass, and garnets.
- A page from an illuminated manuscript, the Lindisfarne Gospels (ca. 700), featured a stylized cross inscribed with layers of intertwined, multicolored scrolls.
- The Utrecht Psalter (ca. 820–840) was decorated with playful pen drawings around the text of the psalms.
- Carolingian ivory carvings were made for use as book covers.
- Charlemagne's chapel (ca. 795) was constructed in Aachen with a central plan based on an octagon and cloisters surrounding it.
- The most important architectural achievement of the Ottonian period was the construction of the Church of Saint Michael in Hildesheim, Germany, with its use of a crossing square and an alternate support system.
- Romanesque architecture used heavy stone arches and generous exterior decoration, mostly sculpture.
- The Bayeux Tapestry was created by a team of women to describe the invasion of England by William the Conqueror in a continuous narrative.
- Monasteries were centers for the development of sacred music.
- Charlemagne promoted the Gregorian chant, which was monophonic and sung a cappella.
- The use of tropes, or verbal elaborations of text, became a standard of liturgical music.
- The manuscript illuminations in the Gospel Book of Charlemagne indicated that the artists were aware of the Roman style.

Philosophy and Religion

- Monasticism became widespread from the third century on, with monks and nuns forming communities under religious vows and adopting ascetic lives, but monastic lifestyles varied.
- In the sixth century, Saint Benedict set forth rules for monasteries to reform them and impose regular religious observance; the motto was "Pray and work."
- Women also entered the monastic life, including Hilda, abbess of Whitby, in seventh-century England.
- Morality plays extolled the virtues of conversion to Christianity and steadfastness in times of persecution and doubt.

The High Middle Ages

10

PREVIEW

A long time ago, on an island far, far away, a small group of monks ventured into the rough seas off the southwest coast of Ireland and scaled precipitous heights—some 714 feet over the Atlantic Ocean—to build a community so isolated and so inaccessible that its only real threat to survival was nature. George Bernard Shaw, the Nobel Prize-winning Irish playwright, described this "incredible, impossible, mad place" as "part of our dream world." There *is* something otherworldly about Skellig Michael, its serrated peaks, at once forbidding and alluring, set against the writhing waters.

The monastic settlements of Skellig Michael (Fig. 10.1) date back to the sixth century, but the monks held on there through the 13th century, when, it is believed, extreme weather conditions finally forced their retreat to the mainland. Thus, Skellig Michael was inhabited for nearly the whole of the time period we discuss in this chapter.

It was a severe, ascetic existence in which the monks divided their days between prayer, study, and survival. Each morning, they descended more than 618 steps—carved out of the living rock by generations of these devout men—to fish and to gather eggs from birds' nests built on countless ledges on the face of the rock. They also developed a system for collecting and purifying water. With stone all around them, the monks built retaining walls for terraces to create patches of arable land on which to cultivate vegetables and beehive-shaped cells to brace against the storm-lashed environment. Intrepid visitors to Skellig Michael—a dedicated UNESCO World Heritage Site—will also find the remnants of a medieval church and graveyard with tombstones bearing Celtic designs.

It is hard to imagine a simpler—and harsher—way of life. It is hard to imagine such extreme isolation. Why did these monks, no more than 12 of them at any given time, dare to live on Skellig Michael? Did they believe that withdrawing from civilization would enable them to achieve unity with God? Did they believe that their spiritual meditations would be untainted, purer? We imagine that whatever they sought, they understood that absolute solitude was necessary to achieve it.

Is this why Skellig Michael was the location chosen for Jedi Luke Skywalker's remote refuge in George Lucas's *Star Wars: The Force Awakens*? The closing scene finds the film's heroine, Rey, breathless, mounting the treacherous stairways—as did the monks every day—to the pinnacle, where she finds Luke, alone, gazing out over the turbulent waters. His expression, as he turns toward her, seems serene, unemotional, and yet, in some way, enlightened.

◀ **10.1** Ruins of the monastery on Skellig Michael, off the southwest coast of Ireland.

THE GOTHIC AGE

The *Annals of Inisfallen*, a chronicle of Ireland in medieval times written sometime between the 12th and 15th centuries—the Gothic Age—record a much earlier Viking attack on the Skellig islands in the year 823, after which a church dedicated to Saint Michael was added to the monastery and the entire site was dedicated to him. Except for one of the approaches on the south peak, the island was difficult to defend; monasteries, more generally, were targets for barbarian tribes looking to pillage treasure such as liturgical objects made of gold and silver, often embellished with precious and semiprecious stones.

The Viking expansion into the territories of the British Isles, Europe and Asia, and the North Atlantic (including North America), represented the last wave of barbarian invasions. By the time the *Annals of Inisfallen* were undertaken in the High Middle Ages, rural monasteries—albeit not as remote as Skellig Michael—were outmoded as centers of learning and religious life with the rise of universities in Europe's burgeoning cities. The most important of these was Paris—the center of Western civilization in the High Middle Ages.

The culture of the Middle Ages derives from the twin sources of all Western high culture: (1) the humane learning inherited from the culture of Greece and Rome and (2) the accepted faith of the West, which had its origin in the worldview of the Judeo-Christian scriptures and religious worldviews.

▲ MAP 10.1 **Europe around 1200.**

The flowering of a distinct expression of culture in and around medieval Paris from about 1150 to 1300 was made possible by many factors. There was a renewed interest in learning, fueled largely by the discovery of hitherto lost texts from the Classical world—especially the writings of Aristotle—that came to the West via the Muslim world. The often ill-fated Crusades began in the 11th century, to retake the Holy Land, and the

The High Middle Ages

1096 CE	1194 CE	1300 CE
EARLY GOTHIC PERIOD	**HIGH GOTHIC PERIOD**	

Universities of Paris and Bologna founded	The rebuilding of Chartres Cathedral begins
During the First Crusade, Christians capture Jerusalem	During the Fourth Crusade, crusaders sack Constantinople on the way to the Holy Land
Oxford University is founded	The University of Cambridge is founded
The Gothic style begins with the construction of Saint-Denis	The Magna Carta, limiting the powers of the king, is signed in England
Saint Bernard de Clairvaux leads the condemnation of Peter Abelard at the Council of Sens	Robert de Sorbon founds a Paris hospice for scholars, the forerunner of the Sorbonne
Philip Augustus ascends to the throne of France and promotes Paris as the capital	Marco Polo travels to China and India
	Acre, the last Christian stronghold in the Holy Land, falls

increasing vogue for pilgrimages created a certain cosmopolitanism that in turn weakened the static feudal society. Religious reforms initiated by new religious orders like the Cistercians in the 12th century and the begging friars in the 13th century breathed new life into the church.

Beyond these more generalized currents, one can also point to intellectuals who were crucial figures in the humanistic renaissance of the time. The University of Paris is inextricably linked with the name of Peter Abelard just as **Scholasticism** is associated with the name of Thomas Aquinas. The Gothic style, unlike most art movements, can be linked to a specific time in a particular place and with a single individual: the Abbey Church of Saint-Denis outside of Paris in the first half of the 12th century under the sponsorship of Abbot Suger (1080–1151).

THE GOTHIC STYLE

It is one of the ironies of art history that the term *Gothic*, associated with some of the most magnificently engineered and aesthetically rich buildings ever erected, began as a pejorative. It was Giorgio Vasari (1511–1574), a Florentine painter and art historian, who coined the word to describe a style that had nothing to do with the Goths—"barbarians"—who attacked the Roman Empire but that he saw as crude and barbaric. Of course, Vasari's perspective was that of an Italian humanist for whom the gold standard was defined as work inspired by Classical Greece and Rome.

Saint-Denis

It is rare to be able to trace a particular style of art to a single work, or the beginning of a movement to a specific date. However, it is generally agreed that the **Gothic style** of architecture began in 1140 with the construction of the **choir** of the church of Saint-Denis just north of Paris. The vaults of the choir consisted of weight-bearing ribs that formed the skeleton of the ceiling structure. The spaces between the ribs were then filled in with cut stone. At Saint-Denis, pointed arches were used in the structural skeleton rather than the rounded arches of the Romanesque style. The vault construction, which lessened the structural role of the more solid Romanesque wall, now permitted the use of larger areas of stained glass, thus dissolving the massiveness of the earlier style.

The Benedictine Abbey Church of Saint-Denis, over which Abbot Suger presided from 1122 until his death nearly 29 years later, was built in Carolingian times and housed the relics of Saint Denis, a fifth-century martyr who had evangelized the area of Paris before his martyrdom. In Suger's day, the **crypt** of the church had already served as the burial place for Frankish kings and nobles from before the reign of Charlemagne, and various legends established a connection between the church and Charlemagne himself. The fictional *Pèlerinage de Charlemagne* (*The Pilgrimage of Charlemagne*), for example, claims that the relics of the Passion housed at the abbey were brought there personally by Charlemagne when he returned

from a pilgrimage crusade to the Holy Land. Legends such as this one, whose main themes were pilgrimages, crusades, and the mythical presence of Charlemagne, were popularized and contributed to establishing the Abbey Church of Saint-Denis as a Christian shrine worthy of the royal city of Paris.

Pilgrims and other visitors would have made the journey to Saint-Denis not only because of the fame of the abbey's relics but also because of the annual *Lendit*, the trade fair held near the precincts of the abbey. Accordingly, in 1124, Suger resolved to design a church that would accommodate the large numbers of worshippers who flocked to the popular pilgrimage destination. He took as models two sacred buildings that by his time already had archetypal significance for Christianity. He wanted his church to be as lavish and brilliant as the Hagia Sophia in Constantinople, which he knew only by reputation, and as loyal to the will of God as the Temple of Solomon described in the Bible.

Suger's rebuilding program took the better part of 15 years and never saw completion. The first phase was demolition and renovation; he had to tear down the parts of the old church that had deteriorated and replace them. He reconstructed the western façade of the church and added two towers. In order to better handle the pilgrimage crowds and the increasingly elaborate processions called for in the medieval liturgy, the entrance was given three portals. The **narthex**, the part of the church one enters first (before the **nave**), was to be rebuilt, and the old nave was to be lengthened by about 40 feet. But in about 1140, Suger abruptly ceased work on the narthex to commence work at the opposite end of the church—the choir. By his own reckoning, he spent three years and three months on this new construction. The finished choir brought revolutionary change in the architecture in the West.

Suger's choir was surrounded by a double **ambulatory**, two semicircular passageways around the **apse** and behind the high altar. The outer ambulatory had seven radiating chapels (that look like petals of a flower) (**Fig. 10.2**) to accommodate

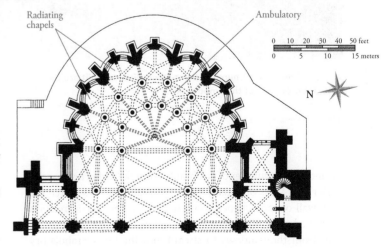

▲ **10.2 The Abbey Church of Saint-Denis, France, built around 1140, floor plan.** The floor plan of the east end of the church shows how the builders used light rib vaults to eliminate the walls between the radiating chapels.

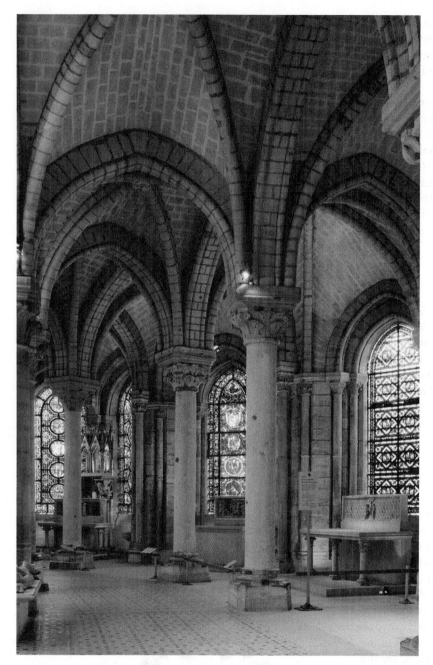

▲ **10.3 The Abbey Church of Saint-Denis, France, built around 1140, interior view of the ambulatory.** The ribbed vaults and pointed arches rise from slender columns, admitting light through the stained glass windows.

the increasing number of celebrants—monks and priests—who performed Mass on a daily basis. Two tall windows pierce the back wall of each chapel, so there is little masonry in relation to stained glass. The chapels are shallow enough to permit the light from the windows to stream into the inner ambulatory (Fig. 10.3).

Suger's Saint-Denis was a catalyst for a surge of cathedral construction in cities and towns radiating out from Paris, comprising the Île-de-France. The Gothic style, though, did not remain the exclusive purview of the French. By the end of the 13th century, there were outstanding examples of Gothic architecture in England, Germany, and Italy as well.

Characteristics of the Gothic Style

One of the characteristics of Gothic cathedrals is an awe-inspiring verticality. Everything seems to strive upward—the clusters of thin columns rising from the nave floor toward "the heavens," the pointed arches and pinnacles, the lofty ceilings. Another is colored light—an almost mystical light that penetrates jewel-like panes of stained glass, disperses into prismatic hues, and seems to etherealize the solid stone on which it lands. Innovations in structural design—particularly the exterior **flying buttress** that supported the nave walls without completely abutting them—made it possible to open up large areas of wall to glass (Fig. 10.4).

As the Gothic period progressed, all efforts were directed toward the dissolution of stone surfaces. Nave elevations rose to astounding heights, stained glass achieved a level of accomplishment equivalent to painting, and carved details became more complex and delicate. There was a transcendent quality to these buildings in the way they seemed exempt from the laws of gravity. Engineering know-how and, one could say, sheer bravery, led to vaults that rose ever higher over the decades. The Cathedral of Notre-Dame in Paris has a nave height of 115 feet (Fig. 10.5, part a); Chartres, 120 feet (part b); and Amiens, 144 feet (part c), and Beauvais—whose roof collapsed—stretched a stunning 157 feet from the pavement to the tip of the roof arches.

NOTRE-DAME CATHEDRAL One of the most famous buildings in the history of architecture is the Cathedral of Notre-Dame de Paris (Fig. 10.6). Perched on the eastern bank of the Île de la Cité, an island in the Seine River, Notre-Dame is a mixture of Gothic styles applied over time that reminds us that the construction of cathedrals can go on for generations. Notre-Dame was begun in 1163 and was not completed until almost a century later, undergoing extensive modifications between 1225 and 1250. Consequently, Notre-Dame offers us a look at stylistic and structural characteristics from both the Early and the High Gothic periods.

A comparison between the interiors of Saint Sernin and Notre-Dame offers a good visual summary of the distinctions between the Romanesque and Gothic styles. Saint Sernin has a barrel-vaulted ceiling (see Fig. 9.19), whereas Notre-Dame's

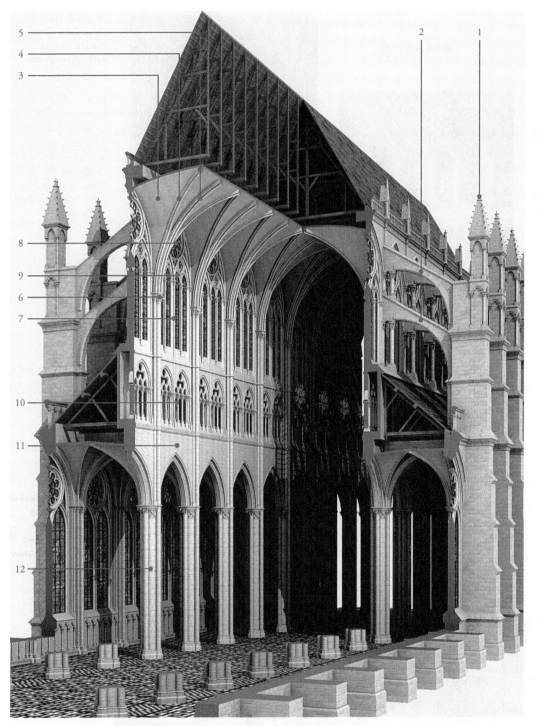

Pinnacle (1) A sharply pointed ornament capping the piers or flying buttresses; also used on cathedral façades.

Flying buttresses (2) Masonry struts that transfer the thrust of the nave vaults across the roofs of the side aisles and ambulatory to a tall pier rising above the church's exterior wall.

Vaulting web (3) Thee masonry blocks filling the area between the ribs of a groin vault.

Diagonal rib (4) One of the ribs forming the X of a groin vault.

Transverse rib (5) A rib crossing the nave or aisle at a 90-degree angle.

Springing (6) The lowest stone of an arch; in Gothic vaulting, the lowest stone of a diagonal or transverse rib.

Clerestory (7) The windows below the vaults in the nave elevation's uppermost level. By using flying buttresses and rib vaults on pointed arches, Gothic architects could build huge clerestory windows and fill them with stained glass held in place by ornamental stonework called tracery.

Oculus (8) A small, round window.

Lancet (9) A tall, narrow window crowned by a pointed arch.

Triforium (10) The story in the nave elevation consisting of arcades, usually blind arcades but occasionally filled with stained glass.

Nave arcade (11) The series of arches supported by piers separating the nave from the side aisles.

Compound pier (cluster pier) with shafts (responds) (12) A pier with a group, or cluster, of attached shafts, or responds, extending to the springing of the vaults.

▲ **10.4 Cutaway View of a Typical French Gothic cathedral (John Burge).** The extreme verticality of the interior elements is evident, from the delicate clusters of thin engaged columns enveloping the piers and stretching upward to the vault, to the pointed arches and steeply pitched roof. These vertical elements almost completely override the horizontal delineations of the three stories of the nave elevation. We can also see how the exterior buttressing works to provide support and to allow wall space to be devoted to glass. Thick buttress piers are attached to the outer walls of the side aisles. Once they reach the level of the triforium (just above the side-aisle roofline), though, they clear the wall. Two sets of struts then "fly away" from the vertical pier and attach to the uppermost part of the nave wall—the clerestory. The buttresses channel much of the weight of the roof and walls laterally and then downward. Because the struts only touch the masonry in two places, they don't occlude the window space. The result is a clerestory with very tall windows that illuminate what would be an otherwise dark vault. The net result of such technical innovations was to lessen the thickness, weight, and mass of the walls of the Gothic cathedral.

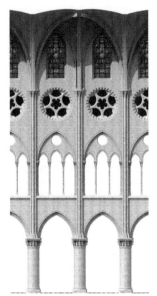

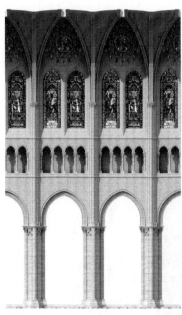

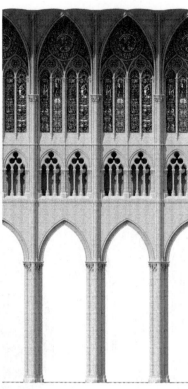

a Notre-Dame of Paris
height of nave, 115′

b Chartres
height of nave, 120′

c Amiens
height of nave, 144′

◀ **10.5 Nave elevations of three French Gothic cathedrals at the same scale.** Gothic nave designs evolved from the Early Gothic four-story elevation to the High Gothic three-story elevation (arcade, triforium, and clerestory). The height of the vault also increased from 80 to 144 feet.

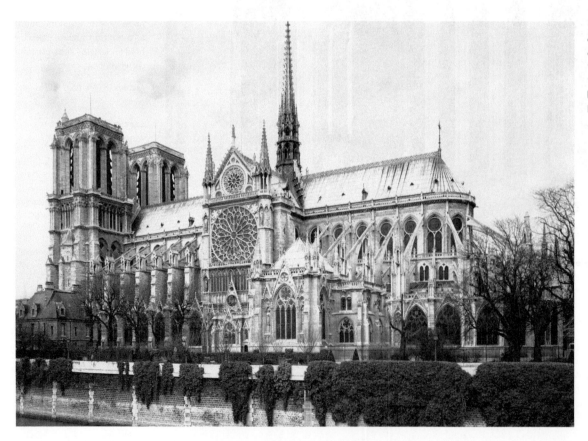

◀ **10.6 Cathedral of Notre-Dame de Paris, begun 1163, completed 1250; exterior view looking northwest. Paris, France.**

nave is covered with **sexpartite rib vaults**; each bay, framed by pointed transverse arches, is separated into six parts by criss-crossed ribs (**Fig. 10.7**). Saint Sernin's nave elevation consists of two stories with no windows directly beneath the vault; Notre-Dame's nave walls—although originally designed to have four stories—consist of three stories with plenty of glass in the upper regions—a feature made possible by the use of flying buttresses all around the perimeter of the cathedral (see Fig. 10.6). The blocky appearance of the Romanesque exterior gives way in the Gothic to a more visually unified design with smoother transitions from one part to another. The overall feeling of the Gothic style is more organic than geometric.

Although the façade of Notre-Dame (**Fig. 10.8**) was one of the last parts of the cathedral to be completed (between 1240 and 1250, well into the High Gothic period), the architectural design and sculptural elements more closely resemble those of earlier Gothic buildings. The clearly articulated sections, or stories, the balance between vertical and horizontal elements, and shallow penetration of the portals and fenestration create a grid-like effect that results in a planar aspect to the façade.

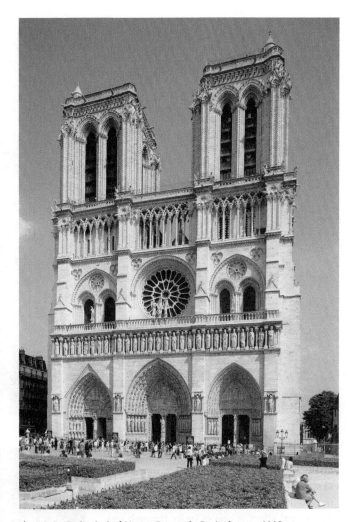

▲ **10.8** Cathedral of Notre-Dame de Paris, begun 1163, completed 1250, Western façade.

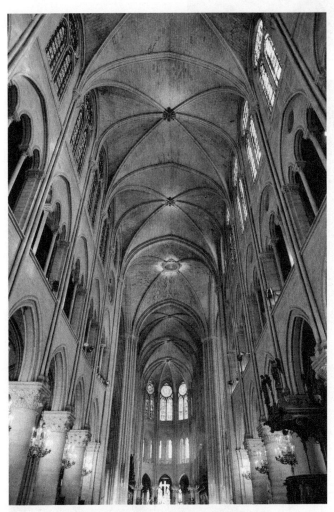

▲ **10.7** Cathedral of Notre-Dame de Paris, begun 1163, completed 1250; interior, nave vaults showing sexpartite scheme.

High Gothic cathedral façades, by contrast, accentuate verticality; the portals are carved deep into the plane of the façade, and the whole of its design is alive with juxtapositions of solid and void, light and shadow (also see Fig. 10.11).

CHARTRES CATHEDRAL Chartres Cathedral is generally considered to be the first true High Gothic church. If Notre-Dame in Paris is one of the world's most beloved Gothic cathedrals, Chartres is one of the most influential (**Fig. 10.9**). The architectural innovations evident in the Chartres plan became a template for High Gothic architecture, including Amiens Cathedral, whose nave height surpassed that of Chartres by 24 feet (see Fig. 10.5).

The cathedral we visit today, however, was constructed after a devastating fire in 1194 that left only the original (Romanesque) façade and crypt (on opposite ends of the building) intact. Unlike Notre-Dame, the rebuilding of Chartres was planned from the beginning to have a three-level wall elevation and flying buttresses, allowing for larger windows in the clerestory that would admit significantly more light into the

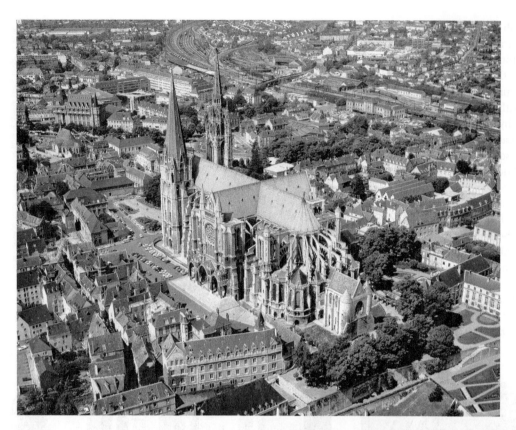

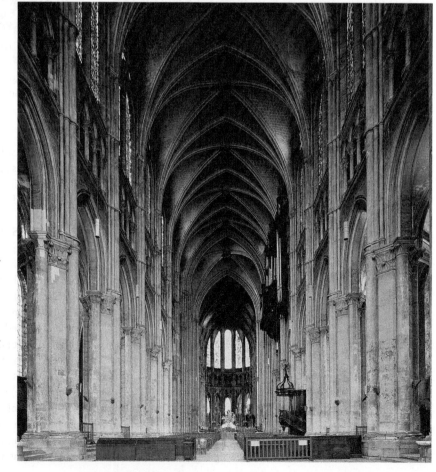

◀ **10.9 Chartres Cathedral, begun 1134, rebuilt after 1194. Chartres, France, aerial view.** Considered the first High Gothic church, Chartres was planned to have a three-level wall elevation and flying buttresses. Flying buttresses support the walls and roof from the exterior, permitting the installation of more nonsupporting glass windows.

interior (**Fig. 10.10**). Chartres's vaulting is also distinctly High Gothic: in its **rectangular bay system**, each bay in the vault is now divided into four parts by ribs in the shape of an "X." The visual effect is one of unity through repetition, a near-continuous flow of perfect pattern from portal to apse.

AMIENS CATHEDRAL All that was begun in the cathedrals you have just seen came to brilliant fruition in Amiens Cathedral (**Fig. 10.11**), where the vocabulary of the High Gothic was completely internalized by the architects. There is a continuous sweep of space from the narthex to the apse and an astonishing vertical thrust from floor to vaults, enhanced by the increased heights of the arches in the nave arcade and clerestory windows. The walls seem etherealized by the removal of much of the weight-bearing massiveness and the quantities of stained glass that flood the interior with spectacular patterns of

▶ **10.10 Chartres Cathedral, begun 1134, rebuilt after 1194. Chartres, France, interior view.** We see the tripartite elevation, including the nave arcade, the triforium, and the clerestory.

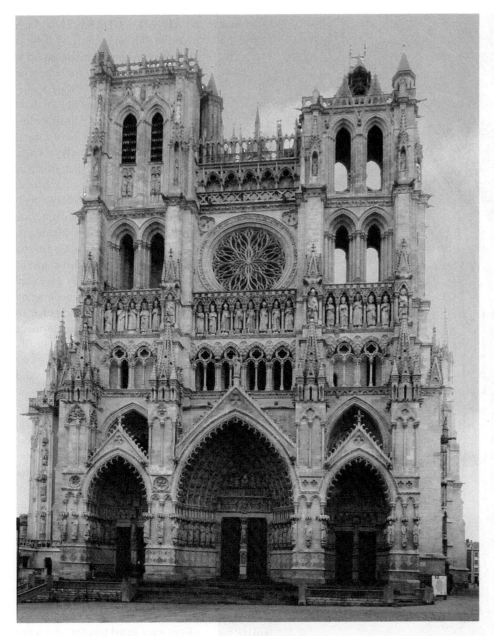

Constantinople, his cousin, Baldwin II. As dazzling and rich as is the interior of Louis's chapel, its extravagance was only exceeded by his generosity toward the poor and the mendicant orders that served them. Known for his charity, self-sacrifice, and piety (as well as his political integrity and acumen), Louis led his knights in two (albeit, failed) Crusades, losing his life in Tunisia. Less than three decades after his death, Pope Boniface VIII (r. 1294–1303) canonized him Saint Louis.

Sainte-Chapelle, a structure in the so-called *rayonnant* (radiant) style of the High Gothic, was damaged considerably during the French Revolution of 1789 but was restored in the 19th century. Almost all of the original, 13th-century stained glass was preserved.

The Mysticism of Light

The key characteristic of Gothic architecture that sets it apart from the Romanesque is luminosity.

Abbot Suger wrote two short booklets about his stewardship of, and his ideas about, the building and decorating program he initiated for the Abbey Church of Saint-Denis—sources for our understanding of the thought that stood behind the actual work of the builders and artists. Underlying Suger's description of the abbey's art treasures and architectural improvements was a theory of beauty. Suger was heavily indebted to his reading of certain mystical treatises written by Dionysius the Areopagite (whom Suger and many of his contemporaries wrongly assumed was the Saint Denis for whom the abbey was named), a fifth-century Syrian monk whose works on mystical theology were strongly influenced by Neo-Platonic philosophers as well as by Christian doctrine. In the doctrine of the Pseudo-Dionysius (as later generations have called him), every created thing partakes, however imperfectly, of the essence of God. There is an ascending hierarchy of existence that ranges from inert mineral matter to the purity of light, which is God. The Pseudo-Dionysius

soft-colored light. The architects directed all of their efforts toward creating a spiritual escape to another world. They did so by effectively defying the properties of matter: creating the illusion of weightlessness in stone and dissolving solid surfaces with mesmerizing streams of colored light.

SAINTE-CHAPELLE It has been said that as the Gothic progressed, walls became nothing more than scaffolding for colored glass. Admittedly an exaggeration, the image this conjures might well describe the interior of a small jewel of a royal chapel built by King Louis IX on the Île de la Cité not far from Notre-Dame. Three-quarters of the interior is comprised of stained glass—some 6450 square feet in all.

Sainte-Chapelle (Fig. 10.12) was built to house relics of the Passion of Jesus Christ—including the crown of thorns—that were purchased by King Louis from the Latin emperor of

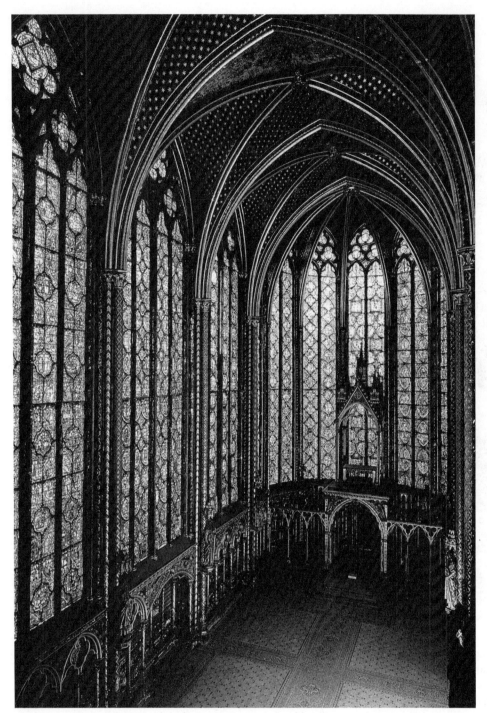

▲ 10.12 Sainte-Chapelle, 1243–1248. Paris, France. Interior of the upper chapel. Built to house relics of Christ's Passion, this is an exquisite example of Gothic luminosity. Although the chapel has been restored heavily, the overall effect of skeletal architecture used to frame the windows has nonetheless been maintained.

STAINED GLASS The high point of this mysticism of light is expressed in the stained-glass window. Suger believed that when he finished his nave with its glass windows (never completed, in fact) to complement his already finished choir, he would have a total structure that would make a single statement: "Bright is that which is brightly coupled with the bright, and bright is the noble edifice which is pervaded by the new light [*lux nova*]." The *lux nova* is an allusion to the biblical description of God as the God of light. Suger did not invent stained glass, but he fully exploited its possibilities both by encouraging an architecture that could put it to its most advantageous employment and by providing a theory to justify and enhance its use.

No discussion of light and glass in this period can overlook the famous windows of the Chartres Cathedral. When the cathedral was rebuilt after the fire, the new design gave wide scope to the glazier's art. More than 173 windows were installed, covering an area of about 2000 square yards. Except for some finer details like facial contours, the glass is not hand painted. The glaziers produced the colors by adding metallic salts to molten glass; the blues and reds of Chartres are renowned, and their exact tones have never been reproduced. Individual pieces were fitted together like a jigsaw puzzle and fixed in place by lead framing. Pieces were rarely larger than eight feet square, but 30-foot sections could be bonded together safely in the leading process. The sections were set into the stone window frames (**mullions**) and reinforced with iron retaining rods. Windows as large as 60 feet high could be created in this fashion.

It is interesting to compare the aesthetics of the stained-glass window to the mosaics discussed in Chapter 7 (see pp. 238–246). There was a strong element of mysticism of light in the art of Byzantine mosaic decoration, derived from some of the same sources later utilized by Abbot Suger: Neo-Platonism and the allegorical reading of the Bible. The actual perception of light in the two art forms, however, was radically different. The mosaic scattered reflected light off an opaque surface. The

described all of creation under the category of light: Every created thing is a small light that illumines the mind a bit. Ultimately, as light becomes more pure, one ascends the hierarchy and gets closer to pure light, which is God.

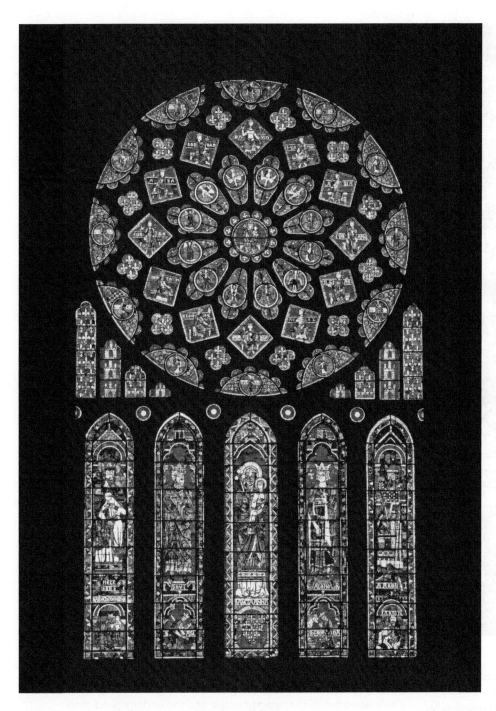

the church and looks back toward the portals, the tracery disappears into darkness and the stained glass panels—with their figures and stories—seem to hover in space like colorful pieces of a kaleidoscope.

The rose window and the five lancets (tall, narrow windows with pointed arches) in the north transept of Chartres Cathedral (Fig. 10.13) were a gift to the church from Queen Blanche of Castile, the wife of King Louis VIII and the mother of Louis IX (Saint Louis). In the very center of the rose is an image of the Virgin Mary enthroned as the queen of heaven with the Christ child on her lap. Small, petal-shaped windows emblazoned with doves—the symbol of the Holy Spirit—surround them. As we move outward from the center, the second ring of windows bears four images of the Holy Spirit, accompanied by eight angels, and the squares beyond contain images of kings from the Hebrew Bible, including David and Solomon. The entirety of the symbolic scheme of the rose window portrays the lineage of Jesus, the Messiah, as it was prophesied by Isaiah (11:1–3).

Directly beneath the rose to the left and right, in windows of ascending height, are symbols of the union of Blanche of Castile and Louis VIII of France. The gold, stylized iris on a field of blue—the *fleur-de-lis*—is the emblem of French royalty, which you can also see on the ceiling of Sainte-Chapelle (see Fig. 10.12), and the golden castle against a red background is the symbol of the Spanish Kingdom of Castile.

IMAGES OF THE VIRGIN AND THE CHRIST CHILD *La Belle Verrière* (*Our Lady of the Beautiful Window*) (Fig. 10.14), created in the 12th century, was saved from the rubble of the fire of 1194 and reinstalled in the new church. The window, with its characteristic pointed arch frame, depicts the Virgin enthroned with the Christ child, surrounded by worshipping angels bearing candles and **censers** (incense vessels). Directly above her is the dove that represents the Holy Spirit,

sacred aura of the light in a Byzantine church comes from the oddly mysterious breaking up of light as it strikes the irregular surface of the mosaic tesserae. The stained-glass window was the medium through which the light was seen directly, even if it was subtly muted into diverse colors—pure as well as blended.

The meaning of a stained-glass window can only be read by looking at it from the inside with an exterior light source—the sun—illuminating it. From the outside, contrasting dark panes create a backdrop for delicate stone tracery, as do the large, circular ("rose") windows on the façades of Notre-Dame and Amiens (see Figs. 10.8 and 10.11). When the visitor enters

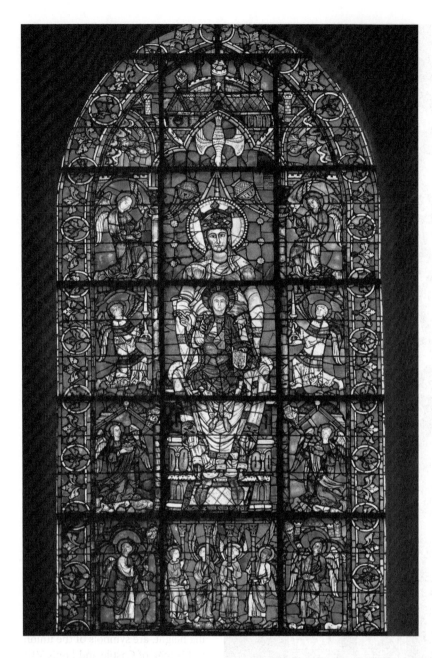

◀ **10.14** *Notre Dame de la Belle Verriére*, **Virgin and Child panel, ca. 1170, side panels with angels, 13th century, stained glass, 12' 9" high, choir of Chartres Cathedral, Chartres, France.** Almost all of the stained glass in Chartres Cathedral is original, giving us a good sense of the colored light effects that the designers had in mind. Chartres is particularly known for its blue and red glass.

changing the glass. The analogy of Christ to light and Mary to glass is an apt and deepened metaphor to be seen in *La Belle Verrière*.

The entire decorative scheme of a cathedral was an attempt to tell the story of the history of salvation. Modern visitors may be overwhelmed by an apparent jumble of sculptures and stained glass depicting biblical scenes, allegorical figures, symbols of the labors of the months, signs of the zodiac, representatives of pagan learning, and panoramic views of the Last Judgment; but for medieval viewers, the various scenes represented a patterned whole. The decoration of the cathedral was, as it were, the common vocabulary of sermons, folk wisdom, and school learning fleshed out in stone.

Sculpture

Sculpture during the Gothic period reveals a change in mood from that of the Romanesque. The iconography is one of redemption rather than damnation. The horrible scenes of Judgment Day that threatened the worshipper upon entrance to the cathedral were replaced by scenes from the life of Jesus or visions of the Apocalypse. The Virgin Mary also assumed a primary role. Carved tympanums, whole sculptural programs,

and at the very top a stylized church building represents the cathedral built in her honor.

The symbol of the Virgin enthroned is of Mary as the seat of wisdom, an ancient religious motif that would have had special significance for the town of Chartres. The cathedral school was a flourishing center of literary and philosophical studies—studies that emphasized that human learning became wisdom only when it led to the source of wisdom: God. The fact that Mary was depicted here in glass would also call to mind an oft-repeated *exemplum* (moral example) used in medieval preaching and theology: Christ was born of a virgin. He passed through her body as light passes through a window, completely intact without

CONNECTIONS Reims (pronounced *rance*) is in a region of France renowned for its champagne grape and the underground chalk cellars (*les crayeres*) where its most famous labels take advantage of their cool climate conditions to keep their bubby at a constant 10 degrees Celsius. Some of the chalk caves date back to Roman times and, in fact, are mentioned by Pliny the Elder in his *Natural History* compendium. The Romans mined the chalk for use as fertilizer and to make quicklime for everything from construction to textile production. In the wake of a German offensive in World War I— during which French citizens took refuge in the chalk caves—Reims became a virtual city underground with schools, shops, services, and, of course wineries. Three decades later, during World War II, the citizens of Reims sheltered allied soldiers and airmen under the streets of their city.

even cathedrals themselves (for example, Notre-Dame, which means "Our Lady"), were dedicated to her.

Gothic sculpture was still generally confined to the decoration of cathedral portals. Every square inch of the tympanums, lintels, and **archivolts** of most Gothic cathedrals was carved with a dazzling array of figures and ornamental motifs (**Fig. 10.15**). However, some of the most advanced full-scale sculpture was carved for jambs, such as those flanking the portals of Chartres Cathedral (**Fig. 10.16**). The poses of the figures are rigid, conforming to the shape of the engaged columns to which they are attached, and the drapery falls in predictable stylized folds reminiscent of those seen in mosaics and manuscript illumination. Yet there is a certain substance to the bodies, and the hinge-like appearance of the limbs has been eliminated, heralding a stylistic change from the Romanesque. During the High Gothic period, these simple features combined to create a budding naturalism that had not been witnessed since Classical times.

Almost exactly 100 years later, the jamb figures of Reims Cathedral (**Fig. 10.17**) illustrate how far and in which direction the High Gothic sculptor had gone. The mixed styles of the figures suggest to us that they were carved by different artists in the years between 1230 and 1255. The two figures facing one another on the left are the Angel Gabriel and the Virgin Mary; together they represent the

▲ **10.15 Tympanum, west façade, right door royal portal, carved 1145–1170. Chartres Cathedral, Chartres, France.** The central panel shows the Virgin and Child framed by adoring angels within an interior arch, while the outer arch depicts the seven liberal arts. At the lower left is Aristotle dipping his pen in ink with the female of Dialectic above him. Under the central panel of the Virgin, the lintel shows scenes from the life of Mary and the young Christ; on the upper level, the Presentation in the Temple, and on the lower level (from left), representations of the Annunciation, the Visitation, the Nativity, and the Adoration of the Shepherds can be seen.

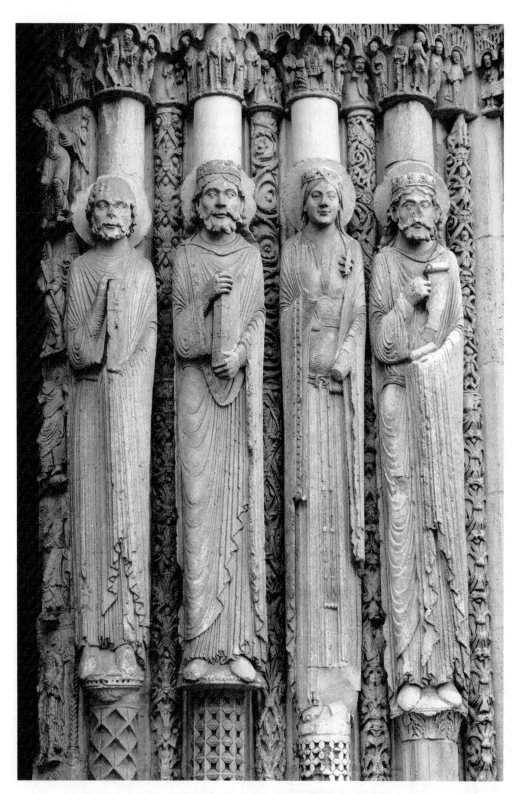

▲ **10.16** Jamb figures, west portals, Chartres Cathedral, ca. 1140–1150. Chartres, France.

and the long vertical folds and expanse of smooth stone in her mantle convey dignity and serenity. Both figures are significantly more naturalistic than their column-bound counterparts from Chartres Cathedral. Standing surefootedly on their pedestals, they have weight and occupy space.

The so-called Visitation group to the right—the Virgin Mary and Saint Elizabeth—were likely carved by the same sculptor, one who was keen on conveying a knowledge of classical statuary in the use of **contrapposto** and sophisticated arrangement of drapery. Even the facial features and hairstyles are reminiscent of Greek and Roman sculpture. The women "speak" to one another through facial expressions and lively gestures. The worshipper would have recognized the story from the Gospel of Saint Luke as the meeting between the two cousins when they were both with child—Mary with Jesus and Elizabeth with John the Baptist. With this small and isolated attempt to revive Classicism, this unknown artist stands as a transitional figure between the spiritualism of the medieval world and the rationalism and humanism of the Renaissance.

The Many Meanings of the Gothic Cathedral

The cathedral was the preeminent building in the towns of the Île-de-France—literally, the "island of France" but referring to Paris and the region around it. The cathedral overwhelms the town either by crowning a hilly site, as at Laon, or rising up above the town plain, as at Amiens. The cathedrals were town buildings (Saint-Denis, a monastic church, is a conspicuous exception), and one might well inquire into their functional place in the life of the town.

Annunciation, the moment when Gabriel, sent by God, brings the news to Mary that she will bear the Christ child. Gabriel's expression is sweet and joyful, and his bearing is elegant and courtly. His drapery moves with him, enunciating the delicate, S-curve of his body. Mary's garments, by contrast, are simple,

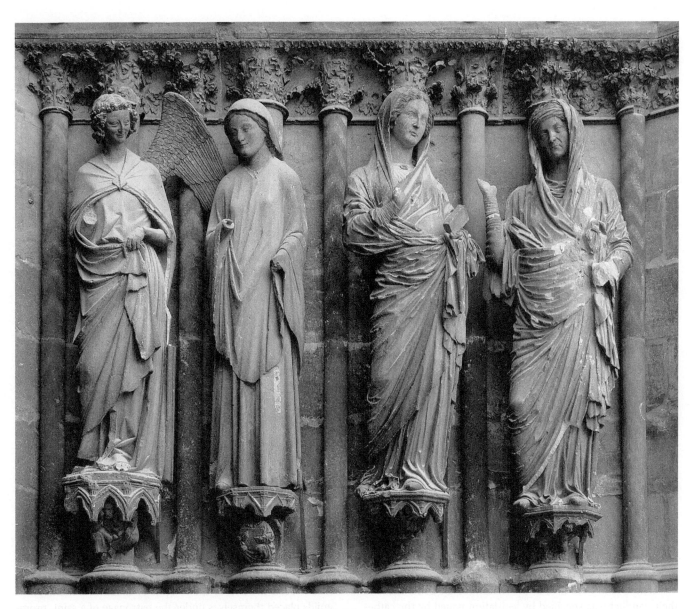

▲ 10.17 Jamb figures, west portals, Reims Cathedral, begun 1210. Reims, France.

A modern analogy illustrates the social function of architecture and building. Many a small town in America, especially in rural areas of the South and the Northeast, centers its civic and commercial life in a town square. The courthouse symbolically emanates social control (justice), social structures (registration of births, weddings, and deaths), power (the workplace of the sheriff, commissioners or aldermen, and mayor), and—to a degree—culture, with its adjacent park and military or civic monuments to the founders and war dead. The better stores, the churches, and the other appurtenances of respectability—banks, lawyers' and physicians' offices—cluster about the square. The cathedral square of the typical European or Latin American town is the ancestor of the courthouse square. The difference is that the medieval cathedral exercised a degree of social control and integration more comprehensive than that of the courthouse.

The cathedral shaped individual and social life in the town. Individuals were baptized in, made communicants of, married in, and buried from the cathedral. Schooling was obtained from the cathedral school and social services (hospitals, relief of the poor, orphanages, and so on) directed by the decisions of the cathedral staff (the *chapter*). The daily and yearly round of life was regulated by the **horarium** of the cathedral. People rose and ate and went to bed in rhythm with the tolling of the cathedral bell, just as they worked or played in line with the feast days of the liturgical calendar of the church year. Citizens could sue and be sued in the church courts, and those same courts dispensed justice on a par with the civil courts; the scenes of the Last Judgment over the central portals of medieval cathedrals referred to more than divine justice.

More significant than the social interaction of town and cathedral was the economic impact of the cathedral on the town. The building of a cathedral was an extremely expensive enterprise. When the people of Chartres decided to rebuild their cathedral in 1194, the bishop pledged all of the diocesan revenues for three years (equivalent to three to five million U.S. dollars in today's money) simply to initiate the project. A town like Chartres was small in the late 12th century, with no more than 10,000 to 15,000 residents.

From the late ninth century, Chartres had been a major pilgrimage site. The cathedral claimed possession of a relic of the Virgin (the tunic she wore when Jesus was born), given in 877 by Charles the Bald, the great-grandson of Charlemagne. **Relics** were popular throughout the Middle Ages, and this particular one was especially important to the pilgrims of the time: the relic had not been destroyed by the fire of 1194, a sure sign in the eyes of the populace that the Virgin wished the church rebuilt. Furthermore, the four great feasts of the Blessed Virgin in the liturgical year (the Purification of Mary on February 2, the Annunciation on March 25, the Assumption on August 15, and the Nativity of the Virgin on September 8) were celebrated in Chartres in conjunction with large trade fairs that drew merchants and customers from all over Europe.

These fairs were held in the shadow of the cathedral, and their conduct was specified by legislation issued by the cathedral chapter. For example, the prized textiles of the area were to be sold near the north portal, while the purveyors of fuel, vegetables, fruit, and wine were to be located by the south portal. There were also vendors of images, medals, and other religious objects (forerunners of the modern souvenir) to the pilgrims, who came both for the fair and for reasons of devotion. The church, then, was as much a magnet for outsiders as it was a symbol for the townspeople.

GUILDS The patrons who donated the windows of Chartres Cathedral also give some indication of the economics of the place. Some of the large windows—such as rose windows—were the gift of a royal family. A tall, pointed *lancet* window, such as those in the choir, were given by the nobility or the higher clergy. Many of the windows, however, were donated by the members of the local craft and commercial guilds; their signature frames can be found at the bottoms of the windows. Five large windows in honor of the Virgin in the *chevet*, the east end of the cathedral, were donated by merchants—principally

▲ **10.18** **Vintner's window, Chartres Cathedral, ca. 1215. Stained glass roundel. Chartres, France.** This panel from a window donated by the winemakers of the area shows a wine merchant transporting a cask of wine.

the bakers, butchers, and vintners—which is suggestive of the power of the guilds (**Fig. 10.18**).

The guild, a fraternal society of craftsmen or merchants, was a cross between a modern-day union and a fraternal organization like the Elks or the Knights of Columbus. Members of guilds placed themselves under the patronage of a saint, promised to perform charitable works, and acted as a mutual-aid society. Many of the economic guilds appear to have developed out of earlier, more religious groups. One had to belong to a guild to obtain regular work. The guild—the forerunner of the union—accepted and instructed apprentices; certified master craftsmen; regulated prices, wages, and working conditions; and maintained funds to care for older members and bury their dead. The university developed from the guild in the 12th century.

BUILDERS The motivation for the building of a medieval cathedral, then, came from theological vision, religious devotion, civic pride, and socioeconomic interest. The construction depended on people who raised the money and hired the master builder or architect. He, in turn, hired the master craftsmen, designed the building, and created the decorative scheme. Master craftsmen (masons, stonecutters, glaziers) hired their crews, obtained their materials, and set up work quarters. Manual and occasional labor was recruited from the local population, but construction crews usually migrated from job to job.

▲ **10.19** Villard de Honnecourt, folio 20v, *Mason's Geometry*, 1220–1250. Pen and ink on parchment showing practical geometry for the construction of buildings, 9¼" × 6⅛" (23.5 × 15.5 cm). Bibliothèque Nationale de France, Paris, France.

The names of several master builders, including the builder of Chartres, have been lost, but others have survived in funerary inscriptions, commemorative plaques, and building records. Notes written by Villard de Honnecourt (ca. 1235), an architect from northern France, and intended for students of buildings are preserved in a unique copy at the Bibliothèque Nationale in Paris. They provide us a rare glimpse into the skills of a medieval cathedral builder. Honnecourt writes that he could teach a willing apprentice skills ranging from carpentry and masonry to practical geometry (**Fig. 10.19**) and plan drafting. The notebook also has sketches and ideas jotted down for his personal use; they include religious figures to serve as models for stone carvers, animals and buildings that caught his eye, a perpetual-motion machine (which did not work), the first example of clockwork in the West, and a self-operating saw for cutting huge timbers for buttressing and roofing. He visited Reims and made sketches of the cathedral. He traveled as far as

Hungary to get work. Honnecourt's notebook reveals a highly skilled, persistently inquisitive, and inventive man.

A cathedral has more than religious and social significance; it is a stunning technological achievement, as we see in the elegant spire of Strasbourg Cathedral. Finished in 1439, the spire is 466 feet high from pavement to tip—as high as a 40-story building.

For those who entered a cathedral in faith, it provided a transcendental religious experience of passing from the profane to the sacred world. In his wonderfully eccentric book, *Mont-Saint-Michel and Chartres*, Henry Adams—a journalist and descendent of the President John Adams—writes that only a person coming to Chartres as a pilgrim could understand the building. The pilgrim is a central metaphor for the medieval period, whether one is speaking of an actual pilgrim or of life itself as a pilgrimage toward God. Pilgrims to Chartres or the other cathedrals journeyed in both senses: they traveled to visit a tangible sanctuary and, at the same time, hoped to find peace and salvation as they passed through its doors.

MUSIC OF THE SCHOOL OF NOTRE-DAME

In the Gothic era of artistic and architectural development, the austere music of the early church also underwent change. From the time Charlemagne introduced Gregorian chant into the church life of the Frankish kingdom, there were further developments of that musical form. In the 11th century, Guido d'Arezzo worked out a system of musical notation that provided the basis for the development of the musical notation used today. Church musicians from the 10th century on also experimented with a single melodic line of plainchant by adding parallel voices at different musical intervals above the line of chant. This first step toward **polyphony**, a musical term for many voices, was called **organum**. Outside the church, the knightly classes also composed and performed secular music. Some of the melodies of the *troubadours* have survived, providing insight into secular music in the 12th and 13th centuries. The German *minnesingers* (*minne* means "love") of the 13th century used traditional church modes and melodies to create secular and sacred songs.

The school of Notre-Dame in Paris was the center of systematic musical study and composition in the 12th century. Léonin's *Magnus liber organi* (ca. 1160) is an important source for our knowledge of music in the period of the Gothic cathedral. Léonin's book was a collection of organum compositions for use during the liturgical services throughout the church year. His work was carried on by the other great composer of the century, Pérotin, who assumed the directorship of the music school of Notre-Dame sometime around 1181.

As in the listening selection of Gregorian chant in Chapter 9, a clear pronunciation of the text remains the music's main feature. But as opposed to the earlier monophony, here Léonin introduces a new musical element by using additional voices or lines to provide

GO LISTEN!
LÉONIN

"Viderunt omnes fines terre"

interest. Most of the time, particularly in the opening, the additional lower voice simply serves as a bass background, but as the piece develops, parallel voices enter to accompany the principal line. This organum form was to become increasingly important in the development of Western music. It must be added that many modern scholars believe that Léonin did not so much compose the music (in the modern sense) as encourage his singers to improvise. The form in which we have his work was not written down until over a century after his death. The music is still purely vocal, although secular music of the same period may well have made use of musical instruments.

In Pérotin's music, the Notre-Dame organum utilized the basic melodic line of the traditional chant (the *cantus firmus*), while a second melodic line (the *duplum*), a third (*triplum*), and in some cases a fourth (*quadruplum*) were added above the melody. These added lines mirrored the rhythmic flow of the cantus firmus. It was soon learned, however, that pleasing and intricate compositions could be created by having the duplum and triplum move in opposition to the cantus firmus. This *counterpoint* (from *contrapunctus*, "against the note") meant, at its most basic level, that a descending series of notes in the cantus firmus would have an ascending series of notes in the melodic lines above it.

One development in the Gothic period deriving from the polyphony of organum was the motet. The *motet* usually had three voices (in some cases four). The tenor—from the Latin *tenere* ("to hold")—another term for *cantus firmus*, maintained the traditional line, usually derived from an older ecclesiastical chant. Because some of the manuscripts from the period show no words for this tenor position, it has been thought that for many motets, the tenor line was the musical accompaniment. Above the tenor were two voices who sang interweaving melodies. In the early 13th century, these melodies were invariably in Latin and exclusively religious in content. In the late 13th century, it was not uncommon to sing the duplum in Latin and the triplum in French. The two upper voices could be singing quite distinct songs: a hymn in Latin with a love lyric in French with a tenor voice (or instrument) maintaining an elaborated melody based on the melismas of Gregorian chant.

This increasingly sophisticated music, built on a monastic basis but with a new freedom of its own, is indicative of many of the intellectual currents of the period. It is a technically complex music rooted in the distant past but open to daring innovation, a blend of the traditional and the vernacular—all held together in a complicated balance of competing elements. Gothic music was an aural expression of the dynamism inherent in the medieval Gothic cathedral.

▶ **MAP 10.2 The location of universities of the High Middle Ages.**

SCHOLASTICISM

Several modern-day institutions have their roots in the Middle Ages. Trial by jury is one, constitutional monarchy another. A third institution perhaps has the most relevance to the majority of readers of this book: the university.

The Rise of the Universities

Some of the most prestigious centers of European learning today stand where they were founded more than 800 years ago: Oxford and Cambridge in England; the University of Paris in France; the University of Bologna in Italy (see **Map 10.2**). There is also a remarkable continuity between the organization and purposes of the medieval university and our own, with the exception of coeducation. Medieval students would be puzzled by the well-manicured campuses, college team sports, or degrees in business or health and exercise science that are part of the picture of an American university. But the same students would find themselves at home with a liberal-arts curriculum, Bachelor's, Master's, and Doctoral degrees, and the high cost of textbooks. They would also be well acquainted with drinking parties and fraternities. The literature that has come down to us from the period is full of complaints about poor housing, high rents, terrible food, and

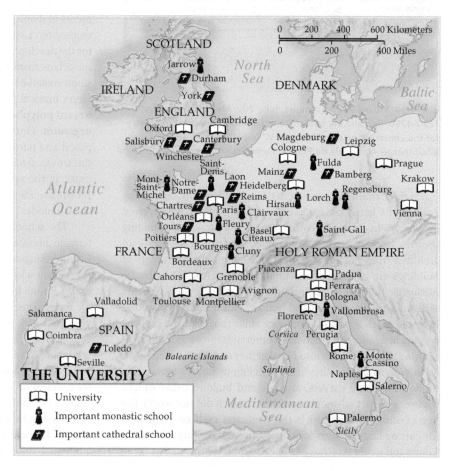

THE UNIVERSITY

📖 University

🏛 Important monastic school

✝ Important cathedral school

lack of jobs after graduation. Letters from the Middle Ages between students and parents have an uncanny contemporaneity about them.

European universities—exclusively male—developed in the late 12th and early 13th centuries along with the emergence of city life. In the Early Middle Ages, schools were most often associated with monasteries, which were generally situated in rural areas. As cities grew in importance, schools also developed at urban monasteries or, increasingly, under the aegis of bishops whose cathedrals were in the towns. The episcopal or cathedral school was a direct offshoot of the increasing importance of towns and the increasing power of bishops, the spiritual leaders of town life. In Italy, where town life had been relatively strong throughout the Early Middle Ages and where feudalism never took hold, there was also a tradition of schools controlled by the laity. The center of medical studies in Salerno and the law faculty of Bologna had been in secular hands since the 10th century.

Several factors help explain the rapid rise of formal educational institutions in the 12th century. First, the increasing complexity of urban life created a demand for an educated class who could join the ranks of administrators and bureaucrats. Urban schools were not simply interested in providing basic literacy; they were designed to produce an educated class who could give support to the socioeconomic structures of society. Those who completed the arts curriculum of a 12th-century cathedral school (like the one at Chartres) could find ready employment in either the civil or the ecclesiastical bureaucracy as lawyers, clerks, or administrators.

There were also intellectual and cultural reasons for the rise of the universities. In the period from 1150 to 1250 came a wholesale discovery and publication of texts from the ancient world, principal among which were lost books by Aristotle that came to Europe through Muslim sources in Spain. Christian contact with Muslim scholars also brought scientific, mathematical, and geographic knowledge into Western Europe. There was also a renaissance of legal studies centered primarily at Bologna, the lone intellectual center that could rival Paris, and the only institution, legend has it, that accepted a female teacher (so long that her lessons were taught outdoors). Theologians and philosophers began to apply the principles of logic to the study of philosophy and theology, and, with that, such scholars as Peter Abelard and Peter

Lombard embraced the intellectual model of **dialectics**. Abelard's book, *Sic et non* (1121), combined conflicting opinions concerning theological matters with contradictory passages from the Bible and the church fathers, then attempted to reconcile the divergences. This method was later refined as Scholasticism, so called because it was the philosophical method of the schools, the communities of scholars at the nascent universities.

Although a university education was rarer than it is today, students in some ways look familiar enough. The seated Bologna student in the relief sculpture in **Figure 10.20** seems to be daydreaming.

THE UNIVERSITY OF PARIS The best-known university to emerge in the Middle Ages was the University of Paris. The eminence of Paris rested mainly on the fame of its professors, many of whom were recruited from abroad. At this stage of educational development, the teacher was the school. Students in the 12th century flocked from all over Europe to frequent the lectures of teachers such as William of Champeaux (1070–1121) and his student and critic, Peter Abelard (1079–1142). Paris also had other well-reputed centers of learning. There was a school attached to the Cathedral of Notre-Dame, a theological center associated with the canons of the Abbey of Saint-Victor, and a school of arts maintained at the ancient Abbey of Sainte-Geneviève.

The University of Paris developed in the final quarter of the 12th and early part of the 13th centuries. Its development began with the *magistri* (masters or teachers) of the city forming a corporation after the manner of the guilds. At this time, the word **universitas** simply meant a guild or corporation.

The masters formed the universitas in Paris in order to monitor the quality of teaching and the performance of students. At Bologna, the reverse was true: the students formed

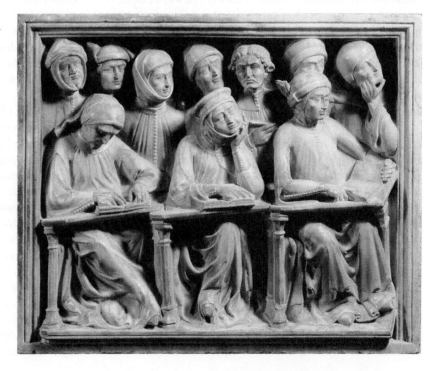

▶ **10.20 Jacobello and Pier Paolo dalle Masegne, Students, 1383–1386. Detail from the Tomb of Giovanni da Legnano. Marble, 25" × 30⅛" (63.3 × 76.5 cm). Museo Civico, Bologna, Italy.** The facial expressions of the students suggest that the professor has not earned their rapt attention. The seated student in the center would appear to be a woman, which would be unusual because women were generally excluded from professions such as medicine and law during the Middle Ages. Moreover, most women who received education at all during that time did so privately.

CULTURE AND SOCIETY

Dialectics

In ancient Greece, *dialectics* originally described the "art of conversation." By the fifth century, dialectics was associated with techniques used to come to logical conclusions based on a rigorous style of reasoning. Plato singled out dialectics in the *Republic* as a mark of the philosopher–king, whereas Aristotle saw it containing the "path to the principles of all inquiries."

The rediscovery of dialectics (which was the common medieval term for *logic*) coincided with the rise of the university. The studies of theology and philosophy were increasingly cast into terms that could be expressed in modes of logic like the deductive syllogism. University professors of theology, for example, had three duties: to explain the text of scripture; to preach; and to dispute—that is, to set out Christian doctrines in some logical form. What was true of these Christian scholars was also true of contemporary Muslim and Jewish thinkers who had also inherited the tradition of Aristotle's logic. Modern scholars have pointed out that dialectical reasoning, with its focus on resolving problems, had ramifications for both literature and architecture.

The greatest weakness of this emphasis was the temptation to turn the logical process into an end in itself, forgetting the search for truth in a desire to dazzle people with the sheer technique of logic. Dante would open canto 9 of the *Paradiso* with a critique of such mental pyrotechnics as he complained of those who were useless in their "reasoning" (literally: their "syllogisms") that made the wings of the mind bend "in downward flight."

the universitas to hire the teachers with the best qualifications and on the most advantageous financial terms.

The Universitas soon acquired a certain status in law, with a corporate right to borrow money, to sue (and be sued), and to issue official documents. As a legal body, it could issue stipulations for the conduct of both masters and students. When a student completed the course of studies and passed examinations, the universitas would grant him a teaching certificate that enabled him to enter the ranks of the masters: he was a master of arts (our modern degree has its origin in that designation). After graduation, a student could go on to specialized training in law, theology, or medicine. The completion of this specialized training entitled one to be called *doctor* (from the Latin *doctus*, "learned") in his particular field. The modern notion that a professional person (doctor, lawyer, and the like) should be university trained is an idea derived directly from medieval university usage.

Since the Carolingian period—indeed, earlier—the core of education was the arts curriculum. In the late 12th century in Paris, the arts began to be looked on as a prelude to the study of theology, which became a source of tension between the arts faculty and the theology masters. In 1210, this tension resulted in a split, with the masters and students of arts moving their faculty to the Left Bank of the Seine, where they settled in the area intersected by the rue du Fouarre ("Straw Street"—so named because the students sat on straw during lectures). That part of the Left Bank has traditionally been a student haunt. The name *Latin Quarter* reminds us of the language that was once the only tongue used at the university.

Most of university life was tied to the church. Most masters were clerics (except at Bologna), and most students depended on ecclesiastical *benefices* (pensions) to support them. There were

exceptions. There seem to have been women in universities in both Italy and Germany. At Salerno, famous for its faculty of medicine, there may have been women physicians who were attached to the faculty. By the 14th century, Salerno was licensing women physicians. There is also a tradition that Bologna had a woman professor of law who, according to the story, was so beautiful that she lectured from behind a screen so as not to dazzle her students. It is well to remember that the universities were conservative and traditional institutions. It was not until the 20th century, for example, that provisions were made for women's colleges at Oxford that enjoyed the full privileges of university life. The discrimination against women at the university level was something, for example, that moved the bitter complaints of the English novelist Virginia Woolf as late as the 1920s.

STUDENT LIFE By the end of the 12th century, Paris was the intellectual center of Europe. Students flocked there from all over Europe. We do not have reliable statistics about their number, but an estimate of 5000 to 8000 students would probably not be far from the mark for the early 13th century. The students were organized into *nations* by their place of national origin. By 1294, there were four recognized nations in Paris: the French, the Picard, the Norman, and the Anglo-German. Student support came from families, pious benefactors, church stipends, or civic grants. Certain generous patrons provided funds for hospices for scholars, the most famous of which was that underwritten by Robert de Sorbon in 1258 for graduate students in theology; his hospice was the forerunner of the Sorbonne in Paris.

By our standards, student life in the 13th century was harsh. Food and lodging were primitive, heating scarce, artificial lighting nonexistent, and income sporadic. The daily schedule was

CONNECTIONS In a sorrowful scandal of the period, Peter Abelard and a private student, Héloïse, entered into a love affair; she became pregnant in the home of her uncle, Canon Fulbert, in 1119. The couple secretly had a son and were married. But Fulbert, enraged at learning of the affair that took place under his roof, hired criminals to castrate Abelard and had Héloïse banished to a convent. Humiliated as well as grievously injured, Abelard retreated to the monastic life at Saint-Denis under Abbot Suger. Abelard left Saint-Denis in about 1121 to found a Benedictine monastery, the Paraclete (from the Greek for "one who consoles"). When Abelard was elected abbot of another monastery, he turned the Paraclete over to Héloïse, who became its abbess and remained there for the rest of her life. Although the couple rarely saw each other, they exchanged letters that have become famous. The couple was buried together at the Paraclete—Abelard upon his death in 1142 and Héloïse 22 years later. Their remains laid interred at the monastery for more than 600 years, until they were transferred to Père-Lachaise Cemetery in Paris.

▲ **10.21 The resting place of Héloïse and Abelard, Père-Lachaise Cemetery, Paris, France.** After their brief love affair was discovered, Héloïse was placed in a convent and Abelard sought refuge in a monastery. They rose to abbess and abbot and saw each other only rarely, but they exchanged letters that have become renowned, and they were buried together.

Because books were expensive, emphasis was put on note taking and copying so that students might build up their own collections of books. Examinations were oral, before a panel of masters. Students were also expected to participate in formal debates (called disputations) as part of their training.

LITERATURE

Literature continued to develop in the High Middle Ages. Some would say that there was the beginning of a rebirth of literature that would reach fruition in the 13th century, with the magnificent epic poems of Chaucer and Dante, and in the Renaissance. The 12th and 13th centuries saw a continuation of the translation of Classical works and commentaries on

rigorous, made more so by the shortage of books and writing material. An "ideal" student's day, as sketched out in a late medieval pamphlet for student use, now seems rather grim.

A master's lectures consisted of detailed commentaries on certain books the master intended to cover in a given term.

them. There were writings on religion and philosophy, including works by the religious figures and scholars Moses Maimonides, Francis of Assisi, and Thomas Aquinas. We also had the birth of the modern love song and tales of the heroics of knights and kings, and of courtly love.

CULTURE AND SOCIETY

A Student's Day at the University of Paris

4:00 A.M.	Rise
5:00–6:00	Arts lectures
6:00–8:00	Mass and breakfast
8:00–10:00	Lectures
11:00–12:00	Disputations before the noon meal
1:00–3:00 P.M.	Repetitions—study of morning lectures with tutors
3:00–5:00	Cursory lectures (generalized lectures on special topics) or disputations
6:00–7:00	Supper
7:00–9:00	Study and repetitions
9:00	Bed

The Medieval Parent and Student

The following letter was written by a parent to a son at the university in Orléans during the 14th century. Today the message might be communicated by telephone or e-mail, but the content is hauntingly familiar.

> I have recently discovered that you live dissolutely and slothfully, preferring license to restraint and play to work and strumming a guitar while the others are at their studies, whence it happens that you have read but one volume of law while more industrious companions have read several. I have decided to exhort you herewith to repent utterly of your dissolute and careless ways that you may no longer be called a waster and that your shame may be turned to good repute.

The following letter is the answer of the student at Orléans to his father. The language might be a bit formal, but again, the content might be familiar. Notice the common request: "Send money!"

> We occupy a good and comely dwelling, next door but one from the schools and market-place, so that we can go to school each day without wetting our feet. We have good companions in the house with us, well advanced in their studies, and of excellent habits—an advantage which we appreciate for, as the psalmist says "with an upright man thou wilt show thyself upright." Wherefore, lest production should cease for lack of material, we beg your paternity to send us by the bearer money for the purchase of parchment, ink, a desk, and the other things which we need, in sufficient amount that we may suffer no want on your account (God forbid!) but finish our studies and return home with honor. The bearer will also take charge of the shoes and stockings which you will send us, and any news at all.

Troubadours and Trobairitz

Those who accede to the stereotype of the Middle Ages as dark may be surprised by the brilliance, elegance, and just plain fun that leaps from the written page. Nowhere is this more evident than in the *troubadours* (male) and *trobairitz* (female) who created the love song as we know it. The songs are accompanied by pleasant melodies, many of which we have. They have inspired poets and songwriters since the Middle Ages, from Dante and Chaucer to the Romantic poets to contemporary rock-and-roll lyricists. The themes are familiar enough. We saw them in the songs of ancient Egyptians, Greeks, and Romans: Why don't you love me as I love you? Why do you have all that clothing on? (And, Where is your clothing?) Why are women like that? Why are men like that? Love in springtime. Look what you've done to me. It is endless and very fresh, as new as the springtimes to which many of the songs refer. And some of them are quite raw.

GUILLEM DE PEITEUS Consider a couple of verses by Guillem de Peiteus (1071–1127), the first of the known troubadours. For a French nobleman, both a count and a duke, he was also a rebel. He feuded constantly with his underlings, the king, and the church. He joined Richard the Lion-Hearted late on the First Crusade, and because of lack of coordination, Guillem's army was all but destroyed. Yet it is said of Guillem that he was a great gallant—"one of the most courtly men in the world and also one of the great deceivers of women; and he was a good knight-at-arms and generous in his gallantry; and he could write good poetry

and sing well."[1] One of his "credentials" as a deceiver and a philanderer is that he was excommunicated by the church—twice. On one occasion, a shiny-headed bishop demanded that Guillem discontinue his adulterous relationship with a viscountess. Guillem retorted, "I will only repudiate her when your hair needs a comb." By his death, however, Guillem had apparently resolved his differences with the church, as we see in Reading 10.1:

READING 10.1 GUILLEM DE PEITEUS

"A New Song for New Days," lines 1–6 and 19–24

Such sweetness spreads through these new days:
As woods leaf out, each bird must raise
In pure bird-Latin of its kind
The melody of a new song.
It's only fair a man should find
His peace with what he's sought so long.

. . .

That morning comes to mind once more
We two made peace in our long war;
She, in good grace, was moved to give
Her ring to me with true love's oaths.
God grant me only that I live
To get my hands beneath her clothes.

1. Guillem de Peiteus, *A New Song for New Days*, quoted in Robert Kehew, ed., *Lark in the Morning: The Verses of the Troubadours*, trans. Ezra Pound, W. D. Snodgrass, and Robert Kehew (Chicago: University of Chicago Press, 2005), 23.

BERNART DE VENTADORN Bernart de Ventadorn was a Celt who lived from ca. 1130 or 1140 to ca. 1190 or 1200. He has been referred to as the Master Singer, and he may have been in the court of Eleanor of Aquitaine. At times he portrayed women as pure, divine, above reproach. At other times, he depicted them as Eve, who led man to what Saint Augustine called the "original sin" and thereby brought death into the world.[2] We have some 45 songs of Bernart, including "When I See the Skylark Moving." The skylark represents hope taking wing because the bird sings as it takes flight. This verse from the poem paints women as ruinous and impossible for men to understand:

READING 10.2 BERNART DE VENTADORN

"When I See the Skylark Moving," lines 25–32

I've lost all my hope in women;
I'll place my faith in them no more;
Just as I used to support them,
From this point on I'll let them go.
Since I see none to help against
The one who ruins and confounds me,
I'll disbelieve and fear them all,
For I know well they're all alike.

BERTRAN DE BORN We have a bitter satirical poem by Bertran de Born (ca. 1140–1215), a minor nobleman whose livelihood depended on the spoils of war. The song is directed against foolish heroism and Richard the Lion-Hearted, who was not only a crusader but also himself a troubadour. Like Guillem de Peiteus, Bertran was a malcontent. Bertran joined a revolt against his duke, and as a result, his castle was burned to the ground and he was taken prisoner. However, he eventually received a pardon. Perhaps his greatest claim to fame is that Dante, in the *Inferno*, mentions Bertran as one of his "sowers of discord." The following lines about the time of Easter, which one might think should be a time of peace, reveal Bertan's bloodthirstiness:

READING 10.3 BERTRAN DE BORN

"I Love the Glad Time of Easter," lines 21–30 and 37–40

And I love just as much the lord,
When he is first in the assault
Astride his horse, armed, unafraid;
Thus he emboldens his vassals
With valiant and lordly deeds.
And then when battle is joined,
Each man must hold himself ready
And follow him with a light heart,
For no man is of any worth,

Till he's given what he's received.
…
When the battle has been engaged,
Any truly noble man
Wants only to cleave heads and arms,
Better off dead than caught alive.

Carmina Burana

The student subculture of the High Middle Ages invented a mythical Saint Golias, who was the patron saint of wandering scholars. Verses (called *goliardic verse*) were written in honor of the "saint." The poems that have come down to us are a far cry from the sober commentaries on Aristotle's *Metaphysics* that we usually associate with the medieval scholar.

One of the more interesting collections of these medieval lyrics was discovered in a Bavarian monastery in the early 19th century. The songs in this collection were written in Latin, Old French, and German and seem to date from the late 12th and 13th centuries. Their subject range is wide but, given the nature of such songs, predictable: there are drinking songs, laments over the loss of love or the trials of fate, hymns in honor of nature, salutes to the end of winter and the coming of spring, and cheerfully obscene songs of exuberant sexuality. The lyrics reveal a shift of emotions ranging from the happiness of love to the despair of disappointment, just as the allusions range from classical learning to medieval piety. One famous song, for example, praises the beautiful powerful virgin in language that echoes the piety of the church. The last line reveals, however, that the poem salutes not Mary but generous Venus.

In 1935 and 1936, German composer Carl Orff set some of these poems to music under the title *Carmina Burana*. His brilliant, lively blending of heavy percussion, snatches of ecclesiastical chant, strong choral voices, and vibrant rhythms have made this work a modern concert favorite. The listener gets a good sense of the vibrancy of these medieval lyrics from the use of the modern setting. Because the precise character of student music has not come down to us, Orff's new setting of these lyrics is a fine beginning for learning about the musicality of this popular poetry from the medieval university.

The *Romance of the Rose*

The *Romance of the Rose*[3] is a 13th-century love poem in two parts. It was written in Old French beginning in about 1230. The first part, containing 4058 lines, was penned by Guillaume de Lorris. Dreams were a popular topic in medieval days, so the poet begins with the tale of a 20-year-old man's dream vision, in which he falls in love with a rosebud in a perfumed springtime

2. Elizabeth Aubrey, *The Music of the Troubadours* (Indianapolis: Indiana University Press, 1996).

3. Guillaume de Lorris and Jean de Meun, *The Romance of the Rose*, trans. Charles Dahlberg (Princeton, NJ: Princeton University Press, 1971).

CULTURE AND SOCIETY

Chivalry and Courtly Love

You may have heard the expression "Chivalry is dead!" If so, what was the context? Why was it invoked? The context is almost always an interaction between men and women. The likely reason for the exclamation is that someone was behaving in a rude, uncaring, ungenerous way when it came to simple courtesy or a gesture of kindness. Picture a man and woman, 20 feet apart, hailing a taxi on a city street in the pouring rain. The car stops near the man who, seeing the woman nearby, offers the taxi to her and opens the door for her to climb in. "Chivalry is alive and well!" she might say. A similar scenario: the taxi stops, and the man runs toward it, jumping in before the woman can even get near it; the taxi speeds off, splashing through a puddle of water and soaking the woman from head to toe. "Chivalry is dead," is her obvious retort. In our day, chivalrous behavior connotes graciousness, courtesy, generosity, and considerate behavior—particularly toward women. Our notion of chivalry has its roots in the Middle Ages, but the earliest use of the word was in connection with making war and not love.

The word *chivalry* derives from the French word for horse, *cheval*, and the practice was associated in the Middle Ages with knights—warriors in the heavy (armored) cavalry—who were expert horsemen. Knighthood was synonymous with valor and expert skills on the battlefield in sword-and-shield combat and with weapons like lances. Knights lived in castles or noble manors, or could be part of a royal court. When they were not off fighting battles for one lord attempting to wrest control from another within a fairly violent feudal structure, they kept their skills honed in competitive tournaments.

Feudalism, knighthood, and Christianity intersected with the church's attempt to limit violence and marauding on behalf of nobles and divert the knights' aggression to a higher purpose: protecting society's weak and defenseless and, as time passed, fighting "just wars" to defend the Christian faith in campaigns like the Crusades. It is in this intersection that our concept of the chivalrous knight was born: courageous and gallant; loyal to God, church, and feudal lord (in that order); protective of the poor and weak; and, perhaps most familiarly, dutiful and gentle in serving ladies. The ideal code of ethics and behavior for the chivalric knight was voiced in *The Song of Roland*, a poem written in the 11th century.

> To fear God and maintain His Church
> To serve the liege lord in valor and faith
> To protect the weak and defenseless
> To give succor to widows and orphans
> To refrain from the wanton giving of offence
> To live by honor and for glory
> To despise pecuniary reward
> To fight for the welfare of all
> To obey those placed in authority
> To guard the honor of fellow knights
> To eschew unfairness, meanness and deceit
> To keep the faith
> At all times to speak the truth
> To persevere to the end in any enterprise begun

garden. The rosebud is a symbol of a beautiful woman or of sex. However, the rosebud is guarded, and the dreamer is thwarted in his efforts to secure it—making him want it more. The first part ends with the disconsolate lover yearning for his rosebud, which has become imprisoned in a castle of Jealousy. The second part, of 17,724 lines, was composed some 40 years later by a scholar at the University of Paris: Jean de Meun. It explores religion and philosophy, history, science, love and sex, marriage, and, of course, women. The lover's relationship with the rosebud is ultimately consummated in rather sexually explicit terms.

Along the way, we come across many characters, whose names indicate that the poem is intended to be an **allegorical** account of the art of courtly love: Courtesy, Narcissus, Sir Mirth, Gladness, Beauty, Simplicity, Independence,

Companionship, Fair Seeming, Pride, Jealousy, Villainy, Shame, Despair, Faithlessness. The young man falls in love at the Fountain of Narcissus; the poet is apparently saying that love, which may on the surface appear to be generous and selfless, suggests vanity and self-preoccupation laying underneath. The God of Love, Cupid, is sinister, and his darts are painful. There is an attempt by Reason to prevent love, but it fails.

One of the most unforgettable characters in the *Romance of the Rose* is La Vieille (the old woman), whose sexual appetite remains strong although her beauty has vanished. In Reading 10.4, we first see her reminiscing about her past. Then we see her admitting her lack of judgment when it came to a particularly aggressive lover. La Vieille also advises women to have as many lovers as they can, just as men do:

To respect the honor of women
Never to refuse a challenge from an equal
Never to turn one's back upon a foe.*

Waiting for your "knight in shining armor," in modern-day parlance, suggests holding out for a relationship with a man who will treat you—well, like a knight would treat his lady. In the Middle Ages, this entailed the rules and rituals of courtly love that were established in Spain and spread to southern France and northern Europe in the 12th century. For the nobility and aristocracy, marriage was an arranged affair that brought material and political advantages but had little or nothing to do with love. Since marriage and love were, one could say, oxymoronic, husbands and wives might look for romance elsewhere, as did the knight Sir Lancelot and Queen Guinevere in the story of King Arthur and his Knights of the Round Table in the legendary court of Camelot. Minstrels and troubadours sang ballads about courtly love and recited long poems describing the valor and chivalry of knights. In the 12th century, Andreas Capellanus penned a treatise on courtly love, *De amore* (About Love)**, in which he cited 31 observations about true, ennobling love and guidelines on how to find it and hold onto it.

1. Marriage should not be a deterrent to love.
3. A double love cannot obligate an individual.
7. A lover must observe a two-year widowhood after his beloved's death.
8. Only the most urgent circumstances should deprive one of love.

11. A lover should not love anyone who would be an embarrassing marriage choice.
12. True love excludes all from its embrace but the beloved.
13. Public revelation of love is deadly to love in most instances.
14. The value of love is commensurate with its difficulty of attainment.
18. Good character is the one real requirement for worthiness of love.
22. Suspicion of the beloved generates jealousy and therefore intensifies love.
23. Eating and sleeping diminish greatly when one is aggravated by love.
24. The lover's every deed is performed with the thought of his beloved in mind.
26. Love is powerless to hold anything from love.
27. There is no such thing as too much of the pleasure of one's beloved.
30. Thought of the beloved never leaves the true lover.
31. Two men may love one woman or two women one man.

* From Alchin, L.K. *The Middle Ages*. Retrieved: March 2, 2016 from http://www.middle-ages.org.uk/knights-code-of-chivalry.htm.

** Appendix 1. *The Rules of Courtly Love*, based on the *De Amore* of Andreas Capellanus. "A Middle English Anthology," edited by Ann S. Haskell. Copyright 1985 by Wayne State University Press, Detroit, Michigan 48202, pp. 513–514.

READING 10.4 GUILLAUME DE LORRIS AND JEAN DE MEUN

"La Vieille" (The Old Woman), from the *Romance of the Rose*, lines 12930ff and 14471ff.

LINES 12930FF

"O God! But it still pleases me when I think back on it. I rejoice in my thought and my limbs become lively again when I remember the good times and the gay heart for which my heart so strongly yearns. Just to think of it and remember it makes my body young again. Remembering all that happened gives me all the blessings of the world, so that however they may have deceived me, at least I have had my fun."

LINES 14471FF

"A woman has very poor judgment, and I was truly a woman. I never loved a man who loved me, but, do you know, if that scoundrel had... broken my head, I would have thanked him for it. He wouldn't have known how to beat me so much that I would not have had him throw himself upon me, for he knew very well how to make his peace, however much he had done against me.... Thus he had me caught in his snare, for this false, treacherous thief was a hard rider in bed. I couldn't live without him; I wanted to follow him always. If he had fled, I would certainly have gone as far as London in England to seek him, so much did he please me and make me happy."

RELIGION, PHILOSOPHY, AND WRITING

Writers on religion and philosophy also made a great impact during the height of the Middle Ages. Among them are Moses Maimonides, Francis of Assisi, and Thomas Aquinas. Many consider Aquinas to be the most influential writer about Christianity since Augustine of Hippo.

Moses Maimonides

Moses Maimonides (1135–1204) was a physician and biblical scholar, and is considered to be the most important medieval Jewish philosopher. He was born and reared in Spain, during a period referred to as the golden age of Jewish culture. These were the centuries following Moorish rule and prior to the Inquisition (1492). Maimonides traveled extensively, settling in Egypt, where he served as court physician who treated the grand vizier of Egypt, Sultan Saladin, and—during the Crusades—Richard the Lion-Hearted. But at the end of the day, he treated the poor. He was well acquainted with the writings of the Greek, Christian, and Muslim scholars and philosophers as well as those in his own tradition, and his writings influenced philosophers beyond his tradition, including St. Thomas Aquinas.

One of his best-known works is *The Guide for the Perplexed*,[4] which was written in Arabic. It attempts to explain why people who are not interested in religion ought to be and what the Hebrew Bible might truly mean. For example, Maimonides wrestles with the concept in Genesis that man was made in the image of God. He spends a chapter discussing translations and interpretations of the words *image* or *likeness*, and he concludes that Genesis is not saying that people *look like* God, for God may have no bodily form at all. In the *Guide*, Maimonides discusses the reality of God, theories about the beginning of the universe and whether the universe is eternal, the celebration of the Sabbath, human intelligence, and why people are responsible for the evil that befalls them.

The *Guide* was translated by many people into many different languages. A contemporary of Maimonides, Shmuel ibn Tibbon, translated the work into Hebrew and wrote Maimonides that he would like to visit him to discuss some problems in translation. Maimonides's response provides some insight into the life he was leading in Egypt at the time:

READING 10.5 MOSES MAIMONIDES

A letter to Shmuel ibn Tibbon

I dwell at Fostat, and the sultan resides at Cairo [about a mile and a half away].... My duties to the sultan are very heavy. I am obliged to visit him every day, early in the morning, and when he or any of his children or any of the inmates of his harem are indisposed, I dare not quit Cairo, but must stay during the greater part of the day in the palace. It also frequently happens that one of the two royal officers fall sick, and I must attend to their healing. Hence, as a rule, I leave for Cairo very early in the day, and even if nothing unusual happens, I do not return to Fostat until the afternoon. Then I am almost dying with hunger.... I find the antechamber filled with people, both Jews and gentiles, nobles and common people, judges and bailiffs, friends and foes—a mixed multitude who await the time of my return.

I dismount from my animal, wash my hands, go forth to my patients and entreat them to bear with me while I partake of some slight refreshment, the only meal I take in the twenty-four hours. Then I go forth to attend to my patients, and write prescriptions and directions for their various ailments. Patients go in and out until nightfall, and sometimes even, I solemnly assure you, until two hours or more in the night. I converse with and prescribe for them while lying down from sheer fatigue; and when night falls I am so exhausted that I can scarcely speak.

In consequence of this, no Israelite can have any private interview with me, except on the Sabbath. On that day the whole congregation, or at least the majority of the members, come to me after the morning service, when I instruct them as to their proceedings during the whole week; we study together a little until noon, when they depart. Some of them return, and read with me after the afternoon service until evening prayers. In this manner I spend that day.

Maimonides also formulated 13 principles of Jewish faith that may strike you as quite familiar because of the influence they achieved. They begin with the idea that God exists, is one, and is eternal and spiritual in nature. God alone should be worshipped. God's will was revealed through prophets, and in Maimonides's eyes, Moses was the preeminent prophet. (Muslims include Jesus and Muhammad as prophets. Christians, of course, see Jesus as God.) Maimonides affirmed that God's law was given to humanity on Mount Sinai and was recorded accurately in the Hebrew Bible. God has foreknowledge of all events. God rewards virtue and punishes evil. There will be a Jewish Messiah (whom Christians believe is Jesus), and the dead will be resurrected. However, Maimonides also agreed with Aristotle that the intellect or soul—not the body—becomes immortal when it seeks virtue and godliness. Although bodily resurrection was an article of faith, Maimonides most often seemed to support the view that immortality is spiritual rather than physical. He also composed a code of Jewish law in his *Mishneh Torah*.

The *Guide* also teaches a "negative theology" that describes God in terms of what God is *not*. For example, it would be correct to say "God is not unintelligent" rather than "God is wise," or "God is not without existence" rather than "God exists." Maimonides was reluctant to describe God affirmatively, because he believed that people cannot understand the nature of God.

4. Moses Maimonides, *The Guide for the Perplexed*, trans. M. Friedlander, accessed 2/23/16, http://www.teachittome.com/seforim2/seforim/the_guide_for_the_perplexed.pdf.

Maimonides's views on the problem of evil are similar to Augustine's. He believed that God was good and all-powerful but that evil could exist because evil is the lack of God, as shown, for example, by people who freely choose to reject belief in God or God's laws.

Francis of Assisi

In Italy at the end of the 12th century, a young man was born who would reshape medieval religious and cultural life. Giovanni di Bernadone, born in 1181 in the Umbrian hill town of Assisi, was renamed Francesco ("Little Frenchman") by his merchant father. The son of wealthy parents, Francis grew up as a popular, somewhat spendthrift, and undisciplined youth. He joined the volunteer militia at a young age to do battle against the neighboring city of Perugia, only to be captured and put into solitary confinement until a ransom could be met.

That incident seems to have marked a turning point in his life. He dropped out of society and began to lead a life of prayer and self-denial. Eventually, he concluded that the life of perfect freedom demanded a life of total poverty. He renounced worldly goods and began a life of itinerant preaching that took him as far away as the Middle East. His simple lifestyle attracted followers who wished to emulate him. By 1218, there were over 3000 Little Brothers (as he called them) who owed their religious allegiance to him. Francis died in 1226 when the movement he started had already become a powerful religious order—the Franciscans—within the Catholic church.

Devotion to Saint Francis continues, and on some lawns in some neighborhoods even today, you might spot a statuette of a robed Francis with a bird on its shoulder. That he could be found preaching to the birds is part of the legend of St. Francis, but to think of him only as a medieval Doctor Dolittle speaking to animals is to trivialize a man who altered medieval culture profoundly. First, his notion of a *mendicant* (begging) brotherhood that would be mobile and capable of preaching in the newly emerging cities of Europe was a worthy substitute for the more rural, land-bound monasteries of the past. Second, Francis believed that the Gospels could be followed literally, and this led him to identify closely with the humanity of Christ. It is said that in 1224, he had so meditated on the Passion of Christ that his own hands and feet bore the bloodied marks of Jesus's crucifixion (*stigmata*). This emphasis on Jesus's humanity would come to shape representations of Him in more realistic, vivid ways. Finally, Francis's attitude toward religious faith was powerfully affirmative. He praised the goodness of God's creation; he loved the created world; he preached concern for the poorest of the poor; he felt that all creation was a gift and that everything in creation praised God in its own way. Some scholars have argued that the impact of the Franciscan vision on the imagination of European culture was a remote cause of the Renaissance preoccupation with the natural world and the close observation of nature.

Two years before he died, Francis—blind and in ill health—wrote "The Canticle of Brother Sun" (see Reading 10.6) with the hope that his brothers would sing it on their preaching journeys. It was one of the earliest poems written in Italian. It reflects his—and Franciscan—devotion to and celebration of nature as the evidence of the Divine.

The Berlinghieri altarpiece—one of the earliest depictions of Francis of Assisi—in the Franciscan church at Pescia has a central panel depicting the saint, with scenes from his life on

READING 10.6 SAINT FRANCIS OF ASSISI

"The Canticle of Brother Sun"

Most high, omnipotent, good Lord
To you alone belong praise and glory, honor and blessing.
No one is worthy to breathe Your name.
Be praised, my Lord, for all Your creatures.
In the first place for [per] the blessed Brother Sun
who gives us the day and enlightens us through You.
He is beautiful and radiant in his great splendor
giving witness to You, most omnipotent One.
Be praised, my Lord, for Sister Moon and the stars
formed by You so bright, precious, and beautiful.
Be praised, my Lord, for Brother Wind
and the airy skies so cloudy and serene.
For every weather, be praised because it is life giving.
Be praised, My Lord, for Sister Water
so necessary yet humble, precious, and chaste.
Be praised, my Lord, for Brother Fire
who lights up the night.
He is beautiful and carefree, robust and fierce.
Be praised, my Lord, for our sister, Mother Earth
who nourishes and watches over us
while bringing forth abundant fruits and colored
 flowers and herbs.
Be praised, my Lord, for those who pardon through Your love
and bear witness and trial.
Blessed are those who endure in peace
for they will be crowned by You, Most High.
Be praised, my Lord, for our sister, bodily Death,
whom no one living can escape.
Woe to those who die in sin.
Blessed are those who discover Your holy will.
The second death will do them no harm.
Praise and bless the Lord.
Render Him thanks.
Serve Him with great humility.
Amen.

both sides (**Fig. 10.22**). Such altarpieces were not only tributes to the saint but also ways of reminding viewers of incidents of his life, which would have been read out to congregations to reinforce stories about him. These early sacred biographies were known as legends (from the Latin *legere*, "to read") because they were read aloud. Such altarpieces served the double purpose of teaching about the saint's life and providing devotional aids for the people.

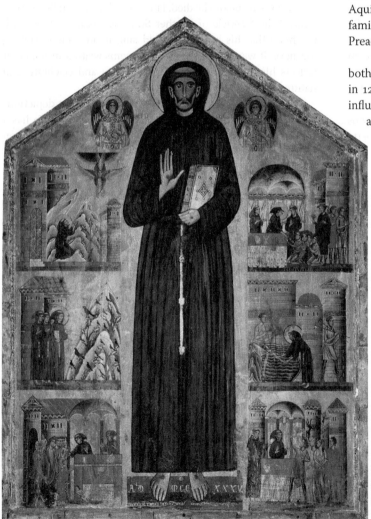

◀ **10.22** Bonaventura Berlinghieri, *Scenes from the Life of St. Francis*, 1235. Tempera on wood, predella panel of altarpiece, 63" × 48⅜" (160 × 123 cm). San Francesco, Pescia, Italy. Note that Francis looks forward to the viewer so that one could speak directly to the saint.

Thomas Aquinas

The Franciscans were one of two prominent mendicant orders that originated in the 12th and 13th centuries. The other was the Dominican order, founded by the Spanish monk, Dominic de Guzman (ca. 1170–1221). Perhaps the most renowned member of the Dominicans was Thomas Aquinas (1225–1274), who embraced the dialectical method of Peter Abelard and who is closely associated with the nexus of theology, dogma, and scholasticism.

The 13th century could be called the golden age of the University of Paris, and Thomas Aquinas was a part of it. Along with other distinguished professors from other parts of Europe (Albert the Great from Germany; Alexander of Hales from England; Bonaventure from Italy), Aquinas (also from Italy), contributed to the international character of medieval university scholarship and life.

Aquinas is one of the 33 doctors of the Roman Catholic Church, a title given to particular saints whose writings and preaching are considered seminal to the teaching of the Christian faith and applicable across the ages. He, like Francis of Assisi, was born to privilege; he also had familial ties to Holy Roman emperors. Although it was expected that he would follow in an uncle's footsteps and join the Benedictine order, Aquinas was recruited by a Dominican preacher, and, to his family's shock and disappointment, joined the ranks of the Preaching Friars of Saint Dominic (the Dominicans) in 1243.

From 1245 to 1248, he studied with Albert the Great at both Paris and Cologne and was made a **magister** of theology in 1258 after completing his doctoral studies. His intellectual influence went far beyond the lecture halls of Paris, however, and is felt to this day.

Aquinas's life ended before he was 50, but in that time span, he produced a vast body of writings (they fill 40 folio volumes) on theology, philosophy, and biblical studies. Of his many written works, the *Summa theologica* and the *Summa contra gentiles* are his most well known. Although his writings touched on a wide variety of subjects, at root Aquinas was interested in, and made a lifetime study of, a basic problem: how does one harmonize those things that are part of human learning (reason) with those supernatural truths revealed by God in the Bible and through the teaching of the church (revelation)? Aquinas's approach was to steer a middle path through two diametrically opposed opinions, both of which had avid supporters in the Middle Ages: the position of *fideism*, which held that religious faith as an

READING 10.7 THOMAS AQUINAS

From *Summa Theologica*, Part I, question 1, article 1

It was necessary for man's salvation that there should be a knowledge revealed by God besides philosophical science built up by human reason. Firstly, indeed, because man is directed to God, as to an end that surpasses the grasp of his reason: "The eye hath not seen, O God, besides Thee, what things Thou hast prepared for them that wait for Thee" (Is. 66:4).... Hence it was necessary for the salvation of man that certain truths which exceed human reason should be made known to him by divine revelation. Even as regards those truths about God which human reason could have discovered, it was necessary that man should be taught by a divine revelation; because the truth about God such as reason could discover, would only be known by a few, and that after a long time, and with the admixture of many errors. Whereas man's whole salvation, which is in God, depends upon the knowledge of this truth. Therefore, in order that the salvation of men might be brought about more fitly and more surely, it was necessary that they should be taught divine truths by divine revelation. It was therefore necessary that besides philosophical science built up

by reason, there should be a sacred science learned through revelation.

Reply to Objection 1: Although those things which are beyond man's knowledge may not be sought for by man through his reason, nevertheless, once they are revealed by God, they must be accepted by faith. Hence the sacred text continues, "For many things are shown to thee above the understanding of man" (Ecclus. 3:25). And in this, the sacred science consists.

Reply to Objection 2: Sciences are differentiated according to the various means through which knowledge is obtained. For the astronomer and the physicist both may prove the same conclusion: that the earth, for instance, is round: the astronomer by means of mathematics (i.e., abstracting from matter), but the physicist by means of matter itself. Hence there is no reason why those things which may be learned from philosophical science, so far as they can be known by natural reason, may not also be taught us by another science so far as they fall within revelation. Hence theology included in sacred doctrine differs in kind from that theology which is part of philosophy.

absolute is indifferent to the efforts of human reason (*credo quia absurdum est,* "I believe because it is absurd"), and *rationalism,* which insists that everything, revelation included, must meet the test of rational human scrutiny. Aquinas wanted to demonstrate that the liberal arts, the things and seasons of the world, and the mysteries revealed by God could be brought into some kind of intellectual harmony based on a single criterion of truth.

For Aquinas, reason finds truth when it sees evidence of truth. The mind judges something true when it has observed a sufficient number of facts to compel it to make that judgment. The mind gives assent to truth on the basis of evidence. Aquinas was convinced that there was a sufficient amount of observable evidence in the world to conclude the existence of God. He proposed five arguments in support of such a position. Still, he recognized that such argumentation yields only a limited understanding of God. Aquinas did not believe that the naked use of reason could ever discover or prove the mysteries about God revealed in the Bible: that God became a man in Jesus Christ or that there was a Trinity of persons in God. God had to tell us that. Our assent to it is not based on evidence, but on the authority of God who reveals it to us. If we could prove the mysteries of faith, there would have been no need for revelation and no need of faith.

Thus, for Aquinas there is an organic relationship between reason and revelation. Philosophy perfects the human capacity to know, and revelation perfects one beyond the self by offering salvation and eternal life. Aquinas stated this relationship between reason and revelation at the beginning of his great work of theology, the *Summa theologica* (see Reading 10.7).

When we read Aquinas today, we get some sense of his stark and rigorous attempt to think things through. For one thing, he offers no stylistic adornment to relieve his philosophical and rational discourse. For another, he makes clear that philosophical and theological reasoning is difficult; it is not a pastime for the incompetent or the intellectually lazy. Yet Aquinas was not a mere machine for logic. He had the temperament of a mystic. Some months before he died, he simply put down his pen; when his secretary asked him why he had stopped writing, he said that in prayer and quiet he had had a vision and that what he had written "seemed as straw." Aquinas was a rare combination of intellectual and mystic.

The intellectual tradition that Aquinas used in his writing was that of the Greek philosopher Aristotle. He first knew Aristotle's work in Latin translations, based on Arabic texts, done by Muslim scholars in the south of Spain and North Africa. Later, Aquinas was able to use texts translated directly out of Greek by a Flemish friar and sometime companion, William of Moerbeke. Aquinas's use of Aristotle was certainly not a novelty in the Middle Ages. Such Arabic scholars as Avicenna (980–1036) and Averröes of Córdoba (1126–1198) commented on Aristotle's philosophy and its relationship to the faith of Islam.

Two other characteristics of the thought of Aquinas should be noted. First, his worldview was strongly hierarchical. Everything has its place in the universe, and that place is determined in relation to God. A rock is good because it *is* (to Aquinas, existence itself was a gift), but an animal is more nearly perfect because it has life and thus shares more divine attributes. In turn, men and

women are better still because they possess mind and will. Angels are closer yet to God because they, like God, are pure spirit.

This hierarchical worldview explains other characteristics of Aquinas's thought in particular and medieval thought in general: It is wide-ranging, it is encyclopedic, and in interrelating everything it is synthetic. Everything fits and has its place, meaning, and truth. That a person would speak on psychology, physics, politics, theology, and philosophy with equal authority would strike us as presumptuous, just as any building decorated with symbols from the classics, astrology, the Bible, and scenes from everyday life would now be considered a hodgepodge. Such was not the case in the 13th century, because it was assumed that everything ultimately pointed to God.

Although Aquinas is often thought of as a philosopher, he understood himself to be a commentator on the Bible—"Master of the Sacred Page." Like all such lecturers, he was charged by the university with three tasks: reading (of the Bible), disputing (using logic and argument to solve theological problems), and preaching. While attention is often given to his great *Summas*, it is well to remember that he also wrote long commentaries on specific books of the Bible, as well as compiled anthologies of early commentators on biblical material. In addition, he composed hymns that are still sung today.

The 13th century saw the rise of two complementary impulses that would energize late medieval culture: the affective and emotional religion of Francis of Assisi and the intellectualism of the schools epitomized in someone like Thomas Aquinas. Those two impulses would be best synthesized in the masterpiece that summed up high medieval culture: the *Divine Comedy* of Dante Alighieri, which we see in the following chapter.

GLOSSARY

Allegory (p. 332) The expression by means of symbolic figures and actions of a hidden or emblematic meaning, often spiritual in nature.

Ambulatory (p. 311) In a church, a continuation of the side aisles into a passageway that extends behind the choir and **apse** and allows traffic to flow to the chapels, which are often placed in this area (from *ambulare*, Latin for "to walk").

Apse (p. 311) A semicircular or polygonal projection of a building with a semicircular dome, especially on the east end of a church.

Archivolt (p. 321) An ornamental molding around an arched wall opening.

Censer (p. 319) A container carrying incense that is burned, especially during religious services.

Choir (p. 311) In architecture, the part of a church occupied by singers, usually located between a **transept** and the major **apse**.

Contrapposto (p. 322) A position in which a figure is obliquely balanced around a central vertical axis. The body weight rests on one foot, shifting the body naturally to one side; the body becomes curved like a subtle S.

Crypt (p. 311) An underground vault or chamber, particularly beneath a church, that is used as a burial place.

Dialectics (p. 327) Intellectual techniques involving rigorous reasoning to arrive at logical conclusions.

Flying buttress (p. 312) In architecture, an arched masonry support that carries the thrust of a roof or a wall away from the main structure of a building to an outer pier or buttress.

Gothic style (p. 311) A style of architecture that flourished during the High and Late Middle Ages, characterized by pointed arches, rib vaulting, and a visual dissolving of stone walls to admit light into a building.

Horarium (p. 323) The daily schedule of members of a religious community, such as a monastery.

Magister (p. 336) A graduate degree indicative of readiness to teach in a university. The term is similar to a master's degree today, although as advanced as today's doctorate.

Mullion (p. 318) In architecture, a slender vertical piece that divides the units of a window or door.

Narthex (p. 311) A church vestibule that leads to the **nave**, constructed for use by individuals preparing to be baptized.

Nave (p. 311) The central aisle of a church, constructed for use by the congregation at large.

Organum (p. 325) An early form of **polyphony** using multiple melodic lines.

Polyphony (p. 325) A form of musical expression characterized by many voices.

Rectangular bay system (p. 316) A floor plan that places rectangular units in the nave, such that each is defined by its own vault and a square unit in the side aisles.

Relic (p. 324) In this usage, a part of a holy person's body or belongings used as an object of reverence.

Scholasticism (p. 311) The system of philosophy and theology taught in medieval European universities, based on Aristotelian logic and the writings of early church fathers; the term has come to imply insistence on traditional doctrine.

Sexpartite rib vault (p. 315) In architecture, a rib vault divided into six parts and formed by the intersection of barrel vaults.

Transept (p. 319) In a cross-shaped church, the shorter arm of the cross, which lies across from the nave.

Triforium (p. 313) A gallery or arcade above the arches of the **nave**, **choir**, or **transept** of a church.

Universitas (p. 327) A corporation; a group of persons associated in a guild, community, or company.

THE BIG PICTURE THE HIGH MIDDLE AGES

Language and Literature

- European languages in use today developed from Old French and Middle English.
- The 12th century was the golden age of the University of Paris under scholastic masters.
- Peter Abelard began teaching in Paris in 1113 and met Héloïse.
- Troubadours and trobairitz composed songs, many of which had to do with courtly love, some with debauchery, and others with political matters.
- The 13th century was an era of writing of secular poetry, including goliardic verse.
- The allegorical *Romance of the Rose* was begun ca. 1230 by Guillaume de Lorris and completed some 40 years later by Jean de Meun.
- Villard de Honnecourt wrote his notebooks on the construction of cathedrals ca. 1235.

Art, Architecture, and Music

- The Gothic style began with Abbot Suger's undertaking of the construction of Saint-Denis in 1140.
- The Cathedral of Notre-Dame was constructed in Paris ca. 1163–1250.
- Chartres Cathedral was destroyed by fire in 1194, and rebuilding in the Gothic style began.
- The *Notre-Dame de Belle Verrière*, a stained-glass window, was installed at Chartres Cathedral.
- The Christ blessing trumeau was sculpted at the south porch of Chartres Cathedral ca. 1215.
- Guild windows were set in place at Chartres Cathedral ca. 1215–1250.
- The Cathedral at Amiens was constructed ca. 1220–1269.
- The Saint Francis of Assisi altarpiece was constructed at San Francesco, Pescia, Italy in 1235.
- Organum developed in the 10th century.
- Guido d'Arezzo invented the musical notation used today in the 11th century.
- Troubadours and trobairitz created the love song as we know it today.
- The Notre-Dame school of Paris was the center of music study and composition.
- German minnesingers flourished during the 13th century.
- Polyphonic motets were the principal form of composition ca. 1250.

Philosophy and Religion

- Scholasticism was born in the early 12th century.
- Moses Maimonides wrote his *Guide for the Perplexed* ca. 1190.
- Saint Francis of Assisi wrote his "Canticle of Brother Sun" ca. 1224.
- Thomas Aquinas wrote his *Summa theologica* ca. 1267–1273.

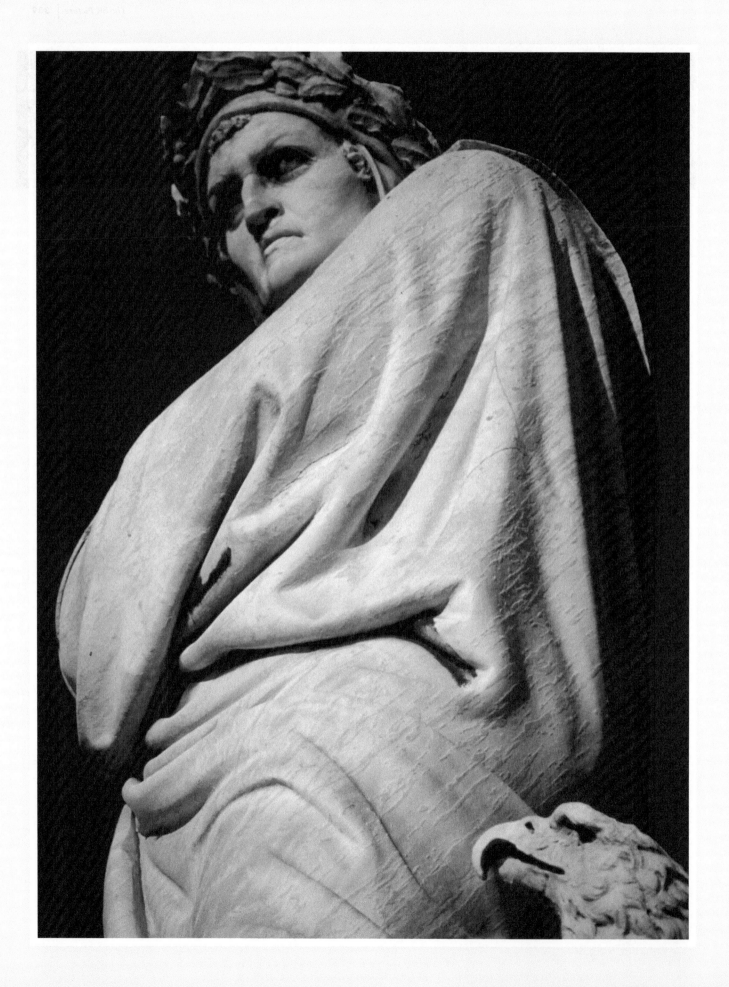

The Fourteenth Century:
A Time of Transition

PREVIEW

On a wall in the Chapel of the Bargello Palace in Florence, there is a portrait of the famed poet Dante by his friend Giotto, the most famous Italian artist of the 14th century. The man is instantly recognizable to us as Dante. We have seen this image in countless iterations—an aquiline nose and strong, jutting chin, a signature red robe and head covering. The portrait dates to the 1300s, Dante's lifetime, and Giorgio Vasari—author of the 16th-century art-historical landmark Lives of the Artists—*tells us that Giotto painted it. In his life of Giotto, Vasari documents the relationship between the poet and painter, recounting a meeting between the two in Padua, where Dante saw Giotto's work in progress. Dante then went on to immortalize Giotto in his renowned poetic narrative* The Divine Comedy, *in which he contrasts the success and fame of the young painter with that of his older teacher, Cimabue, whose work had lost its luster. Just as Dante preserved Giotto's name in the poem, Giotto preserved Dante's likeness in the painting.*

◀ **11.1** Enrico Pazzi, *Dante Alighieri*, 1865. Piazza Santa Croce, Florence, Italy.

This is the story that any tour guide in Florence might tell, but almost none of it is true. Art historian E. H. Gombrich writes, "Dante is the first person for almost a thousand years whose name immediately evokes a vivid image of his physical presence"[1] and yet that image has no basis in reality. Gombrich juxtaposes the legend that history has long embraced with the facts we know about Giotto, Dante, and Florence in in the first few decades of the 14th century. It is not even clear that Dante and Giotto ever knew one another.

What do we know about these men and their place in history, and whether or not they can be yoked together by this painting? Giotto indeed was the most eminent painter in Florence, if not all of Italy, at the time that Dante was writing. His innovative approach to art, based on a close observation of the everyday natural world, laid the groundwork for the masterful illusions of three-dimensionality on a two-dimensional surface that would raise the art of painting to unimaginable heights in the two centuries that followed. Dante, whose *Divine Comedy* was written in Italian, the everyday language of his fellow citizens, would be seen as the greatest poet in the history of Florence, if not all of Italy. Giotto's talents would become so sought after and jealously guarded that the city of Florence would appoint him *capomaestro* (head master), overseeing all of its artistic and civic projects. They were afraid that Giotto might leave town and seek work elsewhere. And,

1. E. H. Gombrich, "Giotto's Portrait of Dante?," *The Burlington Magazine* 121, no. 917 (Aug. 1979): 471.

although Dante became enmeshed in a political struggle that led to his exile from the city in 1301 (his *Divine Comedy* was written in exile and may have been intended to bring him back into the good graces of the city fathers), the city would eventually decree public readings of the poem and create a "poets' corner" in the Florence Cathedral to honor its literary masters—Dante among them.

All signs point to this conclusion about the portrait in the Bargello: it is not a painting of Dante by Giotto. Now the questions are these: Why does this iconic image persist? What purpose does it serve for us? Gombrich quotes Pliny the Elder's *Natural History* on the practice of hanging the portraits of authors in libraries in his own time: "Our desires bring forth even the images which have not come down to us, as was the case with Homer. For I think there can be no greater happiness than the perpetual desire to know what someone was like."[2]

THE FOURTEENTH CENTURY

The 14th century (often called the **Trecento**, Italian for "300") is usually described by historians as the age that marks the end of the medieval period and the beginning of the Renaissance in Western Europe. If we accept this rather neat summation, we should expect to see strong elements of the medieval sensibility as well as some stirrings of the "new birth" (*renaissance*)

2. Quoted in Gombrich, "Giotto's Portrait of Dante?," 483.

of culture that was the hallmark of 15th-century European life. But we must not imagine the break between the Middle Ages and the Renaissance to be clean and dramatic. History rarely unfolds so precisely. Neither should we imagine that cultural history moves in a straight line toward greater modernity or greater perfection. In fact, the 14th century was a period of natural calamity (bubonic plague), institutional decay (internal and external challenges to the medieval Christian church), and cruel violence (peasant revolts and the Hundred Years' War). There is a reason that Barbara Tuchman added a subtitle to her 1978 history of life in 14th-century France, *A Distant Mirror*: "The Calamitous Fourteenth Century." It was against this backdrop that some of the most famous names in literature and art emerged: the poets Dante, Boccaccio, Petrarch, and Chaucer, and the artists Cimabue and Giotto.

The Black Death

Overshadowing the achievements of the 14th century is the terrible pandemic of infectious disease we know as the **Black Death**. Midway through the century, in 1348, the bubonic plague swept through Europe, killing untold numbers of people and disrupting trade, culture, and daily life in ways that are difficult to imagine.

The plague first appeared in Central Asia, and, in 1347, a fleet of ships from the Crimea carrying infected rats and fleas brought it to the port of Messina, Sicily. Within a year, the plague had begun its journey throughout most of Europe. Medieval physicians had no idea how the plague was transmitted,

The Fourteenth Century

1299 CE	1309 CE	1378 CE	1417 CE
	CAPTIVITY OF THE PAPACY	**THE GREAT SCHISM**	
The Ottoman Turk dynasty is founded	The captivity of the papacy at Avignon begins	Reign of Richard II in England	
Pope Boniface VIII proclaims the first Jubilee Year ("Holy Year")	Earliest known use of cannon	The Great Schism in the Roman Catholic Church begins	
Philip the Fair of France imprisons and abuses Pope Boniface VIII	Hundred Years' War between France and England	Peasants' Revolt in England	
	Reign of Charles IV, Holy Roman emperor	Reign of Henry IV in England	
	Bubonic plague devastates Western Europe	The English defeat the French at Agincourt	
	The English defeat the French at Poitiers	The Council of Constance ends the Great Schism with the election of Pope Martin V	
	The lower classes in France revolt		
	Reign of Philip the Bold, Duke of Burgundy		
	The papacy returns to Rome from Avignon		

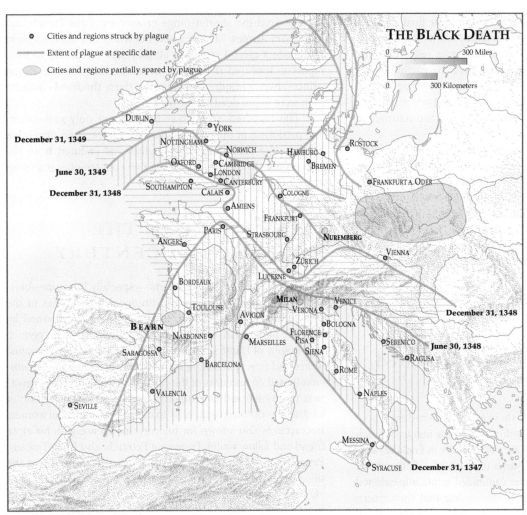

THE BLACK DEATH

○ Cities and regions struck by plague

— Extent of plague at specific date

⬭ Cities and regions partially spared by plague

0 — 300 Miles

0 — 300 Kilometers

although they did understand that it was contagious. Many refused to treat victims. Family members abandoned infected relatives. Cemeteries ran out of space to bury the dead. The cities were the worst affected; it has been estimated that some cities in Italy lost as many as two-thirds of their population in 1348 alone. Wealthier citizens took refuge in the countryside—a survival maneuver described by the writer and eyewitness, Giovanni Boccaccio, in his collection of stories entitled the *Decameron.*

The plague's human toll brought with it equally devastating psychological and cultural effects. The decline in population and the interruption in agriculture and the production of goods such as cloth and construction materials devastated the economy. Labor shortages led to higher wages for those who could (or would) work, and they, in turn, led to higher market prices and social unrest among those who could not afford to live from day to day. From 1350 to 1450, Europe was rocked by waves of peasant and worker uprisings against employers. To many, the events triggered by the Black Death seemed to prefigure the end of the world. As one observer noted, "It was as if the voice of existence in the world had called out for oblivion, and the world responded to its call."[3]

The Avignon Papacy and the Great Schism

Nature was not the only scourge of 14th-century Europe. The medieval Christian church—that most powerful and enduring of institutions in medieval life—underwent convulsive changes in the 14th century, changes that issued early warning signals of the Reformation to come two centuries later.

In 1300, Pope Boniface VIII celebrated the first Jubilee Year in Rome—a tradition that continues every 25th year to this day. It brought pilgrims and visitors from all over the Christian West to pay homage to the papacy and the Catholic Church.

3. Ibn Khaldoun, *The Muquddimah: An Introduction to History*, ed. N. J. Dawood, trans. Franz Rosenthal (Princeton: Princeton University Press, 1969).

This event, however, turned out to be one of the final symbolic moments of papal supremacy over European life and culture. Three years later, Philip the Fair of France, in response to an edict that declared papal supremacy over the earthly power of monarchs, attacked the Boniface's palace in Anagni, Italy, imprisoning him and starving him of food and water for days. Boniface was rescued by the people of Anagni and returned to Rome. He died a month later.

In 1309, under severe pressure from the French, the seat of the papacy was removed to Avignon in southern France, where it was to remain for nearly 70 years until Pope Gregory XI returned to Rome. The result of his move is what has come to be known as the **Great Schism**—a split within the Catholic Church that produced two sets of rival Popes and groups of hostile supporters who pledged allegiance to one or another of the claimants to the papacy. Not until 1417 was this breach in church unity healed. The Council of Constance ended the schism and deposed three papal pretenders to bring about the reunification of the church.

Peasant Revolts and the Hundred Years' War

The societal disarray caused by these events spawned ever more insistent demands for church reforms. Popular literature (such as the works of Boccaccio in Italy and Chaucer in England) satirized the decadence of the church unmercifully. Catherine of Siena (1347–1380), who was later canonized, wrote impassioned letters to the popes of Avignon, demanding that they return to Rome and free the church from the political constraints of the French monarchy. In England, John Wycliffe's cries against the immorality of the higher clergy and the corruption of the church fueled indignation at all levels, inciting the Peasants' Revolt of 1381.

This was only the last in a series of class struggles and revolutions that occurred in the 14th century around Europe. The frequency and magnitude of these revolts signified a profound dissatisfaction with the church and the nobility—with institutional authority. Perhaps it is no coincidence that the story of Robin Hood, the heroic figure who "robbed from the rich to give to the poor," was born in the 14th century.

Class-related violence was not the only cause of bloodshed during this period. The Hundred Years' War between the kings of France and England over the legitimacy of the French crown was waged from 1337 to 1453 in a series of deadly conflicts that lasted for generations. The famous battles of the period—Poitiers, Crécy, Agincourt—may now seem vaguely romantic, but they brought unrelenting misery to France. Between campaigns and conquests, roaming bands of mercenaries pillaged the landscape ruthlessly to compensate for poor wages.

The military raids were horrific in and of themselves. According to Jean Froissart's *Chronicles*, King Edward III of England sent a group of his men to examine the loss of life after the Battle of Crécy in 1346 in which English longbow weaponry

overpowered the shorter-range crossbows of the French and mercenary armies: "They passed the whole day upon the field and made a careful report of all they saw. According to their report it appeared that eighty banners, the bodies of eleven princes, twelve hundred knights, and thirty thousand common men were found dead on the field."[4]

The Hundred Years' War instilled not only nationalism and patriotism in the people but also deep fears and suspicions between the French and the English that endured from the 15th century to the 20th, until the two countries became allies against Germany in two World Wars.

LITERATURE IN THE FOURTEENTH CENTURY

Human creativity in all of the arts—especially literature—blossomed amid the natural and institutional catastrophes of the 14th century. Dante Alighieri, a Florentine, was renowned by the time of his death in 1321. Giovanni Boccaccio, who penned a biography of Dante in 1348, earned a reputation as a humanist writer and poet, publishing many works, including the *Decameron* (based on accounts of the Black Death and his own eyewitness testimony) and *On Famous Women*, the first collection of biographies devoted exclusively to the lives of influential women. Boccaccio is also known for his correspondence with his close friend and fellow writer, Francesco Petrarch, also from Tuscany. Petrarch's poetry—and sonnets, in particular—earned him the title of Poet Laureate, the first bestowed in Italy since antiquity. He became an international literary sensation. In England, Geoffrey Chaucer, considered one of the greatest authors in the history of English letters, wrote, as did Dante, in the vernacular—his own language. He, too, achieved great fame in his lifetime, not only as a poet–author, but also as a philosopher and astronomer. And in France, the Italian-born Christine de Pizan, whose family moved there from Venice to serve the court of King Charles V, composed at least 15 books—including poems and ballads.

Dante Alighieri

If Aquinas's *Summa Theologica* represents a masterpiece of the hierarchical and synthetic religious humanism of the Middle Ages, Dante Alighieri's (1265–1331) *Divine Comedy* represents an equivalent achievement in literature of the 14th century. Although Dante was a Florentine (see **Fig. 11.2**), he was deeply influenced by the intellectual currents that emanated from the Paris of his time. His family lived comfortably, but, unlike Aquinas, who was already studying at the University of Paris at the age of 20, Dante was likely mostly self-educated. Certainly his published work offers evidence of a deep love of learning. Dante wrote on the origin and development of language (*De vulgari*

4. Jean Froissart, *Chronicles*, trans. Geoffrey Brereton (London: Penguin Books, 1968).

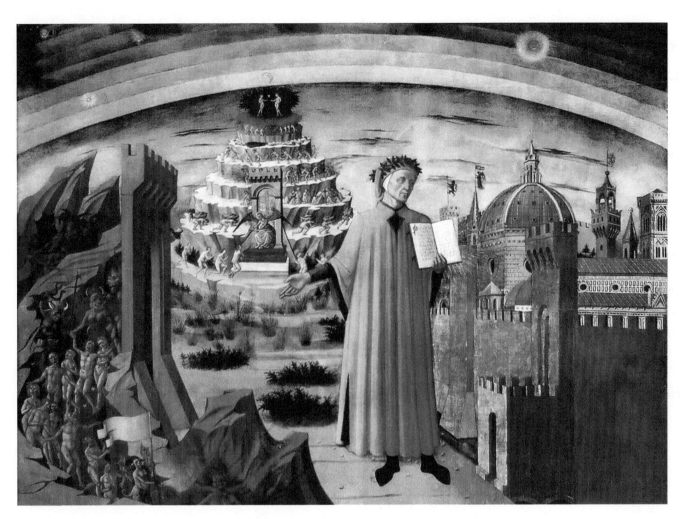

▲ **11.2 Domenico di Michelino,** *Dante Illuminated the City of Florence with His Book* **The Divine Comedy, 1465. Fresco 91" high × 114" wide (232 × 290 cm). Cathedral of Santa Maria del Fiore (the Duomo), Florence, Italy.** Dante's significance to the city of Florence was memorialized in a monument in the Florence Cathedral. He stands with his book open between hell, to which he gestures, and the city walls, behind which the Florence Cathedral and the tower of the Palazzo della Signoria can be seen. The mountain of Purgatory, with its seven terraces that symbolize the seven deadly sins, is in the middle distance. Its prominent place in the fresco refers to Dante's climb in the *Purgatorio* toward Paradise and Florence's ascent to spiritual enlightenment.

eloquentia), political theory (*De monarchia*), and generalized knowledge (*Convivio*), as well as his own poetic aspirations (*La vita nuova*). His *La Divina Commedia* (*The Divine Comedy*) is considered to be his magnum opus of poetic verse—a kind of epic narrative across three books that recounts his fictional journey through hell, purgatory, and heaven. It begins on Good Friday in 1300 and ends three days later. His conceptualization of each is outlined in the nearby Religion feature.

In the first two parts, the *Inferno* (hell) and the *Purgatorio* (purgatory), Dante is guided by the ancient Roman poet Virgil. Virgil's *The Aeneid* was a great inspiration to Dante, and he borrowed especially from Book 6, which recounts Aeneas's own journey to the underworld. From the border at the top of the mountain of purgatory to the pinnacle of heaven in the *Paradiso* (paradise), where Dante glimpses the "still point of light" that is God, the poet's guide is Beatrice, an actual young woman in Dante's life whom he loved passionately, if only platonically.

The organization of *The Divine Comedy* is precise. The poem is made up of 100 **cantos**. The first canto of the *Inferno* serves as an introduction to the entire poem. There are then 33 cantos for each of the three major sections (*Inferno*, *Purgatorio*, and *Paradiso*). The poem is written in a form called **terza rima** (*aba*, *bcb*, *cdc*, and so on) that is difficult to duplicate in English because of English's relative shortage of rhyming words. Each group of three lines is called a **tercet**. Consider the first tercets in Italian. *Vita* rhymes with *smarrita* in the first tercet (*aba*). Then, *oscura* in the first tercet rhymes with *dura* and *paura* in the second tercet (*bcb*):

> *Nel mezzo del cammin di nostra vita*
> *mi ritrovai per una selva oscura,*
> *ché la diritta via era smarrita.*

RELIGION

Hell, Purgatory, and Heaven in Dante's *The Divine Comedy*

HELL		PURGATORY	PARADISE	
The Anteroom of the Neutrals		**Ante-Purgatory: The Excommunicated, The Lazy, The Unabsolved, and Negligent Rulers**	The Moon	The Faithful who were inconstant
Circle 1	The Virtuous Pagans (Limbo)	The Terraces of the Mount of Purgatory	Mercury	Service marred by ambition
Circle 2	The Lascivious	The Proud	Venus	Love marred by lust
Circle 3	The Gluttonous	The Envious	The Sun	Wisdom; the theologians
Circle 4	The Greedy and the Wasteful	The Wrathful	Mars	Courage; the just warriors
Circle 5	The Wrathful	The Slothful	Jupiter rulers	Justice; the great
Circle 6	The Heretical	The Avaricious	Saturn	Temperance; the contemplatives and mystics
Circle 7	The Violent against Others, Self, God, Nature, and Art	The Gluttonous	The Fixed Stars	The Church Triumphant
Circle 8	The Fraudulent (subdivided into 10 classes, each of which dwells in a separate ditch)	The Lascivious	The Primum Mobile	The Order of Angels
Circle 9	The Lake of the Treacherous against kindred, country, guests, lords, and benefactors. Satan is imprisoned at the center of this frozen lake.	The Earthly Paradise	The Empyrean Heavens	Angels, Saints, the Virgin, and the Holy Trinity

Ahi quanto a dir qual era è cosa dura
esta selva selvaggia e aspra e forte
che nel pensier rinova la paura!

We expect the first and third lines of the third tercet will rhyme with *forte*, propelling us forward.

An English translation by a fine 20th-century American poet, John Ciardi,[5] finds the Italian rhyme scheme incompatible with English and instead uses the scheme *aba*, *cdc*, and so on:

Midway in our life's journey, I went astray
from the straight road and woke to find myself
alone in a dark wood. How shall I say

what wood that was! I never saw so drear,
so rank, so arduous a wilderness!
Its very memory gives a shape to fear.

When you listen to the poem in Italian, even without understanding the language, you quickly come to see that its unique form of beauty may not be translatable into English. But its ideas are.

The number three and its multiples, symbols of the Trinity, occur over and over. Hell is divided into nine regions plus a vestibule, and the same number is found in purgatory. Paradise contains the nine heavens of the Ptolemaic system plus the empyrean, the highest heaven. This scheme mirrors the whole poem's 99 cantos plus one. The sinners in hell are arranged according to whether they sinned by incontinence, violence, or fraud (a division Dante derived from Aristotle's *Ethics*), while the yearning souls of purgatory are divided in three ways according to how they acted or failed to act in relation to love. The saved souls in paradise are divided into the layfolk, the active, and the contemplative. Nearest the throne of God, but reflected in the circles of heaven, are the nine categories of angels.

Dante's interest in the symbolic goes beyond his elaborate manipulation of numbers. Sinners in hell suffer punishments that have symbolic value; their sufferings instruct as well as punish. The gluttonous live on heaps of garbage under driving storms of cold rain, the flatterers are immersed in pools of sewage, and the sexually perverse walk burning stretches of sand in an environment as sterile as their attempts at love.

Canto 3 tells of the poet's entrance into hell—the *Inferno*—and includes inscriptions carved in stone above the gate. Line 9 of the canto is one of the best known in the history of poetry:

5. From *The Divine Comedy* by Dante Alighieri, translated by John Ciardi. Copyright 1954, 1957, 1959, 1960, 1961, 1965, 1967, 1970 by the Ciardi Family Publishing Trust. Used by permission of W. W. Norton & Company, Inc.

> ### READING 11.1 DANTE
>
> *The Divine Comedy, Inferno,* canto 3, The Vestibule of Hell, lines 1–9
>
> I AM THE WAY INTO THE CITY OF WOE.
> I AM THE WAY TO A FORSAKEN PEOPLE.
> I AM THE WAY INTO ETERNAL SORROW.
>
> SACRED JUSTICE MOVED MY ARCHITECT.
> I WAS RAISED HERE BY DIVINE OMNIPOTENCE,
> PRIMORDIAL LOVE AND ULTIMATE INTELLECT.
>
> ONLY THOSE ELEMENTS TIME CANNOT WEAR
> WERE MADE BEFORE ME, AND BEYOND TIME I STAND.
> ABANDON ALL HOPE YE WHO ENTER HERE.

Conversely, in paradise, the blessed dwell in the circles symbolic of their virtue. The theologians are in the circle of the sun because they enlightened the world, and the holy warriors dwell in the sphere of Mars.

The Divine Comedy is replete with mythological and historic figures. We find people in the second circle of hell who abandoned themselves to the tempest of their passions. Their punishment, therefore, is to be perpetually lashed by the tempest. Dante asks his guide, Virgil, to explain what is happening:

> ### READING 11.2 DANTE
>
> *The Divine Comedy, Inferno,* canto 5, Circle Two, lines 49–69
>
> And watching their shadows lashed by wind, I cried:
> "Master, what souls are these the very air
> lashes with its black whips from side to side?"
>
> "The first of these whose history you would know,"
> he answered me, "was Empress of many tongues.
> Mad sensuality corrupted her so
>
> that to hide the guilt of her debauchery
> she licensed all debauchery alike,
> and lust and law were one in her decree.
>
> She is Semiramis of whom the tale is told
> how she married Ninus and succeeded him
> to the throne of that wide land the Sultans hold.
>
> The other is Dido; faithless to the ashes
> of Sichaeus, she killed herself for love.
> The next whom the eternal tempest lashes
>
> is sense-drugged Cleopatra. See Helen there,
> from whom such ill arose. And great Achilles,
> who fought at last with love in the house of prayer.
>
> And Paris. And Tristan." As they whirled above
> he pointed out more than a thousand shades
> of those torn from the mortal life by love.

Dante then sees the lovers Paolo and Francesca, tempest-tossed. Francesca da Rimini (1255–1285) was a contemporary of Dante whose father Guido, at war with the Malatesta family, sought to bring peace by marrying her to Giovanni Malatesta. Giovanni was deformed, and Guido knew Francesca would not consent to the marriage. Therefore, he had her marry Giovanni's handsome brother, Paolo, by proxy. Francesca fell in love with Paolo, and they became so impassioned when reading the love story of Lancelot and Guinevere that they made love. They were discovered by Giovanni and murdered before they could repent, and thus were consigned to the second circle of hell. In the following passage, Dante manages to speak with Francesca as she and Paolo are swirling around, "one in Hell," Francesca says, "as we were above." The passage is noted for its poetic narrative of the couple's love:

> ### READING 11.3 DANTE
>
> *The Divine Comedy, Inferno,* canto 5, Circle Two, lines 124–140
>
> "On a day for dalliance we read the rhyme
> of Lancelot, how love had mastered him.
> We were alone with innocence and dim time.
>
> Pause after pause that high old story drew
> our eyes together while we blushed and paled;
> but it was one soft passage overthrew
>
> our caution and our hearts. For when we read
> how her fond smile was kissed by such a lover,
> he who is one with me alive and dead
>
> breathed on my lips the tremor of his kiss.
> That book, and he who wrote it, was a pander.
> That day we read no further." As she said this,
>
> the other spirit, who stood by her, wept
> so piteously, I felt my senses reel
> and faint away with anguish. I was swept
>
> by such a swoon as death is, and I fell,
> as a corpse might fall, to the dead floor of Hell.

We learn more of the density and complexity of Dante's symbolism when we come across Satan, "the Emperor of the Universe of Pain" (*Inferno*, canto 34, Cocytus, line 28). Our common image of Satan is that of a sly tempter (in popular art, he is often in formal dress whispering blandishments in a willing ear, with just a whiff of sulfur about him) after the manner of Milton's proud, perversely tragic, heroic Satan in *Paradise Lost*. For Dante, Satan is a huge, stupid beast, frozen in a lake of ice in the pit of hell. He beats six bat-like wings (a demonic leftover from his angelic existence; see Isaiah 6:1–5) in an ineffectual attempt to escape the frozen lake that is watered by the four rivers of hell. He is grotesquely three-headed (a parody of the Trinity), and his slavering mouths remorselessly chew the bodies of three infamous traitors from sacred and secular history (Judas, Cassius, and Brutus).

Why does Dante portray Satan so grotesquely? It is clear that he borrowed from Byzantine mosaics, with which he would

have been familiar, in the baptistery of Florence. Beyond that, the whole complex of Satan is heavily weighted with symbolic significance. Satan lies in frozen darkness at a point in the universe farthest from the warmth and light of God. He is the fallen angel of light (*Lucifer*—another name for the archangel Satan—means "light bearer"), now encased in a pit in the center of the earth that has been excavated by the force of his own fall from heaven. Satan is immobile, in contrast to God, who is the mover of all things. Satan is inarticulate because he represents the souls of hell who have lost what Dante calls "the good of intellect." Satan and all the souls in hell will remain unfulfilled as created rational beings, because they are cut off from the ultimate source of rational understanding and fulfillment: God. Intellectual estrangement from God is for Dante, as it was for Thomas Aquinas, the essence of damnation. This estrangement is most evident in the case of Satan, whose very being symbolizes the loss of rationality.

Dante, following a line of thought already developed by Abbot Suger and Thomas Aquinas, conceived the human journey as a slow ascent to the purity of God by means of the created things of this world. To settle for less than God was, in essence, to fail to return to the natural source of life. Light is a crucial motif in *The Divine Comedy*. Neither light nor the source of light (the sun) is ever mentioned in the *Inferno*. The overwhelming visual impression of the *Inferno* is darkness—a darkness that begins when Dante is lost in the "dark wood" of canto 1 and continues until he climbs from hell and sees the stars (the word *stars* ends each of the three major parts of the poem) of the Southern Hemisphere. In the ascent of the Mountain of Purgatory, daylight and sunset are controlling motifs to symbolize the reception and rejection of divine light. In the *Paradiso*, the blessed are bathed in the reflected light that comes from God. At the climax of the *Paradiso*, the poet has a momentary glimpse of God as a point of light and rather obscurely understands that God, the source of all intelligibility, is the power that also moves the "sun and the other stars." Yet the experience is ineffable; it cannot be communicated:

READING 11.4 DANTE

The Divine Comedy, Paradiso, canto 33, The Empyrean, lines 97–108

> My tranced being
> stared fixed and motionless upon that vision,
> ever more fervent to see in the act of seeing,
>
> Experiencing that Radiance, the spirit
> is so indrawn it is impossible
> even to think of ever turning from it.
>
> For the good which is the will's ultimate object
> is all subsumed in It; and, being removed,
> all is defective which in It is perfect.
>
> Now in my recollection of the rest
> I have less power to speak than any infant
> wetting its tongue yet at its mother's breast.

Within the broad reaches of Dante's philosophical and theological preoccupations, the poet still has the concentrated power to sketch unforgettable portraits: the doomed lovers Paolo and Francesca—each of the tercets that tell their story starts with the word *amore* ("love"); the haughty political leader Farinata degli Uberti; the pitiable suicide Pier delle Vigne; and the gluttonous caricature Ciacco the Hog. Damned, penitent, or saved, the characters are by turns symbols and people. Saint Peter represents the church in the *Paradiso* but also explodes with ferociously human anger at its abuses. Brunetto Latini in the *Inferno*—with "his brownbaked features"—is a condemned sodomite, anxious that posterity remember his literary accomplishments.

The comprehensiveness of *The Divine Comedy* has often been its major obstacle for the modern reader. Beyond that hurdle is the strangeness of the intellectual world in which Dante dwelled, so at variance with our own: earth-centered, manageably small, sure of its ideas of right and wrong, orthodox in its theology, prescientific in its outlook, Aristotelian in its philosophy. For all that, Dante is to be read not only for his store of medieval lore but also because he is, as the 20th-century poet T. S. Eliot once wrote, the most universal of poets. He had a deeply sympathetic appreciation of human aspiration, love and hate, and the meaning of nature and history.

Giovanni Boccaccio

In the infamous plague year of 1348, Giovanni Boccaccio (1313–1375) was 35 years old. Although it is unclear whether he was in his native Florence when the city was stricken, his *Decameron*, which he began writing sometime the following year, has the ring of authenticity. It became one of the most well-known pieces of writing on the plague that ravaged Europe.

The premise of the *Decameron* is this: A group of seven young women and three young men flee Florence, seeking refuge in a deserted villa just outside the infected city. Thus the plague becomes the "frame story" for Bocaccio's 100 stories, or tales, that the protagonists tell over the course of the two weeks that they spend together. There are rules for this makeshift household as they pass the time away: every person must tell *one* story on 6 out of 7 nights (one day is reserved for chores). Only on holy days do they neither work nor tell their tales. The result after two weeks together is 100 stories—10 nights of tales by each of the 10 housemates (*decameron* is the Greek word for "10 days"). The theme for each night is decided by the "King" or "Queen," each of the members taking a turn at royalty.

The 100 stories constitute a brilliant collection of folktales, **fabliaux** (ribald fables), **exempla** (moral stories), and romances that Boccaccio culled from the oral and written traditions of Europe. Because of its romantic elements, earthiness, and somewhat shocking bawdiness, the *Decameron* has often been called the "Human Comedy" to contrast it with the lofty moral tone of Dante's epic work, *The Divine Comedy*. However delightful and pleasing these stories may be, they stand in sharp contrast to the horrific picture Boccaccio draws of the plague in

CULTURE AND SOCIETY

Giovanni Boccaccio, Witness to the Black Death

Boccaccio's account of the Black Death is the prologue to the tales that make up the *Decameron*. It reflects the personal experience of the writer through the plague year of 1348 and his reflections on the psychological effects of the plague on the population. He wrote that some sought boundless pleasures as death approached the door, whereas others turned to God for solace. The very whisper of plague destroyed public order and family bonds.

From the Preface to the Ladies

. . .

I say, then, that the sum of thirteen hundred and forty-eight years had elapsed since the fruitful Incarnation of the Son of God, when the noble city of Florence, which for its great beauty excels all others in Italy, was visited by the deadly pestilence. Some say that it descended upon the human race through the influence of the heavenly bodies, others that it was a punishment signifying God's righteous anger at our iniquitous way of life. But whatever its cause, it had originated some years earlier in the East, where it had claimed countless lives before it unhappily spread westward, growing in strength as it swept relentlessly on from one place to the next.

In the face of its onrush, all the wisdom and ingenuity of man were unavailing. Large quantities of refuse were cleared out of the city by officials specially appointed for the purpose, all sick persons were forbidden entry, and numerous instructions were issued for safeguarding the people's health, but to no avail. Nor were the countless petitions humbly directed to God by the pious, whether by means of formal processions or in any other guise, any less ineffectual. For in the early spring of the year we have mentioned, the plague began, in a terrifying and extraordinary manner, to make its disastrous effects apparent. It did not take the form it had assumed in the East, where if anyone bled from the nose it was an obvious portent of certain death. On the contrary, its earliest symptom, in men and women alike, was the appearance of certain swellings in the groin or the armpit, some of which were egg-shaped whilst others were roughly the size of the common apple. Sometimes the swellings were large, sometimes not so large, and they were referred to by the populace as *gavòccioli*.* From the two areas already mentioned, this deadly *gavòcciolo* would begin to spread, and within a short time it would appear at random all over the body. Later on, the symptoms of the disease changed, and many people began to find dark blotches and bruises on their arms, thighs, and other parts of the body, sometimes large and few in number, at other times tiny and closely spaced. These, to anyone unfortunate enough to contract them, were just as infallible a sign that he would die as the *gavòcciolo* had been earlier, and as indeed it still was.

Against these maladies, it seemed that all the advice of physicians and all the power of medicine were profitless and unavailing. Perhaps the nature of the illness was such that it allowed no remedy: or perhaps those people who were treating the illness (whose numbers had increased enormously because the ranks of the qualified were invaded by people, both men and women, who had never received any training in medicine), being ignorant of its causes, were not prescribing the appropriate cure. At all events, few of those who caught it ever recovered, and in most cases death occurred within three days from the appearance of the symptoms we have described, some people dying more rapidly than others, the majority without any fever or other complications.

But what made this pestilence even more severe was that whenever those suffering from it mixed with people who were still unaffected, it would rush upon these with the speed of a fire racing through dry or oily substances that happened to be placed within its reach. Nor was this the full extent of its evil, for not only did it infect healthy persons who conversed or had any dealings with the sick, making them ill or visiting an equally horrible death upon them, but it also seemed to transfer the sickness to anyone touching the clothes or other objects which had been handled or used by its victims. . . .

One day . . . the rags of a pauper who had died from the disease were thrown into the street, where they attracted the attention of two pigs. In their wonted fashion, the pigs first of all gave the rags a thorough mauling with their snouts, after which they took them between their teeth and shook them against their cheeks. And within s short time they began to writhe as though they had been poisoned, then they both dropped dead to the ground, spread-eagled upon the rags that had brought about their undoing.

These things, and many others of a similar or even worse nature, caused various fears and fantasies to take root in the minds of those who were still alive and well. And almost without exception, they took a single and very inhuman precaution, namely to avoid or run away

* Little goiters, or swellings of the neck, usually from thyroid disease.

continued

CULTURE AND SOCIETY *(continued from page 349)*

from the sick and their belongings, by which means they all thought that their own health would be preserved.

Some people were of the opinion that a sober and abstemious mode of living considerably reduced the risk of infection. They therefore formed themselves into groups and lived in isolation from everyone else. Having withdrawn to a comfortable abode where there were no sick persons, they locked themselves in and settled down to a peaceable existence, consuming modest quantities of delicate foods and precious wines and avoiding all excesses. They refrained from speaking to outsiders, refused to receive news of the dead or the sick, and entertained themselves with music and whatever other amusements they were able to devise.

Others took the opposite view, and maintained that an infallible way of warding off this appalling evil was to drink heavily, enjoy life to the full, go round singing and merrymaking, gratify all of one's cravings whenever the opportunity offered, and shrug the whole thing off as one enormous joke. Moreover, they practiced what they preached to the best of their ability, for they would visit one tavern after another, drinking all day and night to immoderate excess;

In the face of so much affliction and misery, all respect for the laws of God and man had virtually broken down and been extinguished in our city. For like everybody else, those ministers and executors of the laws who were not either dead or ill were left with so few subordinates that they were unable to discharge any of their duties. Hence everyone was free to behave as he pleased. . . .

[This] scourge had implanted so great a terror in the hearts of men and women that brothers abandoned brothers, uncles their nephews, sisters their brothers, and in many cases wives deserted their husbands. But even worse, and almost incredible, was the fact that fathers and mothers refused to nurse and assist their own children, as though they did not belong to them. . . .

Such was the multitude of corpses (of which further assignments were arriving every day and almost by the hour at each of the churches), that there was not sufficient consecrated ground for them to be buried in, especially if each was to have its own plot in accordance with long-established custom. So when all the graves were full, huge trenches were excavated in the churchyards, into which new arrivals were placed in their hundreds, stowed tier upon tier like ships' cargo, each layer of corpses being covered over with a thin layer of soil till the trench was filled to the top. . . .

Thus it came about that oxen, asses, sheep, goats, pigs, chickens, and even dogs (for all their deep fidelity to man) were driven away and allowed to roam freely through the fields, where the crops lay abandoned and had not even been reaped, let alone gathered in. And after a whole day's feasting, many of these animals, as though possessing the power of reason, would return glutted in the evening to their own quarters, without any shepherd to guide them. . . .

Ah, how great a number of splendid palaces, fine houses, and noble dwellings, once filled with retainers, with lords and with ladies, were bereft of all who had lived there, down to the tiniest child! How numerous were the famous families, the vast estates, the notable fortunes, that were seen to be left without a rightful successor! How many gallant gentlemen, fair ladies, and sprightly youths, who would have been judged hale and hearty by Galen, Hippocrates and Aesculapius** (to say nothing of others), having breakfasted in the morning with their kinsfolk, acquaintances and friends, supped that same evening with their ancestors in the next world!

** Famed Greek physicians and, the latter, a Greco-Roman god of medicine.

his introduction to the *Decameron*. His vivid prose, as shown in the Culture & Society feature above, gives some small sense of what the plague must have been like for people who possessed only the most rudimentary knowledge of medicine and no knowledge about the source of the disease.

Francesco Petrarch

Both Dante and Boccaccio wrote in the vernacular—the dialect of Italian spoken in the region of Tuscany. But it was Petrarch (Francesco Petrarca, 1304–1374) who most directly influenced the formation of the modern Italian language. A poet and a scholar who discovered Cicero's letters (see Chapter 4, p. 132) and introduced them to the 14th century, Petrarch has been called the Father of Humanism. His life spanned the better part

of that century, and, in that life, we can see the clash between medieval and Early Renaissance ideals being played out.

Petrarch was born in Arezzo, a small town in Tuscany southeast of Florence. As a young man, in obedience to parental wishes, he studied law for a year in France and for three years at the law faculty in Bologna. He abandoned his legal studies immediately after his father's death to pursue a literary career. To support himself, he accepted some minor church offices, but he was never ordained to the priesthood.

Petrarch made his home at Avignon, but for the greater part of his life, he wandered from place to place. Some have referred to him as the first known tourist. He could never settle down; his restlessness prevented him from accepting lucrative positions that would have made him a permanent resident of any one place. He received invitations to serve as a secretary to various popes in Avignon and, through the intercession of his

close friend Boccaccio, was offered a professorship in Florence. He accepted none of these positions.

Petrarch was insatiably curious. He fed his love for the classics by searching out and copying ancient manuscripts that had remained hidden and unread in the various monasteries of Europe. It is said that at his death he had one of the finest private libraries in Europe. He wrote volumes of poetry and prose, carried on a vast correspondence, advised the rulers of the age, took a keen interest in horticulture, and kept a wide circle of literary and artistic friends. We know that at his death he possessed pictures by both Simone Martini and Giotto, two of the most influential artists of the time. In 1348, Petrarch was crowned poet laureate of Rome, the first artist so honored since the ancient days of Rome.

One true mark of the Renaissance sensibility was a keen interest in the self and an increased thirst for personal glory and fame. Petrarch surely was a 14th-century harbinger of that spirit. Dante's *Divine Comedy* is totally oriented toward the next life; the apex of Dante's vision is that of the soul rapt in the vision of God in eternity. Petrarch, profoundly religious, never denied that such a vision was the ultimate goal of life. At the same time, his work exhibits a tension between that goal and his thirst for earthly success and fame. In his famous prose work *Secretum* (*My Secret*), written in 1343, the writer imagines himself in conversation with Saint Augustine. In a dialogue extraordinary for its sense of self-confession and self-scrutiny, Petrarch discusses his moral and intellectual failings, his besetting sins, and his tendency to fall into fits of depression. He agrees with his great hero Augustine that he should be less concerned with his intellectual labors and the fame that derives from them, and more with salvation and the spiritual perfection of his life. However, Petrarch's argument has a note of ambivalence: "I will be true to myself as far as it is possible. I will pull myself together and collect my scattered wits, and make a great endeavor to possess my soul in patience. But even while we speak, a crowd of important affairs, though only of this world, is waiting for my attention."[6]

The inspiration for the *Secretum* was Augustine's *Confessions*, a book Petrarch loved so much that he carried it with him everywhere. It may well have been the model for his "Letter to Posterity," one of the few examples of autobiography we possess after the time of Augustine. That Petrarch would have written an autobiography is testimony to his strong interest in himself as a person. The letter was probably composed in 1373, the year before his death. Petrarch reviews his life up until 1351, where the text breaks off abruptly. The unfinished work is clear testimony to Petrarch's thirst for learning, fame, and self-awareness. At the same time, it is noteworthy for omitting any mention of the Black Death of 1348, which carried off the woman he loved. The letter is an important primary document of the sensibility of the 14th-century proto-Renaissance.

Petrarch regarded as his most important works the Latin writings over which he labored with devotion and in conscious imitation of his most admired classical masters: Ovid, Cicero, and Virgil. Today, however, only a literary specialist or an antiquarian is likely to read his long epic poem in Latin called *Africa* (written in imitation of the *The Aeneid*), or his prose work in praise of the past masters of the world (*De viris illustribus*), or his meditation on the benefits of the contemplative life (*De vita solitaria*). What has assured Petrarch's literary reputation is his incomparable vernacular poetry, which he considered somewhat trifling but collected carefully into his **Canzoniere** (*Songbook*). The *Canzoniere* contains more than 300 **sonnets** (14-line poems) and 49 **canzoni** (songs) written in Italian over the span of Petrarch's career.

The subject of a great deal of Petrarch's poetry is his love for Laura, a woman with whom he fell in love in 1327 after seeing her at church in Avignon. Laura died in the plague of 1348. The poems in her honor are divided into those written during her lifetime and those mourning her untimely death. Petrarch poured out his love for Laura in more than 300 sonnets, which he typically broke into an eight-line octave and a six-line sestet. Although they were never actually lovers (Petrarch says in the *Secretum* that this was due more to her honor than to his; Laura was a married woman), his Laura was no mere literary abstraction. She was a flesh-and-blood woman. One of the characteristics of his poetry, in fact, is the palpable reality of Laura as a person; she never becomes (as Beatrice does for Dante) a symbol without earthly reality.

The interest in Petrarch's sonnets did not end with his death. Petrarchianism, which means the Petrarchan form of the sonnet and particularly the poet's attitude toward his subject matter—praise of a woman as the perfection of human beauty and the object of the highest expression of love—was introduced into other parts of Europe before the century was over. In England, Petrarch's sonnets were first imitated in form and subject by Sir Thomas Wyatt in the early 16th century. Although the Elizabethan poets eventually developed their own English form of the sonnet, the English Renaissance tradition of poetry owes a particularly large debt to Petrarch, as shown by the poetry of Sir Philip Sidney (1554–1586), Edmund Spenser (1552–1599), and William Shakespeare (1564–1616). Their sonnet sequences follow the example of Petrarch in linking together a series of sonnets in such a way as to indicate a development in the relationship of the poet to his love:

READING 11.5 PETRARCH

Canzoniere, Sonnet XIV

As when some poor old man, grown pale and gray,
 Sets out from where he lived his whole life-tide,
 And from his little household terrified,
 Foreseeing their dear father's quick decay,
Whilst his last time elapses, day by day,
 He still drags on from home his ancient side

6. Francesco Petrarca, *Petrarch's Secret or the Soul's Conflict with Passion (Three Dialogues Between Himself and S. Augustine)*, trans. William H. Draper. Project Gutenberg EBook, release date July 17, 2015. https://www.gutenberg.org/files/49450/49450-8.txt.

As best he can, with strong will fortified,
 Broken by years and weary of the way,
And following to Rome his guiding love
 Sees there the holy countenance of One,
 Whom he hopes yet to see in heaven above.
So I, outworn, hunt round at ties to view,
 Lady, elsewhere, so far as can be done,
 The very features, that I love in you.

Note the rhyme scheme *abba*, *abba*, *cdc*, *efe*. Petrarch's sonnets all have the same rhyme scheme for the octave. The scheme for the sestet varies. The first three lines (or tercet) of the sestet usually reflect on the themes of the poem, and the second tercet forms a conclusion as in the following sonnet:

READING 11.6 PETRARCH

Canzoniere, Sonnet XVIII

Ashamed at times, that your fair qualities,
 Lady, are still unsaid by me in rhyme,
 I think of when I saw you first, yon time,
 Such that from thenceforth none beside can please,
But find the weight too heavy for my knees,
 The work for my poor brushes too sublime;
 Therefore the mind, that knows its power to climb,
 In trying at the task, begins to freeze.
Of times ere now, I op'ed my lips to say,
 But then my breath stopped short without effect,
 Indeed, what voice could rise to such a height!
Of times I have begun to write some lay,
 But then the pen, the hand, the intellect
 Stopped, conquered at the entrance on the fight.

Geoffrey Chaucer

While it is possible to see the beginning of the Renaissance spirit in Petrarch and other Italian writers of the 14th century, some scholars believe that the greatest English writer of the century, Geoffrey Chaucer (1340–1400), still reflects the culture of his immediate past. It could be argued that the new spirit of individualism discernible in Petrarch was less evident in Chaucer, although readers of the prologue to the Wife of Bath's Tale may find a most finely etched individual. In the latter part of the 15th century, largely under the influence of Italian models, we can speak of a general movement toward the Renaissance in England.

Scholars have met with only partial success in reconstructing Chaucer's life. We know that his family had been fairly prosperous wine merchants and vintners and that he entered royal service early in his life, eventually becoming a squire to King Edward III. After 1373, he undertook various diplomatic tasks

for the king, including at least two trips to Italy to negotiate commercial contracts. During these Italian journeys, Chaucer came into contact with the writings of Dante, Petrarch, and Boccaccio. There has been some speculation that he actually met Petrarch, but the evidence is tenuous. Toward the end of his life, Chaucer served as the customs agent for the port of London on the river Thames. He was thus never a leisured man of letters; his writing had to be done amid the hectic round of public affairs that engaged his attention as a high-placed civil servant.

As many other successful writers of the Late Middle Ages, Chaucer could claim a widespread acquaintance with the learning and culture of his time. This was an age when it was still possible to read most of the available books. Chaucer spoke and wrote French fluently, and his poems show the influence of many French allegories and dream visions. That he also knew Italian literature is clear from his borrowings from Dante and Petrarch, and from his use of stories and tales in Boccaccio's *Decameron* (although it is not clear that he knew that work directly). Chaucer also had a deep knowledge of Latin literature, both classical and ecclesiastical. Furthermore, his literary output was not limited to the composition of original works of poetry. He made a translation from Latin (with an eye on an earlier French version) of Boethius's *Consolation of Philosophy* as well as a translation from French of the 13th-century allegorical erotic fantasy *Romance of the Rose*. He also composed a short treatise on the astrolabe and its relationship to the study of astronomy and astrology (disciplines that were not clearly distinct at that time).

The impressive range of Chaucer's learning pales in comparison to his most memorable and noteworthy talents: his profound feeling for the role of the English language as a vehicle for literature, his efforts to extend the range of the language (the richness of Chaucer's vocabulary was not exceeded until Shakespeare), and his incomparable skill in the art of human observation. Chaucer's characters are so finely realized that they have become standard types in English literature: his pardoner is an unforgettable villain, his knight the essence of courtesy, his wife of Bath a paradigm of rollicking bawdiness—but also a rational precursor of feminism.

These characters, and others, are from Chaucer's masterpiece, *The Canterbury Tales*, begun sometime after 1385. To unify this vast work, a collection of miscellaneous tales, Chaucer used a typical literary device: a narrative frame—in this case, a journey during which people amuse one another with tales. As we noted earlier, Boccaccio used a similar device in the *Decameron*.

Chaucer's plan was to have a group of 30 pilgrims travel from London to the shrine of Saint Thomas à Becket at Canterbury and back. After a general introduction, each pilgrim would tell two tales on the way and two on the return trip in order to pass the long hours of travel more pleasantly. Between tales they might engage in perfunctory conversation or prologues of their own to cement the tales further into a unified whole.

Chaucer never finished this ambitious project; he died before half of it was complete. The version we possess has a General Prologue (Fig. 11.3), in which the narrator, Geoffrey Chaucer, describes the individual pilgrims, his meeting with

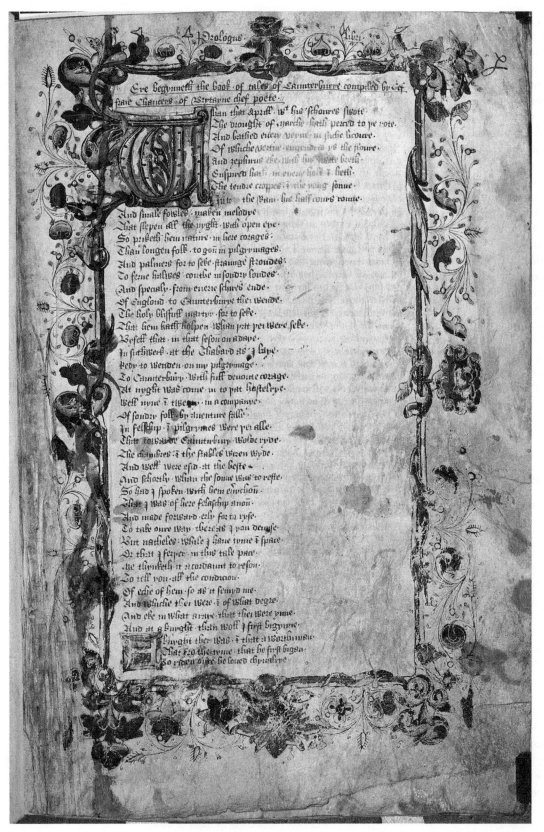

◀ **11.3** Geoffrey Chaucer, *Canterbury Tales*, General Prologue, manuscript page, ca. 1450–1460. British Library, London, United Kingdom. All copies of Chaucer's work were handwritten, as the printing press would not be invented for another 50 years. In this copy, fanciful painted borders of brilliant color surround the calligraphic text.

them at the Tabard Inn in London, and the start of the journey. Only 23 of the 30 pilgrims tell their tales (none tells two tales), and the group does not reach Canterbury. There is even some internal evidence that the material we possess was not meant for publication in its present form.

Although *The Canterbury Tales* is only a draft of what was intended to be Chaucer's masterwork, it is of incomparable literary and social value. A close reading of the General Prologue, for instance—with its representative, although limited, cross section of medieval society (no person lower in rank than a plowman or higher in rank than a knight appears)—affords an effortless entry into the complex world of Late Medieval England. With quick, deft strokes, Chaucer not only creates verbal portraits of people who at the same time seem both typical and uniquely real, but he also introduces us to a world of the gradual decline of chivalry—a world filled with such contrasts as clerical foibles, the desire for knowledge, the ribald taste of the lower social classes, and an appetite for philosophical conversation.

The General Prologue follows the literary convention we saw with the troubadours, among others, of beginning in the spring, when the world is reborn and aromas from the dampened earth invigorate the senses. *The Canterbury Tales* is written in rhyming couplets in **iambic pentameter**, a meter in poetry consisting of five feet, each one containing an unaccented syllable followed by an accented syllable. Chaucer often ends a line with an extra unaccented syllable. Note, for example,

the structure of the accents in line 2 (we have updated the spelling to make the structure of the line clearer):

The dróught of Márch hath píerc-ed tó the róot-eh.

Because modern translations do not capture the sounds and cadences of the original, let us begin the General Prologue in Middle English, as we see in Reading 11.7. We will translate some words and unfamiliar ideas.

After the General Prologue, the various members of the pilgrim company begin to introduce themselves and proceed to tell their tales. Between the tales, they engage in small talk or indulge in lengthy prologues of their own. In the tales that he completed, we see that Chaucer drew on the vast treasury of literature—both written and oral—that was the common heritage of medieval culture. The Knight's Tale is a courtly romance; the miller and reeve tell stories that spring from the ribald fabliau tradition of the time; the pardoner tells an exemplum such as any medieval preacher might employ; the prioress draws from the legends of the saints; the nun's priest uses an animal fable; and the parson characteristically enough provides a somewhat tedious example of a medieval prose sermon.

At places, as in the prologue to the Wife of Bath's Tale, we get from Chaucer an extended meditation on some of the problems of the age. The Wife of Bath, who has been married

READING 11.7 CHAUCER

The Canterbury Tales, General Prologue, lines 1–18, in Middle and Modern English

In Middle English:
Whan that Aprill with his shoures soote
The droghte of march hath perced to the roote,
And bathed every veyne in swich licour
Of which vertu engendred is the flour;
Whan Zephirus eek with his sweete breeth
Inspired hath in every holt and heeth
The tendre croppes, and the yonge sonne
Hath in the Ram his halve cours yronne,
And smale foweles maken melodye,
That slepen al the nyght with open ye
(so priketh hem Nature in hir corages),
Thanne longen folk to goon on pilgrimages,
And palmeres for to seken straunge strondes,
To ferne halwes, kowthe in sondry londes;
And specially from every shires ende
Of Engelond to Caunterbury they wende,
The hooly blisful martir for to seke,
That hem hath holpen whan that they were seeke.

In Modern English:
When the sweet showers of April have pierced
The drought of March, and pierced it to the root,
And every vein is bathed in that moisture
Whose quickening force will engender the flower;
And when the west wind too with its sweet breath
Has given life in every wood and field
To tender shoots, and when the stripling sun
Has run his half-course in Aries, the Ram,
And when small birds are making melodies,
That sleep all the night long with open eyes,
(Nature so prompts them, and encourages);
Then people long to go on pilgrimages,
And palmers[7] to take ship for foreign shores,
And distant shrines, famous in different lands;
And most especially, from all the shires
Of England, to Canterbury they come,
The holy blessed martyr there to seek,
Who gave his help to them when they were sick.

7. Pilgrims.

five times, introduces her tale with a discourse explaining why the persistent tradition against women (misogyny) is unjust and contrary to authentic Christian theology. She also makes a passionate plea for seeing sexual relations as a good given by God. This may strike us as unnecessary in the 21st century, but in an age that prized celibacy (for example, for monks, nuns, and priests), it was a fascinating and courageous poke in the eye of authority:

READING 11.8 CHAUCER

The Canterbury Tales, Prologue of the Wife of Bath's Tale, lines 1–38

"Experience—and no matter what they say
In books—is good enough authority
For me to speak of trouble in marriage.
For ever since I was twelve years of age,
Thanks be to God, I've had no less than five
Husbands at church door—if one may believe
I could be wed so often legally!
And each a man of standing, in his way.
Certainly it was told me, not long since,
That, seeing Christ had never more than once 10
Gone to a wedding (Cana, in Galilee)
He taught me by that very precedent
That I ought not be married more than once.
What's more, I was to bear in mind also
Those bitter words that Jesus, God and Man,
Spoke in reproof to the Samaritan
Beside a well—'Thou hast had,' said He,
'Five husbands, and he whom now thou hast
Is not thy husband.' He said that, of course,
But what He meant by it I cannot say. 20
All I ask is, why wasn't the fifth man
The lawful spouse of the Samaritan?
How many lawful husbands could she have?
All my born days, I've never heard as yet
Of any given number or limit,
However folk surmise or interpret.
All I know for sure is, God has plainly
Bidden us to increase and multiply—
A noble text, and one I understand!
And, as I'm well aware, He said my husband 30
Must leave father and mother, cleave to me.
But, as to number, did He specify?
He named no figure, neither two nor eight—
Why should folk talk of it as a disgrace?
And what about that wise King Solomon:
I take it that he had more wives than one!
Now would to God that I might lawfully
Be solaced half as many times as he!"

Christine de Pizan

Christine de Pizan (1365–1428) is an extraordinary figure in Late Medieval literature, not only for her prodigious and prolific body of work, but also because of her pioneering role as one of Europe's first female professional writers to make her living with the power of her pen.

Born in Venice, Christine accompanied her father Thomas de Pizzano to the French court of Charles V when she was still a young child. Thomas was the king's physician, astrologer, and close adviser. He evidently gave his daughter a thorough education: she was able to write in both Italian and French and probably knew Latin well enough to read it. At 15, she married Étienne du Castel, a young nobleman from Picardy. That same year (1380), the king died and the family fell on hard times with the loss of royal patronage. Five years later, her father and her husband were both dead, leaving Christine the sole supporter of her mother, niece, and three young children. To maintain this large family, Christine came up with an almost unheard-of solution for a woman of the time: she turned to writing and the patronage such writing could bring to earn a living.

Between 1399 and 1415, Christine de Pizan composed 15 books—a staggering record in the pre-printing press era. In 1399, she added her voice to a famous literary debate surrounding the *Romance of the Rose* and Jean de Meun's 1275 continuation of the poem ("art of love") that was violently critical of women. Christine attacked his misogynistic additions in a treatise called "The Letter to the God of Love." In 1404, she wrote her final word on this debate in a longer work titled *The Book of the City of Ladies*.

The Book of the City of Ladies is indebted for its structure to Augustine's *The City of God*, and, for its sources, to a Latin treatise by Boccaccio titled *De claris mulieribus*. Through use of stories of famous women (*clarae mulieres*), Christine demonstrates that they possess virtues precisely opposite to those vices imputed to women by Jean de Meun.

In *The Book of the City of Ladies*, Christine presents an argument against the antifeminine writers of the day who condemn women as the snare of Satan and inferior to men. In the extracts shown in Reading 11.9, she speaks of the accomplishments of the ancient poet Sappho and of the daughter of a professor at the University of Bologna.

Christine de Pizan shows that victims often do not realize they are victims. Many victims, in fact, strive to maintain the social order that prevents them from rising in the belief that it is right and proper. Some, of course, do not want others of their kind to share in the benefits that they are denied.

The year after *The Book of the City of Ladies* (1405), Christine wrote *The Treasure of the City of Ladies*, a book of etiquette and advice to help women survive in society. What is remarkable about this book is the final section, in which the author pens advice for every class of women—from young brides and wives of shopkeepers to prostitutes and peasant women.

Around 1418, Christine retired to a convent in which her daughter was a nun and continued to write. Besides a treatise on arms and chivalry and a lament about the horrors

READING 11.9 CHRISTINE DE PIZAN

From *The Book of the City of Ladies*, chapters 30 and 36

30 This Sappho had a beautiful body and face and was agreeable and pleasant in appearance, conduct, and speech. But the charm of her profound understanding surpassed all the other charms with which she was endowed, for she was expert and learned in several arts and sciences, and she was not only well-educated in the works and writings composed by others but also discovered many new things herself and wrote many books and poems. Concerning her, Boccaccio has offered these fair words couched in the sweetness of poetic language: "Sappho, possessed of sharp wit and burning desire for constant study in the midst of bestial and ignorant men, frequented the heights of Mount Parnassus, that is, of perfect study. Thanks to her fortunate boldness and daring, she kept company with the Muses, that is, the arts and sciences, without being turned away. She entered the forest of laurel trees filled with may boughs, greenery, and different colored flowers, soft fragrances and various aromatic spices, where Grammar, Logic, noble Rhetoric, Geometry, and Arithmetic live and take their leisure. She went on her way until she came to the deep grotto of Apollo, god of learning, and found the brook and conduit of the fountain of Castalia, and took up the plectrum and quill of the harp and played sweet melodies, with the nymphs all the while leading the dance, that is, following the rules of harmony and musical accord." From what Boccaccio says about her, it should be inferred that the profundity of both her understanding and of her learned

books can only be known and understood by men of great perception and learning, according to the testimony of the ancients. Her writings and poems have survived to this day, most remarkably constructed and composed, and they serve as illumination and models of consummate poetic craft and composition to those who have come afterward. She invented different genres of lyric and poetry, short narratives, tearful laments and strange lamentations about love and other emotions, and these were so well made and so well ordered that they were named "Sapphic" after her.

36 Giovanni Andrea, a solemn law professor in Bologna not quite sixty years ago, was not of the opinion that it was bad for women to be educated. He had a fair and good daughter, named Novella, who was educated in the law to such an advanced degree that when he was occupied by some task and not at leisure to present his lectures to his students, he would send Novella, his daughter, in his place to lecture to the students from his chair. And to prevent her beauty from distracting the concentration of his audience, she had a little curtain drawn in front of her.

Not all men (and especially the wisest) share the opinion that it is bad for women to be educated. But it is very true that many foolish men have claimed this because it displeased them that women knew more than they did. Your father, who was a great scientist and philosopher, did not believe that women were worth less by knowing science; rather, as you know, he took great pleasure from seeing your inclination to learning. The feminine opinion of your mother, however, who wished to keep you busy with spinning and silly girlishness, following the common custom of women, was the major obstacle to your being more involved in the sciences.

of civil war, she also composed prayers and seven allegorical psalms. Of more enduring interest was *The Book of Peace*, a handbook of instruction for the dauphin who was to become Charles VII, and a short hymn in honor of Joan of Arc. Whether Christine lived to see the bitter end of Joan is uncertain, but her hymn is one of the few extant works written while Joan was alive.

Although she was immensely popular in her own time (the Duc de Berry owned copies of every book she wrote), her reputation waned, only to be revived in our own time by scholars who rescued it from literary obscurity.

ART IN ITALY

Giorgio Vasari wrote the earliest historical account of Italian art during the Renaissance. He begins his story of artistic evolution with the life of Cimabue, but he claims that Giotto di Bondone, the 13th-century Florentine painter, was the first Renaissance artist—the one who set painting, once again, on its proper course. That proper course was Classicism, from which Vasari

claims art had strayed during the Middle Ages. When we use the word *Renaissance* to describe Italian art of the 14th through 16th centuries, the rebirth to which we refer is the revival of classical art; the first step was the observation of the natural world.

Italo-Byzantine Style

The first stirrings of a classical revival date to the mid-12th century, yet the style of that period can be thought of as a hybrid of Gothic and classical elements. Artists were still rooted in the Byzantine pictorial traditions, and Italian churches were generally decorated not with lifelike sculptural groups like those we saw on the portals of Reims Cathedral (see Fig. 10.17), but with solemn and stylized frescoes and mosaics in what is called the Italo-Byzantine style. This style would remain an important component in the development of 14th-century art.

PISANO, FATHER AND SON There are notable exceptions to the generally conservative character of Italian art in the 13th century. Nicola Pisano (ca. 1220/1225–1284) and his son

CONNECTIONS The American feminist artist, Judy Chicago, is famed for her installation, *The Dinner Party* (1974–1979) in which she "invites" 100 women to figuratively join one another to celebrate their history of literary, artistic, philosophical, and political accomplishments. One of those honored with a place at the table is Christine de Pizan. Each place setting consists of a porcelain dinner plate painted with an image that, for Chicago, symbolizes the honoree. The artist has said that the wing-like shape that folds back on itself signifies Christine's "efforts to protect women." The colorful border of the table runner is embroidered with what is known as a "Florentine stitch." Flame-like tongues of thread pointing inward toward the plate represent what the artist has characterized as the stifling constrictions placed on women during the Renaissance.

▲ **11.4** Judy Chicago, *The Dinner Party* (detail, *Christine de Pizan*) (1974–1979). Brooklyn Museum of Art, Elizabeth A. Sackler Center for Feminist Art, Brooklyn, NY.

Giovanni (ca. 1245/1250–1314), who took their names after the city of Pisa in which they worked, have been described as the creators of modern sculpture. Nicola's first major work was a marble pulpit for the baptistery in Pisa, completed in 1260. The sculptural reliefs in the pulpit are crowded with figures and the space is filled with lively detail, capturing much of the vitality and realism of late Roman art, along with its restraint (**Fig. 11.5**). For his son Giovanni, classical models were less influential than was contemporary art in northern Europe, particularly the French Gothic style. In a pulpit that Giovanni carved, the figures are more elegant and less crowded than those of his father; the naturalism of the gestures and expression of intense emotion find their counterpart in late Gothic sculpture (**Fig. 11.6**).

Both father and son foreshadowed major characteristics of Renaissance art, Nicola by his emphasis on classical models and Giovanni by the naturalism and emotionalism of his figures. While they both responded to outside influences, most painting in Italy at the time that they were working remained firmly grounded in the Byzantine tradition.

◀ **11.5** Nicola Pisano, *Annunciation, Nativity, and Adoration of the Shepherds*, relief panel on the pulpit, 1259–1260. Marble, 34" × 45" (85 × 114 cm). Baptistery, Pisa, Italy. The reliefs of the baptistery pulpit bear a striking similarity to carvings on Roman sarcophagi, with which Pisano certainly would have been familiar.

◀ **11.6** Giovanni Pisano, *Annunciation, Nativity, and Adoration of the Shepherds*, relief panel on pulpit, 1297–1301. Marble, 34" × 40" (85 × 101 cm). Sant'Andrea, Pistoia, Italy. Whereas Nicola Pisano embraced classical art, his son Giovanni had a taste for the French Gothic. The brisk, lively movement in Giovanni's Nativity contrasts with the repose in Nicola's. A bit of trivia: an asteroid observed in 1960 was named 7313 Pisano after the two sculptors.

Painting in Florence: A Break with the Past

Although elements of the Byzantine style remained in paintings of the late 13th and early 14th centuries, a new naturalism began to appear—a consequence of artists observing the natural world and devising techniques to suggest volume and three-dimensional space. For the next two centuries, painters would work toward creating the illusion of reality on a two-dimensional surface.

CIMABUE Vasari rightfully begins his *Lives of the Most Excellent Painters, Sculptors, and Architects* with Cimabue (ca. 1240–1302), a Florentine painter who was the first to make a true break with the past. His *Madonna Enthroned with Angels and Prophets* (**Fig. 11.7**), while it retains the otherworldly gold background of Byzantine predecessors, departs from them significantly in several important ways. Compare the drapery of Cimabue's Madonna with that of Saint Francis in Berlinghieri's altarpiece (see Fig. 10.22). The Madonna's veil and cloak fall over her head, shoulders, and arm in realistic folds that correspond to the shape of her body beneath. Her knees are spread slightly to balance the baby Jesus on her lap, and between them the drapery falls in a subtle pattern of U-shaped folds. She sits squarely on a substantial throne, the sides of which converge and recede toward the background, creating a sense of space in the composition. Adoring angels to either side of the throne overlap, further enhancing depth, although the stacking of their heads one on top of the other has somewhat of a flattening effect.

Dante memorialized Cimabue in canto 11 of his *Purgatorio*:

> O vanity of human powers,
> how briefly lasts the crowning green of glory,
> unless an age of darkness follows!
>
> In painting Cimabue thought he held the field
> but now it's Giotto has the cry,
> so that the other's fame is dimmed.

Although these lines may seem to diminish Cimabue's achievements, they tell us two important things: first, that Cimabue's position in the Florentine art world of the 13th century was significant, and second, that individual artists were creating names for themselves and garnering fame for their work.

GIOTTO DI BONDONE Like everyone else around him, Giotto (ca. 1267–1337) was influenced by his mentors and contemporaries. He certainly knew the work of Giovanni Pisano and Cimabue and probably contributed to the discourse on Classical art. But Giotto's preeminent contribution to the history of painting was his realism. He acquired it through a close observation of the world around him—not only the natural world but also human behavior. The Byzantine style was defined by rich, glowing surfaces, with elaborate linear designs. Now, for the first time, figures seemed truly three-dimensional, a sense of volume created by a careful manipulation of light and shadow known as **modeling** or **chiaroscuro**. Painted figures had the same palpable presence as sculpture carved in stone; for the 13th-century viewer, they even seemed to live and breathe. Compared to the Madonna in Cimabue's painting, Giotto's *Madonna Enthroned*

▲ **11.7** Cimabue, *Madonna Enthroned with Angels and Prophets*, from Santa Trinità, ca. 1280–1290. Tempera and gold leaf on wood on panel, 151" × 88" (325 × 203 cm). Galleria degli Uffizi, Florence, Italy. As a transitional artist in the late 13th century, Cimabue relied on Byzantine models yet reached for more naturalism in his depiction of three-dimensionality–both in his figures and in his suggestion of space.

▲ **11.8** Giotto di Bondone, *Madonna Enthroned*, from the Church of Ognissanti, ca. 1310. Tempera and gold leaf on wood, 128" × 80" (381 × 224 cm). Galleria degli Uffizi, Florence, Italy. Giotto based his approach to painting on observation of the natural world and its translation to a two-dimensional surface. His Madonna has weight and occupies space; her drapery falls in natural folds, and light and shadow are used to model her face.

(Fig. 11.8) has a majestic solidity. Cimabue's delicate drapery folds embellished with gold, which appeared so much more realistic than the drapery on Byzantine figures, now seem to be overly emphasized in comparison to the simple, unfussy drapery on Giotto's Madonna. Giotto also recreates textures in his contrast between the more delicate white fabric of the Madonna's dress and the heavier blue cloth of her mantle. The throne, which bears some vestiges of the Gothic style in its pointed arches, convincingly occupies space. The groups of angels, who now stand on roughly the same ground line and overlap one another, enhance the depth of the throne. The halos of some of the angels obscure parts of those behind them; this is exactly how a crowd of people would look to us if we were standing in front of the throne.

Each of these aspects of the composition contributes to its overall naturalism. But our true connection with the subject is made possible by Giotto's signature subtle gestures and

specific realistic details. Mary looks like and behaves like a mother. She lightly grasps the baby's knee, almost as if she is trying to keep him from wiggling off her lap. Baby Jesus's face may look a bit mature, but his tiny, plump, and dimpled hands look as though the artist has sketched them directly from a child—maybe one of his own. One of the most enjoyable things about studying Giotto's paintings is searching for these human touches.

Giotto's greatness lay not so much in his technical ability to create realistic images—although he was unsurpassed in his day in imitating nature—as in his use of realism to dramatic effect in religious narratives rendered from a very human perspective. Giotto's most famous work is a fresco cycle for the Arena Chapel in Padua (Fig. 11.9), commissioned by Enrico Scrovegni. The walls of the small, barrel-vaulted chapel are divided into four registers: the three upper ones illustrate scenes from the life of Christ and the life of the Virgin Mary, and the lowest

▲ 11.9 **Giotto di Bondone, Arena Chapel (Capella Scrovegni). Padua, Italy. View of the interior, looking toward the altar.** The chapel, dedicated in 1303, was built by Enrico Scrovegni, who made his fortune in banking. Giotto was commissioned to paint a fresco cycle showing scenes from the life of Christ. He completed 38 framed scenes by 1305.

add authenticity to this illusion of reality—these were Giotto's legacy to the history of Western art.

Painting in Siena

Nicola Pisano traveled from his hometown of Apulia to Pisa, where wealthy patrons held out the promise of fame and fortune—or at least practical circumstances for making a living as an artist. Florence and Siena were both wealthy republics with thriving art markets and opportunities for any number of commissions. As their Florentine counterparts were, early Sienese painters continued to be influenced by Byzantine traditions, but they too would make a break with the past.

DUCCIO DI BUONINSEGNA Giotto's contemporary in Siena, an artist who matched him in renown, was Duccio di Buonisegna (active ca. 1278–1318). His greatest achievement was an enormous multipanel painting for the high altar of the Siena Cathedral, for which he signed a contract on October 9, 1308; he completed it within three years. The principal panel of the altarpiece (Fig. 11.10), which faced the congregants, follows the formula for a **maestà**: it features the Virgin Mary and Christ Child enthroned and surrounded by angels and saints. Duccio's composition begs comparison with the maestàs we have examined by Cimabue and Giotto (see Figs. 11.7 and 11.8). The face of Duccio's Madonna retains a Byzantine quality, as does Cimabue's, but her physical presence more resembles that of Giotto's Madonna. She sits squarely on her throne, the arms of which splay out toward the viewer as if to present her or to welcome the viewer into her presence. The drapery of Duccio's Madonna is realistically handled, devoid (as with Giotto's) of the gold striations that appear more decorative than natural. The figures in the foreground to either side of the throne have distinct facial features, and their gestures are animated, adding to the naturalism of the painting. They are situated in depth, in distinct rows arranged in such a way that each face is clearly visible—almost like a yearbook photograph.

The back of the altarpiece consists of a grid of smaller panels, although not all of them can be seen together in one place today. Some of these panels have made their way into museum collections around the world. The portion that is illustrated here (Fig. 11.11) shows scenes from the Passion of Jesus Christ, beginning (in the lower left) with his entry into Jerusalem (an event commemorated on Palm Sunday of the Christian liturgical calendar) and ending with scenes from his resurrection in the upper right.

The style of Duccio's painting appears more conservative—perhaps a bit more old-fashioned than Giotto's—but that is probably because of the iconic function of the altarpiece itself, placed on the high altar of the cathedral. The gold background

register depicts virtues and vices painted in a palette of gray tones to imitate relief sculpture. Specific events are painted in rectangular segments separated by ornate borders. The chronologies progress from left to right, with visual elements (such as shape and line) leading our eyes from one rectangle to the next.

As you look at paintings, challenge yourself to analyze their formal structures. An artist places things in a composition as a director might arrange actors and scenery in a play; things are where they are for very specific reasons. Giotto's narrative paintings have been related to popular contemporary *mystery plays* that featured actors in tableaus based on biblical stories.

Giotto's work was a major influence on Italian Renaissance painting. Copying nature, observing the world, trying to reproduce exactly what the eye sees on a two-dimensional surface, and capturing the nuances of human behavior and emotion to

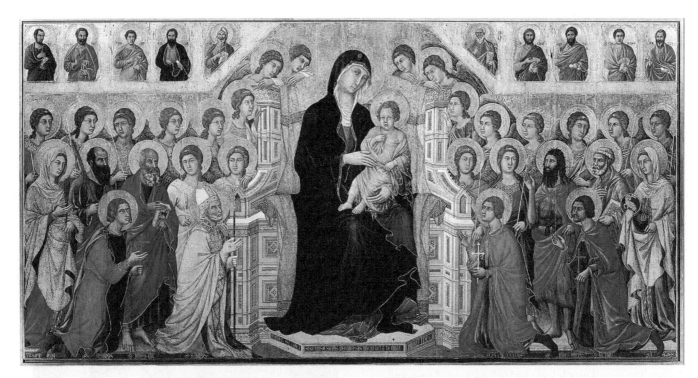

▲ **11.10 Duccio di Buoninsegna, *Virgin and Child Enthroned with Saints*, ca. 1308–1311. Principal panel of the Maestà altarpiece from Siena Cathedral. Tempera and gold leaf on wood, 84" × 156" (213 × 396 cm). Museo dell'Opera Metropolitana del Duomo, Siena, Italy.** The Maestà altarpiece was commissioned for the high altar of the Siena Cathedral. When it was completed in 1311, a grand celebration was held throughout the city as the altarpiece was carried in an elaborate candlelit procession, led by the bishop, from Duccio's studio to its place of honor.

▼ **11.11 Duccio di Buoninsegna, *Life of Jesus*, ca. 1308–1311. Fourteen panels from the back of the Maestà altarpiece, from Siena Cathedral. Tempera and gold leaf on wood, 83½" × 167¼" (212 × 425 cm). Museo dell'Opera Metropolitana del Duomo, Siena, Italy.** The back of the Maestà altarpiece consisted of 43 separate scenes of the life of the Virgin Mary and the life of Christ. Some of the panels are now in museum collections, and others have been lost. The altarpiece was intact until 1711, when it was cut in two to divide the panels between two altars.

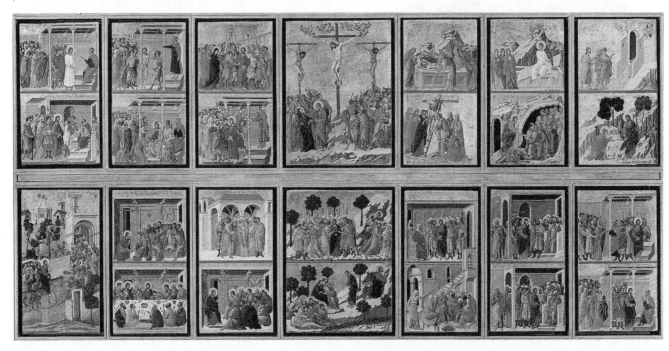

COMPARE + CONTRAST

Scenes from the Passion of Christ by Giotto and Duccio

Florence and Siena were rival republics, and their "favorite sons"—Giotto and Duccio—were the most famous artists of their time and place. Their two big commissions, the Arena Chapel fresco cycle and the Maestà altarpiece for the Siena Cathedral, were created within a few years of each other, and both depict scenes from the lives of Mary and Jesus. Examining scenes from each of the works on the same theme offers an excellent opportunity to consider the artistic choices that each painter made, their stylistic differences, and the impact of their emotional content.

Christ's entry into the city of Jerusalem through one of the gates of its ancient fortification is mentioned in all four of the canonical Gospels, those that were accepted as part of the New Testament or Christian Bible. All four evangelists wrote that this arrival took place after Jesus's miracle of raising a man named Lazarus from the dead and a few days before the Last Supper. Throngs of people were said to have greeted Jesus and

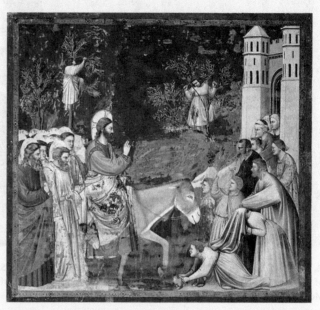

▲ 11.13 Giotto di Bondone, *Entry of Christ into Jerusalem*, ca. 1305. Fresco, 78 ¾" × 72 ¾" (200 × 185 cm). Arena Chapel (Capella Scrovegni), Padua, Italy.

his apostles upon their arrival at the gate. This is the scene depicted here by both Duccio (Fig. 11.12) and Giotto (Fig. 11.13). In both paintings, Jesus rides a donkey—a symbol of peace—and blesses the onlookers; some of them lay down their cloaks before him and a couple of others climb trees to get a better look. But beyond these few narrative pieces, the works are very different. In Duccio's painting, there is a distinction between Jesus and his followers and the crowd that spills—almost literally—through the city gate. Jesus's group processes calmly, looking forward; their heads are all visible, and they are placed side by side in two distinct, regimented lines. The crowd, much larger than the one in Giotto's painting, is active and noisy; the onlookers' positions vary, and they all seem to be talking. There is energy in Duccio's composition that conveys a sense of genuine excitement. In Giotto's painting, the apostles also follow behind Jesus in a group, but only the ones nearest to us are visible; their halos obscure the apostles behind them.

A close look reveals that the perspective, or point of view, each artist has chosen is different: we look down on the scene in Duccio's painting, whereas in Giotto's, we look straight ahead, and the proximity of the figures creates the sensation that we are there, on the same path, walking with them. As in many of the scenes in the fresco cycle, Giotto incorporates the results of his close observation of nature—and human nature.

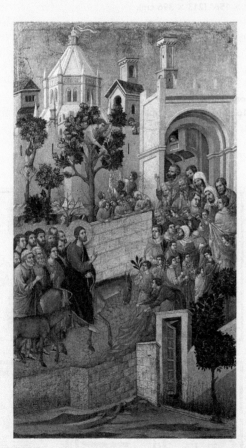

▲ 11.12 Duccio di Buoninsegna, *Entry into Jerusalem*, 1308–1311. Tempera on wood, 39⅜" × 22⅜" (100 × 57 cm). Panel from the back of the Maestà altarpiece. Museo dell'Opera del Duomo, Siena, Italy.

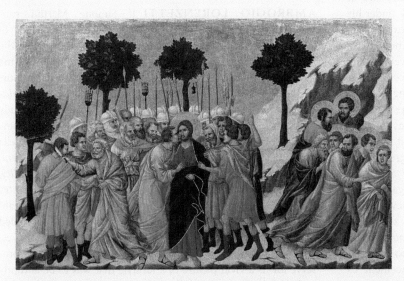

◀ **11.14** Duccio di Buoninsegna, *The Betrayal of Jesus*, 1309–1311. Tempera and gold leaf on wood, 20" × 30" (51 × 76 cm). Panel from the back of the Maestà altarpiece. Museo dell'Opera Metropolitana del Duomo, Siena, Italy.

few players. As in the *Lamentation*, Giotto includes a figure with his back turned toward us; rather than blocking us from entering the scene, his placement makes us feel as if we are close behind him. The most dramatic point of the narrative, of course, is the actual kiss, to which Giotto draws our attention by stretching the diagonal folds of Judas's bright-yellow cloak up to the head of Christ. As Judas embraces him, Jesus does not remain expressionless. He stares directly and deeply into Judas's eyes as if he means for Judas to understand what he has done. Judas's kiss is not the only gesture that constitutes this bitter betrayal: he envelops Jesus in his cloak—a false, hypocritical gesture of comfort and protection.

How do these artistic choices affect the narrative? How do they impact your emotional connection to these characters and their stories?

▼ **11.15** Giotto di Bondone, *The Betrayal of Jesus*, ca. 1305. Fresco, 78 ¾" × 72 ¾" (200 × 185 cm). Arena Chapel (Capella Scrovegni), Padua, Italy.

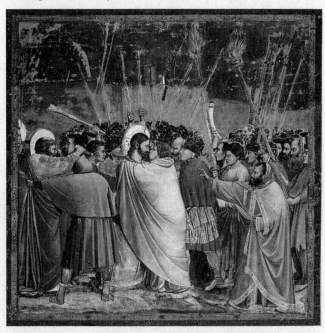

Consider how the people in the lower right corner are spreading their cloaks on the ground—or trying to. In the rush to do so before the honoree passes by, one person struggles with a cloak that has gotten stuck over his head and another is fumbling with his sleeve. When we see elements such as these, we understand that Giotto could have included these actions only if he had seen them before—in reality—and copied them. It is fun to imagine him walking through a crowd at a parade with his sketchbook.

According to the Gospels of Matthew, Mark, and Luke, one of Jesus's apostles—Judas—betrayed him to priests of the Sanhedrin (ancient Israel's supreme court) in the garden of Gethsemane after he dined with the apostles at the Passover meal that would become known as the Last Supper. Judas identified Jesus as the one among them by a kiss. The scene depicted by Duccio (**Fig. 11.14**) and Giotto (**Fig. 11.15**) is called *The Betrayal of Jesus*.

In Duccio's composition, havoc has broken loose. Jesus stands at the center, surrounded by helmeted soldiers and bearded men with angry expressions on their faces. To the left, Peter attacks a soldier with a knife to protect Jesus, cutting off his ear; this action was reported in the Gospels along with Jesus's healing of the wound in the last miracle he would perform before his crucifixion. To the right, Jesus's apostles flee the scene, leaving him alone with Judas, whose face touches Jesus's as he plants his deadly kiss. Jesus stares ahead, expressionless.

Some of the same narrative components are present in Giotto's version of the scene, but they are handled quite differently—particularly when it comes to defining space. The crowd is much larger and much denser in Giotto's composition; Jesus and his apostles are greatly outnumbered. Yet the apostles are relegated to the background, focusing our attention on only a

of Duccio's work certainly limits the credibility of the scenes; on the other hand, it contributes to its splendor. Duccio's colors gleam like jewels; his fabrics glisten.

SIMONE MARTINI AND THE INTERNATIONAL STYLE Giotto's appeal was direct and immediate, and at Florence his pupils and followers continued to work under his influence for most of the 14th century, content to explore the implications of the master's ideas rather than devise new styles. As a result, the scene of the most interesting new developments in the generation after Giotto was Siena, where Duccio's influence (although considerable) was less overpowering. Among Duccio's pupils was Simone Martini (ca. 1285–1344), a close friend of Petrarch, who worked for a time at Naples for King Robert of Anjou and spent the last years of his life at the papal court of Avignon. In Martini's work, we find the last great development of Gothic art, the so-called *International Style* that swept Europe in the 14th and 15th centuries. The elegant courts of France and the French kingdoms of Italy had developed a taste for magnificent colors, fashionable costumes, and richly embellished fabrics. Martini painted his *Annunciation* altarpiece (Fig. 11.16) with his pupil and assistant Lippo Memmi. The Annunciation is the angel Gabriel's announcement to Mary that she will bear the Christ child. The figures in the piece have an insubstantial grace and sophistication that contrast strongly with Giotto's solid and earthy realism (see Fig. 11.8). The resplendent robe and mantle of the angel Gabriel and the deep-blue dress of the Virgin, edged in gold, produce an impression of great splendor, while their willowy figures approach the ideal of courtly elegance.

AMBROGIO LORENZETTI If Simone Martini subordinated naturalism to the decorative lines and shapes of the International Style, two of his fellow Sienese artists—the Lorenzetti brothers—were more interested in applying Giotto's innovations to their own work. Ambrogio was granted an important commission for the Palazzo Pubblico, Siena's city hall (*palazzo pubblico* means "public palace"). Unusual for us in our study of Italian art thus far is this secular—rather than religious—commission. The three large frescoes on the walls of the Sala della Pace (the Hall of Peace) are the *Allegory of Good Government, Bad Government and the Effects of Bad Government on the City*, and *Effects of Good Government on the City and on the Country* (Figs. 11.17 and 11.18). In a panoramic view of Siena, buildings are rendered in elaborate perspective; streets and squares are filled with scenes of daily life. Richly dressed merchants with their wives, craftsmen at work, and graceful girls who dance in the street preserve for us a vivid picture of a lifestyle that was to be abruptly ended by the Black Death. The scenes in the country, on the other hand, illustrate the bounty that attends a republic at peace. They

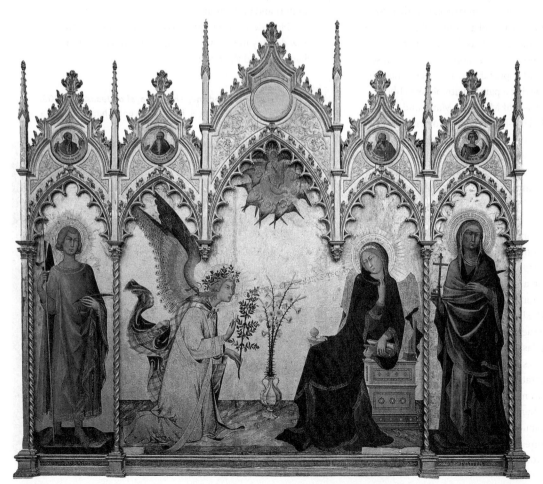

◀ **11.16** **Simone Martini and Lippo Memmi, *Annunciation* altarpiece, 1333. Siena Cathedral, Italy. Tempera and gold leaf on wood, center panel 121" × 96" (305 × 254 cm). Galleria degli Uffizi, Florence, Italy.** The courtly elegance and delicacy of Martini's figures were a hallmark of the International Style. Speaking to the Virgin, the angel Gabriel proclaims, "Ave gratia plena dominus tecum" ("Hail thou that are full of grace, the Lord is with you"). It is the moment when Mary becomes aware that she will bear the Christ child.

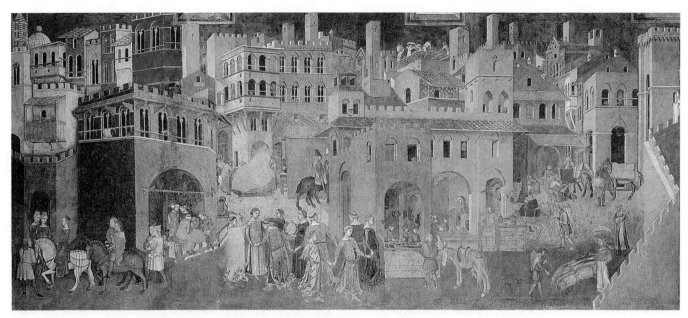

▲ **11.17** Ambrogio Lorenzetti, *Peaceful City*, detail of *Effects of Good Government on the City and the Country*, 1338–1339. Fresco, 47' × 10' (14.3 × 3 m). Sala della Pace, Palazzo Pubblico, Siena, Italy. The panoramic fresco in the Siena city hall is a tribute to the quality of life made possible by prevailing peace and a just and nurturing government. Citizens profit, commerce is congenial, and all are content, relaxed, and joyful. To the left is a shoe shop, in the center a school lesson is in progress, and to the right a tavern keeper is selling wine.

▼ **11.18** Ambrogio Lorenzetti, *Peaceful Country*, detail of *Effects of Good Government on the City and the Country*, 1338–1339. Fresco, 47' × 10' (14.3 × 3 m). Sala della Pace, Palazzo Pubblico, Siena, Italy. Peace spills out of the city and into the countryside in one of the first examples of pure landscape painting since Roman times. The allegorical figure in the top left corner is Securitas (Security), whose scroll reads, "The people will be safe as long as justice rules." She also holds a gallows with a hanged man as a warning to those who might contemplate disturbing the peace.

show a world that survives even today in rural Tuscany: peasants at work on farms and in orchards and vineyards.

LATE MEDIEVAL ARCHITECTURE

Architecture in Europe of the late 13th and 14th centuries—regardless of where it was built—showed the influence of the **French Gothic style** from vaulting techniques to decorative details. Even buildings constructed in Italy during this period, whose lower profiles and basilican plans reach back to the country's Classical roots, bore motifs and embellishments that bespoke familiarity with the prevailing Gothic fashion. Cathedrals remained at the center of society—literally and figuratively—but to varying degrees. Civic pride, reborn in these transitional years, led to the creation of secular centers of city life and, in them, government buildings such as the Palazzo Pubblico in Siena and the Palazzo della Signoria in Florence (also known as the Palazzo Vecchio or "Old Palace")—both city halls.

Secular Architecture

The Palazzo della Signoria (begun 1298) and the Palazzo Pubblico (begun 1288; Fig. 11.19) convey the sense of strong government and civic pride that emerged in these rival republics during the trecento. Both buildings were constructed on city squares and were designed as fortresslike blocks with single tall towers that could be used to spot trouble from invading forces on the horizon or to defend the city authorities from threats by their own disenchanted citizens. The uppermost section of the tower of the Palazzo Pubblico, which served as a belfry, was also constructed in such a way that boiling liquid could be poured through holes in the floor onto enemy troops. From a distance, the building may look imposing and inaccessible, but from the ground level on the square, it feels much more inviting. The contrasting white stonework is light and more airy in appearance, and the entrances have a more human scale. The design of the Palazzo Pubblico broadcasts, at the same

time, Siena's power as a city-centered republic—a force to be reckoned with—and its inclusivity regarding its common citizens.

Both Florence and Siena were wealthy cities, having successfully established themselves in banking and commerce. So too was Venice wealthy; its location on the Adriatic coast of Italy positioned it for strong economic development as it thrived from all sorts of trade relationships. As a city on the water—whose "streets" are water—it was more easily defensible against aggression by other Italian cites than were Siena or Florence. Although the republic of Venice did not shy away from its own military campaigns, it called itself the Serenisima Republica Veneta, the Most Serene Republic of Venice. The Doges' (Dukes') Palace (Fig. 11.20) is the city hall of Venice; it is probably the most beautiful of all government centers in Italy, if not all of Europe. It was constructed ca. 1340–1345 and expanded and remodeled from 1424 to 1438. In the bright sunlight that reflects from the sea, the overall effect of the building is ethereal. An arcade with pointed arches marches along the lowest level of the building, providing an open and airy

▶ **11.19 Palazzo Pubblico, 1288–1309. Siena, Italy.** The tower of the Siena city hall is visible from miles around, its height necessitated by the hilly topography of the city and countryside. It served as a lookout as well as a symbol of power.

▲ **11.20 Doges' Palace, begun ca. 1340–1345, expanded and remodeled 1424–1438. Venice, Italy.** The palace was the most resplendent Italian public building of its day. The creamy white and rose-colored marbles, patterned surfaces, and ornate arches contribute to this unique and elegant interpretation of French Gothic architecture.

▶ **11.21 Gloucester Cathedral, 1089–1420, choir, 1332–1357. Gloucester, United Kingdom, view from the choir toward the transept and east window.** The cathedral was constructed in the Perpendicular style, so called for its emphasis on verticality and proliferation of ribs in the vaulting.

foundation for a more delicate arcade with twice the number of columns and arches. The upper half of the building is solid, with only a few windows puncturing the plane of the façade. From a distance, the Doges' Palace may seem top-heavy, but the delicately patterned brickwork—visible from a closer perspective—has the effect of dematerializing the surfaces, almost like bits of daubed color in an Impressionist painting (see **Chapter 18**).

Cathedral Architecture

Architects who designed cathedrals outside of Italy in the 14th century continued to embrace the lessons of French Gothic architecture. Nave walls continued to aspire to the great heights made possible by elaborate fan vaulting. The upward striving and extreme vertical emphasis in English cathedral architecture became known as the **Perpendicular style**. The choir of Gloucester Cathedral (**Fig. 11.21**) can be

▲ **11.22 Cathedral of Santa Maria del Fiore (the Duomo), 1296–1436. Florence, Italy.** The Duomo was designed in the Late Medieval period by Arnolfo di Cambio and completed in the Early Renaissance when Filippo Brunelleschi constructed the great dome (although the façade was still being worked on in the 19th century). Giotto, the most famous Florentine painter of the 14th century, designed the freestanding campanile, or bell tower. The baptistery, located in a square across from the entrance of the cathedral, was built between 1059 and 1128; it is famous for relief sculpture on its bronze doors, one set of which was created by Giovanni Pisano.

described as a harmony of vertical lines of different lengths and widths; the thicker, unbroken lines of the column clusters in the nave elevation culminate in a sprays of "branches" whose thin stalks spread and interweave into a delicate and intricate pattern of stonework that covers the vault and makes it seem weightless.

On the other hand, Gothic architecture never really crossed the Alps into Italy. Although some of the most important Italian buildings of the 14th century may be labeled Gothic, their style differs markedly from that of their northern counterparts. The cathedral of the city of Florence, Santa Maria del Fiore (better known as the Duomo after the imposing dome that was completed in the 15th century), is weighty, not ethereal (**Fig. 11.22**). Its outer walls are not occluded by a screen of flying buttresses and do not dissolve into planes of colored glass; the floor plan of the cathedral is clearly visible from the outside. Excepting the dome, the profile of the building is low, horizontal; it does not reach heavenward but rather remains earthbound. The embellishment of the stone surfaces is not carved, for the most part, but consists of geometric patterns of green and white marble. And the bell tower—designed by Giotto—is separate from the

façade, unlike the twin towers that are typical of French Gothic architecture and its imitators. When we look at cathedrals such as Notre-Dame or Chartres, the complex structures that surround the exterior, through which we must peer to see the walls, preserve a sense of mystery; the Duomo, with its clear components, has the feeling of rational order. This important difference will impact the nature of Renaissance architecture.

The Cathedral of Santa Maria del Fiore, begun in 1296, would not be completed until 1436. The commission for the massive dome, which has given the cathedral its affectionate moniker (*duomo* means "dome"), went to Filippo Brunelleschi in the opening decades of the 15th century.

A NEW MUSICAL STYLE— ARS NOVA

While Giotto was laying the foundations for a new naturalistic style of painting and writers like Petrarch and Chaucer were breathing fresh life into literary forms, composers in

CONNECTIONS Brunelleschi's dome for Santa Maria del Fiore (the Cathedral of Florence) is an architectural and engineering tour de force—a structure that not only awed his contemporaries but one that has become the signature and enduring symbol of the city. The profile of the dome is instantly recognizable. But what does it look like from the inside—looking up from the pavement beneath? What the visitor sees is not what Brunelleschi intended. He envisioned the inside of the dome covered in glittering mosaic—a concept that never came to fruition after his death. Instead, the walls of the dome were whitewashed and remained so until 1568 when the painter and art historian, Giorgio Vasari—along with Frederico Zuccari—undertook a project to paint the entire dome with scenes from the *Last Judgment*—arranged in tiers, perhaps inspired by Domenico di Michelino's painting of Dante (see Fig. 11.2). Both artists died before completion, and the work was taken up by a number of different artists—in different styles. The result, according to some—including contemporary critics—was a botch. When the restoration of the fresco—which took 14 years and carried with it a hefty cost—was revealed in1995, the controversy over the quality of the painting as a work of art—and the cost of maintaining it—resurfaced. Mark Twain once described the Cathedral of Florence as "a vast pile that has been sapping the purses of her citizens for 500 years." Was this latest project worth it for the sake of art history? One newspaper critic wrote, "God save us from the art historians."

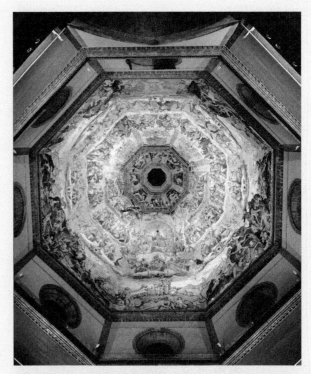

▲ **11.23 Giorgio Vasari, Cupola, Dome of the Cathedral of Florence.**

France and Italy were changing the style of music. To some extent, this was the result of social changes. Musicians had begun to break away from their traditional role as servants of the church and to establish themselves as independent creative figures; most of the music that survives from the 14th century is secular. Much of it was written for singers and instrumentalists to perform at home for their own pleasure (see **Fig. 11.24** on page 370) or for the entertainment of aristocratic audiences. The texts that composers set to music were increasingly varied—ballads, love poems, even descriptions of contemporary events—in contrast to the religious settings of the preceding century.

As the number of people who enjoyed listening to music and performing it began to grow, so did the range of musical expression. The term generally used to describe the sophisticated musical style of the 14th century is **Ars Nova**, derived from the title of a treatise written by the French composer Philippe de Vitry (1291–1361) ca. 1325. The work was written in Latin and called *Ars nova* (*The New Art*). Although it is really concerned with only one aspect of composition and describes a new system of rhythmic notation, the term *Ars Nova* has taken on a wider use and is applied to the new musical style that began to develop in France in the early 14th century and soon spread to Italy.

The chief characteristic of Ars Nova is a much greater richness and complexity of sound than before. This is partly achieved by the use of richer harmonies; thirds and sixths are increasingly employed, and the austere sounds of parallel fifths, unisons, and octaves are generally avoided. Elaborate rhythmic devices are also introduced, including the method of construction called **isorhythm** (from the Greek word *isos*, which means "equal"). Isorhythm consists of allotting a repeated single melody to one of the voices in a **polyphonic** composition. The voice is also assigned a repeating rhythmic pattern. Because the rhythmic pattern is of a different length from the melody, different notes are stressed on each repetition. The purpose of this device is twofold: it creates a richness and variety of texture, and it imparts an element of unity to the piece.

Guillaume de Machaut

The best-known French composer of the period was Guillaume de Machaut (ca. 1304–1377), whose career spanned the worlds of traditional music and the Ars Nova. He was trained as a priest and took holy orders, but much of his time was spent traveling throughout Europe in the service of the kings of Bohemia, Navarre, and France. Toward the end of his life, he retired to

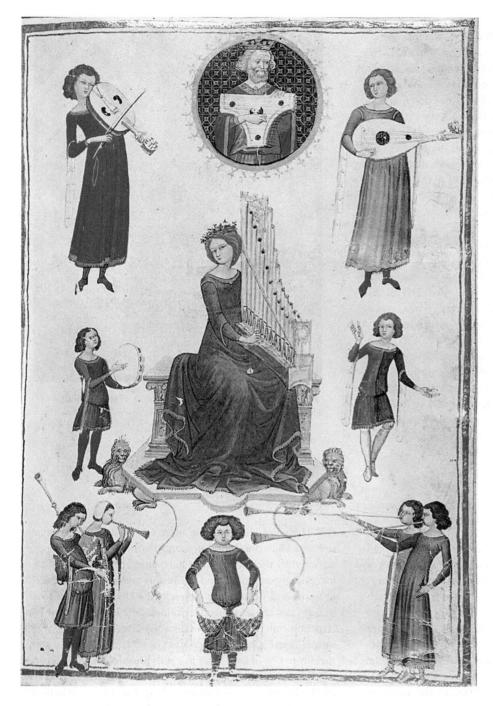

◀ **11.24 Fourteenth-century musicians and instruments, *De musica I.* Manuscript illumination. Biblioteca Nationale, Naples, Italy.** The goddess Music is enthroned in the center, playing a small organ and surrounded by musicians in contemporary dress playing stringed, percussion, and wind instruments. Above, King David of Israel is shown in a round inset plucking a psaltery, a stringed instrument in the harp family. The Hebrew book of Psalms—sacred verses recited or sung—was attributed to King David.

Reims, where he spent his last years as a canon. His most famous composition, and the most famous piece of music from the 14th century, is the Messe de Notre Dame. A four-part setting of the Ordinary of the Mass (discussed shortly), it is remarkable chiefly for the way in which Machaut gives unity to the five sections that make up the work by creating a similarity of mood and even using a single musical motif that recurs throughout.

Machaut's Messe de Notre Dame is the first great example of the entire Ordinary of the Mass set to polyphonic music by a single composer. The Ordinary of the Mass refers to those parts of the Roman Catholic liturgy that do not change from day to day, in contrast to the Propers (the readings from the Gospels or Epistles), which do change daily. The parts of the Ordinary are as follows.

1. The **Kyrie Eleison**: the repeated Greek phrases that mean "Lord have mercy on us!" and "Christ have mercy on us!"
2. The **Gloria**: a hymn of praise sung at all masses except funerals and masses during Lent and Advent.

3. The **Credo**: the profession of faith sung after the Gospel.
4. The **Sanctus and Benedictus**: a short hymn based on the angelic praise found in Isaiah 6, sung at the beginning of the Eucharistic prayer.
5. **The Agnus Dei**: the prayer that begins "Lamb of God," sung before Communion.

With the music of Machaut, we begin to approach the main characteristics of Western music. After a single voice has intoned the opening words of the Credo, the other voices enter to provide the elements absent from Gregorian chant and, to a lesser extent, Léonin's organum: **harmony** (the sounding together of several lines or voices in a pleasing arrangement) and a recognizable rhythmic structure. The rhythm is varied and uses melodic motifs as its basis. Although rooted in the principles laid out in Philipe de Vitry's *Ars nova musicae*, the free flow of the Credo is truly novel.

The four voices move simultaneously so that it is easy for the listener to follow the words, which remain clear but are given a new vigor by the freedom of their treatment. In his rhythmic inventiveness and sense of the structural importance of harmony (note the satisfying way in which the listening selection comes to rest at its conclusion), Machaut points the way to the next stage in the development of Western music.

Machaut's Messe de Notre Dame stands at the head of a long tradition of musical composition in which composers use the Ordinary of the Mass to express the timeless words of the liturgy in their own cultural idiom. In that sense, Machaut's Mass is the ancestor of the Renaissance compositions of Palestrina in the 16th century, the Baroque masses of Johann Sebastian Bach in the 18th century, and the frenetically eclectic modern Mass of Leonard Bernstein.

Machaut is also one of the earliest musicians to leave a substantial body of secular music, contributing to another great musical tradition: secular song. With the increasing use of polyphony, composers began to turn their attention to the old troubadour songs and write new settings that combined several different voices. Machaut's polyphonic secular songs took several forms. His **ballades** were written for two or three voices, the top voice carrying the melody while the others provide the accompaniment. These lower voices were probably sometimes played on instruments rather than sung. As in the ballades of earlier times, the poems consisted of three stanzas, each of seven or eight lines, with the last one or two lines identical in all the stanzas to provide a refrain.

Many of these secular songs, both by Machaut and by other composers, deal with amorous topics, and they are often addressed to the singer's beloved. The themes are predictable—the sorrow of parting, as in Machaut's "Au dèpartir de vous," reproaches for infidelity, protestations of love, and so on—but the freshness of the melodies and Machaut's constant inventiveness prevent them from seeming artificial.

GO LISTEN!
GUILLAUME DE MACHAUT
Messe de Notre Dame, Credo

Francesco Landini

The other important composer of the 14th century was the Italian Francesco Landini (1325–1397), who lived and worked in Florence. Blinded in his youth by smallpox, he was famous in his day as a virtuoso performer on the organ, lute, and flute. Among his surviving works are several **madrigals**, songs for two or three voices unaccompanied by instruments. In addition, he wrote a large number of *ballate* (ballads), including many for solo voice and two accompanying instruments. The vocal lines are often elaborate, and Landini uses rich, sonorous harmonies. But in the case of these and other works of the period, there is no specification of the instruments intended or of the general performance style Landini would have expected (Fig. 11.24). We know from contemporary accounts that in some cases performers would have changed the written notes by sharpening or flattening them, following the convention of the day. This practice of making sounds other than those on the page was called **musica ficta** (fictitious music), but no systematic description of the rules that were followed has been handed down to us. As a result, modern editors and performers often have only their own historical research and instincts to guide them. Although the Ars Nova of the 14th century marks a major development in the history of music, our knowledge of it is far from complete.

The 14th century was a time of stark contrast between the horrors of natural and social disasters and the flowering of artistic and cultural movements that were the harbingers of the 15th-century Renaissance in Italy. Chaucer, as noted, died in 1400, the year that may be taken as the close of the medieval period. By that time, some of the prime figures of the Italian Renaissance—Donatello, Fra Angelico, and Ghiberti—were already in their teens. The great outburst of cultural activity that was to mark Florence in the 15th century was near, even though it would not make a definite impact on England until the end of the century. The "calamitous" 14th century was also the seedbed for rebirth and human renewal.

GLOSSARY

Agnus Dei (p. 371) Latin for "lamb of god."

Ars Nova (p. 369) A 14th-century style of music characterized by freedom and variety of melody, as contrasted with stricter 13th-century music.

Ballade (p. 371) In music, a composition with the romantic or dramatic quality of a narrative poem.

Black Death (p. 342) The epidemic form of the bubonic plague, which killed as much as half the population of Western Europe in the mid-fourteenth century.

Canto (p. 345) A principal division of a long poem.

Canzone (p. 351) A song (plural *canzoni*).

Canzoniere (p. 351) A songbook.

Chiaroscuro (p. 358) An artistic technique in which subtle gradations of value create the illusion of rounded three-dimensional forms in space; also termed *modeling* (from Italian for "light-dark").

Credo (p. 371) The profession of faith sung after the Gospel in the Ordinary of the Mass.

Exemplum (p. 348) In literature, a tale intended as a moral example (plural *exempla*).

Fabliau (p. 348) A medieval tale told in verse and having comic, ribald themes (plural *fabliaux*).

French Gothic style (p. 366) A style of architecture that originated in 12th-century France and is characterized by pointed arches, ribbed vaults, and flying buttresses, which enable the use of ample fenestration.

Gloria (p. 370) A hymn of praise from the Ordinary of the Mass.

Great Schism (p. 344) The division in the Roman Catholic Church during which rival popes reigned at Avignon and Rome.

Harmony (p. 371) In music, a pleasing combination of lines or voices; in art and architecture, a balanced or unified composition arranged in a pleasing manner.

Iambic pentameter (p. 354) A meter in poetry consisting of five feet, each one containing an unaccented syllable followed by an accented syllable.

Isorhythm (p. 369) Alloting a repeated single melody to one of the voices in a composition.

Kyrie Eleison (p. 370) Repeated phrases in the Ordinary of the Mass that translate as "Lord, have mercy on us."

Madrigal (p. 371) A song for two or three voices unaccompanied by instrumental music.

Maestà (p. 360) From the word for "majesty," a work of art that features the Virgin Mary and Christ child enthroned and surrounded by angels and saints.

Modeling (p. 358) In two-dimensional works of art, the creation of the illusion of depth through the use of light and shade (*chiaroscuro*).

Musica ficta (p. 371) Literally "fictitious music"; the practice of making sounds not written on the page of music.

Perpendicular style (p. 367) A form of Gothic architecture developed in England and characterized by extreme vertical emphasis and fan vaulting.

Polyphonic (p. 369) Of a form of musical expression characterized by many voices.

Sanctus and Benedictus (p. 371) A hymn in the Ordinary of the Mass based on the angelic praise found in Isaiah 6.

Sonnet (p. 351) A 14-line poem usually broken into an octave (a group of eight lines) and a sestet (a group of six lines); rhyme schemes can vary.

Tercet (p. 345) A group of three lines of verse; characterized in *The Divine Comedy* by the **terza rima** scheme.

Terza rima (p. 345) A poetic form in which a poem is divided into sets of three lines (**tercets**) with the rhyme scheme *aba*, *bcb*, *cdc*, and so on.

Trecento (p. 342) Literally, "300"; the Italian name for the 14th century.

THE BIG PICTURE THE FOURTEENTH CENTURY

Language and Literature

- Dante wrote *The Divine Comedy* ca. 1303.
- Boccaccio wrote the *Decameron*, set in the plague year, ca. 1348–1352.
- Petrarch compiled his collection of poems in the *Canzoniere* after 1350.
- Petrarch wrote his autobiography, "Letter to Posterity," in 1373.
- Chaucer wrote *The Canterbury Tales* ca. 1385–1400.
- Christine de Pizan wrote *The Book of the City of Ladies* in 1404.

Art, Architecture, and Music

- Nicola and Giovanni Pisano, father and son, "created" modern sculpture ca. 1259–1310.
- Secular music flourished in the 14th century.
- The Florentine painter Cimabue broke with Byzantine predecessors as in his *Madonna Enthroned with Angels and Prophets*, ca. 1280–1290.
- The Palazzo Pubblico was constructed in Siena in fortresslike fashion, with a tall tower, in 1288–1309.
- The Cathedral of Santa Maria del Fiore (the Duomo) in Florence was begun in 1296.
- Giotto painted the Arena Chapel frescoes, which displayed his ability to represent three-dimensional figures in a two-dimensional medium, ca. 1305.
- Giotto brought a new realism to painting, as can be seen in a comparison of his *Madonna Enthroned* (ca. 1310) to that of Cimabue.
- Duccio painted his multipanel altarpiece featuring the Virgin and Child with angels and saints in 1308–1311.
- Vitry penned *Ars nova musicae*, describing a new system of musical notation, ca. 1325.
- The Gloucester Cathedral choir was built in the Perpendicular style in 1332–1357.
- Martini painted in the International style—the final development of Gothic art—in 1333.
- Machaut composed his polyphonic Messe de Notre Dame after 1337.
- Ambrogio Lorenzetti applied Giotto's innovations in his allegory on good government for Siena's Palazzo Pubblico in 1338–1339.
- The Doges' Palace was constructed in Venice ca. 1345–1438.
- Landini composed madrigals and ballades in Florence ca. 1350.

Philosophy and Religion

- Pope Boniface VIII proclaimed the first Jubilee Year ("Holy Year") in 1300.
- The captivity of the papacy in Avignon began in 1309.
- Saint Catherine of Siena urged an end of the Babylonian Captivity of the pope ca. 1370.
- The papacy returned from Avignon to Rome in 1376.
- The Great Schism of the Roman Catholic Church began in 1378.

The Fifteenth Century

PREVIEW

Lorenzo de' Medici and Alessandro Filipepi—a prince and a pauper—were born within five years of each other in the middle of the 15th century. One to the manor born and the other on the backstreets, their paths may never have crossed except for fortuitous timing. The city of Florence, the crucible of the Renaissance, was in the midst of its most glorious historical moment. Lorenzo de' Medici, who would be called "the Magnificent," was the grandson of the man who founded the Medici political dynasty in the Republic of Florence; he was called "Cosimo, Pater Patriae"—the Father of the Nation. Alessandro Filipepi, who would be called Botticelli, was the son of a tanner. Lorenzo Medici, whose wealth was immense and who patronized the arts and letters unstintingly, gathered around him a tight circle of the most talented and influential humanists of his day. Not only would Botticelli become one of them, but he would also become one of Medici's closest and most trusted friends.

By 1475, the date that scholars roughly assign to Botticelli's *Adoration of the Magi* (see Fig. 12.30), the painter had already established himself in the Medici court, as evidenced by the family portraits that appear in that scene. The artist and historian Giorgio Vasari (1511–1574) praises the technique and verisimilitude with which Botticelli depicts them: "The beauty of the heads in this scene is indescribable, their attitudes all different, some full-face, some in profile, some three-quarters, some bent down, and in various other ways, while the expressions of the attendants, both young and old, are greatly varied, displaying the artist's perfect mastery of his profession. Sandro (Botticelli) further clearly shows the distinction between the suites of each of the kings. It is a marvelous work in color, design and composition."[1] Included among the illustrious subjects are Cosimo, who kneels closest to the Madonna and child; his son, Piero (father of Lorenzo), in a red cape, who genuflects in the center foreground; and Piero's sons Lorenzo and Giuliano, to the far left, who focus not on the religious scene but on the words of the famous Renaissance philosopher Giovanni Pico della Mirandola, shown in a red cap. In the *Adoration of the Magi*, Botticelli pays homage to the beneficence of the Medici—who saw themselves as kings and princes—and codifies the reconciliation of Christian belief and humanist thought that marked the discourse of Medici Florence. Botticelli was at the center of it all. In this painting, however, he places himself discreetly to the far right in what scholars believe may be a self-portrait (Fig. 12.1). Dressed not in finery but in a simple ochre cloak, he looks directly at us. Once a son of the poor working class, he moves in the company of princes, his head held high, his confidence and self-worth assured.

◀ **12.1** Sandro Botticelli, *Adoration of the Magi*, ca. 1475, detail showing self-portrait. Galleria degli Uffizi, Florence, Italy.

1. Giorgio Vasari, *The Lives of the Painters, Sculptors and Architects, vol. 3*, trans. A. B. Hinds (London: J. M. Dent and Co., 1900), p. 106.

TOWARD THE RENAISSANCE

The 14th century was a period of social strife and political turmoil, as well as a time of new stirrings in Europe. It was the century of Dante, Petrarch, Boccaccio, and Chaucer, and of the birth of humanism. In art, the long-cherished Byzantine style was challenged by the new naturalism of Cimabue and Giotto in Florence and Duccio and the Lorenzetti brothers in Siena. A new focus on the natural world—the world that is visible—had its roots in the teaching of Saint Francis of Assisi, whose worship of God began with the contemplation of beauty in the world and its creatures.

In the 15th century, Europe's recovery in the aftermath of the plague that had struck in 1348 was aided by political changes and new economic developments. A class of wealthy families emerged, whose claims to eminence were based less on noble blood than on the ability to make money through **capitalism**—commercial trade, banking, and monetary-exchange systems. Centers of international trade sprang up in Northern Europe and in Italy. Bruges in Flanders and Florence in Italy emerged as two of the wealthiest cities. With capitalism came prosperity, and with prosperity came patronage of the arts.

The interconnected nature of European finance in the 15th century is encapsulated in the story of Jan van Eyck's double portrait, *Giovanni Arnolfini and His Wife* (**Fig. 12.2**). Arnolfini was an Italian financier working in Bruges on behalf of the powerful Medici family of Florence, and a man who was prosperous enough to afford to commission a painting from an internationally famous artist. The purpose of the painting is not known for certain; it may have been intended to document the exchange of marriage vows between the couple or, as scholars have recently suggested, to represent the transference of legal rights from Arnolfini to his wife to act on his behalf during his absence. Witnesses to the transaction, one of whom is probably the artist himself, are seen in the reflection in the convex mirror that hangs on the wall behind the couple. Van Eyck signed the painting (as one might a legal document) in what appears as an inscription above the framed circular mirror: *Johannes van Eyck fuit hic* (Latin for "Jan van Eyck was here"). The signature also asserts van Eyck's self-importance as an artist; pride and ownership of one's accomplishments, and the acknowledgement of fame, are new notions associated with Renaissance thought.

The Arnolfini portrait not only carries sociological meaning but also shows us something of what was important to Northern European artists in the 15th century. The subject is a secular one, and as prosperity grew in the merchant class, there was more of a demand for secular work alongside religious paintings. Meticulous realism and symbolism were characteristic of both genres. The extraordinary detail of which Northern European artists were fond reveals much about contemporary

The Fifteenth Century

1400 CE	1434 CE	1494 CE	1520 CE

15th-century Florence is the center of the European banking system

Council of Constance ends the Great Schism

Florentines defeat the Sienese at San Romano

Cosimo de' Medici becomes de facto ruler of Florence

The printing press is invented

Constantinople falls to the Turks; scholarly refugees bring Greek manuscripts to Florence

The Hundred Years' War ends

Piero de' Medici takes power in Florence after the death of Cosimo

Lorenzo de' Medici rules Florence after the death of Piero

Spain is united under Ferdinand and Isabella

Pazzi conspiracy against the Medici fails

The Spanish Inquisition begins

Savonarola begins sermons against Florentine immorality

Lorenzo de' Medici dies

Christopher Columbus sets sail to find a western passage to India

Medici faction goes into exile; Savonarola becomes de facto ruler of Florence; Charles VIII of France invades Italy

Vasco da Gama begins first voyage to India

Savonarola is burned at the stake

Medici power is restored in Florence

Machiavelli is exiled

12.2 Jan van Eyck, *Giovanni Arnolfini and His Wife*, 1434. Oil on wood, 33" × 22½" (81.3 × 59.7 cm). National Gallery, London, United Kingdom. In a Flemish painting, ordinary objects are often invested with symbolic meaning. In the Arnolfini portrait, which represents a sacred vow, the tiny dog symbolizes fidelity (Fido is a name that captures the loyalty of "man's best friend"), the stockinged feet symbolize the holy ground on which the marriage takes place, and the green of the bride's dress is associated with fertility.

life—its customs, fashions, and environs. Whatever the purpose of the Arnolfini portrait, we are offered a glimpse of a 15th-century Flemish interior and what the best-dressed men and women in Bruges were wearing at the time.

The painting is replete with ordinary objects that carry meaningful symbolism: the small dog represents fidelity; the oranges by the windowsill and the green of the bride's apparel, fertility; and the chandelier with its single candle, the unity of a man and woman in marriage. In religious art as well, objects that might appear usual fare for secular paintings are invested with complex symbolism. We should assume that everything in

a Northern European painting is there for a purpose and carries some sort of allusion or meaning.

Late Medieval and Early Renaissance Art in Northern Europe

A glimpse at a map of Europe in the 15th century (see **Map 12.1**) shows the territory of the Holy Roman Empire—the core of

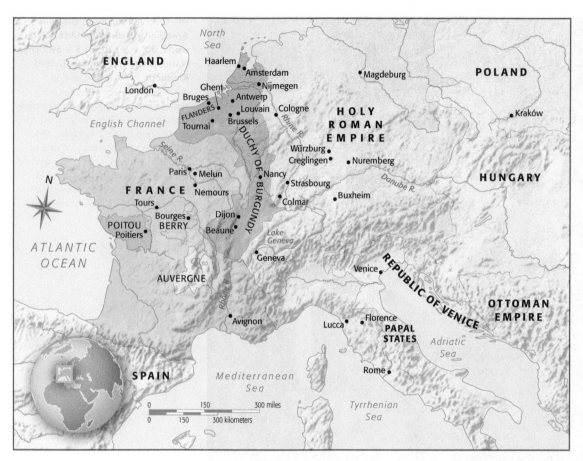

◀ MAP 12.1

Europe in the mid-15th century with France, the duchy of Burgundy, Italy, and the Holy Roman Empire.

which was Germany—stretching southward from the North Sea into parts of Italy, and to the west, into France, whose various territories (duchies) were controlled by dukes. The largest and most powerful of these, created by the political instability of the Hundred Years' War, was the duchy of Burgundy—a crescent-shaped area of fertile land with ports along the North Sea that would come to dominate maritime trade. The duchy controlled Flanders in the northwest tip of the territory and its highly prosperous cities—Bruges, Ghent, Brussels, and Antwerp. Bruges, in particular, which dominated the wool trade, accounted for much of the duchy's wealth. (Even today, Bruges is renowned for its tapestries.) It soon became, in effect, the financial capital of northern Europe. That is why Arnolfini was there.

BURGUNDY AND FRANCE The Duke of Burgundy, Philip the Bold (r. 1363–1404), was one of four sons of King John II (r. 1350–1364) of France; thus, he and his successors were part of the French royal family. They emerged as the most powerful rulers in northern Europe and remained so for most of the 15th century. Philip's brother, Jean (r. 1360–1416), controlled the territories of Berry, Auvergne, and others in France. Both used their considerable wealth to become important patrons of the arts, which, in turn, glorified their power and position. Philip moved his court to Bruges, where his grandson, Philip the Good (r. 1419–1467), would eventually inherit the title of

Duke of Burgundy and employ Jan van Eyck as court painter. As the Duke of Berry, Jean patronized artists working in Paris and Bourges and commissioned what is perhaps the most famous illuminated manuscript in the history of art as a personal prayer book—*Les Très Riches Heures du Duc de Berry (The Very Sumptuous Hours of the Duke of Berry)*.

Limbourg Brothers Books of hours, used by nobility as prayer books, included psalms, litanies, and liturgical passages that were to be recited at certain hours of the day, as well as calendar pages noting religious feast days. *Les Très Riches Heures* was painted for Jean by the Limbourgs, three Netherlandish artist-brothers working in France who probably all died of plague in 1416. Its calendar pages are ornately embellished with finely detailed scenes of events and activities associated with certain months and seasons of the year—from the splendid to the quite ordinary. In *October* (Fig. 12.3), against the backdrop of the medieval palace of the Louvre with its turrets and steep, blue roofs (once the Paris residence of the French kings and now the world-famous museum, under which remnants of the original structure can still be seen), a plowman and farmer work the fields, sowing seed that will blossom in the spring. Birds swoop down to nibble in the foreground, undeterred by the scarecrow that has drawn its bow in the exact center of the scene. Just outside the fortress walls of the palace, city dwellers amble and washerwomen descend

signs associated with the particular month. The illustration for October shows the symbols for Libra and Scorpio.

Although these calendar pages illustrated a holy book, the themes were secular; *Les Très Riches Heures* is an example of the melding of religious and secular concerns in Northern Europe that found its richest expression in Flemish art.

FLANDERS Johan Huizinga, the modern cultural historian, wrote, "All [Flemish] life was saturated with religion to such an extent that the people were in constant danger of losing sight of the distinction between things spiritual and things temporal."[2] In painting, this distinction was a particularly narrow one, as artists filled their compositions with objects that had symbolic significance—just as van Eyck had done in his portrait *Giovanni Arnolfini and His Wife*. Chances are that museumgoers today might not be able to decipher all of the meaning behind ordinary objects in Flemish paintings. Yet they can enjoy the warm feeling of being invited into someone's home and be all the more enriched knowing that there is something more there than meets the eye.

The overwhelming realism of Flemish religious painting results from several factors: the situating of religious narratives in commonplace, secular environments; detailed portrait likenesses and the use of real models for the faces of religious figures; the expression of human emotion; and the illusionistic rendering of textures and surfaces. The finely wrought detail in Flemish paintings was made possible by the development of oil painting, which allowed for controlled, meticulous brushwork and brilliant, enamel-like colors.

Robert Campin, the Master of Flémalle The character of Flemish painting—including its pervasive use of symbolism—is well represented in the Mérode altarpiece (**Fig. 12.4**) by Robert Campin, also known as the Master of Flémalle (ca. 1378–1444). The central panel of the three-panel altarpiece (called a triptych) features the subject of the Annunciation. The archangel Gabriel has just alighted, bringing the news to the Virgin Mary that she will bear a son. His wings are still aflutter, and Mary is not yet aware of his presence. She sits by the fireplace of her comfortable, well-appointed home, reading the Bible. The objects in the room are all typical of what might be found in a Flemish household, but they are also chosen for their symbolic references. A sprig of lilies signifies purity, as do the gleaming copper

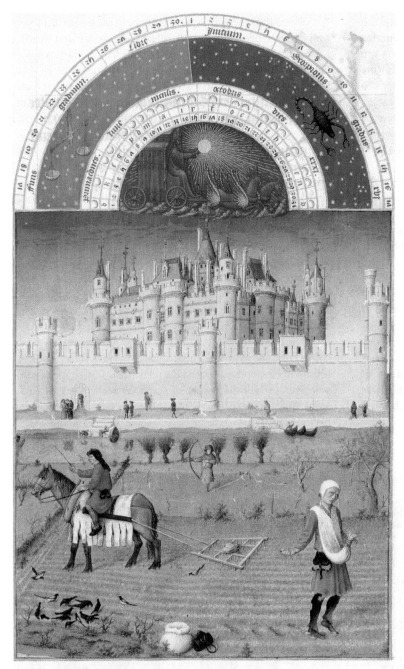

▲ **12.3** Limbourg brothers (Pol, Herman, and Jean), *October*, from *Les Très Riches Heures du Duc de Berry*, 1413–1416. Colors from minerals, plants, or chemicals and ink on vellum, 8⅞" × 5⅛" (22 × 14 cm). Musée Condé, Chantilly, France. Books of hours were prayer books with liturgical passages that were to be recited at certain times of the day. The exquisite paintings in this book illustrate scenes and tasks connected with months of the calendar year, along with their astrological signs.

a few steps to the river's edge to do the laundry. The detail seems all the more extraordinary when we see that the dimensions of the painting are just under nine-by-six inches. Each of the calendar pages features a rectangular painted scene of this sort, on top of which is a semicircular *lunette* with Zodiac

2. Johan Huizinga, *The Waning of the Middle Ages* (London: Edward Arnold and Company, 1924; Berlin: Benediction Books, 2010), p. 140. Citation refers to Benediction Books edition.

kettle in a niche on the back wall, the screened window, and the crisp white linen towels. To the left, a narrower panel contains full-length portraits of the donors of the altarpiece, who are seen kneeling in a garden outside the Virgin's home; the tiny plants and flowers are specifically associated with Mary. To the right of the Annunciation is Saint Joseph in his carpenter's workshop. Jesus's earthly father is building two mousetraps with woodworking tools authentic to the era, ordinary objects symbolizing Christ as the bait with which the devil would be trapped.

The symbolism in the altarpiece is a fascinating web for the observer to untangle and interpret, yet it does not overpower the down-to-earth realism. Flemish religious painting is accessible to the worshipper precisely because the characters can be seen as ordinary people who found themselves in extraordinary circumstances.

Jan van Eyck The painter of the Arnolfini portrait enjoyed a fame unsurpassed in his time and place. Van Eyck worked in the court of Philip the Good, Duke of Burgundy, and received important commissions from wealthy patrons for religious paintings and portraits. The Ghent altarpiece (**Fig. 12.5**) is one of the largest and most spectacular religious paintings of the 15th century in Northern Europe, a **polyptych** that was some 12 feet tall and had multiple panels, some of which could be closed over others.

When the Ghent altarpiece is open, 12 panels are displayed. In the center, presiding overall, is Jesus, enthroned and wearing a papal tiara. To his right is his mother, the Virgin Mary, resplendent in her crown that honors her as the Queen of Heaven. Saint John the Baptist, in a green cloak, sits at Jesus's left hand; his death was seen as a prefiguration of the sacrifice of Jesus. Below these three figures is a scene that represents the salvation of humankind through Jesus's sacrifice and its ongoing commemoration during the sacrifice of the Holy Mass. Crowds of figures representing the apostles, saints, martyrs, prophets, and others converge on a small altar on which a lamb is standing; a chalice—a golden cup—collects the blood that flows from its chest. The lamb symbolizes Jesus Christ (the Lamb of God), and the chalice filling with blood alludes to the wine that is shared in memory of the blood of Jesus—blood that was spilled to fulfill the promise of the salvation of the world. The figures of Adam and Eve on the outermost upper panels remind worshippers of the original sin that necessitated Jesus's sacrifice and also assure them that sinners, however grave their transgressions, can be forgiven.

The extraordinary detail, textural contrasts, and jewel-like colors combine to create a luxurious, glowing surface. Van Eyck represents the epitome of the Flemish artist. With him, Flemish painting reached the height of symbolic realism in both religious and secular subject matter. No one ever quite followed in his footsteps.

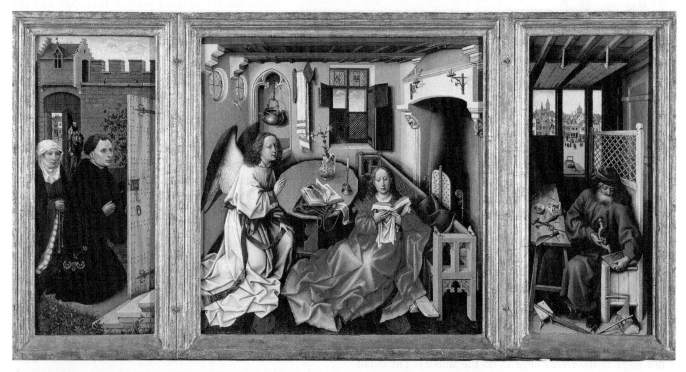

▲ **12.4** Robert Campin (Master of Flémalle), Mérode altarpiece (open), ca. 1428. Oil on wood, center panel 25⅜" × 24⅞" (64.5 × 63.2 cm), each wing 25⅜" × 10⅞" (64.5 × 27.6 cm). Metropolitan Museum of Art (The Cloisters Collection), New York, New York. The realistic detail of the scenes in the altarpiece tells us a great deal about the character of the Flemish home in the early 15th century. The interior is arrayed with objects that have symbolic meaning.

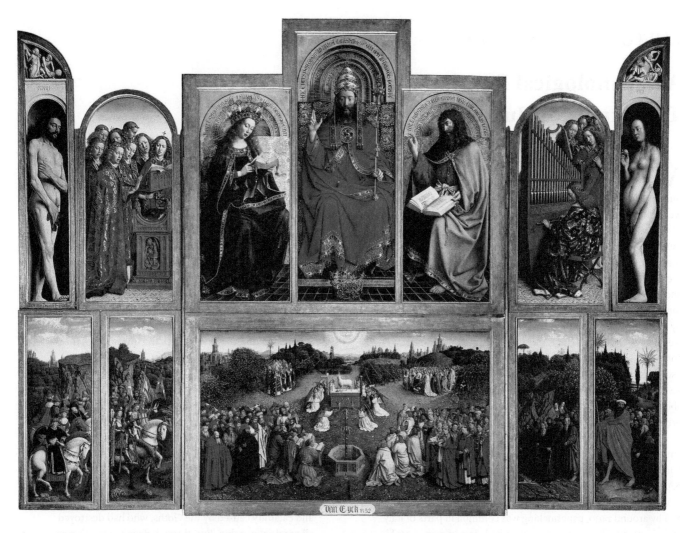

▲ **12.5 Jan van Eyck, Ghent altarpiece, completed 1432. Oil on wood, open, 11' 5" × 15' 1" (347 × 460 cm). Saint Bravo Cathedral, Ghent, Belgium.** The theme of salvation is the subject of van Eyck's brilliantly conceived and meticulously rendered painting. The figures of Adam and Eve are reminders of the original sin that set into motion the events leading to Christ's sacrifice and resurrection.

Florence and the Renaissance

At the beginning of the 15th century, Florence had every reason to be a proud city. It stood on the main road connecting Rome with the North. Its language—known at the time as the Tuscan dialect or the Tuscan idiom—was the strongest and most developed of the Italian dialects; its linguistic power had been demonstrated more than a century earlier by Dante Alighieri and his literary successors, Petrarch and Boccaccio. The 12 great *arti* (trade guilds) of Florence were commercially important for the city; in addition, representatives of the seven senior **guilds** formed the body of magistrates that ruled the city from the fortresslike town hall, the Palazzo della Signoria. This "representative" government, limited though it was to the prosperous guilds, preserved Florence from the rise of the city tyrants who plagued so many other Italian cities.

Florence had been one of the centers of the wool trade since the Late Middle Ages. In the 15th century, it was also the center of the European banking system. In fact, our modern banks (the word *bank* is from the Italian *banco*, which means "counter" or "table"—the place where money is exchanged) and their systems of handling money are based largely on practices developed by the Florentines. They devised advanced accounting methods, letters of credit, and a system of checks; they were the first to emphasize the importance of a stable monetary system. The gold florin minted in Florence was the standard coin in European commerce for centuries.

Great Florentine banking families made and lost fortunes in trading and banking. These families—the Strozzi, Bardi, Tornabuoni, Pazzi, and Medici—were justly famous in their own time. They, in turn, were justly proud of their wealth and their city. A visitor to Florence today walks on streets

CULTURE AND SOCIETY

A Technological Revolution:
The Export of Humanist Learning

When Johannes Gutenberg published the first Bible in 1455 in Mainz, Germany, the event marked a revolution in human communication. It is worthwhile to recall the effort that went into that enterprise. Gutenberg produced about 145 copies of the Latin Vulgate Bible on paper and another 35 copies on much more expensive **vellum** made from animal skin. Not all the work was done in his workshop, however. Gutenberg printed the pages—42 lines of type on each—while a second workshop added color and illuminations (**Fig. 12.6**), and a third handled the binding. Gutenberg's Bibles appeared in two volumes and, by modern standards, were massive. Those printed on paper weigh about 30 pounds, and those on vellum or parchment some 20 pounds more. Those Bibles were not meant for private use (except by nobility) but rather were "pulpit Bibles" meant to be read from a lectern during church services or in monasteries, abbeys, and refectories. Only about 48 complete copies of the original printing have survived.

Gutenberg's invention of moveable type coincided with the emerging technology of papermaking. Muslims had acquired knowledge of the craft from their contacts with China, where paper had been invented. The first European paper mill was founded in the early 12th century near Valencia in Moorish Spain, and by around 1400, papermaking was common in parts of Italy and Germany. The invention of paper had already made possible woodblock prints, but it was Gutenberg who married type and paper, setting the stage for what would become the widespread dissemination of printed materials. Books, pamphlets, and broadsheets were available and affordable; literacy would no longer be the exclusive privilege of the wealthy and learned. Historians have estimated that before 1500, European presses produced between 6 and 9 million books in 13,000 different editions. Nearly 50,000 survive in libraries throughout the world.

Whereas Gutenberg launched his publishing business with the printed Bible, Aldus Manutius (Aldo Manuzio, 1449–1515), in Venice, focused all of his energies on disseminating the work of Classical authors. Recognizing the need for competent and reliable editions of these works, he employed "professional humanists" to collate and correct manuscripts. Erasmus, the most renowned of the Northern European humanists, was, for a time, in his employ.

A humanist scholar himself, Manutius (and later, his son) published, in about 20 years, the complete works of Aristotle and works by Plato, Pindar, Herodotus, Sophocles, Aristophanes, Xenophon, and Demosthenes. He reissued the Latin classics in more readable editions and also published writers like Dante and Petrarch as well as contemporary poets.

This conjunction of pride in humanist learning and technology of printing had profound consequences for European cultures. It permitted the wide diffusion of ideas to large numbers of people in a relatively short time. Writing on this very thing in France in the first half of the 16th century, François Rabelais (ca. 1494–ca. 1553), a former monk, extolled the virtues of humanist education in books and pamphlets published over the span of three decades. In an excerpt from his novel about a giant, Gargantua, and his son, Rabelais takes a swipe at dogmatic, "unenlightened" theologians of what he calls the "dark" Middle Ages and lauds the democratization of learning with the invention of the printing press:

Even though my late father Grandgousier, of blessed memory, strove with all his ability that I should profit from and learn political knowledge, and even though my labors and studies matched or even surpassed his desires, nevertheless, as you can well understand, the times were not fit or favorable for learning as is the present; and I did not have the abundance of such instructors as you have had. The times were still dark, and reflected the misery and calamity caused by the Goths, who had destroyed all good scholarship. But, through divine grace, during my life light and dignity have been restored to learning; and we witness in them so much improvement that now I would have trouble being accepted into a children's beginning class, I who in my maturity was reputed (and not wrongly) the most learned man of he time. I do not say this out of vain boasting—even though I could properly do so in writing to you as you may understand by the authority of Marcus Tulius Cicero in his book *Old Age*, and the teachings of Plutarch in his book titled *How to Praise Oneself Honorably*—but to inspire in you the desire to strive for the highest achievements.

Now all the disciplines have been restored, languages revived: Greek, without which it is shameful for a person to call himself learned: Hebrew, Chaldean, and Latin. Elegant and correct printed editions are available, the result of a divinely inspired invention of my time, as are in contrast guns—the product of diabolical suggestion. The world is full of learned men, fine

From *Gargantua and Pantagruel*, Book 2, chapter 7 (1532).

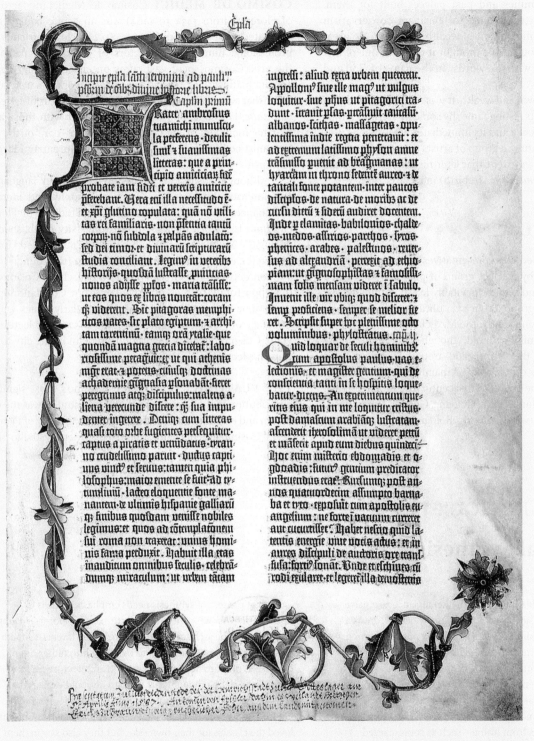

teachers, ample libraries; and it is my opinion that neither in the time of Plato, nor of Cicero…were there such opportunities for study as we see today; and no one should now go out in public who has not been well polished in Minerva's workshop. I see the robbers, hangmen, freebooters and grooms of today more learned than the theologians and preachers of my day. What can I say? Even women and girls aspire to the honor and celestial manna of good learning. Things have changed so much that at my advanced age I have had to learn Greek, which I had not rejected like Cato, but which I had not the leisure to learn in my youth; and I delight in reading the *Morals of Plutarch*, the beautiful *Dialogues of Plato*…as I await the hour at which it may please God, my Creator, to summon and order me to leave this world.

named for these families and past palaces built for them. They combined a steady sense of business conservatism with an adventuresome pursuit of wealth and fame. No great Florentine banker would have thought it odd that one of this group began his will with the words "In the name of God and profit. Amen."

For all their renown and wealth, it was not the bankers who really gave Florence its lasting fame. By some mysterious stroke of good fortune, Florence and its immediate surroundings produced, in the 15th century, a group of artists who revolutionized Western art to such an extent that later historians refer to the period as a time of *renaissance* (rebirth) in the arts.

The Medici Era

Florence was governed by representatives of the major trade guilds. This control by a select group of people who wielded commercial power and wealth inevitably led to domination by the wealthiest of the group. From 1434 until 1492, Florence was under the control of one family: the Medici.

The Medici family had old, though until then undistinguished, roots in the countryside around Florence. Their prosperity in the 15th century rested mainly on their immense banking fortune. By the middle of that century, there were Medici branch banks in London, Naples, Cologne, Geneva, Lyons, Basel, Avignon, Bruges, Antwerp, Lübeck, Bologna, Rome, Pisa, and Venice.

COSIMO DE' MEDICI Cosimo de' Medici (de facto ruler of Florence from 1434 to 1464) was an astute banker and a cultivated man of letters (**Fig. 12.7**). His closest friends were professional humanists, collectors of books, and patrons of the arts. Cosimo spent vast sums on collecting and copying ancient manuscripts. He had his copyists work in a neat cursive hand that would later be the model for the form of letters we call *italic*. His collection of books (together with those added by later members of his family) formed the core of the great humanist collection housed today in the Laurentian Library in Florence.

Although Cosimo never mastered the Greek language, he was intensely interested in Greek philosophy and literature. He financed the chair of Greek at the Studium of Florence (*studium* is a word for a for-profit university established first during the Middle Ages). When Greek prelates visited Florence during the ecumenical council held in 1439 (the council sought a union between the Greek and Latin churches), Cosimo took the opportunity to seek out scholars from Constantinople in the retinue of the prelates. He was particularly struck with the brilliance of Gemistos Plethon (c. 1355–1452), who lectured on Plato. Cosimo persuaded Plethon to remain in the city to continue his lectures.

THE PLATONIC ACADEMY Cosimo's most significant contribution to the advancement of Greek studies was the foundation and endowment of an academy for the study of Plato. For years, Cosimo and his heirs supported a priest, Marsilio Ficino,

CULTURE AND SOCIETY

Intellectual Synthesis

It would be a bit misleading to see the Renaissance as a naïve recovery of the Classical past. What actually occurred was a desire for *synthesis*, which is to say, a recovery of the inherited past of Greece and Rome in order to use that recovery for the needs and aspirations of the time. The first step in this synthesis required a study of the past. It is worthwhile noting how extensive that study was. It ranged from the careful observation and measurement of ancient buildings to the close study of archaeological remains from Rome—such as coins, carved gems, and sculpture—to the humanistic work of editing texts, translating them, and providing aids such as dictionaries that would permit this work to continue. The synthesis came when people took what they had recovered from the past (a process called in French *ressourcement*, "going back to the sources") and transformed it to meet the needs of their contemporary situation.

That process of synthesis needs emphasis if one is to understand what happened in, say, 15th-century Florence. Filippo Brunelleschi, the architect of the dome of the Florence Cathedral, did not study Rome's Pantheon to rebuild it but, rather, as an exercise in order to better create church architecture. Ficino loved Plato, but he thought that in Plato he could explain the Christian faith better than the scholars of an earlier period could. The authors Niccolò Machiavelli and Desiderius Erasmus loved the classics for their own sake, but they also saw in them pragmatic clues that would help in understanding contemporary problems, ranging from how politics ought to be ordered to how church reform might be effected.

If one is to understand the Renaissance, it is crucial to see that the Classical past was not merely ancient history but a source for new and innovative ideas and concepts that addressed real and pertinent issues.

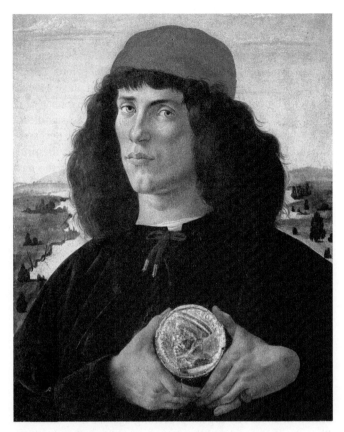

▲ **12.7** Sandro Botticelli, *Portrait of a Young Man with a Medallion of Cosimo I de'Medici ("The Elder")* Tempera on panel, 57 × 44 cms, Galleria degli Uffizi, Florence, Italy.

in order to allow him to translate and comment on the works of Plato. In the course of his long life (he died in 1499), Ficino translated into Latin all of Plato, Plotinus, and other Platonic thinkers. He wrote his own compendium of Platonism called the *Theologia Platonica*. These translations and commentaries had an immense influence on art and intellectual life in Italy and beyond the Alps.

Cosimo often joined his friends at a suburban villa to discuss Plato under the tutelage of Ficino. This elite group embraced Plato's ideas of striving for the ideal good and persistently searching for truth and beauty. This idealism became an important strain in Florentine culture. Ficino managed to combine his study of Plato with his own understanding of Christianity. He coined the term *platonic love* for the spiritual bond between two people who were joined together in the contemplative search for the true, the good, and the beautiful. Cosimo, a pious man in his own right, found great consolation in this Christian Platonism of Ficino. "Come and join me as soon as you possibly can and be sure to bring with you Plato's treatise *On the Sovereign Good*," Cosimo once wrote his protégé: "There is no pursuit to which I would devote myself more zealously than the pursuit of truth. Come then and bring with you the lyre of Orpheus."

A fiercely patriotic Florentine known to his contemporaries as Pater Patriae (Father of the Fatherland), Cosimo lavished his funds on art projects to enhance the beauty of the city, at the same time glorifying his family name and atoning for his sins—especially usury (taking interest on money)—by acts of generous charity. He befriended and supported many artists. He was an intimate friend and financial supporter of the greatest Florentine sculptor of the first half of the 15th century, Donato di Niccolò di Betto Bardi (1386–1466), known as Donatello.

Cosimo's last years were racked with chronic illness and depression brought on by the premature deaths of his son Giovanni and a favorite grandson, as well as the physical illnesses of another son, Piero. Toward the end of his life, Cosimo's wife once found him in his study with his eyes closed. She asked him why he sat in that fashion. "To get them accustomed to it," he replied. Cosimo de' Medici died on August 1, 1464.

Cosimo's position as head of the family and as first citizen of the city was assumed by his son Piero, called "the Gouty" in reference to the affliction of gout from which he suffered all his life. Piero's control over the city lasted only five years. It was a time beset by much political turmoil but continued artistic activity. Piero continued his father's patronage of the sculptor Donatello and the humanist philosopher Marsilio Ficino, who was at work on a translation of Plato's works into Latin. Piero also generously supported religious and civic architectural projects in Florence. He died in 1469. His two sons, Lorenzo and Giuliano, succeeded their father as corulers of Florence.

THE PAZZI CONSPIRACY On April 26, 1478, during High Mass at the Cathedral of Florence, Francesco de' Pazzi and Bernardo Bandi attacked Giuliano and Lorenzo de' Medici in front of 10,000 people. Giuliano was killed, and Lorenzo managed to escape with a stab wound. The Pazzi family, longtime rivals of the Medici, had designs on replacing them as the rulers of Florence—a coup supported by Pope Sixtus IV in Rome. With Lorenzo alive, their efforts failed; the murderers, Pazzi family coconspirators, and others who were complicit were executed. The mantle of power thus settled on the shoulders of Lorenzo, who accepted the responsibility with pragmatic resignation, saying, "It bodes ill for any wealthy man in Florence who doesn't control political power."

CONNECTIONS A commemorative medal bearing the profile of Cosimo de' Medici, along with his name and the letters PPP (symbolizing "Pater Patriae"), was minted after his death and was possibly designed by Donatello. Botticelli built a portrait of an unknown sitter around a life-sized, gilded reproduction of this medal around 1475, which would have been the tenth anniversary of Cosimo's death.

▲ **12.8** Cosimo de'Medici Medal (ca. 1480–1500), bronze, made in Florence, Italy. Victoria & Albert Museum, London.

Lorenzo de' Medici ("The Magnificent")

Lorenzo il Magnifico ("the Magnificent") ruled Florence until his death in 1492. His accomplishments were so many and varied that the last half of the 15th century in Florence is often called the Laurentian Era.

Lorenzo continued the family tradition of art patronage by supporting various projects and by adding to the Medici collection of ancient gems, other antiquities, and books. He was also more directly involved in the arts. Lorenzo was an accomplished poet, but his reputation as a political and social leader has made us forget that he was an important contributor to the development of vernacular Italian poetry. He continued the sonnet tradition begun by Petrarch. One of his most ambitious projects—done in conscious imitation of Dante's *La vita nuova*—was a long work that alternated his own sonnets with extended prose commentaries. This was the *Commento ad alcuni sonetti d'amore* (*Commentary on Some Love Sonnets*, begun ca. 1476–1477). In addition to this ambitious work, Lorenzo wrote hunting songs, poems for the carnival season, religious poetry, and occasional burlesque poems with a cheerfully bawdy tone.

The poem for which Lorenzo is best known is "The Song of Bacchus." Written in 1490, its opening stanzas echo the old Roman dictum of living for the present because life is short and the future is uncertain:

READING 12.1 LORENZO DE' MEDICI

"The Song of Bacchus"

Youth is sweet and well
But doth speed away!
Let who will be gay,
To-morrow, none can tell.
 Bacchus and his Fair,
Contented with their fate,
Chase both time and care,
Loving soon and late;
High and low estate
With the nymphs at play;
Let who will be gay,
To-morrow, none can tell.
 Laughing satyres all
Set a hundred snares,
Lovelorn dryads fall
In them unawares:
Glad with wine, in pairs
They dance the hours away:
Let who will be gay,
To-morrow, none can tell.

Lorenzo's interests in learning ran deep. He had been tutored as a youth by Ficino, and as an adult continued the habit of spending evenings with an elite group of friends (including Ficino). He often took with him his friend, the painter Sandro Botticelli, and a young sculptor who worked in a Medici-sponsored sculpture garden, Michelangelo Buonarroti.

The Laurentian patronage of learning was significant and widespread. Lorenzo contributed the funds necessary to rebuild the University of Pisa and designated it the principal university of Tuscany (Galileo taught there in the next century). He continued to underwrite the study of Greek at the Studium of Florence. The Greek faculty at Florence attracted students from all over Europe. This center was a principal means by which Greek learning was exported to the rest of Europe.

Girolamo Savonarola

The notion that the Renaissance spirit marked a clean break with the Middle Ages must take into account the life and career of the Dominican preacher and reformer Fra Girolamo Savonarola (1452–1498). Savonarola lived at the Convent of San Marco in Florence from 1490 until his execution in 1498. His urgent preaching against the vanities of Florence in general and the degeneracy of its art and culture in particular had an electric effect on the populace. His influence was not limited to the credulous masses or workers in the city. Lorenzo called him to his own deathbed in 1492 to administer the last sacraments, even though Savonarola had been a bitter and open enemy of Medici control over the city. Savonarola, in fact, wanted a restored republic with a strong ethical and theocratic base. Giovanni Pico della Mirandola (1463–1494), one of the most brilliant humanists of the period, turned from his polyglot studies of Greek, Hebrew, Aramaic, and Latin to a devout life under the direction of the friar; only Pico's early death prevented him from joining Savonarola as a friar at San Marco. The humanist painter Botticelli was so impressed by Savonarola that he burned some of his worldlier paintings, and scholars see in his last works a more profound religiosity derived from the contact with the reforming friar. Michelangelo, when an old man in Rome, told a friend that he could still hear the words of Savonarola ringing in his ears.

Savonarola's hold over the Florentine political order (for a brief time, he was the de facto ruler of the city) ended in 1498 when he defied papal excommunication and was then strangled and burned in the public square before the Palazzo della Signoria (**Fig. 12.9**). By that time, Lorenzo had been dead for six years, and the Medici family had lost power in Florence. They were to return in the next century, but the golden age of Lorenzo had ended with a spasm of medieval piety. The influence of the city and its ideals had, however, already spread far beyond its boundaries.

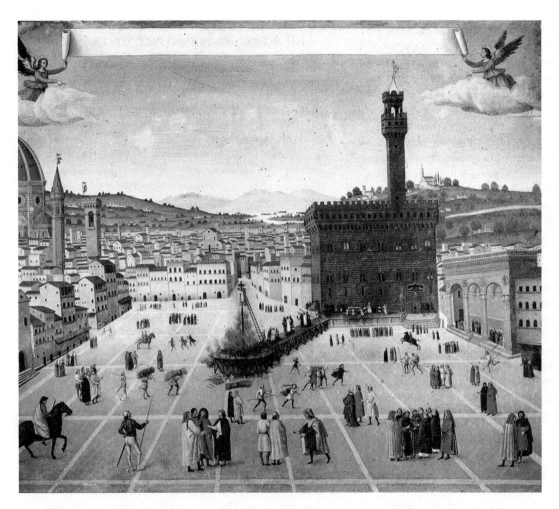

▲ 12.9 *The Execution of Savonarola*, Italian School, ca. 1498. Tempera on panel, 39¾" × 46" (101 × 117 cm). Museo di San Marco, Florence, Italy. The hanging and burning of Girolamo Savonarola in Florence's main square was painted by an anonymous artist who took great pains to record the architectural setting: the dark stone and crenelated tower of the Palazzo Vecchio, the curved arches of the Loggia dei Lanzi to its right, and, along the left edge of the painting, a sliver of the dome of the cathedral of Florence. Even though Brunelleschi's dome would not have been so visible from this specific perspective, its inclusion unmistakably identifies the location as Florence. His Duomo was synonymous with the city.

RENAISSANCE HUMANISM

Jules Michelet, a 19th-century French historian, coined the word *Renaissance* specifically to describe the cultural period of 15th-century Florence. The broad outline of this rebirth is described by the Swiss historian Jakob Burckhardt in his massive *Civilization of the Renaissance in Italy*, published in 1860, a book that remains the foundation for most discussions of the topic. Burckhardt's thesis is simple and persuasive. European culture, he argues, was reborn in the 15th century after a long dormant period that extended from the fall of the Roman Empire until the beginning of the 14th century.

The characteristics of this new birth, according to Burckhardt, were first noticeable in Italy and were the building blocks of the modern world. It was in late-14th- and 15th-century Italy that new ideas about the nature of the political order developed—of which the republican government of Florence is an example—as well as the consciousness of the artist as an individual seeking personal fame. This pursuit of glory and fame was in sharp contrast to the self-effacing and world-denying attitude of the Middle Ages. Burckhardt also saw the thirst for Classical learning, the desire to construct a humanism from that learning, and an emphasis on the good life as an intellectual repudiation of medieval religion and ethics.

Burckhardt's ideas have provoked strong reactions from historians and scholars, many of whom reject his theory as simplistic. Charles Homer Haskins, an American scholar, attacked Burckhardt's ideas in 1927 in a book whose title gives away his line of argument: *The Renaissance of the Twelfth Century*. Haskins points out that everything Burckhardt says about Florentine life in the 15th century could be said with equal justification about Paris in the 12th century. Scholars have also spoken of a Carolingian Renaissance identified with the court of Emperor Charlemagne.

But something new was happening in the intellectual and cultural life of 15th-century Italy, and contemporaries were conscious of it. "May every thoughtful spirit thank God that it has been given to him to be born in this new age, so filled with hope and promise, which already enjoys a greater array of gifted persons than the world has seen in the past thousand years,"[3]

3. Tim Carter, "Renaissance," in *The Cambridge History of Seventeenth-Century Music*, eds. Tim Carter and John Butt (Cambridge: Cambridge University Press, 2014). http://assets.cambridge.org/97805217/92738/excerpt/9780521792738_excerpt.pdf.

wrote Matteo Palmieri, a Florentine businessman, in 1436. Yet this "new age" of which Palmieri spoke did not spring up overnight. Its roots must be traced to Italy's long tradition of lay learning, the Franciscan movement of the 13th century, the relative absence of feudalism in Italy, and the long maintenance of Italian city life. In short, something new was happening precisely because Italy's long historical antecedents permitted it.

The question remains, however: what was new in the Renaissance? The Renaissance was surely more than a change in artistic taste or an advance in technological artistic skill. We need to go deeper. What motivated the shift in artistic taste? What fueled the personal energy that produced artistic innovation? What caused flocks of foreign scholars to cross the Alps to study in Florence and in other centers where they could absorb the new learning?

The answer to these questions, briefly, is this: There arose in Italy, as early as the time of Petrarch (1304–1374) but clearly in the 15th century, a strong conviction that humanist learning not only would ennoble and perfect the individual but could also serve as a powerful instrument for social and religious reform. Very few Renaissance humanists denied the need for God's grace, but all felt that human intellectual effort should be the first concern of anyone who wished truly to advance the good of self or society. The career of Pico della Mirandola, one of the most brilliant and gifted Florentine humanist scholars, exemplifies this belief.

Giovanni Pico della Mirandola

Giovanni Pico della Mirandola was an intimate friend of Lorenzo de' Medici and a companion of the Platonic scholar Marsilio Ficino. Precociously brilliant, Pico was deeply involved with the intellectual life of his day. He once bragged, not totally implausibly, that he had read every book in Italy.

Pico was convinced that all human learning could be synthesized in such a way as to yield basic and elementary truths. To demonstrate this, he set out to master all the systems of knowledge that then existed. He thoroughly mastered the Latin and Greek classics. He studied medieval Aristotelianism at the University of Paris and learned Arabic and the Islamic tradition. He was the first Christian in his day to take an active interest in Hebrew culture; he learned Hebrew and Aramaic and studied the **Talmud** with Jewish scholars. At the age of 20, Pico proposed to defend at Rome his 900 *theses* (intellectual propositions), which he claimed summed up all current learning and speculation. After Church leaders attacked some of his propositions as unorthodox, Pico left Rome and the debate was never held.

The preface to these theses, called the *Oration on the Dignity of Man* (1486), has often been cited as the first and most important document of Renaissance humanism. The following reading from the introduction to the *Oration* argues that humans stand at the apex of the world in such a way as to create the link between the world of God and that of the creation, thereby expressing the core of Renaissance humanism:

READING 12.2 GIOVANNI PICO DELLA MIRANDOLA

From *Oration on the Dignity of Man*, introduction

1. I have read in the records of the Arabians, reverend Fathers, that Abdala the Saracen, when questioned as to what on this stage of the world, as it were, could be seen most worthy of wonder, replied: "There is nothing to be seen more wonderful than man." In agreement with this opinion is the saying of Hermes Trismegistus: "A great miracle, Asclepius, is man." But when I weighed the reason for these maxims, the many grounds for the excellence of human nature reported by many men failed to satisfy me—that man is the intermediary between creatures, the intimate of the gods, the king of the lower beings, by the acuteness of his senses, by the discernment of his reason, and by the light of his intelligence the interpreter of nature, the interval between fixed eternity and fleeting time, and (as the Persians say), the bond, nay, rather, the marriage song of the world, on David's testimony but little lower than the angels. Admittedly great though these reasons be, they are not the principal grounds, that is, those which may rightfully claim for themselves the privilege of the highest admiration. For why should we not admire more the angels themselves and the blessed choirs of heaven? At last it seems to me I have come to understand why man is the most fortunate of creatures and consequently worthy of all admiration and what precisely is that rank which is his lot in the universal chain of Being— a rank to be envied not only by brutes but even by the stars and by minds beyond this world. It is a matter past faith and a wondrous one. Why should it not be? For it is on this very account that man is rightly called and judged a great miracle and a wonderful creature indeed.

Pico brings his wide learning to bear on this fundamental proposition: humanity is a great miracle. He not only calls on the traditional biblical and Classical sources but also cites, from his immense reading, the opinions of the great writers of the Jewish, Arabic, and Neo-Platonic traditions. The enthusiasm of the youthful Pico for his subject is as apparent as his desire to display his learning.

Even so, some scholars disagree on Pico's originality as a thinker and argue that his writings are a hodgepodge of knowledge without any genuine synthesis. There is no disagreement, however, about Pico's immense ability as a student of languages and culture to open new fields of study and, in that way, stimulate the enthusiasm for learning in his own day. His reputation attracted students. The most influential of these was a German named Johannes Reuchlin (1455–1522), who came to Florence to study Hebrew with Pico. After mastering that language and Greek as well, Reuchlin went back to Germany to pursue his studies and to apply them to biblical scholarship. In the early 16th century, he came under the influence of Martin Luther (see Chapter 14), but he never joined the Reformation. Reuchlin passionately defended the legitimacy of biblical studies oriented to

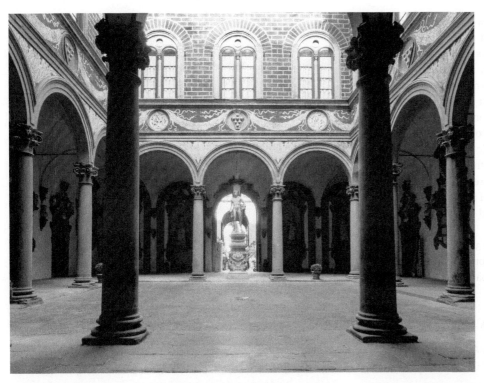

◀ **12.10** Michelozzo di Bartolommeo, Interior court of the Palazzo Medici-Riccardi (looking west), Florence, Italy, begun 1445.

were of men. Thus, it was possible for a young woman from a noble family to study Latin, philosophy, Classical literature, geometry, and other subjects previously available only to men. Slatkin notes that some women, who were educated in the humanist tradition, wound up writing spirited defenses of the intellectual capabilities of their gender. These were typically directed toward men, although the women also found themselves arguing against female peers who thought that they had gone too far in assuming the mantle of scholar or writer or artist. In addition to opportunities for formal study, noblewomen had access to texts (as did literate men), made possible by the invention of the printing press and moveable type. Still, literacy was far from universal, and humanist writings by women uniformly reflect an upper-class culture.

Anthologies of texts by women humanists in Italy demonstrate that most came from the more illustrious families of the time. Ippolita Maria Sforza (1446–1484) was educated in the palace school established by her father, the Duke of Milan. As a teenager, she delivered an oration before the Renaissance humanist Pope Pius II. When she married Duke Alfonso of Calabria, son of the king of Sicily, her trousseau included 12 books, among them works by Cicero; and we are told that on the journey from her native Milan to her husband's home in Sicily, she stopped to buy manuscripts.

Isotta Nogarola (1418–1466) became one of the most renowned Renaissance humanists of her day and, through her example, inspired other female writers, poets, and artists. Her most famous work is a performance piece framed around a dialogue between the characters Isotta and Ludovico on the relative guilt of Adam and Eve for original sin. Nogarola's intellectual argument springs from the basic tenet that Adam and Eve were equals; both possessed the essential goodness of human nature, and both acted out of free will. Nogarola, who was educated in Greek and Latin, also wrote an oration on Saint Jerome, one of the doctors of the church, whose own writings on Christianity were grounded in Classical literature. Nogarola secured her place in the male-dominated humanist circle before influential Renaissance authors of the 16th century began to sing the praises of female potential.

the original languages. When his approach was attacked in one of those periodic outbursts of anti-Semitism so characteristic of European culture of the time, Reuchlin, true to his humanist impulses, not only defended his studies as a true instrument of religious reform but also made an impassioned plea for toleration that was *not* characteristic of the time.

Women and the Renaissance in the 15th Century

As Europe engaged in its transition from feudalism to capitalism, the roles of women—noblewomen, in particular—changed, but not necessarily for the better. Joan Kelly-Gadol, in her essay "Did Women Have a Renaissance?," concludes that "all the advances of Renaissance Italy, its proto-capitalist economy, its states, and its humanistic culture, worked to mold the noblewoman into an aesthetic object; decorous, chaste, and doubly dependent—on her husband as well as the prince."[4] Art historian Wendy Slatkin notes that the design of the Renaissance palazzo—a splendid building such as a palace or a museum—its interior courtyard closed off from the life of the city (see **Fig. 12.10**), separated the public from the private sphere and confined women within the nuclear family.

Humanism in the 15th century, however, brought with it an emphasis on knowledge and formal education, maintaining that these should be the privilege of women as much as they

LAURA CERETA Laura Cereta (1469–1499), whose writings we see in Readings 12.3, 12.4, and 12.5, was born in Brescia,

4. Joan Kelly-Gadol, "Did Women Have a Renaissance?," in *Feminism and Art History*, eds. Norma Bruda and Mary D. Garrard (New York: Harper & Row, 1982).

Italy, the oldest of six children, and was sent to a convent at the age of seven—the best place for a young girl to begin her education. At the age of nine, she was brought back home to help care for her siblings; her father, an attorney and judge, taught her Greek and Latin. As a determined humanist, Cereta maintained a scholarly lifestyle against a tide of criticism both from men who were her peers and from women. Out of those struggles came many letters penned to answer critics, including a defense of learning aimed at male humanists ("All human beings, women included, are born with the right to an education") and a defense of her vocation directed toward her female critics. She also fostered the concept of a community of women intended for scholarship and critiqued housework as a barrier to women's intellectual development.

In the letter we find in Reading 12.3, Cereta not only assails men who would criticize her lifestyle but also upbraids women who pride themselves on playing the pampered siren:

READING 12.3 LAURA CERETA

From Letter to Bibulus Sempronius: A Defense of the Liberal Education of Women

My ears are wearied by your carping. You brashly and publicly not merely wonder but indeed lament that I am said to possess as fine a mind as nature ever bestowed upon the most learned man. You seem to think that so learned a woman has scarcely before been seen in the world. You are wrong on both counts, Sempronius, and have clearly strayed from the path of truth and disseminate falsehood. I agree that you should be grieved, indeed, you should be ashamed, for you have ceased to be a living man, but have become an animated stone; having rejected the studies which make men wise, you rot in torpid leisure. Not nature but your own soul has betrayed you, deserting virtue for the easy path of sin.

...

Only the question of the rarity of outstanding women remains to be addressed. The explanation is clear: women have been able by nature to be exceptional, but have chosen lesser goals. For some women are concerned with parting their hair correctly, adorning themselves with lovely dresses, or decorating their fingers with pearls and other gems. Others delight in mouthing carefully composed phrases, indulging in dancing, or managing spoiled puppies. Still others wish to gaze at lavish banquet tables, to rest in sleep, or, standing at mirrors, to smear their lovely faces. But those in whom a deeper integrity yearns for virtue, restrain from the start their youthful souls, reflect on higher things, harden the body with sobriety and trials, and curb their tongues, open their ears, compose their thoughts in wakeful hours, their minds in contemplation, to letters bonded to righteousness. For knowledge is not given as a gift, but [is gained] with diligence. The free mind, not shirking effort, always soars zealously toward the good, and the desire to know grows ever more wide and deep. It is because of no special holiness, therefore, that we [women] are rewarded

by God the Giver with the gift of exceptional talent. Nature has generously lavished its gifts upon all people, opening to all the doors of choice through which reason sends envoys to the will, from which they learn and convey its desires. The will must choose to exercise the gift of reason.

In a letter to Lucilia Vernacula (Reading 12.4)—a recipient who may well be fictitious, as *vernacula* can be translated as "hussy" or "common slave"—Cereta roundly criticizes women who attacked her learning and scholarly lifestyle:

READING 12.4 LAURA CERETA

From Letter to Lucilia Vernacula: Against Women Who Disparage Learned Women

I thought their tongues should have been fine-sliced and their hearts hacked to pieces—those men whose perverted minds and inconceivable hostility [fueled by] vulgar envy so flamed that they deny, stupidly ranting, that women are able to attain eloquence in Latin. [But] I might have forgiven those pathetic men, doomed to rascality, whose patent insanity I lash with unleashed tongue. But I cannot bear the babbling and chattering women, glowing with drunkenness and wine, whose impudent words harm not only our sex but even more themselves. Empty-headed, they put their heads together and draw lots from a stockpot to elect each other [number one]; but any women who excel they seek out and destroy with the venom of their envy. A wanton and bold plea indeed for ill-fortune and unkindness! Breathing viciousness, while she strives to besmirch her better, she befouls herself; for she who does not yearn to be sinless desires [in effect] license to sin. Thus these women, lazy with sloth and insouciance, abandon themselves to an unnatural vigilance; like scarecrows hung in gardens to ward off birds, they tackle all those who come into range with a poisonous tongue. Why should it behoove me to find this barking, snorting pack of provocateurs worthy of my forbearance, when important and distinguished gentlewomen always esteem and honor me? I shall not allow the base sallies of arrogance to pass, absolved by silence, lest my silence be taken for approval or lest women leading this shameful life attract to their licentiousness crowds of fellow-sinners. Nor should anyone fault me for impatience, since even dogs are permitted to claw at pesty flies.

Cereta married Pietro Serina when she was 15, but he died within 18 months, apparently from plague. She wrote of his passing, as we see in Reading 12.5, and in this prose, a more sensitive and pained side of the writer emerges. We also see that the concept of moral awareness—the knowledge of a self that requires us to take responsibility for our thoughts and actions—is a theme in her letters. The following is a prose poem:

READING 12.5 LAURA CERETA

On the death of her husband

We have soiled our grieving faces enough. Enough has the sickness of a grieving heart afflicted this mournful life. And although no one can escape the ineluctable law of death; although she, the avenger, strikes down even the Gods; and although all things grow old and die, nonetheless it is not wrong to mourn the things we love, nor does the reason for mourning easily leave the heart.

I know: he had lived on the brink of dying, for death—the end of nature—unmakes all things. We are all dust and shadow, but the days of men are unlike one another; unlike are their misfortunes, and unlike their ends. While I have lived, my prayers have come to naught. This life will ever be the nurse of my misery, I believe. But let the injury, forgotten for a short while, be restored to its place in history—the injury which, because of one man's death, has cruelly and unjustly pried up, lacerated, and dismembered my life, once quiet as though selected in safety.

Surely my husband's spirit now lies among the shades; and now unspeakable marble kisses his limbs. Now that ashy dust sighs in my ears, now one cave awaits me who lives among the living. For the dead, this life is a dream, whose course hangs over all humans like a brief watch in the night. And so, if I thought that it was completely unclear how the events of my life would proceed and in what order, and if you cared about these things, I would describe them more fully and at greater length—if my mind should ever become conscious of itself.

A couple of years after Serina's death, Cereta is said to have embarked on a teaching career of seven years at the University of Prada, but records on the issue are unclear. She died, of unknown causes, at the age of 30.

Humanism in Italy and the North: Two Sides of a Single Coin

In the generation after the death of Lorenzo de' Medici, humanism spread from Italy into Northern Europe, where its principles were applied to Christian belief and became part of the discourse of church reform. At the same time, it remained a core philosophy with regard to secular matters in Italy. The distinctions between the applications of humanist thought in Italy and in Northern Europe are embodied in the writings of Niccolò Machiavelli and Desiderius Erasmus.

NICCOLÒ MACHIAVELLI After Lorenzo de' Medici died, his son Piero—called Piero the Unfortunate—took over as the de facto ruler of Florence, but with none of his father's political gifts and alliances. The Medici family lost control of the city in 1494. During their absence, Niccolò Machiavelli (1469–

1527)—humanist, philosopher, and founder of modern political science—was employed as a civil servant for the Florentine Republic, rising to the position of secretary of war. When the Medici came back to power in 1512, Machiavelli was banished from Florence and its politics. It was then that he wrote his famed treatise on politics titled *The Prince* (1513), dedicated first to Giuliano de' Medici (who ruled Florence from 1512–1518) and then, after Giuliano's premature death, to his nephew and successor Lorenzo de' Medici—an attempt to get back into the good graces of the ruling family. It is not clear whether any member of the Medici family ever read the treatise.

The Prince is often considered the first purely secular study of political theory in the West. Machiavelli's inspiration was the government of Republican Rome; he believed that the church's role in politics destroyed the power of the state to govern. For that reason, Machiavelli asserts, the state must restrict the power of the church, allowing it to exercise its office only in the spiritual realm. The prince, as ruler of the state, must understand that the key to success in governing is in the exercise of power. Power is to be used with wisdom and ruthlessness. The prince, in a favorite illustration of Machiavelli, must be as sly as the fox and as brutal as the lion.

Above all, says Machiavelli, the prince must not be deterred from his tasks by any consideration of morality beyond that of power and its ends (see Reading 12.6). In this sense, cruelty or hypocrisy is permissible; judicious cruelty consolidates power and discourages revolution. Senseless cruelty is, however, counterproductive. Note Machiavelli's views on whether it is better for the prince to be loved or feared (see Reading 12.7).

READING 12.6 NICCOLÒ MACHIAVELLI

From *The Prince*, chapter 18, "Concerning the Way in Which Princes Should Keep Faith"

Every one admits how praiseworthy it is in a prince to keep faith, and to live with integrity and not with craft. Nevertheless our experience has been that those princes who have done great things have held good faith of little account, and have known how to circumvent the intellect of men by craft, and in the end have overcome those who have relied on their word. You must know there are two ways of contesting, the one by the law, the other by force; the first method is proper to men, the second to beasts; but because the first is frequently not sufficient, it is necessary to have recourse to the second. Therefore it is necessary for a prince to understand how to avail himself of the beast and the man.

. . .

A prince, therefore, being compelled knowingly to adopt the beast, ought to choose the fox and the lion; because the lion cannot defend himself against snares and the fox cannot defend himself against wolves. Therefore, it is necessary to be a fox to discover the snares and a lion to terrify the wolves. Those who rely simply on the lion do not understand what they are about. Therefore a wise lord cannot, nor ought he

to, keep faith when such observance may be turned against him, and when the reasons that caused him to pledge it exist no longer. If men were entirely good this precept would not hold, but because they are bad, and will not keep faith with you, you too are not bound to observe it with them. Nor will there ever be wanting to a prince legitimate reasons to excuse this nonobservance. Of this endless modern examples could be given, showing how many treaties and engagements have been made void and of no effect through the faithlessness of princes; and he who has known best how to employ the fox has succeeded best.

But it is necessary to know well how to disguise this characteristic, and to be a great pretender and dissembler; and men are so simple, and so subject to present necessities, that he who seeks to deceive will always find someone who will allow himself to be deceived.

READING 12.7 NICCOLÒ MACHIAVELLI

Concerning Cruelty and Clemency, and Whether It Is Better To Be Loved Than Feared

Upon this a question arises: whether it be better to be loved than feared or feared than loved? It may be answered that one should wish to be both, but, because it is difficult to unite them in one person, [it] is much safer to be feared than loved, when, of the two, either must be dispensed with. Because this is to be asserted in general of men, that they are ungrateful, fickle, false, cowardly, covetous, and as long as you succeed they are yours entirely; they will offer you their blood, property, life and children, as is said above, when the need is far distant; but when it approaches they turn against you.... [Men] have less scruple in offending one who is beloved than one who is feared, for love is preserved by the link of obligation which, owing to the baseness of men, is broken at every opportunity for their advantage; but fear preserves you by a dread of punishment which never fails.

Nevertheless a prince ought to inspire fear in such a way that, if he does not win love, he avoids hatred; because he can endure very well being feared whilst he is not hated, which will always be as long as he abstains from the property of his citizens and subjects and from their women.... But when a prince is with his army, and has under control a multitude of soldiers, then it is quite necessary for him to disregard the reputation of cruelty, for without it he would never hold his army united or disposed to its duties.

The basic theme of *The Prince* is the pragmatic use of power for state management of a populace that Machiavelli characterizes as selfish, shortsighted, devious, and treacherous. Previously the tradition of political theory had always invoked the transcendent authority of God to ensure the stability and legitimacy of the state. For Machiavelli, it is power, not the moral law of God, that provides the state with its ultimate

sanction. The final test of the successful ruler is a willingness to exercise power judiciously and a freedom from the constraints of moral suasion. "A wise ruler... cannot and should not keep his word when such an observance would be to his disadvantage," Machiavelli says in one of the most famous passages from his book. His justification is, "If men were all good, this precept would not be good. But since men are a wicked lot and will not keep their promises to you, you likewise need not keep yours to them." This bold pragmatism explains why the Roman Catholic Church put *The Prince* on its index of prohibited books and why the adjective *Machiavellian* means, in English, "devious or unscrupulous in political dealings." Machiavelli had such a bad reputation that many 16th-century English plays had a stock evil character—an Italian called "Old Nick." The English phrase "filled with the Old Nick," meaning "devilish," derives from Machiavelli's reputation as an immoral man. But Machiavelli's realistic pragmatism also explains why Catherine the Great of Russia and Napoléon read him with great care.

In the final analysis, however, the figure of the prince best defines a view of politics that looks to a leader who understands that power is what keeps a political person as a strong ruler. Such a leader uses a simple rule of thumb: how does one exercise power in order to retain power? Such a ruler does not appeal to eternal rules but to simple calculations: Will the exercise of power in this or that particular fashion guarantee the stability of the state? If ruthlessness or violence is needed, let there be ruthlessness or violence (or terror!). Machiavelli did not want to create a monster, and he certainly did not want violence for its own sake. He did favor, however, whatever means it took to keep the state intact and powerful. That is the deepest meaning of the adjective *Machiavellian*.

DESIDERIUS ERASMUS Desiderius Erasmus (1469–1536; Fig. 12.11) has been called the most important Christian humanist in Europe. Born in Holland, he was educated in Latin as a young boy and in his mid-20s entered a monastery to avert poverty. He was ordained a Roman Catholic priest but did not practice for any length of time. Rather, in 1495, he enrolled in the University of Paris, where he came into contact with humanist thought at the time it was entering the academy. He was further engaged with humanism during visits to England, where he met men like John Colet and Thomas More. Fired by their enthusiasm for the new learning, Erasmus traveled to Italy in 1506, where he had lengthy stays in both Rome and Venice. Thereafter he led the life of a wandering scholar, gaining immense fame as a learned thinker and author.

Erasmus's many books attempted to combine Classical learning and a simple interiorized approach to Christian living. In the *Enchiridion militis Christiani* (1502), he attempts to spell out this Christian humanism in practical terms. The title has a typical Erasmus-style pun: the word *enchiridion* can mean either "handbook" or "short sword"; thus, the title can mean the handbook or the short sword of the Christian knight. His *Greek New Testament* (1516) was the first attempt to edit the Greek text of the New Testament by a comparison of extant manuscripts. Because Erasmus used only three manuscripts,

his version is not technically perfect, but it was a noteworthy attempt and a clear indication of how a humanist felt he could contribute to ecclesiastical work.

The most famous book written by Erasmus, *The Praise of Folly* (1509), was dashed off almost as a joke while he was a houseguest of Sir Thomas More in England. Again, the title is a pun; *Encomium Moriae* can mean either "praise of folly" or "praise of More"—Thomas More, his host. *The Praise of Folly* is a humorous work, but beneath its seemingly lighthearted spoof of the foibles of the day, there are strong denunciations of corruption, evil, ignorance, and prejudice in society. Erasmus flails away at the makers of war (he had a strong pacifist streak), venal lawyers, and fraudulent doctors, but above all, he bitterly attacks religious corruption: the sterility of religious scholarship and the superstitions in religious practice. In Reading 12.8, below, Erasmus comments on theologians.

Reading *The Praise of Folly* makes one wonder why Luther never won Erasmus over to the Protestant Reformation (Erasmus debated Luther, in fact). Erasmus remained in the old church, but as a bitter critic of its follies and an indefatigable proponent of its reform. Some have said that Erasmus laid the egg that Luther hatched.

This sweeping social criticism struck an obvious nerve. The book delighted not only the great Sir Thomas More (who was concerned enough about religious convictions to die for them later in the century) but also many sensitive people of the time. *The Praise of Folly* went through 27 editions in the lifetime of Erasmus and outsold every other book except the Bible in the 16th century.

Comparing Machiavelli and Erasmus is a bit like comparing apples and potatoes, but a few points of contact can be noted that help us generalize about the meaning of the Renaissance. Both men were heavily indebted to the new learning coming

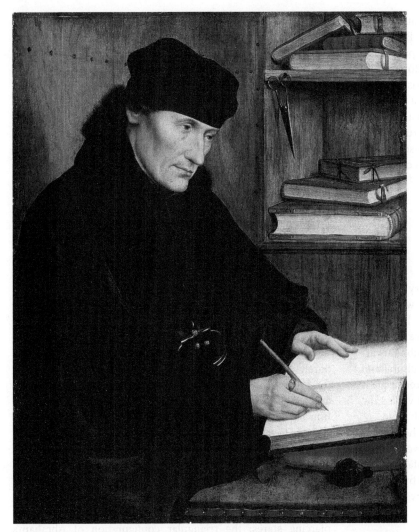

▲ **12.11** Quentin Matsys, *Portrait of Erasmus*, 1517. Oil on panel, transferred to canvas, 23 ¼" × 18 ½" (59 × 47 cm). Galeria Nazionale d'Arte Antica, Rome, Italy. This portrait of Desiderius Erasmus, drawn from life, was the prototype for a coin bearing his profile and for an engraving by the German artist Albrecht Dürer. He is shown standing at his writing desk in a confined cell, spare save for two narrow shelves of scholarly, leather-bound volumes.

READING 12.8 DESIDERIUS ERASMUS

From *The Praise of Folly* (on theologians)

Perhaps it would be better to pass silently over the theologians. Dealing with them, since they are hot-tempered, is like…eating poisonous beans. They may attack me with six hundred arguments and force me to retract what I hold; for if I refuse, they will immediately declare me a heretic.…These theologians are happy in their self-love, and as if they were presently inhabiting a third heaven, they look down on all men as though they were animals that crawled along the ground, coming near to pity them. They are protected by a wall of scholastic definitions, arguments, corollaries, and implicit and explicit propositions.…They come forth with newly invented terms and monstrous sounding words. Furthermore, they explain the most mysterious matters to suit themselves, for instance, the method by which the world was set in order and began, through what channels original sin has come down to us through generations, by what means, in what measure, and how long the Omnipotent Christ was in the Virgin's womb, and how accidents subsist in the Eucharist without their substance.

. . .

And furthermore, they draw exact pictures of every part of hell, as though they had spent many years in that region. They also fabricate new heavenly regions as imagination dictates, adding the biggest of all and the finest, for there must be a suitable place for the blessed souls to take their walks, to entertain at dinner, or even to play a game of ball.

out of 15th-century Italy. Both looked back to the great Classical heritage of the past for their models of inspiration. Both were elegant Latinists who avoided the style and thought patterns of the medieval world. Machiavelli's devotion to the Roman past was total. He saw the historic development of Christianity as a threat and stumbling block to the fine workings of the state. Erasmus, by contrast, felt that learning from the past could be wedded to the Christian tradition to create an instrument for social reform. His ideal was a Christian humanism based on this formula. It was a formula potent enough to influence thinking throughout the 16th century.

RENAISSANCE ART IN ITALY

By some stroke of good fortune, in the 15th century Florence and its surroundings produced a group of artists who revolutionized Western art to such an extent that later historians would refer to the period as a time of *renaissance* (rebirth) in the arts. But talent was not the whole story. Ambitious art projects require wealthy patrons and a nurturing cultural and intellectual environment. It all came together in Florence: great artists, great wealth, and the humanist thought that valued the aspirations of the individual and rewarded them with fame.

Although Florence can rightfully be termed the epicenter of the Early Renaissance, there were other powerful city-states that became cultural centers. Rome, Urbino, Mantua, and others revolved around princely courts established by wealthy dukes, counts, and even popes and cardinals who were major patrons of the arts.

Florence

At the dawn of the 15th century in Florence, the Early Renaissance began, not with a commission but with a competition—for the right to decorate the bronze doors of the Florence Baptistery. Sponsored by the guild of wool merchants, it was announced in 1401 in the midst of a military standoff between Florence and Milan that saw the Duke of Milan's armies surrounding the city. The subject that was chosen for the competition relief was the biblical story of Abraham's sacrifice of Isaac (Genesis 22:1–14). It would have seemed an inspirational one, as the Florentine Republic was on the verge of defeat by the superior forces of the Duke of Milan; Florence could be likened to Isaac and, as such, was in need of some divine intervention. It came in 1402 when the Duke of Milan died unexpectedly.

Sculpture

It is not so often that we can connect specific historical events with the beginning of a new period in art history. In ancient Greece, we saw that a decisive naval battle in 480 BCE launched the Classical period. The outcome of the conflict between the Republic of Florence and the Duchy of Milan coincided with the birth of the Renaissance in Florence.

THE BAPTISTERY COMPETITION: FILIPPO BRUNELLESCHI AND LORENZO GHIBERTI The competition for the high-profile commission for a new set of bronze doors for the Baptistery of San Giovanni drew proposals from many artists, some of whom already had significant reputations in the city. The two finalists, whose submissions survive, were Filippo Brunelleschi (1377–1446) and Lorenzo Ghiberti (1378–1455). A comparison between them illustrates the stylistic and technical differences and allows us to infer the criteria used to judge the winner.

There were specific criteria for the competition panels to which all submissions had to conform. In addition to the Abraham and Isaac story, complete with all of its figures and props, the artists had to arrange all of the imagery within a four-lobed (quatrefoil) frame. One set of doors had already been fashioned by the sculptor Andrea Pisano in the 1330s, and the idea was to match the new to the old. Brunelleschi's version (**Fig. 12.12**) has a vigor and expressiveness that seem barely contained by the Gothic-style frame. Abraham lunges for Isaac's throat with a knife, and at the same moment, an angel comes into the scene, grasping Abraham's arm to stop him from slaying his son. Isaac's head has been wrenched to the side to expose his neck, and his whole body is compressed between the harsh stone of the sacrificial altar on which he kneels and the strength of his father bearing down upon him. Two compositional triangles—one implied and one actual—add to the tension in the scene: the faces of Isaac, Abraham, and the angel are connected along implied diagonal lines with piercing stares; the triangular configuration of Abraham's shoulders, arms, and head leads our eye to the most violent section in the composition.

In Brunelleschi's panel, the scattered figures keep the eye moving and underscore a feeling of agitation. By contrast, Ghiberti's panel on the same subject (**Fig. 12.13**) is divided dramatically by a slashing diagonal line separating the two sets of actors into clearly designated planes of action. The sway of Abraham's body echoes the shape of the rock up to the shoulders and then lunges toward Isaac in a dynamic counterthrust. Isaac, in turn, pulls reflexively away from the knife in his father's hand. His body arches as he looks at the angel overhead, which is drastically foreshortened and appears to be flying into the scene from deep space. It appears that Isaac is aware of his rescue before Abraham even sees the angel. All of the shapes seem to move rhythmically, and although Ghiberti's version is not as graphic and emotionally intense as Brunelleschi's, the impact of his narrative is just as strong. Of special note is the reference to nude Classical sculpture in Ghiberti's portrayal of Isaac. It may be the first such type of figure since antiquity.

Ghiberti's experience as a skilled goldsmith produced a panel that was a technical tour de force—cast only in two pieces. His victory in the competition may have come because

his technique was assessed as superior to Brunelleschi's, but there may have been another reason. In Brunelleschi's panel, Isaac looks like a victim; in Ghiberti's, he seems strong, almost defiant. Given that the subject may have been intended to inspire Florentines to rally and defend their city, Ghiberti's Isaac would have better captured a spirit of resistance.

Ghiberti's response to his success speaks volumes about the growing sense in the Early Renaissance that human beings were entitled to the honor bestowed upon them for their achievements:

> To me was conceded the palm of victory by all the experts and by all…who had competed with me. To me the honor was conceded universally and with no exception. To all it seemed that I had at that time surpassed the others without exception, as was recognized by a great council and an investigation of learned men…highly skilled from the painters and sculptors of gold, silver, and marble.

Ghiberti worked for almost a quarter of a century on the north doors, completing 20 panels. Just as he was finishing, the cathedral authorities commissioned him to create another set of panels for the east doors, those facing the cathedral. This project occupied the next quarter of a century (1425–1452), and the results of these labors were so striking that Michelangelo

later in the century declared Ghiberti's east doors worthy to be called the Gates of Paradise. They are so called to this day.

The east doors (**Fig. 12.14**) differ dramatically in style and composition from the north-door panels. Rectangular frames replace the Gothic-style quatrefoils, and each is treated as a defined pictorial space not unlike a painting. By the time Ghiberti was at work on this project, his rival Brunelleschi had developed *linear perspective*—a scientific method used for creating the illusion of three-dimensionality on a two-dimensional surface; Ghiberti used it in the Gates of Paradise. Linear perspective was the most important development in the history of Western painting, and its inventor, the man who lost the Baptistery competition, went on to be the most important architect of the Early Renaissance.

DONATELLO The sculptor Donato di Niccolò di Betto Bardi—known simply as Donatello—was a close friend of Brunelleschi. After the competition, the two went off to Rome to study the architecture and sculpture of antiquity. In fact, Giorgio Vasari tells us that the pair were reputed to be treasure hunters because of their incessant prowling amid the ruins of the Roman Forum. For Brunelleschi, these intensive studies led to the development of linear perspective as well as construction methods and motifs that he would employ in his own

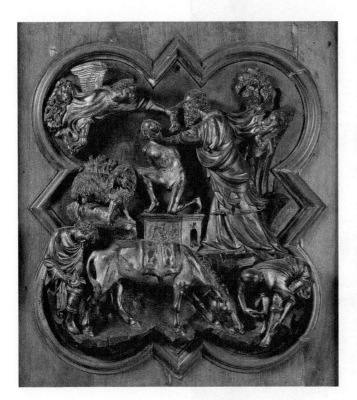

▲ **12.12** Filippo Brunelleschi, *Sacrifice of Isaac*, 1401–1402. Competition panel for the east doors of the Baptistery of San Giovanni, Florence, Italy. Gilded bronze, 21" × 17 ½" (53 × 44 cm). **Museo Nazionale del Bargello, Florence, Italy.** The nervous energy and scattering of figures in Brunelleschi's panel recalls Giovanni Pisano's relief for the pulpit at Sant'Andrea; both were influenced by the expressionism of the Late Gothic style.

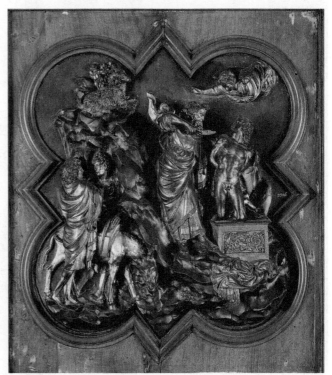

▲ **12.13** Lorenzo Ghiberti, *Sacrifice of Isaac*, 1401–1402. Competition panel for the east doors of the Baptistery of San Giovanni, Florence, Italy. Gilded bronze, 21" × 17 ½" (53 × 44 cm). **Museo Nazionale del Bargello, Florence, Italy.** Ghiberti's Isaac, inspired by sculpture from Greece and Rome, may be the first example of a fully nude, classically modeled figure since antiquity.

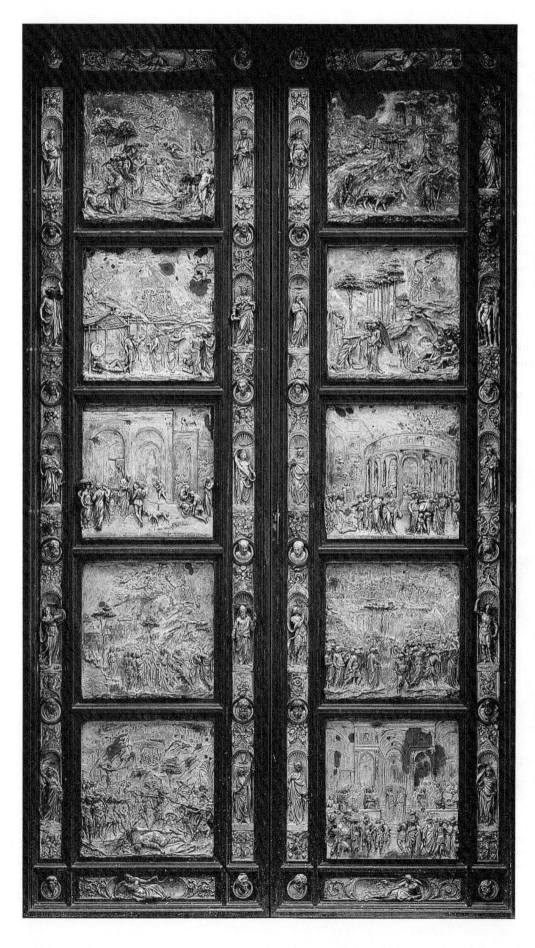

◀ **12.14 Lorenzo Ghiberti, east doors (Gates of Paradise), 1425–1452 (modern replica, 1990). Baptistery of San Giovanni, Florence, Italy. Gilded bronze, 17' (5.18 m) high. Original panels in the Museo dell'Opera del Duomo, Florence, Italy.** Brunelleschi's innovations for creating the illusion of three-dimensionality on a two-dimensional surface using systematic mathematical laws of perspective were employed by Ghiberti to create the illusion of deep space in the square panels of his east doors of the Florence Baptistery. Michelangelo called them the Gates of Paradise.

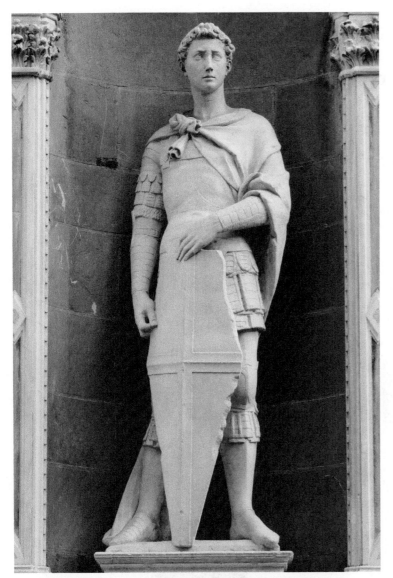

▲ **12.15** Donatello, *Saint George*, ca. 1410–1415. Orsanmichele, Florence, Italy (modern copy in exterior niche). Marble, 82" (208 cm) high. Original statue in the Museo Nazionale del Bargello, Florence, Italy. Saint George was a Roman soldier and early Christian martyr who was renowned for a legend in which he slew a dragon and saved a pagan princess from certain death, thus winning the gratitude and respect of her people—along with their conversion to Christianity. The legend of Saint George was a popular subject in romance literature.

George's facial expression. This bit of agitation is, overall, balanced by serenity and control, and thus harkens to the Classical ideal. Donatello's sculpture was carved at the same time that Florence was under attack by the troops of King Ladislas of Naples. Just as the *Sacrifice of Isaac* had meaning to the Florentines when the Duke of Milan besieged their city, so too did the saintly knight George have meaning at a time when the city again was defending itself against threats to its independence. And once again, victory against the Florentines was thwarted by fortuitous circumstances: Ladislas died abruptly in 1414. Donatello's *Saint George*, begun in 1410, was completed in 1415.

Donatello's most Classically inspired work is his *David* (see Fig. 12.16), commissioned for the garden of the Medici palace; it is the first life-size, freestanding statue of a nude figure since antiquity. The sinuous **contrapposto** stance and body proportions are reminiscent of Greek prototypes that were mimicked by Roman artists. What is different—and new—here is that Donatello used the Classical style, one that focused on the beauty of the male form, to portray a Christian biblical subject. David, destined to become the second king of Israel, slew the Philistine giant Goliath—felling him with his slingshot and then decapitating him. For this, Donatello did not choose a godlike figure or heroic nude as a model, but rather what appears to be a preadolescent peasant boy, whose long, soft curls still fall down to his shoulders and whose arms are still thin and muscles undeveloped. David rests his sword on the ground after cutting off Goliath's head, as if it is too heavy for him to hold. He glances downward at the head—and his own body—as if incredulous at what he has accomplished. Herein lies the humanity and thus the power of Donatello's sculpture. He has achieved the perfect reconciliation of idealism and realism.

ANDREA DEL VERROCCHIO One of the most important and versatile artists of the mid-15th century in Florence was Andrea del Verrocchio (1435–1488). Trained as a goldsmith, Verrocchio was also a painter and sculptor who ran an active studio shop; the young Leonardo da Vinci was one of the artists who apprenticed there. Verrocchio's *David* (Fig. 12.17), also commissioned by the Medici family, is quite different from Donatello's. Although both represent David as an adolescent, Verrocchio's hero is somewhat older (his muscles are better developed, although wiry) and has a look of pride and self-confidence rather than a dreamy gaze of disbelief. Donatello's David is introspective; Verrocchio's looks bold. Both sculptures feature David after the fight, but the long sword in Donatello's piece seems unwieldy, as if David can barely manage it, whereas in Verrocchio's sculpture, the shorter blade, aimed outward, seems a still-threatening extension of David's arm. The most significant difference, of course, is that Donatello draws attention to David's body in his nudity, whereas Verrocchio tries to communicate something of David's personality though his sharp and cocky demeanor. The increasing sense of realism in

architectural projects. For Donatello, the close encounter with antique reliefs and statuary would lead to the revival of Classical principles in his sculpture.

Donatello's *Saint George* (**Fig. 12.15**) was created originally for a niche on the exterior of the Orsanmichele church in Florence, the site of the headquarters of the city's guilds. Each of the guilds had been assigned a niche in which to place a sculpture representing their patron saint; Saint George was the patron saint of armorers and sword makers. Donatello's figure exudes intelligence and courage in his piercing gaze and confident pose, but there is an element of tension—even worry—in Saint

COMPARE + CONTRAST

The *David*s of Donatello, Verrocchio, Michelangelo, and Bernini

Sometime soon after the year 1430, a bronze statue of *David* (Fig. 12.16) stood in the courtyard of the house of the Medicis. The work was commissioned from Donatello by Cosimo de' Medici himself, the founding father of the Republic of Florence. It was the first freestanding, life-size nude since Classical antiquity, poised in the same contrapposto stance as the victorious athletes of Greece and Rome—but soft, and somehow oddly unheroic. And the incongruity of the heads: David's boyish, expressionless face, framed by soft tendrils of hair and shaded by a laurel-crowned peasant's hat; Goliath's tragic, contorted expression, made sharper by the pentagonal helmet and coarse, disheveled beard. Innocence and evil; the

weak triumphing over the strong; perhaps even the Republic of Florence triumphing over the aggressive dukes of Milan? This is David as a civic monument.

In the year 1469, Ser Piero from the Tuscan town of Vinci moved to Florence to become a notary. He rented a house on the Piazza San Firenze, not far from the Palazzo Vecchio. His son, who was a mere 17 years old upon their arrival, began an apprenticeship in the Florentine studio of the well-known artist Andrea del Verrocchio. At that time, Verrocchio was at work on a bronze sculpture of the young *David* (Fig. 12.17). Might the head of this fine piece be a portrait of Leonardo da Vinci?

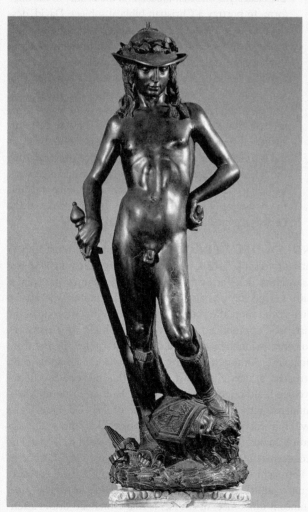

▲ **12.16** Donatello, *David*, ca. 1440–1460. Bronze, 62¼" (158 cm) high. Museo Nazionale del Bargello, Florence, Italy.

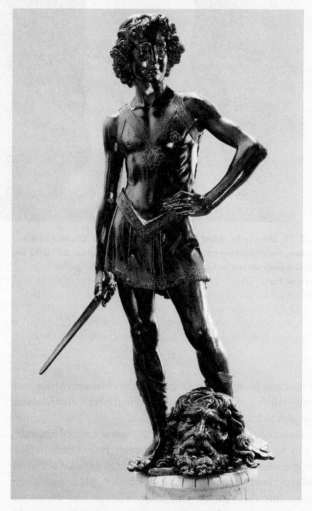

▲ **12.17** Andrea del Verrocchio, *David*, ca. 1465–1470. Bronze, 49¼" (125 cm) high. Museo Nazionale del Bargello, Florence, Italy.

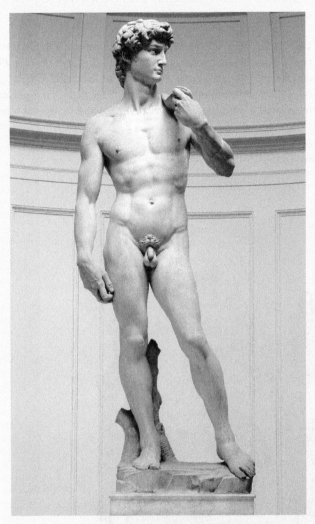

▲ **12.18** Michelangelo, *David*, 1501–1504. Marble, 17' (5.17 m) high. Gallerie dell'Accademia, Florence, Italy.

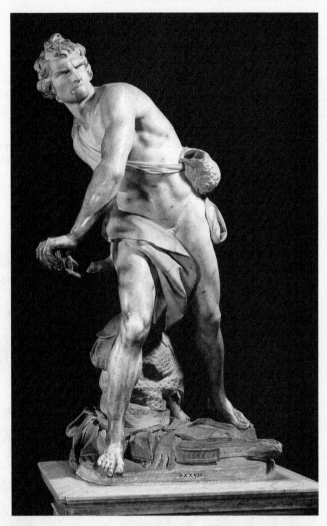

▲ **12.19** Gian Lorenzo Bernini, *David*, 1623. Marble, 66¼" (170 cm) high. Galleria Borghese, Rome, Italy.

For many years, a block of marble lay untouched, tossed aside as unusable, irretrievable evidence of a botched attempt to carve a human form. It was 18 feet high. A 26-year-old sculptor, riding high after the enormous success of his figure of the Virgin Mary holding the dead Christ, decided to ask for the piece. The wardens of the city in charge of such things let the artist have it. What did they have to lose? Getting anything out of it was better than nothing. So this young sculptor named Michelangelo measured and calculated. He made a wax model of David with a sling in his hand. And he worked on his *David* (**Fig. 12.18**) continually for some three years until, Vasari tells us, he brought it to perfect completion—without letting anyone see it.

A century later, a 25-year-old sculptor stared into a mirror at his steeled jaw and determined brow. A contemporary source tells us that on this day, perhaps, the mirror was being held by Cardinal Maffeo Barberini (who would become Pope Urban VIII)

while Bernini transferred what he saw in himself to the face of his *David* (**Fig. 12.19**). Gian Lorenzo Bernini, sculptor and architect, painter, dramatist, and composer—who centuries later would be called the undisputed monarch of the Roman High Baroque—identifying with David, whose adversary is seen only by him.

The great transformation in style that occurred between the Early Renaissance and the Baroque (see Chapter 15) can be followed in the evolution of David. Look at them: A boy of 12, perhaps, looking down incredulously at the physical self that felled an unconquerable enemy; a boy of 14 or 15, confident and reckless, with enough adrenaline pumping through his body to take on an army; an adolescent on the brink of adulthood, captured at that moment when, the Greeks say, sound mind and sound body are one; and another full-grown youth, caught in the midst of action, at the threshold of his destiny as king.

Renaissance art was the result not only of imitating nature but also of recording aspects of human nature.

Painting

The International Style, originated by Simone Martini in Siena in the mid-14th century (see Fig. 11.16), continued to have a presence throughout Italy in the 15th century, when the lure of

lush possibilities of the courtly manner in painting coexisted with efforts to revive Classicism and to seek ways to express the doctrine of humanism in art.

GENTILE DA FABRIANO Complete mastery of the International Style in the 15th century is most evident in the work of Gentile da Fabriano (ca. 1370–1427). His altarpiece *Adoration of the Magi* (Fig. 12.20) is brimming with exquisite detail that gleams golden, from lavish costumes to bejeweled crowns and richly embossed

▼ **12.20** Gentile da Fabriano, *Adoration of the Magi*, **1423. Altarpiece from the Strozzi Chapel, Santa Trinità, Florence, Italy. Tempera on wood, 119" × 111" (302 × 281 cm). Galleria degli Uffizi, Florence, Italy.** This sumptuous painting straddles the Gothic style, with its sinuous lines and lushly decorated surfaces, and that of the Early Renaissance, with its attention to realistic detail based on an observation of the natural world and human behavior.

halos. The figures have the courtly bearing and graciousness of nobility. The splendor of the painting—its brilliant color and elaborate gold frame—seems fit for a king—in this case, Palla Strozzi, a banker and one of the wealthiest men in Florence.

Although elements of the Gothic style dominate the *Adoration of the Magi*, the observation of the natural world that is central to the new aesthetic can also be seen in some of the detail—the individualized, expressive faces of the crowd, the hunched-over man at the feet of the red-stockinged king who removes his spurs, the twisting, turning positions of the animals, and the squirming legs of the baby Jesus. Gentile achieved balance between the ornamental and the naturalistic in a painting that dazzles.

MASACCIO Only five or so years after Gentile completed his altarpiece, Tomasso di Giovanni di Simone Cassai (1401–1428), known as Masaccio, painted *The Holy Trinity* (Fig. 12.21) for the church of Santa Maria Novella in Florence. It is a strikingly different approach by a precocious young artist who transformed contemporary painting by melding the innovations of Giotto with Brunelleschi's mathematical systems of perspective. *The Holy Trinity* is only one of several important fresco commissions Masaccio received between 1424 and 1427. Within a year after they were completed, he died, at the age of 27. *The Holy Trinity* is our first best example of linear perspective in Renaissance painting, begun at around the same time as Ghiberti was working on the Gates of Paradise. Both artists were experimenting with the illusion of deep space on a two-dimensional surface and both were applying mathematics to do so.

Linear perspective is a way of structuring pictorial space so that the figures and objects therein mimic the real-world perception of three-dimensional space from a single, fixed vantage point (Fig. 12.22). (In *The Holy Trinity*, that vantage point is outside of the painting, below the figures, at a spectator's eye level.) From that fixed point, one looks into the distance (for example, the background of the painting) to a horizon line on which is placed a single point (the vanishing point). Lines are then drawn from the edges of the picture frame in such a way that they all converge at this single point; these lines are called *orthogonals*. A perspectival grid is created through the intersection of the orthogonals and *transversals*, lines that are parallel to the horizon line and appear to come closer together as they approach it. The spaces of the grid (larger in the foreground, smaller at the horizon line) are used to determine the relative scale of figures and objects. This mathematical system reflects what the eye sees in nature: things that are closer to us appear larger and those that are farther away, smaller.

▲ 12.21 Masaccio, *The Holy Trinity*, ca. 1424–1427. Fresco, 21' 10⅝" × 10' 4¾" (6.7 × 3.2 m). Santa Maria Novella, Florence, Italy. Altarpieces and other monumental paintings for church interiors were frequently funded by wealthy donors, whose generosity was acknowledged and recorded for posterity by the inclusion of their portraits in the work. Here, Masaccio shows Lorenzo Lenzi and his wife kneeling in prayer outside the chapel.

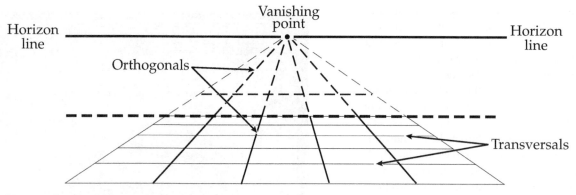

▲ **12.22** Diagram of one-point linear perspective.

In *The Holy Trinity*, Masaccio uses these laws of perspective to construct the spatial illusion of a barrel-vaulted chapel in which God the Father supports the arms of a cross with the crucified Christ. The Virgin Mary and Saint John are at Jesus's feet, where the orthogonals of the coffered ceiling converge. Between the heads of Jesus and God the Father, the Holy Spirit—a dove—spreads its wings and hovers in place. Outside of the space, the donors—Lorenzo Lenzi and his wife—kneel in prayer. The plane that they occupy sits between the mystical scene of the painted chapel and the concrete space of the spectator.

The illusion of three-dimensional space in *The Holy Trinity* is dramatic, but the painting's realism can be attributed also to the way that Masaccio rendered the figures—they have weight and occupy space. The carefully painted drapery folds and the modeling of the flesh are a further extension of Giotto's technique of chiaroscuro, the foundation of Masaccio's style. To this he would add psychological depth to his figures by capturing the spectrum of human emotion.

In this single fresco appear many of the characteristics of Florentine Renaissance painting that separate it from earlier styles: clarity of line, a concern for mathematically precise perspective, close observation of real people, concern for psychological states, and an uncluttered arrangement that rejects the earlier tendency to crowd figures into all of the painting's available space.

Masaccio's fresco paintings for the Brancacci Chapel of the Church of Santa Maria del Carmine in Florence are startling in their realism, in terms of both his convincing rendering of three-dimensional figures in a two-dimensional space and his expression of human behavior and feelings. In *Tribute Money* (**Fig. 12.23**), a three-part narrative that takes place in a single, continuous landscape, a Roman tax collector (in a short tunic) approaches Jesus and his apostles for payment

▼ **12.23** Masaccio, *Tribute Money*, ca. 1424–1427. Fresco, 8' 4⅛" × 19' 7⅛" (2.5 × 5.9 m). **Brancacci Chapel, Church of Santa Maria del Carmine, Florence, Italy.** Masaccio suggests the passage of time by showing, simultaneously, three moments in the story of Jesus and the Roman tax collector found in Matthew 17:24-27.

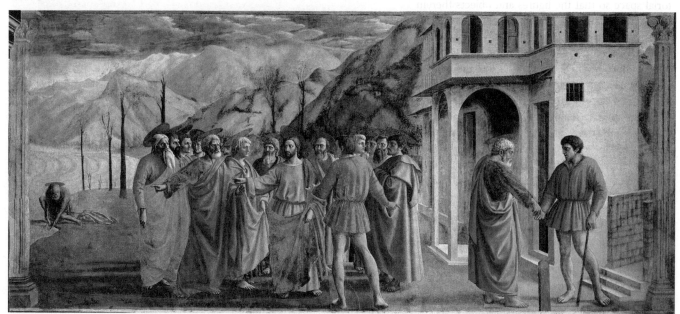

(Matthew 17: 24–27). Jesus, in the center of the group, motions to Peter (with gray hair and a short gray beard) to go to the shore of Lake Galilee in the distance on the left, where a fish will swim to him with a coin in its mouth. Peter takes off his orange cloak and crouches to receive it. On the right side of the composition, we see Peter again, this time forcing the coin into the tax collector's hand.

The space in the painting is defined by the figures themselves, who cluster in a half-circle around Jesus as he speaks; the architecture, the lines of which converge at Jesus's head; the diminishing scale of the barren trees as they march toward the background; and the misty, atmospheric perspective used to suggest the distant hills and sky. The figures, as in *The Holy Trinity*, are weighty and corporeal beneath their drapery, and the expressions on their faces show their reactions to the circumstance: Jesus is serene and resigned, but Peter is peeved and confused. The individualized facial features of all of the characters contribute to the overall sense of authenticity.

The revolutionary character of Masaccio's work was recognized in his own time, and his influence on Florentine painters who worked later in the century is clear. Two generations after Masaccio's death, the young Michelangelo often crossed the river Arno to sketch the frescoes in the Brancacci Chapel. In the next century, Giorgio Vasari in his *Lives of the Artists* would judge Masaccio's influence as basic and crucial: "The superb Masaccio…adopted a new manner for his heads, his draperies, buildings, and nudes, his colors, and foreshortening. He thus brought into existence the modern style which, beginning during his period, has been employed by all of our artists down to the present day."

FRA ANGELICO The works of Masaccio were ambitious in many ways: complex spatial illusion, believable physicality, authenticity of human emotion, and the visual correlate to humanist thought. The results had monumentality. How different, then, is the quiet, unassuming, quality of the art of Fra Angelico (ca. 1400–1455), a Dominican friar who devoted his life to religious painting. His *The Annunciation* (**Fig. 12.24**) was commissioned for the Dominican monastery of San Marco and was executed in a corridor in the friars' dormitory. The pronounced linear aspect of the fresco, and its clear and simple shapes, construct a humble scene for quiet contemplation. Although Fra Angelico seems far removed from the humanist discourse of Florence, the graceful arches of the covered terrace that spring from Corinthian capitals illustrate an awareness of the fashion for Classical motifs in architecture. The setting for *The Annunciation* may have been inspired by Brunelleschi's design for the loggia of the Ospedale degli Innocenti (see Fig. 12.32).

PAOLO UCCELLO Linear perspective swept Florence and found one of its most literal proponents in Paolo Uccello (1397–1475), a painter who married elements of the International Style with the new approach based on Brunelleschi's mathematical systems. *The Battle of San Romano* (**Fig. 12.25**) was one of three paintings commissioned to commemorate Florence's defeat of Siena in 1432, all of which illustrate Uccello's fascination with perspective. The jousting combatants engage on a battlefield littered with broken lances that have fallen in a near-grid pattern and are aimed toward a vanishing point somewhere in the distance. The foreshortened body of a fallen soldier, his feet touching the left front edge of the painting, parallels the orthogonals

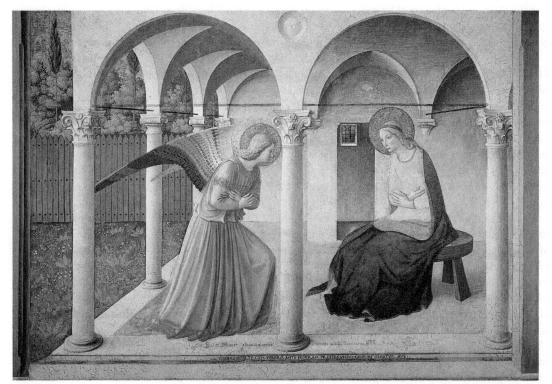

◀ **12.24** Fra Angelico, *The Annunciation*, ca. 1438–1447. Fresco, 85" × 126" (216 × 320 cm). San Marco, Florence, Italy. Though a simple, devotional painting, *The Annunciation* is not without small details derived from a close observation of nature: botanists have identified the flowers strewn amid the grasses of the sheltered garden.

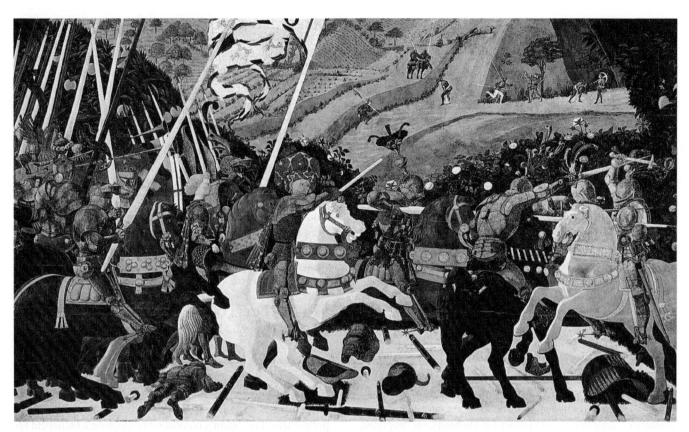

▲ 12.25 Paolo Uccello, *The Battle of San Romano*, ca. 1456. Tempera on wood, 72" × 126" (182 × 320 cm). National Gallery, London, United Kingdom. Uccello's obsession with mathematical systems of perspective is conspicuous in the unnatural, grid-like placement of broken lances and spears along the ground. The painting, which represents a battle between the Florentines and the Sienese, once hung in Lorenzo de' Medici's bedroom.

of the lances. Uccello depicts the clash and confusion of heated battle but, in the end, the paintings seem as much a vehicle for the artist's study of perspective as anything else.

PIERO DELLA FRANCESCA The artists of the Renaissance, along with the philosophers and scientists, shared a sense of the universe as an orderly place that was governed by natural laws and could be expressed in mathematical terms. Piero della Francesca (ca. 1420–1492) was trained in mathematics and geometry and is credited with writing the first theoretical treatise on the construction of systematic perspective in art. Piero's art, like his scientific thought, was based on an intensely rational construction of forms and space.

His *Resurrection* (Fig. 12.26), a fresco painted for the town hall of Borgo San Sepolcro, reveals the artist's obsessions with order and geometry. Christ, transcendent in his expressionlessness, steps out of his tomb, grasping a flag in his right hand that signifies his victory over death. Beneath him are the sleepy soldiers who were charged with guarding the burial site. The figures are contained within a triangle—what would become a frequent compositional device in Renaissance painting—with Christ's head at the apex. The sleeping figures and the marble sarcophagus provide a strong and stable base for the upper two-thirds of the composition. Regimented trees are arranged

in procession behind Jesus in a landscape whose juxtaposed elements are anything but serendipitous; the branches in the grove on the left are barren and the ones on the right in leaf, symbolizing death and resurrection, or rebirth. The feeling of restraint that pervades the painting is a by-product of Piero's geometrization.

SANDRO BOTTICELLI The prevailing trend in 15th-century art was the realistic representation of the natural world, buttressed by order, geometry, and references to classical style. Sandro Botticelli (1445–1510), however, bucked this trend. Seminal to the tradition of Giotto and Masaccio in painting was the illusion of roundness in figures modeled by subtle gradations of *value*, that is, tonal contrasts of light and shade. Botticelli's principle element of art, by contrast, was *line*—line that delimits and therefore flattens form, line that plays across figures and surfaces and seems to have a life of its own. His art relied primarily on drawing. As distinct as Botticelli's style was from those of other artists of his day, he shared with them a strong feeling for humanism and, with that, a penchant for Classical art and subjects.

Botticelli painted *Primavera* (*Springtime*) (Fig. 12.27) for a cousin of Lorenzo the Magnificent named Lorenzo di Pierfrancesco de' Medici on the occasion of his wedding. One of the most

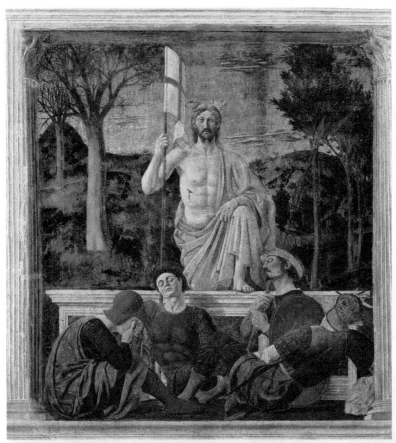

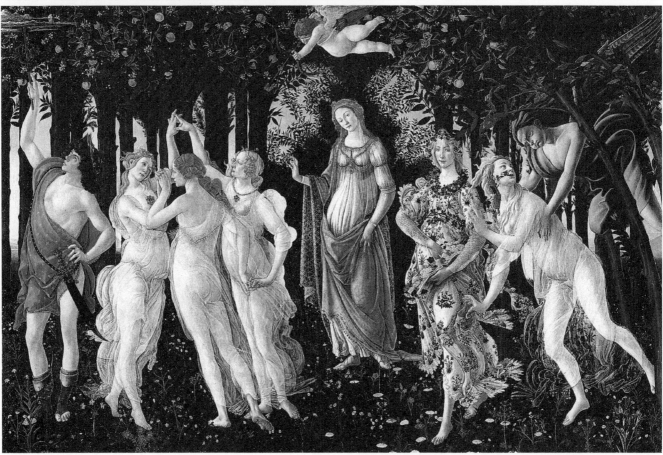

◀ **12.26 Piero della Francesca,** *Resurrection,* **ca. 1463–1465. Fresco, 88⅝" × 78¼" (225 × 199 cm). Palazzo Comunale, Sansepolcro, Italy.** The precise drawing, emphasis on geometry, and overall serenity of the scene characterize all of Piero's compositions. The figure of Christ the Savior, draped and nude from the waist up, undeniably suggests a familiarity with Graeco-Roman sculpture.

popular paintings in Western art, *Primavera* is an elaborate allegory of love, presided over by the figure of Venus in the center of the composition standing beneath her son, Cupid. To the right, the god of the wind, Zephyrus, abducts the nymph Chloris—who, after the two are wed, is transformed into Flora, the graceful figure who tosses petals from the bunched up folds of her floral-patterned dress. To the left, three maidens—the Three Graces—dance while nearby, the god Mercury lifts his staff toward the floating strata of a gloomy cloud. Cupid hovers and aims his love arrow in the direction of the Graces. The painting has been interpreted as a symbolic representation

▼ **12.27 Sandro Botticelli,** *Primavera,* **ca. 1482. Tempera on wood, 80" × 124" (203 × 314 cm). Galleria degli Uffizi, Florence, Italy.** This work is one of the best examples of Botticelli's fusion of pagan symbolism and Christian humanism.

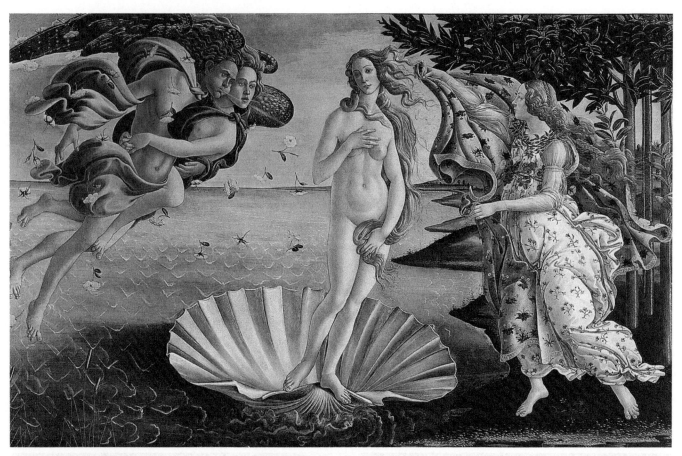

▲ **12.28 Sandro Botticelli,** *The Birth of Venus*, **ca. 1484–1486. Tempera on canvas, 69" × 110" (172 × 277 cm). Galleria degli Uffizi, Florence, Italy.** The statuesque quality of Venus was likely inspired by a classical sculpture, the Aphrodite of Knidos (see Fig. 12.29), although the narrative that unfolds in the composition takes some of its details from a poem by one of Botticelli's fellow humanists.

of the joining of physical love (desire) and spiritual love (the love of God) in the sacred bond of matrimony.

Botticelli's most famous painting, perhaps, is *The Birth of Venus* (**Fig. 12.28**), a work that may have been inspired by a poem by the humanist Angelo Poliziano on the same subject:

> You could swear that the goddess had emerged
> from the waves, pressing her hair with her right
> hand, covering with the other her sweet mound
> of flesh; and where the strand was imprinted by
> her sacred and divine step, it had clothed itself
> in flowers and grass; then with happy, more than
> mortal features, she was received in the bosom
> of the three nymphs and cloaked in a starry garment.

—From "La Giostra," Angelo Poliziano, 1475–1478

CONNECTIONS Botticelli's Venus and the sculpture that indirectly inspired her—the *Aphrodite of Knidos*—have something in common. Each, in its own time, was a first. Praxiteles's fourth century BCE original was the first representation of a Greek goddess completely in the nude (**Fig. 12.29**); with his *The Birth of Venus*, Botticelli became the first Renaissance artist to revive the subject of the female nude in painting. Placing a sculpture of an unclothed *Aprhrodite* in a temple—a sacred space—might have been viewed as inappropriate, just as Botticelli's life-sized goddess, in all of her nudity, might have been viewed as profane. Yet Praxiteles's Aphrodite was a sensation; Pliny reported that those who traveled to see her were "overcome with love for the statue." And, in the humanist, Neo-Platonic circle of 15th-century Florence, it was believed that pondering the physical beauty of one such as Botticelli's goddess (and the naked human form more broadly) inspired spiritual contemplation of the divine.

▶ **12.29 Praxiteles,** **Aphrodite of Knidos,** **Roman copy of a** **marble statue of** **ca. 350–340 BCE. Marble,** **80" (203.2 cm) high.** **Musei Vaticani, Vatican** **City State, Italy.**

Poliziano was a scholar and member of the Neo-Platonist circle around Lorenzo the Magnificent, and *The Birth of Venus* was painted for the Medici. Venus, born of the foam of the sea, drifts along on a large scallop shell to the shore of her sacred island of Cyprus, aided by the sweet breaths of entwined zephyrs. The nymph Pomona, wearing a billowing, flowered dress, awaits her with a luxurious patterned mantle. Venus was derived from an antique sculpture of the type Venus Pudica (the modest Venus), similar to the Aphrodite of Knidos. Her face may have been based on a portrait of Simonetta Vespucci, a cousin of Amerigo Vespucci, the navigator and explorer after whom the continents of North and South America are named. The graceful rhythms in the composition are evoked through a plethora of lines, from the V-shaped ripples in the sea and the radiating pattern of the seashell to the subtle curves and vigorous arabesques that caress the figures; shading is confined to areas within the sculptural contours of the figures.

Neo-Platonic references to spiritual fulfillment made possible by the contemplation of ideal beauty were evident in Botticelli's painting, just as they were in Lorenzo de' Medici's poetry (see page 386). As a kindred spirit, Botticelli remained closely allied with the Medici for decades, although he did have other wealthy patrons. The *Adoration of the Magi* (Fig. 12.30) was commissioned by the Florentine banker Gaspare di Zanobi del Lama for a private chapel in Santa Maria Novella (now destroyed) and includes a portrait of the donor (in the right-hand group in a blue cape, looking out toward the viewer) in the midst of the city's most cultured and powerful. Botticelli, as if upstaging him, stands even closer to us in the right foreground.

▼ 12.30 Sandro Botticelli, *Adoration of the Magi*, ca. 1475. Tempera on panel, 44" × 53" (111.8 × 134.6 cm). Galleria degli Uffizi, Florence, Italy. The painting reads as a veritable who's who of Florence's rich and famous. Many scholars believe that the young blond man in an ochre cloak in the extreme right foreground is Botticelli himself.

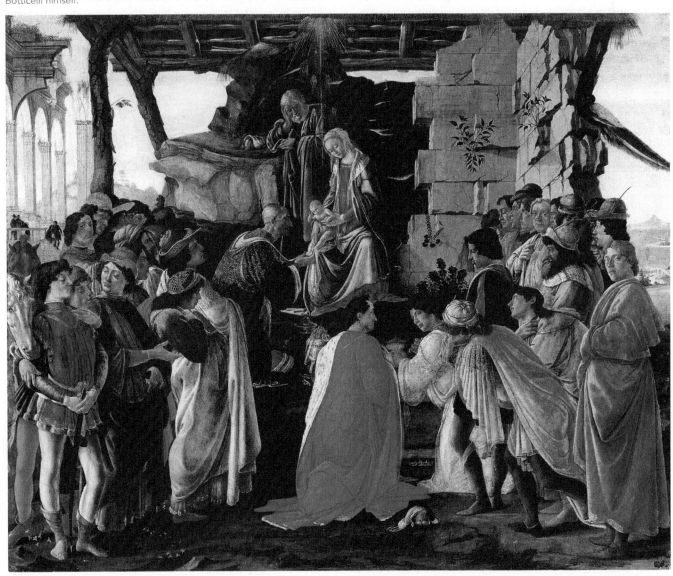

Architecture

In a way, Brunelleschi's loss to Ghiberti in the competition for the bronze doors of the Florence Baptistery was fortuitous for the history of Renaissance architecture. His intensive study of the structures and engineering techniques of Classical antiquity altered the way architects thought about and constructed buildings. His drawings and precise measurements, particularly of ruins in the Roman Forum, created a template for Renaissance architecture that reached deeper than the simple appropriation of classically inspired motifs.

FILIPPO BRUNELLESCHI AS ARCHITECT The Cathedral of Florence, begun by Arnolfo di Cambio at the end of the 14th century, was still unfinished in the opening decades of the 15th century. The nave was completed, but no one had quite figured out how to span the great area of the crossing square without immense buttresses on the exterior of the building and supporting armatures within. Brunelleschi worked on a design for the dome between 1417 and 1420, trying both to solve the complicated engineering puzzle of its construction and to convince skeptical cathedral overseers that it could be done. He won the day eventually—ironically beating out Ghiberti for the commission—but work on the dome was not completed until 1436.

His solution was to combine the buttressing methods of the Gothic cathedral with Classical vaulting techniques that he had mastered from his careful study of the Roman Pantheon and other buildings from antiquity. By putting a smaller dome within the larger dome to support the greater weight of the outside dome (**Figs. 12.31A** and **12.31B**), he could not only cover the great tambour (drum, or base) but also could free the inside of the dome of the need for elaborate armatures or supporting structures. This dome was strong enough to support the lantern that eventually crowned the whole construction (see Fig. 11.23). It was a breathtaking technical achievement, as well as an aesthetic success, as any person viewing Florence from the surrounding hills can testify. Years later, writing about his own work on the dome of Saint Peter's in the Vatican, Michelangelo had Brunelleschi's dome in mind when he said, "I will create your sister; bigger but no more beautiful."

The technical brilliance of Brunelleschi's dome cannot be overpraised, but his real architectural achievement lies in building designs that break entirely from vestiges of the medieval tradition. His loggia for the Ospedale degli Innocenti (Hospital of the Innocents) in Florence (**Fig. 12.32**), considered by some to be the first structure in a pure Renaissance style, is a light and airy sheltered gallery with an arcade that runs the length of the building. The Ospedale was a home for abandoned children supported by the guild of silk manufacturers and goldsmiths;

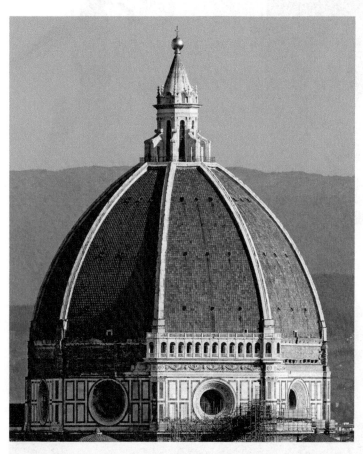

▲ **12.31A** Brunelleschi, Florence Cathedral dome, 1420–1436.

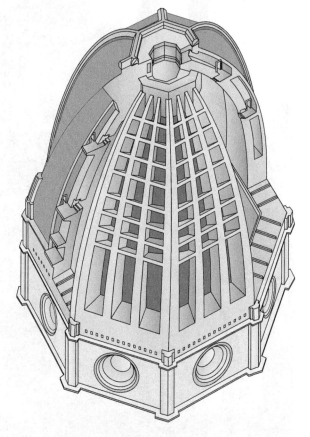

▲ **12.31B** Brunelleschi, Florence Cathedral dome, cutaway drawing.

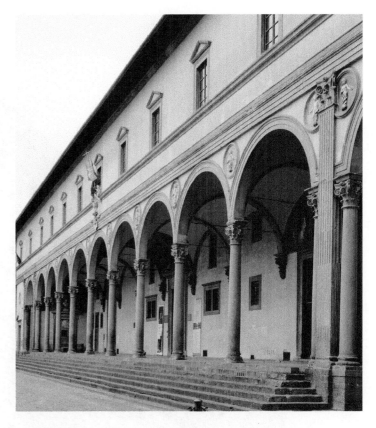

► **12.32 Filippo Brunelleschi, loggia of the Ospedale degli Innocenti ("Hospital of the Innocents" Foundling Hospital), begun 1419. Florence, Italy.** The sheltered gallery of the Ospedale degli Innocenti was a place where abandoned children and those placed in the orphanage could be dropped off. The mission of the Ospedale—to care for unwanted children—is reinforced by the images of swaddled children in glazed terra-cotta medallions above the columns. They were a later addition to the façade by artists working in the della Robbia ceramics workshop in Florence.

the commission for the project was given to Brunelleschi, who was one of its members. The loggia is defined by hemispherical arches supported by Corinthian columns on street level; above, rectangular windows crowned with small triangular pediments are placed directly over the center of each arch. The horizontal progression of arches is reiterated in the gray stone moldings that separate the two levels of the façade. Despite its simple appearance, the building's intricate proportions and relationships were calculated with mathematical precision: the height of the columns is equal to the space between them and to the distance between them and the wall of the loggia.

This same concern with mathematical proportion, order, and harmony can be seen in Brunelleschi's finest work—a chapel for the Pazzi family (**Fig. 12.33**) next to the Franciscan church of Santa Croce in Florence. The arched and columned portico and classicizing motifs are reminiscent, overall, of the Roman triumphal arches Brunelleschi sketched in and around the Forum (see Fig. 4.8). The chapel's unimposing façade leads to a central-plan interior in which a hemispherical dome, resting on massive piers and arches, is the central focus. Brunelleschi's decoration is spare, but dramatic; the combination of white stucco with gray stone accents, seen also in the Ospedale degli Innocenti, was his signature design element.

LEON BATTISTA ALBERTI Some of the purest examples of Classical revival in Renaissance architecture are found in the work of Leon Battista Alberti (1404–1472). Among the first to study the treatises of Roman architects—the most famous of whom was Vitruvius—he combined his knowledge of antique buildings with innovative designs in his grand opus, *Ten Books on Architecture*. Alberti is also credited with canonizing Brunelleschi's principles of mathematical perspective in an essay on painting (*Della pittura*). One of

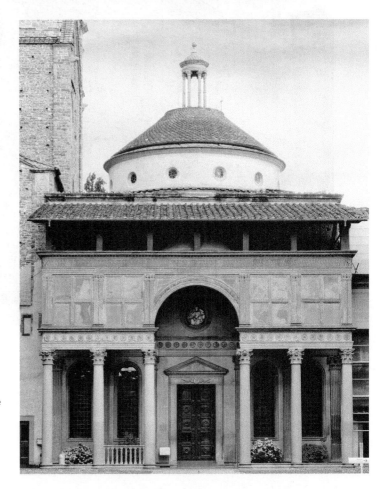

► **12.33 Filippo Brunelleschi, Pazzi Chapel, begun 1433. Santa Croce, Florence, Italy.** Brunelleschi spent countless hours sketching and measuring ancient structures in Rome, particularly in the Forum. The façade of the Pazzi Chapel is an adaptation of a Roman triumphal arch. The Pazzi family is infamous for the conspiracy that led to the murder of Giuliano de' Medici and the wounding of his brother, Lorenzo. In spite of their heinous deed, the Pazzi were allowed to bury their dead family members in the chapel.

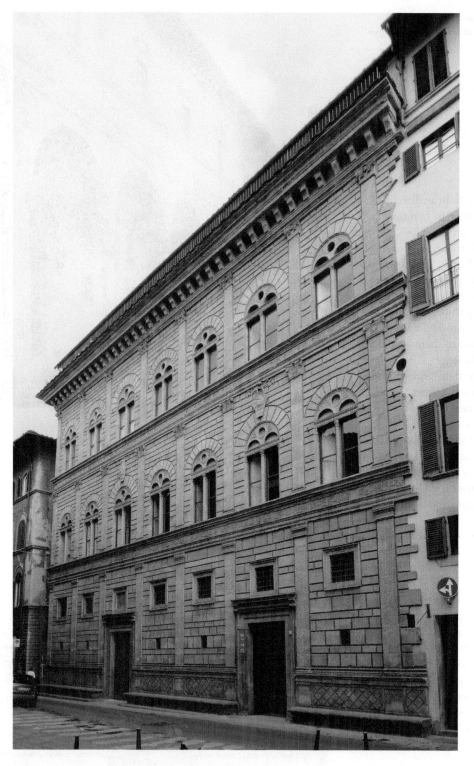

Alberti's most pristine and harmonious designs in the Classical tradition is the Palazzo Rucellai (**Fig. 12.34**) in Florence, an atrium-style palatial residence built around an interior courtyard (see Fig. 12.10). The building has three stories, separated by horizontal entablatures and crowned by a heavy cornice. Within each story, pilasters with capitals of different orders frame the fenestration; they provide a vertical counterpoint to the strong horizontals, as does the vertical alignment of the windows. As the elevation rises from ground level toward the roof, the pattern of the masonry becomes more delicate—smaller-cut stones, placed closer together. The palazzo's design, with its clear articulation of parts, rhythmic repetition, and overall balance and harmony of shape and line, illustrates the degree to which Alberti

internalized Classical design and adapted it successfully to the contemporary nobleman's needs.

In analyzing the art and architecture of 15th-century Italy, certain recurring words and themes offer a clear description of what the Renaissance style reflects: a rejection of the ethereal otherworldliness of medieval artistic traditions in favor of a focus on the natural world; a technical ability to handle space and volume in a credible way; a studious approach to the artistic models of antiquity, especially ancient Rome; and a greater concern for realism in the depiction of human behavior and emotion. The Florentine artistic temperament in particular leaped over its medieval heritage (although not completely) to reaffirm the power of the Classical ideals of the ancients.

MUSIC

By the early 15th century, the force of the Italian Ars Nova movement in music had spent itself. The principal composers of the early Renaissance were from Northern Europe. Strong commercial links between Florence and the North ensured the exchange of ideas, and a new musical idiom that had been developed to please the ear of the prosperous merchant families of the North soon found its way to Italy.

GUILLAUME DUFAY Guillaume Dufay (ca. 1400–1474), the most famous composer of the century, perfectly exemplifies the tendency of music to cross national boundaries. As a young man, Dufay spent several years in Italy studying music and singing in the papal choir at Rome. He later served as music teacher in the French (Burgundian) court of Charles the Good. The works he composed there included masses and motets; he was one of the first composers after Machaut to write complete settings of the Mass. His secular works include several charming **chansons** (songs) that are free in form and expressive in nature.

Among the changes introduced into music by Dufay and his Burgundian followers (many of whom went to Italy for employment) was the secularization of the motet, a choral work that had previously used a religious text. Motets were now written for special occasions like coronations or noble marriages and the conclusions of peace treaties. Composers who could supply such motets on short notice found welcome in the courts of Renaissance Italian city-states.

Dufay was also one of the first composers to introduce familiar folk tunes into the music of the Mass, the best-known example being his use of the French folk tune "L'homme armé" ("The Man in Armor") in a mass that is now named for it. Other composers followed suit, and the so-called *chanson masses* were composed throughout the 15th and 16th centuries. "L'homme armé" alone was used for more than 30 different masses. The intermingling of secular with religious elements is thoroughly in accordance with Renaissance ideals.

Among Dufay's most prominent pupils was the Flemish composer Johannes Ockeghem (ca. 1410–1497), whose music was characterized by a smooth-flowing but complex web of contrapuntal lines generally written in a free style (the lines do not imitate one another). The resulting mood of the music is more serious than Dufay's, partly because of the intellectual complexity of the counterpoint and partly because Ockeghem sought a greater emotional expression. The combination of intellect and feeling is characteristic of the Renaissance striving for Classical balance. Ockeghem's Requiem Mass is the oldest of the genre to survive (Dufay wrote one, but it has not survived).

Music in Medici Florence

The fact that Italian composers were overshadowed by their Northern contemporaries did not in any way stifle Italian interest in music. Lorenzo de' Medici founded a school of harmony that attracted musicians from many parts of Europe, and he had some skill as a lute player. Musical accompaniment enlivened the festivals and public processions of Florence. Popular dance tunes for the *saltarello* and the *pavana* have survived in lute transcriptions.

We know that the Neo-Platonist writer Marsilio Ficino played the lyre before admiring audiences, although he had intentions more serious than mere entertainment. Unlike the visual artists, who had models from Classical antiquity for inspiration, students of music had no Classical models to follow: no Greek or Roman music had survived in any significant form. Still, the ideas about music expressed by Plato and other writers fascinated Ficino and others. Greek music had been patterned after the meter of verse and its character carefully controlled by the mode in which it was composed. The Greek doctrine of ethos is still not fully understood today, but Ficino and his friends realized that Plato and Aristotle regarded music as of the highest moral (and hence political) significance. The closest they could come to imitating ancient music was to write settings of Greek and Roman texts in which they tried to follow the meter as closely as possible. Among the most popular works was Virgil's *The Aeneid*: the lament of Dido was set to music by no fewer than 14 composers in the 15th and 16th centuries.

A more popular music form was the **frottola**, probably first developed in Florence, although the earliest surviving examples come from the Renaissance court of Mantua. The frottola was a setting of a humorous or amorous poem for three or four parts consisting of a singer and two or three instrumentalists. Written to be performed in aristocratic circles, the frottola often had a simple folk quality. The gradual diffusion of frottole throughout Europe gave Italy a reputation for good simple melody and clear vigorous expression.

The **canto carnascialesco** (carnival song) was a specifically Florentine form of the frottola. Written to be sung during the carnival season preceding Lent, such songs were very popular. Even the great Flemish composer Heinrich Isaac wrote some during his stay with Lorenzo de' Medici around 1480. With the coming of the Dominican reformer Savonarola, however, the carnivals were abolished because of their alleged licentiousness.

The songs also disappeared. After the death of Savonarola, the songs were reintroduced, but they died out again in the 16th century.

The tug of war between Classicism and Christianity may be one key to understanding the Renaissance. It may even help us understand something about the character of almost everything we have discussed in this chapter. The culture of the 15th century often was, in fact, a dialectical struggle: At times Classical ideals clashed with biblical ideals; at other times, the two managed to live either in harmony or in a temporary marriage of convenience. The strains of Classicism and Christianity interacted in complex and subtle ways. This important fact helps us understand a culture that produced, in a generation, an elegant scholar like Ficino and a firebrand like Savonarola, a pious artist like Fra Angelico and a precocious genius like Masaccio; a Machiavelli and an Erasmus.

GLOSSARY

Canto carnascialesco (p. 411) A carnival song, written for the carnival season before Lent.

Capitalism (p. 376) A way of organizing the economy so that the manufacture and distribution of goods—and the exchange of wealth—is in the hands of individuals rather than the government.

Chanson (p. 411) Song.

Contrapposto (p. 397) A position in which a figure is obliquely balanced around a central vertical axis; also known as the *weight-shift principle*.

Frottola (p. 411) A humorous or amorous poem set to music for a singer and two or three instrumentalists.

Guild (p. 381) Generally, an association of people with common interests; in medieval times, typically a group of merchants or artisans who sought to maintain their standards and protect their interests.

Polyptych (p. 380) An arrangement of four or more painted or carved panels that are hinged together.

Talmud (p. 388) A collection of Jewish law and tradition created ca. fifth century CE.

Vellum (p. 382) Calfskin, kidskin, or lambskin used as a surface for writing.

THE BIG PICTURE THE FIFTEENTH CENTURY

Language and Literature

- Gutenberg invented moveable printing type in 1446–1450.
- The Gutenberg Bible was printed at Mainz in 1455–1456.
- William Caxton published the first book printed in English, *The Recuyell of the Historyes of Troye*, in 1475.
- Lorenzo de' Medici began *Comento ad alcuni sonetti* ca. 1476–1477.
- Laura Cereta's humanist writings appeared in the latter 1400s.
- Giovanni Pico della Mirandola published *Oration on the Dignity of Man* in 1486.
- Lorenzo de' Medici published "The Song of Bacchus" in 1490.
- Aldus Manutius established the Aldine Press in Venice ca. 1494.
- Niccolò Machiavelli published *The Prince* in 1513.

Art, Architecture, and Music

- Claus Sluter created *The Well of Moses* ca. 1395–1406.
- Lorenzo Ghiberti won the competition for the commission to create the north doors of the Florence Bapistery in 1401.
- Donatello sculpted *Saint George* ca. 1415 and the façade of the Pazzi Chapel in 1433.
- The Limbourg brothers created manuscript illuminations for *Les Très Riches Heures du Duc de Berry* ca. 1413–1416.
- Filippo Brunelleschi designed and began construction of the dome of the Florence Cathedral ca. 1417–1420.
- Brunelleschi began the loggia of the Ospedale degli Innocenti in 1419.
- Gentile da Fabriano painted *Adoration of the Magi* at the Strozzi Chapel in 1423.
- Masaccio painted *The Holy Trinity*, *Tribute Money*, and *Expulsion of Adam and Eve from Eden* ca. 1424–1427.
- Robert Campin painted the Mérode altarpiece ca. 1428.
- Guillaume Dufay, teacher and composer, secularized the motet and popularized chanson masses in the 1430s.
- Ghiberti created the Gates of Paradise in 1425–1452.
- Jan van Eyck painted his Ghent altarpiece in 1432 and *Giovanni Arnolfini and His Wife* in 1434.
- Paolo Uccello painted *The Battle of San Romano* ca. 1456.
- Fra Angelico painted his *Annunciation* ca. 1438–1447.
- Donatello sculpted his *David* ca. 1440–1460.
- Johannes Ockeghem composed his Missa pro Defunctis, the earliest known requiem mass, ca. 1450–1500.
- Leon Battista Alberti built the Palazzo Rucellai ca. 1452–1470.
- Piero della Francesca created his *Resurrection* ca. 1463–1465.
- Andrea del Verrocchio created his sculpture of *David* ca. 1465–1470.
- Sandro Botticelli painted *Adoration of the Magi* ca. 1475, *Primavera* ca. 1482, and *The Birth of Venus* ca. 1484–1486.

Philosophy and Religion

- Marsilio Ficino published *Theologia Platonica* in 1482.
- Girolamo Savonarola began sermons against Florentine immorality in the late 1480s.
- Erasmus published *Enchiridion militis Christiani* in 1502.
- Erasmus published *The Praise of Folly* in 1509.
- Erasmus published the *Greek New Testament* in 1516.

The High Renaissance and Mannerism in Italy

13

PREVIEW

The Italians had a word for awe-inspiring power and grandeur, overwhelming emotional intensity, intractable will, and incalculable rage: *terribilità*. That they used the word to describe two outsized personalities—Pope Julius II and Michelangelo Buonarroti—whose intertwined destinies shaped both history and the history of art and give us insight into the Renaissance papacy, patronage of the arts, and the lust for legacy.

On his fourth attempt to secure the papacy, Giuliano della Rovere, called "il Terribilis," was elected almost unanimously in 1503 by a conclave of cardinals, several of whom he most certainly bribed—heavily. He took the name Julius II, not in honor of the canonized fourth-century pope by the same name but in emulation of Julius Caesar, the great Roman statesman, conqueror, and architect of the future empire. Julius II would become known as the Warrior Pope who brought the Papal States back under control of Rome after the Avignon papacy and who waged military campaigns against the Republic of Venice in partnership with the Holy Roman emperor and the kings of France and Aragon.

Like Caesar, Julius II would aim to glorify Rome, using art and architecture conspicuously to assert his power and wealth and to ensure his legacy. He directed his energies—and funds from the papal treasury—toward several pet projects that would reflect his authority, influence, and personal taste. They included the construction of a new Saint Peter's on the site of Constantine's fourth-century basilica and major works of art for the Vatican. An advocate for and patron of contemporary artists, Julius II was, in the words of the author R. A. Scotti, "a one-man MoMA."[1] In every way, he was larger than life. A Venetian ambassador to the Vatican said: "No one has any influence over him, and he consults few or none....It is almost impossible to describe how strong and violent and difficult to manage he is....Everything about him is on a magnificent scale, both his undertakings and his passions."[2] As it happened, Julius II might have spoken those very words in describing Michelangelo, for their relationship was anything but smooth.

By the time he was 30, the Florentine sculptor Michelangelo had secured his position as the hottest artistic commodity in Italy. With at least two significant, attention-getting works under his belt—the *Pietà* in a chapel in Old Saint Peter's Basilica and the *David* in the Piazza della Signoria in Florence—Michelangelo was destined for work in Rome. That was where power and the money were. And that is where Julius II would use him to realize his grand plans—beginning with his own funerary monument, a massive freestanding pyramidal structure with 40 carved figures to be placed in none other than the basilica of Saint Peter's. It was the commission of a lifetime,

◄ 13.1 Michelangelo, *Moses*, detail, 1513–1515. Marble, 92 ½" (235 cm) high. San Pietro in Vincoli, Rome, Italy.

1. MoMA is the acronym for the Museum of Modern Art in New York City.
2. Quoted in R. A. Scotti, *Basilica: The Splendor and the Scandal; Building St. Peter's* (New York: Penguin, 2006), p. 4.

and Michelangelo threw himself into the project with passion and zeal. But while the sculptor was away from Rome choosing perfect, creamy-white marble from the quarries in Carrara (his favorite material), Julius turned his attention to something even grander: a new Saint Peter's. Julius's choice of the architect Donato Bramante—a longtime bitter rival of Michelangelo—and sporadic provision of adequate funds for the tomb project caused tension and, eventually, outright conflict. Worst, perhaps, was the fact that Michelangelo was not getting the attention from the pope to which he was accustomed, and Julius II made a habit of adding insult to injury by granting several important commissions to his competitors. Michelangelo's rage, obstinacy, and moodiness—and the legendary temper of Julius II—amounted to a clash of titans.

Completion of the tomb plagued Michelangelo throughout Pope Julius II's reign (Julius's other "side projects" for the artist included the Sistine Chapel ceiling fresco), and things would not improve after the pontiff's death. Subsequent popes wanted to harness Michelangelo's talent for their own projects and purposes; very few were interested in glorifying their dead predecessor, particularly with a mammoth monument-tomb in as high profile a place as Saint Peter's. In the end, a completed work—much diminished from its first, grand design—was erected in the church of San Pietro in Vincoli (that is, "Saint Peter in Chains") where it can still be seen today. Julius, who always intended to have his remains interred in Saint Peter's, is indeed buried there—alas, beneath the floor, his grave marked by a simple inscription carved in marble.

The masterwork of the monument to Pope Julius II is Michelangelo's *Moses* (Fig. 13.1), a portrait of the great Hebrew prophet and lawgiver fresh from his communion with God, gripping the tablets inscribed with the Ten Commandments, glowering in fury at the idolaters about to be destroyed. A figure of awesome might, uncompromising will, fearsome temperament,

and unwavering belief—he is the artistic embodiment of *terribilità*. In his face, we see Julius; we see Michelangelo.

THE SIXTEENTH CENTURY IN ITALY: POLITICS, POPES, AND PATRONAGE

Culturally, one could argue that the Renaissance in Italy affected the daily lives of only the few. Pope Martin V returned the papacy to Rome in 1420, but much of the city was poor and in ruins from its history of invasions, the loss of its position as the seat of the papacy during the "Babylonian Captivity," and the fallout of the Great Schism. But the century between Pope Martin's move back to Rome and the Holy Roman Emperor Charles V's (r. 1519–56) sack of Rome in 1527 was a period of growth and renewal and the return of power to the hands of the papacy.

That said, the 16th century witnessed a continuation of wars among the city-states, the most prominent among them Milan, Florence, Siena, Genoa, Venice, Naples, and the Papal States—territories in central and northern Italy as well as France that were directly controlled by the pope (see Map 13.1). As leader of the faith, the pope held ecclesiastical power but, as a head of state, he also held temporal power. The papacy had governed territories in central Italy from the Middle Ages (ca. 756) and securing and defending these holdings was a priority; Pope Julius II led armies to do so over and over again. Territories under the control of the papacy in Rome continued into the 19th century; the last Papal State, which we know as Vatican City, was established in 1929. Although the territory is located within the geographical boundaries of the city of Rome, it is a separate country.

The High Renaissance and Mannerism in Italy

1471 CE	1501 CE	1520 CE	1600 CE

Reign of Pope Sixtus IV (della Rovere)

Columbus lands in the Americas

Foreign invasions of Italy begin

Leonardo da Vinci paints *The Last Supper*

Michelangelo sculpts *David*

Leonardo da Vinci paints *Mona Lisa*

Reign of Pope Julius II (della Rovere)

Michelangelo paints the ceiling of the Sistine Chapel

Venetian trade declines as a result of new geographic discoveries

Reign of Pope Leo X (de' Medici)

Reformation begins in Germany with Luther's 95 Theses challenging the practice of granting indulgences

Reign of Pope Clement VII (de' Medici)

Sack of Rome by Charles V

Churches of Rome and England separate

Titian paints *Venus of Urbino*

Council to reform the Catholic Church begins at Trent

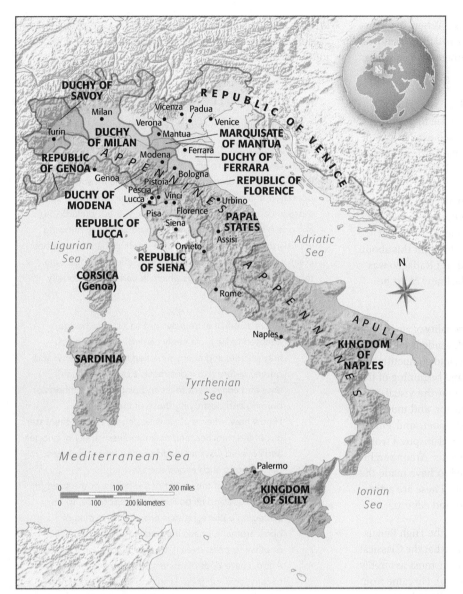

◄ **MAP 13.1** **Italy in the early 15th century.**

coffers of papal patronage in Rome. Pope Sixtus IV (r. 1471–1484) had commissioned many eminent Florentine artists—among them Ghirlandaio, Botticelli, and Perugino—to paint the walls of a new Papal Chapel (the Sistine) named after himself, as well as to work on other projects that caught his artistic fancy. Not the least of these was the enlargement and systematization of the Vatican Library.

The period known as the High Renaissance really began, however, in 1503, when a cardinal nephew of Sixtus IV, Giuliano della Rovere, succeeded the Spanish pope, Alexander VI (Borgia) to become Pope Julius II. As we noted in the opening of this chapter, Julius was a fiery man who did not hesitate to don full military armor over his vestments to lead his papal troops into battle. But he also summoned both Michelangelo and Raphael to Rome to glorify the Church—and his papal reign—in art and architecture.

It should be noted that although the papal court of the Vatican in Rome became the preeminent center of arts and culture in 16th-century Italy, patronage—and power politics—did not stop elsewhere. In Florence, the Medici dynasty's political influence waned but was far from over. The territory of Florence expanded, becoming the Grand Duchy of Tuscany in 1569. Between 1523 and 1605, the Medici family produced four popes and a queen of France (Catherine de' Medici, who reigned from 1547 to 1559). Their second queen of France, Marie de' Medici, reigned at the beginning of the 17th century, from 1600 to 1610. They remained serious patrons of the arts, competing with the Sforza and Visconti families in Milan, the Gonzagas in Mantua, and foreign monarchs for the services of Italy's most renowned artists. But the twin gravitational fields of patronage and the Church were inexorably pulling the center of the art world toward Rome.

THE VISUAL ARTS

The High Renaissance ushered in a new era for the most sought-after artists—one of respect, influence, fame, and, most important, the power to shape their circumstances. Here is an example: Sometime in 1542, Julius II and Michelangelo were in the midst of one of their many conflicts, and the artist was feeling the brunt of the pope's rage. Julius seemed to be backing out of the tomb project and was refusing to pay Michelangelo

The papacy in the 15th and 16th centuries was awash in powerful family names who used their influence—and often, money—to secure the papal seat: Colonna (Martin V), della Rovere (Sixtus IV and Julius II), Farnese (Pope Paul III), Medici (Leo X, Clement VII). Starting with Julius II, Michelangelo worked for all of them—and others. As Rome proceeded to claim its position as the capital of a unified church and Christendom's most important (and lucrative) pilgrimage destination, the Renaissance popes projected their power as patrons of the arts and letters. Inspired by classical architecture, the discovery and collection of ancient art, and the classics of Greek and Latin literature, under their leadership, Rome became a center of artistic excellence, humanist learning, and the revival of all things antiquity. If you were an intellectual or an artist in the 16th century, Rome was the place to be.

By the second half of the 15th century, artists already were chasing opportunity as it shifted from the generous and refined **patronage** of powerful Florentine families to the even deeper

for the materials he had already purchased. When the artist sought to redress these grievances, Julius had him removed from the Vatican. Michelangelo let his outrage be known—as well as his suspicions:

> A man paints with his brains and not his hands, and if he cannot have his brains clear he will come to grief. Therefore I shall be able to do nothing well until justice has been done me.... As soon as the Pope [carries] out his obligations towards me I [will] return, otherwise he need never expect to see me again.
>
> All the disagreements that arose between Pope Julius and myself were due to the jealousy of Bramante and of Raffaello da Urbino; it was because of them that he did not proceed with the tomb,...and they brought this about in order that I might thereby be ruined. Yet Raffaello was quite right to be jealous of me, for all he knew of art he learned from me.[3]

This passage offers us a good look at the personality of an artist of the High Renaissance. He was in demand, independent, and indispensable—and could be arrogant, aggressive, and competitive.

In Italy at the end of the 15th century and beginning of the 16th, three artists dominated the discourse on the visual arts: Leonardo da Vinci, a painter, scientist, inventor, and musician; Michelangelo, a painter, sculptor, architect, poet, and enfant terrible; and Raphael, a painter whose classical-inspired works were thought to have rivaled those of the ancients. Among architects, it is Donato Bramante who is deemed to have made the most significant contributions of this period. These are artistic descendants of Giotto, Donatello, Masaccio, and Alberti.

LEONARDO DA VINCI If the Italians of the High Renaissance could have nominated a counterpart to what the Classical Greeks referred to as the "four-square man," it most assuredly would have been Leonardo da Vinci (1452–1519). He came from Vinci, a small Tuscan town near Florence, but lived in Florence proper until the 1480s when he left for Milan. From there, he moved from place to place until his death in France—the country in which he is buried.

Leonardo's capabilities in engineering, the natural sciences, music, and the arts seemed unlimited, as he excelled in everything from solving mundane drainage problems (a project he undertook in France just before his death) and designing prototypes for airplanes and submarines, to creating some of art history's most iconic paintings.

We know that in about 1481, Leonardo looked for work with Ludovico Sforza, the son of the Duke of Milan. Just as we sometimes tailor our résumés to coincide with the job we are seeking, so too did Leonardo write his letter of introduction stressing those talents that he felt might be of greatest interest to Sforza—designing instruments of war—and mentioning just briefly his

artistic abilities. Leonardo's application (see Reading 13.1) was accepted, and he left Florence for Milan in 1482 where he stayed for the next 17 years.

READING 13.1 LEONARDO DA VINCI

Letter of Application to Ludovico Sforza (ca. 1481)

Most Illustrious Lord, Having now sufficiently considered the specimens of all those who proclaim themselves skilled contrivers of instruments of war, and that the invention and operation of the said instruments are nothing different from those in common use: I shall endeavor, without prejudice to any one else, to explain myself to your Excellency, showing your Lordship my secrets, and then offering them to your best pleasure and approbation to work with effect at opportune moments on all those things which, in part, shall be briefly noted below.

1. I have a sort of extremely light and strong bridge, adapted to be most easily carried, and with it you may pursue, and at any time flee from the enemy; and others, secure and indestructible by fire and battle, easy and convenient to lift and place. Also methods of burning and destroying those of the enemy.
2. I know how, when a place is besieged, to take the water out of the trenches, and make endless variety of bridges, and covered ways and ladders, and other machines pertaining to such expeditions.
3. If, by reason of the height of the banks, or the strength of the place and its position, it is impossible, when besieging a place, to avail oneself of the plan of bombardment, I have methods for destroying every rock or other fortress, even if it were founded on a rock, etc.
4. Again, I have kinds of mortars; most convenient and easy to carry; and with these I can fling small stones almost resembling a storm; and with the smoke of these cause great terror to the enemy, to his great detriment and confusion.
5. And if the fight should be at sea I have kinds of many machines most efficient for offense and defense; and vessels which will resist the attack of the largest guns and powder and fumes.
6. I have means by secret and tortuous mines and ways, made without noise, to reach a designated spot, even if it were needed to pass under a trench or a river.
7. I will make covered chariots, safe and unattackable, which, entering among the enemy with their artillery, there is no body of men so great but they would break them. And behind these, infantry could follow quite unhurt and without any hindrance.
8. In case of need I will make big guns, mortars, and light ordnance of fine and useful forms, out of the common type.
9. Where the operation of bombardment might fail, I would contrive catapults, mangonels, trabocchi,

3. Michelangelo Buonarroti, *Michelangelo: A Record of His Life as Told in His Own Letters and Papers*, trans. Robert W. Carden (Boston and New York: Houghton Mifflin Company, 1913), p. 201.

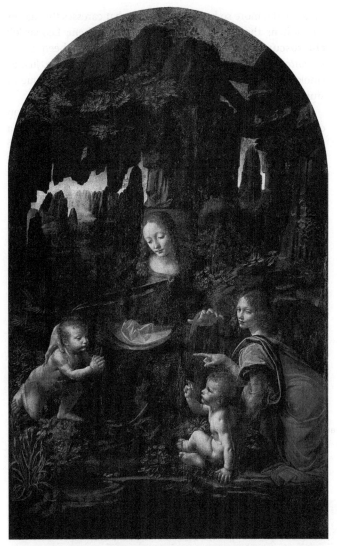

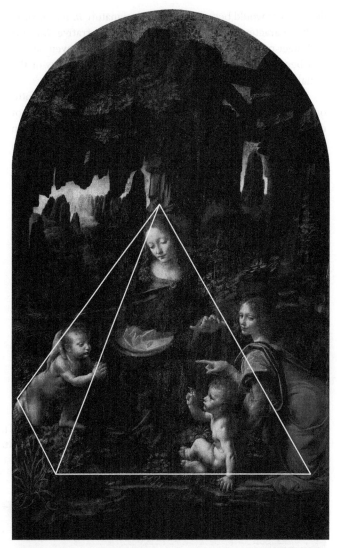

▲ **13.2A** Leonardo da Vinci, *Madonna of the Rocks*, ca. 1483–1490. Oil on panel, transferred to canvas, 78 ¼" × 48" (199 × 122 cm). Musée du Louvre, Paris, France. The *Madonna of the Rocks* was commissioned as the central painting for an altarpiece for a church in Milan. Leonardo did not comply with the deadline, and lawsuits followed.

▲ **13.2B** The pyramidal structure of Leonardo da Vinci's *Madonna of the Rocks.* The favorite compositional device of the Renaissance painter was the triangle (or pyramid). It provided a focal point as well as stability to figural groups.

and other machines of marvelous efficacy and not in common use. And in short, according to the variety of cases, I can contrive various and endless means of offense and defense.

10. In times of peace I believe I can give perfect satisfaction and to the equal of any other in architecture and the composition of buildings public and private; and in guiding water from one place to another.

11. I can carry out sculpture in marble, bronze, or clay, and also I can do in painting whatever may be done, as well as any other, be he who he may. Again, the bronze horse may be taken in hand, which is to be to the immortal glory and eternal honor of the prince your father of happy memory, and of the illustrious house of Sforza.

And if any of the above-named things seem to anyone to be impossible or not feasible, I am most ready to make the experiment in your park, or in whatever place may please your Excellency—to whom I commend myself with the utmost humility, etc.

Leonardo only left us about 30 paintings—an exceptionally small number for a Renaissance artist of such stature. One of his earliest was completed in Milan soon after his arrival. *Madonna of the Rocks* (**Fig. 13.2A**) was commissioned as part of an altarpiece for the chapel of the Confraternity of the Immaculate Conception in the church of San Francesco Grande. In it we

detect what would become Leonardo's signature *humanization* of the characters in Christianity's dramatic narrative: Mary is no longer portrayed as the venerated Queen of Heaven (as she had been during the Middle Ages and the early years of the Renaissance); she is a mother, she is human, she is "real."

But the visual representation of Mary as a mother in a grotto on an outing with her son and his cousin, John the Baptist, is not the only aspect of this painting that creates a more human vision of the Madonna. The dramatic tableau that Leonardo stages is the thing that makes the painting remarkable. We cannot be sure of the actual meaning of the painting, but the action and inter-connected gestures compel us to interpret what may be going on. Mary is the centerpiece of the composition (see **Fig. 13.2B**). She extends her arms outward toward the two boys, placing her arm around John (on the left, kneeling and praying) and reaching for Jesus (in the right foreground, sitting with one hand raised in an attitude of blessing). Her left hand might have reached her son were it not for the hand of an angel that interrupts the contact with a pointed finger. The boys look at one another, the angel looks at us, and Mary looks downward, her head cocked to one side. How do we read her expression? Sadness? Resignation? Perhaps both. Does the angel's gesture represent the Word of God that will prevent Jesus's mother from protecting him as he fulfills his destiny as Redeemer? The moment is a tender one,

made all the more so by the warm light that caresses the figures and softens the atmosphere that surrounds them. Leonardo's **chiaroscuro**—his use of light and shadow—has been called *sfumato*, from the Italian word "fumo" meaning smoke. Just as smoke obscures the edges of things, so does the technique of sfumato create a blurry, soft, or vague effect.

Leonardo's compositional scheme emerged as a common one during the High Renaissance. The figures are placed in a triangular (or pyramidal) configuration: Mary's head is in the apex of the triangle, her arms and, in extending the line there-from, the backs of John and the angel, form the two sides of the triangle, and the horizontal of the ground line at the water's edge forms the base. These actual lines are complemented by implied lines that connect Mary's sideward glace toward John, her left hand to the top of Jesus's head, the glances of the two cousins, and the angel's glance toward us—the viewers—outside of the picture space. These implied lines create the action—the movement, the energy—in the piece and are balanced by the stabilizing (actual) lines of the compositional triangle.

The *Last Supper* (**Fig. 13.3**), commissioned by Ludovico Sforza for the refectory (dining room) of the convent of the church of Santa Maria delle Grazie in Milan stands as one of Leonardo's greatest works. The condition of the work is poor because of his experimental fresco technique—although the

▼ **13.3 Leonardo da Vinci, *The Last Supper*, ca. 1495–1498. Fresco (oil and tempera on plaster), 15' 1" × 28' 10" (460 × 880 cm). Refectory, Santa Maria delle Grazie, Milan, Italy.** There had been many paintings on the subject of the Last Supper, but the people in Leonardo's composition are individuals who display real emotions. They converse with one another animatedly, yet most heads are turned toward Jesus, focusing the viewer's attention of the center of the composition.

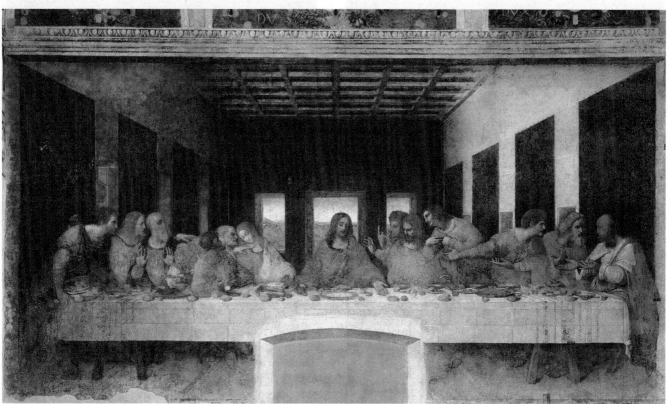

humidity in Milan certainly has been a contributing factor in its deterioration over time. A 21-year-long restoration of the mural (1978–1999) was undertaken to remove centuries of grime and overpainting and to stabilize what was left of Leonardo's brushwork. Unlike the fresco paintings you have seen in previous chapters, the *Last Supper* was painted not on wet plaster (*buon fresco*) but on dry plaster (*fresco secco*). An advantage of buon fresco is that the paint is absorbed into the plaster and the two dry simultaneously. Leonardo chose to paint on dry plaster, in all likelihood to duplicate the spontaneous effect of painting on wood, but the mural began to flake not long after it was completed. In spite of its condition, however, we can perceive the Renaissance ideals of Classicism, humanism, and technical perfection that came to full fruition in the hands of Leonardo. The composition is organized through the use of one-point linear perspective. Solid volumes are constructed from a masterful contrast of light and shadow. A hairline balance is struck between emotion and restraint.

The composition of the *Last Supper* is one of near absolute symmetry, with Jesus positioned as the fulcrum to the left and right of which are six animated—one could say agitated—apostles. All of the lines in the composition (**orthogonals**) converge at a single point on the horizon, seen in the distance through the center of three windows behind Jesus. Our attention is held by His isolation; the apostles lean away reflexively at His accusation that one among them will betray Him. Incredulous, they gesture expressively and turn to one another—and to Jesus—for answers. "Who can this be?" "Is it I?" It is a testament to Leonardo's convincing portrayal of human reaction and emotion that we find ourselves imagining their dialogue. The guilty one, of course, is Judas, shown, elbow on the banquet table, clutching a bag of silver pieces at Jesus's left. The two groups of apostles are subdivided into four clusters of three, pacing the eye's movement along the strong horizontal line of the table. At the ends, left and right, the "parenthetic" poses of the men coax the viewer back inward to Jesus at the center. Leonardo's exacting use of perspective and his subtle balance of motion and restraint represent two significant aspects of Renaissance composition.

The misty, hazy atmosphere and mysterious landscape of the *Madonna of the Rocks*, deftly handled chiarsoscuro, and the cryptic expression on the face of the Virgin Mary, were still in Leonardo's pictorial repertory when he created what is arguably the most famous portrait in the history of art—the *Mona Lisa* (**Fig. 13.4**). It is a portrait of Lisa di Antonio Maria Gherardini, commissioned by her banker-husband, Francesco del Giocondo. The portrait, which is sometimes referred to as "La Gioconda" takes its name from the Italian contraction of the words "ma donna (*my lady*) Lisa." What is it about this portrait that has contributed to its iconic status? To begin with, it is one of his relatively few completed paintings. With his *Mona Lisa*, Leonardo modernized portraiture: he replaced the typical profile view of a sitter with a natural three-quarter-turned body position by which a visual dialogue could be established between the sitter and all of us outside of the picture space. He departed from convention by fixing the sitter's confident eyes on the viewer when it would have been considered inappropriate for a woman to look directly into the eyes of a man. For Leonardo, the face (particularly the eyes) and the hands (their placement and gestures) conveyed much about the personality of the sitter, inviting us to "know" them rather than just to see them. That invitation is accepted by about 6 million people per year who see her

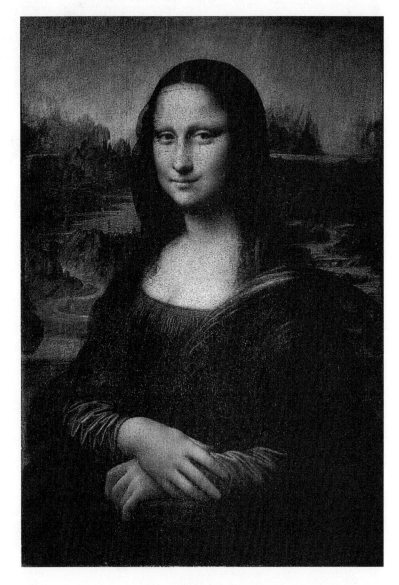

▶ **13.4 Leonardo da Vinci, *Mona Lisa*, ca. 1503–1505. Oil on wood panel, 30¼" × 21" (77 × 53 cm). Musée du Louvre, Paris, France.** *Mona Lisa* has been called the most famous portrait in the world, even the most famous painting. The sitter's face, subtly modeled with gradations of color, has been called inscrutable. Is her gaze engaging the viewer or perhaps the artist? The gentle repose of her hands has been considered exquisite. The scenic backdrop is fantasy.

at Paris's Louvre museum who may wonder about who might be the object of her glance or what conversation brings a mysterious smile to her lips. Leonardo was a master of the fine line between revealing and concealing, and thus our interpretation of the painting is limited only by our capacity to imagine. The American singer-songwriter Bob Dylan wrote that "Mona Lisa must have had the highway blues; you can tell by the way she smiles."

If we had been bequeathed nothing but Leonardo's *Notebooks*, we would still say that he had one of humanity's most fertile minds. By means of his sketches, one could say that he "invented" flying machines, submarines, turbines, elevators, ideal cities, and machines of almost

CONNECTIONS Leonardo's *Notebooks* were comprised of leaves of paper, a relatively new drawing material that was introduced to Italy in the late 15th century, fast on the heels of Gutenberg's first printing press. Until that time, artists made drawings on either parchment or vellum—both derived from animal skins. The material was expensive to produce and thus drawings were made with great attention and precision; the idea of quick, experimental sketches would have been out of the question. But in the late 15th century, the process of creating paper from pulp in great quantities made the material affordable and, with that, drawings became extremely common—a vital part of the artist's conceptual and creative process.

Papermaking came late to Europe. Archaeologists date the invention of papermaking to China some 2000 years ago. The Chinese closely guarded the secret of paper manufacturing, but it eventually spread to the rest of the world via the Silk Road. Arabs, who learned papermaking from the Chinese and created a paper industry in Baghdad as early as 793, also kept the process secret. It was not until 1150 that paper arrived in Spain from North Africa as a result of the Crusades.

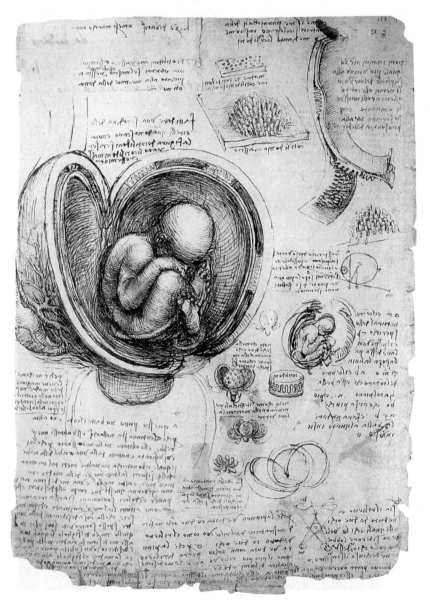

every description. His knowledge of anatomy was unsurpassed (he came close to discovering the circulatory path of blood), and his interest in the natural worlds of geology and botany was keen. The *Notebooks*, in short, reflect a restlessly searching mind that sought to understand the world and its constituent parts. Leonardo's investigations were driven by an obsession with science and mathematics, a deep respect for the natural world, explorations into the psychology of human behavior, and a love for beauty—interests that were part and parcel of the Renaissance spirit. A page from Leonardo's *Notebooks* (**Fig. 13.5**) shows one of the first drawings of a human fetus and lining of the uterus. Typical for his notebook pages are copious annotations that fill virtually every square inch of space, along with myriad smaller drawings of different things and thoughts.

RAPHAEL SANZIO Raphael Sanzio (1483–1520) was born in Urbino, a center of humanist learning east of Florence dominated by the court of the Duke of Urbino. His precocious talent was first nurtured by his father, a painter, whose death in 1494 cut short the son's mentoring. The young Raphael then went to Perugia as an apprentice to

◀ **13.5 Leonardo da Vinci, anatomical drawing, medical studies of the human body, 1509–1514. Black and red chalk, pen and ink wash on paper, 12" × 8⅝" (30.5 × 22 cm). Royal Library, Windsor Castle, London, United Kingdom.** Leonardo's anatomical drawings show great drafting skill, but the slight scientific inaccuracies reflect the state of knowledge of his day.

One of Raphael's most outstanding works—and certainly one of the most important for defining the meaning of the 16th-century Renaissance in Rome—is a fresco painted in 1510–1511 on a wall of the Stanza della Segnatura, a room in the papal apartments that was originally used by Julius as a library and private office. The iconographic program of the frescoes concerns the education of a contemporary pope; *The School of Athens* (**Fig. 13.8A**), which occupies one full wall of the square room, represents philosophy; the others symbolize law, theology, and poetry.

Philosophy (The School of Athens) portrays an imagined gathering of the great minds of antiquity in an immense vaulted space that must have been inspired by the impressive ruins of Roman baths and basilicas, and perhaps the work new Saint Peter's, then under construction. The central figures, framed by the most distant of a succession of arches, are the two giants of Classical-era philosophy—Aristotle (on the right) and his mentor, the elder Plato (on the left). On a par with one another as they stride toward us, the two are flanked to either side by those whose views of the world and accomplishments were framed by their distinct philosophies: Plato's theory of Forms and concern with the mysteries that transcend human experience, and Aristotle's belief that knowledge is rooted in empirical observation. By virtue of their attributes, some of the figures have been identified, and several feature portraits of contemporary artists who allied with these competing philosophies. In the left foreground—on Plato's side—we see Pythagoras making notes while a younger man, standing before him, displays the harmonic scale. Sprawled on the steps in a blue garment is the Cynic philosopher, Diogenes, and the pendant figure to Pythagoras on the opposite side—Aristotle's side—is Euclid, who bends over a slate with a compass to demonstrate a theorem. This is thought to be a portrait of the architect, Bramante, a great supporter of Raphael's. Above his head, echoing its round,

▼ **13.8A** Raphael, *Philosophy (The School of Athens)*, 1509–1511. Fresco, 25' 3" × 18' (770 × 548 cm). **Stanza della Segnatura, Stanze di Raffaello, Vatican Palace, Vatican City State, Italy.** The central figures represent Plato and Aristotle. The man in the forefront is believed to be Michelangelo resting his head on his fist. This is no static portrait: people move about in all directions, some with their backs turned to the viewer. One tries to scribble in a notebook held precariously on his raised knee.

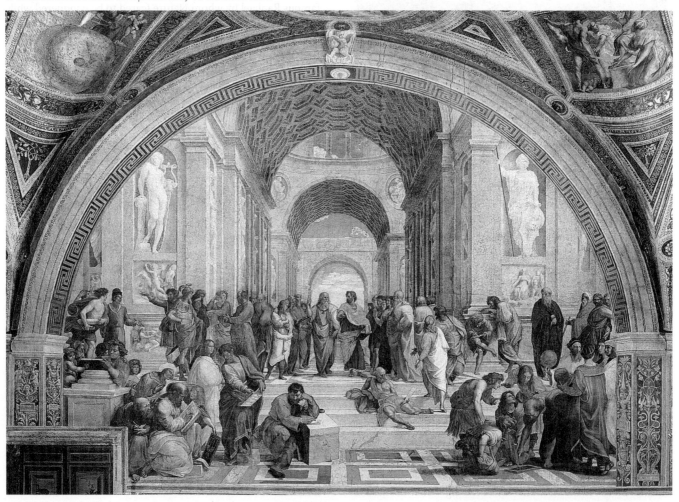

◄ 13.8B Raphael, *Philosophy (The School of Athens)*, 1509–1511. Fresco (detail), 25'3" × 18' (770 × 548 cm). Stanza della Segnatura, Stanze di Raffaello, Vatican Palace, Vatican City State, Italy. Raphael included a self-portrait in the lower right corner of the fresco, placing himself firmly within the rationalist tradition of Aristotle.

balding pate, are the two astronomers, Zoroaster and Ptolemy (see detail, **Fig. 13.8B**), both holding globes. Just beyond their right, tucked into the corner and staring out at us in a black velvet hat, is Raphael himself—soundly placed in the company of the Aristotelians.

Raphael's *Philosophy (The School of Athens)* could be seen as a textbook exercise in linear perspective (**Fig. 13.8C**), with all of the compositional lines above and below the horizon converging at a single point, waist-level, between Plato and Aristotle. The compulsively ordered space acts as a stable foil for the myriad gestures and body positions of the assembly of humanist celebrities.

That such a fresco should adorn a room in the Vatican, the center of Christian authority, is not difficult to explain. The papal court of Julius II shared the humanist conviction that philosophy is the servant of theology and that beauty, even if derived from a pagan civilization, is a gift from God and not to be despised. To underscore this point, Raphael's homage to theology across the room, his fresco called the *Disputà*, shows in a panoramic composition similar to *Philosophy (The School of Athens)*, the efforts of theologians to penetrate divine mystery.

Finally, in the lower center of Raphael's *Philosophy (The School of Athens)* is a lone figure leaning an elbow on a block of marble and scribbling, taking no notice of the exalted scene about him. Strangely isolated in his stonecutter's smock, the figure has recently been identified, at least tentatively, as Michelangelo. If this identification is correct, this is the younger artist's homage to the solitary genius who was working just a few yards away from him in the Sistine Chapel.

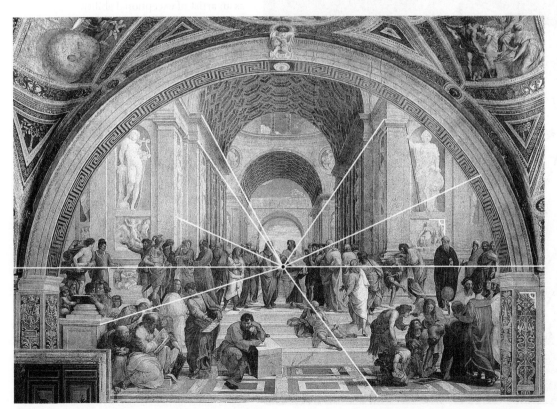

◄ 13.8C One-point perspective in Raphael's *Philosophy (The School of Athens)*. In one-point perspective, parallel lines converge at a single vanishing point on the horizon.

MICHELANGELO BUONARROTI Of the artists considered to be the three great figures of the arts of the Italian Renaissance, Michelangelo Buonarroti (1475–1564) is probably most familiar to us. During the 1964 World's Fair in New York City, hundreds of thousands of culture seekers and devout pilgrims were trucked along a moving walkway for a brief glimpse of his *Pietà* at the Vatican Pavilion. A year later, Hollywood captured the saga of the Sistine ceiling and the relationship between Pope Julius II and Michelangelo in a film version of Irving Stone's 1961 biographical novel, *The Agony and the Ecstasy* (1961). More recently, Ross King's impeccably researched *Michelangelo and the Pope's Ceiling* (2003) brought the complicated history of the project and the relationship between the two men to light again in his definitive book.

Michelangelo's first apprenticeship was in the studio of the Florentine painter, Domenico Ghirlandaio, but one might say that his education as an artist began in earnest when he was brought into the circle of Lorenzo de Medici. It was through this lofty connection that he first studied sculpture. He might have stayed in Florence for a while but, with Lorenzo's death in 1492 and the subsequent demise of Medici supremacy, Michelangelo left the city for Venice. He made his way to Rome in 1496. Two years later, he created the **Pietà** (**Fig. 13.9**), his first work for a Roman patron—a French cardinal living in Rome.

The subject, the Virgin Mary holding her dead son in her lap, was a common theme in French and German art. Yet Michelangelo's rendering of the subject displays a profound sensitivity and as yet unparalleled mastery of textural effects in his handling of the marble. But beyond technique, Michelangelo introduced an aspect of his approach to the human form that digressed from both Leonardo's and Raphael's calculated ideal. He was more interested in practice than theory—more interested in what his eyes told him about the totality of the form than in any systems by which he might perfect it. How is this evident in the *Pietà*? An exacting observer might wonder how it is that Mary, so slight in frame, can believably cradle a fully grown man in her lap as if she were holding a sleeping child. The answer is that Michelangelo manipulated the proportions of the figure to make it work visually. The lower part of Mary's body, concealed beneath voluminous drapery, appears to have expanded to accommodate the body of Christ.

If Leonardo's *Mona Lisa* is one of the best-known paintings in Western art, in the medium of sculpture, Michelangelo's *David* (**Fig. 13.11**) is certainly one of the best-known sculptures—if not the best-known. It was commissioned upon Michelangelo's return to Florence in 1501, and the artist worked on a massive piece of Carrara marble that had lain abandoned behind the cathedral in Florence since the middle of the preceding century. For Michelangelo, as he described his creative process, the task was to see the form within the block of stone and to liberate it—to remove the material that surrounded and "imprisoned" it. He succeeded in doing just that with *David*, cementing his reputation as an artist of exceptional ability.

By the time Michelangelo crafted his own *David*, earlier versions of the biblical hero had been on display in Florence for several years— one by Donatello (see Fig. 12.16) and the other by Verrocchio (see Fig. 12.17). Michelangelo departed from these forerunners in many ways. His David is older, more mature—someone who does not simply fulfill his destiny but writes it. Donatello and Verrocchio depict him after he fells the giant with his slingshot and beheads him with a sword; the severed head lies at the youth's feet. Michelangelo gives us

◄ **13.9** Michelangelo, *Pietà*, 1498–1499. Marble, 69" (175 cm) high. Saint Peter's, Vatican City State, Italy. Michelangelo's *Pietà*, like those that preceded it, shows the Virgin Mary holding her dead son, Jesus, in her lap. Although it is an intensely religious work, it stirred controversy because Mary is portrayed as beautiful and not mature enough to have an adult son. Michelangelo countered that her beauty represented her purity. Julius II endorsed the sculpture by commissioning Michelangelo to create several other works after viewing the *Pietà*.

CONNECTIONS Forty-one years after Laszlo Toth jumped over a railing in Saint Peter's Basilica and attacked Michelangelo's *Pietà* with a hammer, the Vatican Museums held a seminar on the statue and on the controversies that arise over how (and why) damaged works of art should be restored. Toth had struck the figure of the Madonna 12 times, knocking off her left hand and arm completely and smashing her nose and the back of her head. At least 100 marble fragments had lain strewn on the floor of the chapel where the *Pietà* was displayed. One would think that restoring it would have been a simple, uncontested decision, but it was not. Some felt that the statue should remain in its damaged state as a reminder of the attack. Some thought that it should be repaired but that the missing pieces should be filled in with a material that would make them obvious. In the end, the *Pieta* was restored to the look of the original (using so-called integral restoration), reattaching pieces that remained and infilling the missing pieces with their equivalents, which were created from molds of an existing, full-scale copy of the statue. A Reuters reporter wrote, "restorers painstakingly pieced together the chunks and fragments, including one that arrived anonymously from the United States. A tourist who was in the basilica picked up a piece in the confusion as the police were arresting Toth. The tourist later apparently felt guilty and mailed it back [to the Vatican]."*

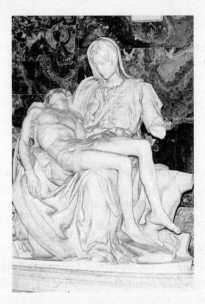

▲ 13.10 Michelangelo's *Pietà*, shown after the attack.

* Philip Pullella. (2013, May 21). Vatican marks anniversary of 1972 attack on Michelangelo's Pieta. http://www.reuters.com/article/us-vatican-pieta-idUSBRE94K0KU20130521.

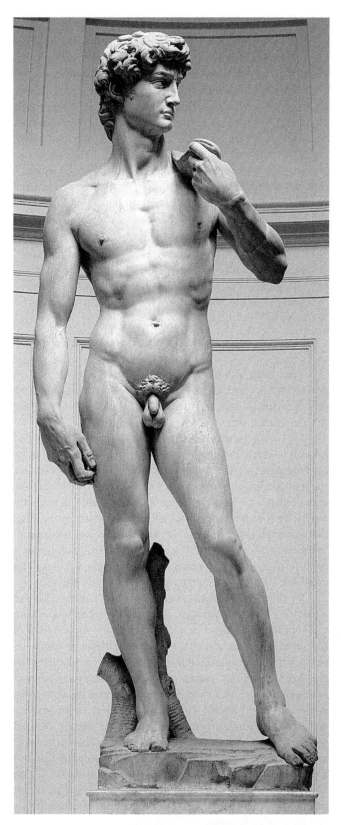

▲ 13.11 Michelangelo, *David*, 1501–1504. Marble, 14'3" (434 cm) high. Galleria dell'Accademia, Florence, Italy. David's weight is shifted to his right leg, causing a realignment of his body and lending to the realism of the sculpture. True, he stands there, but he is certainly not inert. He is contemplating his attack on the giant Goliath, and we imagine him pulling the sling from his shoulder and unleashing its missile.

David before the deadly encounter. He stares intently at his enemy, his knitted brows reflecting the inner workings of his razor-sharp mind. Michelangelo captures David caught in the moment between choice and action with what would become a signature physical and emotional tension. The sculptor's portrayal of the body at rest (with flawless contrapposto) compels our eyes to linger, to take in the details of David's splendid form. Michelangelo's version of David is a perfect reflection of the humanist notion that human beings are at the center of the universe, the "measure of all things." A century after Michelangelo carved his *David*, William Shakespeare would pen some of his most famous lines in a reflection on humankind conveyed through the character of Hamlet:

> "What a piece of work is man! How noble in reason, how infinite in faculty! In form and moving how express and admirable! In action how like an angel, in apprehension how like a god! The beauty of the world. The paragon of animals."

> WILLIAM SHAKESPEARE, *HAMLET*, ACT 2, SCENE 2

The statue was placed outside the Palazzo Vecchio as a symbol of the civic power of the city, where it remained until ongoing damage from weather and pollution led to its transfer to a museum in 1873.

Michelangelo was called back to Rome in 1505 by Pope Julius II to create the monumental tomb we spoke about in the opening pages of this chapter. According to Ascanio Condivi, the artist's biographer, it was to be a three-story structure replete with perhaps 47 figures glorifying Julius's spiritual and temporal power: Victory, bound captives, allegorical figures representing the active and contemplative life, and larger-than-life-size statues such as *Moses* (**Fig. 13.12**), the only one by Michelangelo's hand to make it into the final, much-diminished design. The crowning glory likely would have been the Pope's effigy.

Work on *Moses* began after Julius's death in 1513, a mere eight years after Michelangelo accepted the commission from the Pontiff. Originally to be positioned on the second level of the tomb, it was intended that the statue of Moses be seen from below rather than at ground level as in its current placement.

Michelangelo is a master of restrained energy and pent-up emotion, and we see it in *Moses* just as we do in his *David*. His awesomeness is palpable. From the carefully modeled particulars of musculature, drapery, and hair to the fiercely inspired look on his face, Moses has the appearance, we can only imagine, of one who has seen God. His face radiates divine light but also divine fury toward the idolaters he spies when he comes down from Mount Sinai after receiving the Ten Commandments. He looks as though he will rise to judge the unrighteous and the earth will quake.

Michelangelo had hardly begun work on the Pontiff's tomb when Julius directed him to paint the ceiling of the Sistine Chapel to complete the work done in the previous century under Sixtus IV. Michelangelo fiercely resisted the project (he actually fled Rome and had to be ordered back by papal edict). Nevertheless,

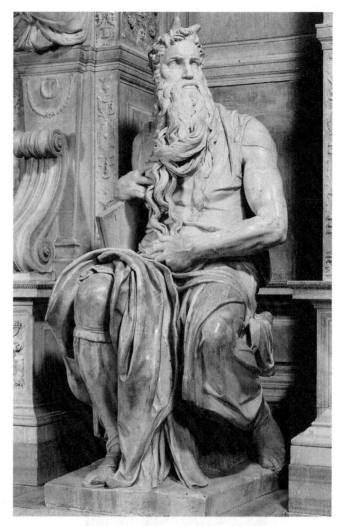

▲ **13.12** Michelangelo, *Moses*, 1513–1515. Marble, 92½" (235 cm) high. San Pietro in Vincoli, Rome, Italy. Moses has brought the commandments from Mount Sinai, and now he sits—momentarily—with his face twisting into a terrible wrath as he views idolaters. The "horns" on his head represent rays of light; the use of horns instead of rays is based on a mistranslation in the Latin Vulgate Bible.

he relented and, in spite of numerous technical problems and a steep learning curve for the artist in the art of fresco, he finished the ceiling in just under four years (1508–1512) (**Fig. 13.13**). He signed it "Michelangelo, Sculptor" to remind Julius of his reluctance and his own true vocation.

The vault measures some 5800 square feet and is almost 70 feet above the floor. After much anguish and the abandonment of a first design that would have populated the ceiling with a variety of colossal religious figures (eventually more than 300 in all), Michelangelo took command of the space by dividing it into painted, architectural "frames" into which he would place scenes from Genesis and other vignettes, biblical prophets and sibyls (female prophets), and *ignudi*—20 seated male nudes. In the four corners of the vault are scenes that depict heroic action in the Hebrew Bible (Judith beheading Holofernes, David slaying Goliath, Haman being punished for his crimes, and the rod

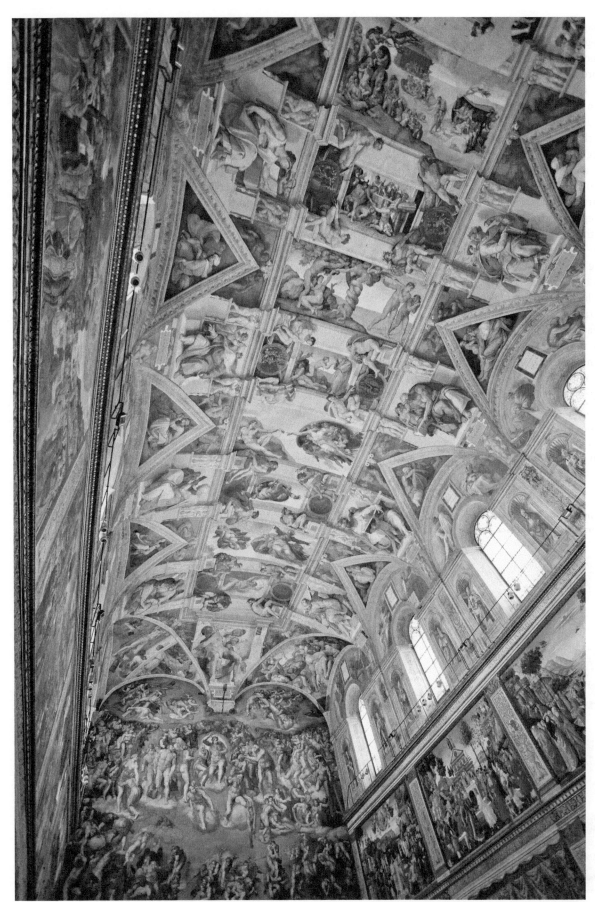

◀ **13.13**
Michelangelo, ceiling of the Sistine Chapel, 1508–1511. Fresco, 44' × 128' (13.44 × 39.01 m). Sistine Chapel, Vatican Palace, Vatican City State, Italy. The more than 300 figures painted by Michelangelo contain biblical scenes of the creation and fall of humankind. The fresco cycle took the artist some four years. Michelangelo would suffer the physical effects of working on the project for the rest of his life.

of Moses changing into a serpent). The other eight triangles—four on each long side of the rectangular space—are devoted to the biblical ancestors of Jesus Christ. Sandwiched between them are ten figures representing, alternately, Hebrew prophets and pagan sibyls. Ten major intermediate figures are alternating portraits of pagan sibyls (female prophets) and Hebrew prophets. The rectangular central panels that fill the vault from the entrance to the chapel to the altar wall on the opposite end, feature scenes beginning with God's creation of the world (closest to the altar) and ending with the Drunkenness of Noah (Genesis 9:20–27) after the great flood (closest to the entrance). Michelangelo started with the last scenes and, moving the scaffolding as each segment was completed, worked his way backwards in time to the creation, getting better and more confident as he went along.

Arguably the most famous of these scenes is *The Creation of Adam* (**Fig. 13.14**) and, in viewing the fresco, it becomes clear why Michelangelo saw himself more as a sculptor than as a painter. In translating his sculptural techniques to a two-dimensional surface, he conceived his figures in the round and used the tightest, most expeditious line and modeling possible to render them in paint. The fresco, demonstrating Michelangelo's ability to combine physical bulk with linear grace and a powerful display of emotion, well exemplifies the adjective *Michelangelesque*, applied to many later artists who were influenced by his style.

In this fresco panel, Michelangelo imagined the most dramatic moment in God's creation of the first human. Adam lies listless for lack of a soul on a patch of fertile green and looks directly at God the Father as He rushes toward him amidst a host of angels nestled under billowing drapery. The entire composition pulls toward the left, echoing the illuminated diagonal of empty sky that provides a backdrop for the very moment of creation. The atmosphere is electric; the hand of God reaches out to spark spiritual life within Adam—but does not touch him! In some of the most dramatic negative space in the history of art, Michelangelo has left it to the spectator to complete the act.

The full force of Michelangelesque style can be seen in the artist's second contribution to the Sistine Chapel: *The Last Judgment*, painted on the wall behind the main altar between the years 1534 and 1541 (**Fig. 13.15**). An enormous fresco marking the end of the world when Christ returns as judge, *The Last Judgment* shows the enthroned Messiah in the top-center of the chaotic scene, the world beneath Him being divided into the damned to His lower left (our right) and those who are called to glory above. Into that great scene, Michelangelo poured both his own intense religious vision and a reflection of the troubled days during which he lived. It was painted after the Holy Roman Emperor Charles V had sacked Rome in 1527 and after the Catholic Church had been riven by the Protestant Reformation following Martin Luther's posting of his 95 Theses in 1517. It is a fearsome representation of the wrath of God and trembling souls that resided in Michelangelo's imagination and was, in this fresco, made real. His own anxiety and dread did not escape representation. To the right of Jesus, just below and along an

▼ **13.14 Michelangelo, *The Creation of Adam*, 1508–1512. Fresco (detail), ca. 9' 2" × 18' 8" (280 × 570 cm). Sistine Chapel, Vatican Palace, Vatican City State, Italy.** The spark of life is passed from God to Adam. The composition of the work unifies the figures, but they do not actually touch.

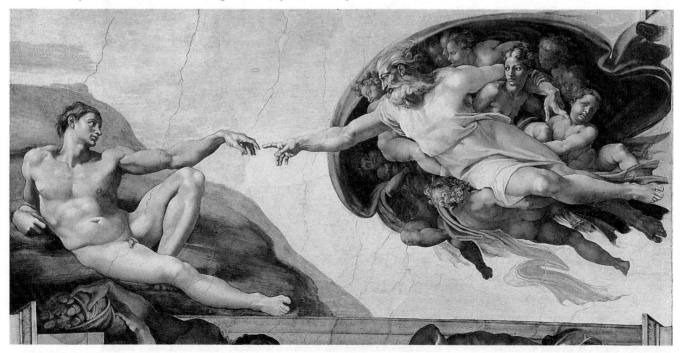

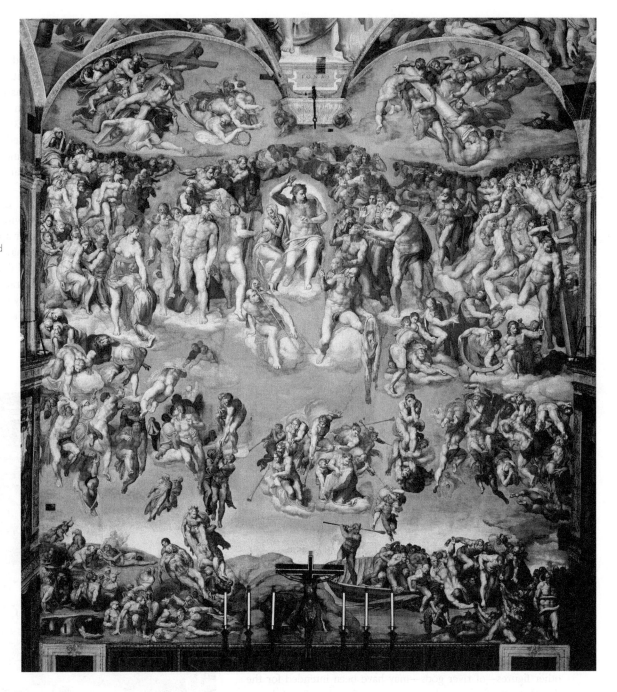

► **13.15**

Michelangelo, *The Last Judgment*, 1534–1541. Fresco (restored), 44' 11" × 40' (13.7 × 12.2 m). Sistine Chapel, Vatican Palace, Vatican City State, Italy. The loincloths on the figures were added later to appease the prudish sensibilities of post-Reformation Catholicism. The flayed skin of Saint Bartholomew below and to the right of Christ is a self-portrait of the painter.

implied diagonal line, is the martyr Saint Bartholomew who holds, in his left hand, a flayed human skin representing the horrific method by which he was slain. The head on the limp remains bears Michelangelo's self-portrait.

Between the two projects for the Sistine Chapel, Michelangelo accepted a commission by Pope Leo X and the future Pope Clement VII—both from the Medici family—to design a funerary chapel in the Florentine Church of San Lorenzo to house the tombs of Medici dukes, Lorenzo di Piero and Giuliano di Lorenzo, and their more illustrious forbearers, Lorenzo the Magnificent and Giuliano de' Medici, one-time co-rulers of Florence. Although Michelangelo first conceived the project in 1519, he

worked on it only in fits and starts from 1521 to 1534 when he departed for Rome permanently. He never personally saw it to completion, the final realization left to the hands of his Florentine pupils.

The interior of the Medici Chapel—the New Sacristy (**Fig. 13.16**)—echoes Brunelleschi's design for the Old Sacristy, also part of the Church of San Lorenzo, and his Pazzi Chapel in its dramatic contrast of white stucco and grayish "pietra serena" stone, Corinthian pilasters, arches, and other classical architectural motifs. The tombs of Giuliano and Lorenzo sit across from one another in the space, their figural groups arranged in a triangular shape above the **sarcophagi** that house their remains.

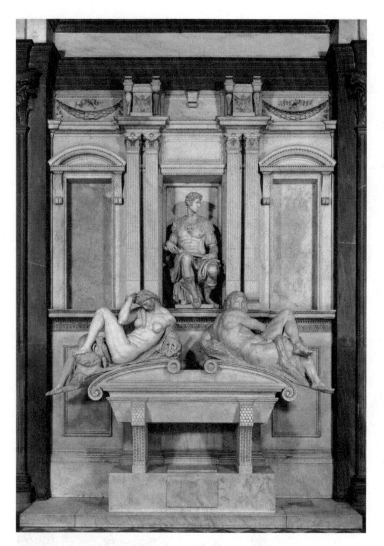

▲ **13.16 Michelangelo, Medici Chapel with tomb of Giuliano de' Medici, 1519–1534. Church of San Lorenzo, Florence, Italy.**

Scholars have suggested that, in addition to what we see, two other figures—of river gods—may have been intended for the floor beneath the sarcophagi, creating a "weightier" visual base and completing what they believe was a complex iconographic scheme based on Neo-Platonic philosophy. The statues of Lorenzo and Giuliano are a study in contrasts; Lorenzo is portrayed as introspective and meditative, Giuliano imposing and confident. The photograph in Figure 13.16 shows Giuliano's tomb, and the pendant figures beneath his statue are Night (on the left) and Day (on the right); Lorenzo's tomb includes figures of Dawn and Dusk. Both the stark decoration of the chapel and the positioning of the statues (Duke Lorenzo seems always turned to the dark with his head in shadow, whereas Duke Giuliano seems more readily to accept the light) form a mute testament to the rather pessimistic and brooding nature of their creator.

The New Saint Peter's

In 1506, Pope Julius II commissioned the architect Donato Bramante (1444–1514) to rebuild Saint Peter's Basilica in the Vatican (**Figs. 13.17**). Old Saint Peter's had stood on Vatican Hill since it was first constructed more than 1000 years earlier, during the time of the Roman emperor Constantine. By the early 16th century, it had repeatedly suffered roof fires, structural stresses, and the general ravages of time. In the minds of the Renaissance "moderns," it was a shaky anachronism.

BRAMANTE'S PLAN Bramante's design envisioned a domed, central-plan featuring a cross with arms of equal length that each terminated in a semicircular apse (**Fig. 13.18A**) and portal. Access to the interior would have been possible from any of the four portals and the central dome equidistant from each. The plan was not executed in Bramante's lifetime, but a small chapel in Rome commissioned by Ferdinand and Isabella of Spain and begun in 1502 may give us a clue to what Bramante

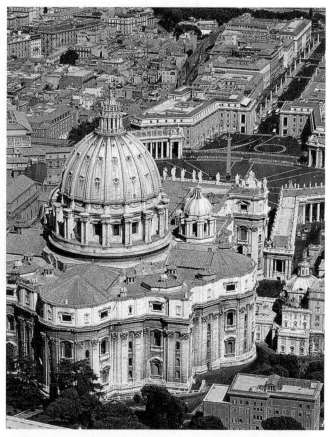

▲ **13.17 Michelangelo, Saint Peter's Basilica (looking northeast), 1546–1564 (dome completed in 1590 by Giacomo della Porta). Vatican City State, Italy. Length of church, ca. 694' (212 m); diameter of dome, 138' (42 m); height of nave, 152' (46 m); height from nave floor to summit of cross on dome, 435' (133 m).**

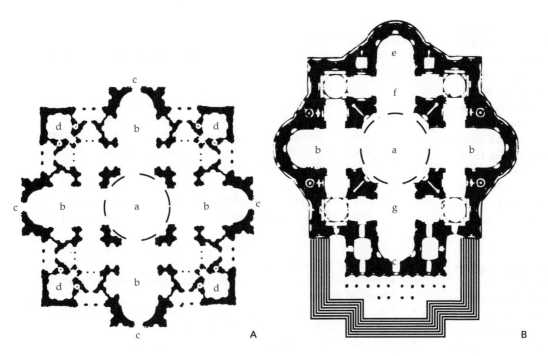

had in mind for the dome. The so-called *Tempietto* ("little temple," **Figure 13.19**) has elements that are similar to the image of Bramante's proposed St. Peter's on a 1506 coin minted to commemorate the new building (**Fig. 13.20**).

MICHELANGELO'S PLAN After Bramante's death, other architects—including Raphael—worked on the massive project, and in 1547, Michelangelo was appointed chief architect. He returned to Bramante's plan for a central-domed church (see **Fig. 13.18B**) and envisioned a ribbed dome somewhat after the manner of the cathedral in Florence, but on a far larger scale.

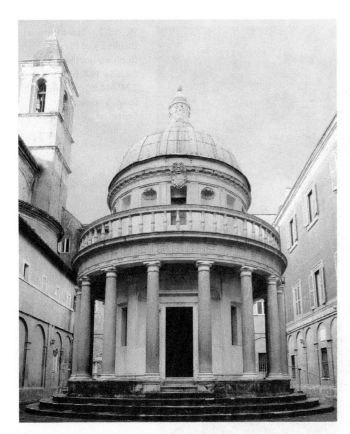

▲ **13.19** Donato D'Angelo Bramante. **Tempietto, San Pietro in Montorio, Rome, Italy, begun 1502.** The image is similar to the design of Bramante's vision for St. Peter's.

▲ **13.20** Cristoforo Foppa Caradosso, attributed, **cast bronze medal of Pope Julius II commemorating the building of St Peter's.** Rome, Italy, 1506. British Museum, London, Great Britain.

The main façade of the present-day Saint Peter's gives us no clear sense of what Michelangelo had in mind when he drew up his plans. It is only from the aerial view looking eastward at the back of the basilica that we can appreciate the undulating contours, multiple apses, and, most importantly, the relationship between the dome and the rest of the structure (see Fig. 13.17). Michelangelo's central plan included a vestibule and an extended columned portico, which was eventually elongated by Carlo Maderno, who added the present nave in the early 17th century. **Figure 13.21** shows the façade, designed by Maderno, that we see today, as well as the colonnaded elliptical piazza in front of the basilica that was completed under the direction of Gian Lorenzo Bernini in 1656–1667, almost a century after Michelangelo's death. Michelangelo lived to see the completion of the drum that was to support his dome, which was raised some 25 years after his death by Giacomo della Porta.

CONNECTIONS Michelangelo Buonarotti of Florence worked in Rome under the patronage of six different popes for a total of nearly 60 years.

- Julius II (1503–1513): Nephew of Pope Sixtus IV of the della Rovere family; commissioned his tomb and accompanying sculpture (a gargantuan freestanding structure originally planned for Saint Peter's but downsized considerably and set, instead, in the transept of San Pietro in Vincoli) and the Sistine Chapel ceiling frescoes
- Leo X (1513–1521): Son of Lorenzo the Magnificent of Florence's Medici dynasty; commissioned the reconstruction of the façade of the church of San Lorenzo in Florence along with figurative sculpture (never completed)
- Clement VII (1523–1534): Grandson of Lorenzo the Magnificent; commissioned the Medici tombs in Florence, the Laurentian Library in the church of San Lorenzo, and *The Last Judgment* for the Sistine Chapel in Rome
- Paul III (1534–1549): Commissioned the Piazza del Campidoglio and the upper floor of the Farnese Palace, both in Rome
- Julius III (1550–1555): Appointed Michelangelo chief architect of Saint Peter's in Rome
- Pius IV (1559–1565): Commissioned the Porta Pia gate in Rome's ancient Aurelian Walls

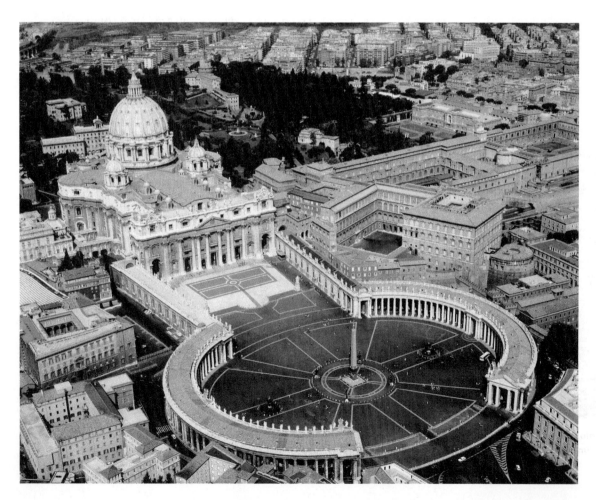

◀ **13.21 Saint Peter's Basilica and Piazza (looking northwest). Façade 147' high × 374' (44.8 × 114 m) long. Vatican City State, Italy.** The building combines Renaissance and Baroque elements. The nave and façade were finished by Carlo Maderno (1556–1629) between 1606 and 1612, and the colonnades around the square were built between 1656 and 1663, according to Bernini's design.

The High Renaissance in Venice

The brilliant and dramatic outbreak of artistic activity in 16th-century Rome and Florence found its counterpart in the Republic of Venice to the north. While Rome produced renowned examples of architecture, sculpture, and fresco painting, Venice (and its territory) became famous for its revival of Classical architecture and for its oil paintings. Venice's impressive cosmopolitanism derived from its position as a maritime port and its trading tradition.

ANDREA PALLADIO The leading architect of the whole of northern Italy in the High Renaissance, the only one to rival the achievements of Tuscan architects of the caliber of Alberti and Michelangelo, was Andrea di Pietro della Gondola (1508–1580)—better known as Palladio. Coined by his first patron, Gian Giorgio Trissino of Vicenza, the name derives from that of the ancient Greek goddess Pallas Athena and indicates the main source of Palladio's inspiration: the architecture of Classical Greece as he saw it reflected in the buildings of ancient Rome. The young Palladio and his patron made several visits to Rome, studying both High Renaissance buildings and the ruins of the ancient city. His designs for villas, churches, and palaces stressed the harmonic proportions and Classical symmetry that the Romans had inherited from the Greeks. His *Four Books of Architecture* (1570) spread his style throughout Europe. The Palladian style became particularly popular in 18th-century England and in due course was exported to North America, where it inspired much of the "Greek Revival" architecture of the Southern United States.

Whether Palladio was born in Vicenza is uncertain, but it is this city that contains the largest number of his buildings, both public and private. As a result, Vicenza is one of the most beautiful and architecturally interesting cities of Renaissance Venetian territory, and indeed of Italy as a whole. The Villa Rotunda is perhaps the finest example of Palladio's style (Fig. 13.22). Built for a monsignor of the Papal court who retired from service, the plan owes much to prototypes from antiquity—particularly the Pantheon in Rome (see Fig. 4.33)—in its symmetry and temple-front porticos. But Palladio was not just an imitator, his work not just derivative. He internalized the mathematical systems and structural vocabulary of the Classical era and composed his own, highly original architectural essays, as it were. The plan of the Villa Rotunda is essentially a circle within a square within a cross. From the center of the villa—the domed space—one can look in four directions that culminate in beautifully framed views of the surrounding landscape. The sense of harmony and balance of proportion is a perfect example of the Renaissance revival of Classical ideals.

Painting in Venice

Renaissance art in Florence and Rome was based, first and foremost, on the study of form. From Masaccio to Michelangelo, whether with line or light (chiaroscuro), artists endeavored to convincingly portray the substance of form through meticulous drawing and the illusion of space using mathematical systems. But for the Venetians, color—not sculptural form—was the primary focus, and oil painting—not drawing—was the vehicle for capturing vibrant, intense hues and the brilliance and subtlety of Venetian light. First popularized in the north, oil painting provided the artist unparalleled opportunities to enrich and deepen color with applications of multiple, translucent layers of paint. Venetian painters, like their counterparts in Northern Europe, also had an eye for detail and a passion for landscape (an ironic interest, since Venice had so little land).

TITIAN Tiziano Vecellio (ca. 1488/1490–1576), called Titian, was the master of the colorist methods and painting techniques for which Venice was renowned. His work had an impact not

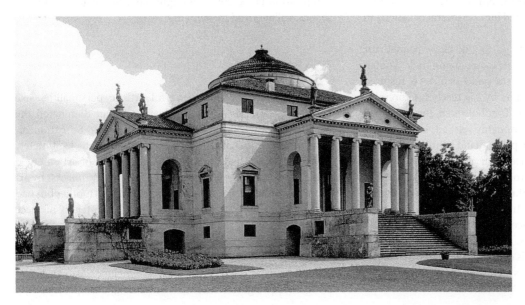

◄ **13.22 Andrea Palladio, Villa Rotunda (looking southwest), near Vicenza, Italy, ca. 1550–1570.** The villa revives Classical ideals. Parts of it resemble Roman temples, yet it is also highly innovative.

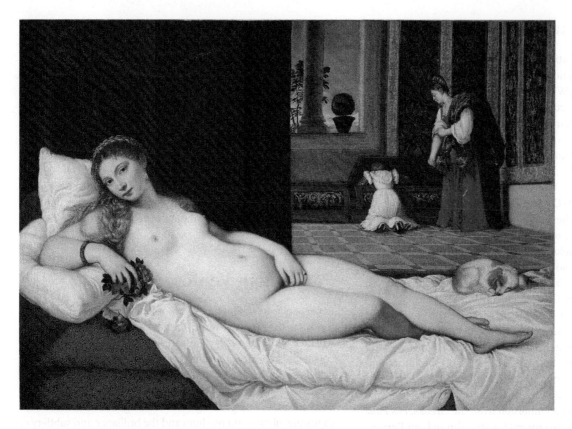

◀ **13.23** Titian, *Venus of Urbino*, 1538. Oil on canvas, ca. 47" × 65" (119 × 162 cm). Galleria degli Uffizi, Florence, Italy. The artist created the radiant golden tones of Venus's body through the application of multiple glazes over pigment.

only on his contemporaries but also on later, Baroque painters in other countries—Peter Paul Rubens in Antwerp and Diego Velasquez in Spain. He had more in common with the artists who would follow him than with his Renaissance contemporaries in Florence and Rome. Titian's pictorial method differed from those of Leonardo, Raphael, and Michelangelo; he constructed his compositions by means of color, brushwork, and **glazing** rather than with line and chiaroscuro.

Titian's artistic output during 70 years of activity was vast. He was lionized by popes and princes and was a particular favorite of Holy Roman Emperor Charles V, who granted him noble rank after having summoned him on several occasions to work at the royal court.

Titian's *Venus of Urbino* (**Fig. 13.23**), likely painted for the Duke of Urbino, Guidobaldo II, is a reclining nude woman in a bedchamber in the guise of the goddess of love. Inspired by a painting of a sleeping Venus by his teacher, Giorgione, Titian's goddess lounges on a red, upholstered couch draped in pure white linens. She is thoroughly relaxed, legs crossed, arm draped discretely over her pelvis, hand gently clutching a small cluster of roses. Venus meets our gaze and blushes, ever so slightly, her rosy cheeks mirrored in the pink-tinged glow of her luminescent flesh created through extremely subtle gradations of pigment blended into transparent glazes. Titian's virtuoso brushwork seems to dance across the canvas, delighting in a display of textural contrasts: the smooth flesh and soft tendrils of hair against delicate folds of drapery, the silky coat of the little pet dog curled up at Venus's feet, the delicate flower petals against rich brocade fabric.

Titian's use of color as a compositional device is also significant. A square block of green velvet drapery provides a stark backdrop for Venus's head, shoulders and torso, encouraging our eyes to linger on the most important part of the scene. At the same time, the strong contrast between that drapery and the light in the distant part of the room draws our attention to the action occurring in the right background. The patch of red in the upholstery and the red dress of the servant—diagonally opposed—capture the eye and shift it from foreground to background and back again. Titian thus subtly balances the composition using color and light, curvilinear and geometric shapes, stillness and movement.

Mannerism

There is no doubt that powerful artistic personalities like Leonardo, Raphael, Michelangelo, and Titian dominated the Italian art scene during the High Renaissance. So extraordinary were their accomplishments that one might legitimately wonder, "What was there to do next?" Works of art emerged among the next generation of artists—termed *Mannerist* by art historians—that were distinct in style from one another but had in common a rejection of many of the artistic tenets of these "Old Masters." Collectively, **Mannerist** artists set a different course, one that often seems in direct opposition to the High Renaissance styles of Florence, Rome, and Venice.

Characteristics of Mannerist art include distortion and elongation of figures; flattened and ambiguous space; lack of

compositional balance and defined focal point; and discordant pastel hues. In general, the pursuit of naturalism that preoccupied painters since Giotto was abandoned as Mannerist artists took pleasure instead in highlighting the "artmaking" aspect of their work—the artifice.

JACOPO DA PONTORMO In the *Entombment of Christ* (Fig. 13.24) by Jacopo da Pontormo, we witness this strong shift from the typical High Renaissance style. The sculpturesque figures of Michelangelo and Raphael and the ideal proportions of Leonardo have been replaced with figures that seem to float, almost weightless. Their bodies and limbs are elongated, and their heads, much smaller in proportion, are dwarfed by their billowing, pastel-colored robes. There is a certain innocent beauty in the common facial features, haunted expressions, and nervous glances. The movement swirls around an invisible vertical axis; the figures press forward to the picture plane and outward toward the borders of the painting, leaving a void space in the center of the composition.

The weightlessness, distortion, and ambiguity of space create an almost otherworldly aspect—an atmosphere in which objects and people do not come under an earthly gravitational force. The artist proffers this strangeness with no apology, and we find ourselves taking the ambiguities in stride. In fact, it really is not clear whether the subject is the descent from the cross or the entombment of Christ; for Pontormo and other Mannerists, conventional narratives and **iconography** are irrelevant.

BRONZINO Agnolo di Cosimo di Mariano Tori (1503–1572), known as Bronzino, was a student of Pontormo. Bronzino's 16th-century masterpiece *Venus, Cupid, Folly, and Time (The Exposure of Luxury)* (Fig. 13.25) is a classic example of a work in which there is much more than meets the eye. On the surface, it is a fascinating jumble of mostly

▲ **13.25** Bronzino, *Venus, Cupid, Folly, and Time (The Exposure of Luxury)*, ca. 1546. Oil on wood, 57½" × 45⅝" (146.1 × 116.2 cm). National Gallery, London, United Kingdom. Along with its eroticism, the painting has the ambiguity of meaning and obscurity of imagery that are considered characteristic of Mannerism.

pallid figures, some of which possess body proportions that, as in the Pontormo painting, do little to convince us that they would exist in the real world. Over the years, the work has alternately titillated and intrigued viewers because of the manner in which it weaves an intricate allegory, with many actors, many symbols. Venus, undraped by Time and spread in a languorous diagonal across the front plane, is fondled by her son Cupid. Folly prepares to cast roses on the couple, while Hatred and Inconstancy (with two left hands) lurk in the background. Masks, symbolizing falseness, and other objects, with meanings known or unknown, contribute to the intricate puzzle. What is symbolized here? Is Bronzino saying that love in an

environment of hatred and inconstancy is foolish or doomed? Is something being suggested about incest? Self-love? Can one fully appreciate Bronzino's painting without being aware of its iconography? Is it sufficient to respond to the elements and composition, to the figure of a woman being openly fondled before an unlikely array of onlookers? No simple answer is possible, and a Mannerist artist such as Bronzino would have intended this ambiguity. Certainly one could appreciate the composition and the subject matter for their own sake, but awareness of its meaning would enrich the viewing experience.

LAVINIA FONTANA The daughter of an accomplished painter in Bologna, Lavinia Fontana (1552–1614) trained in her father's studio and traveled to Rome to study the works of Michelangelo and Raphael. There she found patronage, primarily as a portrait painter, even at the level of the Papal court. Her husband, Gian Paolo Zappi, gave up his own career after they married in 1577 to manage her prolific one.

Fontana's painting *Noli Me Tangere* (*Do Not Touch Me*) (Fig. 13.26) is noteworthy in that women artists of the era were far less likely to acquire commissions for religious paintings than were male artists. Yet Fontana painted altarpieces as well as the usual portraits. *Noli Me Tangere* refers to the words attributed to the risen Christ in the Gospel of John (20:11–18). Mary Magdalene visits Jesus's tomb on the third day following his execution (pictured in the left background) and finds it empty. Soon thereafter, she has a chance encounter with a man disguised as a gardener (her figure now repeated in the foreground) and comes to realize his true identity. Jesus has risen from the dead. She drops to her knees and reaches for Him, but He rejects her touch.

The subject was not unusual, but Fontana's presentation is. Artists typically placed the visual emphasis on Jesus but Fontana, in positioning the Magdalene's plaintive face front and center, focuses our attention on her and the emotions that she must be experiencing—joy that Jesus is risen but confusion and melancholy when He keeps her away. Recalling the way in which Renaissance artists humanized their religious figures to draw feelings of empathy, it is imaginable that Fontana tapped into her viewers' own experiences with personal loss to create a dialogue between them and her subject.

SOFONISBA ANGUISSOLA In 1556, Giorgio Vasari traveled to Cremona to see the "marvels" of six sisters, children of the Anguissola family, who were "excellent in painting, music,

◄ **13.26** Lavinia Fontana, *Noli Me Tangere*, **1581. Oil on canvas, 31 ½" × 25 ¾" (80 × 65.5 cm). Galleria degli Uffizi, Florence, Italy.** Fontana was an important portrait artist in Bologna whose father Prospero, himself a painter, had taught her to paint in the Mannerist style. But Fontana also made a number of religious paintings, with *Noli Me Tangere* considered to be among her best.

and *belles artes*." The beneficiary of a humanist education at home, the most famous of these sisters was Sofonisba (ca. 1532–1625), who enjoyed a great degree of fame in her own lifetime. As a young woman, she traveled with her father to Rome, where she most likely met Michelangelo. Anguissola also spent time in Milan and, in 1560, traveled to Spain on the invitation of King Philip II to serve as a court portraitist. She remained in Spain for most of the next decade, moving back to Italy after her marriage to a Sicilian nobleman. She died in Palermo in 1625.

Anguissola was enormously successful. Most of her large body of work reflects the regional, realistic style of Cremona rather than the Mannerist stylizations that were popular elsewhere in Italy. Her taste for meticulous detail was certainly influenced by Flemish portrait painters, including Anthony van Dyck, who painted Anguissola's portrait. *A Game of Chess* (**Fig. 13.27**), painted in 1555 when the artist was only 23, is a group portrait of three of the artist's sisters playing chess while a nanny-servant looks on. The brocade fabric of their elaborate dresses and the patterned tablecloth attest to the family's affluence and gentility, although the girls are anything but stilted in their behavior. The oldest, Lucia, looks up from

◄ **13.27** Sofonisba Anguissola, *A Game of Chess*, **1555. Oil on canvas, 28 ¼" × 38 ¼" (72 × 97 cm). National Museum in Poznan, Poland.** Anguissola was one of the earliest women artists to be internationally renowned. Her father was influenced by Castiglione's *The Book of the Courtier* and saw to it that Anguissola attained a proper education.

▲ **13.28** Tintoretto, *The Last Supper*, 1592–1594. Oil on canvas, 12' × 18'8" (366 × 569 cm). Chancel, San Giorgio Maggiore, Venice, Italy. Tintoretto's impassioned application of pigment lends energy to the painting. Although Tintoretto was a student of Titian, he constructed his forms in a more linear fashion, foregoing layer upon layer of glazing. A comparison with Leonardo's *Last Supper* quickly reveals Tintoretto's creation of a sense of motion and his dramatic use of light—both characteristics of the Baroque era to come.

the game to meet our gaze, self-assured and poised. Her sister Minerva seems to try to catch her attention, her hand raised and her lips slightly parted as if about to speak. The youngest looks on, her face brimming with joy, it seems, that Minerva appears to be losing the game. Animated gestures and facial expressions combine to create a work that is less a formal portrait than an absolutely natural and believable scene. Anguissola pushes beyond mere representation to suggest the personalities of her sisters and the relationships among them. This easy, conversational quality will become a familiar characteristic of group portraiture in the 17th century, particularly in the north.

TINTORETTO The last of the giants of 16th-century Venetian painting was Jacopo Robusti, called Tintoretto (1518–1594)—"little dyer," after his father's trade. His style combined the color of Titian, the drawing of Michelangelo, and the devices of Mannerism. His dynamic compositional structure and arrested momentary action, along with dramatic use of light and darkness, though, set the stage for the Italian Baroque style of the 17th century.

A comparison between Tintoretto's *Last Supper* (Fig. 13.28) and Leonardo's *Last Supper* (see Fig. 13.3) will illustrate the dramatic changes that had taken place in both the concept and style of art over almost a century. The depiction of time and motion are added to that of space, light has a drama all its own, and theatricality is the dominant aspect. In Tintoretto's painting, everything and everyone is set into motion. The space, sliced by a sharp, rushing diagonal that goes from lower left to upper right, seems barely able to contain all of the commotion, but this cluttered effect enhances the energy of the event.

Leonardo's obsession with symmetry, along with his balance between emotion and restraint, yields a composition that appears static in comparison to the asymmetry and overpowering emotion in Tintoretto's canvas. Leonardo's apostles seem posed for the occasion when seen side by side with Tintoretto's spontaneously gesturing figures. A particular moment is captured; we feel that if we were to look away for a fraction of a second, the figures would have changed position by the time we looked back.

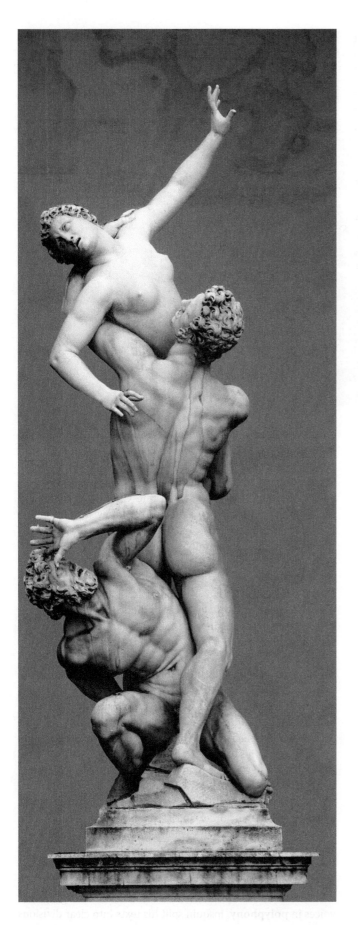

The moment that Tintoretto has chosen to depict—when Jesus shares bread and wine with His apostles and charges them to repeat this in memory of Him—also differs from Leonardo's—the moment when Jesus announces that one among them will betray Him. Leonardo chose a moment signifying death, Tintoretto a moment signifying life, depicted within an atmosphere that is teeming with life.

GIOVANNI DA BOLOGNA Mannerist elements are not exclusive to painting; we detect them in sculpture and architecture as well. Giovanni da Bologna (1529–1608) was born Jean de Boulogne in Flanders, under Spanish rule at the time, and moved to Italy, where he assumed the Italian form of his name. He settled in Florence in 1552 where he attracted the attention of Francesco de' Medici. He became one of the most significant court sculptors of the Medici family, who kept him in their employ for life, fearful that another royal family would recruit him.

His *Abduction of the Sabine Women* (**Fig. 13.29**), assigned this title only after the work had been exhibited, has a complex spiral composition that encourages the viewer to walk around the statue and take it in all from all angles. This movement reveals different combinations of line and shape, solid and void so that no single perspective is the same as another. It is the viewer who constructs the entirety of the action by virtue of his or her "participation" in the piece.

MICHELANGELO'S VESTIBULE FOR THE LAURE-TIAN LIBRARY Aspects of the mannerist style show up in some of Michelangelo's later art, specifically in his *Last Judgment*. They can also be seen in his design for the vestibule and staircase for the Laurentian Library (**Figure 13.30**) connected to the church of San Lorenzo in Florence and built by the Medici pope, Clement VII. The contrast of creamy white stucco and pietra serena has become familiar to us in Florentine architecture, but that Renaissance stylistic tradition is about the only one that Michelangelo adhered to in his design. If we see the Mannerist artist as one who subverts, one by one, established conventions, then Michelangelo is here a Mannerist artist. The vestibule is an eclectic adaptation of familiar architectural elements that serve the overall form rather than function in the literal sense of the word: columns and corbels support nothing; pilasters taper toward the base, inverting their visual weight; windows appear to be boarded up; the frames of pediments are broken. The result is a more active, spirited iteration of the at times pedantic classical references in Renaissance architecture.

◀ **13.29 Giovanni da Bologna,** *Abduction of the Sabine Women,* **ca. 1581–1583. Marble, 13' 5" (409 cm) high. Loggia dei Lanzi, Florence, Italy.** The work was sculpted in the *figura serpentina* style—an upward spiral movement intended to be viewed from all sides.

◄ **13.30 Michelangelo Buonarroti, vestibule of the Laurentian Library, Florence, Italy, 1525–1534; staircase, 1558–1559.** With this architectural endeavor, Michelangelo broke tradition with established conventions and any notion that form need be connected with function.

The show-stopping part of the design, however, is the staircase that connects the vestibule to the reading library. Here, Michelangelo breaks stride from the geometry of the vestibule walls and switches, unpredictably, to curving lines and organic shapes for the central part of the staircase. The steps seem to ripple like wavelets from the doorway of the reading room to the foot of the staircase, as if to suggest that the knowledge contained therein must flow out into the world.

It is fitting to open and close our discussion of the High Renaissance and Mannerism in Italy with Michelangelo. His life was long and his legacy was never ending.

MUSIC

Much of the painting, sculpture, and architecture we see during the Renaissance was intended for the service of Roman Catholic worship. Fine music was also subsidized and nurtured in Rome at the papal court.

Music at the Papal Court

The patronage of the popes for the creation and the performance of music dates back to the earliest centuries of the papacy. Gregorian chant, after all, is considered a product of the interest of Pope Gregory and the school of Roman chant. In 1473, Pope Sixtus IV established a permanent choir for his private chapel, which came to be the most important center of Roman music. Sixtus's nephew Julius II endowed the choir for Saint Peter's, the Julian Choir.

The Sistine Choir used only male voices. Preadolescent boys sang the soprano parts, while older men—chosen by competition—sang the alto, tenor, and bass parts. The number of voices varied then from 16 to 24 (the choir eventually became, and still is, much larger). The Sistine Choir sang a cappella (without accompaniment), although we know that the popes enjoyed instrumental music outside the confines of the church. Benvenuto Cellini, for example, mentions that he played instrumental motets for Pope Clement VII.

JOSQUIN DES PREZ While Botticelli and Perugino were decorating the walls of the Sistine Chapel, the greatest composer of the age, Josquin des Prez (ca. 1450–1521), was in the service of the Sistine Choir, composing and directing music for its members from 1486 to 1494. From his music, we can get some sense of the quality and style of the music of the time.

Josquin, who was Flemish, spent only those eight years in Rome, but his influence was widely felt in musical circles. He has been called the bridge figure between the music of the Middle Ages and the Renaissance. Although he wrote **madrigals** and many masses in his career, it was in the motet for four voices—a form not held to traditional usage in the way masses were—that he showed his true genius for creative musical composition. Josquin has been most praised for homogeneous musical structure, a sense of balance and order, and a feel for the quality of the lyrics. These are all characteristics common to the aspirations of the 16th-century Italian humanists. In that sense, Josquin combined the considerable musical tradition of Northern Europe with the new intellectual currents of the Italian south.

The Renaissance motet uses a sacred text sung by four voices in **polyphony**. Josquin split his texts into clear divisions

but disguised them by using overlapping voices, so that one does not sense any break in his music. He also took considerable pains to marry his music to the obvious grammatical sense of the words while still expressing their emotional import by the use of the musical phrase.

PALESTRINA The 16th-century composer most identified with Rome and the Vatican is Giovanni Pierluigi da Palestrina (1525–1594). He came from the Roman hill town of Palestrina as a youth and spent the rest of his life in the capital city. At various times in his career, he was the choirmaster of the choir of Saint Peter's (the Julian Choir), a singer in the Sistine Choir, and choirmaster of two other Roman basilicas (Saint John Lateran and Saint Mary Major). Finally, from 1571 until his death, he directed all music for the Vatican.

Palestrina flourished during the rather reactionary period in which the Catholic Church, in response to the Protestant Reformation, tried to reform itself by returning to the simpler ways of the past. It should not surprise us, then, that the more than 100 masses he wrote were conservative. His polyphony, while a model of order, proportion, and clarity, is closely tied to the musical tradition of the ecclesiastical past. Rarely does Palestrina move from the Gregorian roots of church music. For example, amid the polyphony of his Missa Papae Marcelli (Mass in Honor of Pope Marcellus), one can detect the traditional melodies of the Gregorian Kyrie, Agnus Dei, and so on. Despite that conservatism, he was an extremely influential composer whose work is still regularly heard in the Roman basilicas. His music was consciously imitated by the Spanish composer Vittoria (or Victoria, ca. 1548–1611), whose motet "O Vos Omnes" is almost traditional at Holy Week services in Rome, and by William Byrd (ca. 1539/40–1623), who brought Palestrina's style to England.

GO LISTEN!
PALESTRINA
Missa Papae Marcelli, Credo

In this listening selection, we hear Palestrina's successful return to earlier traditions of church music, a return that satisfies the Counter-Reformation requirement of keeping the text clearly audible. Indeed, he may have composed the mass to illustrate the musical seriousness and textual intelligibility laid down as requirements by the Council of Trent.

Nevertheless, for all Palestrina's conservatism, his work is clearly more complex and advanced than that of Machaut (see Chapter 11). The richness of harmony and the perfect balance of the voices produce a smoothness of texture and beauty and a variety of line that break new ground in the history of Western music. Note the entrance of one voice immediately after another, and the decorative ornamentation of many of the phrases that by the addition of shorter notes adds musical interest without blurring the text.

In the purity of his style, his return to the ideal values of the past, and the inventiveness of his own musical contributions, Palestrina is a perfect example of a Renaissance artist. His music has remained widely admired, and a 19th- and 20th-century composer, Hans Pfitzner (1869–1949), wrote the opera *Palestrina* to pay homage to the inner certainties of artistic genius.

Venetian Music

The essentially conservative character of Palestrina's music can be contrasted with the far more adventuresome situation in Venice, a city less touched by the ecclesiastical powers of Rome. In 1527, a Dutchman—Adriaan Willaert—became choirmaster of the Saint Mark's Basilica. He in turn trained Andrea Gabrieli and his more famous nephew, Giovanni Gabrieli, who became the most renowned Venetian composer of the 16th century.

The Venetians pioneered the use of multiple choirs for their church services. Saint Mark's regularly used two choirs, called split choirs, which permitted greater variation of musical composition in that the choirs could sing to and against each other in increasingly complex patterns. The Venetians were also more inclined to add instrumental music to their liturgical repertoire. They pioneered the use of the organ for liturgical music. The independent possibilities of the organ gave rise to innovative compositions that highlighted the organ. These innovations in time became standard organ pieces: the prelude, the music played before the services began (called in Italy the *intonazione*), and the virtuoso prelude called the toccata (from the Italian *toccare*, "to touch"). The toccata was designed to feature the range of the instrument and the dexterity of the performer.

Both Roman and Venetian music were deeply influenced by the musical traditions of the north. Josquin des Prez and Adriaan Willaert were, after all, both from the Low Countries. In Italy, their music came in contact with the intellectual tradition of Italian humanism. Without pushing the analogy too far, it could be said that Rome gave musicians the same Renaissance sensibility that it gave painters: a sense of proportion, Classicism, and balance. Venetian composers, much like Venetian painters of the time, were interested in color and emotion.

LITERATURE

The High Renaissance in Italy not only marked the achievement of some of the most refined artistic accomplishments, but, as in other times and in other places, it was also a period of great upheaval. The lives of Raphael and Leonardo ended at precisely the time Luther was struggling with the papacy. In 1527, Rome was sacked by Emperor Charles V's soldiers in an orgy of rape and violence the city had not seen since the days of the Vandals in the fifth century.

Writing continued. Some of it was in the form of notebooks, as we see with Leonardo da Vinci. Some was in the form of poetry, as we see in the sonnets of Michelangelo and Vittoria Colonna. Some of it was philosophizing, as in Castiglione's fictionalized dialogues in *The Book of the Courtier*. And some of it was autobiography, as we find in the self-serving work of Cellini.

LEONARDO DA VINCI When we think of Leonardo da Vinci, paintings such as the *Mona Lisa* and *The Last Supper* may spring into mind. And they should. But so ought we to contemplate his 13,000 pages of notes, replete with well-known drawings. They were made throughout his travels and daily

undertakings, mostly written from right to left, as seen through a mirror. Leonardo was left-handed, and it has been speculated that it might have been easier for him to write "backwards."

Some of the notes were published, or intended for publication, during his lifetime: notes on mathematics with geometric drawings; treatises on anatomy, focusing on the skeleton, muscle, and sinews; observations on landscape and the nature of light. Many of his writings and illustrations seem as though they would be the science fiction of his day: fanciful inventions that presage our own times with just enough detail to suggest that they were, in fact, plausible. Included among these are helicopters and hang gliders, submarines, a 720-foot-long bridge, and war machines such as the tank, which would resist defensive measures and protect land forces following behind. (In 2006, the Turkish government decided to build the bridge.)

MICHELANGELO BUONARROTI If Leonardo had never held a paintbrush, we would know him today because of the richness of his written works. It is difficult to know whether we would know of Michelangelo's poetry if he had never held a brush or a chisel. The poems have received a mixed review, yet many of them show the vitality of an artist more than occasionally at odds with his patrons and society.

The following sonnet, written to his longtime (platonic) friend Vittoria Colonna, compares the artist's quest for forms residing in dumb blocks of stone to his search for certain properties in the woman—"Lady, divinely proud and fair." It is of interest that Michelangelo's poems to Tomasso de'Cavalieri, a male friend, are more erotically charged—one of the suggestions that Michelangelo might have been gay.

READING 13.2 **MICHELANGELO**

The master-craftsman hath no thought in mind
That one sole marble block may not contain
Within itself, but this we only find
When the hand serves the impulse of the brain;
The good I seek, the harm from which I fly,
Lady, divinely proud and fair, even so
Are hid in thee, and therefore I must die
Because my art is impotent to show
　My heart's desire; hence love I cannot blame,
Nor beauty in thee, nor thy scorn, nor ill
Fortune, nor good for this my pain, since life
Within thy heart thou bearest at the same
Moment as death, and yet my little skill
Revealeth death alone for all its strife.

VITTORIA COLONNA Colonna (1492–1547) was a member of an affluent Roman family that patronized Petrarch, so it is fitting that she wrote mainly in Petrarchan sonnets (see Chapter 11). She numbered Michelangelo and the epic poet Ludovico Ariosto among her friends. Her social life seems to have largely come to a halt when her husband died in battle in 1525. Nearly all of the more than 400 poems that have come

down to us idealize her husband. They look back to love and the promise of a rich life; they look forward to emptiness and darkness. Although her writings became reasonably predictable, Michelangelo refers to them as composed in "sacred ink." Ariosto said of her poetry that it "rescued her triumphant spouse from the dark shore of the Styx." Her spouse was triumphant in seizing the poet's heart unto perpetuity, not on the battlefield.

READING 13.3 **VITTORIA COLONNA**

Sonnet IX

Once I lived here in you, my now blest Light,
　With your soul joined to mine, for you were kind;
　Each, to the dearer one, had life resigned,
　And dead to self, there only lived aright.
Now that, you being in that heavenly height,
　I am no longer graced such joy to find,
　Your aid deny not to a faithful mind,
　Against the World, which arms with us to fight.
Clear the thick mists, which all around me lie,
　That I may prove at flying freer wings,
　On your already travelled heavenward way.
The honour yours, if here, midst lying things,
　I shut my eyes to joys which soon pass by,
　To ope them there to true eternal day.

▲ **13.31 Raphael,** *Baldassare Castiglione,* **ca. 1514. Oil on panel, transferred to canvas, 32 ¼" × 26 ¼" (82 × 67 cm). Musée du Louvre, Paris, France.** Raphael would have known the famous humanist through family connections in his native Urbino.

BALDASSARE CASTIGLIONE Baldassare Castiglione (1478–1529) served in the diplomatic corps of Milan, Mantua, and Urbino. He was a versatile man—a person of profound learning, equipped with physical and martial skills, and possessed of a noble and refined demeanor. Raphael's portrait of Castiglione (**Fig. 13.31**) faithfully reflects Castiglione's aristocratic and intellectual qualities.

While serving at the court of Urbino from 1504 to 1516, Castiglione decided to write *The Book of the Courtier*, a task that occupied him for a dozen years. It was finally published by the Aldine Press in Venice in 1528, a year before the author's death. Castiglione's work was translated into English by Sir Thomas Hoby in 1561. It exerted an immense influence on what the English upper classes thought an educated gentleman should be. We can detect echoes of Castiglione in some of the plays of Ben Jonson as well as in Shakespeare's *Hamlet.*

> Oh, what a noble mind is here o'erthrown!
> The courtier's, soldier's, scholar's eye, tongue, sword:
> The expectancy and rose of the fair state,
> The glass of fashion and the mould of form,
> The observed of all observers…

The most common criticism of Castiglione's courtier is that he reflects a world that is overly refined, too aesthetically sensitive, and excessively preoccupied with the niceties of decorum and decoration. The courtier's world, in short, is the world of the wealthy, the aristocratic, and the most select of the elite.

In *The Book of the Courtier*, cast in the form of an extended dialogue, Castiglione has his learned friends discuss a range of topics: the ideals of chivalry, Classical virtues, the character of the true courtier. Castiglione insistently pleads that the true courtier should be a person of humanist learning, impeccable ethics, refined courtesy, physical and martial skills, and fascinating conversation. He should not possess any of these qualities to the detriment of any other. The *uomo universale* (well-rounded person) should do all things with *sprezzatura*, or effortless mastery. The courtier, unlike the pedant, wears learning lightly, while his mastery of sword and horse has none of the fierce clumsiness of the common soldier in the ranks. The courtier does everything equally well but with an air of unhurried and graceful effortlessness.

Book 3 deals with the position of women in the courtly life of Renaissance Italy. We find one strikingly modern note in this selection when the Magnifico argues that women imitate men not because of masculine superiority but because they desire to "gain their freedom and shake off the tyranny that men have imposed on them by their one-sided authority."

The Magnifico argues that women are as capable as men of understanding worldly affairs. Signor Gaspare counters with the "wisdom" of various philosophers and says that he is astonished that the Magnifico would allow that women are capable of understanding social and political issues as are men:

READING 13.4 BALDASSARE CASTIGLIONE

From *The Book of the Courtier*, Book 3, "The Perfect Lady"

"Leaving aside, therefore, those virtues of the mind which she must have in common with the courtier, such as prudence, magnanimity, continence and many others besides, and also the qualities that are common to all kinds of women, such as goodness and discretion, the ability to take good care, if she is married, of her husband's belongings and house and children, and the virtues belonging to a good mother, I say that the lady who is at Court should properly have, before all else, a certain pleasing affability whereby she will know how to entertain graciously every kind of man with charming and honest conversation, suited to the time and the place and the rank of the person with whom she is talking. And her serene and modest behavior, and the candor that ought to inform all her actions, should be accompanied by a quick and vivacious spirit by which she shows her freedom from boorishness; but with such a virtuous manner that she makes herself thought no less chaste, prudent and benign than she is pleasing, witty and discreet. Thus she must observe a certain difficult mean, composed as it were of contrasting qualities, and take care not to stray beyond certain fixed limits."

…

The Magnifico laughed and said:

"You still cannot help displaying your ill-will towards women, signor Gaspare. But I was truly convinced that I had said enough, and especially to an audience such as this; for I hardly think there is anyone here who does not know, as far as recreation is concerned, that it is not becoming for women to handle weapons, ride, play the game of tennis, wrestle or take part in other sports that are suitable for men."

Then the Unico Aretino remarked: "Among the ancients women used to wrestle naked with men; but we have lost that excellent practice, along with many others."

Cesare Gonzaga added: "And in my time I have seen women play tennis, handle weapons, ride, hunt and take part in nearly all the sports that a knight can enjoy."

The Magnifico replied: "Since I may fashion this lady my own way, I do not want her to indulge in these robust and manly exertions, and, moreover, even those that are suited to a woman I should like her to practice very circumspectly and with the gentle delicacy we have said is appropriate to her. For example, when she is dancing I should not wish to see her use movements that are too forceful and energetic."

…

The Magnifico Giuliano…remarked:

"It appears to me that you have advanced a very feeble argument for the imperfection of women. And, although this is not perhaps the right time to go into subtleties, my answer, based both on a reliable authority and on the simple truth, is that the substance of anything whatsoever cannot receive of itself either more or less; thus just as one stone cannot, as far as its essence is

(continued on p. 448)

COMPARE + CONTRAST

Courtesans, East and West

Baldassare Castiglione's most famous work, *The Book of the Courtier*, was written one year before he died, at age 50, from the plague. The funerary monument dedicated to him informs posterity that he was "endowed by nature with every gift and the knowledge of many disciplines" and that "he drew up *The Book of the Courtier* for the education of the nobility." Castiglione's book lays out the model for the perfect Renaissance gentleman—a virtuous, noble, and devoted public servant, educated in the classics, skilled in rhetoric, able to converse knowledgeably on all subjects including the humanities and history, and gifted in poetry, music, drawing, and dance. Above all, these wide-ranging talents ought to come naturally to the ideal courtier, or at least give the appearance of authenticity; this is the quality Castiglione calls *sprezzatura*—an apparent effortlessness, or "art that conceals art."

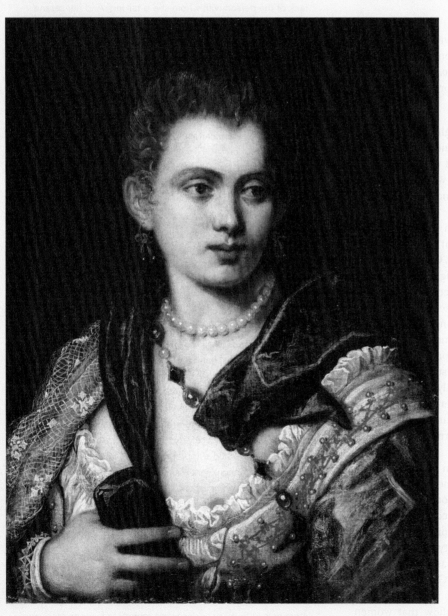

Although the setting that inspires *The Book of the Courtier* is the court of the duke of Urbino, the philosophical conversation "recorded" by Castiglione offers a good barometer of the social climate in early-16th-century Italy—including contemporary views on the role of women, their capabilities and gender disadvantages, and their contribution to the life and intellectual discourse of the court. In fact, Elisabetta Gonzaga, the duchess of Urbino, was the moderator of the four-day-long salon (a gathering meant to educate and inspire participants through conversation on subjects such as politics, art, literature, poetry, and scholarship) described by Castiglione in his book. Gonzaga was an educated noblewoman and was regarded as one of the most cultured and virtuous women (she remained loyal to her invalid husband) in Renaissance courtly circles.

The role of courtier was not, then, exclusive to males. On the contrary, in some places where less rigid and more tolerant views prevailed—like the Republic of Venice—female courtesans were an important part of the social fabric. The most renowned courtesan of Renaissance Venice was Veronica

◀ **13.32** Tintoretto, *Veronica Franco*, late 16th century. Oil on canvas, 18" × 24" (46 × 61 cm). Worcester Museum of Art, Worcester, Massachusetts.

Franco (1546–1591), a complex woman of great prestige and many talents whose mantle as a public servant included the creation of a charitable institution for women involved in prostitution and their children.

Franco (**Fig. 13.32**) was the daughter of what Venetians called a *cortigiana onesta* (an honest, upstanding, virtuous courtesan), trained by her mother to be a proper consort of nobility and princes. She was well educated, a skilled musician, a poet, and a brilliant conversationalist. Courtesans like Franco were sought-after companions and entertainers who may or may not have engaged in sexual liaisons. In Venice, a lower class of courtesans—the *cortigiane di lume*—comprised women for whom prostitution was a means of financial survival or security. *Cortigiane oneste* could rise from modest backgrounds to the upper rungs of society, their profession providing one way to gain influence within a patriarchal oligarchy that otherwise suppressed the status of women.

Versions of courtesanship have existed in many cultures, including Japan (**Fig. 13.33**), China, and Turkey, but physical beauty is certainly a common denominator (it is also an important quality of the ideal woman in Castiglione's book). The history of Japanese courtesans, like their European counterparts, has run the gamut from poor young women selling sexual services and high-class prostitutes to *geisha*—erudite companion-entertainers (*geisha* means "entertainer" in Japanese) trained in classical music, dance, vocal performance, conversation, and traditional Japanese rituals such as serving tea.

Although the term *geisha girl* entered common parlance after World War II among American soldiers stationed in Japan to describe women working as prostitutes, these women were not geisha in the true definition of the term. In geisha society, which was highly structured and cloistered, authentic geisha were not associated with clients paying for sex; their business lives and love lives were entirely separate.

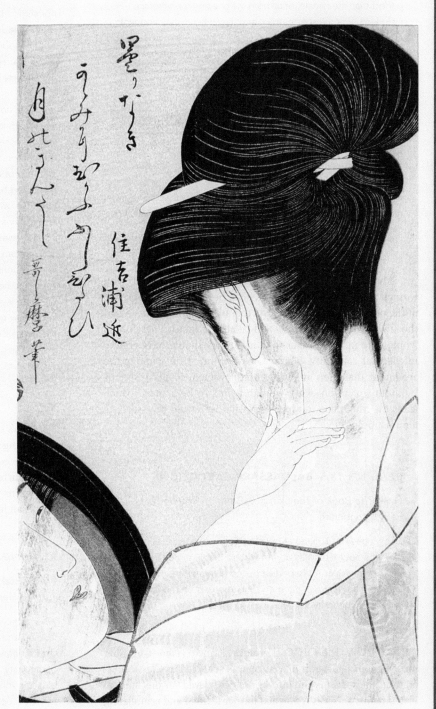

▲ **13.33** Kitagawa Utamaro, *White make-up*, 1795–1796. Color woodblock print, 14 ½" × 8 ¾" (37.0 × 22.3 cm). Musée national des arts asiatiques Guimet, Paris, France.

(continued from p. 445)

concerned, be more perfectly stone than another stone, nor one piece of wood more perfectly wood than another piece, so one man cannot be more perfectly man than another; and so, as far as their formal substance is concerned, the male cannot be more perfect than the female, since both the one and the other are included under the species man, and they differ in their accidents and not their essence. You may then say that man is more perfect than woman if not as regards essence then at least as regards accidents; and to this I reply that these accidents must be the properties either of the body or of the mind. Now if you mean the body, because man is more robust, more quick and agile, and more able to endure toil, I say that this is an argument of very little validity since among men themselves those who possess these qualities more than others are not more highly regarded on that account; and even in warfare, when for the most part the work to be done demands exertion and strength, the strongest are not the most highly esteemed. If you mean the mind, I say that everything men can understand, women can too; and where a man's intellect can penetrate, so along with it can a woman's."

There follows a discussion of what Nature "intended" with women and men, and how neither can be perfect in the absence of the other. The Magnifico jests that philosophers believe that those who are weak in body will be able in mind. Therefore, if women are in fact weaker than men, they should have greater intellectual capability. Signor Gaspare, intent on winning the argument that men are superior to women, finally responds "without exception every woman wants to be a man," which leads the Magnifico to reply with what we would now see as a feminist point of view:

READING 13.5 BALDASSARE CASTIGLIONE

From *The Book of the Courtier*, Book 3, "The Perfect Lady," continued

The Magnifico Giuliano at once replied:
 "The poor creatures do not wish to become men in order to make themselves more perfect but to gain their freedom and shake off the tyranny that men have imposed on them by their one-sided authority."

VERONICA FRANCO Veronica Franco (1546–1591), the most famous courtesan in Venice, was schooled in Classical literature, knew the ins and outs of politics, played various musical instruments, and was renowned for her learned and scintillating conversation. She wrote letters to the elite of Venice and Europe, letters that have survived because the recipients valued them. She also wrote poems in **terza rima**, the difficult verse used by Dante in his *Divine Comedy*. Franco's collected poems in terza rima include pieces that are seductive, poetic dialogues with her suitors, and many that challenge the patriarchal status quo in Venice:

READING 13.6 VERONICA FRANCO

From *Poems in Terza Rima*, chapter 2, lines 34–39 and 154–171

Since I will not believe that I am loved,
nor should I believe it or reward you
for the pledge you have made me up to now,
win my approval, sir, with deeds:
prove yourself through them, if I, too,
am expected to prove my love with deeds.

. . .

So sweet and delicious do I become,
when I am in bed with a man
who, I sense, loves and enjoys me,
that the pleasure I bring excels all delight,
so the knot of love, however tight
it seemed before, is tied tighter still.
Phoebus, who serves the goddess of love,
and obtains from her as a sweet reward
what blesses him far more than being a god,
comes from her to reveal to my mind
the positions that Venus assumes with him
when she holds him in sweet embraces;
so that I, well taught in such matters,
know how to perform so well in bed
that this art excels Apollo's by far,
and my singing and writing are both forgotten
by the man who experiences me in this way,
which Venus reveals to people who serve her.

Franco's efforts to help and protect Venetian women who were working as prostitutes through her charitable institution, Casa del Soccorso, acknowledged the dangers and indignities of life as a courtesan—particularly among the *cortigiane di lume*. Franco warns the mother of a young woman of the sordid side of courtesan life in a letter:

READING 13.7 VERONICA FRANCO

From letter 22, "A Warning to a Mother Considering Turning Her Daughter into a Courtesan"

Where once you made [your daughter] appear simply clothed and with her hair arranged in a style suitable for a chaste girl, with veils covering her breasts and other signs of modesty, suddenly you encouraged her to be vain, to bleach her hair and paint her face. And all at once, you let her show up with curls dangling around her brow and down her neck, with bare breasts spilling out of her dress, with a high, uncovered forehead, and every other embellishment people use to make their merchandise measure up to the competition.

. . .

I'll add that even if fate should be completely favorable and kind to her, this is a life that always turns out to be a misery. It's a most wretched thing, contrary to human reason, to subject one's body and labor to a slavery terrifying even to think of. To make oneself prey to so many men, at the risk of being stripped, robbed, even killed, so that one man, one day, may snatch away from you everything you've acquired from many over such a long time, along with so many other dangers of injury, and dreadful contagious diseases; to eat with another's mouth, sleep with another's eyes, moving according to another's will, obviously running toward the shipwreck of your mind and your body—what greater misery? What wealth, what luxuries, what delights can outweigh all this? Believe me, among all the world's calamities, this is the worst. And if to worldly concerns you add those of the soul, what greater doom and certainty of damnation could there be?

BENVENUTO CELLINI Benvenuto Cellini (1500–1571) was a talented Florentine goldsmith and sculptor whose life, frankly chronicled, was a seemingly never-ending panorama of violence, intrigue, quarrel, sexual excess, egotism, and political machination. His autobiography, much of it dictated to a young apprentice who wrote while Cellini worked, is a vast and rambling narrative of Cellini's life from his birth to the year 1562. We read vignettes about popes and commoners, artists and soldiers, cardinals and prostitutes, assassins and artists, as well as a gallery of other characters from the Renaissance demimonde of Medicean Florence and papal Rome.

Above all, we meet Benvenuto Cellini, who makes no bones about his talent, his love of life, or his taste for violence. Cellini is not one of Castiglione's courtiers. He fathered eight children in and out of marriage; was banished from Florence for sodomy; was imprisoned for assault; fled Rome after murdering a man; and fought on the walls of the Castel Sant'Angelo in Rome during the siege of 1527, in defense of the Medici pope Clement VII. Anyone who thinks of the Renaissance artist solely in terms of proportion, love of the classics, Neo-Platonic philosophy, and genteel humanism is in for a shock when encountering Cellini's autobiography.

One particular part of Cellini's book is interesting not for its characteristic bravado or swagger but for its insight into the working methods of an artist. In a somewhat melodramatic account, Cellini describes the process of casting the bronze statue of Perseus that turned out to be his most famous work (**Fig. 13.34**). Completed in 1554 for Duke Cosimo I de' Medici, it is a highly refined work, all the more interesting for Cellini's record of its genesis.

In the extract from his autobiography shown in Reading 13.8 on page 450, Cellini recalls his casting of the statue. The casting of bronze statues is a complex process in which a model of the statue, made of a material such as wax or clay, is translated into the more durable bronze. Bronze has been used most frequently because of its appealing surface and color characteristics. It involves the use of a kiln, and accidents occur quite often. Cellini's casting of the bronze Perseus involved a series of such accidents, some of which could have been quite dangerous. As

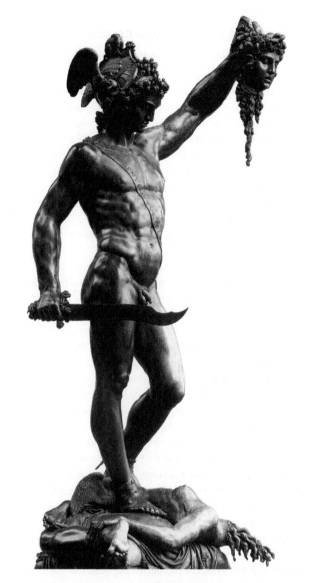

▲ **13.34** Benvenuto Cellini, *Perseus Holding the Head of Medusa*, **1545–1554. Bronze, 126" (320 cm) high (after restoration). Loggia dei Lanzi, Florence, Italy.** Earlier models of this statue, including a first effort in wax, are preserved in the Bargello Museum in Florence.

the reader encounters the process, she or he comes across much more than delays, illness, masterly skill, and perseverance; the ego of the artist is also inescapable. Here the artist is attempting to explain the difficulties of the process to the duke—his patron.

Despite his skepticism of the process and his impatience with the manner of the artist, the duke asks Cellini to explain matters to him, which he does, at the same time asking for more money. We are then led through the complicated casting process, including an illness during which Cellini is certain he will die. But upon hearing that his work is in danger of being destroyed, the "selfless" Cellini springs out of bed and summons all of his assistants and all of his skills to the achievement of the task. Once the statue is complete, Cellini journeys to Pisa to inform his patron, in effect, that he—the artist—was correct in his predictions.

READING 13.8 BENVENUTO CELLINI

From *The Autobiography*, Casting Perseus

I had cast the Medusa [whose severed head is held high by the victorious Perseus]—and it came out very well—and then very hopefully I brought the Perseus towards completion. I had already covered it in wax, and I promised myself that it would succeed in bronze as well as the Medusa had. The wax Perseus made a very impressive sight, and the Duke thought it extremely beautiful. It may be that someone had given him to believe that it could not come out so well in bronze, or perhaps that was his own opinion, but anyhow he came along to my house more frequently than he used to, and on one of his visits he said:

"Benvenuto, this figure can't succeed in bronze, because the rules of art don't permit it."

I strongly resented what his Excellency said.

"My lord," I replied, "I'm aware that your Most Illustrious Excellency has little faith in me, and I imagine this comes of your putting too much trust in those who say so much evil of me, or perhaps it's because you don't understand the matter."

He hardly let me finish before exclaiming: "I claim to understand and I do understand, only too well."

"Yes," I answered, "like a patron, but not like an artist. If your Excellency understood the matter as you believe you do, you'd trust in me on the evidence of the fine bronze bust I made of you: that large bust of your Excellency that has been sent to Elba. And you'd trust me because of my having restored the beautiful Ganymede in marble; a thing I did with extreme difficulty and which called for much more exertion than if I had made it myself from scratch: and because of my having cast the Medusa, which is here now in your Excellency's presence; and casting that was extraordinarily difficult, seeing that I have done what no other master of this devilish art has ever done before. Look, my lord, I have rebuilt the furnace and made it very different from any other. Besides the many variations and clever refinements that it has, I've constructed two outlets for the bronze: that was the only possible way of ensuring the success of this difficult, twisted figure. It only succeeded so well because of my inventiveness and shrewdness, and no other artist ever thought it possible.

"Be certain of this, my lord, that the only reason for my succeeding so well with all the important and difficult work I did in France for that marvelous King Francis was because of the great encouragement I drew from his generous allowances and from the way that he met my request for workmen—there were times when I made use of more than forty, all of my own choice. That was why I made so much in so short a time. Now, my lord, believe what I say, and let me have the assistance I need, since I have every hope of finishing a work that will please you. But if your Excellency discourages me and refuses the assistance I need, I can't produce good results, and neither could anyone else no matter who."

The Duke had to force himself to stay and listen to my arguments; he was turning now one way and now another, and, as for me, I was sunk in despair, and I was suffering agonies as I began to recall the fine circumstances I had been in [when] in France.

All at once the Duke said: "Now tell me, Benvenuto, how can you possibly succeed with this beautiful head of Medusa, way up there in the hand of the Perseus?"

Straight away I replied: "Now see, my lord: if your Excellency understood this art as you claim to then you wouldn't be worried about that head not succeeding; but you'd be right to be anxious about the right foot, which is so far down."

At this, half in anger, the Duke suddenly turned to some noblemen who were with him and said:

"I believe the man does it from self-conceit, contradicting everything."

. . .

Seeing that the work was so successful I immediately went to Pisa to find my Duke. He welcomed me as graciously as you can imagine, and the Duchess did the same. Although their majordomo had sent them news about everything, it seemed to their Excellencies far more of a stupendous and marvelous experience to hear me tell of it in person. When I came to the foot of the Perseus which had not come out—just as I had predicted to his Excellency—he was filled with astonishment and he described to the Duchess how I had told him this beforehand. Seeing how pleasantly my patrons were treating me I begged the Duke's permission to go to Rome.

GLOSSARY

Chiaroscuro (p. 420) From the Italian for "light–dark"; an artistic technique in which subtle gradations of value create the illusion of rounded, three-dimensional forms in space; also called *modeling*.

Glaze (p. 436) In painting, a semitransparent coating on a painted surface that provides a glassy or glossy finish.

Horizon line (p. 423) In linear perspective, the imaginary line (frequently where the earth seems to meet the sky) along which converging lines meet; this spot is known as the vanishing point.

Iconography (p. 437) A set of conventional meanings attached to images; as an artistic approach, representation or illustration that uses the visual conventions and symbols of a culture. Also, the study of visual symbols and their meaning (often religious).

Madrigal (p. 442) A song for two or three voices unaccompanied by instrumental music.

Mannerism (p. 436) A style of art characterized by distortion and elongation of figures; a sense of flattened space rather than depth; a lack of a defined focal point; and the use of clashing pastel colors.

Orthogonal (p. 421) In perspective, a line pointing to the vanishing point.

Patronage (p. 417) In the arts, the act of providing support for artistic endeavors.

Pietà (p. 426) In artistic tradition, a representation of the dead Christ, held by his mother, the Virgin Mary (from the Latin word for "pity").

Polyphony (p. 442) Music with two or more independent melodies that harmonize or are sounded together.

Sarcophagus (p. 431) A coffin; usually cut or carved from stone, although Etruscan sarcophagi were made of terra-cotta.

Terza rima (p. 448) A poetic form in which a poem is divided into sets of three lines (*tercets*) with the rhyme scheme *aba*, *bcb*, *cdc*, and so on.

THE BIG PICTURE THE HIGH RENAISSANCE IN ITALY

Language and Literature
- Leonardo da Vinci began to write his treatises on art and science ca. 1490–1495.
- The Aldine Press was established in Venice ca. 1494.
- Strozzi wrote his poem on Michelangelo's *Night* ca. 1531.
- Vittoria Colonna began writing poems in memory of her husband in 1525.
- Castiglione published *The Courtier* in 1528.
- Michelangelo and Colonna began exchanging letters and poems in 1538.
- Cellini wrote his autobiography ca. 1558–1566.
- Sir Thomas Hoby translated *The Book of the Courtier* into English in 1561.

Art, Architecture, and Music
- Sixtus IV establishes the Sistine Choir in 1473.
- Leonardo da Vinci painted his *Madonna of the Rocks* in 1483, *The Last Supper* in 1495–1498, and *Mona Lisa* ca. 1503–1505.
- Josquin des Prez composed masses and motets for the Sistine Choir ca. 1486–1494.
- Raphael painted *Madonna of the Meadow* in 1508 and *Philosophy (The School of Athens)* in 1509–1511.
- Michelangelo sculpted the *Pietà* in 1498–1499, *David* in 1501–1504, and *Moses* in 1513–1515.
- Michelangelo painted the ceiling of the Sistine Chapel in 1508–1511 and *The Last Judgment* ca. 1534–1541.
- Pope Julius II established the Julian Choir for Saint Peter's Basilica in 1512.
- Adriaan Willaert became the choirmaster of Saint Mark's in Venice in 1527.
- Palladio began the construction of the Villa Rotunda ca. 1550.
- Titian painted *Venus of Urbino* in 1538.
- Tintoretto painted his *Last Supper* in the Mannerist style in 1592–1594.
- Pontormo painted *Entombment* in 1525–1528.
- Bronzino painted *Venus, Cupid, Folly, and Time (The Exposure of Luxury)* ca. 1546.
- Palestrina composed *Missa Papae Marcelli* in 1567.
- Fontana painted *Noli Me Tangere* in 1581.
- Anguissola painted *A Game of Chess* in 1555.
- Bologna sculpted *Abduction of the Sabine Women* ca. 1581–1583.
- Cellini sculpted *Perseus Holding the Head of Medusa* ca. 1545–1554.

Philosophy and Religion
- Luther presented his 95 Theses, triggering the Reformation in Germany in 1517.
- Castiglione published *The Book of the Courtier*, a philosophical treatise on the courtly life in 1528.
- The churches of Rome and England separated in 1534.
- The Council of Trent initiated the Counter-Reformation in 1545–1564.

Glossary
With Pronunciation

A cappella Sung without instrumental accompaniment.

Acropolis Literally "high city"; the flat-topped rock in Athens that rises 490 feet above sea level and has buildings that were erected during the Golden Age, including the Parthenon.

Agnus Dei Latin for "lamb of god."

Allah The Arabic word for God.

Allegory The expression by means of symbolic figures and actions of a hidden or emblematic meaning, often spiritual in nature.

Alliteration A form of rhyme characterized by the repetition of consonant sounds in nearby words.

Ambulatory In a church, a continuation of the side aisles into a passageway that extends behind the choir and **apse** and allows traffic to flow to the chapels, which are often placed in this area (from *ambulare*, Latin for "to walk").

Antiphonal singing A form of religious singing in which segments of a congregation chant alternating verses of a psalm.

Apse A semicircular or polygonal projection of a building with a semicircular dome, especially on the east end of a church.

Aragonite The primary mineral in mother-of-pearl, the iridescent inner layer of a mollusk shell.

Archivolt An ornamental molding around an arched wall opening.

Arian controversy The dispute as to whether Jesus was divine and unified with God the Father and the Holy Spirit (the Orthodox Christian view) or whether Jesus, as the created Son, was distinct from the eternal God the Father (the view held by Arius).

Ars Nova A 14th-century style of music characterized by freedom and variety of melody, as contrasted with stricter 13th-century music.

Aryan A member of one of the peoples supposedly descended from Indo-Europeans; particularly, a speaker of an Iranian or Indian language in ancient times.

Assonance A form of rhyme characterized by the repetition of vowel sounds in nearby words.

Atman The basic principle of life; the individual self, known after enlightenment to be identical with Brahman.

Atrium A courtyard, especially as surrounded by a colonnaded arcade.

Aulos A double-reed musical instrument similar to the modern oboe.

Avatar An incarnation of an animal or a human.

Ballade In music, a composition with the romantic or dramatic quality of a narrative poem.

Barrel vault A roofed-over space or tunnel constructed as an elongated arch or vault.

Basilica A large oblong building or hall with colonnades and an apse; used for public functions, such as a court of law, or as a church.

Beveled Cut to create a slanted edge.

Bhagavad Gita A section of the Mahabharata; considered a great scripture of the Hindu religion.

Black Death The epidemic form of the bubonic plague, which killed as much as half the population of Western Europe in the mid-fourteenth century.

Black-figure technique A Greek vase-painting technique in which only the figural elements are applied using a mixture of fine clay and water (see **slip**); kiln firings produce the combination of a reddish clay pot with black figures. Details are added to the figures with a fine-pointed implement that scratches away some of the black paint.

Boule The ruling council of the Athenian Ecclesia.

Brahma The Hindu god of creation.

Brahman In Hinduism, the one true reality, which cannot be fully understood by humans.

Cadence A modulation or inflection of the voice.

Caliph A spiritual and secular leader of the Islamic world, claiming succession from Muhammad.

Calligraphy Decorative handwriting, particularly as produced with a brush or a pen.

Canon A code of law, an honored list, or an ecclesiastical regulation enacted by a religious council; as in a canon of "great works of literature" or a canon of writings that belong in a bible.

Canon of proportions A set of rules (or formula) governing what are considered to be the perfect proportions of the human body or correct proportions in architecture.

Canto A principal division of a long poem.

Canto carnascialesco A carnival song, written for the carnival season before Lent.

Cantor A singer, especially a person who takes a special role in singing or leading songs at a ceremony or at synagogue and church services.

Canzone A song (plural *canzoni*).

Canzoniere A songbook.

Capital In architecture, the uppermost part of a column on which rests the horizontal lintel.

Capitalism A way of organizing the economy so that the manufacture and distribution of goods—and the exchange of

wealth—is in the hands of individuals rather than the government.

Capitulary A royal rule or decree, especially one made by a Frankish king.

Carolingian Of Charlemagne.

Caryatid A stone sculpture of a draped female figure used as a supporting column in a Greek-style building.

Caste system A system of rigid social stratification characterized by being heritable and limiting of marriage prospects to a member of one's own caste.

Catacomb An underground cemetery consisting of tunnels or chambers that have recesses for coffins and tombs.

Catharsis A cleansing of the soul, or release of pent-up emotions.

Cella The small inner room of a Greek temple, used to house the statue of the god or goddess to whom the temple was dedicated; located behind solid masonry walls, the cella was accessible only to temple priests.

Censer A container carrying incense that is burned, especially during religious services.

Chanson A French word meaning song, often used to refer to a song that is free in form and expressive in nature.

Chi-rho A symbol for Christ, consisting of the first two letters of the Greek word *christos*.

Chiaroscuro From the Italian for "light–dark"; an artistic technique in which subtle gradations of value create the illusion of rounded, three-dimensional forms in space; also called *modeling*.

Choir In architecture, the part of a church occupied by singers, usually located between a **transept** and the major **apse**.

Chorus In Greek drama, a company or group of actors who comment on the action in a play, either by speaking or singing in unison.

Christ The Messiah, or savior, as prophesied in the Hebrew Bible; Jesus of Nazareth, held by Christians to be the fulfillment of the prophecy.

Chryselephantine Made of gold and ivory.

Ci poetry A form of Chinese lyric poetry meant to be sung and usually expressing desire.

Clerestory High windows permitting light to enter a building but not enabling people to look in or out.

Cloister A covered walkway, particularly in a monastery, convent, college, or church, with a wall on one side and a row of columns open to a quadrangle on the other side.

Codex A bundle of manuscript pages that are stitched together in a manner resembling a modern book.

Colonnade A series of columns, usually capped by a lintel, that can support a roof.

Column A vertical weight-bearing architectural member.

Conceptual representation The portrayal of a person or object as it is known or thought (conceptualized) to be rather than copied from nature at any given moment. Conceptual figures tend to be stylized rather than realistic.

Contrapposto A position in which a figure is obliquely balanced around a central vertical axis; also known as the *weight-shift principle*.

Corbeled arch An arch in which each successive layer of stone projects slightly beyond the course below.

Couplet A pair of rhyming lines of poetry.

Course A horizontal row of stone or brick.

Covenant Agreement; referring to the "special relationship" between God and the Israelites.

Credo The profession of faith sung after the Gospel in the Ordinary of the Mass.

Crossing square The area of overlap in a church plan formed by the intersection of the **nave** and the **transept**.

Crypt An underground vault or chamber, particularly beneath a church, that is used as a burial place.

Cuneiform A system of writing featuring wedge-shaped characters; used in ancient Akkadian, Assyrian, Babylonian, and Persian writing.

Cyclopean masonry Walls constructed of extremely large and heavy stones.

Cyclopes A mythical race of one-eyed giants known for their inhuman strength.

Dactylic hexameter The rhythmic scheme used in epic poetry by Homer and Virgil; each line consists of six dactyls. A dactyl is a long syllable followed by two short syllables.

Dadabwaan A kind of Islamic drum.

Decalogue Another term for the Ten Commandments, as set forth in the book of Exodus.

Delian League A politically neutral organization of Greek city-states that kept a treasury on the island of Delos to fund military defenses in case of an attack.

Dialectics Intellectual techniques involving rigorous reasoning to arrive at logical conclusions.

Dithyramb A frenzied or impassioned choral hymn of ancient Greece, especially one dedicated to Dionysus, the god of wine.

Doctor of the church A title given by the Roman Catholic Church to 33 eminent saints, including Augustine, who distinguished themselves by soundly developing and explaining church doctrine.

Dome A vaulted roof usually having a circular base and shaped like half a sphere.

Doric The earliest and simplest of the Greek architectural styles, consisting of relatively short, squat columns, sometimes unfluted, and a simple, square-shaped capital.

Dramatic irony The literary technique in which the words spoken by a character have particular significance for the audience although the character himself or herself is unaware of their meaning.

Dromos A narrow passageway leading to a tomb.

Dukkha Suffering.

Ecclesia The main assembly of the democracy of Athens during its golden age.

Ekphrasis A literary device in which a work of art is described in such detail that a clear visual picture emerges.

Engaged column A column embedded in a wall and partly projecting from the surface of the wall.

Entablature In architecture, a horizontal structure supported by columns that in turn supports any other element, such as a pediment, that is placed above; from top to bottom, the entablature consists of a *cornice*, a **frieze**, and an *architrave*.

Entasis In architecture, a slight convex curvature of a column, which provides the illusion of continuity of thickness as the column rises.

Epicureanism A school of philosophy that argues that the world consists of chance combinations of atoms and that happiness or the avoidance of pain and anxiety are the greatest goods, although pleasure is to be enjoyed in moderation.

Epithet A descriptive word or phrase that refers to a particular quality in a person or thing

Ethos Literally "character"; used by Greeks to describe the ideals or values that characterize or guide a community.

Exemplum In literature, a tale intended as a moral example (plural *exempla*).

Exodus A mass departure.

Fabliau A medieval tale told in verse and having comic, ribald themes (plural *fabliaux*).

Fenestration The presence and arrangement or design of windows and doors in a building.

Feudalism The dominant social system in medieval Europe from the 9th through the 15th centuries, in which vassals were granted fiefs—estates or property—by their lords and were required to serve under their lords in the event of war.

Flying buttress In architecture, an arched masonry support that carries the thrust of a roof or a wall away from the main structure of a building to an outer pier or buttress.

Foreshortening A perspective technique used to convey the appearance of contraction of a figure or object as it recedes into space.

Forum An open public space in the center of a Roman city (plural *fora*).

Fourth In music, the distance between the lowest note and the fourth note up an octave.

French Gothic style A style of architecture that originated in 12th-century France and is characterized by pointed arches, ribbed vaults, and flying buttresses, which enable the use of ample fenestration.

Fresco A type of painting in which pigments are applied to a fresh, wet plaster surface or wall and thereby become part of the surface or wall (from Italian for "fresh").

Frieze In architecture, a horizontal band between the *architrave* and the *cornice* that is often decorated with sculpture.

Frottola A humorous or amorous poem set to music for a singer and two or three instrumentalists.

Glaze In ceramics, a coating; a coating of transparent or colored material applied to the surface of a ceramic piece before it is fired in a kiln.

Gloria A hymn of praise from the Ordinary of the Mass.

Gospel The teachings of Jesus and the apostles, especially as described in the first four books of the New Testament; also conceived as "good news" in that redemption has become possible.

Gothic style A style of architecture that flourished during the High and Late Middle Ages, characterized by pointed arches, rib vaulting, and a visual dissolving of stone walls to admit light into a building.

Great Schism The division in the Roman Catholic Church during which rival popes reigned at Avignon and Rome.

Guild Generally, an association of people with common interests; in medieval times, typically a group of merchants or artisans who sought to maintain their standards and protect their interests.

Hadith A collection of the sayings of Muhammad and reports of his behavior.

Harmony In music, a pleasing combination of lines or voices; in art and architecture, a balanced or unified composition arranged in a pleasing manner.

Henotheism The belief that there are many gods but only one is chosen for worship.

Heroic verse The meter or rhythm used in epic poetry, primarily in Greek and Latin.

Hieroglyphics An ancient Egyptian system of writing that used pictures or symbols.

Hollow-casting A sculpture technique using molds that are lined with molten material—such as copper or bronze—rather than filled with the material (which would yield a solid rather than a hollow form).

Holocaust Mass slaughter or destruction, as by fire or nuclear war; the name given to the Nazi slaughter of Jews during World War II.

Horarium The daily schedule of members of a religious community, such as a monastery.

Horizon line In linear perspective, the imaginary line (frequently where the earth seems to meet the sky) along which converging lines meet; this spot is known as the vanishing point.

Hubris Extreme pride or arrogance, as shown in actions that humiliate a victim for the gratification of the abuser.

Iambic pentameter A poetic metrical scheme with five feet, each of which consists of an unaccented syllable followed by an accented syllable.

Icon An image or symbol.

Iconoclastic controversy The dispute as to whether or not it was blasphemous to use images or icons in art, based on the second of the Ten Commandments, in which God forbids the creation and worship of "graven images"; the Greek word *iconoclasm* translates as "image breaking" and refers to the destruction of religious icons within a culture.

Iconography A set of conventional meanings attached to images; as an artistic approach, representation or illustration that uses the visual conventions and symbols of a culture. Also, the study of visual symbols and their meaning (often religious).

In medias res Literally, "in the middle of things"; a phrase used to describe a narrative technique in which the reader encounters the action in the middle of the story rather than at the beginning.

Isorhythm Alloting a repeated single melody to one of the voices in a composition.

Jus civile Rules and principles of law as derived from the laws and customs of Rome.

Ka'bah Arabic for "cube"; the cube-shaped building in Mecca, believed by Muslims to have been built by Abraham and to lie directly beneath heaven, which is the holiest site of Islam.

Karma The path according to which one carries out one's duty according to his or her caste.

Kithara A seven-stringed lyre.

Kore Literally, "girl"; a clothed female figure as represented in the sculpture of the Archaic period of Greek art, often carved with intricate detail. A counterpart to the kouros (plural *korai*).

Kouros Literally, "boy"; a male figure as represented in the sculpture of the Geometric and Archaic periods of Greek art (plural *kouroi*).

Krater A wide-mouthed ceramic vessel used for mixing wine and water.

Kufic Styles of calligraphy that were largely developed in the Iraqi city of Kufah.

Kyrie Eleison Repeated phrases in the Ordinary of the Mass that translate as "Lord, have mercy on us."

Lapis lazuli An opaque blue, semiprecious stone.

Latin cross plan A cross-shaped church design in which the nave is longer than the transept.

Latin fathers The early and influential theologians of Christianity.

Lekythos An oil flask used for funerary offerings and painted with mourning or graveside scenes (plural *lekythoi*).

Lintel In architecture, a horizontal member supported by posts or columns, used to span an opening.

Liturgical Relating to public worship.

Liturgy The arrangement of the elements or parts of a religious service.

Living rock Natural rock formations, as on a mountainside.

Longitudinal plan A church design in which the nave is longer than the transept and in which parts are symmetrical against an axis.

Lyric poetry A form or genre of poetry characterized by the expression of emotions and personal feelings; so called because such poetry was sung to a lyre.

Madrigal A song for two or three voices unaccompanied by instrumental music.

Madrigal A song for two or three voices unaccompanied by instrumental music.

Maestà From the word for "majesty," a work of art that features the Virgin Mary and Christ child enthroned and surrounded by angels and saints.

Magister A graduate degree indicative of readiness to teach in a university. The term is similar to a master's degree today, although as advanced as today's doctorate.

Mahabharata The Mahabharata (ca. 400 BCE–400 CE), attributed to Krishna Dvaipayana Vyasa, is an epic poem that embellishes probable events of India's heroic age.

Mahdi The redeemer of Islam.

Mandala A geometric Hindu and Buddhist symbol that represents the universe.

Mannerism A style of art characterized by distortion and elongation of figures; a sense of flattened space rather than depth; a lack of a defined focal point; and the use of clashing pastel colors.

Meander A continuous band of interlocking geometric designs.

Melisma A group of notes or tones sung to a single syllable of text.

Messiah Savior; from the Hebrew for "anointed one."

Metope In architecture, a panel containing *relief sculpture* that appears between the *triglyphs* of the Doric frieze.

Middle Kingdom The period in ancient Egyptian history ca. 2040–1640 BCE.

Middle relief Relief sculpture that is between low relief and high relief in its projection from a surface.

Mihrab A niche in the wall of a mosque that indicates the direction of Mecca so that the congregation can direct their prayers in that direction.

Minbar The pulpit in a mosque.

Mode In music, the combination of two *tetrachords*.

Modeling In two-dimensional works of art, the creation of the illusion of depth through the use of light and shade (*chiaroscuro*).

Monasticism The style of life under religious vows in which a community of people shares an ascetic existence in order to focus on spiritual pursuits.

Monophonic Having a single melodic line.

Monotheism Belief that there is one god.

Mortuary temple An Egyptian temple in which pharaohs worshipped during their lifetimes and were worshipped after death.

Mosaic An image created by assembling small pieces of materials such as glass, stone, or tile.

Mosque An Islamic house of worship (as a synagogue in Judaism or a church in Christianity).

Muezzin The crier who calls Muslims to prayer five times a day.

Mullion In architecture, a slender vertical piece that divides the units of a window or door.

Musica ficta Literally "fictitious music"; the practice of making sounds not written on the page of music.

Narthex A lobby or vestibule that leads to the **nave** of a church.

Naturalism Representation that strives to imitate appearances in the natural world.

Nave The central part of a church, constructed for the congregation at large; usually flanked by aisles with less height and width.

Neo-Platonism The school of philosophy that developed Plato's concept of the One, the source of all life, which is transcendent and unknowable through reasoning.

Neolithic The New Stone Age.

New Kingdom The period in ancient Egyptian history ca. 1550–1070 BCE, marked by the height of Egyptian power and prosperity; also referred to as the Egyptian Empire.

Nirvana A state characterized by the absence of suffering.

Noh A type of Japanese drama in which actors wear wooden masks.

Nostos Literally, "homecoming"; the theme of the heroes' journeys homeward in the Homeric epics (plural *nostoi*).

Obsidian A black, semiprecious, glass-like substance formed naturally by the rapid cooling of lava.

Octave The interval of eight degrees between two musical pitches whose frequencies have a ratio of 2:1; originated from Pythagorean ideas about harmony.

Oculus A circular opening in a dome that allows the entry of natural light from above.

Old Kingdom The period in ancient Egyptian history ca. 2575–2040 BCE, during which the civilization achieved its first golden age.

Optical representation The portrayal of a person or object as it is seen at any given moment from any given vantage point.

Order An architectural style as described, primarily, by the design of the columns and frieze.

Organum An early form of **polyphony** using multiple melodic lines.

Orientalizing period The early phase of Archaic Greek art, so named for the adoption of motifs from Egypt and the Near East.

Orthodox Christians Christians who believe in the divinity of Christ and the unity of Jesus, God the Father, and the Holy Spirit.

Orthogonal In linear perspective, a line pointing to the vanishing point.

Oud A short-necked stringed instrument that is plucked like a guitar; a lute.

Paleolithic The Old Stone Age, during which the first sculptures and paintings were created.

Patriarch The male head of a family or a tribe.

Patrician A member of an elite family in ancient Rome.

Patronage In the arts, the act of providing support for artistic endeavors.

Pediment In architecture, any triangular shape surrounded by *cornices*, especially one that surmounts the *entablature* of the *portico façade* of a Greek temple.

Peloponnesian War The war between Athens and its allies and the rest of Greece, led by the Spartans.

Pendentive A triangular section of vaulting between the rim of a dome and each adjacent pair of the arches that support it.

Peplos A body-length garment worn by women in Greece prior to 500 BCE.

Peripteral Referring to a Greek temple design that has a colonnade around the entire cella and its porches.

Perpendicular style A form of Gothic architecture developed in England and characterized by extreme vertical emphasis and fan vaulting.

Pharaoh An ancient Egyptian king believed to be divine.

Pietà In artistic tradition, a representation of the dead Christ, held by his mother, the Virgin Mary (from the Latin word for "pity").

Pillow book Generally, a book of observations and musings, which reveal a period in a person's life.

Plebeian A landowning Roman citizen, but not a patrician.

Polis A self-governing Greek city-state (plural *poleis*).

Polymath A person of great learning and achievement in several fields of study, especially unrelated fields such as the arts and the sciences.

Polyphonic Of a form of musical expression characterized by many voices.

Polyphony Music with two or more independent melodies that harmonize or are sounded together.

Polyptych An arrangement of four or more painted or carved panels that are hinged together.

Polytheism Belief in many gods.

Portico A roofed entryway, like a front porch, with columns or a colonnade.

Post-and-lintel construction Construction in which vertical elements (posts) are used to support horizontal crosspieces (lintels).

Prehistoric Prior to record keeping or the written recording of events.

Prophet A person who speaks with the authority of God, either to predict the future or to call people to observance.

Psalm A song, hymn, or prayer from the book of Psalms; used in Jewish and Christian worship.

Qur'an The Muslim holy book, which is believed to have been revealed by Allah to Muhammad.

Ramadan The ninth month of the Islamic calendar; considered a holy month during which there are limitations on eating, smoking, and sex (alcohol is prohibited at all times).

Rebab A long-necked stringed instrument played with a bow.

Rectangular bay system A floor plan that places rectangular units in the nave, such that each is defined by its own vault and a square unit in the side aisles.

Red-figure technique A Greek vase-painting technique in which everything *but* the figural elements is covered with a mixture of fine clay and water (see **slip**); kiln firings produce a combination of a black pot with reddish figures.

Refectory A room used for communal dining, as in a monastery or college.

Register A horizontal band that contains imagery; registers are usually placed one on top of another to provide continuous space for the depiction of a narrative (like a comic strip).

Reincarnation One's rebirth into another body, according to one's karma.

Relic In this usage, a part of a holy person's body or belongings used as an object of reverence.

Relief sculpture Sculpture in which figures project from a background; often used to decorate architecture or furniture. *High relief* sculpture projects from its background by at least half its natural depth. *Low relief* sculpture projects only slightly from its background.

Relieving triangle An open triangular space above a lintel, framed by the beveled contours of stones, that relieves the weight carried by the lintel; seen, for example, in the Lion Gate at Mycenae.

Responsorial singing A form of religious singing in which a cantor intones lines from psalms and the congregation responds with a simple refrain.

Rig-Veda A collection of 1028 hymns to the Hindu gods.

Rock-cut tomb A burial chamber cut into a natural rock formation (living rock), usually on a hillside.

Romanesque Referring to a style of European art and architecture from the 9th through 12th centuries, descended from Roman styles; in architecture, characterized by heavy masonry, round arches, and relatively simple ornamentation.

Rosetta Stone An ancient Egyptian stele dating to 196 BCE with text inscribed in three languages: hieroglyphics, demotic Egyptian, and Greek. Discovery of the stone enabled Europeans to decipher the meaning of hieroglyphics.

S curve A double weight shift in Classical sculpture in which the body and posture of a figure form an S shape around an imaginary vertical axis or pole.

Samurai Japanese professional warriors in medieval times.

Samurai-dokoro The official in feudal Japan who led legal and military affairs.

Sanctus and Benedictus A hymn in the Ordinary of the Mass based on the angelic praise found in Isaiah 6.

Sangha A Buddhist monastery.

Sanskrit An ancient Indo-Aryan language; the classical language of India and Hinduism.

Sarcophagus A coffin; usually cut or carved from stone, although Etruscan sarcophagi were made of terra-cotta (plural *sarcophagi*).

Satyr play A lighthearted play; named for the satyr, a mythological figure of a man with an animal's ears and tail.

Scholasticism The system of philosophy and theology taught in medieval European universities, based on Aristotelian logic and the writings of early church fathers; the term has come to imply insistence on traditional doctrine.

Scriptorium A room dedicated to writing.

Semitic A family of languages of Middle Eastern origin, including Akkadian, Arabic, Aramaic, Hebrew, Maltese, and others.

Septuagint An ancient Greek version of the Hebrew scriptures that was originally made for Greek-speaking Jews in Egypt.

Sexpartite rib vault In architecture, a rib vault divided into six parts and formed by the intersection of barrel vaults.

Shariah The moral code and religious law of Islam.

Shia The Islamic denomination that believes that Muhammad, as commanded by Allah, ordained his son-in-law, Ali, as the next caliph and that legitimate successors must be drawn from the descendants of Ali.

Shintoism The native Japanese religion, which teaches of many beneficent gods and love of nature.

Shiva The Hindu god of creation and destruction; the "destroyer of worlds."

Shogun Another term for the **samurai-dokoro**.

Slip In ceramics, clay that is thinned to the consistency of cream; used in the decoration of Greek vases (**see black-figure technique** and **red-figure technique**).

Sonnet A 14-line poem usually broken into an octave (a group of eight lines) and a sestet (a group of six lines); rhyme schemes can vary.

Soothsayer A person who can foresee the future.

Sophist A wise man or philosopher, especially one skilled in debating.

Sphinx A mythical creature with the body of a lion and the head of a human, ram, or cat. In ancient Egypt, sphinxes were seen as benevolent, and statues of sphinxes were used to guard the entrances to temples.

Spondee A foot of poetry consisting of two syllables, both of which are stressed.

Stele An upright slab or pillar made of stone with inscribed text or relief sculpture, or both. Stelae (pl.) served as grave markers or commemorative monuments.

Stoa A covered colonnade; a roofed structure, like a porch, that is supported by a row of columns opposite a back wall.

Stoicism A school of philosophy with the view that the universe was ordered by the gods and that people could not change the course of events; people could, however, psychologically distance themselves from tragic events by controlling their attitudes toward them.

Studia Schools.

Stupa A dome-shaped reliquary of the Buddha, possibly also of Buddhist texts.

Stylobate A continuous base or platform that supports a row of columns.

Sufism The inner, spiritual dimension of Islam.

Sunken relief In sculpture, the removal of material from a surface so that the figures appear to be cut out or recessed.

Sunni The Islamic denomination that believes that Muhammad's rightful successor was his father-in-law, Abu Bakr, and that the Qur'an endorses the selection of leaders according to the consensus of the Muslim community.

Sura A section of the Qur'an; a chapter.

Talmud A collection of Jewish law and tradition created ca. fifth century CE.

Tercet A group of three lines of verse; characterized in *The Divine Comedy* by the **terza rima** scheme.

Terza rima A poetic form in which a poem is divided into sets of three lines (**tercets**) with the rhyme scheme *aba*, *bcb*, *cdc*, and so on.

Tessellation Tiling a plane (flat surface) with one or more geometric shapes, called tiles, without overlapping or gaps.

Testament Originally, a covenant between God and humans; now referring more often to either of the two main divisions of the Bible: the Hebrew Bible (Old Testament) and the Christian Bible (New Testament).

Tetrachord A group of four pitches, the two outer ones a perfect fourth interval apart and the inner ones variably spaced.

Theaters A round or oval structure, typically unroofed, having tiers of seats rising gradually from a center stage or arena.

Tholos A tomb chamber in the shape of a beehive.

Torah A Hebrew word meaning "teaching" or "law" and used to refer to the first five books of the Hebrew Bible; also known as the *Pentateuch.*

Transept The side parts of a church plan with a **crossing square**, crossing the **nave** at right angles.

Trecento Literally, "300"; the Italian name for the 14th century.

Tribune gallery In architecture, the space between the nave arcade and the clerestory that is used for traffic above the side aisles on the second stage of the elevation.

Tribune The title given elected officials in Rome; they could convene the Plebeian Council and the Senate and propose legislation.

Triforium A gallery or arcade above the arches of the **nave**, **choir**, or **transept** of a church.

Triglyph In architecture, a panel incised with vertical grooves (usually three, hence *tri-*) that serve to divide the scenes in a *Doric* **frieze**.

Trilogy A series of three tragedies.

Triumphal arch A monumental structure that takes the form of one or more arched passageways, often spanning a road, and commemorates a military victory.

Trochee A foot of poetry consisting of two syllables, in which the first syllable is stressed and the second is unstressed.

Trope A literary or rhetorical device, such as the use of metaphor or irony.

Tympanum A semicircular space above the doors of a cathedral.

Ummah The Muslim community at large.

Universitas A corporation; a group of persons associated in a guild, community, or company.

Upanishads A series of classical Indian teaching texts addressing issues such as karma, death, and dreams.

Value In art, the relative lightness or darkness of a color.

Vellum Calfskin, kidskin, or lambskin used as a surface for writing.

Vernacular The native dialect or language of a region or country, as contrasted with a literary or foreign language.

Vishnu A Hindu god; the preserver of the universe.

Votive chapel A chapel that is consecrated or dedicated to a certain purpose.

Votive In a sacred space like a temple, a voluntary offering to a god put in place as a petition or to show gratitude; as in votive candle.

Voussoir A wedge-shaped or tapered stone that is used in the construction of an arch.

Vulgate Bible A late-fourth-century version of the Bible, largely translated into Latin by Saint Jerome.

Yakshi A pre-Buddhist voluptuous goddess who was believed to embody the generative forces of nature.

Ziggurat In ancient Mesopotamia, a monumental platform on top of which a temple was erected. The height of the ziggurat was intended to bring worshippers closer to the gods.

Photo Credits

CHAPTER 1 1.1 Atelier Daynes Paris/National Geographic Creative; **1.2** Photo by John Weinstein/Field Museum Library/Getty Images; **1.3** Luka Mjeda; **1.4** Photograph by Francesco d'Errico & Christopher Henshilwood/© University of Bergen, Norway; **1.5** Gonzalo Azumendi/AGE Fotostock; **1.6** SISSE BRIM-BERG/National Geographic; **1.7** Rmn-Grand Palais/Art Resource, NY; **1.8** Erich Lessing/Art Resource, NY; **1.9** Zev Radovan www.biblelandpictures.com; **1.10** Adam Woolfitt/Encyclopedia/Corbis; **1.11** Female Figurine, late fifth millenium (clay & pigment), Prehistoric/Brooklyn Museum of Art, New York, USA/Hagop Kevorkian Fund & Designated Purchase Fund/Bridgeman Images; **1.12** Steatopygous figure, Syria, 7th–6th Millennium BCE (hardstone), Neolithic/Private Collection/Photo © Heini Schneebeli/Bridgeman Images; **1.13** The Granger Collection, NYC; **1.14** Danita Delimont/Gallo Images/Getty Images; **1.15A** Richard Ashworth/Robert Harding; **1.15B** Cengage Learning; **1.16** Erich Lessing/Art Resource, NY; **1.17A** Rmn-Grand Palais/Art Resource, NY; **1.17B** Erich Lessing/Art Resource, NY; **1.17C** Erich Lessing/Art Resource, NY; **1.18** Copyright culture-images/Lebrecht; **1.19** The Trustees of the British Museum/Art Resource, NY; **1.20** Image copyright © The Metropolitan Museum of Art. Image source: Art Resource, NY; **1.21** Scala/Art Resource, NY; **1.22** Victory stele of Naram-Sin, King of Akkad, over the mountain-dwelling Lullubi, Akkadian Period, c.2230 BCE (pink sandstone), Mesopotamian/Louvre, Paris, France/Bridgeman Images; **1.23** Rmn-Grand Palais/Art Resource, NY; **1.24** The Trustees of the British Museum/Art Resource, NY; **1.25** bpk, Berlin/(name of museum)/(name of photographer)/Art Resource, NY; **1.26** David Poole/Robertharding/Alamy; **1.27A** Werner Forman/Art Resource, NY; **1.27B** Erich Lessing/Art Resource, NY; **1.28** The Trustees of the British Museum/Art Resource, NY; **1.29** akg-images; **1.30** Yann Arthus-Bertrand/Terra/Corbis; **1.31** Jon Arnold/Alamy; **1.32** Araldo de Luca; **1.33** De Agostini/SuperStock; **1.34** Robert O'Dea/Akg-Images; **1.35** Jon Arnold Images/Alamy; **1.36** Sean Gallup/Getty Images News/Getty Images; **1.37** Bpk, Berlin/Art Resource, NY; **p. 34** Rosetta stone (Egypt) studied by Jean Francois Champollion, Egyptologist, in 1799. It's a decree by Ptolemee written in three languages: hieroglyphs, demotic, and Greek. With this stone Champollion could decipher hieroglyphs. It's at the British Museum/RUE DES ARCHIVES (RDA)/Bridgeman Images; **1.38** The innermost coffin of the king, from the Tomb of Tutankhamen (c.1370–1352 BCE) New Kingdom (gold inlaid with semi-precious stones) (for detail, see 343642), Egyptian 18th Dynasty (c.1567–1320 BCE)/Egyptian National Museum, Cairo, Egypt/Photo © Boltin Picture Library/The Bridgeman Images; **1.39** Erich Lessing/Art Resource, NY; **1.40** Nimatallah/Art Resource, NY; **1.41** Cengage Learning; **1.42** Cengage Learning; **1.43** Roger Wood/Fine Art/Corbis; **1.44** Gianni Dagli Orti/The Art Archive at Art Resource, NY; **1.45** Erich Lessing/Art Resource, NY;

1.46 Kevin Fleming/Encyclopedia/Corbis; **1.47** Achim Bednorz/Bildarchiv Monheim GmbH/Alamy; **1.48** Vanni Archive/Encyclopedia/Corbis; **1.49** Nimatallah/Art Resource, NY.

CHAPTER 2 2.1 Royal Collection Trust/© Her Majesty Queen Elizabeth II 2016; **2.2** The Trustees of the British Museum/Art Resource, NY; **2.3** Universal Images Group/Superstock; **2.4** Imaginary reconstruction, gouache, © Sian Frances); **2.5** Artepics/Alamy; **2.6** Smithsonian American Art Museum, Washington, DC/Art Resource, NY; **2.7** Photo courtesy of Architect of the Capitol; **2.8** RMN-Grand Palais/Art Resource, NY; **2.9** Photo by Tom Oates.; **2.10** The Metropolitan Museum of Art/Art Resource, NY; **2.11** Copyright the Trustees of The British Museum; **2.12** Image copyright The Metropolitan Museum of Art. Image source: Art Resource, NY; **2.13** Gianni Dagli Orti/Fine Art/Corbis; **2.14** Nimatallah/Art Resource, NY; **2.15** Marie Mauzy/Art Resource, NY; **2.16** Nimatallah/Art Resource, NY; **2.17** Side B of the Francois Vase, made by Ergotimos (fl.575–560 BCE) c.570 BCE (pottery), Kleitias (fl.575–560 BCE)/Museo Archeologico, Florence, Italy/Bridgeman Images; **2.18** Scala/Art Resource, NY; **2.19** Scala/Ministero per i Beni e le Attività culturali/Art Resource, NY; **2.20** © 2018 Cengage Learning; **2.21** © Cengage Learning; **2.22** © 2008 Fred S. Kleiner; **2.23** The Metropolitan Museum of Art/Art Resource, NY.

CHAPTER 3 3.1 The Trustees of the British Museum/Art Resource, NY; **3.2a** Yann Arthus-Bertrand/Terra/Corbis; **3.2b** Cengage Learning; **3.3** Carolyn Clarke/Alamy; **3.4** © The Trustees of the British Museum; **3.5** Fine Art Premium/Corbis; **3.6** Print Collector/Getty Images; **3.7** Marie Mauzy/Art Resource, NY; **3.8** Erich Lessing/Art Resource, NY; **3.9** Marie Mauzy/Art Resource, NY; **3.10** Scala/Art Resource, NY; **3.11** Scala/Ministero per i Beni e le Attività culturali/Art Resource, NY; **3.12** RMN-Grand Palais/Art Resource, NY; **3.13** Nimatallah/Art Resource, NY; **3.14** The Metropolitan Museum of Art/Art Resource, NY; **3.15** Pictorial Press Ltd/Alamy; **3.16** © Studio Kontos, photographersdirect.com; **3.17** Attic Red-Figured Kylix vessel (terracotta)/Brygos Painter (c.500–475 BCE)/J. Paul Getty Museum, Los Angeles, USA/Bridgeman Images; **3.18** © Beowulf Sheehan. All rights reserved.; **3.19** Statue of Hermes and the Infant Dionysus, c.330 BCE (parian marble), Praxiteles (c.400–c.330 BCE)/Archaeological Museum, Olympia, Archaia, Greece/The Bridgeman Art Library; **3.20** Apoxyomenos (marble), Roman, (1st century)/Vatican Museums and Galleries, Vatican City/Photo © AISA/Bridgeman Images; **3.21** Art Resource, NY; **3.22** Pergamon Museum I, Berlin, 2001 (c-print)/Struth, Thomas (b.1954)/DALLAS MUSEUM OF ART/Dallas Museum of Art, Texas, USA/Bridgeman Images; © Thomas Struth **3.23** bpk, Berlin/Antikensammlung, Staatliche Museen, Berlin, Germany/Johannes Laurentius/Art Resource, NY; **3.24** Araldo de Luca/Fine Art/Corbis; **3.25** DEA PICTURE LIBRARY/Getty Images;

3.26 DEA/G. DAGLI ORTI/Getty Images; **3.27** Araldo de Luca/Fine Art Premium/Corbis.

CHAPTER 4 4.1 Andrea Jemolo/Scala/Art Resource, NY; **4.2** Araldo de Luca/Fine Art/Corbis; **4.3** Model of an Etruscan temple, reconstruction, 4th–5th century BCE (plastic)/Institute of Etruscology, University of Rome, Italy/The Bridgeman Art Library; **4.4** Sarcophagus of the Spouses, 525–500 BCE (stone), Etruscan, (6th century BCE)/Louvre, Paris, France/Bridgeman Images; **4.5** Gianni Dagli Orti/The Art Archive at Art Resource, NY; **4.6** Araldo de Luca/Fine Art Premium/Corbis; **4.7** Vanni Archive/Art Resource, NY; **4.8** Cengage Learning/JPoore; **4.9** Fred S. Kleiner 2011; **4.10** Scala/Art Resource, NY; **4.11** © 2018 Cengage Learning; **4.12** Courtesy of the American Numismatic Society; **4.13** Bust of Marcus Tullius Cicero (106–43 BCE) (marble) (detail of 168173), Roman, (1st century BCE)/Musei Capitolini, Rome, Italy/Bridgeman Images; **4.14** Cengage Learning; **4.15** © Cengage Learning; **4.16** Gianni Dagli Orti/The Art Archive at Art Resource, NY; **4.17** David Hiser/National Geographic Creative/Corbis; **4.18** Canabi/Hugo/Iconotec/Alamy; **4.19** Scala/Art Resource, NY; **4.20** Actors mosaic, House of the Tragic Poet, Naples National Archaeological Museum, Naples, Italy.; **4.21** Luciano Romano; **4.22** Aeneas sacrificing to Penates, on main panel of Ara Pacis Augustae (Altar of Augustan Peace), Rome, Lazio, Italy, Roman civilization, 1st century BCE/De Agostini Picture Library/Bridgeman Images; **4.23** Altar of Augustan Peace (Ara Pacis Augustae), 13–9 BCE., 1st Century BCE marble, 12x11 m/Rome, Italy/Mondadori Portfolio/Electa/Andrea Jemolo/Bridgeman Images; **4.24** Sasika Ltd. Cultural Documentation.; **4.25** Scala/Art Resource, NY; **4.26** © Cengage Learning; **4.27** © Cengage Learning; **4.28** © 2018 Cengage Learning; **4.29** HIP/Art Resource, NY; **4.30** Cengage Learning/JPoore; **4.31** Album/Art Resource, NY; **4.32** Fred S. Kleiner; **4.33** Cengage Learning/JPoore; **4.34** Bridgeman Art Library; **4.35** © Cengage Learning; **4.36** © 2018 Cengage Learning; **4.37** Google Maps; **4.38** Jordan: Al Khazneh (The Treasury), Petra/Pictures from History/David Henley/Bridgeman Images; **4.39** © Lois Fichner-Rathus; **4.40** Jonathan Poore/Cengage Learning; **4.41** © 2018 Cengage Learning.

CHAPTER 5 5.1 The Metropolitan Museum of Art/Art Resource, NY; **5.2** Borromeo/Art Resource, NY; **5.3** Scala/Art Resource, NY; **5.4** Erich Lessing/Art Resource, NY; **5.5A** Freer Gallery of Art, Smithsonian Institution, Washington, DC. Purchase, F1949.9a-d; **5.5B** Freer Gallery of Art, Smithsonian Institution, Washington, DC. Purchase, F1949.9a-d; **5.6** Yogesh S. More/age fotostock/SuperStock; **5.7** akg-images; **5.8** Benoy K. Behl; **5.9A** David Keith Jones/Alamy; **5.9B** John Burge; **5.10** Tony Waltham/Robertharding/Getty Images; **5.11** RMN-Grand Palais/Art Resource, NY; **5.12** Seated Buddha in meditation (basalt)/Indian School, (10th century)/Musée

Literary Credits

CHAPTER 1 Page 27: Miriam Lichtheim, *Ancient Egyptian Literature*, Vol. II: The New Kingdom. Berkeley and Los Angeles, CA: University of California Press, 1976, p. 125. **MindTap Voices Feature:** Source: *The Literature of Ancient Egypt*, edited by William Kelly Simpson, New Haven and London, Yale University Press, 1973. http://www.philae.nu/akhet/Ptahotep.html.

CHAPTER 2 Page 56: Source: http://www.ancientgreekonline.com/Language/EpicMeter.htm. **Pages 62–63:** Ovid, *Heroides: Letter from Penelope*. Trans. H.A. S. Hartley. Classical Translations. London: J. & A. McMillan, 1889, p. 113. **Page 63:** Excerpt from Book XXIII, lines 231–240; 259–270 from *The Odyssey* translated by Robert Fitzgerald. Copyright © 1961, 1963 by Robert Fitzgerald. Copyright renewed 1989 by Benedict R.C. Fitzgerald, on behalf of the Fitzgerald children. Reprinted by permission of Farrar, Straus and Giroux, LLC. CAUTION: Users are warned that this work is protected under copyright laws and downloading is strictly prohibited. The right to reproduce or transfer the work via any medium must be secured with Farrar, Straus and Giroux, LLC. **Page 63:** Anne Killigrew. "Penelope" in *Poems* by Mrs. Anne Killigrew. London: Samuel Lownedes, 1686. **Page 63:** "Penelope", copyright 1928, renewed © 1956 by Dorothy Parker, from *The Portable Dorothy Parker* by Dorothy Parker, edited by Marion Meade. Used by permission of Gerald Duckworth & Co. Ltd and Viking Books, an imprint of Penguin Publishing Group, a division of Penguin Random House LLC. **Page 64:** From *The Iliad* of Homer, trans. Richmond Lattimore. Chicago: University of Chicago Press, 2011. © 1951, 2011 by The University of Chicago. All rights reserved.

CHAPTER 3 Page 96: From *The Iliad* of Homer, trans. Richmond Lattimore. Chicago: University of Chicago Press, 2011. © 1951, 2011 by The University of Chicago. All rights reserved.

CHAPTER 5 MindTap Voices Feature: Edith Holland. *The Story of the Buddha*. London: George G. Harrap & Company, LTD, 1918.

CHAPTER 7 Page 237: Source: *The Consolation of Philosophy of Boethius*. Translated into English Prose and Verse by H. R. James, M.A., Oxford. London: Elliot Stock, 62, Paternoster Row. 1897. Pages 79–80. **MindTap Voices Feature:** Procopius of Caesarea, On Buildings, pp. 9–29. Translated by H. B. Dewing, Glanville Downey. Loeb Classical Library 343. Harvard University Press. 1940.

CHAPTER 8 Page 255: From The Table Spread, in *The Meaning of Glorious Koran*, translated by Mohammed Marmaduke Pickthall, 1930, George Allen & Unwin, an imprint of HarperCollins Publishers, Ltd., 1930. **Page 265:** Found on the web here: http://www.alhambradegranada.org/en/info/epigraphicpoems.asp, translated from the poem by Ibnu Zamrak (1333–1393).

CHAPTER 9 MindTap Voices Feature: Jo Ann McNamara, trans. Pierre Riché, Daily Life in the World of Charlemagne.

CHAPTER 10 Page 330: Christopher J. Lucas. *American Higher Education: A History*. New York: St. Martin's Press, 1994. **Pages 332–333:** From Alchin, L.K. The Middle Ages. Retrieved: April 20, 2012 from http://www.middle-ages.org.uk/knights-code-of-chivalry.htm.

CHAPTER 11 Pages 350–351: Extracts from 11.01 "First Day" taken from *The Decameron* by Giovanni Boccaccio, translated with an introduction and notes by G. H. McWilliam (Penguin Classics 1972, Second Edition 1995). Copyright © G. H. McWilliam, 1972, 1995. Reproduced by permission of Penguin Books Ltd. **MindTap Voices Feature:** Geoffrey Berenton, trans. Froissart, Chronicles. Penguin Books, 1968.

CHAPTER 12 Page 395: Ghiberti, "I commentarii," Book II. Quoted in Elizabeth Gilmore Holt, ed., *A Documentary History of Art, I: The Middle Ages and the Renaissance*. Princeton, N.J.: Princeton University Press, 1981, 157–158. **Page 406:** David L. Quint, trans. The Stanze of Angelo Poliziano. Penn State University Press, 1993. **MindTap Voices Feature:** Anne Borelli, Maria Pastore Passaro, trans., Donald Beebe, ed. *Selected Writings of Girolamo Savonarola: Religion and Politics, 1490–1498*. Yale University, 2006.

CHAPTER 13 Page 418: Michelangelo Buonarroti, *Michelangelo: A Record of His Life as Told in His Own Letters and Papers* (trans. Robert W. Carden). Boston & New York: Houghton Mifflin Company, 1913, p. 201. **Page 428:** W.G. Clark, W. A. Wright, & E. Dowden. *The Complete Works of William Shakespeare Arranged in Their Chronological Order*. Chicago: Morrill, Higgins & Co., 1892. **Page 445:** W.G. Clark, W. A. Wright, & E. Dowden. *The Complete Works of William Shakespeare Arranged in Their Chronological Order*. Chicago: Morrill, Higgins & Co., 1892. **MindTap Voices Feature:** Herbert Von Einem. *Michelangelo*. London: Methuen and Company, Ltd, 1973.

READING SELECTIONS

CHAPTER 1 Readings 1.1: Excerpts from *The Epic of Gilgamesh, with an Introduction and Notes*, translated by Maureen Gallery Kovacs. Copyright © 1989 by the Board of Trustees of the Leland Stanford Jr. University, All rights reserved. With the permission of Stanford University Press, www.sup.org. **Readings 1.2:** Excerpts from *The Epic of Gilgamesh, with an Introduction and Notes*, translated by Maureen Gallery Kovacs. Copyright © 1989 by the Board of Trustees of the Leland Stanford Jr. University, All rights reserved. With the permission of Stanford University Press, www.sup.org. **Readings 1.3:** Excerpts from *The Epic of Gilgamesh, with an Introduction and Notes*, translated by Maureen Gallery Kovacs. Copyright © 1989 by the Board of Trustees of the Leland Stanford Jr. University, All rights reserved. With the permission of Stanford University Press, www.sup.org. **Readings 1.4:** Excerpts from *The Epic of Gilgamesh, with an Introduction and Notes*, translated by Maureen Gallery Kovacs. Copyright © 1989 by the Board of Trustees of the Leland Stanford Jr. University, All rights reserved. With the permission of Stanford University Press, www.sup.org. **Readings 1.5:** Excerpts from *The Epic of Gilgamesh, with an Introduction and Notes*, translated by Maureen Gallery Kovacs. Copyright © 1989 by the Board of Trustees of the Leland Stanford Jr. University, All rights reserved. With the permission of Stanford University Press, www.sup.org. **Reading 1.6:** Robert Francis Harper (trans.), *The Code of Hammurabi King of Babylon*, Union, NJ: The Lawbook Exchange, Ltd., 1904. **Reading 1.7:** John L. Foster (trans.), *Ancient Egyptian Literature: An Anthology*, University of Texas Press, 2001. **Reading 1.8:** John L. Foster (trans.), *Ancient Egyptian Literature: An Anthology*, University of Texas Press, 2001. **Reading 1.9:** John L. Foster (trans.), *Ancient Egyptian Literature: An Anthology*, University of Texas Press, 2001. **Reading 1.10:** John L. Foster (trans.), *Ancient Egyptian Literature: An Anthology*, University of Texas Press, 2001. **Reading 1.11:** John L. Foster (trans.), *Ancient Egyptian Literature: An Anthology*, University of Texas Press, 2001.

CHAPTER 2 Reading 2.1: Excerpt from Book VIII, lines 4–49; 78–84; 90–98 from *The Odyssey* translated by Robert Fitzgerald. Copyright © 1961, 1963 by Robert Fitzgerald. Copyright renewed 1989 by Benedict R.C. Fitzgerald, on behalf of the Fitzgerald children. Reprinted by permission of Farrar, Straus and Giroux, LLC. CAUTION: Users are warned that this work is protected under copyright laws and downloading is strictly prohibited. The right to reproduce or transfer the work via any medium must be secured with Farrar, Straus and Giroux, LLC. **Reading 2.2:** From *The Iliad* of Homer, trans. Richmond Lattimore. Chicago: University of Chicago Press, 2011. © 1951, 2011 by The University of Chicago. All rights reserved. **Reading 2.3:** From *The Iliad* of Homer, trans. Richmond Lattimore. Chicago: University of Chicago Press, 2011. © 1951, 2011 by The University of Chicago. All rights reserved. **Reading 2.4:** From *The Iliad* of Homer, trans. Richmond Lattimore. Chicago: University of Chicago Press, 2011. © 1951, 2011 by The University of Chicago. All rights reserved. **Reading 2.5:** From *The Iliad* of Homer, trans. Richmond Lattimore. Chicago: University of Chicago Press, 2011. © 1951, 2011 by The University of Chicago. All rights reserved. **Reading 2.6:** Excerpt from Book I, lines 417–430 from *The Odyssey* translated by Robert Fitzgerald. Copyright © 1961, 1963 by Robert

Fitzgerald. Copyright renewed 1989 by Benedict R.C. Fitzgerald, on behalf of the Fitzgerald children. Reprinted by permission of Farrar, Straus and Giroux, LLC. CAUTION: Users are warned that this work is protected under copyright laws and downloading is strictly prohibited. The right to reproduce or transfer the work via any medium must be secured with Farrar, Straus and Giroux, LLC. **Reading 2.7:** Excerpt from Book II, lines 91–114 from *The Odyssey* translated by Robert Fitzgerald. Copyright © 1961, 1963 by Robert Fitzgerald. Copyright renewed 1989 by Benedict R.C. Fitzgerald, on behalf of the Fitzgerald children. Reprinted by permission of Farrar, Straus and Giroux, LLC. CAUTION: Users are warned that this work is protected under copyright laws and downloading is strictly prohibited. The right to reproduce or transfer the work via any medium must be secured with Farrar, Straus and Giroux, LLC. **Reading 2.8:** Excerpt from Book II, lines 292–300 from *The Odyssey* translated by Robert Fitzgerald. Copyright © 1961, 1963 by Robert Fitzgerald. Copyright renewed 1989 by Benedict R.C. Fitzgerald, on behalf of the Fitzgerald children. Reprinted by permission of Farrar, Straus and Giroux, LLC. CAUTION: Users are warned that this work is protected under copyright laws and downloading is strictly prohibited. The right to reproduce or transfer the work via any medium must be secured with Farrar, Straus and Giroux, LLC. **Reading 2.9:** Excerpt from Book V, lines 32–47 from *The Odyssey* translated by Robert Fitzgerald. Copyright © 1961, 1963 by Robert Fitzgerald. Copyright renewed 1989 by Benedict R.C. Fitzgerald, on behalf of the Fitzgerald children. Reprinted by permission of Farrar, Straus and Giroux, LLC. CAUTION: Users are warned that this work is protected under copyright laws and downloading is strictly prohibited. The right to reproduce or transfer the work via any medium must be secured with Farrar, Straus and Giroux, LLC. **Reading 2.10:** Excerpt from Book XXIV, lines 603–614 from *The Odyssey* translated by Robert Fitzgerald. Copyright © 1961, 1963 by Robert Fitzgerald. Copyright renewed 1989 by Benedict R.C. Fitzgerald, on behalf of the Fitzgerald children. Reprinted by permission of Farrar, Straus and Giroux, LLC. CAUTION: Users are warned that this work is protected under copyright laws and downloading is strictly prohibited. The right to reproduce or transfer the work via any medium must be secured with Farrar, Straus and Giroux, LLC. **Reading 2.11:** From *The Iliad* of Homer, trans. Richmond Lattimore. Chicago: University of Chicago Press, 2011. © 1951, 2011 by The University of Chicago. All rights reserved. **Reading 2.12:** Lines 25–42 from *Theogony; Works and Days; Elegies* by Hesiod and Theognis, translated with an introduction by Dorothea Wender (Penguin Classics, 1973). Copyright © Dorothea Wender, 1973. Reproduced by permission of Penguin Books Ltd. **Reading 2.13:** Lines 690–697 and 705–717 from *Theogony; Works and Days; Elegies* by Hesiod and Theognis, translated with an introduction by Dorothea Wender (Penguin Classics, 1973). Copyright © Dorothea Wender, 1973. Reproduced by permission of Penguin Books Ltd. **Reading 2.14:** Richard Lattimore, trans. Greek Lyrics, second edition. Chicago: University of Chicago Press, 1960. Used with permission. **Reading 2.15:** Excerpt from *Sappho and the Greek Lyric Poets*, translated by Willis Barnstone, copyright © 1962, 1967, 1988 by Willis Barnstone. Used by permission of the author. **Reading 2.16:** Excerpt from *The Classics in Translation*, Volume I, edited by Paul L. MacKendrick and Herbert M. Howe, copyright 1952. Reprinted by permission of The University

of Wisconsin Press. **Reading 2.17:** 850 words and a 10-line inscription from *The Histories* by Herodotus, translated by Aubrey de Sélincourt, revised with introductory matter and notes by John Marincola (Penguin Classics 1954, Second revised edition 1996). Translation copyright 1954 by Aubrey de Sélincourt. This revised edition copyright © John Marincola, 1996. Reproduced by permission of Penguin Books Ltd.

CHAPTER 3 Reading 3.1: Richard Crawley (trans.) *Thucidides History of the Peloponnesian War.* London: J. M. Dent & Sons, 1866 **Reading 3.2:** Richard Crawley (trans.) *Thucidides History of the Peloponnesian War.* London: J. M. Dent & Sons, 1866 **Reading 3.3:** Richard Crawley (trans.) *Thucidides History of the Peloponnesian War.* London: J. M. Dent & Sons, 1866. **Reading 3.4:** J. J. Pollitt (trans.) *The Art of Ancient Greece: Sources and Documents.* New York: Cambridge University Press, 1990, p. 76. **Reading 3.5:** Excerpt from *The Classics in Translation*, Volume I, edited by Paul L. MacKendrick and Herbert M. Howe, copyright 1952. Reprinted by permission of The University of Wisconsin Press. **Reading 3.6:** Book VII of "The Republic: Allegory of the Cave" from The *Great Dialogues of Plato* by Plato, translated by W. H. D. Rouse. Copyright © 1956 and renewed 1984 by J. C. G. Rouse. **Reading 3.7:** *Nicomachean Ethics*, Book VII, "The Nature of Happiness," Edwin L. Minar, Jr., trans., from *Classics in Translation, Vol. I, Greek Literature*, Paul MacKendrick and Herbert M. Howe, ed., Madison: University of Wisconsin Press, 1952. **Reading 3.8:** Benjamin Jowett (trans.) Aristotle's *Politics*. Oxford: Clarendon Press, 1906. **Reading 3.9:** E. G. Sihler (Ed.). *The Protagoras of Plato*. New York: Harper & Brothers, 1881. **Reading 3.10:** Robert Fagles (trans.) *The Oresteian Trilogy: Agamemnon, The Choephori, The Eumenides.* Penguin Classics, 1973. **Reading 3.11:** Robert Fagles (trans.) *The Oresteian Trilogy: Agamemnon, The Choephori, The Eumenides.* Penguin Classics, 1973. **Reading 3.12:** Robert Fagles (trans.) *The Oresteian Trilogy: Agamemnon, The Choephori, The Eumenides.* Penguin Classics, 1973. **Reading 3.13:** Robert Fagles (trans.) *The Oresteian Trilogy: Agamemnon, The Choephori, The Eumenides.* Penguin Classics, 1973. **Reading 3.14:** Robert Fagles (trans.) *Sophocles: The Three Theban Plays: Antigone, Oedipus the King, Oedipus at Colonus.* Penguin Books, 1982, 1984. **Reading 3.15:** Robert Fagles (trans.) *Sophocles: The Three Theban Plays: Antigone, Oedipus the King, Oedipus at Colonus.* Penguin Books, 1982, 1984. **Reading 3.16:** Robert Fagles (trans.) *Sophocles: The Three Theban Plays: Antigone, Oedipus the King, Oedipus at Colonus.* Penguin Books, 1982, 1984. **Reading 3.17:** Robert Fagles (trans.) *Sophocles: The Three Theban Plays: Antigone, Oedipus the King, Oedipus at Colonus.* Penguin Books, 1982, 1984. **Reading 3.18:** Robert Fagles (trans.) *Sophocles: The Three Theban Plays: Antigone, Oedipus the King, Oedipus at Colonus.* Penguin Books, 1982, 1984. **Reading 3.19:** S. H. Butcher (trans.) *Aristotle's Theory of Poetry and Fine Art*, Third Edition. New York: Macmillan & Co., LTD, 1902. **Reading 3.20:** Translated by George Theodoridis, 2010.http://bacchicstage.wordpress.com/. **Reading 3.21:** Translated by George Theodoridis, 2010.http://bacchicstage.wordpress.com/. **Reading 3.22:** Translated by George Theodoridis, 2010.http://bacchicstage.wordpress.com/. **Reading 3.23:** Translated by George Theodoridis, 2010.http://bacchicstage.wordpress.com/. **Reading 3.24:** Douglass Parker (trans.) Aristophanes *Lysistrata*. University of Michigan Press, 1964. **Reading 3.25:** J. J. Pollitt

(trans.) *The Art of Greece 1400–31 BCE: Sources and Documents*. Englewood Cliffs, NJ: Prentice-Hall, 1965, p. 144.

CHAPTER 4 Reading 4.1: De bello civili: Book 1, from W. A. McDevitte & W. S. Bohn, trans. *Caesar's Commentaries.* New York: Harper & Brothers, 1869. **Reading 4.2:** Walter Miller, trans. *Cicero de Officiis.* New York: The Macmillan Co., 1921, p. 293. **Reading 4.3:** Copyright © 1956, 1972 by the Estate of Horace Gregory, from his *Poems of Catullus* (W. W. Norton, 1972). Used with permission. **Reading 4.4:** W. E. Leonard, trans. *Of the Nature of Things.* New York: E. P. Dutton & Co., 1921. **Reading 4.5:** Moses Hadas, trans. *The Stoic Philosophy of Seneca: Essays and Letters.* New York: W. W. Norton, 1958. **Reading 4.6:** W. A. Oldfather, trans. *Epictetus*, Volume II. Loeb Classical Library. Cambridge: Harvard University Press, 1928. **Reading 4.7:** Gregory Hays, Trans. *Meditations* by Marcus Aurelius, translated and with an introduction by Gregory Hays. 2002. **Reading 4.8:** MacKendrick, Paul and Herbert M. Howe. *Classics in Translation*, Vol II. © 1952 by the Board of Regents of the University of Wisconsin System. Reprinted by permission of The University of Wisconsin Press. **Reading 4.9:** *The Aeneid of Virgil.* Humphries, Rolfe and Wilke, Brian. Macmillan: New York. 1987. **Reading 4.10:** *The Aeneid of Virgil.* Humphries, Rolfe and Wilke, Brian. Macmillan: New York. 1987. **Reading 4.11:** *The Aeneid of Virgil.* Humphries, Rolfe and Wilke, Brian. Macmillan: New York. 1987. **Reading 4.12:** *The Aeneid of Virgil.* Humphries, Rolfe and Wilke, Brian. Macmillan: New York. 1987. **Reading 4.13:** *The Aeneid of Virgil.* Humphries, Rolfe and Wilke, Brian. Macmillan: New York. 1987. **Reading 4.14:** Trans. By Jon Corelis. Reprinted with his permission. **Reading 4.15:** C. E. Bennett, trans. *The Odes and Epodes of Horace.* Cambridge: Harvard University Press, Loeb Classical Library, 1914. **Reading 4.16:** The Third Satire of Juvenal in *The Miscellaneous Works of John Dryden*, Vol. 4. London: J. and R. Tonson, 1767, pg. 229–230. **Reading 4.17:** Translated by Laurence Eusden. From: Samuel Garth, Ovid's *Metamorphoses*. London: Jacob Tonson, 1717.

CHAPTER 5 Reading 5.1: Chakravari Narasimhan, trans. *The Mahabharata.* Columbia University Press, 1997. **Reading 5.2:** *The Norton Anthology of World Literature*, second edition, Volume A. Sarah Lawall and Maynard Mack (Eds.). New York: W. W. Norton & Company, 2002, pp. 1014–1018. **Reading 5.3:** Dominic Goodall, trans. *Hindu Scriptures.* J. M. Dent, a division of The Orion Publishing Group, 1996. **Reading 5.4:** R. C. Zaehner, trans. *The Hindu Scriptures.* Everymans Library, 1966. **Reading 5.5:** From *The Upanishad*, translated with an introduction by Juan Mascaro (Penguin Classics, 1965). **Reading 5.6:** From *The Wisdom of Buddhism*, trans. Christmas Humphries, pp. 36–37, 42–45. **Reading 5.7:** *Columbia Book of Chinese Poetry: From Early Times to the Thirteenth Century.* **Reading 5.8:** *Columbia Book of Chinese Poetry: From Early Times to the Thirteenth Century.* **Reading 5.9:** "Like a Dream" by Stephen Owen, Editor and Translator, from *An Anthology of Chinese Literature: Beginnings to 1911*, edited by Stephen Owen and The Council for Cultural Planning and Development of the Executive Yuan of the Republic of China. Used by permission of W. W. Norton & Company, Inc. **Reading 5.10:** Arthur Waley, trans. Murasaki Shikibu. *The Tale of Genji* by Rutland: Tuttle Publishing, 2010.

CHAPTER 6 **Reading 6.1:** From Genesis, Exodus, Job, Amos, Matthew, Acts, I Corinthians, and II Corinthians of Revised Standard Version Bible, copyright 1946, 1952, 1972 by the Division of Christian Education of the National Council, Churches of Christ in the U.S.A. **Reading 6.2:** From Genesis, Exodus, Job, Amos, Matthew, Acts, I Corinthians, and II Corinthians of Revised Standard Version Bible, copyright 1946, 1952, 1972 by the Division of Christian Education of the National Council, Churches of Christ in the U.S.A. **Reading 6.3:** From Genesis, Exodus, Job, Amos, Matthew, Acts, I Corinthians, and II Corinthians of Revised Standard Version Bible, copyright 1946, 1952, © 1972 by the Division of Christian Education of the National Council, Churches of Christ in the U.S.A. **Reading 6.4:** From Genesis, Exodus, Job, Amos, Matthew, Acts, I Corinthians, and II Corinthians of Revised Standard Version Bible, copyright 1946, 1952, © 1972 by the Division of Christian Education of the National Council, Churches of Christ in the U.S.A. **Reading 6.5:** From Genesis, Exodus, Job, Amos, Matthew, Acts, I Corinthians, and I Corinthians of Revised Standard Version Bible, copyright 1946, 1952, © 1972 by the Division of Christian Education of the National Council, Churches of Christ in the U.S.A. **Reading 6.6:** From Genesis, Exodus, Job, Amos, Matthew, Acts, I Corinthians, and II Corinthians of Revised Standard Version Bible, copyright 1946, 1952, © 1972 by the Division of Christian Education of the National Council, Churches of Christ in the U.S.A. **Reading 6.7:** From Genesis, Exodus, Job, Amos, Matthew, Acts, I Corinthians, and II Corinthians of Revised Standard Version Bible, copyright 1946, 1952, © 1972 by the Division of Christian Education of the National Council, Churches of Christ in the U.S.A. **Reading 6.8:** Lawrence C. Cunningham, *The Catholic Heritage*, Wipf & Stock Publishers, 2002.

CHAPTER 7 **Reading 7.1:** From Book VIII and Book IX of *Confessions* by Saint Augustine, translated with an introduction by R. S. Pine-Coffin (Penguin Classics, 1961). **Reading 7.2:** From Book XIX of *Concerning the City of God: Against the Pagans* by Saint Augustine, translated by Henry Bettenson, introduction by G. R. Evans (First published in Pelican Books 1972, Reprinted in Penguin Classics, 1984, Reissued Penguin Classics 2003). Translation copyright © Henry Bettenson, 1972. Chronology, Introduction, Further Reading copyright © G. R. Evans, 2003. Reprinted by permission of Penguin Books, Ltd. **Reading 7.3:** From Book XIX of *Concerning the City of God: Against the Pagans* by Saint Augustine, translated by Henry Bettenson, introduction by G. R. Evans (First published in Pelican Books 1972, Reprinted in Penguin Classics, 1984, Reissued Penguin Classics 2003). Translation copyright © Henry Bettenson, 1972. Chronology, Introduction, Further Reading copyright © G. R. Evans, 2003. Reprinted by permission of Penguin Books, Ltd. **Reading 7.4:** From *St. Augustine, the Literal Meaning of Genesis*, vol. 1, *Ancient Christian Writers*, vol. 41. Translated and annotated by John Hammond Taylor, S.J. New York: Paulist Press, 1982. **Reading 7.5:** Source: *The Consolation of Philosophy of Boethius*. Translated into English Prose and Verse by H. R. James, M. A., Oxford. London: Elliot Stock, 62, Paternoster Row. 1897. Pages 6–7.

CHAPTER 8 **Reading 8.1:** From "The Opening," "The Table Spread," "The Children of Israel," "The Coursers," "The Unity" from *The Meaning of Glorious Koran*, translated by Mohammed Marmaduke Pickthall, 1930, George Allen & Unwin, an imprint of HarperCollins Publishers, Ltd., 1930. **Reading 8.2:** From "The Opening," "The Table Spread," "The Children of Israel," "The Coursers," "The Unity" from *The Meaning of Glorious Koran*, translated by Mohammed Marmaduke Pickthall, 1930, George Allen & Unwin, an imprint of HarperCollins Publishers, Ltd., 1930. **Reading 8.3:** Powys Mathers, trans. "The Thousand and One Nights," in *The Longman Anthology of World Literature: Compact Edition*, ed. David Damrosch & David L. Pike, (Upper Saddle River, NJ: Pearson Education, 2008), 1113, 1148, and 1151. **Reading 8.4:** Powys Mathers, trans. "The Thousand and One Nights," in *The Longman Anthology of World Literature: Compact Edition*, ed. David Damrosch & David L. Pike, (Upper Saddle River, NJ: Pearson Education, 2008), 1113, 1148, and 1151. **Reading 8.5:** Edward Fitzgerald, trans. *The Rubaiyat of Omar Khayyam*. fifth edition, 1889. **Reading 8.6:** Edward Fitzgerald, trans. *The Rubaiyat of Omar Khayyam*. fifth edition, 1889. **Reading 8.7:** From *Readings from the Mystics of Islam*, translated by Margaret Smith, 1950. Copyright Pir Press. All rights reserved. Reproduced by permission. **Reading 8.8:** *The Mathnawi of Jalalu'ddin Rumi*, trans. and ed. Reynold A. Nicholson, Vol. 4. Gibb Memorial New Series 4. (London: E. J. W. Gibb Memorial Trust/Luzac & Co., 1921), 3.1259–1268. **Reading 8.9:** Excerpt from *Essential Rumi*, translated by Coleman Barks and John Moyne.

CHAPTER 9 **Reading 9.1:** John Stevens, trans. *The Ecclesiastical History of the English Nation: The Venerable Bede*. London: J. M. Dent & Sons Ltd., 1910. **Reading 9.2:** Extracts from *Beowulf*. A new verse translation by Seamus Heaney Bilingual edition, New York: W. W. Norton & Company. Copyright © 2000 by Seamus Heaney. **Reading 9.3:** Extracts from *Beowulf*. A new verse translation by Seamus Heaney Bilingual edition, New York: W. W. Norton & Company. Copyright © 2000 by Seamus Heaney. **Reading 9.4:** Extracts from *Beowulf*. A new verse translation by Seamus Heaney Bilingual edition, New York: W. W. Norton & Company. Copyright © 2000 by Seamus Heaney. **Reading 9.5:** From *Hildegard of Bingen: Scivias*, translated by Mother Columbia Hart and Jane Bishop. **Reading 9.6:** From: *Causae et Curae*, quoted and translated by Peter Dronke. **Reading 9.7:** *The Conversion of the Harlot Thais* by Hrosvitha von Gandersheim, translated by Katharina Wilson. **Reading 9.8:** "Everyman" from *Everyman and Medieval Miracle Plays*, edited by A. C. Crowley, 1952, © Everyman's Library, Northburgh House, 10 Northburgh Street, London ECIVOAT. **Reading 9.9:** Robert Harrison, trans. *The Song of Roland*. New York: SIGNET CLASSICS, a division of Penguin Group. Copyright © Robert Harrison, 1970.

CHAPTER 10 **Reading 10.1:** Robert Kehew, ed., Ezra Pound, W. D. Snodgrass, & Robert Kehew, trans. *Lark in the Morning: The Verses of the Troubadours*. Chicago: The University of Chicago Press, 2005, p. 23. **Reading 10.2:** David Damrosch & David L. Pike, eds. *The Longman Anthology of World Literature, Compact Edition*. New York: Pearson Longman, 2008, p. 1183. Translated by David L. Pike and used with his permission. **Reading 10.4:** David Damrosch & David L. Pike, eds. *The Longman Anthology of World Literature, Compact Edition*. New York: Pearson Longman, 2008, p. 1187. Translated by David L. Pike and used with his permission. **Reading 10.5:** *The Romance of the Rose*, third edition by Guillaume de Lorris & Jean de Meun (Trans.) Charles Dahlberg. Princeton, NJ: Princeton University Press, Copyright: 1971, Second Edition preface: 1983, Third Edition preface: 1995. **Reading 10.6:** Israël Abrahams, *Jewish Life in the Middle Ages*, MacMillan and Co., Ltd, London, 1896. **Reading 10.7:** Lawrence S. Cunningham, trans. *Francis of Assisi: Performing the Gospel Life*. Wm B. Eerdmans Publishing Co., 2004. Reprinted by permission of Lawrence S. Cunningham. **Reading 10.8:** Fathers of the English Dominican Province, trans. The "Summa Theologica" of *St. Thomas Aquinas, Part I*. London: Burns Oates & Washbourne Ltd., 1921.

CHAPTER 11 **Reading 11.1:** From *The Divine Comedy* by Dante Alighieri, translated by John Ciardi. **Reading 11.2:** From *The Divine Comedy* by Dante Alighieri, translated by John Ciardi. **Reading 11.3:** From *The Divine Comedy* by Dante Alighieri, translated by John Ciardi. **Reading 11.4:** From *The Divine Comedy* by Dante Alighieri, translated by John Ciardi. **Reading 11.5:** Translations from Dante, Petrarch, Michael Angelo, and Vitoria Colonna. London, Kegan Paul & Co.: 1879. **Reading 11.6:** Translations from Dante, Petrarch, Michael Angelo, and Vitoria Colonna. London, Kegan Paul & Co.: 1879. **Reading 11.7:** *The Canterbury Tales* by Chaucer, translated by Wright (2011) 56 lines from "General Prologue" and "Reading 43". By permission of Oxford University Press. **Reading 11.8:** *The Canterbury Tales* by Chaucer, translated by Wright (2011) 56 lines from "General Prologue" and "Reading 43". By permission of Oxford University Press. **Reading 11.9:** From *The Book of the City of Ladies*, by Christine de Pizan. Translated by Earl Jeffrey Richards. Copyright © 1982 by Persea Books, Inc.

CHAPTER 12 **Reading 12.1:** Lorna De Lucchi, trans. *An Anthology of Italian Poems, 13th 19th Century*, New York: Knopf, 1922. pp. 103, 105. **Reading 12.1A:** Francois Rabelais, *Gargantua and Pantagruel*, Book 2, chapter 7 (1532-64), tr. Paul Brians (Harcourt Custom Publishing, 1999). **Reading 12.2:** "Oration on the Dignity of Man," translated by Elizabeth Livermore Forbes, in T*he Renaissance Philosophy of Man*, edited by Ernst Cassirer, Paul Oskar Kristeller, John Herman Randall, Jr. (Chicago: University of Chicago Press, 1948), 223–54. **Reading 12.3:** Excerpt by Laura Cereta from *Her Immaculate Hand: Selected Works by and about the Women Humanists of Quattrocento Italy*, by Margaret L. King and Albert Rabil (Eds.), Second Revised Edition. © 1997 Pegasus Press, Asheville, NC 28803. Used with permission. **Reading 12.4:** Excerpt by Laura Cereta from *Her Immaculate Hand: Selected Works by and about the Women Humanists of Quattrocento Italy*, by Margaret L. King and Albert Rabil (Eds.), Second Revised Edition. © 1997 Pegasus Press, Asheville, NC 28803. Used with permission. **Reading 12.5:** Diana Robin trans. Laura Cereta, *Collected Letters of a Renaissance Feminist*, Chicago: The University of Chicago Press, 1997. **Reading 12.6:** Excerpt from *The Prince* by Niccolo Machiavelli. Translated by W. K. Marriott, 1908. http://www.constitution.org/mac/prince18.htm. **Reading 12.7:** Excerpt from *The Prince* by Niccolo Machiavelli. Translated by W. K. Marriott, 1908. http://www.constitution.org/mac/prince17.htm. **Reading 12.8:** The Praise of Folly, from *The Essential Erasmus* by Erasmus, translated by John P. Dolan.

CHAPTER 13 **Reading 13.1:** Jean Paul Richter. (Ed. & trans.). *The Literary Works of Leonardo da Vinci.* 2 vols. London: S. Low, Marston, Searle & Rivington, 1883. **Reading 13.2:** Lorna de' Lucchi, trans. *An Anthology of Italian Poems 13th–19th Century.* New York: Alfred A. Knopf, 1922, p. 127. **Reading 13.3:** Source: Translations from Dante, Petrarch, Michael Angelo, and Vitoria Colonna. London, Kegan Paul & Co.: 1879, p. 317. **Reading 13.4:** "On Women" from *The Book of the Courtier* by Baldesar Castiglione, translated by George Bull (Penguin Classics, 1967). Copyright © George Bull, 1967. **Reading 13.5:** "On Women" from *The Book of the Courtier* by Baldesar Castiglione, translated by George Bull (Penguin Classics, 1967). Copyright © George Bull, 1967. Reprinted by permission of the publisher Penguin Books, Ltd. **Reading 13.6:** Veronica Franco, *Poems and Selected Letters.* Edited and translated by Ann Rosalind Jones and Margaret F. Rosenthal. Chicago: The University of Chicago Press, 1998. pp. 38–39. Reprinted by permission of University of Chicago Press. **Reading 13.7:** Ann Rosalind Jones and Margaret F. Rosenthal, trans. *Veronica Franco, Poems and Selected Letters.* Chicago: The University of Chicago Press, 1998, pp. 38–39. **Reading 13.8:** From *The Autobiography of Benvenuto Cellini*, translated by George Bull (Penguin Classics, 1956). Copyright George Bull, 1956. Reprinted by permission of Penguin Books, Ltd.

Index

Pages marked in italics indicate illustrations.